AMERICAN ART TO 1900

MILTON W_{olf} BROWN

American Art to 1900

Painting · Sculpture · Architecture

HARRY N. ABRAMS, INC., PUBLISHERS

NEW YORK

TO BLANCHE, OF COURSE

Theresa C. Brakeley, Editor

LIBRARY OF CONGRESS CATALOGING IN PUBLICATION DATA

Brown, Milton Wolf, 1911-
~~History of~~ American art to 1900.

Bibliography:
Includes index.
1. Art, American—History. 2. Art, Colonial—
United States. 3. Art. Modern—19th century—
United States. I. Title.
N6505.B76 709'.73 72-99241
ISBN 0-8109-0207-9

Library of Congress Catalogue Card Number: 72-99241
Published 1977 by Harry N. Abrams, Incorporated, New York
All rights reserved. No part of the contents of this book may be
reproduced without the written permission of the publishers
Printed and bound in Japan

CONTENTS

PREFACE

Scholarship in American art is relatively young and, although the literature has become fairly extensive in recent years, there is much still to be done. The debt I owe to all who have worked in the field is beyond expression; the selected bibliography is only a partial list of those to whom I am beholden. I regret that it is impossible to thank individually all the scholars, and collectors, and all the libraries, museums, historical societies, and other institutions whose staff members have been kind enough to answer queries or supply information. A book of this kind is largely a compendium of knowledge gathered by others, though I take total responsibility for the use of that knowledge and the opinions expressed.

I should like to thank those graduate students in the Ph.D Program in Art History at the City University of New York who, as part of their training, served as research assistants in collecting material and checking facts—Judith Wolfe, Robert Lamb, Nancy Grove, Phoebe Jacobs. I am grateful to Milton S. Fox, who saw the project through its early stages, for his assistance and unfailing sympathy. I deeply regret that he is not alive to see it completed. The staff at Harry N. Abrams, Inc., has been helpful and pleasant. I am especially grateful to Margaret L. Kaplan for her supervision of the manuscript through all its phases. For the herculean task of gathering the illustrative material I can scarcely thank Barbara Lyons of the picture department enough. And my sincerest admiration goes to Theresa Brakeley for her editorial contributions to this book. I appreciate the graciousness of my colleague William H. Gerdts in sharing his limitless knowledge of American art with me. My thanks also go to Mrs. Florence Brill and Mrs. Melba Warren for their dedication and care in transcribing and typing the manuscript in its various stages. And, lastly and mostly, I owe a profound debt to my wife, Blanche, for her constant support and understanding through a long and difficult undertaking.

I hope this book will serve as a guide to an understanding of America's cultural traditions in art and architecture and as an introduction to our own times. There is much to learn from the past, even more to appreciate. Though American culture is part of the heritage of Western civilization, we have added to it something of our own, expressing our "genius" through the creative talents of our artists. This is an attempt to tell that story.

Graduate School
City University of New York

PART ONE

THE COLONIAL PERIOD

Introduction: The New World

The colonization of the Americas was part of the world-wide expansion of Europe beginning in the sixteenth and seventeenth centuries, a phase of a larger historical epoch which is only now coming to an end. The basic character of European colonialism was one of territorial spread and exploitation as part of an emerging mercantile capitalism, but within this general picture the American experience was an exception. This exceptionalism, which has helped form our national character, our culture, and our art, was the result of historical factors too complex and extensive to go into at length here, but some of them are pertinent to an understanding of the early stages of our artistic development and must be dealt with even at the risk of oversimplification.

In the first place, without denying the contributions of many national groups to American colonial life, there is no question that it was dominated by the English and their traditions. The English settlements in the New World were basically different from those of the Spanish and French and even from those of the Dutch. Curiously enough, they were also different from the normal patterns of English colonialism in other parts of the world, India, for instance. The truth is that the English colonies in America were something of an anachronism for mercantile capitalism, a throwback to a more ancient form of colonization, remarkably similar to the Greek colonial expansion of the seventh and sixth centuries B.C., when consorts of citizens for a variety of reasons left their home city-states to found new city-states in other parts of the Mediterranean area. The American and Greek experiences were similar in that both sought permanent settlement in a new land; were organized under some form of compact, charter, or constitution; thought of themselves as English or Greek; carried with them the traditions and the rights of the mother country and tried to maintain them in a new world; and had cultural and sentimental ties which tended to loosen with time. Both groups were fundamentally concerned not with the subjugation and exploitation of an indigenous population but with the conquest and exploitation of the land through their own efforts and labor. In this the English colonies in America

differed most markedly from their Spanish counterparts.

This difference is due in part to a second factor, historical accident, which was to determine the nature of future developments. The pre-Columbian inhabitants of the American land mass presented a cultural spread from the urban civilizations of the Incas and Aztecs to the Stone Age tribes of the Sioux, and comparable variations in population density. The Spaniards found highly organized empires with large populations which they proceeded to conquer, reorganize, and exploit as colonial dependencies, but over the centuries the overwhelming native populations absorbed the conqueror and his culture into their own, creating a synthesis in which one can still discern the divergent sources. In contrast, the English found a land sparsely settled by fairly primitive peoples, at most transitional from a hunting to a rudimentary agricultural economy, unwilling or unable to be exploited either through peonage or slavery. The Indian was eventually eliminated as an element in the environment. At most the Europeans may have learned something about living in the wilderness from the natives, and though they readily adopted indigenous agricultural products from them, there was never any real cultural interplay between the two peoples. The uncompromisingly aggressive and expansionist drive of the colonists, motivated by a constantly increasing population and the need for new land, made even physical coexistence impossible. Thus, English expansion in the New World was really colonization rather than colonialism, and the failure to recognize that distinction colored the relationship between the colonists and the mother country. While the former thought themselves Englishmen abroad, the latter could never convince herself that they were not part of her imperialist empire.

Perhaps the most crucial factor in the North American colonization was the proliferation of its European population, with expanding enclaves of settlers unremittingly hacking their way into the wilderness and establishing new settlements. Unimpeded by any massive opposition and without the possibility of an exploitative colonialism, the English colonies were simply extensions of English culture. This is equally true of the Dutch, Swedish, and,

to a lesser extent, French settlements. American culture of the Colonial period is, thus, essentially a provincial offshoot of European culture. As time went on and the colonies grew and developed their own roots, they took on a new coloration and a more independent stance, but their ties in tradition, language, and customs were still with the Old World. Of all the other early influences, the Spanish in Florida, the Southwest, and California was the strongest and the only one in which some admixture of indigenous Indian forms is apparent. However, the Spanish areas became part of the United States only in the middle of the nineteenth century, long after the mold of American culture had been set, so that, although the Spanish is the only major exceptional phase of our artistic heritage, it has remained largely local and not especially generative. Long before the Revolution the thirteen original colonies were thoroughly English in language, culture, and political orientation, and it is back toward England that one must look for the influences that helped shape American art.

When the first colonists arrived in the New World, their first efforts were naturally utilitarian. Unlike the aborigines, for whom "art" was an integral part of existence, the civilized Europeans conceived of it as a luxury. The first activities of the colonists were therefore "artless." But, with increasing stability and wealth, art began to emerge from utility and craft. The Europeans understood art as something apart from necessity, something special that expressed their way of life, a mark of station, a sign of wealth, and a symbol of their heritage. Despite stringent conditions of immigration, they did bring with them books, an occasional portrait, an especially valued piece of furniture, or an heirloom. These were mementos of a former life but also standards for a new one they were intent on achieving. The land was new, but the people were not. They came with age-old traditions and crafts, and they sought to create for themselves as soon as possible a physical and cultural environment like the one they had left. In its beginnings American culture in general and American art in particular were not new in a radical sense but provincial and quite conservative manifestations of a European heritage.

CHAPTER ONE

Early Colonial Architecture

The First Settlements

THE ENGLISH COLONIES

Shelter is one of the primary needs of man, and the settlers had to protect themselves from the weather almost immediately on arrival. The makeshift shelters erected in Jamestown, Plymouth, Salem, and New Amsterdam have long since disappeared, but examples have been reconstructed from contemporary descriptions and may be studied today in Pioneer Park, Salem, Mass. (plate 1). Among these, the *dugout* was the most primitive in form, like a cave dug into the earth or the side of a hill, sometimes built up with sod and covered over with poles and bark, obviously temporary and not very weathertight. Somewhat more ambitious was the *palisade hut* or *cabin,* which was built of upright poles driven into the ground,

fitted together to form tables and stools, beds were made of boughs and straw, most utensils were wooden, and woven with wattles, chinked with clay, and roofed with turf or thatch. The *wigwam* may be derived from the building traditions of local Indians, although there seem to be some English antecedents in the meager hut shelters of poorer yeomen. These wigwams were constructed by bending and tying stripped saplings into a vault, interweaving them with twigs, and covering them with bark. For added insulation the interior might be sheathed with straw. Fireplaces and chimneys were made of fieldstones laid in clay as high as they would remain in place and then carried upward in wood daubed with clay. These were indeed flimsy expedients, which could not long withstand the accidents of weather or fire. Split logs and poles were

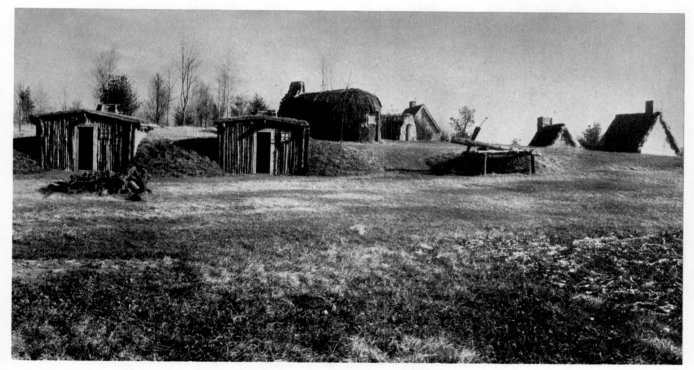

1 Pioneer Village, Salem, Mass., showing dugouts. Theoretical reconstruction, 20th century

only the iron cooking pots which they had brought with them gave any indication of the advanced technology out of which these people had come.

Yet before long, in some places within the year, the colonists began to erect more permanent *cottages,* which reveal their architectural traditions. Most of the New England settlers came from the rural areas of East Anglia, and the building forms of that region, ingrained in the life and craft of these people, were transplanted, though modified by local conditions and materials. Although English urban and manor architecture was already reflecting the influence of the Renaissance in the early years of the seventeenth century, the vernacular style of the countryside was still predominantly Gothic. Houses were constructed of oak-beamed frames which were mortise-and-tenon jointed, the intervening spaces packed with wattle and daub (twigs and clay), cat and clay (chopped straw and clay), or brick, called "nogging." The exterior was at times left unfinished except for whitewashing the filling material, at others surfaced with plaster, weather-boarded, or hung with tiles or slate shingles. Such houses offered a richly patterned and picturesque appearance, and there is some evidence that early cottages in the colonies followed these traditions, although no examples now remain. The common type in New England, perhaps because of the rigors of climate, abundance of wood, and scarcity of some materials, were of half timber with weatherboarding, which in America was called clapboarding, for added insulation.

The framed half-timbered house in America continued a long medieval European tradition of carpentry construction. Individual members were not nailed together;

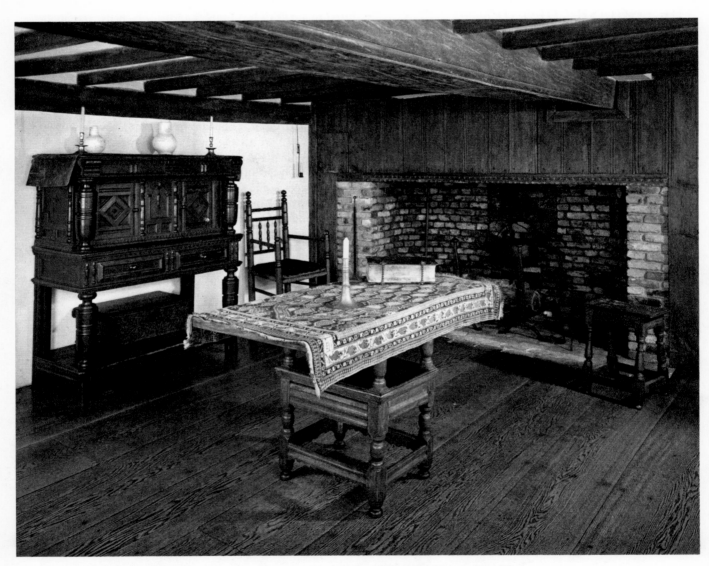

2 Room from Thomas Hart House, Ipswich, Mass. c. 1640. American Wing, The Metropolitan Museum of Art, New York

3 Typical plans of New England Colonial houses, rendered by Philip White. Courtesy Hugh Morrison, from his *Early American Architecture . . .*, 1952

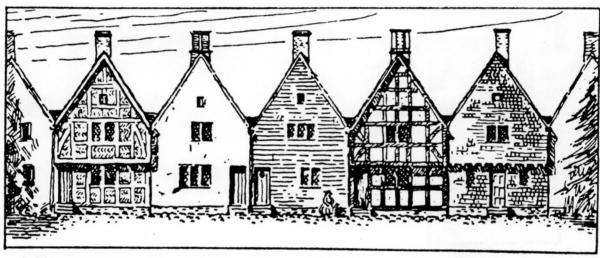

4 Five types of architectural treatment in English houses. From Forman, *The Architecture of the Old South . . .*, 1948

5 Mortise-and-tenon joints, rendered by Stevenson Flemer. Courtesy Hugh Morrison, from his *Early American Architecture . . .*, 1952

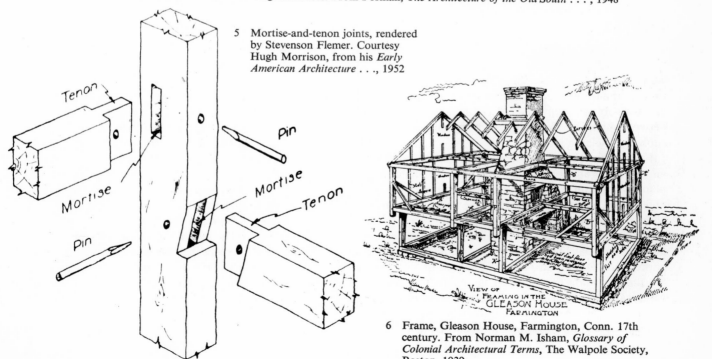

6 Frame, Gleason House, Farmington, Conn. 17th century. From Norman M. Isham, *Glossary of Colonial Architectural Terms*, The Walpole Society, Boston, 1939

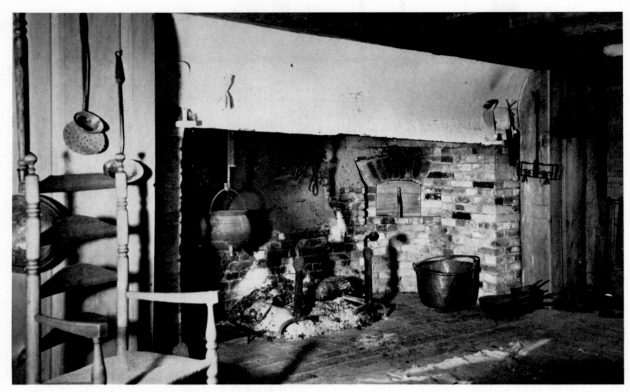

7 Interior, Parson Capen House, Topsfield, Mass. 1683

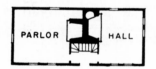

PARLOR HALL

8 Ground plan, Parson Capen House, Topsfield, Mass. 1683. Courtesy Hugh Morrison, from his *Early American Architecture . . .*, 1952

the heavy timbers were intricately joined and pegged into a rigid interlocking frame. Posts, girts, plates, and studs were dovetailed to make the sides and then raised as units to form the frame. Beams and joists supported the floors, and the roof was composed of rafters and purlins. Areas between members were filled with cat and clay or other rubble-and-clay mixtures.

Early New England houses were simple cottages of an organic, functional character, deriving their limited plan and random expansion from necessity. In the beginning, most houses consisted of one room and an attic, with a fireplace on the short wall. Roofs were covered with shingles or thatch, and chimneys were made of logs daubed with clay. This type was long continued in use by poorer inhabitants, new arrivals, and those who pushed on into the wilderness. One of the characteristics of the American experience during its long history of territorial expansion has been this recapitulation of the past, a repeated return to beginnings and, consequently, to pro-

vincialism. For the more affluent, the earlier form was soon supplanted by the so-called "classic" type, like the Parson Capen House (1683), Topsfield, Mass. (color-plate 1). It had two stories and an attic, two rooms to a floor, one on either side of a central firestack built of brick (plates 7, 8). Many such houses retained the Gothic overhang, with the upper stories projecting slightly beyond the lower, usually in the front, and with carved drop ornaments, called "pendills" (pendants), at the vertical posts. Gothic and also functional in a northern climate was the steeply pitched roof running the length of the building. Roofs were by this time normally covered with wood shingles. The attic floor was lit only by windows in the short ends, except in a few cases, such as the Whipple House (1639, plate 10), Ipswich, Mass., where cross gables were introduced. The door was centered on the long side and made of a double thickness of boards, vertical on the outside and horizontal on the inside, joined together by large decoratively studded, hand-forged nails. Win-

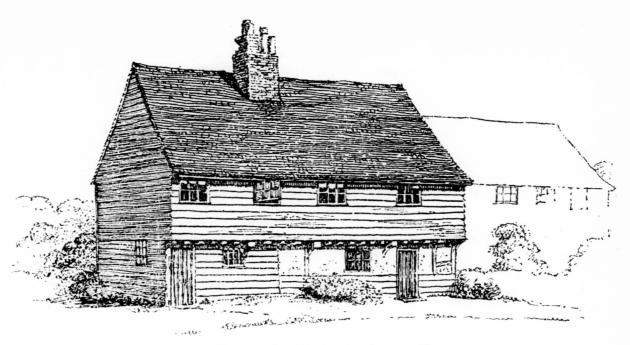

9 House at Kingsbury Green, Middlesex, England. 17th century. From Briggs, *The Homes of the Pilgrim Fathers*, 1932

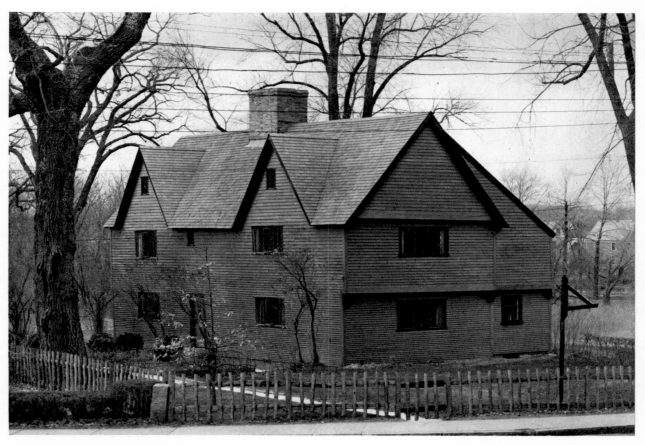

10 Whipple House, Ipswich, Mass. 1639

dows were either stationary or casement with small diamond-shaped panes of blown glass, which had to be imported. These panes were set in lead and, when necessary, reinforced by iron bars. The Whipple House is also a fine example of how such houses grew in response to family needs; whole sections, individual rooms, or lean-tos were added as changing circumstances demanded. Carefully sited, irregularly expanded, with the unpainted wood silvered or darkened by weather, the buildings have a picturesque and sturdy charm.

The interiors were largely conditioned by limitations of materials and technology and by the needs of the self-sufficient household economy of the early settlers. Living space was specialized only in that daytime activities took place in the "hall," and formal entertainment or occasions in the "parlor." These two large rooms on the ground floor flanked the central firestack, which contained back-to-back fireplaces. Sleeping was confined to the attic and the two rooms on the second floor, called the "hall chamber" and the "parlor chamber," reached by a narrow staircase abutting the firestack.

The architectural character of the interior was often enhanced by the exposed wooden frame. Walls and ceiling were plastered, sometimes revealing the vertical wooden members or posts and usually the major supporting "summer" beam and joists of the ceiling. Wainscoting was also common, with vertical or horizontal boards, either plain or simply beaded, covering the wall from floor to ceiling or extending only part way up and forming a dado. The floor was usually a double thickness of planks with the visible surface in varying widths of oak or, in later years, of pine. Every room had a fireplace for heating, but in the hall the cavernous brick or stone hearth, with its great log lintel, served for cooking, as well, and was the focus of daily family life. In expanded houses the function of cooking was often transferred to the lean-to. Such interiors, with their dark, low-ceilinged rooms, areas of whitened wall and ceiling, aged and scoured wood, and clutter of implements and utensils, have an air of functional simplicity, warmth, and security.

11 Ground plan, Fairbanks House, Dedham, Mass. c. 1637.
Courtesy Hugh Morrison,
from his *Early American Architecture* . . ., 1952

Only a few authentic wooden cottages of this type remain. Among the notable examples besides the Parson Capen House and Whipple House are the Fairbanks House (c. 1637, plate 11), Dedham, Mass., which is the earliest in date; the Scotch-Boardman House (1651), Saugus, Mass., a typical saltbox type, very little altered, with a long sloping roof at the back; and two very fine gabled houses in Salem, Mass., the John Ward House (1684), and the much remodeled Turner House (c. 1670), better known as "The House of Seven Gables."

Brick and stone buildings were common enough in England but were rare at first in the colonies because of the shortage of lime for mortar. Even when lime became available and masonry houses began to symbolize wealth and status, the architecture of New England at least retained throughout the Colonial period a preference for its earlier wood tradition. New England had plenty of stone, and mortar made from shell lime was available in Rhode Island, so that a local type of cottage called the "stone-ender" developed there, one of the best examples being the Eleazer Arnold House (1687, plate 12), Lincoln. The most famous New England stone house now extant is the Henry Whitfield House (1639–40, plate 13), Guilford, Conn., originally the minister's residence but also used as a meetinghouse and fort. Although brick was manufactured in New England as early as 1629 (in Salem), houses built of brick were not common. The earliest existing one is the Tufts-Craddock House (1675, Medford, Mass.). By far the most splendid house in seventeenth-century New England, the Peter Sergeant House in Boston, erected in 1676–79, has been demolished. The short ends had curved Flemish gables and rich clustered chimneys in the Tudor manner.

The major English variant from the New England cottage was the plantation house of the southern colonies—Virginia, Maryland, and the Carolinas. The same Gothic traditions prevailed there, but because of the difference in economic and social life and background of these colonists, their architecture tended to imitate the English manor house rather than the yeoman's cottage (plate 14). Also, these settlers came from different areas of England, bringing with them a greater variety in plan and a predilection for brick rather than wooden building. Although many wooden houses were built in the South, none have survived, and the later brick houses, which were larger and more complex, have a more formal and sophisticated appearance than those of New England.

Virginia house plans ranged from the simpler single- and double-room types to a double-room type with a central hallway and finally to a cruciform plan with projecting porches at front and rear (plate 15). Generally, however, these houses were only one and a half stories in height. The chimneys were at the ends, rather than coupled in the center, and, in a characteristic Virginia type, extended beyond the end walls. The two largest and

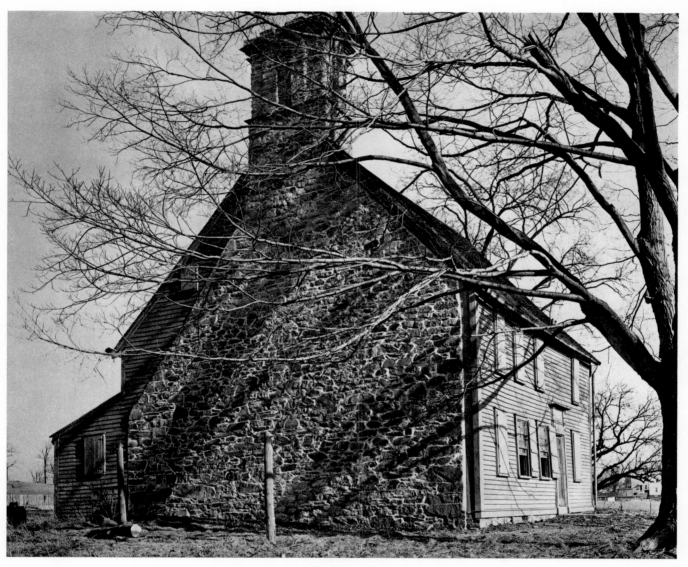

12 Eleazer Arnold House, Lincoln, R.I. 1687. View from the southwest before restoration

13 Henry Whitfield House, Guilford, Conn. 1639–40

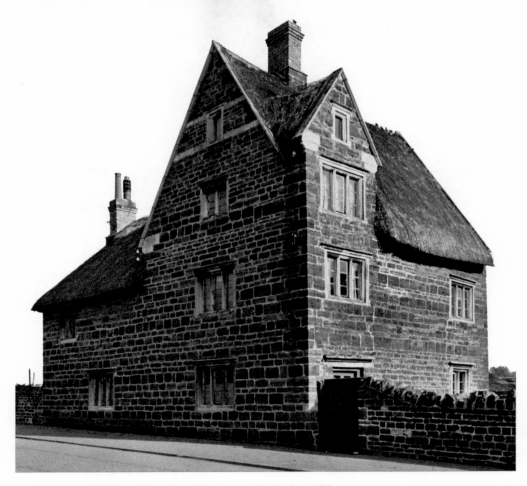

14 Yeoman's House, Broughton, Northants, England. c. 1600.
From John N. Summerson, *Architecture in Britain,1530–1830*, Penguin, London, 1963

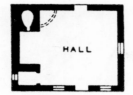

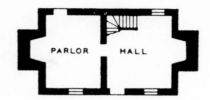

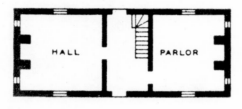

15 Types of 17th-century house plans in Virginia, rendered
by Philip White. Courtesy Hugh Morrison, from his
Early American Architecture . . ., 1952

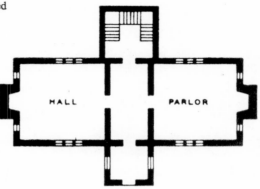

finest Virginia houses of the seventeenth century—Green-spring, near Jamestown, built for Sir William Berkeley shortly after his appointment as governor of the colony in 1642, and Fairfield, on Carter's Creek in Gloucester County, built for Lewis Burwell in 1692—have been destroyed. The Adam Thoroughgood House (1636–40, plate 16), the earliest extant house in Virginia; the War-burton House (c. 1680), James City County; and Foster's Castle (1685–90), New Kent County, are examples of the more modest southern cottage. The Arthur Allen House (c. 1655), better known as "Bacon's Castle" because of its use as the insurgents' headquarters during Bacon's Rebellion, is the largest and most elaborate of the existing seventeenth-century southern plantation houses and one of the outstanding monuments of Colonial architecture. This two-and-a-half-story edifice was constructed of

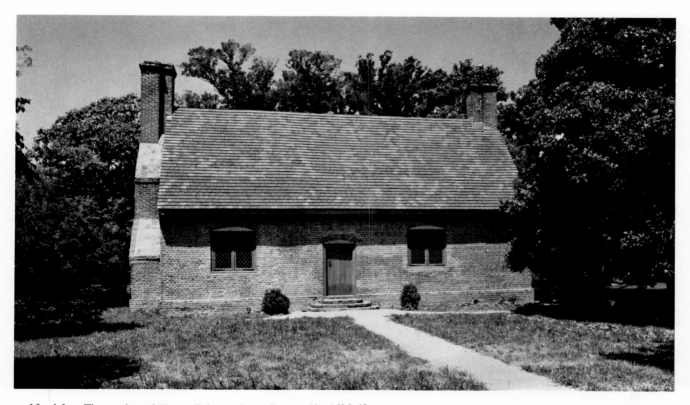

16 Adam Thoroughgood House, Princess Anne County, Va. 1636–40

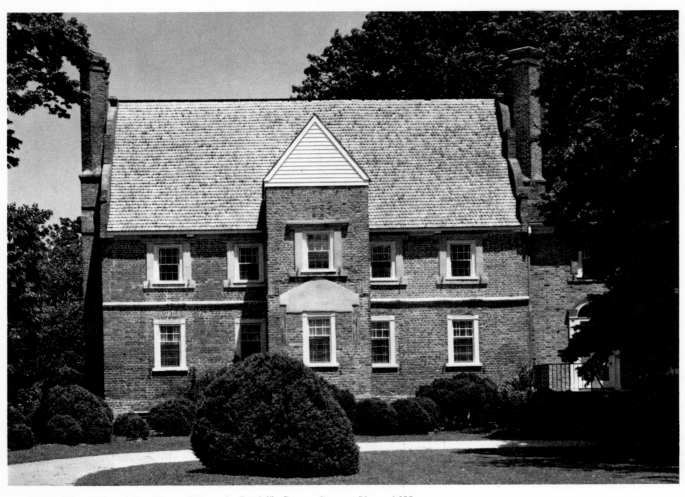

17　Facade, Arthur Allen House ("Bacon's Castle"), Surrey County, Va. c. 1655

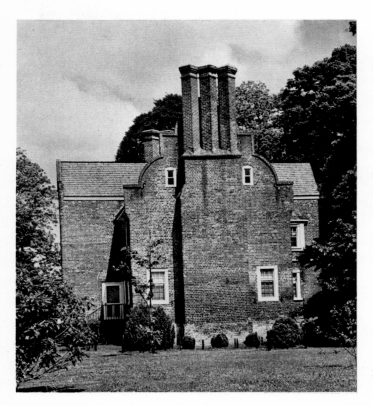

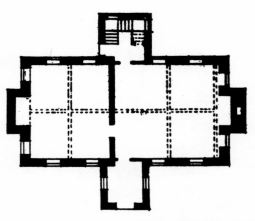

19　Ground plan, Arthur Allen House ("Bacon's Castle"), Surrey County, Va. c. 1655. From Waterman, *The Mansions of Virginia . . .*, 1946

18　Rear view, Arthur Allen House ("Bacon's Castle"), Surrey County, Va. c. 1655

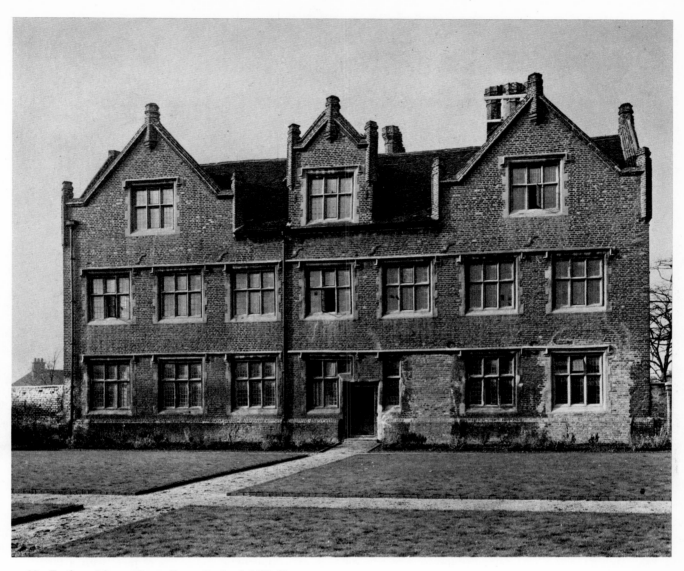

20 Eastbury Manor House, Essex, England. 1572–73

brick on a cruciform plan in the Tudor Gothic style (plates 17–19). Its genealogy traces back to the smaller medieval manor houses of England, such as Eastbury Manor, Essex (plate 20).

The domestic architecture of Maryland was much like that of Virginia except for a special predilection for glazed-brick patterning, double chimneys with pent-roofed closets between them at the ends, and the early use of the gambrel roof. No examples of this seventeenth-century type remain. The Carolinas, settled later in the century, also had an architecture much like that of Virginia, but again, no examples survive.

Public buildings during this early period were rather small and were eventually replaced by larger, more permanent structures. Only two major monuments, both religious

buildings, can be dated unequivocally to this period. Religious persecution in the Old World and the search for religious freedom in the New played such an important role in early American history that it is natural to find the colonists putting a primary emphasis on places of worship. In theocratic colonies these overshadowed other forms of public building, and among the many different Protestant sects that settled in this country there was a conscious desire to find new architectural forms to express new religious concepts. However, perhaps because of the limitations of a subsistence economy, the only new form was the modest and simple New England meetinghouse.

Old Ship Meeting House (1681, plate 21), Hingham, Mass., is the only surviving example of the Protestant meetinghouse so common in seventeenth-century New England. Foursquare in form, it was consciously con-

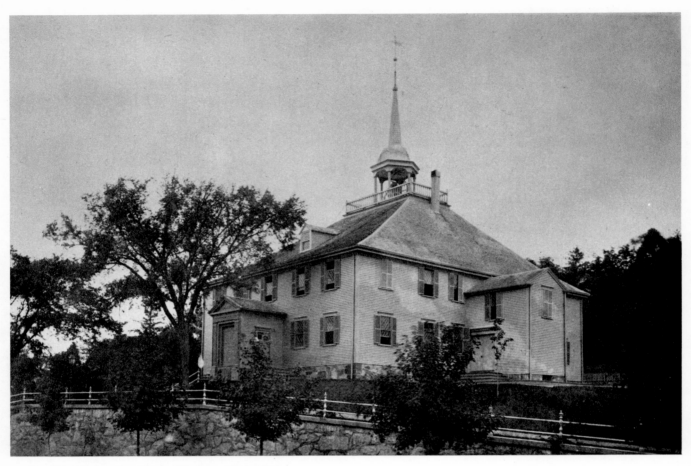

21 Old Ship Meeting House, Hingham, Mass. 1681

ceived as breaking away from "Popery," from the Catholic and Anglican past as symbolized by the Gothic church architecture of England. Expressive of new anti-ceremonial and congregational religious attitudes is the replacement of the altar at the end of a long nave, which is the focal point of the ritual of the mass, by a pulpit on the long side opposite the entrance, from which the sermon is delivered (plates 22, 23). The original oak benches which ran the length of the church and faced the pulpit were replaced by pews in the eighteenth century. Old Ship Meeting House is a wooden structure, its exterior hip-roofed and clapboarded, and is capped by a simple belfry. The interior is dominated by a lofty Gothic trussed-rafter ceiling, whose curved beams, resembling the inverted hull of a ship, were probably executed by the local ship carpenters and give the building its name.

On the other hand, the Newport Parish Church (plates 24, 25), in Smithfield, Va., known as the "Old Brick Church" and for a long time popularly as St. Luke's, is thoroughly Anglican in character. Once dated 1682 but now considered to have been erected in 1632, it is properly an English Gothic parish church (cf. plate 26) built of brick, with wall buttresses, lancet windows under round

arches, a square tower of three stages with ornamental quoins in brick at the west end, and an interior consisting of a long nave and a flat chancel with a large tracery window at the east end. The original furniture and decorations have disappeared, but the whole has been restored and refurbished.

Blockhouses and garrison houses were common features of life at the edges of an unstable frontier, but except for the William Damm Garrison House (c. 1675, plate 27), Exeter, N.H., and the Micum McIntyre Garrison House in Scotland, Me., whose date of 1640–45 is debatable, no other seventeenth-century example is still standing. Although such houses were built of hewn logs, they follow closely the plan and appearance of the New England cottage. Fort Halifax in Winslow, Me., a square structure with a pyramidal roof and continuous overhang, was built of hewn logs and, though it dates from 1754, gives us a good idea of what earlier blockhouses looked like. Commercial buildings—stores, warehouses, trading posts, taverns, and inns—also followed the cottage form, but no examples remain. The occasional windmills still to be seen today are all later in date but probably reflect earlier forms with no appreciable differences.

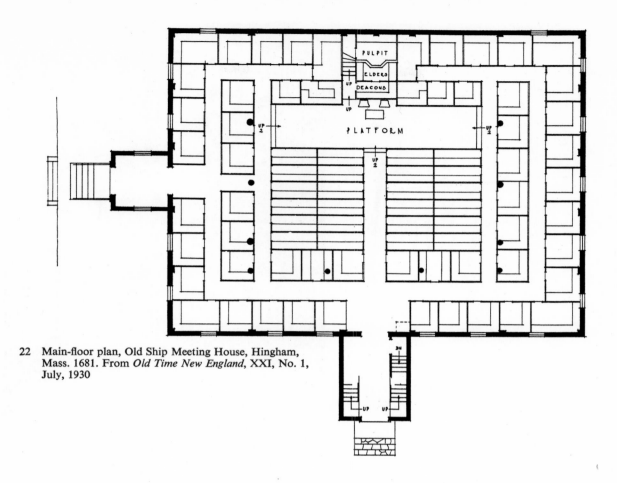

22 Main-floor plan, Old Ship Meeting House, Hingham, Mass. 1681. From *Old Time New England*, XXI, No. 1, July, 1930

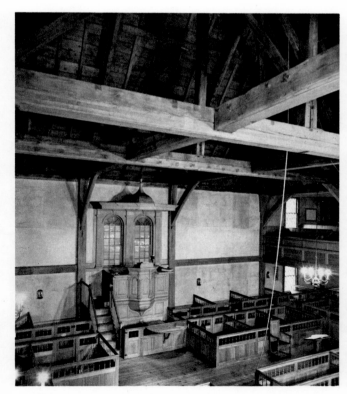

23 Interior, Old Ship Meeting House, Hingham, Mass. 1681

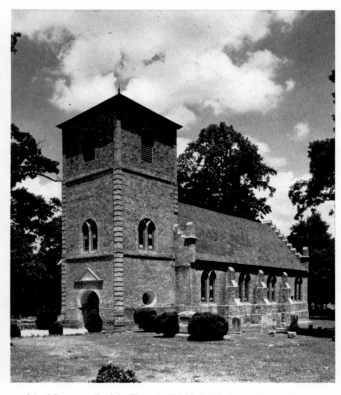

24 Newport Parish Church ("Old Brick Church," or St. Luke's), Smithfield, Va. 1632

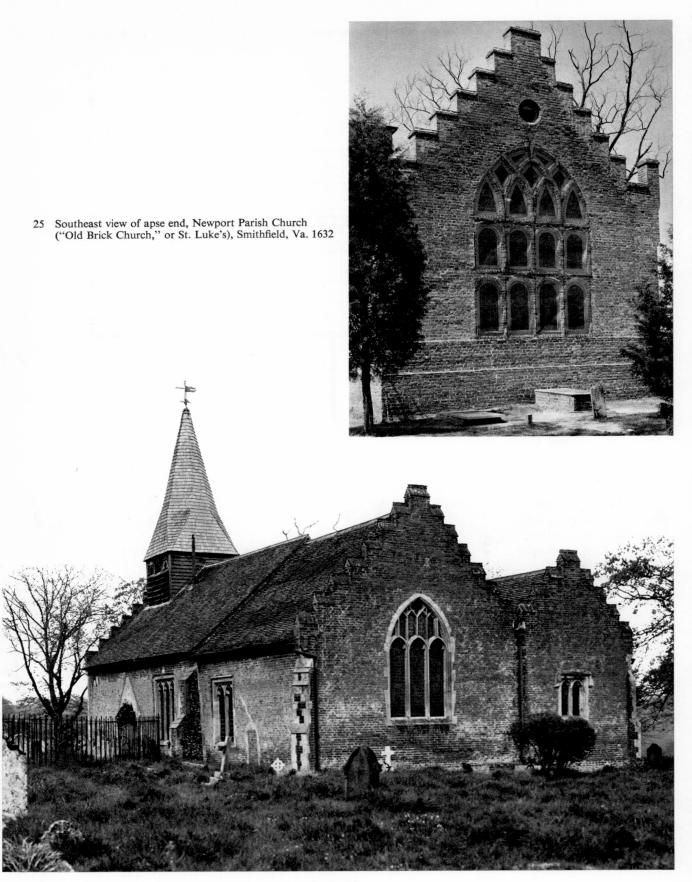

25 Southeast view of apse end, Newport Parish Church
("Old Brick Church," or St. Luke's), Smithfield, Va. 1632

26 Apse view, Woodham Walter Parish Church, Essex, England. 1563

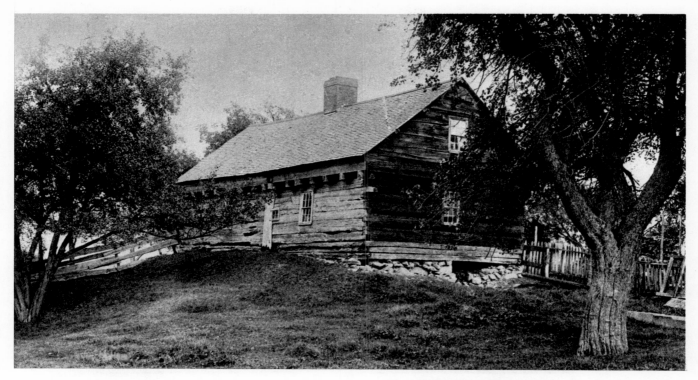

27 William Damm Garrison House, Exeter, N.H. c. 1675

From the very outset the American concern with public education, motivated by both democratic and religious intentions, was phenomenal, and this tendency was especially strong in New England. Harvard College was established in 1636, and the Boston Latin School, the first free public school, in 1643. However, none of the early buildings which housed these institutions exists today. The original "Old College" at Harvard (plate 28), the first college building in America, was begun in 1638, finished for the first commencement in 1642, and torn down in 1679. It was oak-framed and clapboarded like the New England houses of the time, but much grander in scale and probably E-shaped, as shown in the reconstruction, with gables and clustered chimneys. Unfortunately, its successor, Harvard Hall (1674–77), built of brick and the most impressive building in the English colonies in its time, was destroyed by fire in 1764. As seen in the Burgis print of 1726 (plate 29), it was an oversized house with gambrel roof, six cross gables, clustered chimneys, and a belfry.

No town halls or other government buildings of the seventeenth century have survived, though descriptions of some, notably the First Town House (1657–58, plate 30), Boston, exist. From the original specifications one can reconstruct at least the general form of this structure, which obviously stemmed from medieval guild and town halls. Built of wood and supported by twenty-one hewn posts, it contained an open market on the ground floor and upper rooms for a court, assembly hall, armory, and library. It was destroyed by fire in 1711.

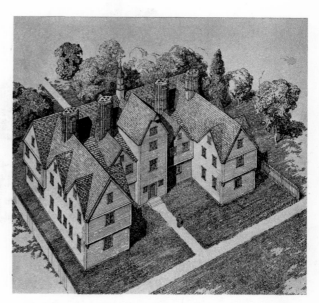

28 "Old College" at Harvard, Cambridge, Mass. 1638–79. Conjectural reconstruction, drawn by H. R. Shurtleff, 1933. Society for the Preservation of New England Antiquities, Boston

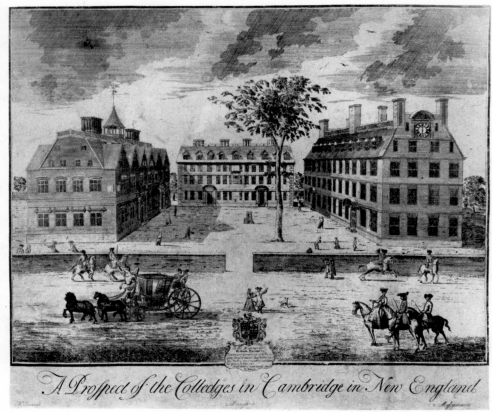

A Prospect of the Colledges in Cambridge in New England

29 William Burgis. *Harvard College in 1726*. Engraving. Massachusetts Historical Society, Boston

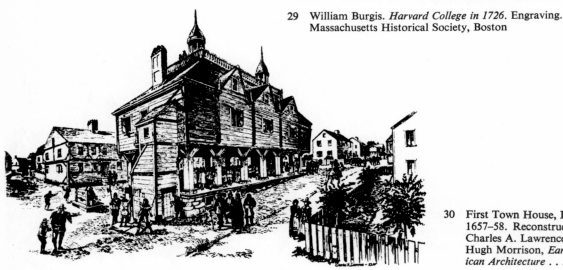

30 First Town House, Boston. 1657–58. Reconstruction, after Charles A. Lawrence, from Hugh Morrison, *Early American Architecture . . .*, 1952

NEW HOLLAND

A major variant from the dominant English architectural types, in form as well as material, reflecting different cultural backgrounds and artistic traditions, was the Dutch, actually distinguishable as two separate traditions: one Dutch, which dominated the Hudson Valley and New Amsterdam; the other Flemish, which spread through western Long Island and, in the eighteenth cen-

tury, into northern New Jersey. The Dutch variety was built of brick and tile beautifully and intricately handled. Similar to houses still to be seen in Dutch cities such as Amsterdam, they were narrow, two or three and a half stories high, with stepped gables, patterned brickwork in a great variety of modes, and ornamental wrought-iron clamps which served to rivet the brick exterior to the wooden frame. None remains in New York City, but there are isolated examples with straightedged gables and

elbow corners in the Hudson Valley. Of these, Fort Crailo (1642?, plate 31), Rensselaer, built by the patroon Kiliaen van Rensselaer to serve as administrative building and fortress for the eastern part of his estate, is the largest and finest. There is some question as to its date, and important additions as well as interior remodeling were carried out during the eighteenth century, but, with its now completely renovated interior and handsomely sturdy exterior, it is a splendid example of the Dutch style. Most of the other, smaller examples, some of stone, though built in this tradition, date from the eighteenth century.

It is the Flemish-style house which is commonly thought of as Dutch Colonial. This type was usually constructed of wood, but a picturesque and informal admixture of stone and brick was also employed. It was topped by the characteristic "Dutch cap" roof, either peak or gambrel, curving out and projecting appreciably beyond the front and rear walls. Among the few such homely but charming farmhouses of the seventeenth century still standing are the Pieter Wyckoff House (c. 1639–41, plate 32), Brooklyn, and the Bergen House (c. 1680, plate 33), Brooklyn. However, this rural style had its greatest development during the eighteenth century, long after the colony had come under English rule, in such specimens as the Ackerman House (1704, plate 34), Hackensack, N. J., a rich variant common to northern New Jersey, in which stone was used up to the eaves and wood above. In the later eighteenth century, the flaring roof projection was extended and supported by slender posts to create a "stoep," "piazza," or porch along the front. The Dyckman House (c. 1783, plate 35), New York, is

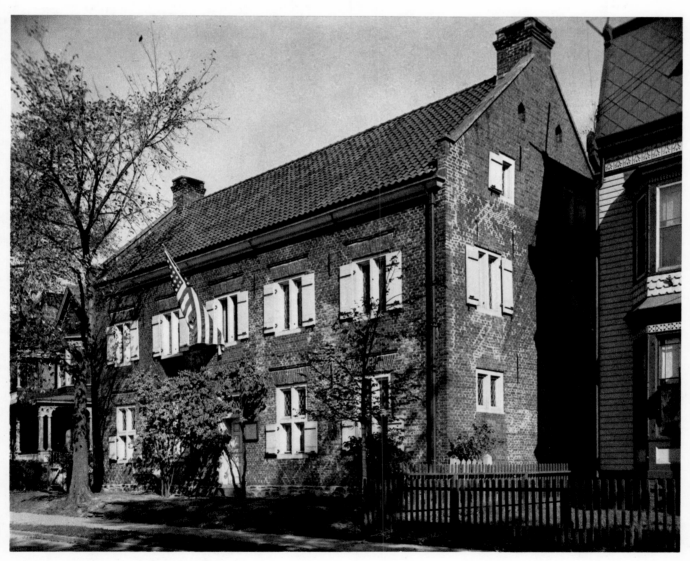

31 Fort Crailo, Rensselaer, N.Y. 1642?

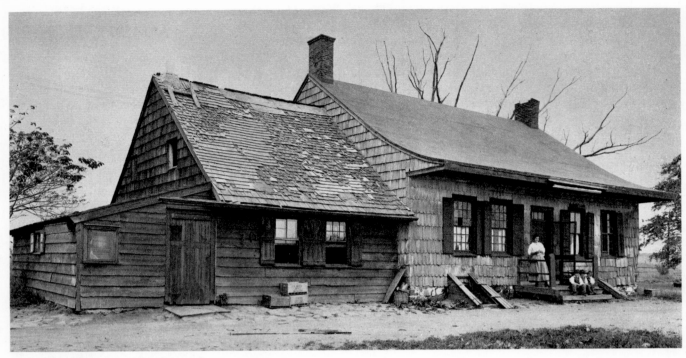

32 Pieter Wyckoff House, Brooklyn, N.Y. c. 1639–41

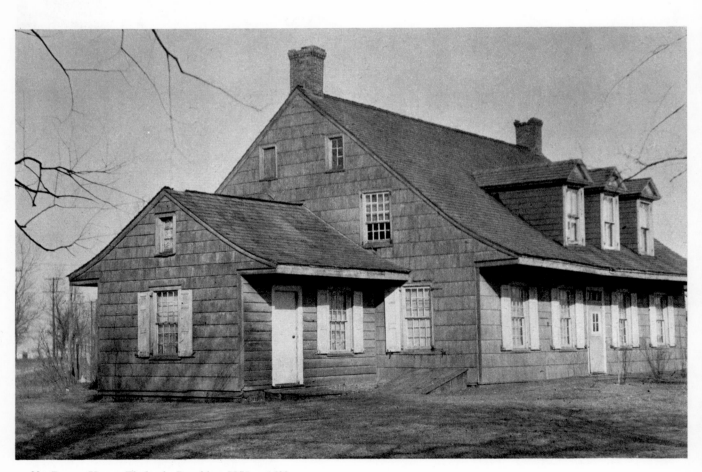

33 Bergen House, Flatlands, Brooklyn, N.Y. c. 1680

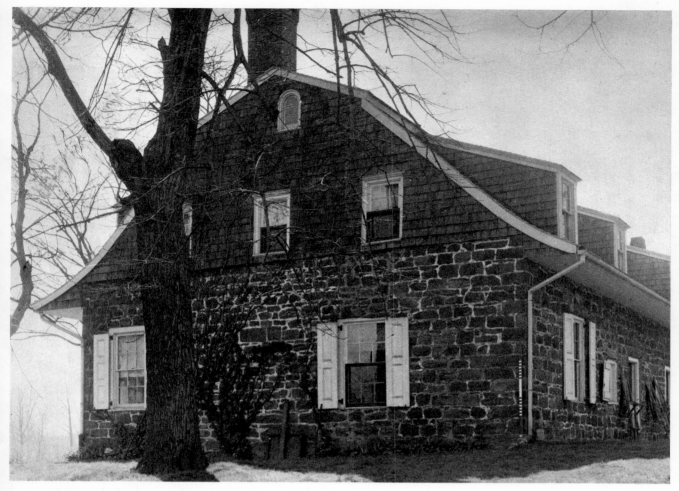

34 Abraham Ackerman House, Hackensack, N.J. 1704

35 Dyckman House, New York. c. 1783

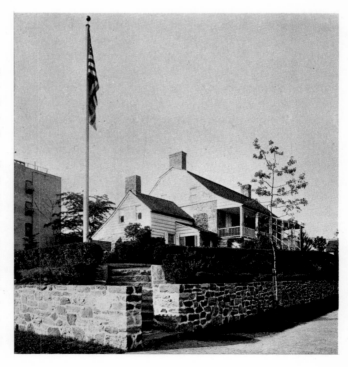

perhaps the finest example of the type in its sensuous feeling for texture and color in materials and the picturesque relation of volumes. This vernacular style was so ingrained in the region that, in spite of changing architectural fashions, it continued in rural areas well into the nineteenth century.

The public buildings of the Dutch are known to us only through pictorial records. The Stadthuys (plate 36) in New Amsterdam was an overblown brick house with tiled roof and stepped gables. However, the Dutch did bring with them an unusual Protestant church form. Developed in the late sixteenth century in Holland, it was octagonal in plan, with the pulpit opposite the door and a very steeply pitched, spirelike roof. Many such small churches were built in the colony, but all have disappeared except for the much renovated Sleepy Hollow Church (1699), erected by the Philipse family in Tarrytown, N.Y., which is nearly rectangular in plan and has rubble stone walls.

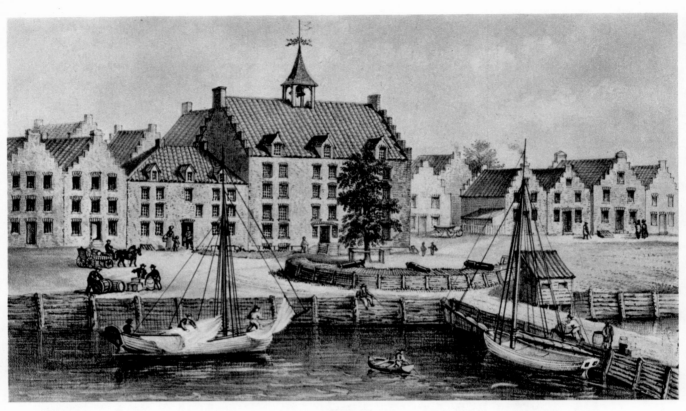

36 Stadthuys, New Amsterdam. 1679. From a print. Museum of the City of New York. J. Clarence Davies Collection

NEW SWEDEN

The Swedes in Delaware had only a short-lived autonomous existence, but they brought with them a long heritage of wooden building which had a marked influence on their neighbors. They built the first log houses that later, in the hands of Scotch-Irish immigrants, became the log cabin of the frontier. Such houses were constructed of round logs fitted together by notching the corners and permitting the ends to protrude. There was also a more refined type utilizing square-hewn logs and dovetailed corners so carefully fitted that they needed no chinking. None of the cruder log houses remains; perhaps the earliest extant example in America is the Lower Log House (c. 1640?, Darby, Pa.), constructed of hewn logs. Another early example is the John Morton Homestead (1654, plate 37) in Prospect Park, near Chester, Pa. Other Swedish contributions to American building include the corner fireplace, the so-called Quaker plan of three rooms, which became fairly common along the migration route from Pennsylvania to North Carolina, and the awkward, steeply pitched "Swedish gambrel" roof, which one finds in the adjacent areas of New Jersey, Pennsylvania, Delaware, and Maryland.

Considering the scarcity of seventeenth-century public buildings, it is a remarkable coincidence that two Swedish Lutheran churches, built at the same time under English rule but reflecting Swedish tradition in some ways, are still standing—Holy Trinity (1698–99, Wilmington, Del.), and Gloria Dei (1698–1700, Philadelphia), both called "Old Swedes." Although commissioned by Swedish congregations, both churches were built by Philadelphia craftsmen of English descent. Holy Trinity (plate 38) was originally a simple rectangular structure with massive stone walls three feet thick and an odd, steep-gabled, jerkinheaded roof. In the eighteenth century a south porch of stone and brick was added to buttress the buckling wall, and the west end was extended; not until 1802 were the small square tower and belfry completed. The interior has a false shallow vault of plastered wood, box pews, and a red-brick floor.

Gloria Dei (plate 39), built of brick, offers a decidedly Scandinavian flavor in its steeply pitched roof and attenuated spire. Here too the walls had to be buttressed, and in 1703 an entrance porch on the south and a small vestry on the north side were added. In the interior the wooden trusses are hidden by a hung vaulted ceiling of somewhat curious shape. Despite Scandinavian elements, both buildings are largely English in character and, in their classical ornamentation and trim, already Georgian rather than Gothic in inspiration. Since they were built at the turn of the century, they might properly be considered within the compass of eighteenth-century architecture.

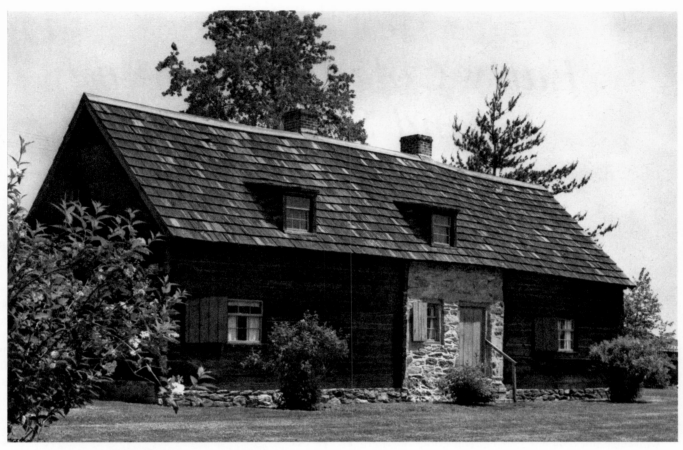

37 John Morton Homestead, Prospect Park, Pa. 1654

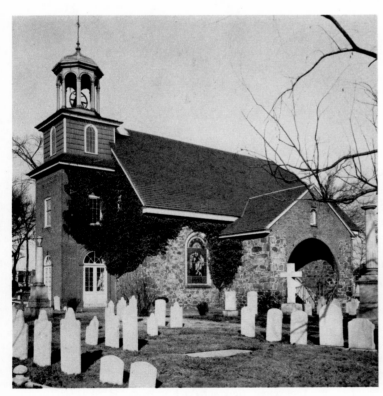

38 Holy Trinity Church ("Old Swedes"), Wilmington, Del. 1698–99

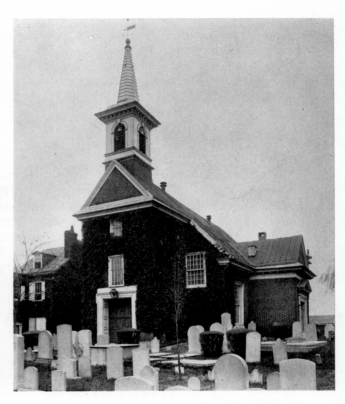

39 Gloria Dei ("Old Swedes"), Philadelphia. 1698–1700

CHAPTER TWO

Early Colonial Painting and Sculpture

Artisans and Limners

The scarcity of painting and the practical nonexistence of sculpture during the seventeenth century were due to a variety of reasons. Economically, at least, there was as yet not much demand for luxury goods, and the average settler came from a background in which the presence of these arts was not usual. Religious attitudes in Protestant areas prohibited the idolatrous image in churches, and even in the secular field moral precepts concerning vanity and ostentation placed severe restrictions upon the production of painting and sculpture. Then, also, the English at that time were not especially receptive to or distinguished in the visual arts. On the contrary the Dutch arrived during the golden age of Dutch painting, and there is some evidence that the wealthier had brought with them not only portraits but collections of paintings. Still, for a long time people generally felt that one could do better by importing luxury goods from abroad than by depending on local production. As a result there was almost no religious art, and in the secular realm painting was confined to the occasional wall or overmantel landscape decoration and portraiture. Sculpture was even more severely limited to the functional, including decorative carving on furniture, signs, weathervanes, gravestones, and ship figureheads.

PAINTING

Throughout the Colonial period the overwhelmingly dominant pictorial expression remained the portrait in paint, just as it did in England. During the seventeenth century there were only limners, anonymous artisans with no formal training, who did occasional portraits. In most cases they were probably sign painters. The naive character of their efforts has led to a designation of such works as "primitive" or "folk," but naive as they are, as faint as the echo may sometimes become, these paintings still reflect the memory of established forms carried on through prints or preserved in painted originals. An anonymous portrait of Peter Stuyvesant (c. 1660, plate 40), governor of New Amsterdam, is probably Dutch in origin, although there has been some effort to assign it, as well as the portrait of his son, to a Hendrick Couturier

who was listed in New Amsterdam in 1663 and is said to have done a portrait of the governor and drawings of his sons. Dutch also are the portraits of the De Peyster children (1631, plates 41, 42). As provincial as is the *Governor Winthrop* (1640?, plate 43), it is still so far beyond any comparable New England portrait of the period in its handling of three-dimensional form that it would be difficult to ascribe to a local artist, and so Dutch in composition, painting style, and costume that it hardly seems English. It may have been painted before Winthrop left England in 1630 by a provincial artist responding to the

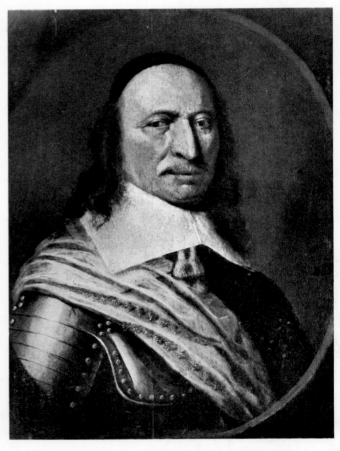

40 Anonymous. *Governor Peter Stuyvesant* (1592–1672). Wood panel, 21½ × 17½″. The New-York Historical Society

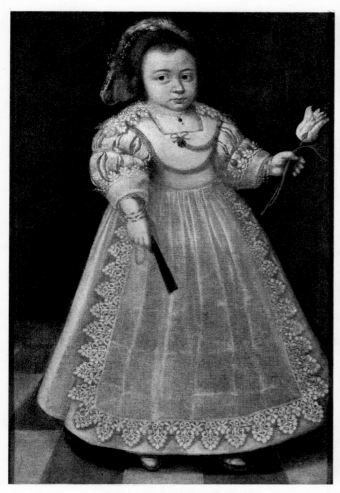

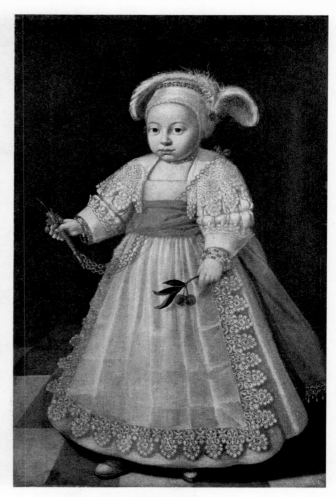

41 Anonymous Dutch. *Portrait of Sarra De Peyster*. 1631. Canvas, 38¼×24⅜″. The Metropolitan Museum of Art, New York, Gift of Livingston L. Short and Anna Livingston Jones, 1961

42 Anonymous Dutch. *Portrait of Jacques De Peyster*. 1631. Canvas, 39×24¾″. Collection James S. De Peyster, Jr., New York

current interest in Dutch portraiture among English painters.

Authentic examples of this period are extremely rare and at times over-restored and repainted. A number of such portraits from New England, dated about 1670, are charming, strongly patterned, flat, and linear. It is difficult to say whether such stylistic features are the result of the natural tendency of the naive painter to reduce form to a two-dimensional conceptual image or a reflection of Elizabethan painting in its arid, post-Holbein version of sixteenth-century Mannerism. The anonymous portraits, *John Freake* and *Mrs. Freake and Baby Mary* (c. 1674, plate 44), despite the artist's obvious limitations as a draftsman and his uncertainties in the face of basic problems of three-dimensional representation, show a fine sense of composition in the boldness of the silhouettes, a feeling for decorative detail in the lace, and an intuitive felicity with color. The portrait of the mother and child even has a surprisingly authentic psychological mood. It is perhaps pretentious to designate so primitive a crafts-

man with the title Freake Master, as has been done, but there is no denying the presence of an artistic personality.

Very similar in spirit to the Freake family portraits are a series of portraits of children, resembling one another closely and perhaps by the same painter, although they have been attributed to two anonymous sources, the Gibbs Master and the Mason Master. The three paintings of the Gibbs children, Margaret, Robert, and Henry, and the two Mason portraits, one of Alice and the other of her three siblings, David, Joanna, and Abigail, are all similarly inscribed and dated 1670. Furthermore, they are closely connected in composition, black-and-white-squared floors and dark backgrounds, details of dress and pose, and even errors in drawing. The children all look like little china dolls, stiffly and self-consciously posed, with practically no differentiation in physiognomy or personality, except perhaps in the *Margaret Gibbs* (color-plate 2), which seems not only more forcefully realized but more carefully painted than the others. However, each is charmingly characterized by iconographic attri-

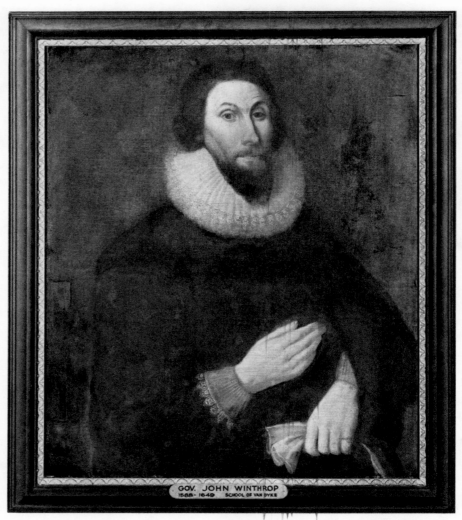

43 Anonymous. *Governor John Winthrop.* 1640. Canvas, 35 × 29″. American
Antiquarian Society, Worcester, Mass.

butes—the older boys as gentlemen, Robert (only four
and a half years old) with gloves and David with gloves
and a cane; Margaret and Joanna as ladies with fans;
Abigail with a flower; Alice with an apple or peach; and
little Henry with a bird. They are endearing portraits. The
artist's untutored simplicity of conception and almost
childish delight in detail underline the very nature and
appeal of childhood.

A comparison of these portraits with the De Peyster
children reveals a remarkable similarity in iconography
as well as composition, but a complete variance in style.
The Dutch pictures reflect, even if heavy-handedly, the
newer Baroque conception of visual realism which saw
such a rich development in seventeenth-century Holland.
An example of the Dutch style in this country, and quite
different from the New England portraits of children, is
that of the seventeen-year-old Nicholas William Stuyve-
sant (1666, New-York Historical Society), which, in spite
of the curious disproportion of head to body and the
rather contorted hobbyhorse on which he sits with such

aplomb, exhibits a much more sophisticated handling of
paint. The conception of space and movement, the land-
scape background, and the fairly bold rendering of form
in the head and especially in the young man's leg also
indicate a stronger awareness of contemporary European
art.

Toward the end of the century the Baroque style was
beginning to make itself felt among the New England
limners, possibly as a provincial extension of the change
in English painting under the impact of Sir Anthony Van
Dyck, the Flemish master who had become court painter
to Charles I in 1632. The establishment of the identity of
a seventeenth-century American painter, Thomas Smith,
is conjectural, but several related portraits indicate the
existence of an artistic personality intent on expressing
himself in terms of this new visual realism. On the basis
of a record of payment by Harvard College in 1680 of
four guineas to a Thomas Smith for a portrait of a Dr.
Ames, another portrait of a man in which the monogram
TS appears has been called a *Self-Portrait* (c. 1690, color-

plate 3). The connection is tenuous, but, considering the limited range of art relationships at that time, persuasive. The portrait is in the traditional form of a *memento mori,* or reminder of death, in which the man holds a skull, and the accompanying inscribed poem expresses an appropriately Puritan rejection of the vanities of life and an embracing of the glory of death. The drawn curtain on the right, a standard portrait prop, balances the view of a naval battle seen through an opening on the left. This is in all respects a stock portrait, but the direct, even crude modeling of the face projects a forcefulness and immediacy which obscure the inadequacies of the painting, as in the skull and the lace. Other portraits have been attributed to Thomas Smith, and two at least are so close to the *Self-Portrait* in composition, iconography, and style that they may well be by the same hand: *Captain George Corwin* (1675, plate 45) and *Major Thomas Savage* (1679, Collection Henry L. Shattuck, Boston). Another portrait, identified as that of his daughter *Maria Catherine Smith* (c. 1690, plate 46), exhibits the same crude delineation of form and patently reflects the Restoration style of Sir Peter Lely in its striving for courtly elegance. Thomas Smith's painting, limited as it may appear, moves into a new phase and onto a new level of American art.

In general, limners toward the end of the century were beginning to respond, probably through the medium of prints, to the changing fashion in English painting, and such portraits as *Mrs. Patteshall and Child* (1670–90, Pilgrim Hall, Plymouth, Mass.) and *Mrs. Elizabeth Paddy Wensley* (1670–90, plate 47) are distantly but unmistakably related to more current European models.

45 Thomas Smith (attrib.). *Captain George Corwin.* c. 1675 (repainted all but head by Hannah Crowninshield, 1819; retouched by Howarth, Boston, 1864). Oil on canvas, 49 × 36″. Essex Institute, Salem, Mass.

44 Anonymous. *Mrs. Freake and Baby Mary.* c. 1674. Canvas, 42½ × 36¾″. Worcester Art Museum. Gift of Mr. and Mrs. Albert W. Rice

46 Thomas Smith. *Maria Catherine Smith.* c. 1690. Oil on canvas, 26⅞ × 25¼″. American Antiquarian Society, Worcester, Mass.

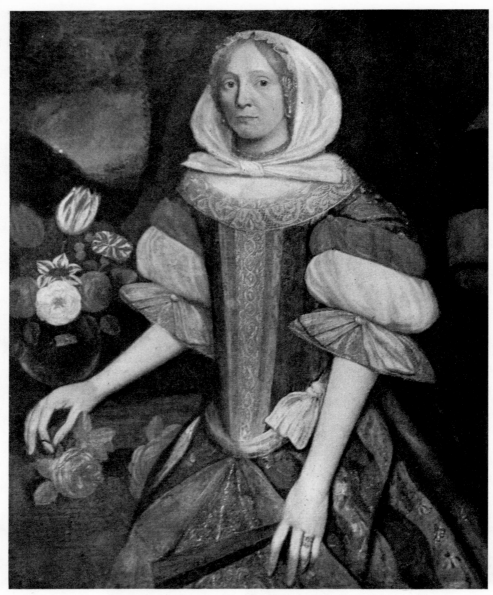

47 Anonymous. *Mrs. Elizabeth Paddy Wensley*. 1670–90. Oil on canvas,
40½ × 33″. The Pilgrim Society Collection, Pilgrim Hall, Plymouth, Mass.

SCULPTURE

Death knows no classes, and the grave marker is hardly
a luxury even to the indigent, which is one reason why,
for more than a century, gravestone carving remained
almost the only form of sculpture practiced in the colo-
nies. As a highly specialized craft, it had even less relation
to the sophisticated art of the period than did painting.
Still, humble as it was, it was the only art of the Early
Colonial era in which a religious and philosophical atti-
tude found expression. The Protestant fixation on death,
fostered so graphically by the sermons of the early
divines, was echoed in these stone warnings to the living
of the vanities of the world, the passage of time, and the

mortality of man. Predictably the most striking of these
gravestones are from Puritan-dominated New England.

The earliest grave markers were mostly of slate, which
lends itself to easy but shallow carving. Though limestone
was introduced at the turn of the century, it was some
time before artisan stonecutters attempted anything but
low relief. The first and simplest seventeenth-century
gravestones gave only vital statistics—name, age, date of
death, and family relationship. By mid-century such
rudimentary ornamental elements as rosettes and radiat-
ing sun disks were added, and the scalloped top with a
large semicircle in the center flanked by a smaller one on
each side became common. This basic type saw various
elaborations during the second half of the century: the

transformation of the semicircles into scrolls, the development of vertical side panels with geometric and floral ornaments, and the definition of pictorial fields as the iconography became richer. Beginning with the winged skull, the earliest and most common motif, the mortuary vocabulary was soon expanded into a more detailed iconography of death—hourglass, crossed bones, winged-soul's head, coffin, symbolic plant forms, Death as a skeleton, Father Time, and a catalogue of appropriate homilies. There seem not to have been any pattern books for stonecutters, but though the constant repetition of certain motifs may be ascribed to a deep-seated folk tradition going back to the Middle Ages, the particular visual imagery recurring in many cases and in complex pictorial forms presupposes graphic prototypes. The Baroque forms of the Joseph Tapping gravestone (d. 1678, King's Chapel, Boston) are matched by the involutions in its symbolism. It includes not only the usual skull, hourglass, and the inscriptions "Fugit Hora" and "Memento Mori," conveying the message in a kind of theological shorthand, but also a pictorial elaboration representing Father Time accompanying the skeleton figure of Death, the former with his hourglass and scythe, the latter with the arrow of death in one hand and a candlesnuffer in the other, advancing to smother the flame of life supported by the globe of the earth. The identical composition, though carved by another hand, occurs on the tombstone of the publisher, printer, and sometime painter John Foster (d. 1681, plate 48). Despite its comic garbling, the scene is obviously derived from a sophisticated rendering of figures moving in space. Allan I. Ludwig cites as the source a little engraving from Francis Quarles's *Hieroglyphiques of the Life of Man* (1638, London). Similar images of Death and Time, rearranged in a symbolic rather than pictorial composition and cut with greater refinement, appear on the stone of Timothy Lindall (d. 1699, plate 49).

Ability to handle representational form and pictorial composition varied greatly among artisans, ranging from primitive incision to rudimentary three-dimensionality to rich and fanciful carving (cf. plates 178–180).

Although both the English and the Dutch derived from a great medieval tradition of woodcarving, little of it was brought to the colonies. There simply was no demand, especially among Protestants, for elaborate church furniture—carved altars, screens, pulpits, or choir stalls, and certainly not "Popish idols." Nor was there a market for secular sculpture in wood, either public or private. Except for an occasional pendill or newel post, woodcarving was limited to furniture decoration—the turning of a chair spindle or the decoration of a chest—usually nothing more than incising a design on the surface or, at most, carving simplified floral and geometric patterns in low relief. Like stonecutting, woodcarving was so tied to the functions of the craft that there was no room for the development of sculpture for its own sake.

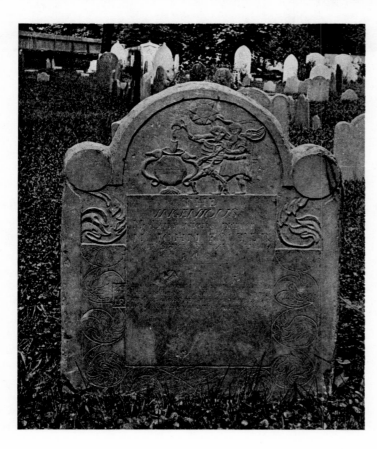

48 Anonymous. Gravestone of John Foster (d. 1681), Dorchester, Mass.

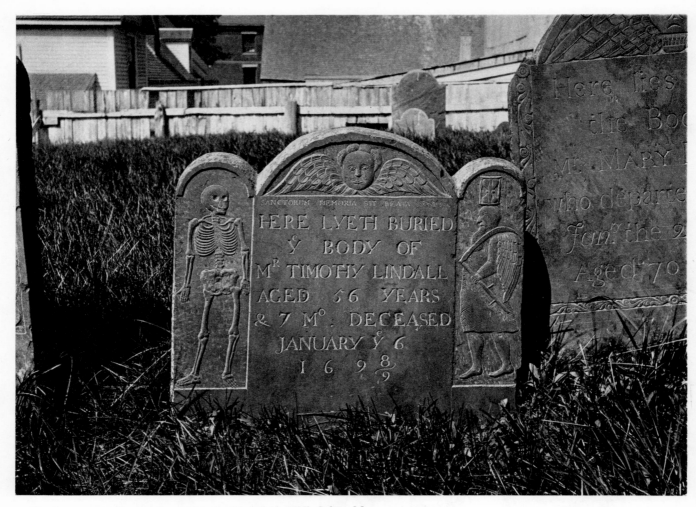

49 Anonymous. Gravestone of Timothy Lindall (d. 1699), Salem, Mass.

CHAPTER THREE

New Spain

Architecture, Painting, and Sculpture

Before the founding of the first permanent English settlements the Spaniards were already established below the Rio Grande, but not until the seventeenth century did they expand significantly northward into what is now the United States. This area was divided for administrative efficiency into five "mission" territories—Florida, New Mexico, Arizona, Texas, and California. Though settlement began in Florida as early as the sixteenth century and in New Mexico at the very end of the century, it did not occur in Arizona until the last years of the seventeenth, and in Texas and California only in the eighteenth. Thus, only in Florida and New Mexico is there any visible evidence contemporary with the American colonies we have been discussing. When speaking of Spanish "settlement," one must keep in mind that the Spanish conquest was a centralized effort of the Crown supported by a monolithic church, as opposed to the rather diffuse sponsorship and rule of the English American colonies. The Spanish were looking for quick returns, the Crown for gold, the Church, motivated by the proselytizing zeal of the Counter-Reformation, for "souls" in the untapped human resources of heathen America. Only in support of this two-pronged effort, and later when "El Dorado" proved to be an illusion, was settlement recognized as necessary.

The first colonial push was with troops accompanied by priests. The native population was subjugated, strong points were established, and the priests then went about converting the Indians. Mission complexes with churches were erected by the natives under the direction of padres. After the pacification of an area settlers might move in and towns grow up, but in many cases the missions remained isolated enclaves. Often only a single Franciscan friar came with his Bible and a tool kit to teach the Indians about salvation and, in the process, the white man's skills, language, and way of life. In mission or town the number of Spaniards in relation to the native population remained small, and in the end the Indian masses absorbed the culture of their Spanish conquerors and transformed it. Hispano-American culture, and especially its art, was, unlike the Anglo-American, a translation into a foreign tongue.

ARCHITECTURE

The earliest Spanish settlement in Florida occurred in 1513, when Ponce de León landed near the site of St. Augustine and attempted to establish a colony. It lasted only a short time, and no further efforts were made for more than half a century. Nearby, the ill-fated Fort Caroline, founded by French Huguenots in 1564, was wiped out the following year by the Spanish, who were in turn driven out by Sir Francis Drake in 1586. The scattered population of the town returned, but not until 1593, with the arrival of twelve Franciscan monks, did the colonization of Florida begin in earnest. Of the forty missions built from the Gulf of Mexico to Miami in the years that followed, not a single one stands today, or very much else to remind us of Spanish rule, except for the great fort of St. Augustine, the Castillo de San Marcos (plates 50, 51). This strategic site suffered innumerable raids by Indians and pirates, and the fort had been rebuilt eight times before the present structure was begun in 1672. It was not entirely completed until almost a century later. It remains today as one of the most impressive monuments of Spanish architecture in the United States and the best example of the type of fortress developed in Europe after the introduction of gunpowder. The fortification, except for the bastions, moat, and outworks, was erected in three years through the combined labor of Indians, slaves, soldiers, and settlers. Built of coquina limestone quarried on nearby Anastasia Island, the stronghold contains an open plaza 100 feet square, surrounded by chambers with massive vaulted ceilings to carry the fort's sixty-four guns mounted above. Included were a chapel, a council chamber, barracks, officers' quarters, storerooms, magazines, and dungeons. The outer walls are 25 feet high, the battered sloping sides 12 feet at the base and 7 at the top, and the moat is 40 feet wide. Fifteen miles south is the impressive ruin of Fort Matanzas, constructed of stone in 1736. Of all the churches founded by the Spanish in Florida, only St. Augustine's Catholic Cathedral (1793–97), which is a very late example, remains, and that was severely damaged by fire in 1887 and was badly restored and transformed.

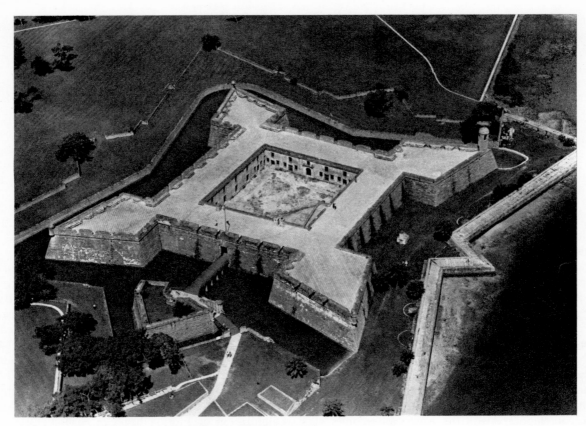

50 Castillo de San Marcos, St. Augustine, Fla. Begun 1672

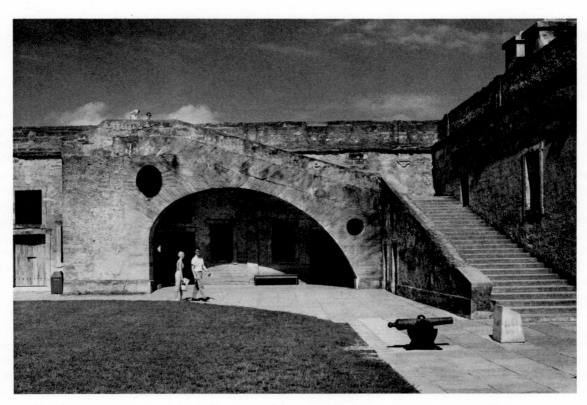

51 Plaza and stairway to the terreplein, Castillo de San Marcos, St. Augustine, Fla. Begun 1672

Whereas the settlement of Florida was of great strategic importance for the Spanish empire in the New World, the venture into the American Southwest never paid off, at least financially. It was a harsh, unfriendly land, far from the centers of men and supplies, and the Spaniards always found this frontier difficult to maintain. Although Francisco Vásquez de Coronado had explored New Mexico in 1540, no attempt to settle there was made until 1598, and not until 1609, two years after the landing at Jamestown, was Santa Fe founded and the building of the Presidio, the fortified administrative center, begun. The Presidio was a walled enclosure, 400 by 800 feet, which included a chapel, barracks, offices, magazines, and prisons, as well as the Governor's Palace (1610–14, plate 52), the oldest extant building by Europeans in the United States. The Palace is a long, low, one-story structure with a porch (*portal*) in the front, supported by wooden posts, facing the open *plaza* to the south. It is built of adobe, or clay, in the manner traditional with the Indians of the region in the construction of their own houses. Although they sometimes laid stones in clay for foundations, they usually built in adobe successively applied in layers and allowed to bake in the sun. The surface was then smoothed with adobe thinned in water and finished with a thin coat

of white gypsum plaster. Roofs were constructed of *vigas,* or log rafters, projecting beyond the walls and carrying lighter transverse limbs, which were then laid with rushes or branches and covered with clay. The Spanish introduced a technical advance in casting the adobe in block forms, which made the process of building much more efficient and the forms more regular, but the finishing of the surface still produced the irregular soft and fluid forms so characteristic of all adobe building.

Like the English, the Spanish tried to re-create their European environment, but, unlike them, lacked the skilled craftsmen to achieve that aim except in the major cities. In the outlying regions the local population was the labor force, and there was no alternative but to adapt to local materials and skills. The result was a synthesis of the European memory and the American present, and, uniquely in New Mexico, because the European image was so faint, an original architectural form grew out of native traditions, naive and rudimentary but moving in its simple dignity, artlessly picturesque, adjusted to terrain and climate, and organically related to the desert landscape. Perhaps because it was earlier and more provincial, the architecture of New Mexico was less magnificent and sophisticated than that of Texas or Arizona,

52 Governor's Palace, Santa Fe, N.M. 1610–14

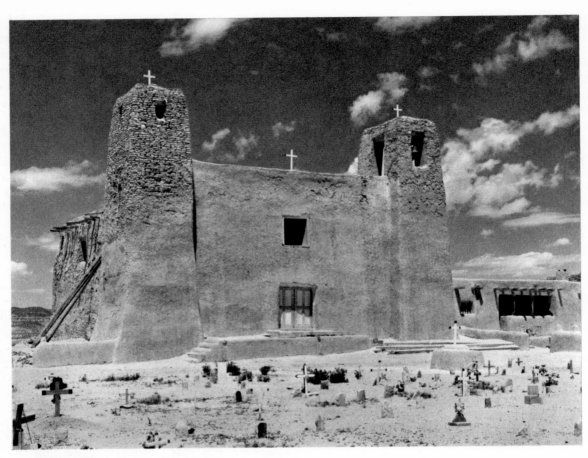

53 San Esteban, Acoma, N.M. Completed c. 1642

even more primitive than that of California, and, because the Spanish strain is so muted, it seems more indigenous than the others. But even a building as simple as the Governor's Palace reveals the mingling of the two cultures. The plan of the Presidio, with its open patio in the center, is, of course, Spanish, as are the brackets on the porch posts and the framing of doors and windows in wood; Indian are the building technique, the flat roofs, and the *vigas* construction.

The New Mexico adventure proving a financial disappointment, it soon became primarily a missionary project. By 1626 there were already forty-three churches in the territory, but only a handful of seventeenth-century examples exists today. Since such churches were much larger than houses, the achievement of greater height and the spanning of wider spaces presented a new challenge to their Indian builders; but they still used adobe or a mixture of stone and adobe, for their skill in cutting stone was limited and wood was scarce. The women and children handled the adobe, as was customary, while the men took care of the carpentry, a more dignified occupation. With such limited means the padre's memory of Baroque splendor had to be scaled down to the simplest forms and a minimum of elaboration. Walls had to be very thick at

the base to carry the height and thus were battered. Large *vigas* supported by corbels projecting from the walls spanned the interior space and carried the flat roof of ceiling boards piled thick with adobe.

The best of the remaining churches of that period is San Esteban (plates 53, 54), probably completed about 1642, on the remote and spectacular mesa of Acoma. Built of stone and adobe, its facade has only a simple doorway and, above, a window opening on the choir loft. It is flanked by two squat towers with belfries. Characteristic of the region are the barnlike interior, the bare walls with a few windows high under the eaves, and the richly painted corbels and *vigas*. Such interiors are coolly serene in their uncluttered space and warm in color. San Esteban is long and narrow in plan, with a polygonal apse and no transepts. Attached to the north side is a walled *convento* containing living quarters ranged around a patio. Rising bold and clear out of the mesa in the brilliant sun and bright air of the desert, the church presents an asymmetrical composition of picturesque silhouette, cubical volumes, and a sharp-edged pattern of light and shadow.

Typical of a simpler variety of mission church is San José (1699–1706, Laguna) built of coarse stone set in

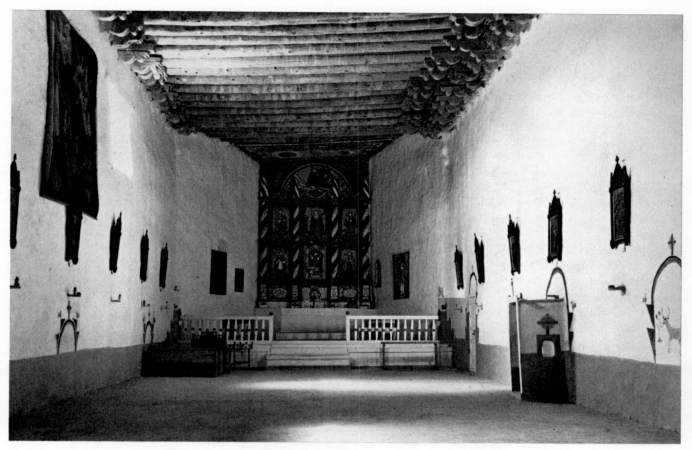

54 Nave and sanctuary, San Esteban, Acoma, N.M. Completed c. 1642

heavy adobe (plate 55). There are no towers, and the facade rises above the body of the nave like a false-fronted parapet shaped into an undulating peak and pierced to hold two bells. Common also is the enclosed *atrio* in front, used for outdoor mass on Sundays or feast days.

Of the domestic buildings of the period nothing remains and little is known except from nineteenth-century examples. They must have resembled the Indian houses of the region, with their softly contoured, low rectangular masses, projecting *vigas,* and flat roofs, but they were probably laid out in the Spanish manner with the rooms shaded by projecting *portales* surrounding a patio.

The early phase of architecture in New Mexico was abruptly ended by the Pueblo Revolt of 1680, when the Indians, cruelly exploited and maltreated by Spanish administrators, rose and in a bloody reprisal killed four hundred Spaniards, including twenty-two priests, and sacked the missions. It was not until 1692 that the Spanish returned to begin reconstruction.

55 Interior, San José, Laguna, N.M. 1699–1706

PAINTING AND SCULPTURE

Painting and sculpture, like architecture, had a varied development in the Spanish colonial empire, but, as in the case of the English, they were essentially provincial imitations of European models. Except for portraiture, Spanish, unlike English, painting and sculpture were predominantly religious. Altarpieces and mural decorations were copied from European prints by immigrant Spanish and Flemish artists. However, such activities, provincial as they may have been, were confined to the major colonial centers and did not extend as far as the North American outposts, where such artistic production as did exist was almost entirely the handwork of the local Indians.

The Indians of the Southwest, at least, had a strong painting tradition of their own, and their practice of ceremonial painting on the walls of the religious chambers known as *kivas* was adapted by the padres to the embellishment of church interiors. Employing the native palette of black, white, blue-green, yellow, and red, the Indians decorated the corbels they had carved in vigorous curves and the undersides of the *vigas*. At San José (Laguna), which contains the most remarkable examples of New

Mexican mission painting, the padres permitted the Indians to cover the nave walls at dado height with their own mythological symbols (colorplate 4). In contrast, the painting of the sanctuary walls and ceiling are an attempt to imitate the typical Spanish or Mexican *reredos* with barbaric vigor in a conglomerate of floral arabesques, representations of the Trinity and saints, symbols of the sun and moon, scrolls, and spiral columns. Although these paintings date from the eighteenth century, they seem to continue an earlier tradition and style. Unfortunately, adobe is far from the ideal surface for mural painting, and few examples have survived.

The further removed the aborigines were from European sources, the more personal and imaginative their creations became, and in the smaller and more intimate images of religious figures the Indians of the Southwest produced a unique genre of acculturated art. Such images of saints carved in soft wood coated with gesso and painted are called *bultos,* and those painted on panels of wood, sometimes stretched with canvas or skin, and on tin, are called *santos* (plate 56). Most are later in date, but they seem to retain local tradition without much change or development. At their best they are naive and touching expressions of sincere religious feeling.

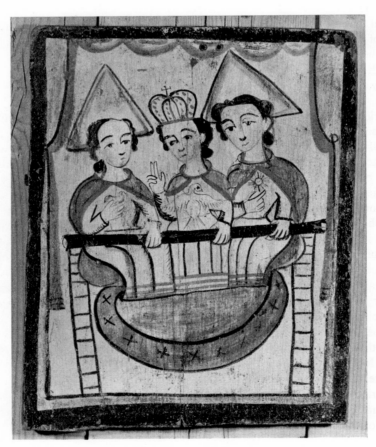

56 *The Holy Trinity.* 19th century. Oil on wood, 12¼ × 9¼".
The Taylor Museum of the Colorado Springs–Fine Arts
Center, Colorado Springs, Colo.

CHAPTER FOUR

Eighteenth-Century Colonial Architecture

An ever-increasing flow of immigrants augmented the growing population of the colonies, and by 1700 there were about a quarter of a million people in the English dependencies. The frontier was moving inexorably westward. Those less adventurous, more skilled, or more solvent remained in the towns of the eastern seaboard and helped transform them into burgeoning cities. By the eighteenth century Philadelphia was second in population only to London in all the English realm, and America had become an important element in the English economy. Although the colonists might resent the restrictions of English trade policies, feel wronged and even exploited, wealth and the standard of living were constantly rising.

Wealthy merchants in the towns and prospering plantation owners in the South were interested in more gracious living and financially able to support a higher level of production in the arts. While southern planters imported many of their luxuries from England, in the North merchants were finding a growing class of artisans—carpenters, cabinetmakers, silversmiths, and even portrait painters—to satisfy their demands. Craft production moved out of the home, became more diversified, and achieved a quite respectable standard of quality in the years before the Revolution. In tune with the attitudes and manners of the new elite, architecture became more formal.

The bustling towns of the New World were much like those back in England, except for New York, which still retained a good deal of its Dutch flavor. On the whole they were probably better laid out and more spacious. However, except for some of the smaller New England towns which have preserved their village greens and a few of the houses fronting on them, very little of eighteenth-century urban America is left. One gets some inkling of what such towns were like only in isolated enclaves in Salem, Annapolis, or Charleston, and in the refurbished downtown section of Philadelphia around Independence Hall or in the reconstructions of Williamsburg, Va., and Sturbridge, Mass. In most cases the natural process of growth, together with the American penchant for newness and progress, has destroyed what we now think of regret-

fully as our cultural heritage. Much of London is still eighteenth-century in character, and Paris and Rome have managed to preserve their essentially Baroque forms, not merely as archaeological relics but as viable contemporary environments. In America there is only an occasional reminder of a fairly recent past in the unaccountable wandering of a street which was once a path, or a name like The Bowery (*Bouwerij*), or Canal or Wall Street. This architectural heritage is often beyond physical recovery, and only recently has scholarship turned to recapturing through records at least some description of it. What we have to go by, aside from written sources, are occasional plans, rare topographical views of towns in prints, and the limited number of surviving monuments.

AMERICAN GEORGIAN

Although separating eighteenth-century architectural style from that of the seventeenth at precisely 1700 may be arbitrary, there can be no doubt that the two were completely different. The so-called "Georgian style" of the eighteenth century is a Baroque manifestation and a far cry from the Gothic inspiration of the seventeenth. One may well ask what happened to the Renaissance and Mannerism in this historical sequence. To simplify matters, it should be noted that England under the Tudors continued an infatuation with the Gothic long after it had been superseded on the Continent, and the introduction of the Renaissance style by Inigo Jones occurred only in the early seventeenth century. The English Baroque, which late in the same century followed a short period of Renaissance classicism, was dominated by the genius of Sir Christopher Wren and was carried into the eighteenth century by such followers as Sir John Vanbrugh, Nicholas Hawksmoor, and James Gibbs. But it was a restrained and classical Baroque, quite different from the florid and fantastic Baroque of the comparably late versions of the style in Germany or Spain.

The architecture of the pre-Revolutionary period of the eighteenth century is commonly designated as "American" or "Colonial" Georgian, to distinguish it from the

English version, which actually emerged before the ascent of George I to the English throne in 1714. It was a style peculiarly adapted to its age and to a new class of moneyed merchants and less rustic landed gentry who had come to dominate English society. The new style was imitated in the colonies on a more modest scale because of obvious limitations of economy, craftsmanship, and materials. Rural areas continued to build in the earlier Gothic vernacular, but the wealthier in towns and on plantations, seeking status as well as comfort and elegance, preferred the new Georgian. Since all the colonies were now under English rule, a truly homogeneous style was developed here for the first time.

There were no trained "professional" architects in the colonies, although some men were active avocationally in designing buildings, and public buildings were frequently the amateur efforts of gentlemen who had acquired some knowledge of architecture in the course of their education or artisans who had some skill in drawing.

The new manner was introduced by more recent immigrants, by colonists who visited or studied in England, but mostly through the medium of architectural books, which were widely circulated at the time. In England in the first half of the century the antiquarian and amateur architect Richard Boyle, third Earl of Burlington, sponsored a series of historic architectural publications. Issued in 1715 were Andrea Palladio's *Four Books of Architecture* in two volumes, with plates by Giacomo Leoni, and *Vitruvius Britannicus* by Colen Campbell, the first volume of which appeared in 1715–16. These were followed in 1727 by William Kent's *Designs of Inigo Jones*. This growing interest in architectural scholarship was augmented by new editions of Leon Battista Alberti in 1726 and Giacomo da Vignola in 1729 and the publication of *Palladio Londinensis* (1734) by William Salmon and *Vitruvius Scoticus* (1750) by William Adam.

However important such works were for the eventual transformation of the Georgian, they were little known in the colonies except by knowledgeable amateurs such as Peter Harrison, John Ariss, and Thomas Jefferson. Most builders, artisans, and clients relied on the more popular guides or handbooks, which simplified current architectural practice with emphasis on practical application and were thus naturally more eclectic and conservative. Such "how-to-do-it" books were extensively employed in the colonies, and new editions were issued to meet the competition as well as changing tastes. Batty Langley was probably the most widely read, *The City and Country Builder's and Workman's Treasury of Designs* (1740) being the most famous of his more than twenty titles in countless editions. But James Gibbs's *A Book of Architecture* (1728) was probably the single most popular architectural book of the century and had the greatest influence on Colonial building, although Robert Morris's *Select Architecture* (1757) had a decided impact, especially through Thomas Jefferson. Later in the century English hand-

books were printed in American editions, the first, Abraham Swan's *British Architect* (1745), issued in Philadelphia in 1775; and toward the end of the century many of James Paine's books were offered in American editions. If Colonial architecture of the Georgian period owed its homogeneity to the currency of such handbooks, it owed its eccentricities to a free, naive, and often whimsical mixing of details found in them.

It is possible to distinguish within the American Georgian an early or transitional phase from about 1700 to 1750 and a later, more fully developed one lasting until the Revolutionary War. The Early Georgian is characterized by an incomplete understanding and a tentative handling of the new style elements, with occasional throwbacks to the earlier Gothic. Its most recognizable features are a generally flatter treatment of the facade; a decided preference for the gambrel roof—almost without exception a hallmark of the Early Georgian—or in the South a very high-pitched hip roof with necessarily taller chimneys; and detailing which is heavier, bolder, and cruder than that of the more sophisticated High Georgian. In general, the development of the Georgian is from a tentative to a consistent usage of the stylistic vocabulary and is, considering its provincial and amateur aspects, surprisingly dependable for purposes of dating.

GEORGIAN PUBLIC BUILDINGS

Public buildings became larger, richer, and more permanent, and a greater number have survived. The impact of the Georgian style, as developed by Wren in the rebuilding of London after the great fire of 1666, made itself manifest earlier in public than in private buildings, in the colonies as well as in England. The earliest, largest, and most splendid secular complex was erected at Williamsburg, Va.: the College of William and Mary (1695–1702), the Capitol (1701–05), and the Governor's Palace (1706–20). All these were destroyed, but they now exist again in scrupulously authentic reconstructions, begun in 1927 with the financial aid of John D. Rockefeller, Jr. The city was laid out with rationality and pomp, the main avenue, the Duke of Gloucester Street, almost a hundred feet wide and almost a mile long, joining the Capitol with the College and affording the kind of vista made popular by Baroque planning of the seventeenth century. The buildings with their formal gardens are Wrenian, although their attribution to him is purely conjectural.

The Capitol (plate 58), especially, is an imposing mass of Baroque formal elements rendered with uncommon decorative reticence. However, one must be wary of making aesthetic judgments on the basis of a modern reconstruction, which can, even with the best of intentions, distort the existing evidence, in this case an eighteenth-century print (plate 57) that is far from a measured drawing. The detailing of the reconstruction may be a bit

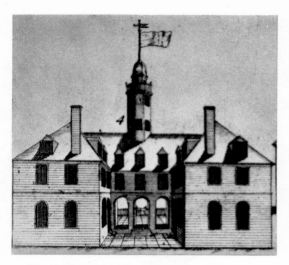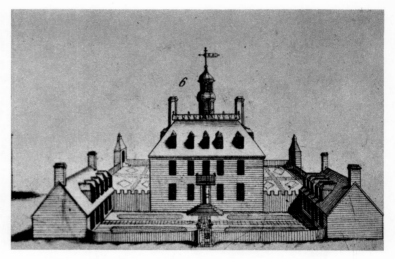

57 Capitol and Governor's Palace, Williamsburg, Va. From an engraving of 1732–47. No. 4: Capitol; No. 6: Governor's Palace. Bodleian Library, Oxford University, England

prim and too neat, and perhaps misleading, but the handsome three-arched loggia entrance, flanked by boldly projecting wings that end in semicircular turret-like masses, is a fine conception. The steeply pitched hip roof and the elongated dormers are features which became common in Early Georgian domestic architecture in Virginia. The rather simple cupola, although a bit spindly, was obviously inspired by Wren's use of the device on public buildings, a feature which became exceedingly popular in the American Georgian, both on secular public buildings and on houses. The Palace (plate 59) and College, handsome as they are, are not much more than overblown houses.

The oldest extant public building of the period is Boston's charming little Town House, commonly known as the Old State House (1712–13, plate 60). The simple rectangular brick structure erected on a sloping street is capped by an ornate cupola. The stepped and ornamented end gables with their lion and unicorn decorations, the insignia of the English crown removed during the Revolution but later restored, are something of a throwback to the Tudor style. Similar, though not so elegant, is the Old Colony House (1739–41) in Newport, R.I., designed by an innkeeper, Richard Munday, a larger building than the Old State House and stylistically more advanced in its pedimented central pavilion, though the curiously truncated end gables are uncharacteristic. Like many Georgian public buildings, both these town houses are of red brick with white trim and resemble enlarged dwellings, even to the inclusion of dormer windows. The most impressive of all Colonial public buildings is undoubtedly the legendary Independence Hall in Philadelphia (plate 61, colorplate 5), Pennsylvania's Old State House, erected after a design by the Speaker of the Assembly, Andrew Hamilton, a lawyer. It was begun in 1731 and completed in 1753, although extensions and renovations

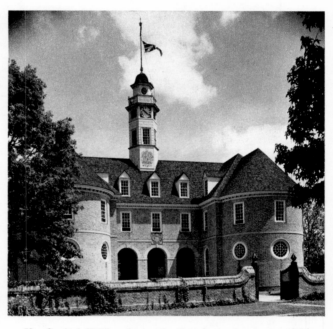

58 Capitol, Williamsburg, Va. Reconstruction begun 1927

continued beyond the turn of the century. It was a more satisfying structure before the erection of its rather heavy-handed, oversized tower in 1750. At that stage it consisted of a central building with a gambrel roof masked at the ends by a screen wall terminating in a cluster of four chimneys, an unusually rich variation of the Early Georgian form, and flanked by symmetrical smaller wings joined by loggias open to the north. The result was a well-proportioned, beautifully cadenced composition of solid masses and light arcades. The interior detailing (plate 62) is later than the exterior, and its full-blown Baroque paneling and carving were by far the most palatial in the colonies.

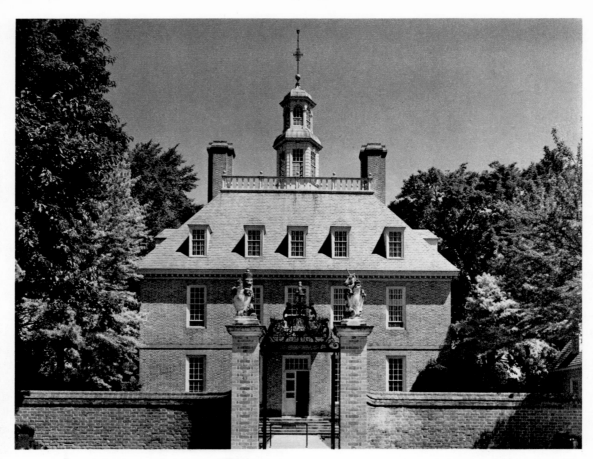

59 Governor's Palace, Williamsburg, Va.
Reconstruction begun 1927

60 Old State House, Boston. 1712–13

61 Andrew Hamilton.
 Independence Hall, Philadelphia.
 Begun 1731

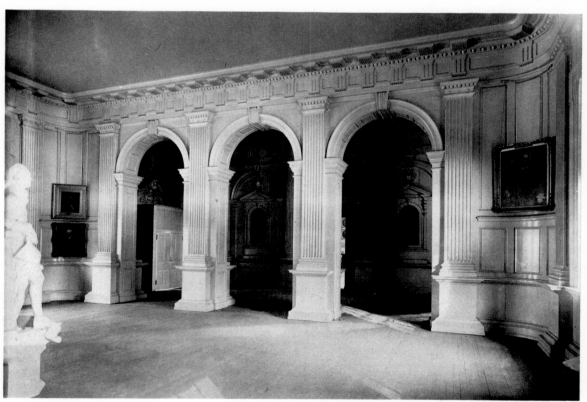

62 Supreme Court Room, Independence Hall, Philadelphia. Begun 1731

Other buildings worth attention are the historic market and "cradle of liberty," Faneuil Hall (1740–42, plates 63, 64) in Boston, designed by the painter John Smibert and greatly but respectfully enlarged by Charles Bulfinch in 1805–06; and the remarkably advanced classical Redwood Library (1748–50) and the lovely small Brick Market (1761–72), both in Newport, R.I., and by Peter Harrison. Faneuil Hall was originally a simple, long, and narrow two-story building with an open arcaded market on the ground floor, in the tradition of medieval guild or town halls, and in its altered state has continued to serve as a market center of Boston to this day.

Peter Harrison (1716–1775) was the most interesting and best of the architectural practitioners of the pre-Revolutionary period. Although a successful sea captain, ship owner, and merchant, he evinced a lifelong interest in architecture and a sincere concern about improving local standards. He accepted commissions at a nominal fee and, during the thirty years that he was active, designed some of the finest Colonial buildings in New England. In the Redwood Library (plate 65), based on a plate from Edward Hoppus's *Andrea Palladio* (plate 66), Harrison revealed an unexpected awareness of English neo-Pal-

ladianism. The disposition of the pedimented portico overshadowing the wings, the heaviness of proportions, and the severely restrained decoration create a quasi-temple form unique for the time, a preview of the later Classical Revival. The Brick Market (plate 67) is the gem of Harrison's architectural career, his most ingratiating and refined effort. Deriving from Inigo Jones's Somerset House (reproduced in *Vitruvius Britannicus*, plate 68), it transforms the grandeur of the late Renaissance into something more modest without losing its essential dignity. The lower floor is distinguished from the upper stages by a variant treatment of the brick, and its three clean arches framing the doorway and flanking windows serve as a base for the more elaborately decorated superstructure. The three-bayed facade is divided by pilasters, doubled at the ends, with alternating pedimented and arched windows on the second floor and square ones on the third level, all characteristic Palladian devices. The relatively restrained, domesticated roofing suggests that for Newport Harrison had gone far enough.

American concern with public education assured the construction of college buildings to house and board students as well as educate them. The earliest extant ex-

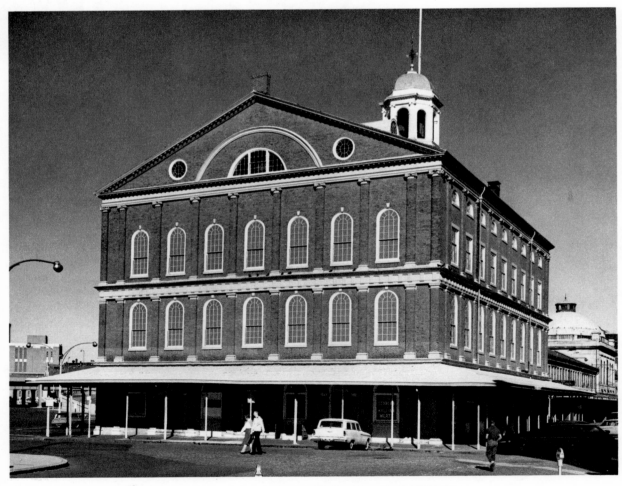

63 John Smibert. Faneuil Hall, Boston. 1740–42 (enlarged by Charles Bulfinch, 1805–06)

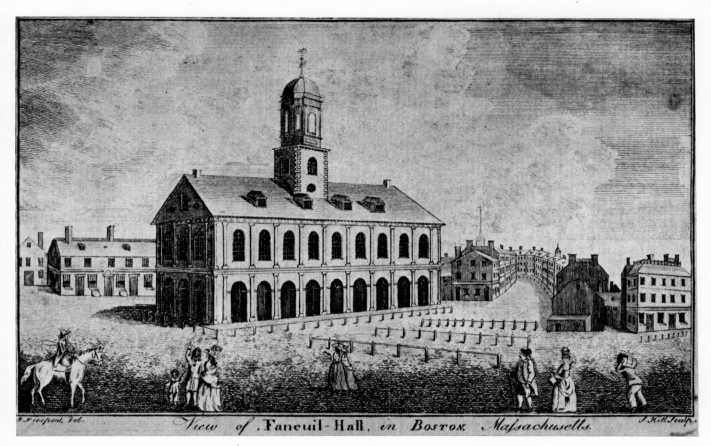

64 John Smibert. Faneuil Hall, Boston. 1740–42. From an engraving in *Massachusetts Magazine*, 1789. Library of Congress, Washington, D.C.

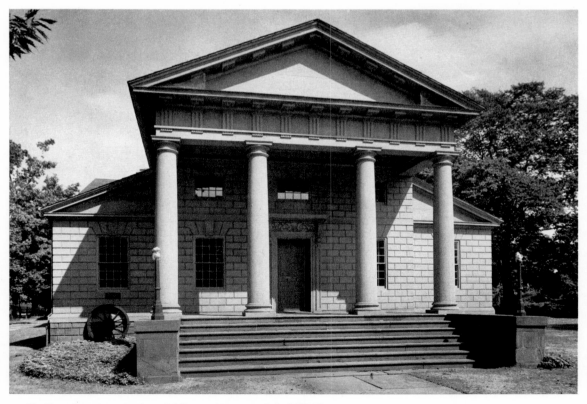

65 Peter Harrison. Redwood Library, Newport, R.I. 1748–50

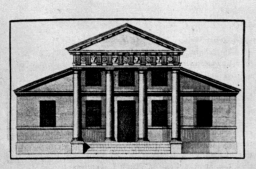

THE

FOURTH BOOK.

⁂⁂⁂⁂⁂⁂⁂⁂⁂⁂⁂⁂⁂⁂⁂

CHAP. I.

Of the Situation to be chosen for the Erection of Temples.

USCANY was not only the first *Italian* Country that received Architecture as a foreign Invention, from whence the *Tuscan* Order had its Dimensions; but with respect to the Things relating to those Gods, which were worshipp'd by the greatest Part of the World (groveling in the Darkness of Error and Superstition) she was the Mistress of all the neighbouring Nations, and shew'd them what kind of Temples they ought to erect, what Places were most commodious, what Ornaments most suitable to the Quality of the several Gods. Altho' in many Temples 'tis too evident that such Observations have not always been duly regarded, yet I shall, with as much Brevity as possible, relate

66 Andrea Palladio (1508–1580). Temple design. From Edward Hoppus, *Fourth Book of Andrea Palladio*, London, 1756

67 Peter Harrison. Brick Market, Newport, R.I. 1761–72

68 Inigo Jones (1516–1652) and John Webb (1611–1672/74). Elevation, Great Gallery, Somerset House, London. From Colen Campbell, *Vitruvius Britannicus*, 1715–16, London, Vol. 1, p. 16

ample and the model for much neo-Georgian college architecture of the twentieth century is Massachusetts Hall (1718–20, plate 69) at Harvard, planned by its president, John Leverett, and Benjamin Wadsworth. This four-story, red-brick dormitory, with its gambrel roof and masking screen walls at the ends, its six massive chimneys, and its flat and undecorated facade, differs from the typical Early Georgian house only in scale. Even the two unaccented entrances seem a calculated avoidance of the monumentality which a central doorway for a building of that size would have demanded. Also in Harvard Yard are the more sophisticated, miniature Holden Chapel (1742–44, plate 70), with its ornamental burst of Baroque carving in the pedimental area over the entrance, and Hollis Hall (1762–63, plate 71), in the full Georgian manner, though essentially simple and restrained. Like Massachusetts Hall, the latter is also four stories high, but with a pedimented pavilion accenting the center, and a hip roof. Connecticut Hall, at Yale, is a straightforward rectangular block with a gambrel roof and, considering its date (1750–52), somewhat retarded. Perhaps the most charming of Georgian college buildings is Dartmouth Hall (plate 72), in Hanover, N.H., a clapboarded building painted white, beautifully proportioned,

and capped by a delicate cupola. Erected in 1784–91 after the Revolution, and still completely Georgian in style, it was carefully reconstructed after a fire in 1904.

Since American colonization had been involved with European religious struggles of the seventeenth century, it was only natural that ecclesiastical building should be one of the primary American considerations. The fanatical doctrinal divisions which had rent communities, divided colonies, and resulted at times in persecution gave way in the eighteenth century to a greater religious tolerance. The hard edge of bigotry had been worn away, a fact symbolized through the acceptance by practically all denominations of the basic Anglican church form developed by Wren. This was usually a long, naved structure with either a single tower and spire or cupola at the front or rising from a columnar porch. The form of the tower had been borrowed from the Gothic, but all its decorative details were now Classical, as were those of the body of the church itself. It was almost as if the indigenous English Gothic were restated in a different architectural language.

The Wrenian type, in its developed eighteenth-century form, is to be seen in a "classic" example, St. Martin-in-the-Fields (1721–26, plate 73) in London, designed by

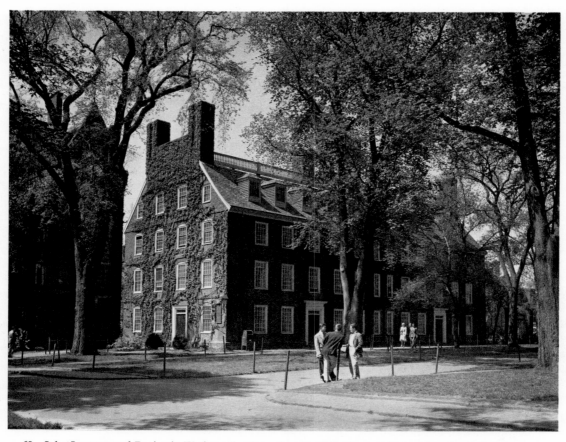

69 John Leverett and Benjamin Wadsworth. Massachusetts Hall, Harvard University, Cambridge, Mass. 1718–20

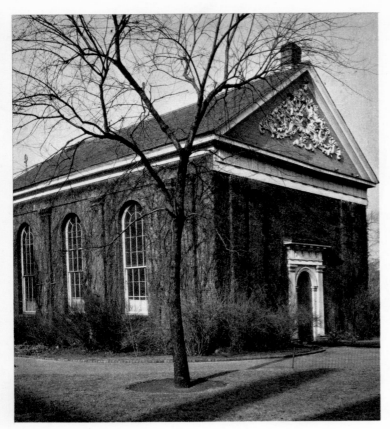

James Gibbs. St. Martin can be described as a Baroque version of a Roman temple with a belfry rising from behind the portico on the west end (plate 74). In the interior (plate 75), the groin-vaulted nave is flanked by two aisles with balconies and sumptuously decorated in a Baroque profusion of Classical architectural motifs. This type was transplanted to the colonies early in the century and brought with it the Classical orders in columns and pilasters; elaborate cornices, balustrades, and urns; windows that were rectangular, roundheaded, Palladian, or bull's-eye; and columned interiors that were vaulted or made to appear so. Eventually even some of the most puritanical Protestant communities were weaned away from the severity of the meetinghouse to the more ornamental richness of Anglican church forms.

In the English colonies the earliest church in the Georgian mode, Bruton Parish (1711–15, plate 76) in Williamsburg, Va., is reputed to have been designed by Governor Alexander Spotswood, recently arrived from England, who would have been conversant with the newer idiom.

70 Holden Chapel, Harvard University,
 Cambridge, Mass. 1742–44

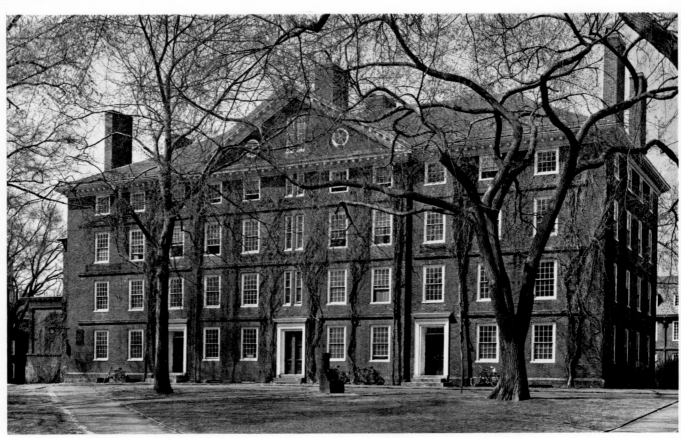

71 Hollis Hall, Harvard University, Cambridge, Mass. 1762–63

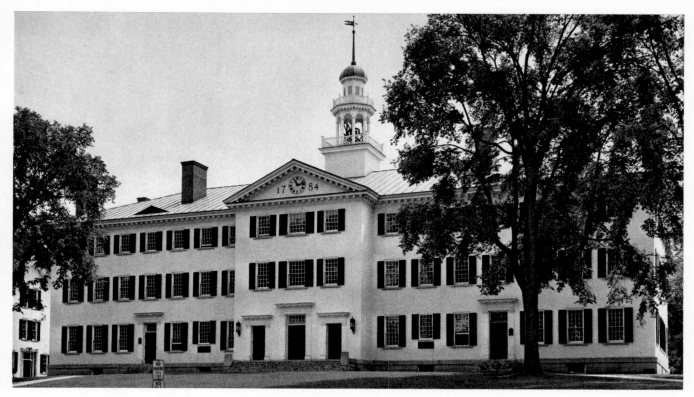

72 Dartmouth Hall, Dartmouth College, Hanover, N.H. 1784–91

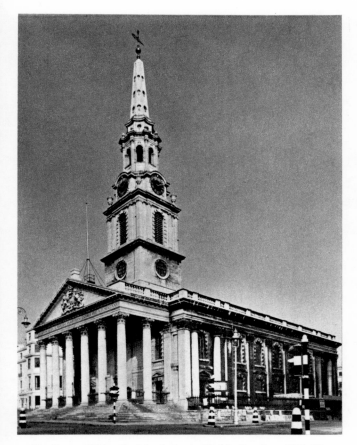

73 James Gibbs. St. Martin-in-the-Fields, London. 1721–26

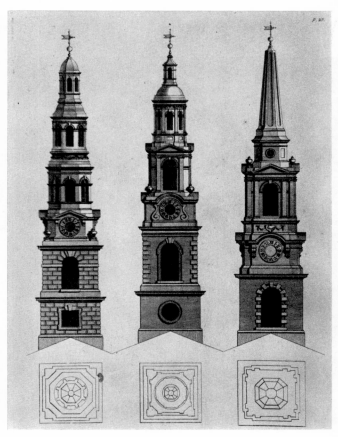

74 James Gibbs. Alternate designs for the tower of St. Martin-in-the-Fields, London. From James Gibbs, *A Book of Architecture*, London, 1728

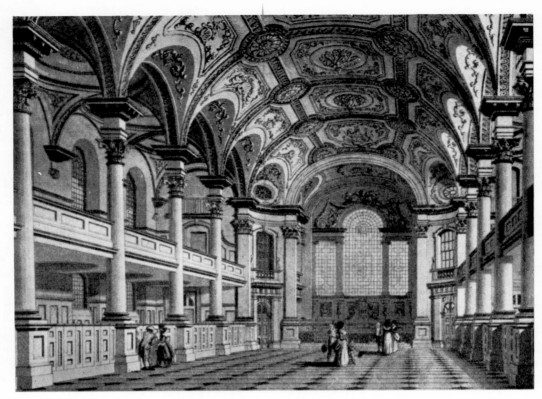

75 James Gibbs. Interior, St. Martin-in-the-Fields, London. 1721–26. From an engraving

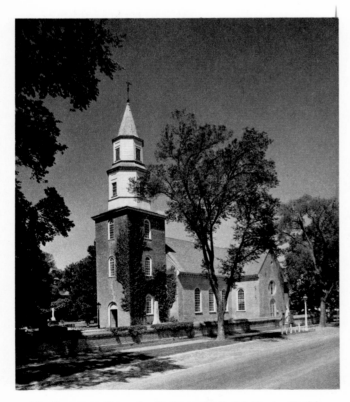

76 Governor Alexander Spotswood (attrib.). Bruton Parish Church, Williamsburg, Va. 1711–15

This small parish church is a stripped-down version of a Wren church done in brick. Unusual in its cruciform plan, it has a modest and rather ungainly square tower with a simplified octagonal spire, which were added in 1769, and a bare, barnlike interior furnished with stationary pews.

The largest of the Early Georgian churches are two in Boston; Christ Church (plates 77, 78), better known as "Old North," from whose belfry the light was flashed to Paul Revere, built by the Anglican congregation in 1723 and designed by William Price, a Boston print dealer; and Old South Meeting House (plate 79), equally famous in the annals of the American Revolution as the meeting place of the "Sons of Liberty," designed by Robert Twelves and built in 1729–30. These buildings established a type which dominated New England church architecture and was widely copied. Both are brick constructions of simple rectangular mass covered by peaked roofs and lit by two ranges of roundheaded windows. The square towers in four stages separated by belt courses, which might very well be designated as "the Boston type," are capped by lofty wooden spires clearly dependent on English sources and emulating their Baroque richness in carpentry. Old South is broader in proportion and retains the meetinghouse plan with pulpit on the side: a large, open interior space with no particular focal point.

The interior of Old North is divided into a nave and side aisles and has a gallery supported by square paneled piers and superimposed fluted ones rising to a false elliptically vaulted plaster ceiling.

A major problem facing Colonial church builders was the limited ability of local masons to cope with brick or stone vaulting. All the roofs were of wooden construction with hung ceilings formed and plastered to imitate vaulting. The characteristic monumental interior columns carrying balconies at the midpoints and vaulting at the tops were beyond the capabilities of the Early Georgian builders, and a two-stage solution was devised, as in Old North. However, by mid-century the monumental column, though still in wood, had become common in Colonial church interiors. An analogous problem presented itself in the church spire. American steeples were inordinately high, and everything above the square brick tower was rendered in wood (except for St. Paul's Chapel, New York City; see below). They were crude and simplified versions of English models, but even beyond this, the designs are patently provincial. A redeeming feature is the almost spidery lightness of form, due, no doubt, to the nature of the carpentry itself.

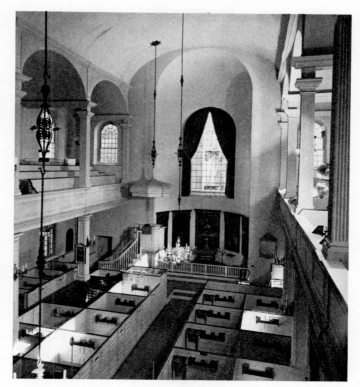

78 William Price. Interior, Christ Church ("Old North"), Boston. 1723

77 William Price. Christ Church ("Old North"), Boston. 1723

79 Robert Twelves. Old South Meeting House, Boston. 1729–30

The Boston type was widely imitated, by Price himself in the entirely wooden version of Trinity Church (1725–26, plate 80) in Newport, R.I., which is almost a verbatim reiteration of Old North, and throughout the century in smaller New England churches such as the Congregational Meeting House (plate 81) in Farmington, Conn., planned by Judah Woodruff in 1771. Christ Church in Philadelphia (plate 82), designed by Dr. John Kearsley, is the most advanced of such Early Georgian churches. Begun in 1727, it was not completed until 1744, and its wooden spire was added a decade later. Its square tower is relatively early in character, but the rest is ornately decorated in the more lavish style of the High Georgian. The apse end exhibits an especially rich composition of Baroque architectural motifs centering on a giant Palladian window flanked by niches. The elaboration and articulation of plastic elements in the interior (plate 83), with the use of giant columns and rich entablature, is the first competent Colonial translation of the Wren-Gibbs manner.

High Georgian churches were larger in scale, more complex and refined in both plan and detail, and were usually characterized by the addition of a columnar portico on the west, or entrance, end. The earliest of these, King's Chapel (1749–54, plate 84) in Boston, was designed by Peter Harrison and built of stone, in itself a conscious striving for monumentality. The portico was

80 William Price. Trinity Church, Newport, R.I. 1725–26

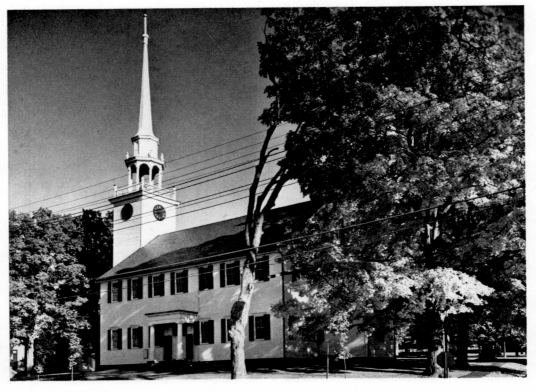

81 Judah Woodruff. Congregational Meeting House, Farmington, Conn. 1771

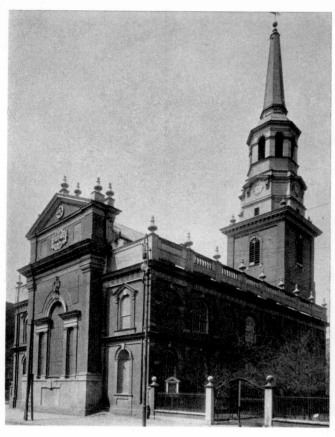

82 John Kearsley. Christ Church, Philadelphia.
Begun 1727

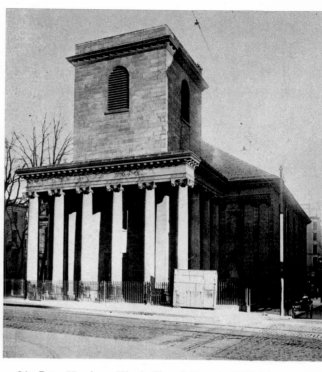

84 Peter Harrison. King's Chapel, Boston. 1749–54

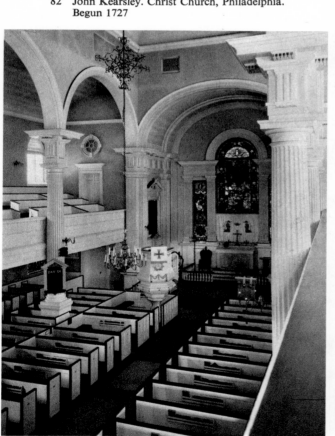

83 John Kearsley. Interior, Christ Church,
Philadelphia. Begun 1727

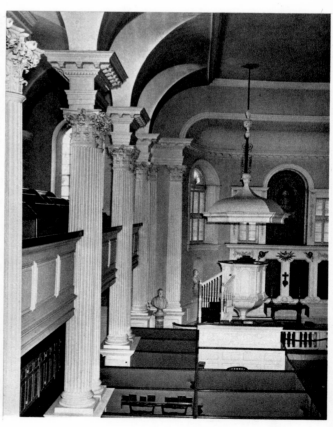

85 Peter Harrison. Interior, King's Chapel,
Boston. 1749–54

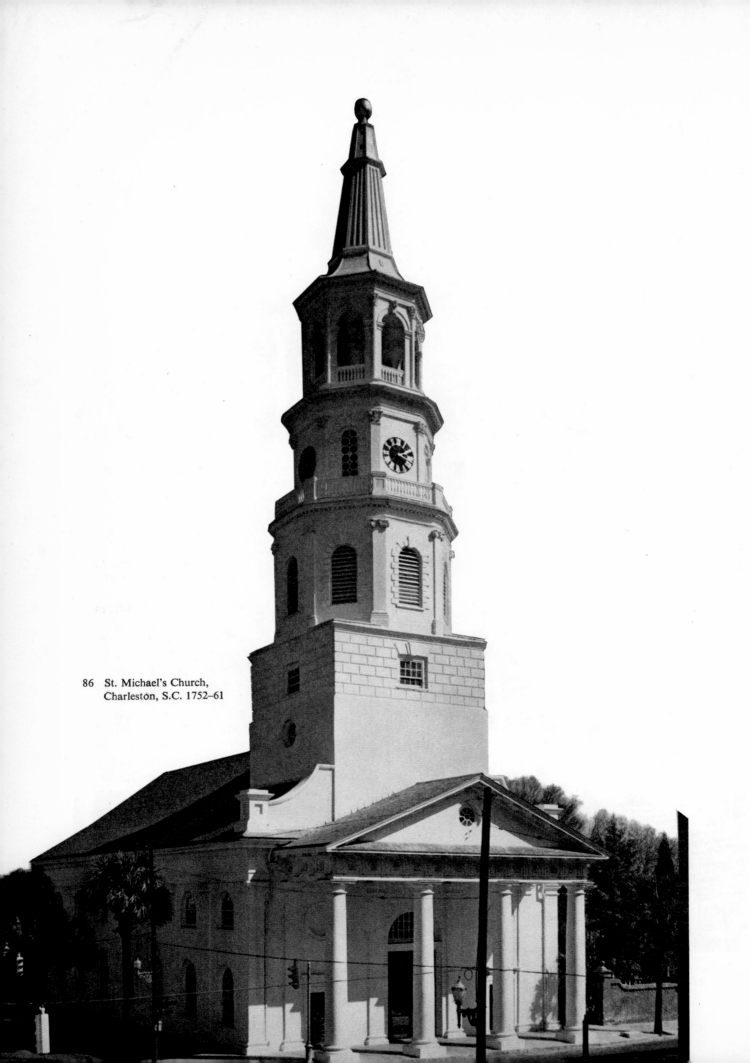

86 St. Michael's Church,
Charleston, S.C. 1752–61

87 Peter Harrison. Jeshuat Israel (Touro Synagogue), Newport, R.I. 1759–63

not completed until 1787, and the steeple was never built. The hip roofing of the church proper as an independent unit, one of Harrison's few aesthetic lapses, along with the truncated tower, makes a disappointing whole. In the interior (plate 85), however, the splendid giant Corinthian columns in pairs and the simulated groin vaulting of the side aisles produce an articulated space of unusual sophistication by American mid-eighteenth-century standards. Harrison was also responsible for the much more modest though charming Christ Church (1759–61), in Cambridge, Mass. The attribution to Harrison of St. Michael's (1752–61, plate 86), in Charleston, S.C., the finest of southern Georgian churches, is about as far-fetched as its occasional attribution to James Gibbs; a local builder, Samuel Cardy, is a more likely candidate. In any case, St. Michael's has the first columnar church portico in the colonies.

Also by Harrison is the unique Jeshuat Israel, or Touro Synagogue (1759–63, plate 87), in Newport, R.I., the earliest extant example of its kind, built for one of the first communities of Jews in the New World. The commission presented an unprecedented problem, and, although Harrison, fortunately, did not attempt an exotic solution, he did approach it as a situation demanding something different both functionally and stylistically. The Jewish community's considered preference for a modest building influenced Harrison's design of an unprepossessing, almost square house form of smooth stucco over brick, with large, unornamented, round-headed windows, completely unaccented except for the small two-columned doorway porch on the west side. The brilliant Baroque interior (colorplate 6) is, however, one

of the finest of the period. The plan calls for a raised and railed platform, or bema, in the center; a large, elegantly decorated Ark of the Covenant on the east wall; and a gallery to house the women and children during services. The gallery is supported by Ionic columns, the ceiling entablature by Corinthian. All the detailing is rich but restrained, and the *leitmotif* is the exceptional feature of a heavy baluster used in the railings of the gallery, bema, and podium of the Ark.

The richest and most knowledgeable High Georgian church is St. Paul's Chapel (plate 88) in New York, designed by Thomas McBean, the son of James, and built in 1764–66 of Manhattan schist with brownstone trim. The reason for the eccentric separation of the elaborate tower and spire at the west end and the columnar portico on the east is not clear, but, although the latter was added thirty years later, in 1794–96, it seems to have been part of the original plan. McBean, who is said to have studied with Gibbs, showed his training, or at least his acquaintance with the latter's handbook (plate 89) in the design of the tall, all-brownstone belfry tower, the one Colonial tower that demonstrates some awareness of the subtle nuances of planned transition from one stage to the next in a continuous flow of geometric complexity and Baroque opulence. The interior (plate 90) also outstrips all others in its richness and sophistication. The majestic columns and sumptuous decorative display are capped by a fully understood vaulting system, the only one in the colonies (but, it should be remembered, still false). The limitations of craftsmanship aside, McBean produced a full, clear, if somewhat diminished echo of St. Martin-in-the-Fields.

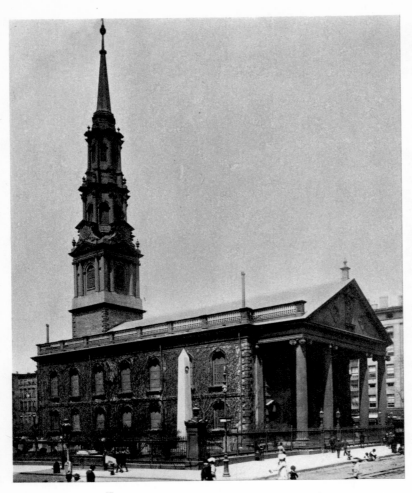

88 Thomas McBean. St. Paul's Chapel, New York. 1764–66

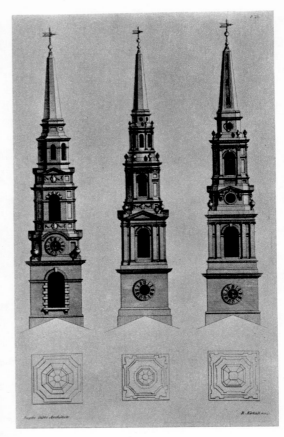

89 James Gibbs. Belfry or tower designs. From James Gibbs, *A Book of Architecture*, London, 1728

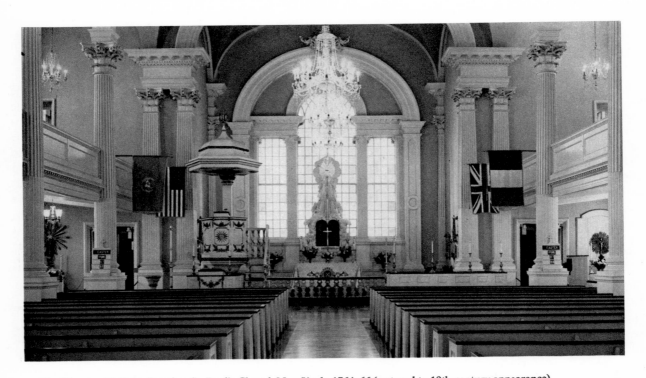

90 Thomas McBean. Interior, St. Paul's Chapel, New York. 1764–66 (restored to 18th-century appearance)

GEORGIAN DOMESTIC BUILDINGS

The Colonial Georgian dwelling, whether Early or High, was essentially an imitation of the English country house or smaller town house made popular by Wren and his followers. The American "classic" type was a boxlike, two-story building with an attic floor lit by the newly introduced dormer windows. Although there were many variations, the plan was usually almost rigidly regular, with one room in each of the four corners and a central hallway leading to a richly balustered staircase. In place of the picturesque, free-form, expansive plan of the seventeenth-century house, the Georgian presented a rationally conceived though immutable shell, into which the process of living was forced. Indeed, the whole cultural style of the period was dominated by formal logic and elegance.

The houses of the southern landed gentry served both as dwellings and as plantation establishments and were naturally larger and usually more sumptuous than those of affluent northerners, which were commonly town houses. The designs of these southern mansions were derived from the villa types found in architectural manuals. They were variously laid out in complexes consisting of a large central building, the house proper, symmetrically flanked by contiguous wings or separate smaller structures housing kitchens, offices, and workshops, all carefully and rationally disposed amid lawns and formal gardens (cf. plate 122).

The rule of symmetry dominated the exterior design, as it did the plan of the Georgian house. The fenestration of the facade usually had five windows to a story, with additional spacing on either side of the central window for axial emphasis, and four windows on the sides. On the Early Georgian facade the center was emphasized by a richly ornamented doorway, which, more than any other feature, betrayed its Baroque sources. Pilasters and engaged columns in all the accepted orders; rusticated quoins; scrolls and brackets; and pediments that might be angled, segmental, or broken with a carved ornament in the center—all were common. High Georgian had a slightly projecting central pavilion framing either the single central window or an augmented set of three, often defined by pilasters or quoins at the outer edges and capped by a pediment breaking above the cornice line. The more stately two-story columnar porch projection of the central pavilion occurred only after about 1750.

The most advanced Georgian roof type was the deck, which served as a logical cap to the rectangular box below. However, the earlier gambrel and hip roofs continued through the first half of the century, and an anomalous peak roof occasionally intruded. Commonly the deck roof was crowned by a balustered railing enclosing the so-called "captain's" or "widow's walk," and many houses were topped by a central cupola. Richly dentilated and bracketed cornices, as well as belt courses

between stories, tied the four sides into a unified whole, emphasizing the horizontal divisions of the structure, while pilasters and quoins reinforced the structural appearance of the corners. Since each room of the house now had its own fireplace on the outside wall or back-to-back on an interior wall, either four separate chimney stacks emerged on the exterior at the cornice line or, in the more advanced solution, two at the deck-roof line. There were, of course, many exceptions and variations resulting from idiosyncratic plans, the exigencies of building, or simple preference.

All the detailing, both exterior and interior, had a pronounced Baroque plasticity, more robust in the Early and more elegant in the High Georgian, reflecting the Rococo taste of the latter half of the century. Doorways were especially richly ornamented, but windows also were emphasized by elaborate framing and pedimental caps, often alternating the angular and segmental, and many fine houses boasted the Palladian window as a central feature of the facade or at the stair landing in the rear.

American building continued to translate European models in terms of local materials, though improved craftsmanship during the eighteenth century made building in brick and stone more common. New England, however, maintained a preference for wood even in its finest houses, and the simulation of stone masonry in wood was fairly frequent. However, elsewhere in the colonies brick and stone had become symbols of economic and social position, and where good stone was available, as in the Middle Atlantic colonies, it was increasingly employed, whereas brick became the preferred material in the South. In brick houses the ornamental trim was sometimes of molded brick, only rarely of stone, but mostly of wood painted white to simulate stone.

The Georgian house interior was adapted to comfortable upper-class life. Compared with a seventeenth-century house, it had larger rooms and higher ceilings and was better lit. Room functions had become more specialized: a normal Georgian house had a kitchen, often relegated to an attached ell or an outbuilding; a dining room; a withdrawing, or drawing, room which also served as a library; and a parlor or ballroom—all on the lower floor. The main bedrooms were on the second floor, with additional bedrooms for children and servants in the garret. This arrangement was somewhat more varied in the southern plantation house, where the grand ballroom or saloon was occasionally on the second floor. A major distinction between Early Colonial and Georgian, and an indication of the new social ostentation, was the development of the modest entryway into an almost ceremonial hallway or reception room, often leading under a sweeping arch or columned portico to a splendid stairway. Ceiling beams and joists were now hidden behind plastered and frequently decorated ceilings. Simple vertical wainscoting gave way, at least in the formal rooms, to

richly articulated paneling in the finest walnut and mahogany. Wood was elaborately turned for balusters and carved for stair ends and overmantels with the opulent Baroque motifs one finds on the exterior. Lesser rooms, bedrooms, and hallways were painted or wallpapered, and even an occasional mural turns up.

Many authentic Georgian domestic buildings still exist, but space permits discussion of only a few of the finest. Unfortunately, several of the most lavish Early Georgian houses in New England have been destroyed. The Governor Hutchinson House (c. 1688) in Boston, which we know only from a print (plate 91), was certainly an impressive building for its time. Built of brick, it was the earliest house to show the new Georgian style in its symmetrical facade, stone pilaster ornamentation, and gambrel roof. Also in Boston, but later in date and built of stone, in itself unusual for the area, was the Governor Hancock House (1737–40, plate 92), exhibiting a richer and fuller Baroque ornamentation, although it retained the transitional gambrel roof. Except for this feature, it is closely analogous to such English models as the Mompesson House (1701) in Salisbury (plate 93).

Still standing is the McPhedris-Warner House (1718–23, plates 94, 95), built by a merchant sea captain on the harbor of Portsmouth, N.H. This brick building is one of the earliest Georgian houses, and, in its almost austerely simple facade, gambrel roof, and irregularity of plan, it betrays its transitional character. However, its alternating angular and segmental pedimented dormers and the decorated doorway reveal it to be a provincial imitation of such prototypes as the Pallant, or "Dodo," House (plate 96) in Chichester, England. An equally early house, the Usher-Royall (1733–37; west facade, 1747–50), in Medford, Mass., is an interesting example of a seventeenth-century cottage renovated to satisfy the changed status and taste of its owners (plate 97). The original Early Colonial house is completely hidden by a brick and wooden shell in the Georgian manner. Both front and rear facades, in wood and of different design, exhibit a rich repertory of Georgian detail. The major rooms of the interior were also remodeled in the latest fashion of elaborate paneling, although the kitchen, used only by servants, was left in its seventeenth-century form.

The finest High Georgian example in New England is the lavishly decorated Jeremiah Lee House (1768, plate 98), Marblehead, Mass. The wooden structure was sheathed in broad boards imitating courses of stone masonry, and the interior (plates 99, 100) was finished in the choicest mahogany paneling and imported hand-painted wallpapers. The overmantels were carved with

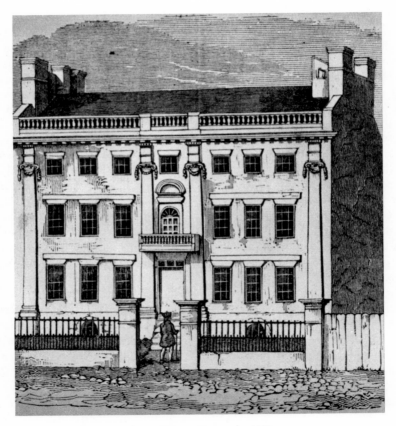

91 Governor Hutchinson House, Boston. c. 1688.
From *The American Magazine*, Vol. 2, p. 237

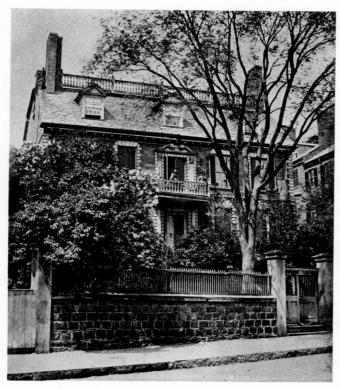

92 Governor Hancock House, Boston. 1737–40

garlands so richly executed that they could hardly have been done on this side of the Atlantic. Simpler, though just as large, is the clapboarded Vassall-Longfellow House (1759, plates 101, 102), Cambridge, Mass. Except for the porches on the short sides, which are later additions, it is considered a classic example of the more restrained High Georgian taste in New England.

New York City now has very little in the way of Georgian houses. The somewhat rustic Van Cortlandt Mansion (1748–49, plate 103) was built as a country house, and it is a curiously provincial building constructed of fieldstone. The interior is extremely simple, still somewhat Dutch and heavy in scale, more in keeping with a farmhouse, which it was, than a mansion, as it is now called. The more sophisticated Morris-Jumel Mansion (1765, plate 104), on the other hand, was conceived and built as such by Roger Morris on Washington Heights, overlooking the Harlem River. The original character of the house was probably changed by renovations during the Federal period, when an octagonal room was built onto the rear, at which time the Neoclassic doorway, with its elliptical fanlight, and the railing at the cornice level may have been added. The giant portico may be original, but the slender columns seem equally Neoclassic in proportion.

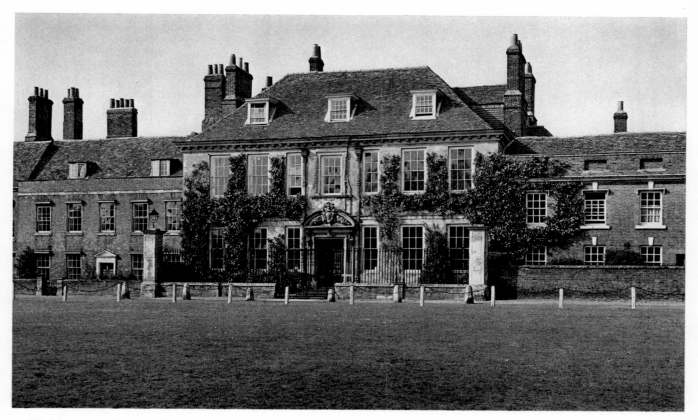

93 Mompesson House, Salisbury, England. 1701

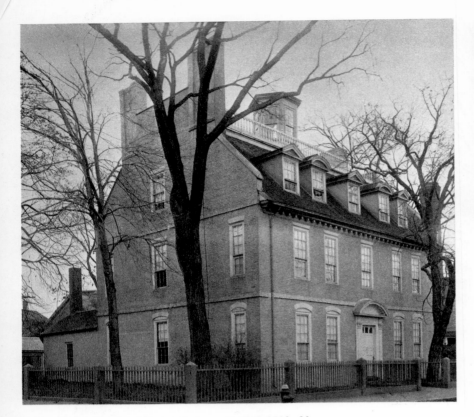

94 McPhedris-Warner House, Portsmouth, N.H. 1718–23

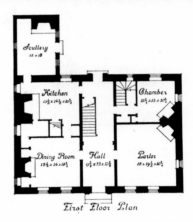

95 North elevation and first-floor plan, McPhedris-Warner House, Portsmouth, N.H. 1718–23. From John Mead Howells, *Architectural Heritage of the Pisquatoca*, Architectural Book Publishing Co., New York, 1937, p. 18

96 Pallant ("Dodo") House, Chichester, England. c. 1712

97 East facade, Usher-Royall House, Medford, Mass. 1733–37

98 Jeremiah Lee House, Marblehead, Mass. 1768

100 Parlor, Jeremiah Lee House, Marblehead, Mass. 1768

99 Stairway, Jeremiah Lee House, Marblehead, Mass. 1768

101 Vassall-Longfellow House, Cambridge, Mass. 1759

102 Plan of Vassall-Longfellow House, Cambridge,
Mass. 1759. From Kimball, *Domestic Architecture
of the American Colonies and of the Early Re-
public*, 1922, fig. 46, p. 73

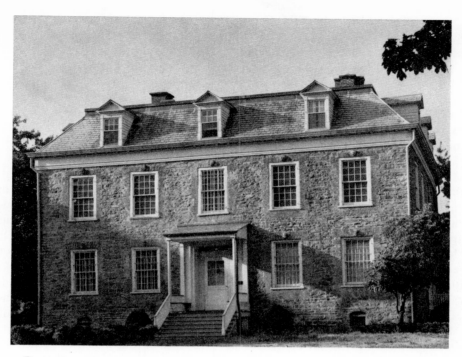

103 Van Cortlandt Mansion, New York. 1748–49

104 Morris-Jumel Mansion, New York. 1765

Philadelphia, especially with its suburb of Germantown, has been luckier than New York City and still retains some splendid Georgian houses. Among Pennsylvania examples are such transitional houses as Wynnestay (1689), Wyck (c. 1690, 1720), and the deceptively rustic, barnlike Graeme Park (1721–22, plate 105) in Horsham. Graeme Park is a long, narrow building of irregular courses of stone masonry which reflect both the limitations of local craftsmanship and the beauty of the natural material. Its ungainly gambrel roof, centrally located chimneys, and the asymmetrical spacing of its facade all hark back to the seventeenth century, but the interior is surprisingly impressive with its boldly scaled wooden paneling. In Philadelphia itself the small, brick Letitia Street House (plate 106), sometimes called the William Penn House, later removed to Fairmount Park and restored, is one of the few modest houses left from this period. Once thought to have been built before the turn of the century, but now dated sometime between 1703 and 1715, it is a very plain, almost nondescript box with a peaked roof. However, such style as it shows is Georgian rather than Gothic, and the interior contains some simple paneling that is clearly Georgian.

Among the more developed houses of Philadelphia is the primly formal Stenton (1728, plate 107), Germantown, which, despite its restraint, exhibits unusual taste in the fine brickwork and a refined sense of proportion in the design of the facade, especially in the composition of the simply framed doorway with independent sidelights and a semicircular stoop of three steps. Much more opulent in decoration is the stone High Georgian Cliveden (1763–64, plates 108–110), also in Germantown, with its urns at the four corners of the cornice and at the ends of the peaked roof (a curiously *retardataire* feature) and the scrolled dormers, which appear to have been a local Philadelphia device. The grandeur of Mount Pleasant (1761–62, plates 111, 112), in Fairmount Park, with its two smaller flanking buildings, is related to the plantation houses of the South. It was built of rubble masonry and stuccoed, and, like Cliveden, has scroll decorations framing its dormers. Its roofs are unique in the colonies, resembling the French Mansard and in the side buildings flaring on the lower slope. Notable also are the two chimney stacks on the main house, each composed of a cluster of four joined by arches. The lavish interior also shows a full repertory of Georgian architectural details.

105 Graeme Park, Horsham, Pa. 1721–22

106 Letitia Street (William Penn) House, Philadelphia. 1703–15

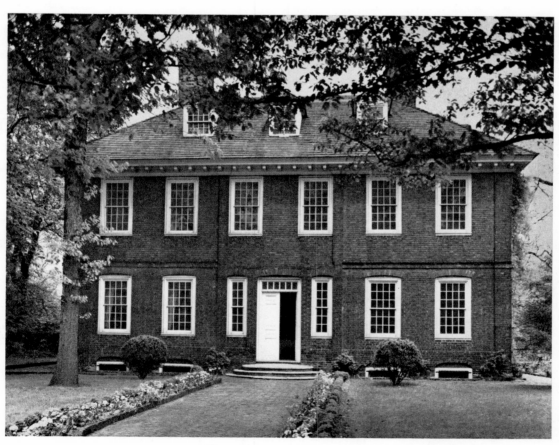

107 Stenton, Germantown, Philadelphia. 1728

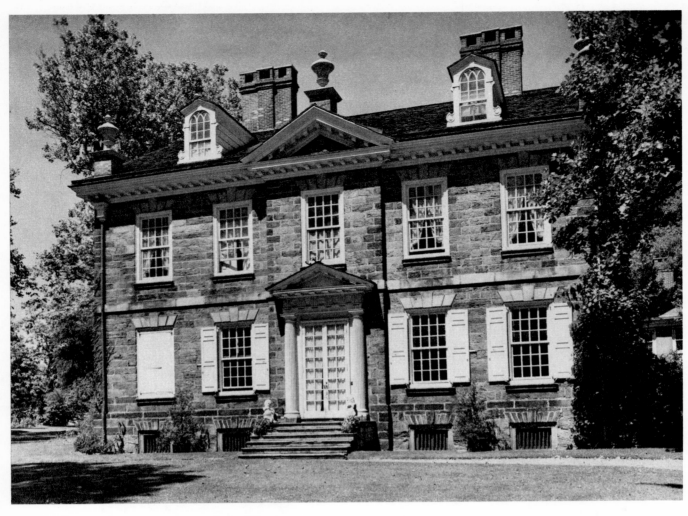

108 Cliveden, Germantown, Philadelphia. 1763–64

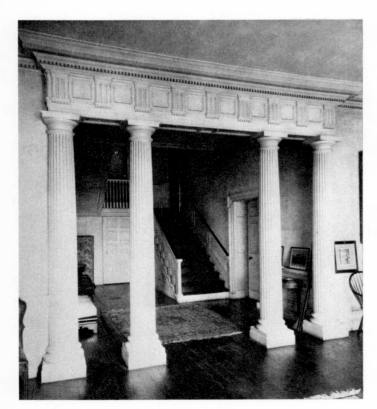

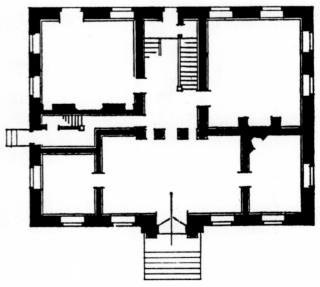

110 Plan, Cliveden, Germantown, Philadelphia. 1763–
64. Courtesy Hugh Morrison, from his *Early
American Architecture* . . ., 1952, fig. 448

109 Entrance hall, Cliveden, Germantown,
Philadelphia. 1763–64

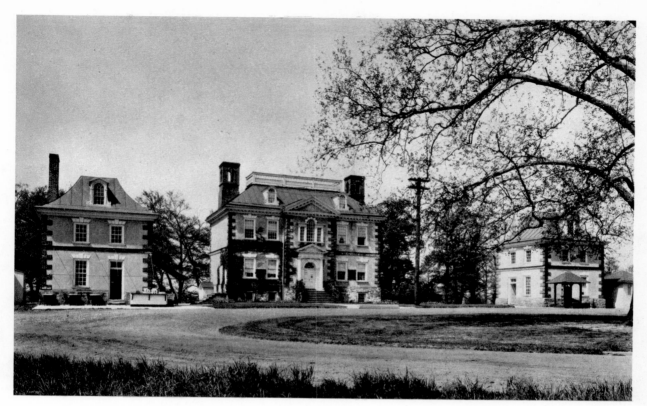

111 Mount Pleasant, Philadelphia (before restoration). 1761–62

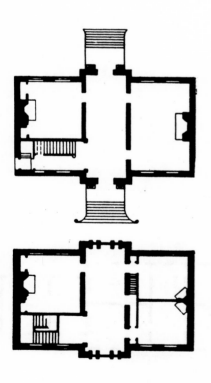

112 Plan, Mount Pleasant, Phila-
delphia. 1761–62. Courtesy Hugh
Morrison, from his *Early Amer-
ican Architecture . . .*, 1952, fig.
446

113 The Moot House, Downton, Wiltshire, England. c. 1690

114 Front (south elevation), Stratford, Westmoreland County, Va. c. 1725–30

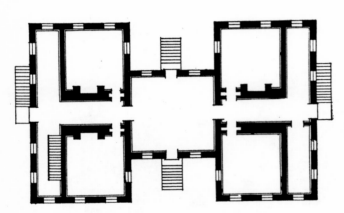

115 Plan, Stratford, Westmoreland County, Va. c. 1725–
30. From Kimball, *Domestic Architecture of the American
Colonies and of the Early Republic*, 1922, fig. 41, p. 67

Virginia, the richest and most populous of the colonies
in the eighteenth century, retains the largest number and
finest examples of Georgian domestic architecture. Of the
Early Georgian, Stratford (c. 1725–30, plates 114, 122),
the Lee family mansion in Westmoreland County, is
exceptional in several respects. The central brick build-
ing, flanked by two smaller structures of the same mate-
rial, is unusual in its H-plan (plate 115), its basement and
single-story elevation without dormers, its long and
stately exterior stairways in front and rear with winged

stairways on the sides, and its quadruple-clustered chim-
neys. Yet, despite its beautiful siting and unique design,
it is a strange mixture of handbook parts that hardly
looks Georgian.

In contrast, Westover (c. 1730–34, plate 116, color-
plate 7), the Byrd Mansion in Charles City County, is the
paradigm, the most famous and perhaps the most beauti-
ful, of all Georgian plantation houses. Set in a magnifi-
cent park, its imposing mass consists of a central building
with attached wings capped by a steeply pitched hip roof
and exceptionally tall chimneys, hallmarks of the Early
Georgian in the South. The comparatively flat facades of

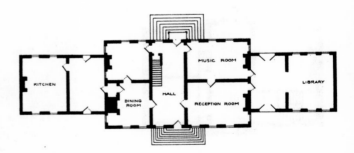

116 Richard Taliaferro (attrib.). First-floor plan,
Westover, Charles City County, Va. c. 1730–34.
From Edith Tunis Sale, *Interiors of Virginia
Houses of Colonial Times*, W. Byrd Press, Rich-
mond, Va., 1927, p. 451

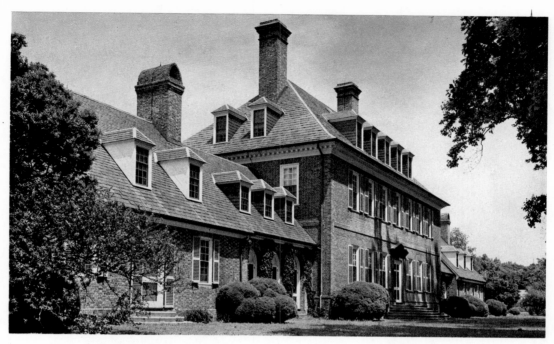

117 Richard Taliaferro (attrib.). Carter's Grove, James City County, Va. 1750–53

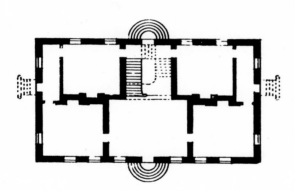

118 Richard Taliaferro (attrib.). Ground plan, Carter's Grove, James City County, Va. 1750–53. Courtesy Hugh Morrison, from his *Early American Architecture* . . ., 1952, fig. 289

119 Richard Taliaferro (attrib.). Entrance hall, Carter's Grove, James City County, Va. 1750–53

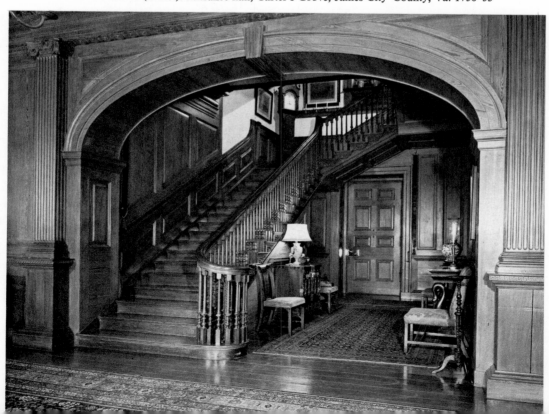

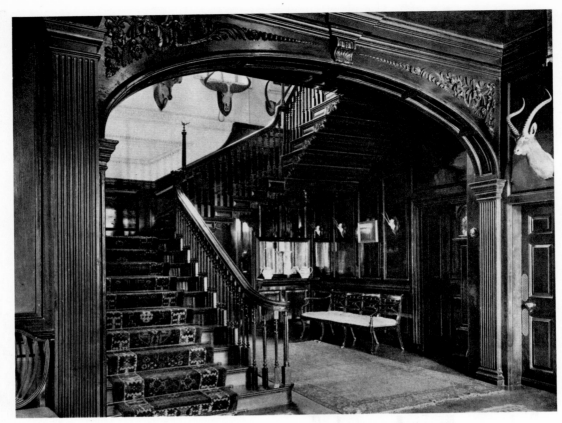

120　Entrance hall, Rutland Lodge, Petersham, Surrey, England. 1660 (altered c. 1720)

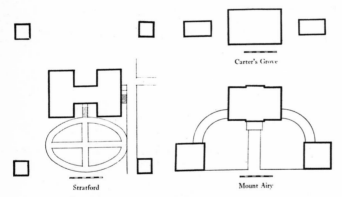

121　Relationship of outbuildings to the house: Stratford, Carter's Grove, and Mount Airy. From Kimball, *Domestic Architecture of the American Colonies and of the Early Republic*, 1922, fig. 53, p. 80

red brick with white trim set off the elaborately Baroque doorways of the front and rear. Similar in design to Westover, although later in date, is Carter's Grove (1750–53, plates 117, 118, 121), the Burwell mansion in James City County. Both have been attributed to Richard Taliaferro (1705–1779), the leading architect in Virginia during the Early Georgian. Carter's Grove was old-fashioned by the time it was built, but its interior panel-

ing, especially in the stately hallway (plate 119), remains one of the masterpieces of the style.

The High Georgian in Virginia produced a series of imposing houses, among the best of which were some designed by John Ariss (c. 1725–1799). His major work, Mount Airy (1758–62, plates 122–123), built for John Tayloe in Richmond County, borrowed almost literally from a plate in James Gibbs (plate 124), is one of the rare stone houses of the South, distinguished by its stately entrance loggia of three arched openings on the south and three rectangular openings on the north facade. Brandon (c. 1765, Prince George County), the home of Nathaniel Harrison, is said to have been the creation of his friend, the young Thomas Jefferson and follows the extended layout of the Palladian "Roman Country House." Jefferson's own home, Monticello (1770–75, plates 125, 211), was redone after the Revolution, but in its various earlier projections indicated a sequence of dependence from Robert Morris to James Gibbs and finally Leoni's English edition of Palladio. It had a two-storied portico, as did Shirley (c. 1769, plate 126), in Charles City County. Mount Vernon (1757–87), the home of George Washington, is more notable in a historical and sentimental context than architecturally. It is interesting, however, as an example of a less formal and somewhat provincial version of the High Georgian, with such untypical features for the South as the imitation in wood of ashlar masonry and

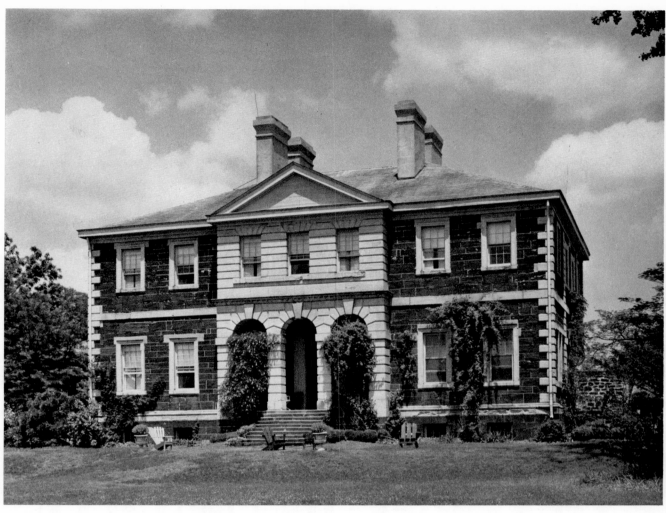

122 John Ariss. Mount Airy, Richmond County, Va. 1758–62

123 John Ariss. Ground plan, Mount Airy,
Richmond County, Va. 1758–62.
Adapted from Kimball, *Domestic
Architecture of the American Colonies
and of the Early Republic,* 1922, P. 77

124 James Gibbs. Design of a house, prototype of
Mount Airy. From James Gibbs, *A Book of
Architecture,* London, 1728, plate LVIII

125 Thomas Jefferson. Monticello, Albemarle County, Va. 1770–1809

126 Ground plan, Shirley, Charles City County, Va. c. 1769. From Kimball, *Domestic Architecture of the American Colonies and of the Early Republic*, 1922, p. 77

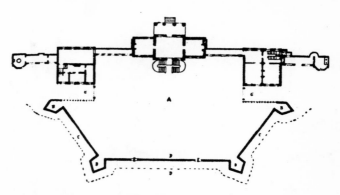

128 Original plan, Whitehall, Anne Arundel County, Md. 1764. Courtesy Hugh Morrison, from his *Early American Architecture . . .*, 1952, fig. 322

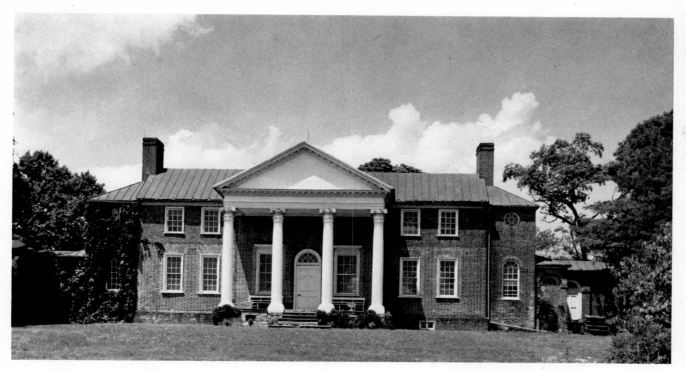

127 Whitehall, Anne Arundel County, Md. 1764

the long riverside portico, a post-Revolutionary addition.

Maryland boasts a series of handsome Georgian plantation houses, much in the manner of Virginia. The most notable date from the middle of the century: Montpelier, in Prince Georges County, built in 1751 for Nicholas Snowden; Tulip Hill, in Ann Arundel County, built for Samuel Galloway about 1756, with a four-columned doorway portico; and the majestic Whitehall (plates 127, 128), also in Anne Arundel County, built for Governor Horatio Sharpe in 1764. Whitehall has one of the rare giant porticos and an interior of architectural detailing in wood of palatial splendor.

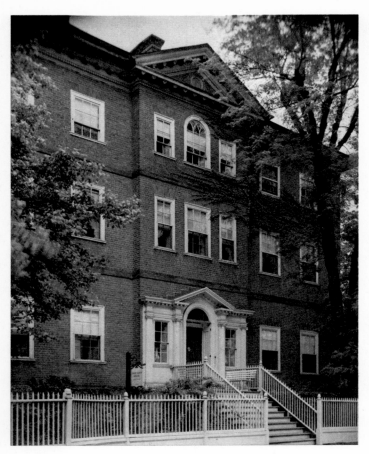

Annapolis, a thriving seaport in the pre-Revolutionary period, luckily retains many of the fine brick town houses built for its prosperous families. It produced an easily recognizable local type, with no dormer attic, a flattened roof hardly visible from below, and a front entrance raised above ground level by a half-story basement. The restrained exterior, cubical in appearance, was clear-edged and almost Neoclassic in feeling. Among the best of Annapolis houses are three attributed to William Buckland: the three-story, boxlike Chase House (1769–74, plates 129, 130), with an opulently decorated dining room; the Hammond-Harwood House (1773–74, plate 131), the "classic" version of the type; and the unconventional Brice House, dated in the early seventies. Buckland's houses are characterized by coherence of design and refinement of both proportion and detail, revealing a greater knowledge and experience in architectural practice than was common in the colonies.

South Carolina's prosperity was reflected in the great river plantation houses as well as the town houses of Charleston. The most imposing of the former is Drayton Hall (1738–42, plate 132), and the most lavish of the latter is the Miles Brewton House (1765–69). Both have the typical Carolinian features of a comparatively wide, two-story, pedimented portico with Doric and Ionic orders

129 William Buckland (attrib.). Chase House,
 Annapolis, Md. 1769–74

130 William Buckland (attrib.). Interior, Chase House, Annapolis, Md. 1769–74

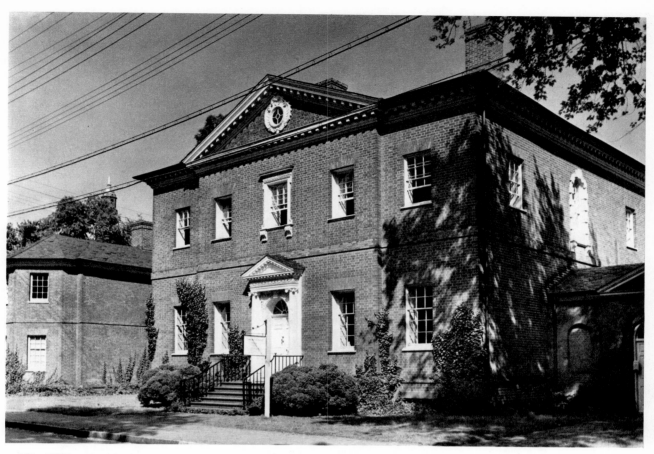

131 William Buckland (attrib.). Hammond-Harwood House, Annapolis, Md. 1773–74

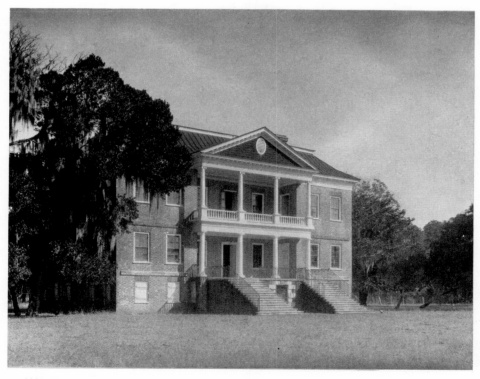

132 Drayton Hall, Ashley River, near Charleston, S.C. 1738–42

and winged staircases. Drayton Hall was a spacious mansion with a basement floor given over to service rooms and servants' quarters and a courtly reception hall on the first floor, above which was the grand ballroom (plate 133). The Miles Brewton House (plate 134) presents a modest face toward the street, hidden as it is behind a high wall, but its rear garden elevation shows a rich elaboration, and its interior decoration is one of the most succulent examples of Rococo influence in Colonial architecture.

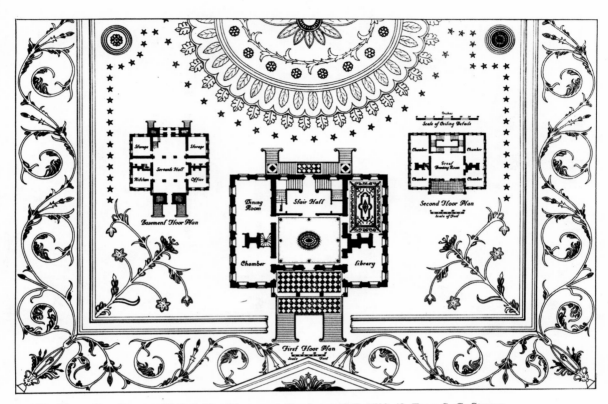

133 Floor plans, Drayton Hall, Ashley River, near Charleston, S.C. 1738–42. From S. G. Stoney, *Plantations of the Carolina Low Country*, Carolina Art Association, Charleston, 1938, p. 147

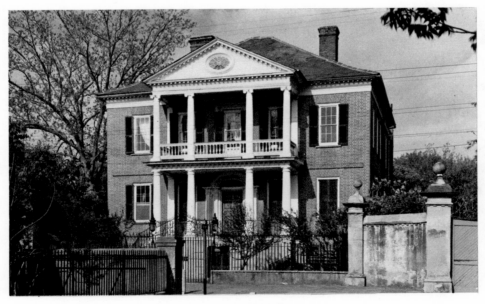

134 Miles Brewton House, Charleston, S.C. 1765–69

SPANISH COLONIAL ARCHITECTURE

The eighteenth century saw the greatest efflorescence of Spanish building in North America and produced several monuments that in scale and aesthetic sophistication are far superior to anything achieved in the English colonies. Yet, in Florida, except for the St. Augustine Cathedral, no major structure of the eigtheenth century has survived. The building advertised as the "oldest house in the United States," in St. Augustine, probably dates from about 1763 and is typical of eighteenth-century Spanish houses in the area. The thick walls of the lower story are of coquina limestone; the second story is constructed of frame and clapboard. Characteristic also are the hip roof, porches on the ends, low ceilings, large fireplaces, and hand-hewn cedar beams.

New Mexico was reconquered in 1692, and a great period of mission rebuilding began, though this region was always something of a frontier, and its economic and cultural levels remained marginal. In 1821, following the Mexican Revolution, the missions were disestablished and eventually fell into ruin, but some of the modest mission churches later rebuilt still exist, the most famous being San Francisco de Asís (1772), the picturesque little church at Ranchos de Taos, which continued without serious alteration the older New Mexican tradition of adobe building (plate 135). Primitive in plan and construction, it is most notable for the massive buttressing of its squat towers and apse. Its trapezoidal battered sides and the boldly simple cubical volumes, made soft and fluid by the adobe surfacing, give it the appearance of some primordial structure organically emerged from the desert flat. Santo Tomás (late eighteenth century) in Trampas, also a small church, is interesting for the complexity of its plan, including a baptistery, transept, and sacristy, and for the facade balcony on the choir-loft level between the two projecting buttresses, a common local feature.

Far different from such charming primitive structures was the rich Baroque architectural expression of Texas and Arizona, a provincial but quite informed version of the Churrigueresque, that frenzied explosion of the late Baroque in Spain made popular by the architect José Churriguera. Texas was a tough and unprofitable territory peopled by hostile Indians, but the Spaniards made a strong effort to maintain it against the southward encroachment of the French and English. Although the eastern settlements along the Gulf of Mexico were not

135 San Francisco de Asis, Ranchos de Taos, N.M. 1772

successful, the Spanish did manage to establish twelve missions in the south and central regions, of which five, all around San Antonio, still stand in varying states of preservation. One can form some notion of their scale and magnificence by considering San José y San Miguel de Aguayo (1723–31), the most splendid of them (color-plate 8). The original mission covered 8 acres surrounded by a wall, and included facilities for administration, priests, supporting troops, and Indians. The mission church, at that time the most ambitious Spanish edifice north of the border, was built of tufa surfaced in stucco with detailing in brown sandstone. This was obviously an importation from Spain through Mexico. Local Indians may have supplied the labor and many of the basic skills, but the planning and technological level of building were European. The nave contained three stone groin-vaulted bays and a fourth capped by a 60-foot dome; the vaults were destroyed in 1868 and the dome in 1874, but the church was entirely restored in 1933 (plate 136). Its facade is typically Churrigueresque in the contrast between the reticence of clean, flat surfaces and the exuberance of decorative detail. The elaborate carving around the doorway and window of the central section (plate 137), probably the finest example of its kind in the United States, was executed by Pedro Huizar, a Mexican sculptor imported for the job.

The church of the famous Alamo, San Antonio de los Álamos (1744–57), except for its richly carved stone portal, is today nothing but a ruin. The twin towers, vaulted nave, and dome all collapsed in 1762 and were never rebuilt. Nuestra Señora de la Purísima Concepción de Acuña (1731), cruciform in plan with a dome over the crossing, is almost as monumental as San José, but it lacks the splendor of the latter's carving. Repaired in 1850, it is the best preserved of the Texas mission churches. The vast complex of San Juan Capistrano (1731) is now largely in ruins, and San Francisco de la Espada (1731) was, except for its facade, torn down and rebuilt in 1845.

The conquest and cultural development of Arizona was ultimately even less successful. After almost a century of effort the failure of the mission was signalized by the removal of the Jesuits from colonial America by Carlos III in 1767 in favor of the Franciscans. Of more than a dozen missions founded during the eighteenth century, only one remains intact today, but that was the most ambitious of all the Spanish missions in North America —San Xavier del Bac (1784–97). The church (plate 138), of baked brick and lime stucco, was built on a cruciform plan, the nave, transept, and apse roofed by brick domes invisible on the exterior, and the crossing marked by a high dome on an octagonal drum. The entire interior is of the most lavish Baroque, culminating in a splendid altar decoration (plate 139). On the exterior, two elaborate towers flank the central facade of red brick, which is buried in a profusion of Churrigueresque ornament. The

136 Interior, San José y San Miguel de Aguayo, San Antonio, Tex. 1723–31 (restored 1933)

137 Pedro Huizar. Portal sculptures, San José y San Miguel de Aguayo, San Antonio, Tex. 1723–31

138 San Xavier del Bac, Tucson, Ariz. 1784–97

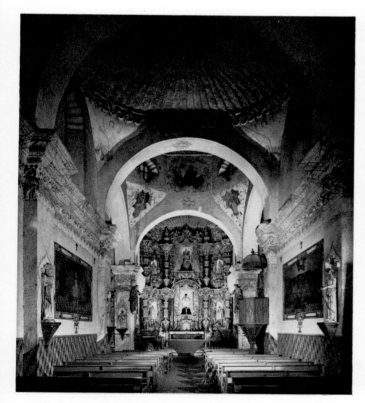

139 Interior, San Xavier del Bac, Tucson, Ariz. 1784–97

theatrical pomp, sensuous profligacy, and structural sophistication of such Colonial Churrigueresque churches are in marked contrast to the provincial awkwardness and Protestant restraint of the Georgian in the English colonies. There could hardly be anything more revealing of the contrast than a comparison between the contemporaneous San José y San Miguel de Aguayo (plates 136, 137) and Old North (plates 77, 78) in Boston.

Since the development of the California mission occurred later, its course will be traced in Chapter 7.

FRENCH COLONIAL ARCHITECTURE

Although France had a brilliant history of exploration in the New World, her colonial population was never large, and settlements were widely scattered. Very little remains even of this limited activity; the old forts of St. Louis and Detroit have been obliterated, the small settlements in the Mississippi Delta were inundated, and the richest manifestation in New Orleans was almost completely wiped out by disastrous fires in 1788 and 1794. However, New Orleans still retains something of its Creole flavor in the Vieux Carré (old quarter), and the French domestic-building type that developed in the Louisiana territory and especially in the Delta had a belated effect on the antebellum architecture of the so-called "Black Belt."

Aside from the large public buildings of New Orleans, French architecture in the Mississippi Valley during the eighteenth century was of a frontier variety, analogous to the seventeenth-century buildings of New England, though quite different in form. The houses were half-timbered but unlike the English in construction. Walls were built of upright cypress or cedar logs driven several feet into the ground and spaced several inches apart, a method called *poteaux-en-terre,* and the interstices were filled with *bouzillage,* a mixture of clay and grass or Spanish moss. A variation on this technique, *pierrotage,* used rubble stone in clay for filling. This method of construction is said to have originated either in Santo Domingo or in Canada, where the Iroquois and Hurons employed a similar system in building their log palisades. However, since surfaces were left exposed, filling eroded, and logs rotted in the ground. *Poteaux-sur-sole* was a structural improvement in which the vertical logs rested on wooden sills supported by stone foundations. In Lousiana a soft, porous brick was used as filling, and the whole was covered with lime plaster—*briqueté-entre-poteaux,* a building technique that became popular in New Orleans.

Frontier houses were usually one story in height, con-taining a row of rooms, with chimneys in the center or on the ends, the whole surrounded by a railed *galerie,* or porch, which offered access to the rooms. The character-istic roof was a steeply pitched hip which covered the house proper and swept out at a lower angle to form the *galerie* roof supported by slender posts. The best-known example of the frontier house is the so-called Cahokia Courthouse (c. 1737, plate 140), in Illinois, originally built as a dwelling but sold to the town in 1793 for a courthouse and jail. It is a comparatively large *poteaux-sur-sole* house, with four rooms and an attic and brick chimneys on the ends. There are similar houses scattered along the river south of St. Louis, in the vicinity of what was once Fort Kaskaskia and in St. Genevieve, Ill.

The plantation houses in the lower parishes of Loui-siana were larger, mostly two stories in height, the lower of stucco-covered brick, the upper of wood, but they had much in common with the frontier type and may have evolved from the "raised cottages" along the river bot-toms, built on stilts to avoid flooding. Stucco-covered brick piers in column form carried the *galerie,* with its railing and wooden colonnettes, usually confined to front and rear, though larger houses had them on all four sides. A notable example is Parlange (1750, plate 141), built by

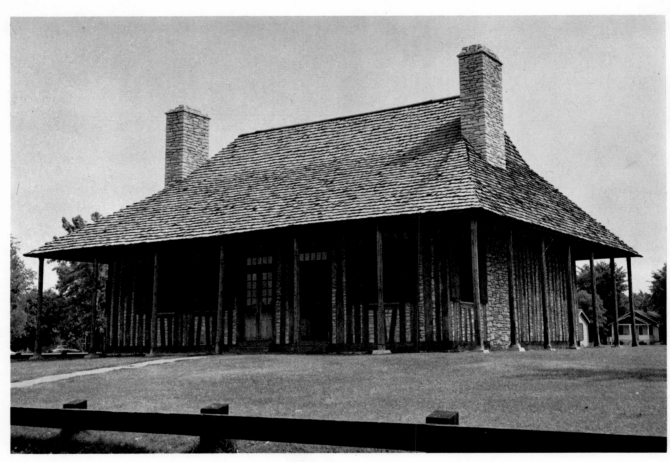

140 Cahokia Courthouse, Cahokia, Ill. c. 1737 (reerected 1939)

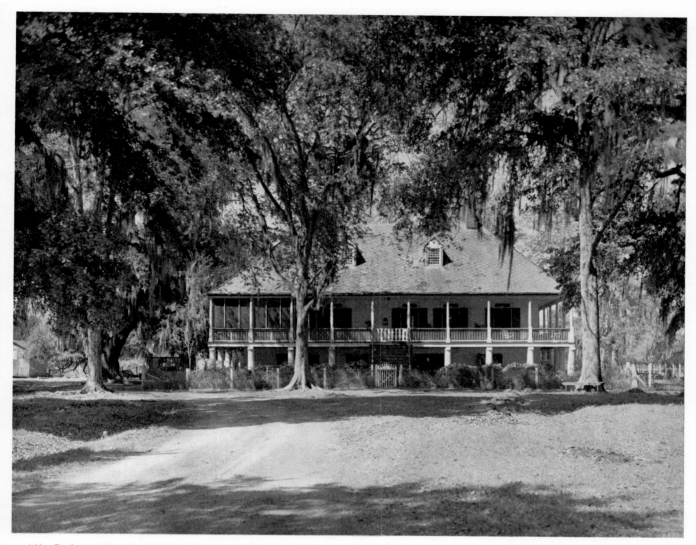

141 Parlange, New Roads, Pointe Coupee Parish, La. 1750

the Marquis Vincent de Ternant. The walls of the lower story, the piers, and the floors are of brick, the upper story walls of cypress and *bouzillage*. A *galerie* with slender colonnettes circles the entire building, which is capped by a hip roof of cypress shingles. Such houses were essentially informal—spacious, open, and simple; conditioned by climate and a particular way of life; concerned more with comfort than ostentation, with ventilation more than privacy. Other examples are Homeplace, or the Keller Mansion (c. 1800), St. Charles Parish, built by the Fortier family and almost identical with Parlange; and Darby (late eighteenth century) on Bayou Teche, built by François Saint-Marr Darby.

New Orleans was settled fairly early by the French, in 1718. It was a planned town, laid out on a grid along the river, with the Place d'Armes, now Jackson Square, surrounded by a church, school, and governor's palace, forming the heart of the Vieux Carré. It became the capital of

Louisiana five years later and soon dominated the towns and settlements along the river, even as far north as St. Louis. New Orleans remained French in character even after its cession to Spain in 1763, although its unusual mixture of peoples—French, Spanish, Canary Islanders, and Acadians, later called Cajuns—gave it a particular flavor. The Vieux Carré has its own unique charm today, but little of eighteenth-century New Orleans is left. The Jean Pascal House (c. 1727, plate 142), better known as "Madam John's Legacy," is of two stories, the lower enclosed, but deriving perhaps from the "raised cottage" type. As is common in French Colonial houses, the staircases lead to the *galerie* above. Lafitte's Blacksmith Shop (1772–91, plate 143) is more like the French provincial houses of that period. Constructed of *briqueté-en-poteaux* surfaced with plaster, it is completely enclosed, without a *galerie*, but with a roof that flares at the eaves.

Of public buildings in New Orleans all that is left are

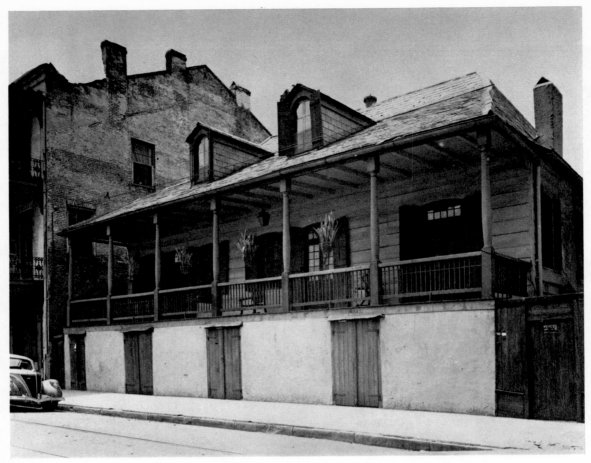

142 Jean Pascal House ("Madam John's Legacy"), New Orleans. c. 1727 (rebuilt 1788–89)

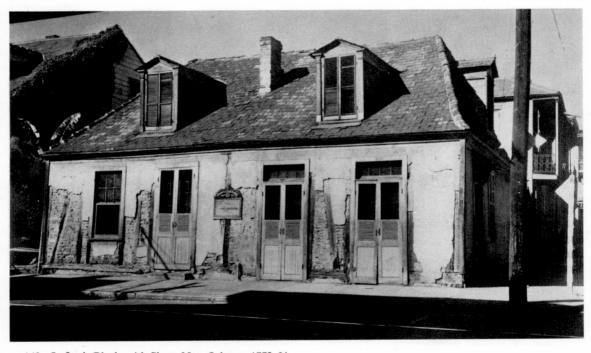

143 Lafitte's Blacksmith Shop, New Orleans. 1772–91

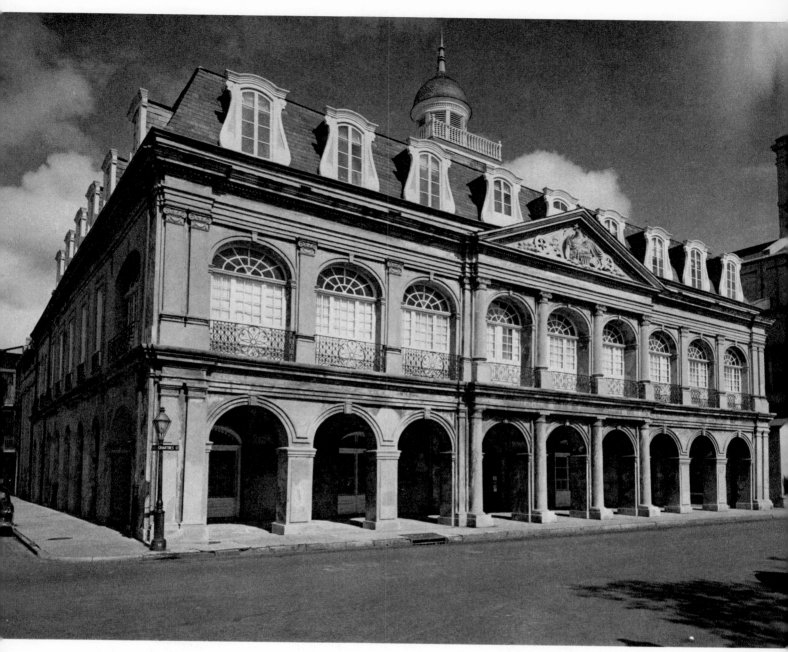

144 The Cabildo, New Orleans. 1795

the Archbishopric (1748–52) and the Cabildo (1795). The former, on Chartres Street, is the much altered second Ursuline Convent designed in the style of Louis XV and constructed of brick faced with stucco. (The first convent, completed in 1734, was of cross-braced, half-timber construction with brick filling, called *colombage,* then common in Louisiana.) The Cabildo (plate 144) was built during Spanish rule to house the legislative and administrative council of the colony. This rather academic,

classicizing Baroque stone edifice is, except for its mansard roof (added in the 1850s), an excellent example of Spanish official Colonial architecture, similar to others in Mexico and the most important reminder of Spanish influence in New Orleans.

However, all the French, as well as Spanish, architectural monuments of the eighteenth century remain as relics of cultures aborted by the expansion of the new and independent nation of the United States of America.

CHAPTER FIVE

Eighteenth-Century Colonial Painting and Sculpture

Professional Artists, Foreign and Native-Born

Increased prosperity in the eighteenth century brought with it an inevitable growth in class distinctions and a widening of the social and cultural gap between merchants and planters, on the one hand, and, on the other, workers and artisans in the cities and independent farmers in the rural areas. Seventeenth-century religious and moral strictures against vanity and worldliness no longer carried much weight, and those who could afford to lived in what, for the time, were splendid houses and wore satin rather than homespun, used silver instead of pewter, bought fine china, ordered the best furniture, sat for their portraits, and, in general, demonstrated their affluence.

As a luxury, painting required a reservoir of wealth on which to draw, and for the first time in colonial history such wealth was available. That the dominant form of painting in those years was portraiture was due to particular circumstances. First, the portrait offered the most obvious status support and ego inflation to the nouveau riche. Second, with what remained of Puritan reserve, portraiture was somewhat more acceptable than more "frivolous" forms such as landscape, still life, or genre painting, and historical painting was irrelevant in the context of eighteenth-century middle-class culture both in America and in Europe. Third, the English, to whom the colonials looked for inspiration, were, unlike the Dutch, almost totally committed to portraiture. For the colonial merchant or planter a portrait served a functional end as decoration in his sumptuous house, as a record of himself and his family, and as an acceptable symbol of his position in society.

For the English colonist, an art collection including other forms of painting, to say nothing of sculpture, was almost inconceivable. Only among the Dutch in New York was the tradition of art collecting, so common among the burghers of Holland, to be found. Indeed, a Dr. De Lange of New York had in his collection, as his will attests, no fewer than sixty-one paintings, among them landscapes, seascapes, still lifes, genre pictures, religious paintings, portraits, and decorative pieces. One

may wonder why some of the wealthier southern squires did not emulate their English cousins, who were forming great collections in the eighteenth century. The remarkable Colonel William Byrd II of Virginia, who had pictures purported to be by Titian and Rubens, no doubt mementos of his sojourn in England, was exceptional.

Although there is evidence that painting in those days was not entirely confined to portraiture, whatever other painting occurred was limited, and its interest is chiefly in the field of folk art—landscape paintings on overmantels or as house decorations, genre pictures on signs, religious themes on funerary paraphernalia, or whatever subjects occurred on firebuckets, carriages, window shutters, or glass windowpanes. Few documented examples of such activity remain. Of portraits, however, we have many, of varying competence and authenticity. Lists of artists known from advertisements and directories to have been active in the colonies have tempted unscrupulous dealers to fakery of various kinds or zealous antiquarians to assign anonymous portraits to identifiable painters. On the whole, early eighteenth-century, like seventeenth-century, portraiture still abounds in enigmas, and attributions are often highly debatable.

From the early part of the eighteenth century, at least partly trained painters migrated to this country to try their luck. They were mostly marginal professionals, only slightly more adept than artisans, though conversant with academic standards and formulas. Like all professional painters, good or bad, they were distinguishable from artisans by their awareness and imitation of current studio practice, and for the new provincial patron this distinction, which could create an illusion of identification with the fashionable in art, was essential. No longer satisfied with the crudities of the itinerant limner, he was willing enough to settle for the modish daubs of the newly arrived professional portraitist.

The style these painters brought with them was that of fashionable European portraiture of the late seventeenth and early eighteenth centuries, exemplified in England by the court painter, Sir Godfrey Kneller (1646/9–1723), a

limited and unimaginative artist of German birth and Dutch training. He carried into the eighteenth century a style that went back to Van Dyck and Lely, both of whom had been in their time court painters also. Working for Charles I and members of his court, Van Dyck had developed an aristocratic style of unparalleled elegance, transforming the robust Flemish Baroque of Rubens into the ultimate in blue-blooded courtliness, superb painting rendered with impeccable taste. All the courtly mannerisms of Van Dyck were adopted by Lely, but translated into a style that was brittle, artificial, more mannered, yet less flamboyant. Lely was not the great master that Van Dyck was, but he retained a fluency and grace in handling that were lost by the time Kneller came on the scene. In comparison, Kneller was less aristocratic, and he was not equipped to match the bravura style of Lely or Van Dyck. His was a much more modest art, largely middle-class in attitude and pedestrian in execution, though its striving for the aristocratic ideal is almost pitifully evident. Still, his sitters seem more human than Lely's elegant puppets, and he remained an adequate and competent painter of fashionable portraits for the nouveau riche, including George I.

Even before the migration of trained European painters to America in the early eighteenth century, some of the anonymous limners were responding, though tentatively and often in a garbled manner, to basic changes in style. Just as the handbooks were the source of changing tastes in architecture, so in painting it was engravings that first spread the new fashions in portraiture in the colonies, and from them were borrowed poses, gestures, dress, symbols of rank, and other obvious details. The limner's naive quality of vision and limitations of technique continued into the early years of the century and, under specifically provincial circumstances, much beyond. Many portraits of the time resemble those of the seventeenth century in their bold linearity and flat patterning, as does the *Mrs. Anne Pollard* (1721, plate 145). The hard-edged literalness in this portrait of a centenarian has nothing to do with the new fashionable portraiture in either a social or an artistic sense. What is remarkable about it is the unfaltering control of artisan means within the limitations of the artisan's vision, raising it to the level of an authentic image. Quite different in character, but just as remarkable in its own way, is *The Reverend James Pierpont* (1711, plate 146), which seems to bypass all the courtly trappings of the new style and to get directly to the heart of portraiture itself, the revelation of personality. In spite of a very modest technical equipment, the artist has conveyed a mood rare in American painting before Robert Feke, indicating that he was conscious of a studio tradition and was something more than an artisan. The companion portrait, *Mrs. Mary Hooker Pierpont* (1711, Yale University Art Gallery, New Haven), projects the same pensiveness, but the sitter remains not much more than a mannequin.

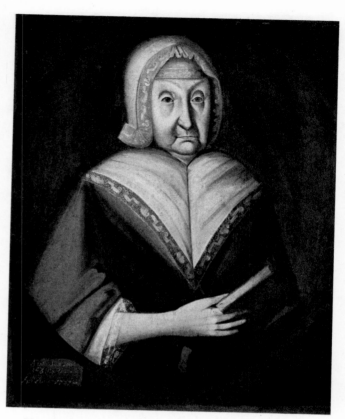

145 Anonymous. *Mrs. Anne Pollard.* 1721. Oil on canvas, 27½ × 22½". Massachusetts Historical Society, Boston

A number of vaguely defined artisan-portraitists of the period borrowed the newer manner from prints. Aristocratic airs and courtly gestures became gauche and even ludicrous in their unskilled hands, but apparently neither they nor their clients noticed, and all were probably delighted by their new-found elegance and worldliness. Among such painters were Nathaniel Emmons (1704–1740) of Boston, traditionally cited as the first artist born and trained in America, who was so tied to engraving that all his portraits are of plate size and in black and white; a painter of fashionable furbelows known only as J. Cooper, active in New England; and an unknown limner who painted several portraits of the Jaquelin and Brodnax families in Virginia.

The richest development of this vein was in the formerly Dutch area of the Hudson Valley, from New York City to Albany. The clients were mostly Dutch patroon families, and the profusion of portraits was within the Dutch tradition, but the visual evidence is that they derive from English engravings or painted models. Surprisingly, despite the great number of portraits extant, none can be unquestionably attributed to an identifiable artist, even to the Duyckincks, active in New York for three generations as artisans and limners. A pair of portraits is

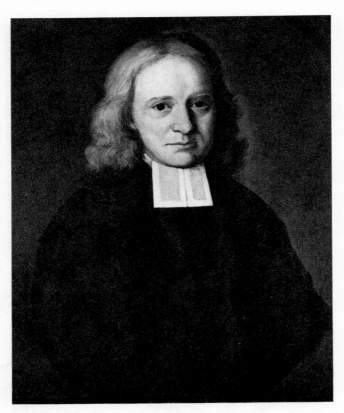

146 Anonymous. *The Reverend James Pierpont*. 1711. Oil on canvas, 31⅛×24⅞″. Yale University Art Gallery, New Haven. Bequest of Allen Evarts Foster, B. A., 1906

assigned on shaky grounds to Gerret Duyckinck (1660–1710); the so-called *Self-Portrait* and *Artist's Wife* (both c. 1700, New-York Historical Society) may seem Dutch in their modest and unassuming directness, yet, naive as they are, they reveal some contact with fashionable portraiture in dress and gesture.

James Thomas Flexner, in *First Flowers of Our Wilderness,* has made a considerable contribution to early American art history in his characterization of this group of anonymous artists, whom he calls the "Patroon Painters," and by his analysis of different manners among them. One group of works was done in what he defines as the De Peyster manner and includes several portraits of the De Peyster children (c. 1728). These are clearly aristocratic in intention and based on courtly models, although transformed by a naive vision which results at times in charming fantasy, as in the *De Peyster Boy with Deer* (1720s, plate 147), and at others borders on the ludicrous, as in the comic gaucherie of the *De Peyster Girl with Lamb* (1720s, New-York Historical Society), and *Eva and Katherine De Peyster* (Collection A. C. M. Azoy, Maplewood, N.J.).

Another group of portraits, most of which may be considered the work of a single painter, is described as the "Aetatis Sue" manner from the inscription giving the

age and date on most of them; this painter has previously been called the Hudson Valley Master, or, on rather circumstantial evidence, Pieter Vanderlyn, grandfather of the more famous John. His is a cruder, more forceful, less aristocratic, and essentially realistic style, especially in the male portraits. Stock poses borrowed from the Lely-Kneller repertory are reduced to a naive artisan level—flat, heavy, and awkward. The male portraits almost invariably have the same stock bodies and paraphernalia, but they are surmounted by heads that seem hacked rather than painted into powerful images of personality and character (plate 148). Obviously the heads were painted from life, and with an almost ferocious intensity, but with such limited knowledge that the physiognomies become caricatures, the expressions grimaces. The courtly gleanings are submerged by the directness and harsh realism of the painter's vision, and we are left with a gallery of the sober, self-confident, aggressive farmer-patroons. Perhaps because the "Aetatis Sue" style lacks even the most rudimentary ingredients of grace, the female portraits of this limner seem more gauche and eccentric. But there is no doubt that, by the force of his vision and from the bedrock of artisan practice, he produced an original American expression from his European models.

A third group of pictures, identified with the Gansevoort Limner, are more sharply linear, flat, patterned artisan paintings in which fashionable elements are either missing or so completely transformed that they are almost unrecognizable. The *Pau de Wandelaer* (c. 1730, colorplate 9) is one of the finest so-called "primitives" in American painting. Beautifully composed in an exquisite relationship of geometric shapes, it creates a sensitive mood of lyric poetry in which the personality of the young boy and the landscape blend in a muted harmony of color and form. The landscape itself, which for the first time looks like the American landscape—the Hudson River with its softly rounded hills—is an identifying mark of this painter's portraits.

The provincial artisan anonymity of American painting was interrupted by the arrival of the first wave of immigrant European painters with some experience in studio practice. John Smibert (1688–1751), born in Scotland, was the best of this first wave. His career was fairly varied and probably characteristic of many painters who worked their way up from artisan to fashionable portraitist. He started as a house painter in Edinburgh, moved on to London, where he decorated carriages, and then began copying old masters, for which there was a market. He attended Sir James Thornhill's Great Queen Street Academy and then spent some three years in Italy studying and making copies of old masters. There he met Dean Berkeley, afterwards the famous Bishop, who later recruited him to the staff of his projected university for the Indians of the New World, planned for Bermuda. Berkeley's party stayed more than a year in Newport, R.I., while he

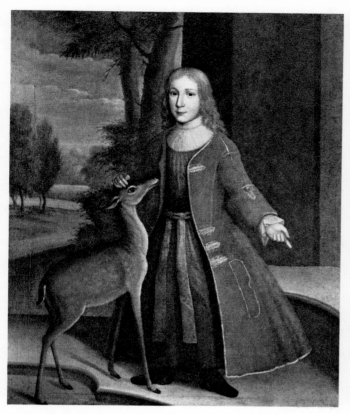

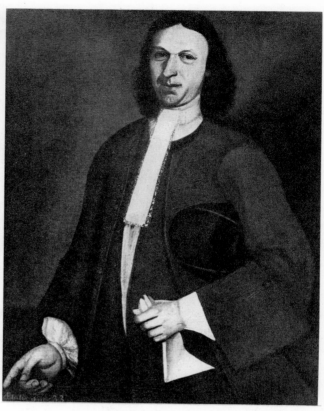

147 Anonymous. *De Peyster Boy with Deer.* 1720s. Oil on canvas, 50¼×41″. The New-York Historical Society

148 Anonymous Hudson Valley artist. *"Thomas van Alstyne."* 1721. Oil on canvas, 39¼×30″. The New-York Historical Society

waited in vain for a parliamentary grant to carry out his project. Meanwhile, Smibert had already recognized the ready market for fashionable portraiture in America and had moved on to Boston with the copies, prints, and plaster casts he had collected in Italy; these were to become almost an academy for a generation of Bostonians.

He married rather well, set himself up in a studio under Beacon Hill, and became Boston's painter laureate. Yet, despite his superiority to any possible competition and the wealth and needs of his clientele, he had to supplement his income by selling art supplies, frames, and prints; at one time he even offered his own print collection for sale. Apparently even under the best circumstances, the artist in the colonies, at least until Copley, had to earn additional income—by trade as did Smibert; by teaching reading, writing, needlework, drawing, and painting on glass, as well as running monthly "Assemblies" in music and dancing; or, on the artisan level, by japanning, gilding, or silvering frames, decorating carriages, painting coats of arms and signs, lettering, cleaning and repairing pictures, or simply house painting.

At his best, Smibert was a competent portraitist in the Kneller manner. He had a solid academic training; drew passably; modeled well, if somewhat pedantically; and painted materials with that particular verve which was

the hallmark of the style. If his compositions were pedestrian, Kneller's were not much better (plate 149), and, like all his English contemporaries, Smibert's backgrounds were the stock-in-trade of curtained and columned interiors and artificial landscape backdrops. On the whole, his style is so closely related to Kneller's that the so-called "Portrait of Oxenbridge Thacher" (n.d., Metropolitan Museum, New York), long attributed to Smibert, has recently been assigned to Kneller.

Smibert's first painting in America, *The Bermuda Group: Dean George Berkeley and His Entourage* (1729, colorplate 10), his most ambitious and complex undertaking, was well composed in an interlocking triangulation of forms common to academic painting of the time; though there is too much misdirected turning of heads and focusing of gazes, the portraits are competent and, in the case of his standing self-portrait at the left and that of Richard Dalton seated in the lower left, even interestingly handled. The generally strong modeling of the heads is weakened by a certain indecision and softness in the clothes and a repetition of formula in the poses and gestures of the sitters, so that, while impressive for America, the painting is not very exciting. At his best, as in *Richard Bill* (1740, plate 150), Smibert exhibits a strong painterly feeling for pigment, a professional handling of physiog-

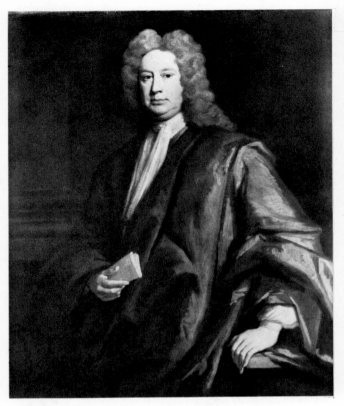

149 Godfrey Kneller. *Portrait of an Unknown Man*. c. 1710. Oil on canvas, 50×40″. The Castle Museum, Nottingham, England

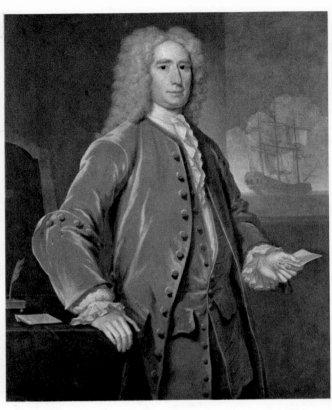

150 John Smibert. *Richard Bill*. 1740. Oil on canvas, 50¼× 40¼″. The Art Institute of Chicago

nomy, if no profound insight into character, and a commendable grace in the painting of the red velvet, the white lace, and the skin texture and color. Unfortunately, many so-called Smiberts do not measure up to this example. With time and the absence of professional standards of competition, his art seems to have deteriorated, becoming drier, harder, and more artificial. Although some of this assumed deterioration may reflect misattributions, certainly the range of quality and works assigned to him is almost incomprehensible in the oeuvre of one artist.

Curiously, Colonial painting, though middle-class in its patronage and general outlook, was unusually retarded in its retention of outmoded Restoration attributes. The translation of the Restoration court beauty, seductive in her dishabille, with artfully tousled hair and a curl falling over a bare shoulder, liquid eyes, luscious rosebud mouth, plump and dimpled chin, as in Lely's *Anna Maria, Countess of Shrewsbury* (c. 1668, plate 151), becomes absurd in the popeyed, double-chinned ungainliness of Smibert's *Mrs. Thomas Bulfinch* (c. 1733, plate 152), who, in spite of her ramrod stiffness and New England reserve, sports a revealing décolleté.

Charles Bridges (active 1735–40) is reputed to have painted portraits in Virginia. A letter from Colonel William Byrd II to former Governor Alexander Spotswood recommends Bridges and states that he had painted

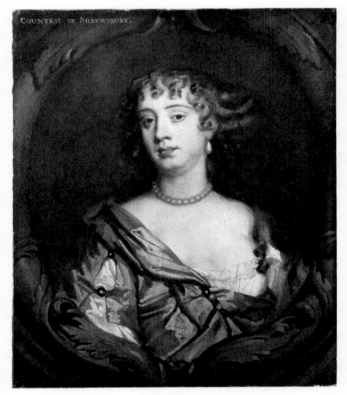

151 Peter Lely. *Anna Maria, Countess of Shrewsbury*. c. 1668. Oil on canvas, 29½×24″. National Portrait Gallery, London

Byrd's children and several other local sitters. Unfortunately, Bridges' artistic personality seems to have vanished, as all former attributions to him have been questioned.

Gustavus Hesselius (1682–1755), born in Sweden, came to this country with his older brother, a Lutheran minister assigned to the Wilmington congregation. Gustavus may have studied art in Sweden or London, where, according to the brother's diary, they stopped for several months. He worked in Delaware, Pennsylvania, and for fifteen years in Maryland, but the scarcity of extant portraits would point to a limited patronage in those colonies. As late as 1740 he was advertising in the *Pennsylvania Gazette* that he was available for ". . . Coats of Arms drawn on Coaches, Chaises, &c or any other kind of Ornaments, Landskips, Signs, Shew-boards, Ship and House Painting, Gilding of all Sorts, Writing in Gold or Colour, old Pictures clean'd and mended, &c." He finally gave up painting for the making of organs and spinets.

Hesselius's manner was modest, direct, and almost puritanical in its reserve, constrained by technical inadequacies that he never overcame. His style, if we can call it such, is nondescript; yet he managed to produce a portraiture of honesty and sobriety. The uncertainty of his drawing and modeling is evident in his *Self-Portrait* (c. 1740) and that of *Mrs. Hesselius* (c. 1740), as well as those of the two Indian chieftains *Tishcohan* (1735, plate 153) and *Lapowinsa* (1735)—all in The Historical Society of Pennsylvania, Philadelphia. His Delaware (Leni-Lenape) chiefs, aside from their historical interest, are remarkable as the first unprejudiced records of the Amerind. There is no effort to transform them into classical figures in native dress, as did the first recorders of aboriginal life, or to treat them as subhuman savages, as had become common among settlers, but as they were —people with character and dignity.

Justus Engelhardt Kühn (active 1708–17), one of the earlier immigrants of the eighteenth century, was so limited in ability that, had he stayed in his native Germany, he would no doubt have remained in oblivion. In Annapolis, Maryland, however, he found employment as portraitist, and the few works he left have some antiquarian import. Several oval bust portraits indicate his dependence on set poses and dress; the individual heads were probably painted on stock figures. Two portraits, *Eleanor Darnall* and her brother, *Henry Darnall III with Slave* (both about 1710, Maryland Historical Society, Baltimore), aside from their naive charm, are notable mostly for the fantastic landscape backgrounds, deriving either from Kühn's European memories or, more likely, from European prints. Eleanor is much like the seventeenth-century *Margaret Gibbs* (colorplate 2), even to the checkered floor, except for the modeling, which, while painfully indecisive, shows a striving for three-dimensionality.

Among other immigrant artists in the early eighteenth

152 John Smibert. *Mrs. Thomas Bulfinch*. c. 1733. Oil on canvas, 29¾ × 24⅞". The Cleveland Museum of Art. Hinman B. Hurlbut Collection

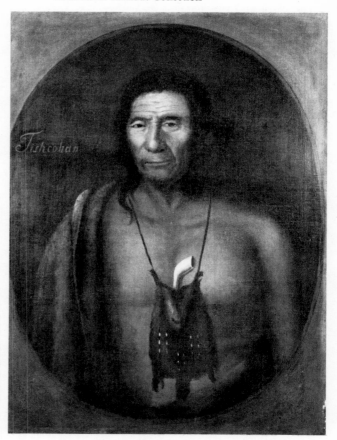

153 Gustavus Hesselius. *Chief Tishcohan*. 1735. Oil on canvas, 33 × 25". The Historical Society of Pennsylvania, Philadelphia

154 Jeremiah Theüs. *Elizabeth Rothmahler*. 1757. Oil on canvas, 29⅞×25″. The Brooklyn Museum. Carll H. De Silver Fund

century was America's first woman artist, Henrietta Johnston (died c. 1728/29), wife of the rector of St. Philip's in Charleston, who did pastel portraits of negligible quality. As for Peter Pelham (1697–1751), he was more important as engraver than painter and even more so as the stepfather and first teacher of John Singleton Copley.

Jeremiah Theüs (c. 1719–1774) seems to have come from Switzerland with his family in about 1735, while still in his teens. By 1740 he was a limner in Charleston. It hardly seems possible that his manner had been formed abroad, being much closer to that of the next generation of Rococo painters than of this earlier group. In the thirty-odd years that he dominated Charleston portrait painting and amassed a tidy fortune, he turned out many routine likenesses, all in the recognizable "pouter-pigeon pose" but somewhat redeemed by a delicate color sense (plate 154).

A generation of American-born painters was influenced by these first professional artists or by engravings of works done by their betters in Europe, but they were, on the whole, not a very prepossessing lot. It is rather hard to deal seriously with a painter like Joseph Badger (1708–1765), who rose to prominence in Boston, possibly because of the failure of Smibert's eyesight. His style is an inept imitation of Smibert's from composition to brushwork. Badger's sitters often appear to have been made of

dough and to have been painted in toothpaste, but they have a clumsy forthrightness. A few of his portraits of children, especially his grandson *James Badger* (1760, Metropolitan Museum, New York), have a redeeming innocence and naive charm. John Greenwood (1727–1792) had more talent, but he left America at twenty-five, before he had much chance to develop. His *Greenwood–Lee Family* (c. 1747, Collection Henry Lee Shattuck, Boston), is an excessively ambitious picture for a young man and, aside from the glimmer of promise, is a disaster. Based on the Smibert and Feke family groups, it has a strong geometric composition, but the cataleptic figures will not stay put.

Painting in Boston in those years would be a story of abject tedium were it not for Robert Feke (1705?–1750?). Feke's life is shrouded in mystery: one can state only that he was married and lived in Newport and painted there and in Boston, in Philadelphia, and possibly on Long Island, from 1741 to 1750, and that he was a "mariner." All the rest, including his birth in Oyster Bay, L.I., and his death in Bermuda, is conjectural. Among the few paintings he left is a *Self-Portrait* (c. 1742–45, Collection Henry Wilder Foot, Cambridge, Mass.), in which, for the first time in American art, the sense of a complete artistic personality shines through, mannerisms disappear, and personality, character, and mood are expressed directly in the aesthetic elements of form and color.

Feke's earliest work was clearly dependent on Smibert, witness his *Isaac Royall and Family* (1741, plate 155), based on the latter's Berkeley group. He obviously had not the knowledge, fluency, or virtuosity of formula that Smibert did; the figures are stiff, the faces stereotyped, the movements awkward, and the painting, especially of the women's costumes, uncertain. But the modeling is strong and volumetric in conception, and the color, as well as the feeling for pigment itself, is more personal and original than Smibert's. Feke eventually evolved a personal style, but his faults, though refined into manner, stayed with him, just as his virtues, refined into style, became his saving grace.

Feke's transformation of the fashionable portrait was a subtle but profound one: he stripped it of its superficial stock mannerisms, especially in his male portraits, and at the same time invested his sitters with an air of nobility deriving from natural dignity rather than painterly flourishes. All the male portraits, full or three-quarter length, have the same ramrod stance of prideful elegance, their dignity increased by the low horizon and the silhouetting of the figure against the sky. The backgrounds are generally artificial, thin, vaporous, more like painted backdrops than actual spatial extensions (though there are notable exceptions), but it is the painting of the figure in this shallow space that identifies Feke. The crisp, non-atmospheric modeling, eminently rational and beautifully precise, is achieved by reducing the infinite value scale of nature to a limited and clearly defined relationship be-

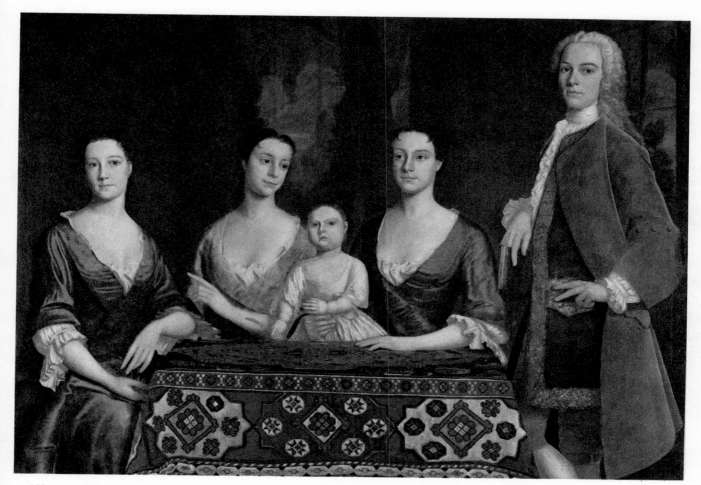

155　Robert Feke. *Isaac Royall and Family.* 1741. Oil on canvas, 54⅝ × 77¾″. Harvard University Law School Collection, Cambridge, Mass.

tween dark, middle, and light tones. The result is an abstract but faithful rendering of reality with a kind of crystalline sparkle. Feke is most successful in the delineation of materials, especially white linen and shining silks and braid, upon which highlights twinkle like jewels. His painting of faces is usually less satisfying, perhaps because the abstraction of form robs them of sensuous surface variation and because a patrician reticence seems to have kept him from plumbing character. His heads are like those of Rococo porcelain or bisque dolls—pretty, polished, and vacant—except for a few male portraits such as the *General Samuel Waldo* (c. 1748–50, colorplate 11), an impressive characterization, or the fiery visage in the bust portrait of *Reverend Thomas Hiscox* (1745, Collection Countess Lâszlo Széchényi, New York), his finest character study.

Feke's portraits of women are more artificial than those of men, almost all of them having nearly identical mask-like faces on heads perched rigidly on columnar throats, rising above tightly corseted torsos, with rather aggressive bosoms and voluminous skirts painted in a virtuoso manner but a routine spirit. However, in a small bust portrait, the so-called *Pamela Andrews* (c. 1741, plate 156), all artificiality and pretense fall away, and the loveliness of an ideal, yet natural beauty shines through with a cool freshness of spirit and a ripe sensuosity.

Feke remained a formula painter, but the formula was his own, forged out of what was available in the painted examples of Smibert or in prints, and fitted to his own personality and talents: a cool elegance, a natural but remarkably subtle sense of color combined with unusual sophistication, and a true painter's feeling for the quality of pigment. Feke's sensuousness is not in the things he paints but in the paint itself. Unquestionably he was America's first authentic artistic talent.

About 1750 a new group of immigrant painters brought with them a change of style which has generally been described as Rococo. An essentially courtly style, it had hard going in England, whose nobility was by mid-eighteenth century largely infiltrated by middle-class wealth, modes, and manners. The English domesticated the Rococo as they did the Baroque, restraining its exuberant fantasy and eliminating its frivolity, retaining

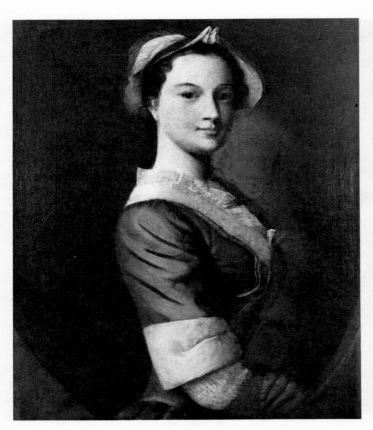

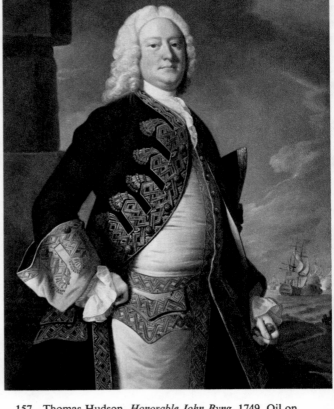

156 Robert Feke. *Pamela Andrews*. c. 1741. Oil on canvas, 30¾ × 23¾″. Museum of Art, Rhode Island School of Design, Providence

157 Thomas Hudson. *Honorable John Byng*. 1749. Oil on canvas, 50 × 40″. National Maritime Museum, Greenwich, England

only its lightness and grace. Of the men who replaced Kneller—Joseph Highmore, Thomas Hudson, and William Hogarth—the two former continued the tradition of the earlier aristocratic style, modifying it into something homier and less artificial (plate 157), while Hogarth expressed in his greater realism an attitude less tinged with aristocratic color. The style imported into America was, thus, more clearly middle-class oriented than that of the previous generation, still with pretensions to aristocracy but less pompous, more natural, and more bourgeois. The men portrayed wear simpler, less ostentatious clothes, short wigs, even their own hair; the women are tightly corseted and often wear shawls to mask their bosoms and lace caps to hide their hair.

Among the painters who came to this country in the third quarter of the century, the most influential were two English "drapery painters," John Wollaston in 1749 and Joseph Blackburn in 1753. When they arrived in the colonies, the Kneller-Lely manner was petering out, and there was little to keep them from making a clean sweep of the field. Both were journeymen painters in the manner of Highmore and Hudson, with a set of stock figures and a bag of fashionable painting tricks. They offered a grace, charm, and prettiness which were new for the colonies; and if the grace was a bit leaden, the charm somewhat

forced, or the prettiness not always convincing, it did not seem so to the colonists. Both painters had plenty of commissions; there are about three hundred American portraits by Wollaston and about one hundred by Blackburn. Blackburn's work did reflect the debonair manner of the Highmore–Hudson tradition. In *Isaac Winslow and His Family* (1757, plate 158), the sprightly movements of the Rococo become nervously agitated; and, although Blackburn never really concerned himself with likeness, much less character, he often produced light, gay, and graceful decorations, as in his *Mary Warner* (c. 1760, Warner House, Portsmouth, N.H.). Wollaston's style (plate 159) was much coarser than Blackburn's and, perhaps because he painted so rapidly, more dependent on a set repertory of elegant mannerisms, all too frequently empty phrases in a meaningless rhetoric. Among his conventions were broad faces with pudgy features, slanted eyes (he was identified as the "almond-eyed artist"), and boneless fingers. But both these artists had a great influence on colonial painters, for, despite their obvious limitations, they turned out professional portraits with all the superficial shimmer of silk and satin, the frill of lace, porcelain skin, sparkling eyes, graceful gestures, pretty colors—a whole dictionary of symbols of social status and cultural refinement.

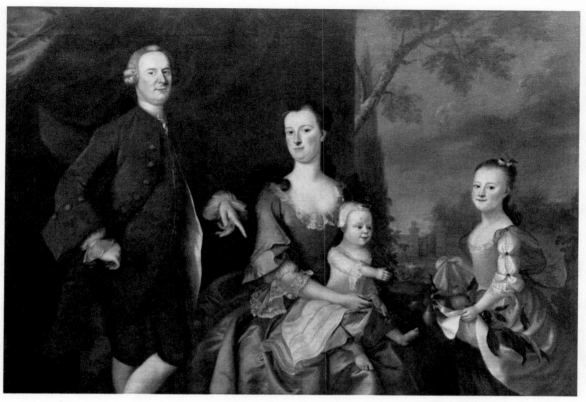

158 Joseph Blackburn. *Isaac Winslow and His Family*. 1757. Oil on canvas, 54½ × 79½″. Museum of
Fine Arts, Boston. Abraham Shuman Fund

159 John Wollaston. *Mrs. Samuel Gouverneur*. c. 1750. Oil
on canvas, 48½ × 39¼″. Henry Francis du Pont Winterthur
Museum, Winterthur, Del.

William Williams, active in Philadelphia and New
York from about 1747 to the Revolution, was an artist of
greater interest, if less importance. His early career indi-
cates no extensive training abroad, but he shows a definite
awareness of contemporary art in England not only in
style but also in the fact that at one time his Philadelphia
studio was "at the sign of Hogarth's Head." Williams
may have been largely self-taught, mostly from prints,
but he produced a charming, personal version of the
Rococo. His pictures have a hard-edged, sparkling clarity
and a flower-like freshness of color, as seen in one of his
finest portraits, *Deborah Hall* (1766, colorplate 12). Even
more interesting are his conversation pieces, unique in
America at the time but characteristic of Hogarth and
later of Thomas Gainsborough, and especially common
among lesser-known and nonaristocratic painters in Eng-
land. Here his limited training results in eccentric com-
positions with strangely motivated characters and a pack
rat's clutter of detail, but they are withal delightfully
refreshing compared with the hack production of Wol-
laston and Blackburn.

Among the American-born painters John Hesselius
(1728–1778) reveals a fundamental sympathy with the
middle-class realism of the time, though he remained es-
sentially provincial. He spent his youth in Philadelphia
and received his first training from his father, Gustavus,

160 John Hesselius. *Mrs. Richard Galloway, Jr. (Sophia Richardson)*. 1764. Oil on canvas, 36¾ × 30". The Metropolitan Museum of Art, New York. Maria De Witt Jesup Fund, 1922

161 John Hesselius. *Charles Calvert*. 1761. Oil on canvas, 50¼ × 40¼". The Baltimore Museum of Art. Gift of Alfred R. and Henry G. Riggs in memory of General Lawrason Riggs

whose portrait-painting business he took over when the latter retired. In 1763 he married a wealthy young widow and settled down to paint in Annapolis for the rest of his life. Over one hundred portraits done between 1750 and 1778 would indicate that he was active in Pennsylvania, Maryland, Delaware, and Virginia. The influence of Wollaston in pose and style is obvious in many of his paintings, but an innate feeling for a homelier simplicity informs such portraits as *Thomas Jefferson* (1768, National Gallery, Washington, D.C.) and *Mrs. Richard Galloway, Jr.* (1764, plate 160). In the latter, one can even perceive an affinity with Badger in the prosaic vision and awkward pose, although the honesty of characterization and clarity of modeling are closer to Copley's work of the early sixties. Hesselius's best-known work is the charming and colorful *Charles Calvert* (1761, plate 161), which manages to combine some of the elegant artificialities of Wollaston with his own sense of solid reality in the painting of three-dimensional form.

COPLEY AND WEST

The brilliant flowering of John Singleton Copley (1738–1815) in a meager soil has led writers on American art to stress his uniqueness and his self-education, when in actuality his dependence upon contemporary models is

absolutely clear. Early in American history a great deal was already made of such self-made native talents. Nathaniel Emmons's obituary in the *New England Journal* in 1740 states: "He was universally own'd to be the greatest master of various Sorts of Painting that ever was born in this Country. And his excellent Works were the pure Effect of his own Genius, without receiving any Instructions from others." The same was said of Feke. The virtues of the self-made—ingenuity, aggressiveness, and perseverance—had already become a national myth.

Copley appears self-made only because he surpassed almost unexplainably the limitations of his sources and his environment. The fact is that, as a youth, he found himself in a most favorable situation for an incipient artist. His widowed mother married Peter Pelham in 1748, when John was eleven. Copley thus came into a household where art was a central concern, and through his stepfather he also came to know the Smibert household, its activities, and its contents. Peter Pelham had a collection of prints, and we know that Smibert had one containing examples of Raphael, Michelangelo, Poussin, and Rubens, as well as his own painted copies of Raphael's *Madonna dell'Impannata*, a Titian *Venus and Cupid*, Poussin's *Continence of Scipio*, Van Dyck's *Cardinal Bentivoglio*, and replica plaster casts of the Medici *Venus* and the bust of *Homer*. Prints and copies of course,

but they were not exactly backwoods fare. Copley's emergence as an artist was not, therefore, so remarkable; only his genius was.

Within three years Pelham was dead and Copley had a half brother and was the head of a household. He must have gone to work immediately as a portrait painter, and his earliest datable works were done when he was only fourteen or fifteen. These paintings were full of gleanings from his stepfather, Smibert, Feke, even Badger and Greenwood, for Copley was always an avid student, borrowing, imitating, and copying throughout his life. Among his earlier works, his *Catherine Moffat Whipple* (c.1753, Collection Alexander H. Ladd, Milton, Mass.) is out of Feke; his *Ann Tyng Shelt* (1756, Estate of Grace M. Edwards, Boston) is inspired by Blackburn's *Mary Sylvester Dering* (1754, Metropolitan Museum, New York); and even as late as about 1765 he copied faithfully an engraving of Reynolds's *Lady Caroline Russell* (1759) for his own *Mary Sherburne Bowers* (Metropolitan Museum, New York).

The appearance of Blackburn in Boston offered a standard to strive for, and Copley's clarity in modeling, lustrous color, and sparkling textures must have derived from the older man. But even while he was entranced by Blackburn's charming artificialities and fashionable trappings, his sense of reality and his concern with portrait likeness were already distinguishing marks. By the time Copley painted the *Mary and Elizabeth Royall* (c.1758, Museum of Fine Arts, Boston), he had absorbed the Rococo style and everything that Blackburn's art could offer and had already formed his own style—a direct and penetrating realism. He was driven by a fanatical search for the truth in the character of his sitters as well as in the material things which surrounded them, and his best portraits are of friends with whom he could be honest, successful men sure of their own position, and old people, both men and women, who no longer had any reason for physical vanity. He never consciously demeaned, although in some examples one might suspect that he was not being altogether kind.

Copley has left us a gallery of memorable portraits of colonial Americans that is not only an incomparable record of American life and character but also a remarkable artistic achievement. Among these are the contemplative old man *Epes Sargent* of Gloucester (1760, plate 162), with his light eyes and his puffy old hand painted almost impressionistically; the sprightly, wizened dowager *Mrs. Thomas Boylston* (1766, colorplate 13), wife of a saddler and mother of eight, wryly accepting the honor of sitting for her portrait because her wealthy merchant sons had paid for it; the successful merchant *Joseph Sherburne* (c.1767–70, Metropolitan Museum, New York), informal and relaxed at home in robe and turban, looking out at the world with benign self-assurance, the image of the self-made man; *Governor and Mrs. Thomas Mifflin* (1773, plate 163), the paradigm of colonial eco-

162 John Singleton Copley. *Epes Sargent*. 1760. Oil on canvas, 49⅞ × 40″. National Gallery of Art, Washington, D.C. Gift of the Avalon Foundation

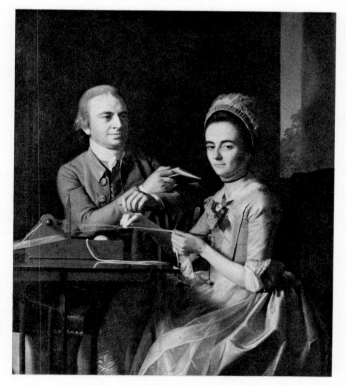

163 John Singleton Copley. *Governor and Mrs. Thomas Mifflin*. 1773. Oil on bed ticking, 61½ × 48″. The Historical Society of Pennsylvania, Philadelphia

nomic and social stability expressed in marital felicity and the encompassing warmth of the home; or the rock-ribbed solidity of the young artisan *Nathaniel Hurd* (c.1765, plate 164).

During the sixties Copley's style changed little, though his grasp of reality and his skill in handling material continued to grow. There is some unevenness in quality, to be expected in a provincial artist without even remote competition, obliged to grind out speaking likenesses of local worthies. All Copley's American work exhibits certain recurring inaccuracies in anatomical drawing and proportion which reflect the narrowness of his training and are difficult to account for in someone so obsessed by visual realism. His color, although bright, sensuous, vital, and even exciting in itself, is essentially naive, almost totally local, without variation in hue or atmospheric modification. This is not entirely an unmixed fault, however, for it reinforces the visual clarity as well as the forthrightness of his characterizations.

In the early sixties he was successful financially and had achieved unparalleled recognition. Yet he felt "peculiarly unlucky in Liveing in a place into which there has not been one portrait brought that is worthy to be call'd a Picture within my memory." In a letter, written but never sent, he said: "Was it not for preserving the resembla[n]ce of perticular persons, painting would not be known in the plac[e]. The people generally regard it no more than any other useful trade, as they sometimes term it, like that of a Carpenter tailor or shewmaker, not as one of the most noble Arts in the World. Which is not a little Mortifying to me. While the Arts are so disregarded I can hope for nothing, eith[e]r to incourage or assist me in my studies but what I receive from a thousand Leagues Distance, and be my improvements what they will, I shall not be benifitted by them in this country, neighther in point of fortune or fame."

To test his true stature as an artist, Copley sent the recently completed portrait of his half brother, Henry Pelham, called *Boy with Squirrel* (1765, private collection), to Sir Joshua Reynolds in London for exhibition at the Society of Artists. This is one of Copley's masterworks, a lyrical portrait created out of a consuming wonder at the material world and sheer delight in painting. Except for the red-curtained background, all unnecessary trappings are removed, and we come face to face with the moving image of a child lost in a dream. It reveals not only his love for the boy, to whom he was so close, but his love for everything paintable—the fuzz of the little animal's fur, the glitter of the metal chain, the sparkle of the glass and water, the texture of skin, and the gleam of satin. Its skill and realism startled the London art world. It was extravagantly praised, Copley was elected a member of the Society, and Reynolds wrote him: "In any Collection of Painting it will pass for an excellent picture, but considering the Dissadvantages you had laboured under, that it was a very wonderfull Performance.

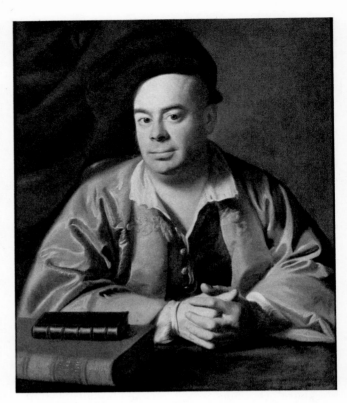

164 John Singleton Copley. *Nathaniel Hurd.* c. 1765. Oil on canvas, 30 × 25½″. The Cleveland Museum of Art. John Huntington Collection

. . . if you are capable of producing such a Piece by the mere Efforts of your own Genius, with the advantages of the Example and Instruction which you could have in Europe, You would be a valuable Acquisition to the Art, and one of the first Painters in the World, provided you could receive these Aids before it was too late in Life, and before your Manner and Taste were corrupted or fixed by working in your little way at Boston." This letter must have done a great deal for Copley's ego, while at the same time forcing him to contemplate his future with a new seriousness. Yet, perhaps because he was making "a pretty living in America," he continued with increasing renown and skill to turn out resemblances. He left Boston only once, to visit New York for six months in 1771 and paint the host of elite anxiously waiting on him, the greatest painter in America.

In the seventies his style became noticeably richer, subtler and much more complex, and his sitters began to appear more affluent, more sophisticated, and more fashionable. The man who had once painted John Hancock and Sam Adams and his friends, the silversmiths Nathaniel Hurd and Paul Revere, with an almost reverent sense of modest realism, was now painting *Mr. and Mrs. Jeremiah Lee* (1769, Collection Thomas Amory Lee, Topeka, Kans., on loan to Museum of Fine Arts, Boston) in ostentatious grandeur.

In June, 1774, he finally made the break, probably guided at least in part by political considerations, and

departed for England. In August he set out for Italy to copy the old masters and, after traveling through Europe, returned to London to find his family among the first Tory emigrés from the Revolutionary War. He soon achieved recognition and commissions, was elected an Associate of the Royal Academy in 1776, and elevated to full membership in 1779.

The forty years Copley spent as an English painter have been slighted by American writers on art. His leaving seems almost a desertion, and he was so profoundly an expression of our colonial past that Americans have difficulty seeing him in any other guise. Copley's American style was provincial by London standards, but in a short time he made himself over into a fashionable English painter and a good one. As a portraitist he would have to be ranked with Reynolds, Gainsborough, and Romney. *The Copley Family* (1776–80, plate 165), *Mrs. Seymour Fort* (c.1778, plate 166), *Midshipman Augustus Brine* (1782, Metropolitan Museum, New York), and individual heads in his historical pictures combine the suave handling of the English school with his own innate realism and are among the finest examples of eighteenth-century portraiture.

But Copley was no longer satisfied with portraiture. He had come to Europe for greater things. Driven by his own ambitions, challenged by Benjamin West's success, he attempted to rival West in historical painting (see below and Chapter 8). Copley's gigantic historical canvases, *Death of the Earl of Chatham* (1779–81, Tate Gallery, London), *Death of Major Peirson* (1782–84, Tate Gallery, London), *The Siege of Gibraltar* (1783–91, Guildhall, London), and *The Victory of Lord Duncan* (1798–99, Camperdown House, Dundee), which the English art historian Ellis K. Waterhouse has called the only series of great modern history paintings done during the eighteenth century in England, brought him fame but not the rewards he had hoped for. He had antagonized his English colleagues. With time his reputation as well as his art declined; his health failed and he spent his last years in loneliness, frustration, regret, and tragic senility.

Benjamin West (1738–1820) left an even more meteoric trail across the artistic skies of the time. In contrast to Copley's introspective, self-doubting, and timid nature, West was an extroverted, gregarious, and generous person upon whom Fortune seemed always to bestow her warmest smile. Though a painter of no great talent, he

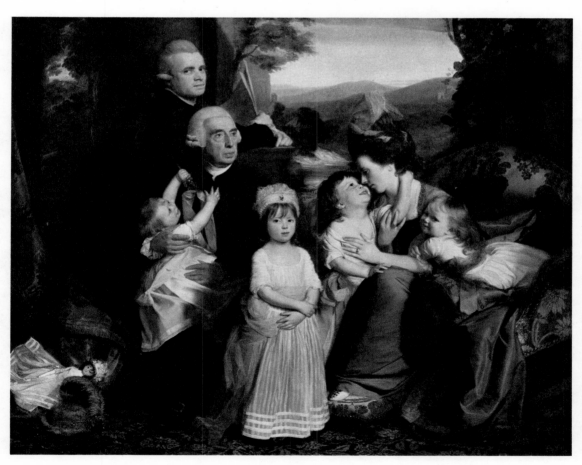

165 John Singleton Copley. *The Copley Family*. 1776–77. Oil on canvas, 72½ × 90⅜″. National Gallery of Art, Washington, D.C. Andrew W. Mellon Fund

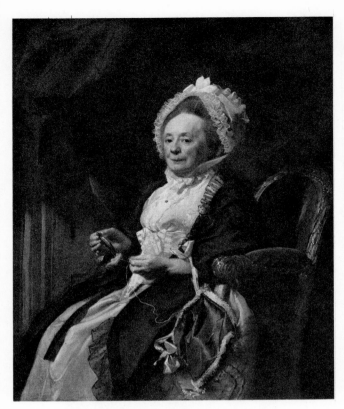

166 John Singleton Copley. *Mrs. Seymour Fort.* c. 1778. Oil on canvas, 50×40″. Wadsworth Atheneum, Hartford, Conn.

played an important role in the innovation of three successive historic styles in European art: Neoclassicism, Realism, and Romanticism. Even the French credit him, along with the English painter Gavin Hamilton, with having arrived at the Classic Revival before Jacques-Louis David. His *Death of Wolfe* (1770, colorplate 14) has long been considered a landmark in eighteenth-century historical painting for its choice of a contemporary event depicted in contemporary costume. And his *Death on a Pale Horse* (1802, plate 167), a large oil sketch acclaimed at the Paris Salon of 1802, was an early probe into Romanticism. Quite an accomplishment for a mediocre painter of provincial origin who is now, if not forgotten, studiously ignored.

West's parents were Quaker innkeepers in what is now Swarthmore, Pa., yet despite severe religious restrictions his artistic interests were not impeded, and he was painting copies of prints at a very early age. Considered a child prodigy, he was taken at the age of eight to William Williams in Philadelphia, and in his early teens he was doing portraits of neighbors. About 1755 he was in Lancaster painting William Henry, the gunsmith, and his wife, and at Henry's suggestion did a *Death of Socrates*. His fame spread, and he was invited to enroll at the College of Philadelphia by its provost, Dr. William Smith, who planned a course of study to prepare him for greatness in the arts. West's earliest portraits show an awkward but straightforward manner, which soon took on the naive elegance of Williams and, before long, the

167 Benjamin West. *Death on a Pale Horse.* 1802. Oil on canvas, 21 × 36″. Philadelphia Museum of Art

168 Benjamin West. *Thomas Mifflin*. 1758–59. Oil on canvas,
48¼ × 36¼″. The Historical Society of Pennsylvania,
Philadelphia

After three years in Italy, West set out for home via England, but his reception there was so enthusiastic that he remained in London. Though portrait commissions were plentiful, he was imbued with the idea that art had higher aims, and he finally had his way. The Archbishop of York, for whom he had painted one of the earliest of Neoclassic pictures, *Agrippina Landing at Brundisium with the Ashes of Germanicus* (1767, plate 169), introduced him and his work to King George III. West struck up an immediate friendship with the King, and William Dunlap was not exaggerating when he wrote that this placed West "on the throne of English art," since he was the only painter commissioned by the King to execute historical pictures. In 1768 West was appointed a charter member of the newly founded Royal Academy of Arts, and in 1772 he became historical painter to the King, for whom he produced a tremendous number of historical pictures, both religious and secular.

To handle such production West needed an atelier on the scale of a Rubens, and this was perhaps one reason for his welcoming many young American artists into his household—among them Charles Willson Peale, Gilbert Stuart, William Dunlap, Ralph Earl, Joseph Wright, and John Trumbull. West's artistic factory has been called "the first effective American art school" (E. P. Richardson). Although these young painters served their apprenticeship under West, few were influenced by him stylistically. Some, including Stuart, were even contemptuous of his powers as a painter, and most remained beholden to him only as a kind and considerate fellow countryman who had helped them on their way and as a symbol of what an artist born in America could achieve.

Most of West's large historical pictures are studio productions and, since he was not a great master, could not be saved by his final touches. Indeed, Stuart's criticism was that West never knew when to stop. He was simply not equal to his opportunities. His best works are his less pretentious and less labored ones: occasional informal portraits, sketches for his elephantine epics, or unfinished works such as the *American Commissioners of the Preliminary Peace Negotiations with Great Britain* (c. 1783, plate 170), in which his native talent comes through uncluttered by theory, eclecticism, or academic polish.

Since West left America before his style had matured, his influence on American painting worked through those men who went to study and work with him in England and through pictures that he sent home to Philadelphia. Copley, on the other hand, had no students except perhaps Henry Pelham, though he did provide some encouragement and assistance to a few artists, including Peale and Trumbull. His influence was, however, more general through the example of his art and was the dominant force in the years immediately before and after the Revolution.

heavy-handed graces of the newest arrival to Philadelphia, Wollaston.

It is to West's credit that he fought his way out of this influence and that by about 1758 he could paint so charming and personal a picture as the *Thomas Mifflin* (1758–59, plate 168), in which only the slanting eyes are reminiscent of Wollaston; the rest, though dependent on Williams, reveals unique qualities in the unusual harmony of blues. Inspired by a Spanish picture reputedly of the school of Murillo, West decided to go abroad to study, spent almost a year in New York painting portraits to raise the money necessary, and finally left America late in 1759 to become a great artist.

The fair stranger from America, who turned out not to be a savage, was something of a curiosity in Rome and before long became the darling of the *dilettanti*. West received private instruction from Raphael Mengs, the artistic arbiter of the circle, met Johann Winckelmann, and copied the old masters in Rome, Florence, Bologna, Parma, and Venice. By chance, the old-fashioned and sketchy education in moral precepts and classical mythology devised by Dr. Smith had prepared West for the academic absolutes of Mengs and the new Classicism of Winckelmann.

American painting came of age in the late Colonial period with the work of Copley and West. It had run the gamut of provincial development through the immigration of minor though professionally trained painters to American artists who, achieving a level almost equal to the best that the mother country had to offer and finding the provincial environment hampering, were drawn irresistibly to the center of their culture, London, there to remain. The next generation began, even before the Revolution and increasingly thereafter, to go to Europe to learn, but with the idea of returning enriched and prepared for the task of building a new culture for a new nation.

169 Benjamin West. *Agrippina Landing at Brundisium with the Ashes of Germanicus.* 1768. Oil on canvas, 64½ × 94½″. Yale University Art Gallery, New Haven. Gift of Louis M. Rabinowitz

170 Benjamin West. *American Commissioners of the Preliminary Peace Negotiations with Great Britain.* c. 1783. Oil on canvas, 28½ × 37½″. Henry Francis du Pont Winterthur Museum, Winterthur, Del.

LANDSCAPE PAINTING
AND OTHER GENRES

Despite a lamentable dearth of nonportrait painting during the Colonial period, it has always been recognized that literary evidence implied at least some activity in such areas. For instance, this rather fulsome listing appeared in an advertisement in a Charleston newspaper in 1766: ". . . History Pieces, Altar Pieces, Landscapes, Sea Pieces, Flowers, Fruit, Heraldry, Coaches, Window blinds, Skreens, Gilding. Pictures copied, cleansed or mended. Rooms painted in Oil or Water in a new Taste. Deceptive Temples, Triumphal Arches, Obelisks, Statues, &c, for Groves or Gardens." In addition there is mention of subject pictures or landscapes in the effects of such artists as Kühn and Theüs, and there are references elsewhere to a landscape by Smibert, a candlelight picture by Copley, and a mythological subject by Feke. While such evidence appears conclusive, its interpretation remains open to question.

One of the genres mentioned most frequently in the advertisements is the "landskip," and yet only a very few landscapes as such, and those questionable, have come down to us. Were these "landskips" intended as works of art or as wall decorations? Occasional examples of such painting have survived: for instance, four panels out of eleven for the Clark–Franklin House in Boston (c. 1712–42, plate 171), two of which are now in the collection of the Maine Historical Society, Portland, and two in the Gay Collection, Boston; four pictorial panels in a room from Marmion, King George County, Va., now in The Metropolitan Museum of Art, New York; and wall paintings in the hallway of the McPhedris–Warner House, Portsmouth, N.H. Such wall paintings were equivalent to or imitations of contemporary wallpaper such as the imported hand-painted papers of the Van Rensselaer Room (Metropolitan Museum, New York) or the Jeremiah Lee House in Marblehead, Mass., which are far more sophisticated. All these scenes are set pieces, painted by artisans following decorators' patterns, of romantic and exotic landscapes or genre scenes. They are, in any case, not landscapes that have anything to do with America, nor are they a reflection of a widening taste for new kinds of subject matter in painting but merely proof of a growing predilection for lavish interior decoration.

The most frequently quoted document suggesting an autonomous landscape form is the obituary of Nathaniel Emmons, which reads in part: "His Pieces are such admirable Imitations of Nature, both in faces, Rivers, Banks and Rural Scenes. . . ." By ignoring "faces" it is possible to say that time has destroyed all his landscape and subject pictures, but the passage can also be read as a description of exactly the kind of English portrait Emmons and others copied from available prints, a figure posed in a landscape. One can hardly build a theory of

171 Anonymous. Landscape panel from the Clark-Franklin House, Boston. c. 1712–42. Oil on panel, 60 × 22¾".
Maine Historical Society, Portland

the prevalence of landscape and subject painting on such slim evidence. In no case in which landscapes or subject pictures are mentioned in inventories is it possible to assume that these were paintings and not prints, or, if they were paintings, that they were by American painters.

As an autonomous genre, landscape painting was probably confined to the artisan-level production of overmantel panels or wall decorations. All the references to landscape painting in advertisements can more easily be understood as of this type, since they are usually listed along with other artisan jobs the painter could handle in a pinch. Isaac Weston, in a squib in the *Pennsylvania Chronicle* in 1768, cites his ability to do "Coach, Chaise, Chair, or any kind of Landscape Painting, also Lettering and Gilding." A clearer indication of the intention of such "landskips" is contained in an advertisement by the Charleston painter Bishop Roberts (?–1739). "Landscapes for Chimney Pieces of all Sizes." But even this common practice has left us few examples, and most overmantel paintings still extant date from after the Revolution. Among the earlier ones are a *View of Holyoke* (c. 1760, National Museum, Washington, D.C.); *Ipswich Harbor* (before 1776, Ipswich Historical Society, Ipswich, Mass.); six attributed to Winthrop Chandler (1747–1790) for houses in Connecticut and Massachusetts; *The South East Prospect of the City of Philadelphia* (c. 1718–20, Library Company of Philadelphia), a long, narrow scene done in great detail but in a crude artisan manner, signed by one Peter Cooper; and the *British Privateers with French Prizes in New York Harbor* (c. 1756–57, plate 172), somewhat more adeptly handled

though still obviously the work of a sign painter. These works are actually less a reflection of traditional landscape painting or even wall decoration than of the popular topographical print.

Topographical views have a tradition as old as the print itself, since satisfying curiosity about distant and famous places was from the outset one of the print's main functions. It was in this area that the first authentic landscapes of America appeared. William Burgis (act. c. 1716–31), something of a rakehell as well as a painter and an innkeeper, did a topographical view of New York (c. 1716–18, plate 173) which was beautifully engraved in London. In Boston, in 1722, he published the earliest view of that city. He did four more of Boston and one of Harvard College (c. 1726) before returning to New York, where he executed two more aspects of the city (c. 1730–32). Recently another series of views of New York, Boston, and Philadelphia, dated about 1731–36 and engraved in London by J. Carwitham some thirty years later, have been attributed to Burgis. Bishop Roberts painted a watercolor view of Charleston seen from the harbor (c. 1737–38), which was engraved by W. H. Toms, also in London. Christian Remick, a Cape Cod mariner and part-time painter, recorded in watercolor the British landing of troops in Boston in 1768, and his *View of the Blockade of Boston* (Essex Institute, Salem, Mass.) looks as if it were intended as an engraving or at least influenced by one. Topographical views of American towns done later in the century, such as the *Scenographia Americana* series (1768) and the extensive *Atlantic Neptune* series (1763–84), were fully English in design and execution.

172 Anonymous. *British Privateers with French Prizes in New York Harbor*. 1756–57. Oil on canvas, 38 × 72½″.
The New-York Historical Society

173 I. Harris (after a drawing by William Burgis). *The Skyline of "Ye Flourishing City of New York."*
c. 1718. Engraving. Collection H. Dunscombe Colt, New York

An occasional landscape painting may be inferred from such rare references as Smibert's writing in a letter that he was "diverting [himself] with something in the Landskip way, which you know I always liked." The only Colonial landscapes that look like what we think of as traditional landscape painting are two small, rather naively executed pictures attributed to Benjamin West. The evidence that West painted them as a child is tenuous, and one can even question their being American.

As for subject pictures, the examples and evidence are just as skimpy. The only true example of a genre painting from the Colonial period is one called *Sea Captains Carousing in Surinam* (c. 1758, plate 174), attributed to John Greenwood and said to have been painted after he

had left America for Surinam. Again the evidence is slim, nor is there much point in fussing over its not having been done in this country, since it is a unique example in any case and an inept painting to boot. Although there are mentions of genre pictures in collections, that in itself is not proof that they were paintings or American. On the other hand, there is incontrovertible documentary evidence of a few. There is written mention that Badger sold a "laughing boy" in 1757, that Copley sold a painting of a nun by candlelight to King's College, and that West, while in New York, had seen a picture of a monk praying by lamplight and had in emulation painted a man reading by candlelight.

History painting, which included religious, secular,

174 John Greenwood. *Sea Captains Carousing in Surinam.* c. 1758. Oil on bed ticking, 37¾ × 75¼". St. Louis Art Museum

175 Gustavus Hesselius. *Bacchus and Ariadne*. c. 1725. Oil on canvas, 24½ × 32⅜″. The Detroit Institute of Arts

176 John Singleton Copley. *The Return of Neptune*. c. 1753–54. Oil on canvas, 27½ × 44½″. The Metropolitan Museum of Art, New York. Gift of Mrs. Orme Wilson, 1959, in memory of her parents, Mr. and Mrs. J. Nelson Borland

and mythological themes, was considered the noblest objective of the artist, and even the provincial who had no hope of doing anything nobler than a portrait of a merchant's wife accepted this as the truth. A rather touching expression of this attitude is an advertisement of John Durand in the *New York Gazette* in 1768, in which he offers to paint historical pictures even though he feels himself unworthy. Apparently not even the inducement of "cheap rates" led to any noticeable clamor for his offerings, and he continued to paint portraits. Copley and West were driven by the urge to paint historical subjects and ultimately left America, at least in part because it could not be satisfied here. While prints dealing with such themes were available and some of them must have hung in homes, American painters, so far as the records go, had no call for these subjects. The occasional painting of this type was done by the artist for his own satisfaction. We actually have two mythological scenes by Gustavus Hesselius, a *Bacchanalian Revel* (Collection Mrs. F. H. Hodgson, Philadelphia) and a *Bacchus and Ariadne* (plate 175), which E. P. Richardson dates in the 1720s and Virgil Barker thinks may have been done before Hesselius arrived here. In any case, they appear to be somewhat naive and clumsy copies rather than original conceptions. Feke copied his *Judgment of Hercules* from the engraved frontispiece of the Earl of Shaftesbury's *Characteristicks,* and West's *Death of Socrates* was also after an engraving; neither painting is now extant. Copley has left us three allegorical scenes, copied from engravings and dated about 1753–54: *The Return of Neptune* (plate 176); *Galatea* (Museum of Fine Arts, Boston); and *Mars, Venus, and Vulcan* (Collection Mrs. James F. Chapman, Pueblo, Colo.). These are interesting visual documents of Copley's development but in themselves tentative efforts of the young painter to learn by translating black-and-white prints into paint.

In spite of attempts to demonstrate that the Protestant proscription against religious art was not so rigid as it would at first appear, and that there was an extensive mortuary art, largely emblematic and decorative, there is very little evidence of religious painting in either churches or homes. Some advertisements offered altarpieces, but the only known commission for a religious painting was for a *Last Supper* by Gustavus Hesselius for Saint Barnabas' Church, Queen Anne's Parish, Prince Georges County, Md., ordered in 1721 and installed in 1722. It remained in place until 1773, after which it disappeared. A painting frequently identified as this *Last Supper* (Collection Mrs. Rose N. Henderson, Fredericksburg, Va.) is seriously questioned by a number of scholars and quite rightly. Two other religious paintings by Hesselius mentioned in literary sources no longer exist: an altarpiece for Christ Church, Philadelphia, seen there in 1744; and a *Crucifixion* in Saint Mary's Roman Catholic Church, Philadelphia, described by John Adams. A large and unique body of religious paintings by John Valentin

177 Paul Revere. *The Boston Massacre*. 1770. Engraving, 7¾ × 8⅝". Worcester Art Museum

Haidt (1700–1780), a missionary of the Moravian Brotherhood and a painter, is still extant in churches in Bethlehem, Lititz, and Nazareth, Pa. Haidt had a modicum of training in Europe, came here as a convert in 1754, and spent the rest of his life decorating the churches of the sect, but his efforts are hardly notable works of art.

One type of the historical genre which became popular before the Revolution was the journalistic print, a record of some important and interesting recent event, usually a battle scene. It became increasingly common after the Revolution and had a wide development during the nineteenth century. The earliest of these is an engraving by Thomas Johnston (c. 1708–1767), after a drawing by Samuel Blodget (1724–1807), which was called *A Prospective Plan of the Battle Fought Near Lake George, Sept. 8, 1755;* it was issued in Boston in the same year and reissued in a new engraving in London the following. Others were Henry Dawkins's *The Paxton Expedition* (1764); Paul Revere's *A View of Part of the Town of Boston in New England and British Ships of War Landing Their Troops, 1768,* published in 1770, and his more famous *The Boston Massacre* (plate 177), which was issued immediately after the event in 1770; and Bernard Romans's *The Battle of Charlestown,* which was printed in Philadelphia shortly after the battle in 1775. The earliest known venture of Ralph Earl (see Chapter 8) was the execution of four paintings concerned with the battles of Lexington and Concord. This early journalistic scoop was achieved when Amos Doolittle published engravings of Earl's paintings in December, 1775.

The evidence for still-life painting is even more meager than for the other types. According to Virgil Barker, there is only one still life that can be dated before the Revolution, a painting by Winthrop Chandler of a row of books, evidently intended as a *trompe-l'oeil*, for a Connecticut house, where it still hangs. After that we are back to documents. An advertisement in a Boston newspaper of 1760 describes two pictures of dead game that were stolen during a fire; no mention is made of the artist or whether they were American pictures. In New York, in 1754, Lawrence Kilburn (Lorenz Kielbrunn), a Dane, offered flower subjects; in Baltimore, in 1774, Samuel Rusbach advertised still-life subjects as decorations for the home; and in the same year, in Charleston, the Stevensons, John and Hamilton, were ready to teach painting of flowers and birds.

It seems fairly obvious that Americans were aware of the kinds of art available in Europe at the time, aware even of the hierarchy of values assigned to the various types, but that they were having little of them. They were inhibited by a level of cultural development which did not as yet value art collecting as a form of conspicuous consumption. Besides, long before Americans would patronize local artists, they would buy imported prints of similar subjects, which would be cheaper and carry more cachet than the efforts of local craftsmen.

SCULPTURE BEFORE THE REVOLUTION

Not until the eighteenth century did sculpture show any signs of climbing above the level of artisan stonecutting or woodcarving, and even then its ascent was much slower than that of painting. No professional sculptors came to the colonies, although handbooks of architecture and furniture had a noticeable effect on the range and sophistication of design. The gravestone still monopolized stonecutting, but increased wealth and cultural changes prepared the way for new mortuary forms. By mid-century the very wealthy were ordering marble tombs from England, modest versions of the newest fashions in funerary monuments with portrait busts that had more to do with vanity than the recognition of mortality. Sir William Pepperell of Kittery, Me., commissioned an elaborate monument for himself from London about 1750, and several imported wall tombs still exist in King's Chapel in Boston: one for Frances Shirley (d. 1744), executed in 1754 and crowned with her portrait; and a quite Baroque monument to Charles Apthorp (d. 1758), with a weeping *putto* leaning on an urn.

Soon after the turn of the century the relaxation in Puritan strictures became evident in the introduction on gravestones of bust portraits in place of winged skulls. Primitive as some of these are, they nevertheless were the first efforts at portraiture in stone. Among the earliest are the gravestones of the Reverend Jonathan Pierpont (d. 1709, plate 178), Wakefield, Mass., and the Reverend Grindall Rawson (d. 1715), Mendon, Mass. By mid-century the type was common all along the eastern seaboard. The change in both attitude and taste, with the introduction of Classical forms and motifs, is apparent in the work of Henry Emmes, a Boston gravestone cutter whose tombs can be found as far south as Charleston. There the Congregational churchyard contains the grave marker of Solomon Milner (d. 1757, plate 179), which bears a profile bust portrait with a toga in the Roman manner, and that of the Reverend William Hutson (d. 1761), in ministerial dress and toga, flanked by weeping *putti*. Even on the highest levels of craftsmanship such tombstones remain provincial and fairly primitive imitations of English models, but on lower levels too there is visual evidence of some connection, however remote, with the same sophisticated sources.

Quite separate from this development toward a high style was the continuation in backwoods areas of the seventeenth-century artisan tradition, evolving into an apparent "primitivism" which was actually a kind of "degeneration" from complexity of form back to simplified, almost abstract pattern, in which rudimentary signs are carved with great refinement. This typical folkloric process occurs in isolation and stems from constant reiteration of a limited vocabulary of forms. Among some eighteenth-century New England carvers the process produced startling resemblances to earlier forms and some handsome examples of an innate sensitivity to abstract design elements, as in the gravestone of Sarah Davis (plate 180) and an almost identical one of Hannah Converse, Brookfield, Mass.

Throughout the eighteenth century carpentry remained a more extensive and highly developed craft than stonecutting, and it was in shops that produced architectural and furniture decoration, signs, and ship figureheads that the first tentative steps toward sculpture as an independent art were made. Again the effects of wealth and an improved standard of living on patronage of the crafts and arts is obvious. Georgian architecture required elaborate exterior and interior carving, and architectural detailing and wood paneling became increasingly rich and refined as the century advanced (plate 181). Architectural handbooks and furniture pattern books after about 1730 brought in a whole new repertory of ornamental design which called for new skills, and by the time of the Revolution colonial cabinetmakers and woodcarvers were beginning to approach their English cousins in virtuosity.

Shipbuilding had become a major industry by the early years of the century in such New England coastal towns as Kittery, Me., Portsmouth, N.H., Boston and New Bedford, Mass., and Mystic, Conn.; and with it ship carpentry in all its forms flourished. When the Admiralty Office in 1727 removed its restrictions on the representa-

178 Gravestone of the Reverend Jonathan Pierpont (d. 1709), Wakefield, Mass.

179 Gravestone of Solomon Milner (d. 1757), Congregational churchyard, Charleston, S.C.

tion of anything but the lion on the prows of English ships, a great era in figurehead carving was opened. The woodcarver's craft expanded to supply the new demand, and many woodcarvers are known to have executed figureheads, but unfortunately none of these early examples has survived. There are records that the first of the Skillins, Simeon Sr., produced such figureheads, including a Minerva for the brig "Hazard" in 1777, but the golden age of figurehead carving is post-Revolutionary.

The production of shop signs was probably the work of the same carvers, but, again, little remains except for a small polychromed wood figure called *The Little Admiral* (1750–70, colorplate 15), immortalized by Nathaniel Hawthorne in "Drowne's Wooden Image." Its attribution to the legendary Shem Drowne is questionable, and its identification as a representation of Admiral Edward Vernon is no more certain. But it seems to be the earliest extant freestanding sculpture done in America. The figure, which once held a nautical instrument (if one assumes that it served as a ship chandler's sign) or a stein (if it was a tavern sign), is awkward, ill-proportioned, and crudely carved. Apart from its historical interest, it offers some indication of the level of competence in pre-Revolutionary figurehead and sign carving. In the same connection, although they are the products of an entirely different craft, mention should be made of the earliest surviving weather vanes, both from Boston: the hammered-copper Indian (c. 1750, plate 182), which once

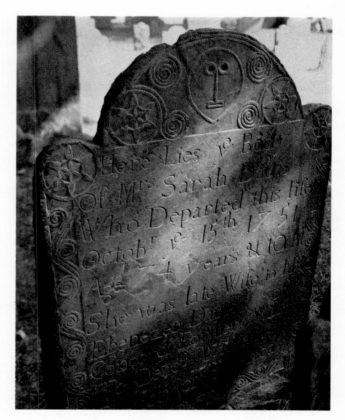

180 Gravestone of Sarah Davis (d. 1751), Concord, Mass.

181 Carved paneling, top of the stairwell, 40 Beacon Street, Boston. 18th century

gyrated above the cupola of the Province House (the remodeled Peter Sergeant House of the seventeenth century); and the Grasshopper (1742, plate 183), also in copper, atop Faneuil Hall. Both have been traditionally attributed to Shem Drowne. Such meager remnants are the first intimations of a three-dimensional figurative art, but there was still a long road to travel from craft to art. America had not produced sculptors equivalent to the painters Feke, Copley, or West.

Just before the Revolution there were indications of an incipient demand for monumental sculpture. As a sign of increasing prosperity and the growth of urban pride, though the motivation must have been political as well, the city of New York in 1766 ordered an equestrian statue of King George III and one of William Pitt from Joseph Wilton, sculptor to the King. Several months later Charleston commissioned a replica of the *Pitt;* all three arrived and were erected in 1770. The *George III,* of gilded lead, probably a duplicate of one Wilton had done for Berkeley Square, London, portraying the mounted monarch in Roman dress and laurel wreath, much in the manner of the famous *Marcus Aurelius* in Rome, was set up amid great pomp but little popular enthusiasm on Bowling Green. The marble statue of the much more popular Pitt, depicted as a Roman senator in oratorical pose and holding the Magna Carta, was erected at the crossing of Wall and William Streets in New York. In 1771 the House of Burgesses ordered a monument to

182 Shem Drowne (attrib.). Indian, weathervane. Mid-18th century. Hammered copper. Massachusetts Historical Society, Boston

183 Shem Drowne (attrib.). Grasshopper, weathervane. 1742. Copper. Faneuil Hall, Boston

honor the recently deceased Royal Governor of Virginia, Norborne Berkeley, Baron de Botetourt, from another leading English sculptor, Richard Hayward; and two years later it was put up in the plaza of the Capitol at Williamsburg. All four figures were in the fashionable English High Baroque, rather grandiose in conception, dramatic in action, and plastically full-bodied. They might have set a standard in the colonies for sculptural elegance and urban grandeur, but within a very short time, caught in the crossfires of the Revolution, all four were vandalized or destroyed. On July 9, 1776, the *George III* was pulled down by a mob fired by the reading of the new Declaration of Independence, and some of the lead was melted into bullets for the Revolutionary Army. The base and part of the horse's tail are now in The New-York Historical Society; other fragments, found in Wil-

ton, Conn., in recent years, belong to scattered collections. In November of the same year the *Pitt* in New York was decapitated and mutilated in retaliation by British troops and subsequently demolished. The Charleston *Pitt* (plate 184) was hit by a British cannonball and badly damaged in a later accident but is now restored and set up in Washington Park. The *Botetourt,* pulled from its pedestal and vandalized by a band of patriots, has also been restored and now adorns the campus of the College of William and Mary. Thus the first phase of European influence on American sculpture was aborted. When American sculpture finally emerged as an art form, it did so out of the native artisan tradition of woodcarving and a second wave of European influence after the Revolution, when a series of professional, even famous, European sculptors came to the new country.

184 Joseph Wilton. *William Pitt*. 1770. Marble, life size. Washington Park, Charleston, S.C.

PART TWO

THE EARLY REPUBLIC

When the American nation was forged in the heat of the War of Independence, the American character was transformed and its culture was given a new direction. Americans as a people were changed from independent, cantankerous, and self-seeking colonists, who opposed not only taxation without representation but also taxation in general, into patriotic, socially minded, even visionary citizens, who might still be against taxes but paid them because they were now Americans. This hyperbole does not mean that they had been transmogrified into paragons of virtue, but that Americans had now accepted their new role with a self-conscious sense of destiny which made historical necessity, moral righteousness, and patriotic fervor almost synonymous. They had postulated a society based on liberty and equality (the cancer of slavery was not large enough then to arouse anxiety in any but a few). This political euphoria was bolstered by a period of economic growth, increased immigration fostered by European political unrest, and westward expansion. The Louisiana Purchase by Jefferson in 1803, which seemed pointless and visionary to some, underlined the growing concept of "manifest destiny." The individual merchant, artisan, or farmer might not see beyond his own self-interest, but America's political leaders, thinkers, and artists took a broader and longer view into the future. What they saw were endless vistas and only the best of auguries. America could and would do it all, being blessed by nature and circumstances with a fecund and virgin new world, waiting to be exploited, and a new society based on reason, justice, and natural law. It did not then seem even remotely possible that nature's gifts might be despoiled or man's ideals betrayed.

Everything had become "American" and thus was related to the total of what America meant. Architects were no longer satisfied with just building structures to serve some utilitarian purpose; what they built had to stand for something, express something American. Painters were no longer satisfied with simply painting likenesses of people; painting must now glorify the nation and its heroes, inform and educate the public, underline the greatness and promise of America. Sculpture, which had hardly existed before, could immortalize America's heroes in imperishable bronze and stone. America would outdo the past—the Renaissance, which because of its

Popish taint was of lesser concern, and, more important, the Romans and the Greeks.

But why were Greece and Rome ideals for a Protestant-dominated nation that had so recently been as opposed to paganism as to the Pope? The intellectual history of the eighteenth century, culminating in the Age of Reason, had undermined the earlier religious parochialism and intolerance that had dominated European culture for centuries. In the search for reason, the Greek philosophers supplanted the Church Fathers. In the search for an equitable society, the concept of representative government challenged the divine right of kings, with the city-states of Greece and the Republic of Rome as models. The Age of Reason even developed a new approach to religion for those who needed it—deism, a rational faith. All this came rather easily, because Protestantism itself had already fought the battle of reason over faith. The middle class, in fact all the lower classes, had no vested interest in the divine right of kings; on the contrary, they were rather militant about its removal. It has been validly suggested that this whole development was really an expression of the growing strength and dynamic momentum of the middle class in its rise to power. Certainly middle-class economic, social, political, moral, and even cultural positions were being furthered. Thomas Jefferson and other men of that day were conscious of the parallelism between their time and Classical antiquity and used it as both a weapon and a defense in their struggle for power. They saw the Classical past not only as an abstract ideal but also as a reservoir of usable ideas.

Also, the rediscovery of Herculaneum and Pompeii during the middle of the century had initiated a fashion for the antique. The ideological formulations of Winckelmann and Mengs and the paintings of West, Hamilton, and then David had sparked a Classical Revival that swept over Europe to replace the aristocratic frivolity of the Rococo with an art which was serious and moral. This tendency was a part of the growing social and political change spearheaded by the emerging middle class; although it had less serious aspects and was treated as a fad in some circles, it was motivated by serious intentions and influenced attitudes and taste in all areas, including those of the aristocracy. The Classical Revival influenced all the arts both in iconography and in style.

CHAPTER SIX

Neoclassic Architecture

In nineteenth-century architecture Neoclassicism was the first of a sequence of revival styles. It has therefore been characterized as part of the Romantic Movement (see Chapter 11) and, along with other revivalist tendencies, as a mistaken effort to find solutions for contemporary problems in the past. Neoclassicism certainly reached into the past, and it opened the sluice gates for the subsequent flood of historical memories which seem at times to have inundated the nineteenth century. But Romanticism and revivalism are not entirely escapist or negative. They are historical responses to specific historical conditions. The late eighteenth century and part of the nineteenth faced an entirely new technological and economic world. The revolutions of the period were expressions of political and economic readjustments, and it is too little understood that the art and architecture of the period were also in search of solutions.

At that time history-mindedness was synonymous with progressivism. There was no fear of searching in the past. In fact, there was a sense of excitement about what one might discover. The past offered material, experience, and ideas that creative artists could and did employ with freedom, originality, and inventiveness. For the Neoclassicist the Classic world made rational sense; for the Romantic the medieval world made mystical sense. Behind the apparent chaos of revival styles lie solutions to the new problems of a new age. The revivalists, after all, built the first modern hospitals, prisons, factories, bridges, canals, banks, hotels, office buildings, schools, railroad stations, and government buildings. They were the first to use new materials—iron, concrete, glass—in modern ways. They worried about spatial organization, adequate sanitary facilities, circulation, and fireproofing. The buildings they designed do not look like twentieth-century International Style architecture, but that should not blind us to the fact that they were often successful attempts to solve basic problems of site, function, materials, and cost.

The war and unsettled conditions under the confederation of states inhibited building for more than a decade, and this hiatus helped produce a clean break between pre- and post-Revolutionary architecture. To designate the latter as "Late Georgian," as has been done, can be misleading. For the English, who still had a king named George, the designation of the Neoclassic or Adam style as "Late Georgian" reflects a reverence for historical neatness. In America, such a term for an art that was now an expression of a new nation which had won its independence from England, and which saw George III as a symbol of colonial subservience, is ironic. Aside from ideological reasons, the Neoclassic, the Adamesque, the Federal, whatever it is called, is not a continuation of the Georgian, since its fundamental aesthetic considerations are at complete variance with those of the Baroque. However, some phases of the Neoclassic style in America still seem closer to the Georgian. Many builders and carpenters, in spite of the war gap, had been trained in the earlier tradition and had difficulty in assimilating the latest fashion, and the new handbooks were often conservative, even resistant to the new style. Given this lag, America achieved the Neoclassic soon enough. More important, there were two wings to the Neoclassic style in America, as in Europe—a conservative and a radical: one which tried to revise what had gone before, and one which tried to make a clean break with the immediate past.

The physical memories of our British past could not be removed, but to a man like Jefferson, Georgian architecture was a particular reminder of monarchy and colonialism. He wanted something modern, which would express a new and independent political and social entity, and eventually he got it. For others, however, such as the merchants in the larger port cities and the southern planters, whose economic ties with England had not been broken, only loosened, England and Georgian architecture carried no stigma, and they continued to look toward England for cultural and artistic leadership. In New England especially there was a pronounced dependence on English architecture, but that itself had changed: England was in the midst of a Classical Revival, its taste dominated by the brothers Robert and James Adam in architecture, by Josiah Wedgwood in decoration, and

by Thomas Sheraton and George Hepplewhite in furniture. America received the new style through architectural handbooks by the Adams, William Paine, and James Pain, and eventually via the first American imitations by Asher Benjamin (1773–1845) in *The Country Builder's Assistant* (1797) and *The American Builder's Companion; or, A New System of Architecture* (1806). Benjamin's seven handbooks eventually spanned the period from the Adamesque through the Greek Revival, but the earlier ones were staunchly Adamesque.

Those who looked for a specifically American architecture went back directly to Classical sources for their inspiration: first to Palladio again, but not seen through the prism of the Baroque; then to the Roman; and finally to the Greek. This radical aspect of Neoclassicism, called Monumental Classicism (or Romantic Classicism), was fundamentally a public architecture with domestic by-products, whereas the more conservative Adamesque was a domestic architecture which produced a limited number of public buildings. The former flourished largely in Washington, D.C., and Philadelphia; the latter in New England and the South.

Extremely important to the development of the Monumental style was the influx of thoroughly professional architects. Opportunity drew these men to America, as it had the first professional painters in the early eighteenth century, with the same effect of transforming the character and raising the level of practice. Pierre-Charles L'Enfant, the French engineering officer who served under Washington during the war, remained to initiate the Monumental style and lay the foundations for rational city planning. James Hoban, Irish, arrived about 1785; Stephen (Étienne Sulpice) Hallet, French, between 1786 and 1788; Joseph Mangin, French, in 1794; George Hadfield, an English Royal Academy prizewinner, in 1795; Benjamin H. Latrobe, English, in 1796; Maximilien Godefroy, French, in 1805; and Jacques-Joseph Ramée, also French, in 1811. Although Thomas Jefferson inspired much of the Monumental style, its character, development, and generally high level of excellence in design and execution were due to these foreign architects. The variety and originality of public buildings in the Monumental style contrast with the general lack of inventiveness of Adamesque domestic architecture, which can be traced to amateur practice and the continued use of architectural books. Even Bulfinch, by all odds the finest of the Adamesque architects, was not professionally trained, and his efforts to translate his domestic style into public building were not wholly successful. It is more than coincidence that the Adamesque practitioners were all American and local products, while all the Monumental architects, except for Dr. William Thornton, an amateur, and the first American-trained professionals, Robert Mills and William Strickland, were immigrants. However, the Classical Revival in its Monumental aspect was not a foreign or imported architec-

ture; it was, in fact, the first truly American style, inspired by the practical needs of a growing country and carried out by youthful talents who, although European-trained, had not been frozen into the set forms of an older culture.

THE ADAMESQUE

The Adam style, out of which the conservative phase of Neoclassicism in America grew, was a rather particular translation of late-Roman art popularized by the rediscovery of Pompeii and Herculaneum. Robert Adam adapted the Augustan so-called "Third Style" of wall decoration (itself a Roman Neoclassicism, an "Empire" rather than "Republican" style), with its small-scale decorative motifs arranged in delicately elegant patterns, to architecture as well as to interior decoration. His style was thus not based on Roman architecture but on Roman painting; it was a free adaptation of an artistic idea borrowed from antiquity. He continued to use basic Georgian architectural elements but transformed them into something quite different. Plasticity gave way to flatness, boldness to delicacy, opulence to spareness, the heavy to the slender or even fragilely attenuated. The resulting style, unlike the rich-textured Baroque, has a clean-cut, sharp-edged purity. If one compares two sets of London buildings, the High Georgian of Cavendish Square (plate 185) and the Adam manner of Bedford Square (plate 186), the similarity of facade compositions is striking, but the appearance is totally different. The Adamesque facade is screenlike in its flatness, with the pilasters seemingly incised on the surface. The plastic elements of Baroque design—columns, pediment, cornices, and window framing—are expunged, and the result looks more like an architectural drawing than a three-dimensional structure, plaster rather than stone. The windows seem to have been punched through the screen of the wall and their proportions subtly elongated, like all the other decorative elements. Instead of a facade full of sensuous movement, plasticity, texture, and light and shade, we have a flat surface on which all the elements are delineated with clarity, precision, and a sensitive elegance. The Adamesque building is the expression of a new age, whose image of the Classical past, as well as of itself, is in terms of Winckelmann—pure, rational, and ideal.

The first handbooks that brought the Neoclassicism of Adam to America treated it as a vocabulary supplementing the older Georgian forms, rather than as a totally new style. It was accepted rather grudgingly at first, especially in conservative rural areas, where the Georgian died hard, but before the turn of the century the basic Adamesque house form was established (plate 188). The pavilion capped by a pediment disappeared, as did columnar porches, leaving only a modest but delicately

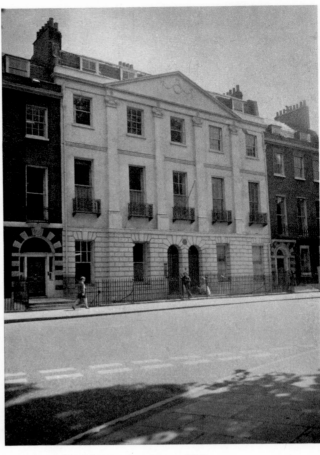

185 Cavendish Square, London. c. 1770
186 Bedford Square, London. c. 1775

proportioned entrance porch. Elaborate window frames gave way to flat-patterned accents at sill and head. Windows were larger and taller in proportion, with larger panes and thinner frames. With no other focus of decoration on the facade, the doorway became more elaborate in design, with fanlight and sidelights subdivided by intricate patterns of wire-thin struts (plate 204). The elliptical fanlight was now preferred to the semicircular, and a passion for spidery lightness eventually forced the use of metal rather than wood. The attic story and its dormer windows, which were considered non-Classical, were replaced by a third story, changing the appearance of the house so that it now resembled a simple cube. This look was reinforced by reducing the roof pitch to a minimum and transferring the balustrade from the deck to the cornice line, thus making the roof shape invisible from ground level.

Adamesque builders continued to use red brick and white trim, as did their Georgian predecessors, though in New England the preference for wood still persisted. Adamesque houses exhibited a greater freedom in planning and a decided advance in utility. The splendor of the

reception hall was abandoned for something simpler and more functional, and the introduction of additional stairways improved circulation. Rooms were given more specialized functions and more variety in shape. For the first time circular, elliptical, and octagonal rooms broke through the tyranny of the rectangle. Rooms now even had elliptical or semicircular vaults, and occasionally a dome.

Many Adamesque buildings are the work of carpenters rather than architects, so that their finest expression is in detail—especially the interior decoration—rather than in planning or composition. The aggressive energy of the Georgian interior gives way to a serene simplicity. Walls are swept clean of paneling, ornamentation, and scenic wallpapers and, instead, are smoothly plastered and painted in pastel colors or papered in small, discreet patterns. White becomes increasingly popular and is now used almost exclusively on woodwork. Moldings, door frames, and fireplaces are covered with a profusion of ornament, but an ornament of tiny elements kept strictly within the larger forms and seen only as surface sparkle of light and shade, all in extremely low relief.

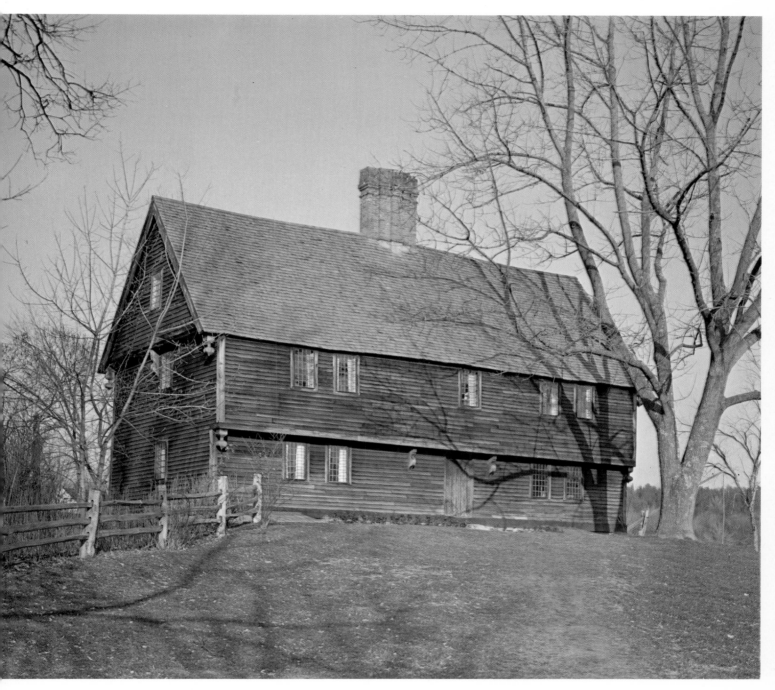

1 Parson Capen House, Topsfield, Mass. 1683

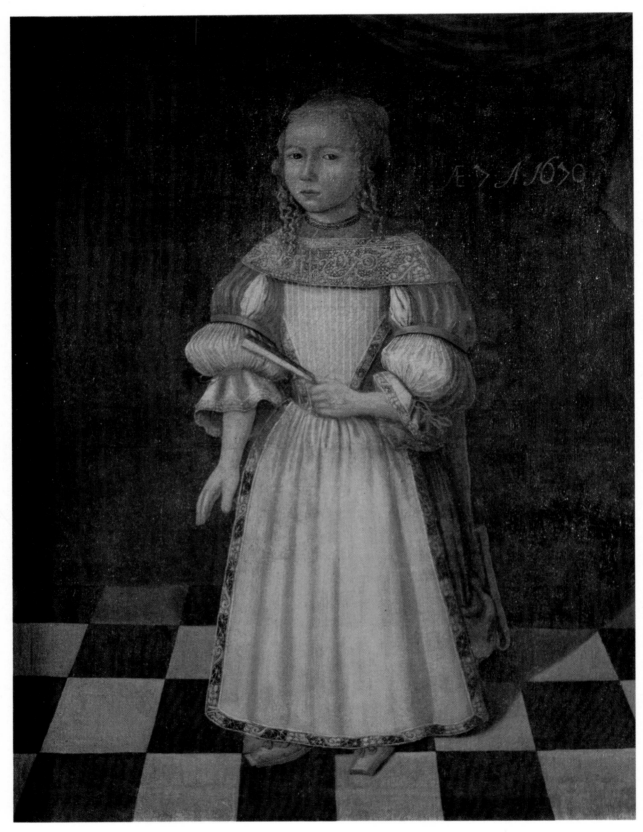

2 Anonymous. *Margaret Gibbs*. 1670. Oil on canvas, 40½ × 33″. Collection Mrs. Elsie Q. Giltinan, Charleston, W. Va.

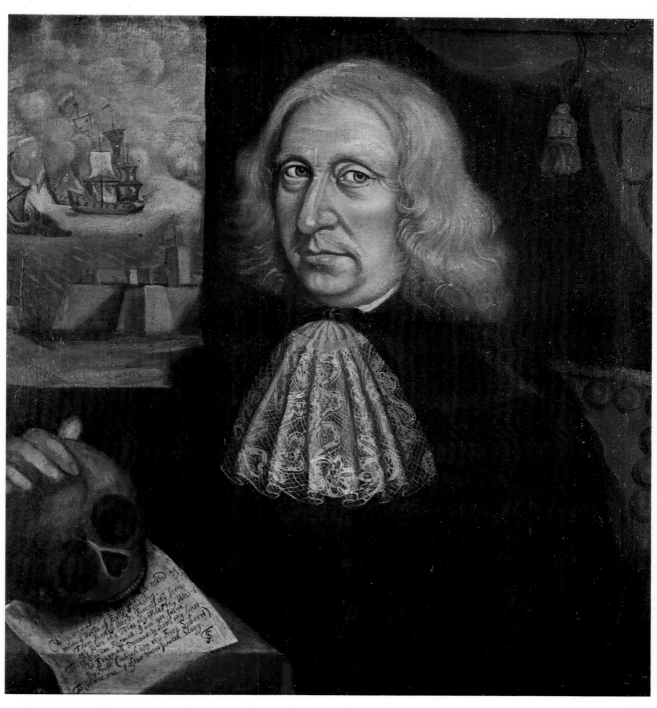

3 Thomas Smith. *Self-Portrait*. c. 1690. Oil on canvas, 24½ × 23¾″. Worcester Art Museum

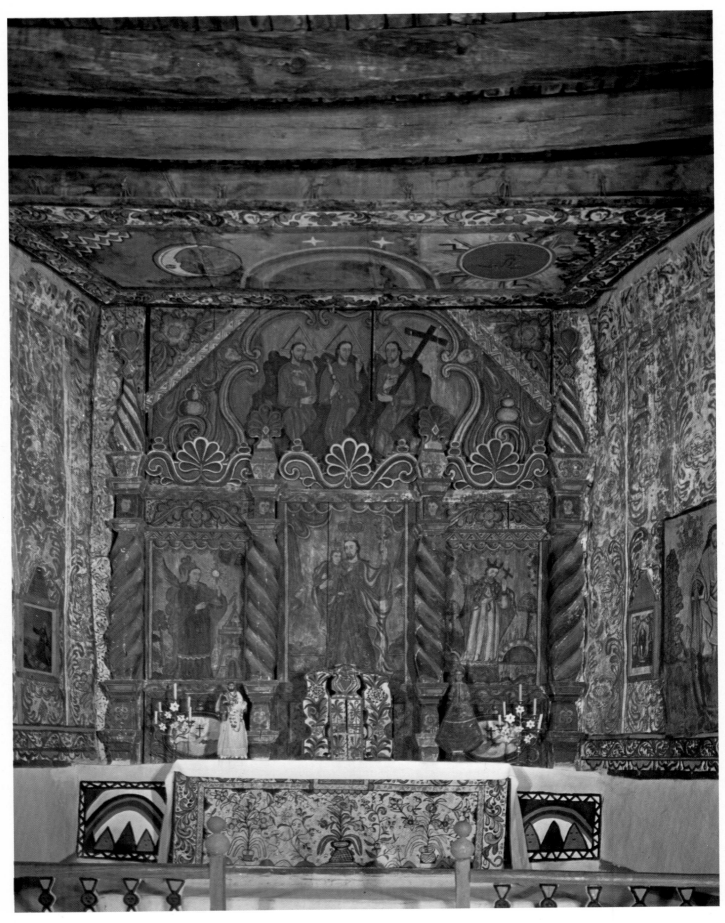

4 Sanctuary and altar, San José, Laguna, N.M. 1699–1706

5 Andrew Hamilton. Rear facade, Independence Hall, Philadelphia. Begun 1731

6 Peter Harrison. Interior, Jeshuat Israel (Touro Synagogue), Newport, R.I. 1759–63

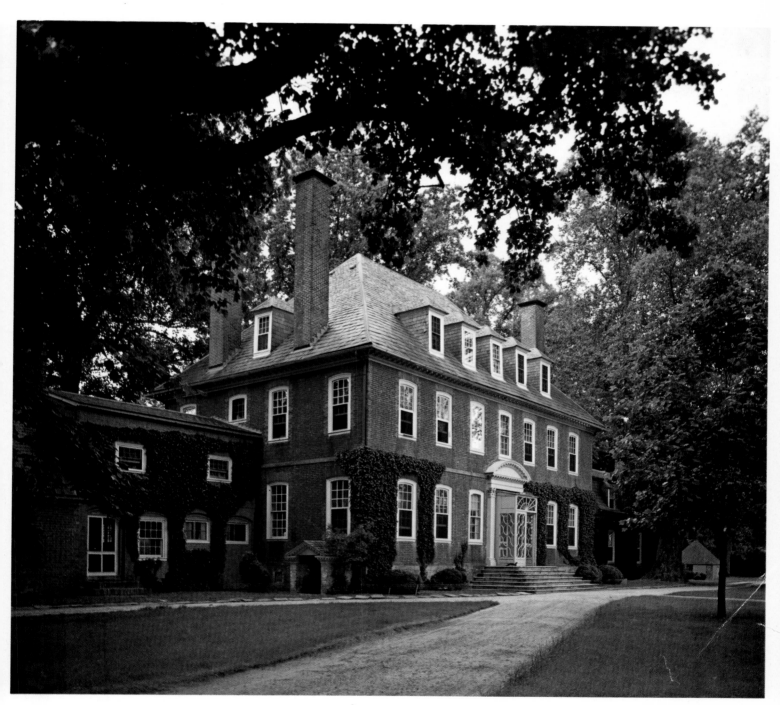

7 Richard Taliaferro (attrib.). Westover, Charles City County, Va. c. 1730–34

8 San José y San Miguel de Aguayo, San Antonio, Tex. 1723–31 (restored 1933)

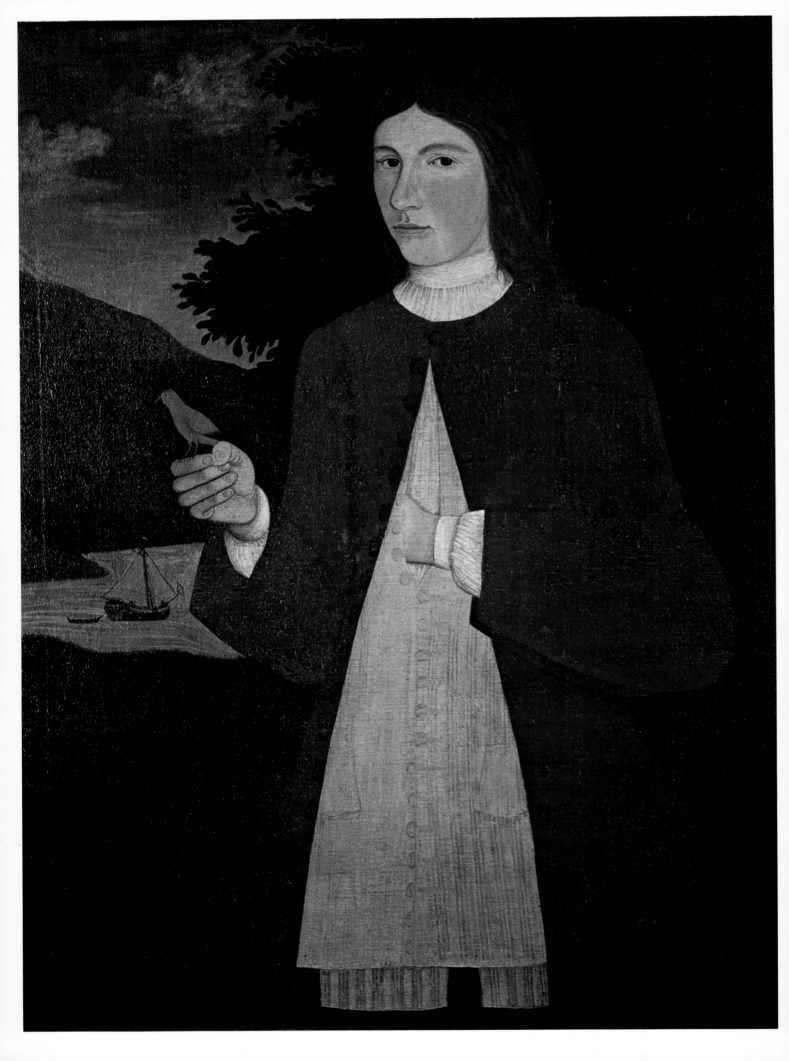

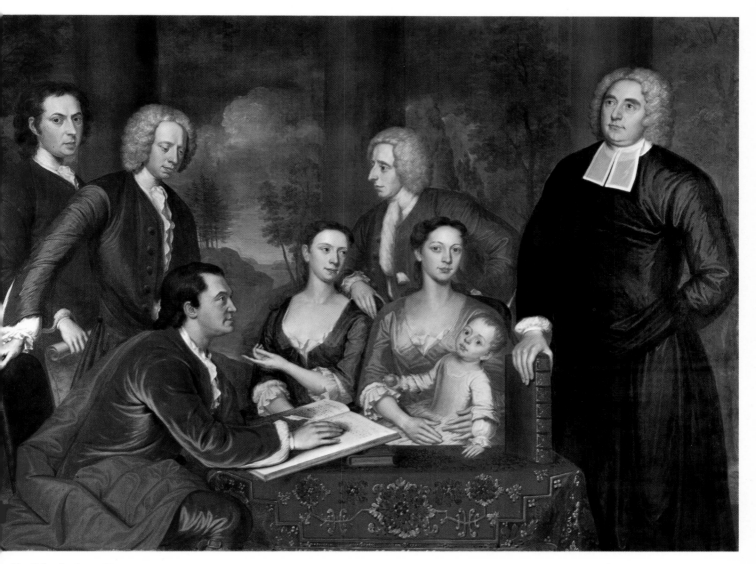

10 John Smibert. *The Bermuda Group: Dean George Berkeley and His Entourage.* 1729. Oil on canvas, 69½ × 93″. Yale University Art Gallery, New Haven. Gift of Isaac Lothrop

9 Left: Anonymous (Gansevoort Limner). *Pau de Wandelaer.* c. 1730. Oil on canvas, 45 × 35⅜″. Albany Institute of History and Art

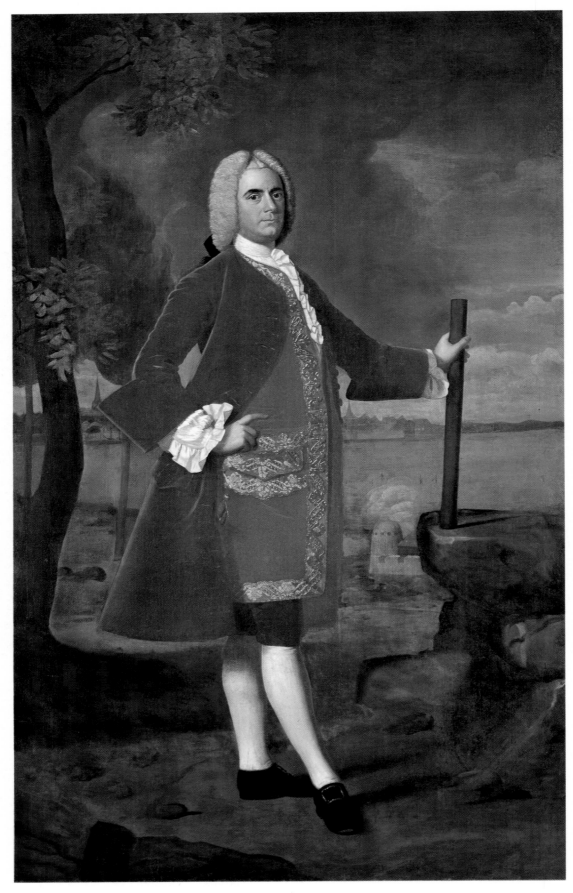

11　Robert Feke. *General Samuel Waldo*. 1748. Oil on canvas, 96¾ × 60¼″. Bowdoin College, Brunswick, Me.

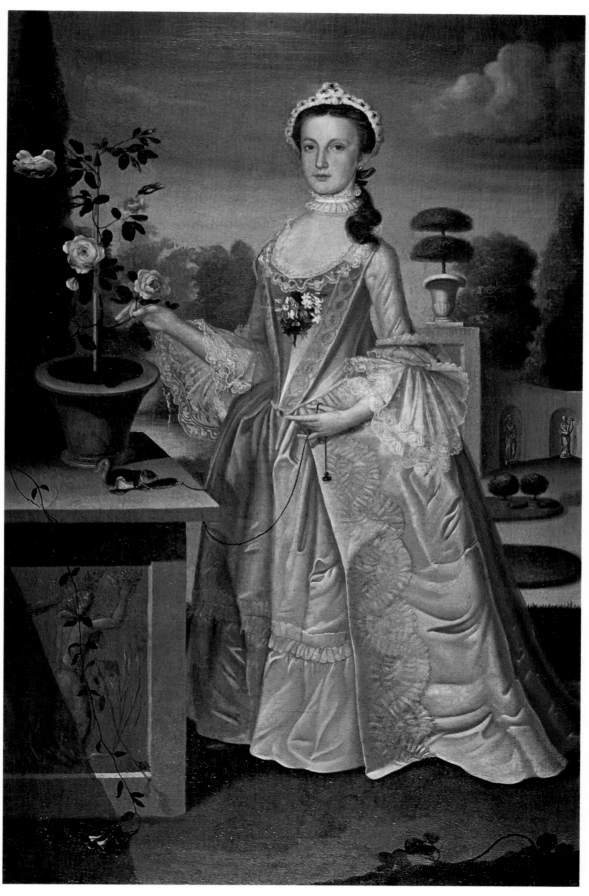

12 William Williams. *Deborah Hall*. 1766. Oil on canvas, 71¼ × 46½″. The Brooklyn Museum

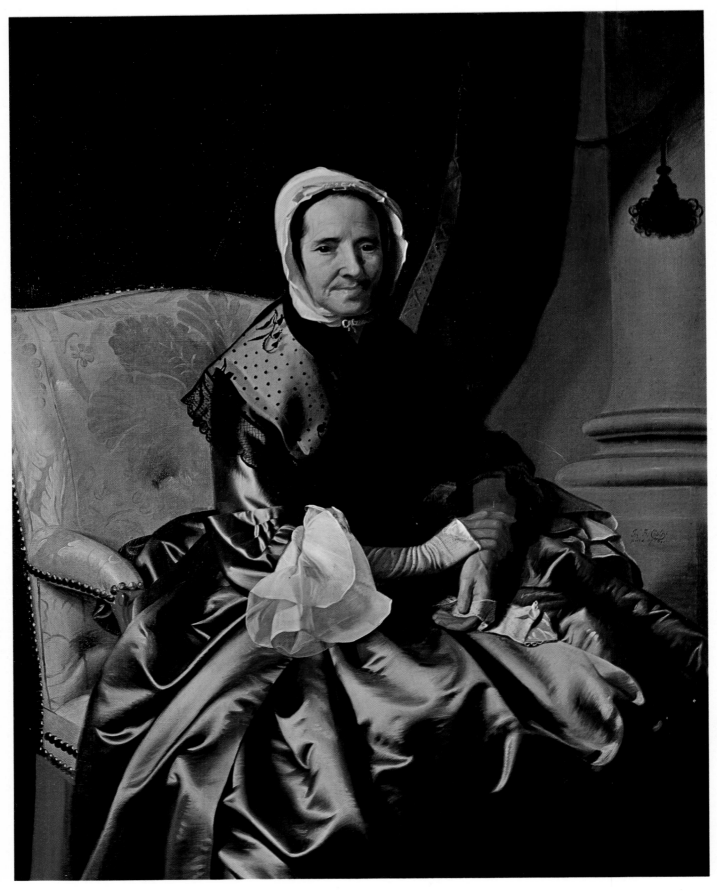

13 John Singleton Copley. *Mrs. Thomas Boylston*. 1766. Oil on canvas, 50⅝ × 40¼″. Harvard University, Cambridge, Mass.

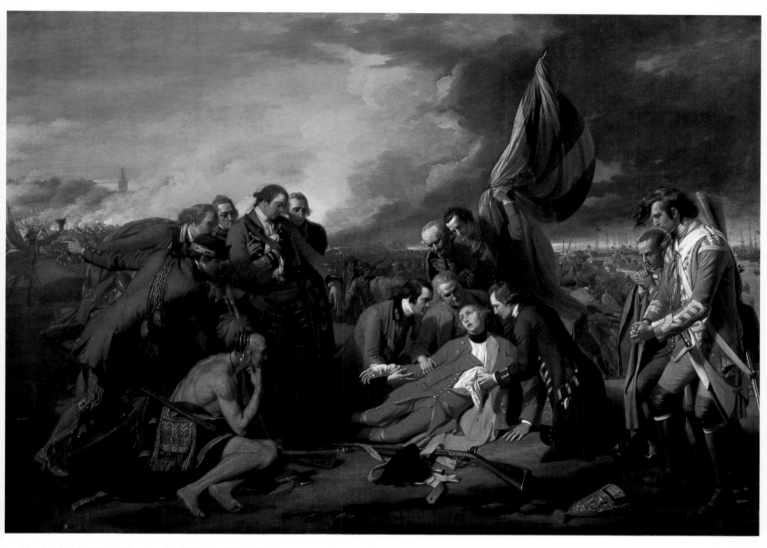

14 Benjamin West. *The Death of Wolfe*. 1770. Oil on canvas, 59½ × 84″. The National Gallery of
Canada, Ottawa

15 Shem Drowne (attrib.). *The Little Admiral.* 1750–70. Painted wood, height 42″. The Bostonian So-
ciety, Old State House, Boston

The ornamental vocabulary changes to impossibly elongated colonnettes and pilasters; miniature triglyphs and dentils; reedings, flutings, and beadings; decorated and fluted ovals and paterae with Classical motifs—urns, garlands, swags, palmettes, and rosettes. Classical bulls' heads and torches mingle with American eagles and sheaves of wheat. The intricacy of the carving eventually led to the use of prefabricated decorations pressed in composition material, a development which began with the Adam brothers and Wedgwood, who used the technological advances of the Industrial Revolution to mass-produce ornamental details and objets d'art as well as ceramics for daily use, the first experiment in the production of "well-designed" objects at reasonable prices to satisfy the growing appetite for luxury of the middle class. Composition products were soon being manufactured in America, and a builder could order moldings by the yard and plaques by the dozen, to be used sometimes indiscriminately and overprofusely. But, on the whole, Adam-style interiors kept their air of delicate and refined simplicity.

McINTIRE AND BULFINCH

The leading exponents of the Adam style, Samuel McIntire and Charles Bulfinch, were both New Englanders. They represent in their separate ways the culmination and demise of the colonial "amateur" tradition in architecture. McIntire, artisan and builder, became an architect through dedication to craftsmanship; Bulfinch, gentleman son of a doctor, became an architect through preference and a good one through perseverance. Samuel McIntire (1757–1811) came from a family of Salem woodcarvers and carpenters and spent all his life in that city and within the framework of his craft and the family shop. His submission of a design for the Capitol competition is a reflection of the vistas the Revolution opened to the common man, and the addition of the word "architect" to his gravestone indicates his achievement as well as his aspiration. Despite his impeccable craftsmanship and native sense of taste and proportion, however, McIntire remained more the artisan and builder than the architect, for he was dependent on handbooks and on the work of others. Yet whatever he touched shows invention and refinement, and some of his interiors and carved details are among the loveliest products of the Adam style. His mark is still to be seen in the quiet, tree-lined streets of old Salem (plates 187, 188) in the houses built for the Derbys, the Peirces, and the Crowninshields during the great days of shipbuilding and sailing after the Revolution. Not all are by McIntire, but they might well have been, and these clusters of sedately elegant cubes in wood and brick are among the few remnants of our architectural heritage.

The earliest McIntire effort in the Adam style, perhaps the earliest in the country, is the Peirce-Nichols House

187 Chestnut Street, Salem, Mass.

(1782, plate 189). Although it is tentative and clumsy in the handling of the new elements, the basic cubical form is clearly stated. The facade is plain, the dormer story has been eliminated, and the roof is hidden by the balustrade. Decorative features of the Georgian still intrude—the heavy corner pilasters, the projecting cornice, the plastic window frames—but the refined carving of the small Classical porch and doorway, the picket fence, and the decorative urns on the gate posts are early evidence of McIntire's style and skill. The Elias Hasket Derby House (1795, plate 190) is usually attributed to McIntire, although designs by others, including Bulfinch, exist. Derby may well have utilized them all in building his mansion, "more like a palace than the dwelling of an American merchant" and probably the grandest new home in all the States. The drawings for this house, which was demolished in 1815, reveal a building like neither McIntire's nor Bulfinch's style. There is something decidedly French about it, very like late Louis XVI architecture, in which the airy grace of the late Rococo is stiffened by a bit of Classical starch. Its only stylistic equivalent in America is New York City Hall (plate 209).

The Ezekiel Hersey Derby House (1799), said to have been done by McIntire after a design by Bulfinch, shows full acceptance of the Adam style and is one of the most elegant and original examples (plate 191). The inspiration is now fully English and Adamesque, and very similar in feeling and detail to the coupled facade of a pair of houses on Finsbury Square, London (c. 1780, plate 192). The sensitivity of scale and proportion, the refinement of detail, and the spacing of elements on the smoothly plastered facade create an architectural bijou unique among American examples of the Adam style. Recessing of windows in arched framing on the ground floor is a device often used by Bulfinch, but the asymmetrical placing of the entrance is a provincialism one might not expect of him, though perhaps of McIntire. However, given a quadripartite division of the facade, there is no solution to the problem.

188 Samuel McIntire. Pingree House, Salem, Mass. 1804. Owned by Essex Institute, Salem

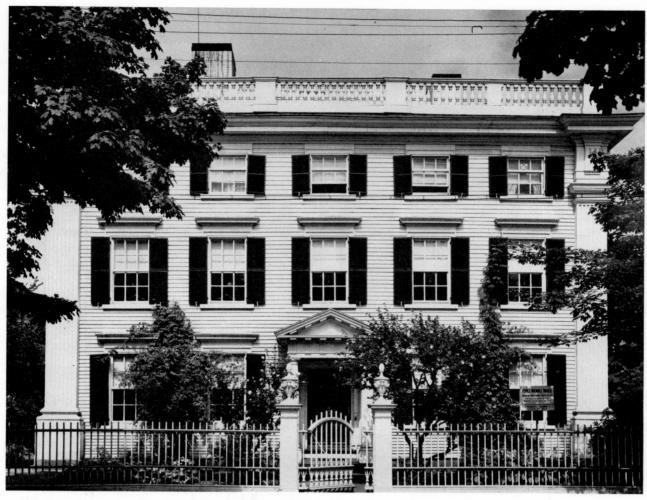

189 Samuel McIntire. Peirce-Nichols House, Salem, Mass. 1782

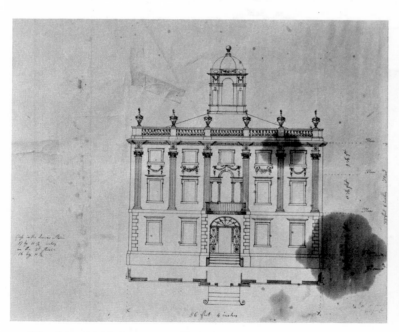

190 Samuel McIntire. Design for front elevation, Elias
Hasket Derby House, Salem, Mass. Built 1795

191 Samuel McIntire. Design for main facade,
Ezekiel Hersey Derby House, Salem, Mass.
Built 1799

192 Houses in Finsbury Square, London. c. 1780

McIntire made few efforts at public building. The Assembly House in Salem, originally built in 1782, was remodeled by McIntire about 1796 and is simply an enlarged house. The surprisingly monumental competition design for the Capitol (1792, plate 193) becomes more impressive if one forgets the charmingly naive but out-of-scale statuary, and the basic logic and competence of the plan almost force us to reevaluate McIntire's creative ability.

Charles Bulfinch (1763–1844) was a man of totally different stripe—urbane, sophisticated, and knowledgeable. His choice of the Adamesque over Monumental Classicism was due as much to conservatism of character as to taste. Reverence for tradition, particularly English tradition, kept him from radical innovation, but his fastidious taste created Adamesque prototypes that dominated New England architectural expression for more than a generation, through his own work and by its propagation in the handbooks of Asher Benjamin. Even the American passion for progress has failed to destroy entirely the character of Boston's Beacon Hill, where Bulfinch and his imitators created a bit of London across the sea.

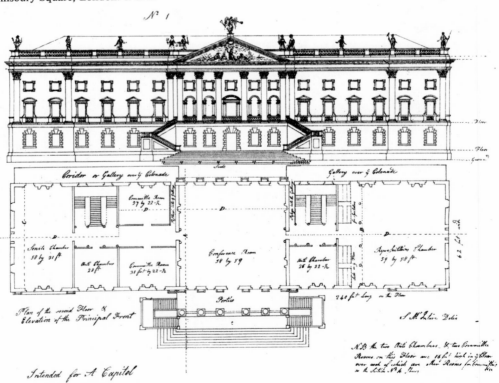

193 Samuel McIntire. Drawing No. 1 for U. S. Capitol design competition. 1792. Maryland Historical Society, Baltimore

194 Charles Bulfinch. First Harrison Gray Otis House, Boston. 1795–96

Bulfinch transformed the Georgian town house in Adamesque terms. The first Harrison Gray Otis House (1795–96, plate 194) had already established the canon— a clean-cut cube of red brick (he seems to have preferred wood for rural houses) with a sharp cornice; immaculate walls with large, slender windows beautifully spaced; horizontal white-stone bands marking the story divisions; and an exquisitely rendered hemispherical porch with elongated columns and pilasters in the Corinthian mode. The reiterative axial accent of entrance porch, Palladian window, and lunette is a reminder of the Georgian emphasis on the center; it may be ascribable to the early date of this particular house, but the fact is that Bulfinch retained an old-fashioned preference for the Palladian window and what seems a consciously anachronistic insistence on the semicircular rather than the elliptical form in lunettes and fanlights. This latter, along with a window recessed in an arch, is almost a signature of the personal Bulfinch manner. Among his beautiful Adamesque houses are two more for Otis in Boston, one on Mount Vernon Street (1800–02) and the other on Beacon Street (1805–08); the Headmaster's House (1811) at Phillips Academy in Andover, Mass., a fine example in wood, attributed to him; and the Larkin House (1817, plate 195) in Portsmouth, N.H., which, though undocumented, is sometimes attributed to him on stylistic grounds. This

195 Charles Bulfinch. Larkin House, Portsmouth, N.H. 1817

last is in many ways a unique variation on the basic Adamesque theme. The reduction of the normal five-bay composition to three emphasizes the walls and the cubical mass within which the fenestration is subordinate, but the window treatment achieves an equilibrium between solid and void with remarkable subtlety. It is the old Palladian window recessed in an arch on which Bulfinch has rung a series of changes, so that the attribution to him seems apt.

Bulfinch's rich and varied production in public architecture, while not always entirely successful, is almost always interesting. His work in semipublic building—the housing development as speculative building—was the first experiment of its kind in this country, and Bulfinch was both architect and entrepreneur. Franklin Place, or the Tontine Crescent (plates 196, 197), erected in Boston in 1793, consisted of sixteen attached single houses in a row, designed as a unit but purchasable singly. The Industrial Revolution had brought with it immense increases in city population, producing urban problems that are still much with us, and among which housing was and still is primary. The major cities of Europe were overcrowded even before the Industrial Revolution, and enclaves for the upper class were planned early in the seventeenth century, as, for instance, Henry IV's Place des Vosges in Paris; and Inigo Jones had designed Covent Garden and Lincoln's Inn Fields. Such developments subsequently became common in large English cities and proliferated into public squares, circuses, and crescents (plates 185, 186). Bulfinch had seen such complexes in London and Bath and probably had been impressed by the Adams's Portland Place and especially by Adelphi Terrace. His Franklin Place is an imitation of such models, with the row of houses ar-

196 Franklin Place, Boston. The Metropolitan Museum of Art, New York. Codman Collection

ranged in a shallow arc facing a gardened park plot which screens it from the public street. It was a solution eagerly accepted, and it spawned the ubiquitous row houses of American cities, which unfortunately exploited only the economic advantages to the builder and sloughed off the amenities. Bulfinch handled the crescent simply but boldly, with the Neoclassic forms confined to the pedimented central pavilion, which housed the Boston

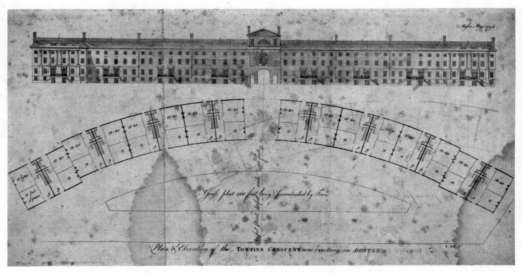

197 Charles Bulfinch. The Tontine Crescent (Franklin Place), Boston. From *Massachusetts Magazine*, Vol. 6, February, 1794

Public Library, and the terminal wings. It is regrettable that the Crescent no longer exists, and even more so that the monumental conception of the unit was ignored even by Bulfinch in his later projects, such as the Park Street development, and by others, who built repetitive strings of houses on deadly grid streets. However, in the process some fine Adamesque buildings were designed for Beacon Hill and Louisburg Square in Boston, Washington Square in New York, and Rittenhouse Square in Philadelphia.

Bulfinch was the dominant personality in New England architecture and naturally received many major government commissions, but his strength was not in monumentality. The Old State House in Hartford, Conn. (1793–96), is graceful but not very impressive; and his most ambitious building, Boston's State House (1795–98, plate 198), similar in arcading and columnar loggia, may be more impressive but is not much more successful. This gold-domed landmark so revered by Bostonians reveals his limitations as a designer. It is probably based on contemporary English examples such as Sir William Chambers's Somerset House. There is no denying the logic, sophistication, and elegance in Bulfinch's handling of the central arcade surmounted by columns, the reasoned interrelationship of elements, the variation in spacing of the arches to support the paired columns at the ends, the echo of the portico columns in the pilasters framing the windows, the refinement of all the proportions and details, and the play of the voids in the center against the clean mass of the red-brick wings. But the exquisite composition of the lower part is vitiated by an inexplicable pedimented section above, capped by an even less defensible dome on a drum and topped by a cupola. The sides of the pedimented section are clumsily abutted by the hip roofs of the wings, the dome does not have enough room on the gable, and the fussy cupola is an inadequate afterthought. The whole layer-cake topping is not only inconsistent with the lower portion but also destroys its scale. Inside, the chamber of the House of Representatives, with its circle of monumental columns supporting a dome on pendentives, is one of the most imposing interiors of the period, beautifully proportioned but, again, somewhat diminished by the niggling Adamesque ornamentation.

In some ways a more impressive achievement is the Massachusetts General Hospital, Boston (1818–23, plate 199). This gray granite structure, almost a throwback to the Georgian, is bolder and simpler in conception and plainer in construction. The spareness of surface

198 Charles Bulfinch. State House, Boston. 1795–98

199 Charles Bulfinch. Massachusetts General Hospital, Boston. 1818–23

and the geometry in the composition of parts are closer to the Monumental style and may be an unconscious reflection of Bulfinch's visit to Washington in 1817. He was most successful where his conservative virtues of restraint, sophistication, and taste were unhampered by considerations of grandeur. The First Church of Christ (1816–17, plate 200), Lancaster, Mass., and the Administration Building, now called Bulfinch Hall (1818–19, plate 201), at Phillips Academy, Andover, Mass., are among his finest buildings. In both, a Georgian type is transformed by Neoclassic taste. Bulfinch Hall, with its red-brick rectangular form, pedimented central accent, and cupola, is like a Georgian public building which has been immersed in a stylistic acid that has wiped away all the surface ornament. The insistence on the immaculate wall and the pristine cube becomes its dominant feature and Bulfinch's most original stylistic trait. The round-headed windows in unaccented repetition are self-effacing, so that the building resembles an anonymous mill or factory, except for its restrained elegance and correctness in proportion, composition, and detail.

Very similar in conception is his masterpiece, the First Church of Christ. A superb delicacy of detail is here combined with bold simplicity of form, arresting in its immediate impact and infinitely rewarding of continued study. The restraint of the whole unfolds rich recompense in the unique transformation of the Georgian porch into an arcaded loggia accented by stripped and "orderless"

200 Charles Bulfinch. Fifth Meeting House of the First Church of Christ, Lancaster, Mass. 1816–17

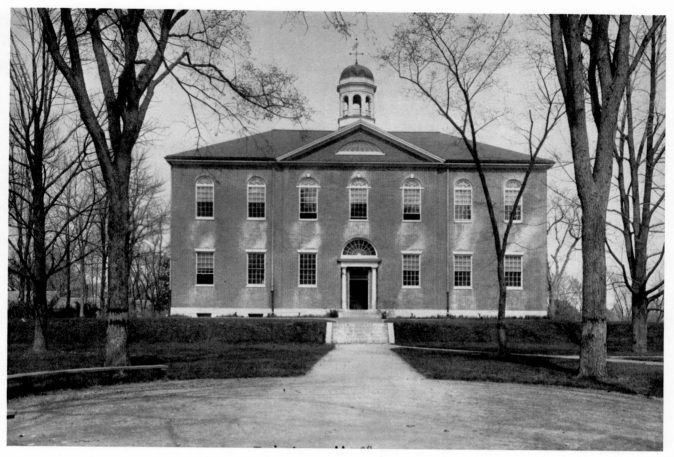

201 Charles Bulfinch. Bulfinch Hall, Phillips Academy, Andover, Mass. 1818–19

pilasters; in the bold, clear, geometric masses against which the elegance of the porch is set; in the fragile, almost ephemeral fan screen which manages to make the transition between the bare cubes; and in the exquisite cupola, like a piece of Wedgwood ware, absolutely impeccable in scale. The all-white interior is even more restrained and spare than the exterior, with the same clarity of conception, conservatism in procedure, and above all, the same taste in solution. The Lancaster church is one of America's loveliest architectural treasures and a monument to a refined aesthetic intelligence.

Unique in New England is the splendid Gore Place (1805–06) in Waltham, Mass., more like a southern plantation house than a New England country residence, with a large central section and extended arms ending in wings (plates 202, 203). Even its hip roofs and tall chimneys are reminiscent of the Georgian and the South, but in its stately sweep, clean surfaces, elegant proportions, and precise detailing it is totally Adamesque and very English. The front facade is fairly plain, but in the rear the rectangle of the central block is broken by a graceful bow created by the magnificent oval room that overlooks the broad lawn sweeping down to the river. The flat brick surface pierced by great windows and flanking French doors (plate 204) with elliptical fanlights creates a sense of serenity. In the extensions and wings the coupling of rectangular windows below and semicircular above, enframed in extremely reticent recessed arches, is an unusual and effective feature which contrasts with the bold simplicity of the central block. Although the house has been attributed to both McIntire and Bulfinch, the recessed arches, the predilection for the semicircular window, and the strong feeling for cubical form are all Bulfinchian features. The suggested attribution to a French architect, Jacques-Guillaume Legrand, seems possible only if one assumes that it was designed originally as a stone building; also, the interior, with its broadly simple walls decorated with small-scale patterns confined to narrow strips, is not French but English in character. Gore Place may be, like many other American buildings, a compendium of ideas, in this case fused into a masterpiece of the Adam style. Its graceful spiral staircase, with simple fragile bannisters and sweeping handrail, seems almost to float in air as it soars up the curved wall of the side hall, a gem of elegant simplicity (colorplate 16).

202 South facade, Gore Place, Waltham, Mass. 1805–06

203 Plan, Gore Place, Waltham, Mass. 1805–06. From Hamlin, *Greek Revival Architecture in America*, 1944, fig. 1, p. 11

204 Doorway on south facade, Gore Place, Waltham, Mass. 1805–06

SPREAD OF THE ADAMESQUE

Bulfinch's influence in New England was pervasive, especially in Boston, where most of Beacon Hill seems to have come from his hand. In fact, most of these handsome houses (plates 320, 321) were designed by such men as Asher Benjamin and Alexander Parris (1780–1852), and lesser-known architects, whose work was moving toward the Greek Revival (see Chapter 12). Outside Boston, Bulfinch's style was imitated directly or through the designs reproduced in handbooks by Asher Benjamin, who was conscious of the differences between England and America in terms of wealth, materials, and craftsmanship, and shrewdly tailored his works to American conditions.

Although the Adamesque never became a vernacular style, perhaps because too much in it depended on subtleties of scale, proportion, and detail that carpenters could not very well manage, it was still widespread, and local variations abound. In western Massachusetts, Issac Damon revealed his indoctrination in the Northampton Meeting House (1812). Providence, R.I., still has many Adamesque houses on the hill near Brown University, notably the Ives House (1806) and several by John Holden Greene. David Hoadley, who had worked under Bulfinch at Hartford, built the United Church in New Haven in 1813–15. In Vermont Lavius Fillmore, a local builder, did the General Samuel Strong House (1796) in Vergennes and probably also the charming First Congregational Church (1805, plate 205) in Bennington, copied from a plate in Benjamin. Portland, Me., was especially fortunate in having Alexander Parris working there for a time; he built a series of houses including the McLellan–Sweat House (1800), which is now part of the Portland Museum of Art. Wiscasset, Me., like many of the thriving coastal towns of that era, boasts several houses in the style, the most famous being the unusually refined Nichels–Sortwell House (1807–12).

Outside New England the Adamesque was not so prevalent, though there are important examples. In New York City some row houses by McComb, Josiah Brady, the young Martin Thompson, and others are still standing. Philadelphia, more strongly influenced by Monumental Classicism, was not entirely free of Adamesque influence. William Thornton's Library Company building (1789–90) was an important landmark, now gone. The Pennsylvania Hospital (1794–1805) by David Evans, Jr., which derives some of its features from the Thornton building, still stands. And in West Philadelphia one of the great houses in the Adam manner, Woodlands (plate 206), also remains. This Georgian mansion was completely remodeled in the new style in 1787–89, with a majestic portico of slim Adamesque proportions. Nearby New Castle, Del., has the George Read II House (1797–1801), which is much like Philadelphia

205 First Congregational Church, Bennington, Vt. 1805

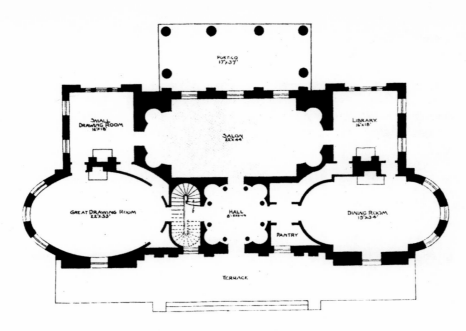

206 Plan, Woodlands, West Philadelphia, Pa. Remodeled in Adamesque
style, 1787–89. From Kimball, *Domestic Architecture of the American
Colonies and of the Early Republic*, 1922

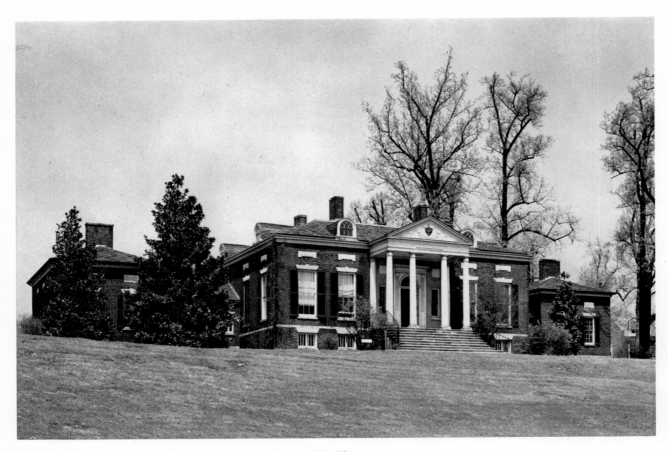

207 William Thornton (attrib.). Homewood, Baltimore. 1801–03

houses. Homewood (1801–03, plate 207), in Baltimore, now part of Johns Hopkins University, has been attributed to Thornton; like Woodlands, it retains its southern Georgian plantation-house form, though all its proportions and details have become Adamesque. Baltimore also had two generations of Longs to set its architectural standards. Among the finest of the senior Robert Cary Long's buildings in the Adamesque style were the Union Bank (1807), now destroyed, and the Municipal Museum (1813), originally the Rembrandt Peale Museum. In Washington, D.C., Thornton's Octagon House (1798–1800, plate 208), a masterpiece of the new formal freedom fostered by the Neoclassic style, is now the home of the American Institute of Architects.

Most of the important postwar building in the South dates from the Greek Revival, but Adamesque examples include: the Wickham House, now the Valentine Museum, in Richmond, Va., by Robert Mills; Montmorenci (c. 1825) near Warrenton, N.C.; and Lowther Hall (1822) in Clinton, Ga. (the last two now destroyed). In Charleston, especially, strong Adamesque influence in the period of prosperity following the war underlines the importance of English ties to the spread of the style in this country. The taste was set by the amateur architect Gabriel Manigault, a wealthy rice planter who took his avocation seriously. Though dependent on Adam and on the handbooks of James Pain, with an admixture of Louis XVI detail, his architecture has a strong individual flavor. An elegance to match even Bulfinch is apparent in the stately Joseph Manigault House (1790–97), and a professional competence distinguishes his public buildings in the city: the City Hall (1801), now the Charleston branch of the Bank of the United States, and the South Carolina Society Hall (1804).

Carpenters and builders, with their handbooks, carried the Adamesque into the frontier territories. New plantation houses in Tennessee, Foxland Hall (c. 1825) and Fairview (1832), were designed by Thomas Baker. The Gratz House (1806) in Lexington, Ky., would have been more at home in New England, and the Ohio Territory, once claimed as part of Connecticut, showed its New England ties in such examples as the Tallmadge Congregational Church (1821–25), erected by Sabbens Saxton and decorated by Colonel Lemuel Porter, and the Baum House (c. 1820), now the Taft Museum, in Cincinnati.

New York's City Hall (1802–12, plate 209) is neither Adamesque nor Monumental, although its conservative adherence to an eighteenth-century mode brings it closer

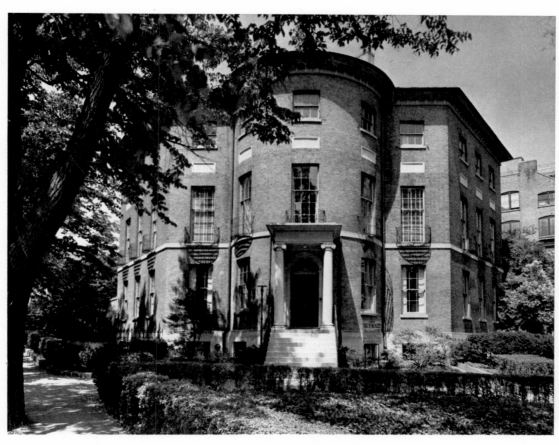

208 William Thornton. Octagon House, Washington, D.C. 1798–1800

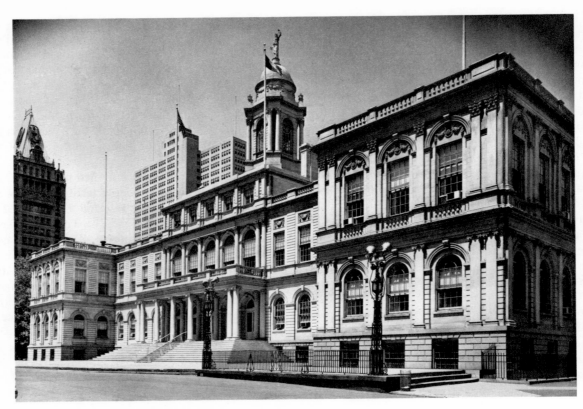

209 Joseph Mangin and John McComb, Jr. City Hall, New York. 1802–12

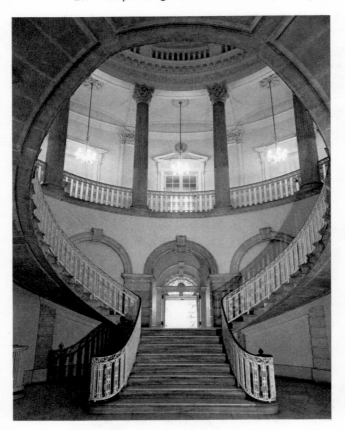

210 Joseph Mangin and John McComb, Jr. Circular stair-
case, City Hall, New York. 1802–12

to the former. It is the only French-inspired public build-
ing of the period. Revulsion against the Reign of Terror
dampened an earlier enthusiasm for things French. Jo-
seph-François Mangin (act. 1794–1818), who, together
with John McComb, Jr., submitted a design for the build-
ing in 1802, was responsible for City Hall's French air.
Mangin first appeared in New York in 1794, when he was
recommended by George Washington to advise the city
on its fortification. Evidently a draftsman and engineer
as well as an architect, he was made City Surveyor,
worked on official city maps, and joined with his brother,
Charles, in an architectural and engineering firm which
designed the Park Theater (1795–98), the New York
State Prison on Christopher Street (1796–98), and later
the first St. Patrick's Cathedral (1809), the earliest Gothic
Revival building in New York. As to the relative impor-
tance of the partners in the eventual form of City Hall,
available evidence indicates that the original design was
Mangin's, while its actual construction, as well as the
adaptation of its detailing to a more English mode, be-
longed to McComb. While it is difficult to pin down its
Louis XVI character to any particular French building
of the period, something in its total design, scale and
proportions, spacing, and general vitality recalls the
Rococo, but a Rococo laced with Classical restraint. Its
exterior remains one of the treasures of American archi-
tecture, and its interior is no less impressive. The same

Classical feeling, yet rich texture, informs the monumental dome and circular staircase of the lobby (plate 210), the spacious and elegant chambers, and the delicacy of ornamental detail. The building remains the single extant example of a French influence which found no permanent home on American soil, just as the French architects—Mangin, Hallet, Brunel, Godefroy, Ramée—never did.

MONUMENTAL CLASSICISM—
THOMAS JEFFERSON

Although Thomas Jefferson's architectural production was not so extensive as a professional's, his contribution to Early Republican architecture is inestimable. His passion for architecture and his concern for the "correct" expression of American principles in architectural terms led him to take an active, even leading, part in the Classic Revival. Jefferson was a remarkably versatile man—one of the last examples of the Renaissance "complete man," planter, statesman, classical scholar, architect, and gadgeteer. A product of the Age of Reason, he was above all both reasonable and rational, a materialist interested in reality, the present, and utility. If he had any limitation, it was his distrust of theory or metaphysics. He was not really interested in anything that did not work, and he judged the validity of an idea by whether it could be put to use. That is why he could never accept the idealism of Plato, and why he revered Palladio, who made architecture seem so rational and practical, an expression of natural law.

As a gentleman's son, Jefferson had received a rudimentary training in architecture, but the practical need for building on his estate elicited a passion and an avocation. His first serious effort is to be seen in the plans for his home, Monticello, for which an elevation drawing exists (plate 211). The dependence on Palladio is clear, which may seem exceptional in the context of the Georgian that surrounded him, but it was not so unusual in the larger sphere of English architecture. Neo-Palladianism had not had much time to affect the colonies before the Revolution, and the less demanding Adamesque had superseded it after. Jefferson's earliest work on Monticello and his designs for other Virginia houses are a definite departure from the Georgian mode. They were based on the so-called "Roman villa," or country house, type, which had a special significance in Palladio's oeuvre, since much of his practice was involved with the design of villas for estates in the Veneto. These were very often working estates, similar to those for which Jefferson designed his houses. The type appealed to him not simply from necessity but because Palladio had combined in this form dignity with utility. The Classical elements of a double-story porch in the correct orders and the Doric frieze were no more important to Jefferson than the plan with its central house, wings, and dependencies spread on the terrain in a commodious way.

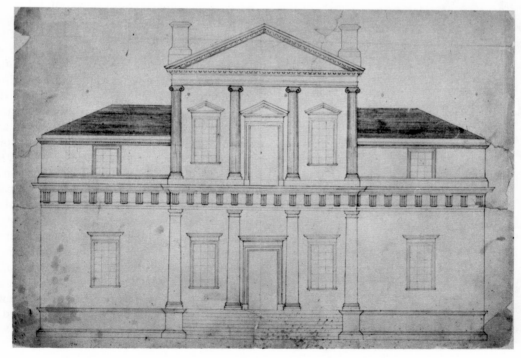

211 Thomas Jefferson. Final elevation, first version of Monticello. Before March, 1771. Massachusetts Historical Society, Boston

All the houses Jefferson actually designed, or even only advised his friends and neighbors about, have this quality of stateliness, rationality, and utility. They were all done after the Revolution, after Jefferson had been Ambassador to France and seen the Roman ruins in Italy. He had been impressed by the new Classicizing style fostered by Louis XV and carried on into the reign of Louis XVI—the Place de la Concorde by Gabriel, Jacques-Germain Soufflot's Panthéon, and the very recent Hôtel de Salm (now the Palais de la Légion d'Honneur)—although he found them too fancy. It was the memory of the Maison Carrée in Nîmes, however, which inspired him to design a Roman temple to house the State Capitol of Virginia (1785–89, plate 212) in Richmond at the request of the State Legislature. He sought the aid of the French architect Charles-Louis Clérisseau in drawing up the plans, but the idea and its modification to fit its function and the limitations of American craftsmen were his own. He changed the Corinthian order to Ionic and eliminated the fluting, removed the decorative frieze, and planned the two-story interior for governmental functions. In construction some of the elegance was lost, and Samuel Dobie, who supervised the building and had pretensions to architecture himself, took it upon himself to cut a semicircular window in the pediment and to add pilasters between the windows on the sides. Thus the Maison Carrée became an American building. But with all its crudities and provincialism, when compared with the Madeleine in Paris, which also copied the Maison Carrée, the Virginia State Capitol, set in Richmond, must have seemed a vision from another world, an ideal to strive for, a building worthy of housing the kind of government Jefferson conceived.

The State Capitol has come in for more criticism than any of Jefferson's other efforts, because it was the first building to use an ancient temple type for a modern purpose. A Classical temple, the repository of an idol, is not, after all, very well adapted to all the functions to which it was eventually put, but the form had ideological significance for Jefferson and his contemporaries, and it helped set the direction in which American architecture was to develop. In Jefferson's hands, at least, it was not simply a slavish copy but an attempt to adapt, to create an image of dignity and power, and, at the same time, to provide for administrative needs. Its interior especially, in its spacious grandeur and its simple Classical monumentality, expresses the Jeffersonian ideal. In the simplification of Classical forms and the stripping away of decoration, it moved toward modernity and Americanism, but his greatest work was to come later.

THE NATION'S CAPITAL AND LATROBE

Before the completion of the Virginia State Capitol, Pierre-Charles L'Enfant (1754–1825) had set the tone for a national architecture of Classicism. L'Enfant had come with Lafayette to fight in the Revolution, and it was through George Washington that he was commissioned to prepare the first capitol of the United States in New York in time for the presidential inauguration in 1789. The shortage of time precluded the erection of a new building, and the city had offered its City Hall to serve the purpose. L'Enfant transformed the H-plan building by filling the space between the wings with an arcade below and a balcony on the second story and capping this central section with a pediment. The result was Federal Hall (1788–89, plate 213), a cubical mass with an air of Classical simplicity. The decoration was Classical in inspiration, but L'Enfant's Americanization of the ornament presaged a new spirit. He had created the first "American" order, a modification of the Doric with stars in the necking of the capitals; the Doric frieze had thirteen metopes with a star in each for the original states of the Union; the pediment carried the symbol of the American eagle holding arrows and olive branches in its claws; and decorative plaques over the windows repeated the arrows and branches. From the outset Classicism was the form but Americanism the content.

However, New York was only a temporary capital, and after a stay in Philadelphia from 1790 to 1800, the

212 Thomas Jefferson. State Capitol, Richmond, Va. 1785–89 (photographed 1865). National Archives, Washington, D.C.

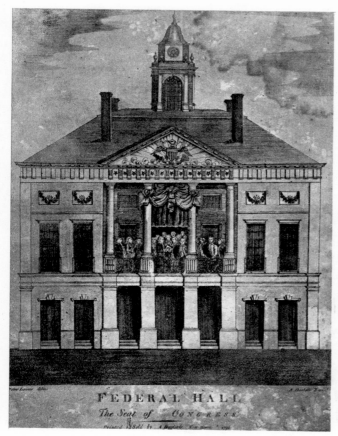

213 Federal Hall, New York. 1790. From an engraving by Lacour & Doolittle. The Metropolitan Museum of Art, New York. Edward W. C. Arnold Collection

national government was established on the Potomac in the projected new city of Washington, D.C. (plate 214). Starting from scratch, the new governmental buildings erected under the watchful supervision of Thomas Jefferson were to set the Monumental Classical style. Jefferson, recently back from France, hovered over the competitions in 1792 for the Capitol and the President's House (plate 215), and he must have had a good deal to do with the selection of the winning designs, for Washington deferred to him in matters of taste in art and architecture. Competitive designs were submitted by many practicing architects and builders, among them Samuel McIntire; James Diamond, with a naive drawing of a monumental Georgian plan; Samuel Dobie, who had worked on the Richmond Capitol, surprisingly with a copy of Palladio's Villa Rotonda; Judge Turner, with a dome that pleased Washington; and Philip Hart, with what looked like an inflated Georgian house. Only Stephen Hallet and William Thornton (plate 216) submitted Monumental Classical conceptions, and curiously similar ones, which eventually led to confusion and recrimination. Hallet always thought, with some justification, that Thornton had got the idea from him, but the com-

mission went to Thornton, and, perhaps as a diplomatic gesture, Hallet was appointed Superintendent of Construction. Both the Thornton and the Hallet plans show a central section surmounted by a low Roman dome and flanked by symmetrical wings to house the two legislative bodies. Both go beyond Palladio back to Roman sources, exactly the kind of Roman grandeur that Jefferson was looking for.

Dr. William Thornton (1759–1828), a West Indian-born English gentleman and physician, was, like Jefferson, a passionate amateur architect. All his previous work shows a conservative English Neoclassicism, but he seems to have understood the need for a new monumentality, going for his design to *Vitruvius Britannicus*. However, although big and impressive in conception, the plan was more Palladian, even Georgian, than Roman. Thornton and Hallet squabbled with each other and both architects wrangled with the commissioners. The English-trained architect George Hadfield was brought in at one point but could not resolve the impossible situation. Finally, Jefferson appointed Benjamin Latrobe in 1803 to supervise construction of the Capitol.

Benjamin H. Latrobe (1764–1820) was a superbly trained young architect who gave up what promised to be a brilliant career in England to come to the United States in 1796. He had worked with Sir Samuel Pepys Cockerell, but his conceptions were closer to Sir John Soane, although Latrobe had left England before Soane developed his own radical style. Claude-Nicolas Ledoux in France and Soane in England evolved a revitalized and modern Classicism that depended not on archaeological accuracy in imitation but on the free and original use of Classical forms for contemporary ends. The result in both cases was an architecture of bold and simple monumentality and dignity expressed in exciting, even eccentric, new formal configurations. The same search for ideological content, functionalism, and modernity is to be found in Latrobe's architecture and writing.

Latrobe's professionalism, knowledge, and authority pulled work on the Capitol together and created a monument out of chaos. He respected Thornton's original plan but eliminated the amateurism in the interior planning and construction and transformed its Palladianism into Monumental Classicism. However, during the occupation of Washington by the British in the War of 1812, the building was gutted by fire and only the outer walls of the wings remained standing.

The second phase of Latrobe's work on the Capitol began in 1815. He repaired the wings, designed a new rotunda and dome as well as new semicircular chambers for the House of Representatives and the Senate, and modified the designs for the eastern and western central facades (plate 217). Bulfinch's appointment as Superintendent in 1818 led to no important changes, and Latrobe's plans were carried out. In all his work on the Capitol, Latrobe utilized a Classical vocabulary, yet his

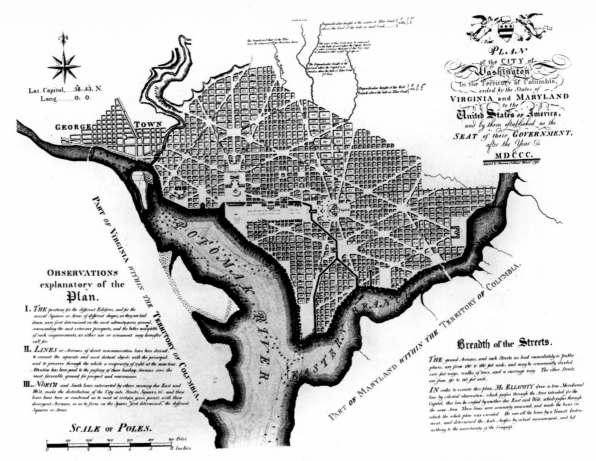

214 Pierre-Charles L'Enfant. Plan of Washington, D.C. (as rendered by Andrew Ellicott). 1792

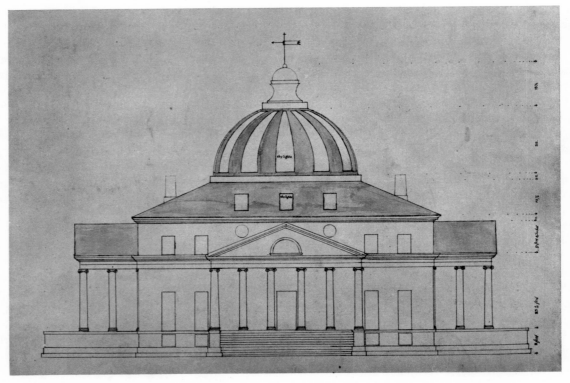

215 Thomas Jefferson. Design for the President's House competition. 1792. Maryland Historical Society, Baltimore

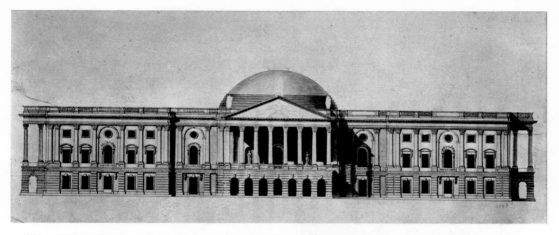

216 William Thornton. Design for east elevation, U. S. Capitol, Washington, D.C. 1792. Library of Congress, Washington, D.C.

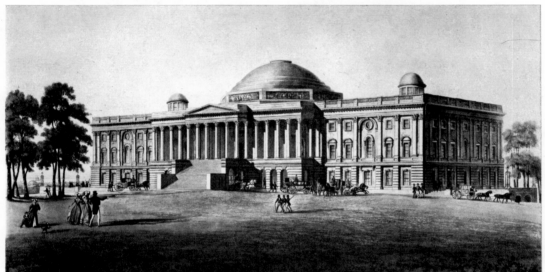

217 Benjamin H. Latrobe. Design for remodeling U. S. Capitol, Washington, D.C. 1815. The New York Public Library. I. N. Phelps Stokes Collection of American Historical Prints

intention was contemporary function and nobility. He produced the first architecture of true grandeur in this country. In later years he was somewhat annoyed that people remembered only his "American orders," the corncob and tobacco capitals (plates 218, 219) he had substituted for the Corinthian acanthus, but they were indications, though minor, of his willingness to use Classical sources freely and with originality. More striking to contemporary taste is his bold and early use of the Doric order in the room under the Old Senate (plate 220) and even more so the stripped "archaic" Doric orders supporting the stone vaulting under the Rotunda (plate 221), meant originally to hold the tomb of Washington.

Compared with the Capitol the White House (1792–1829, plate 222), designed by the Irishman James Hoban (1762–1831), is something of a disappointment. It is not a Monumental Classical building, although it may have appeared so in the original plan (plate 223). Its only claim to monumentality is in its scale, its white stone,

and the porticoes designed by Latrobe in 1807 and constructed in 1824. It is essentially a Georgian building with a heavy dignity rather than the nobility that the Classic Revival was seeking. Hoban seems to have borrowed the design from a plate in Gibbs, with some modifications suggesting Leinster House in Dublin (plates 224, 225).

Even before Latrobe's major involvement with the Capitol he had executed the Bank of Pennsylvania (1798–1800, plate 226) in Philadelphia, now destroyed. Latrobe's problem was the design of a public bank, a new kind of building that was certainly unavailable in the repertory of Classical architecture. He seems, at least superficially, to have used the Roman podium form, but that of a double temple, like the Temple of Venus and Rome in the Forum, unusual in itself, to house the bank. Seen as a Roman borrowing, the dome on a temple form is an anomaly, but it can also be read less archaeologically as a square central block with a low dome and porticoes at either end. Latrobe had created a central space, ample in

218 Benjamin H. Latrobe. Corncob capital (carved by
Giuseppe Franzoni), U. S. Capitol, Washington, D.C.
c. 1815

220 Benjamin H. Latrobe. Columns in room under Old
Senate, U. S. Capitol, Washington, D.C. c. 1815

219 Benjamin H. Latrobe. Tobacco capital (carved by
Francesco Iardella), U. S. Capitol, Washington, D.C.
c. 1815

221 Benjamin H. Latrobe. Crypt under Rotunda, U. S.
Capitol, Washington, D.C. c. 1815

222 James Hoban. The White House, Washington, D.C. 1792–1829

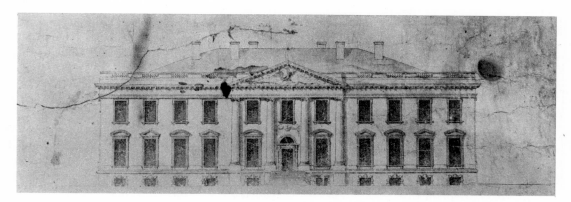

223 James Hoban. Design for an elevation of the White House, Washington, D.C. 1792. Maryland Historical Society, Baltimore

224 Leinster House, Dublin, Ireland. 1779

225 Above and below: James Gibbs. Details of gates, doors, and doorcases. From James Gibbs, *A Book of Architecture*, London, 1728, pp. 99, 108

restrained sensitivity in detail. The Ionic order, possibly borrowed from the Erechtheum, was the first use of a purely Greek order in the United States. Three simple, roundheaded windows, beautifully proportioned and spaced, cut into the masses of solid masonry, and the simplest of undercoated entablature bands tied the various elements together. The Pennsylvania Bank was a functional building of exquisite design, and it is some indication of the level of public taste that it was received with universal praise and set a standard for subsequent architecture in the United States.

Another Monumental Classical landmark in Philadelphia, now gone, the Centre Square Pump House (c. 1800), was also by Latrobe and, like the Pennsylvania Bank, utilized simple forms derived from Classical architecture to house a contemporary function, that of supplying the city with water. As seen in a painting by John Lewis Krimmel, *Fourth of July in Centre Square, Philadelphia* (plate 287), it has the bold and stripped Classicism characteristic of Latrobe. The smooth, rectangular masonry mass is pierced by an entrance with two Doric columns *in antis* flanked by two plain roundheaded windows in shallow recessed arches, the whole capped by a cylindrical drum of two stories with windows below and a matching frieze of recessed rectangles above. The building is again finished by a low dome, but open at the top to emit the smoke of the furnace through a chimney. It stands in the painting like an idyllic Classical temple of love amid a grove of poplars, with a fountain statue by William Rush, *Water Nymph and Bittern* (colorplate 28) in front.

Though Latrobe's preference for the Greek is clear, he could also see that "our religion requires a church wholly different from the [Greek] temples. . . ." Both of the designs he submitted for the Baltimore Cathedral in

scale and dignified in expression, with a coffered dome lit by a simple cupola (plate 227). The flanking cubes contained banking rooms, and the entire structure was raised above ground level and supported by vaults. On the exterior, the bold and spare massing of geometric forms was relieved by an elegance of proportion and a

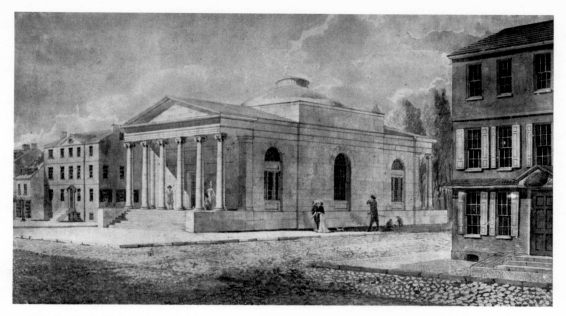

226 Benjamin H. Latrobe. Architectural rendering, Bank of Pennsylvania, Philadelphia. 1798. Watercolor. Maryland Historical Society, Baltimore

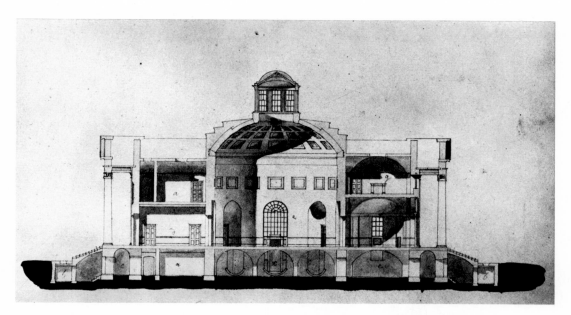

227 Benjamin H. Latrobe. Interior section from east to west, Bank of Pennsylvania, Philadelphia. 1798. Watercolor. The Historical Society of Pennsylvania, Philadelphia

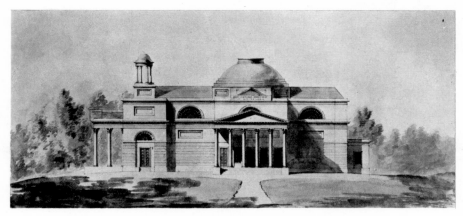

228 Benjamin H. Latrobe. Architectural rendering, Baltimore Cathedral. 1805. Watercolor. Archdiocesan Archives, Baltimore

1805 accepted the centuries-old tradition of the church, one Neoclassic (plate 228) and the other Gothic (plate 367). The disposition of parts was the same in both; only the architectural language was different; as seen in the immaculate watercolor renderings, both his Gothic and his Classical eliminated surface decoration and sought for fundamental architectural forms. The Bishop, imbued with the spirit of the time, selected the Neoclassic version, and the building (plate 229), begun in 1806, was finished in 1818, although the portico was erected only in 1863. Latrobe followed a typical church form, with nave and transept (plate 230), a dome over the crossing, and a portico and two towers at the entrance end; but his signature is seen in the massing of volumes, the low dome, and the virtual elimination of decoration except for the Ionic capitals and the restrained dentilation under the cornice. The absolute smoothness of surface is broken only by the recessed windows and decorative rectangles. Yet, as blunt and original a statement as the building is, it is not entirely successful. The onion domes, not his, are no help, but even without them the building does not jell as a unit, the masses do not coalesce, and the relationship between horizontal and vertical elements is unresolved.

Latrobe's domestic building was as original in conception and refined in execution as his larger efforts, but little of it remains. The Van Ness House (1813–19) in Washington; Brentwood (1818, plate 231), near Washington, its rooms grouped around a central domed chamber; and the Markoe House (1810), with its early bathroom, including tub, washbasin, and water closet—all are now gone. They were designed with breadth and sobriety, an understanding of functional needs, and unfailing taste.

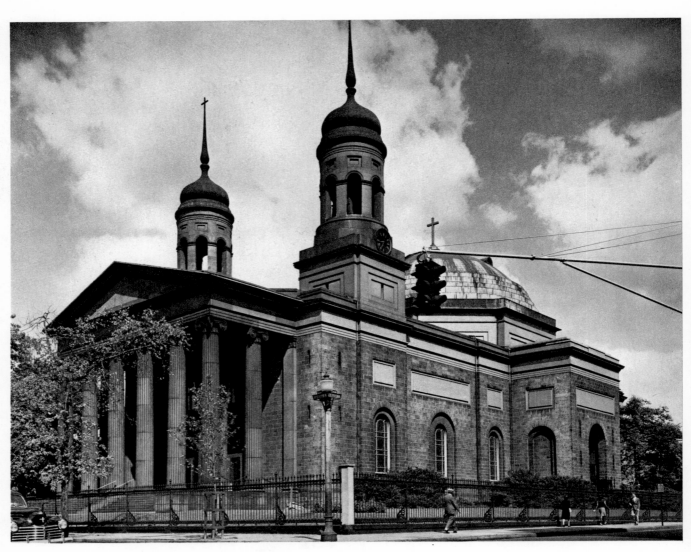

229 Benjamin H. Latrobe. Baltimore Cathedral. 1805–18 (portico 1863)

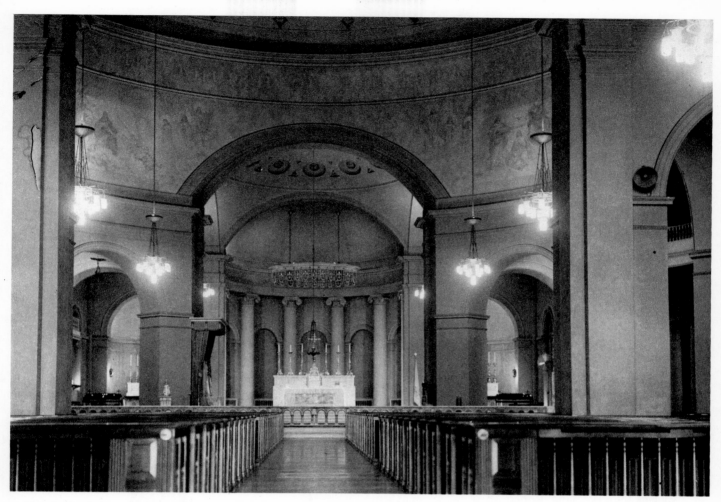

230 Benjamin H. Latrobe. Interior looking toward chancel, Baltimore Cathedral. 1805–18

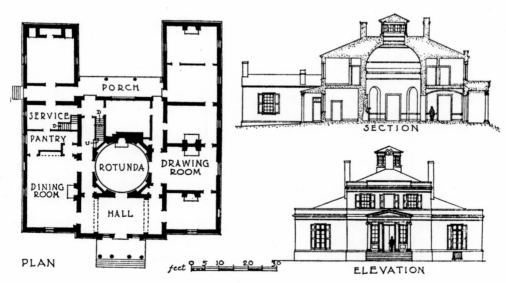

231 Benjamin H. Latrobe (attrib.). Plan, Brentwood, near Washington, D.C. 1818.
From Hamlin, *Greek Revival Architecture in America,* 1944, fig. 4, p. 33

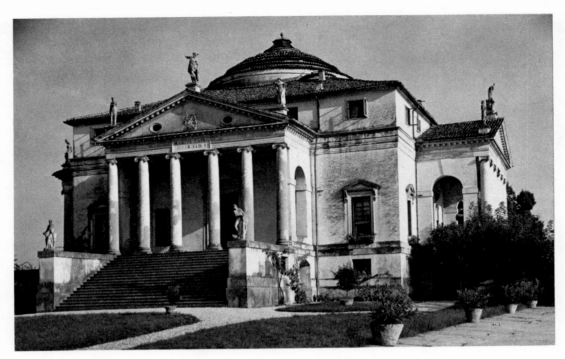

232 Andrea Palladio. Villa Rotonda, Vicenza, Italy. Begun 1550

JEFFERSON'S LATER WORK

Monumental Classicism was carried on by Jefferson, Hadfield, and even Thornton (in Tudor Place; after 1810, Washington, D.C.), and by some of the younger men such as John Haviland, Robert Mills, and William Strickland. Jefferson matured as an architect during this period, continuing to move from Palladianism and Roman influence toward Monumental Classicism. But even with the help of Latrobe and his students, Mills and Strickland, Jefferson's work, despite his originality and intellectual probity, always retained an element of amateurism.

Jefferson redesigned Monticello (plates 125, 211) in 1793 and continued until 1809. He returned to the dome and central plan of Palladio's Villa Rotonda (plates 232, 233), which held a special fascination for him. (As early as 1781 he used it in a study for the Governor's House in Williamsburg, and in 1792, in the competition for the President's House, he submitted anonymously a direct adaptation of it, plate 215.) But it was only a starting point, for the completed structure of Monticello resembles the Villa Rotonda only in the most general way. Jefferson accepted the local materials in the employment of red brick with white trim, but he went to Classicism for the forms to meet his utilitarian needs and express his ideals. The result is actually a freely and imaginatively developed design, which incorporates his conceptions of propriety and dignity, the complex demands of an active existence, and his inveterate addiction to gadgetry.

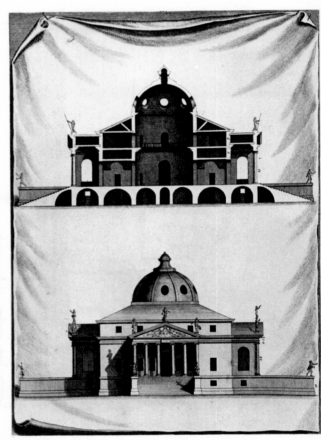

233 Andrea Palladio. Section and elevation, Villa Rotonda, Vicenza, Italy. From Palladio, *I Quattro Libri dell' Architettura*, Leoni edition, London, 1715, Book II, plate 15

Its sober stateliness is radically different from the opulent formalism of the Georgian and the cool elegance of the Adamesque. There is a directness and clarity in its composition, even though the design is not simple. Its complexities are handled with rationality and ingenuity. That it is not a completely satisfying building may be due to the fact that it was additive and that the relationship between separate elements was never resolved. There is also something too weighty about it, a feeling that the forms, in spite of the materials, were intended for a more monumental structure. The moldings, frames of doors and windows, fireplaces, and ceiling cornices are similarly overscaled within their context.

The greatest and most successful of Jefferson's architectural efforts is, no doubt, the complex of buildings he designed for the campus of the University of Virginia (1817–26) in Charlottesville (colorplate 17). When Jefferson left the Presidency in 1809, he settled down to his dream, a life of scholarship. But, as always for him, man's activity demanded a social purpose, and the last and culminating project of his life was the creation of an ideal educational institution. In his own probing way he analyzed the aims, resources, and methods of higher education and planned a curriculum to fit them. The design of the campus was based on an "academical village" for an ideal student body of 125, the number of

buildings on his division of the university into ten "faculties," the form of the buildings on the theory that architecture could be a living heritage and an instrument of education. The buildings were laid out around a lawn in a U shape, the administration and library building set on a terrace dominating two ranks of five buildings facing each other. Each building housed a faculty—the living quarters of the professor, the specialized library, and the classroom—all joined by lower dormitories. A running covered colonnade ties together the ten different pavilions built of red brick with white wood trim. The ten accents are held in place by the regular rhythm of the repeated columns, the entire procession culminating in the Rotunda. The whole, rationally conceived and handsomely landscaped, is undoubtedly the most beautiful campus in the United States.

The individual buildings (plate 234), as lessons in architecture, were borrowed from a variety of Classical sources; each is a variation on a theme, but all are characterized by the straightforward clarity of the Monumental Classical style. The detailing is simple, clean, and, as always in Jefferson's work, a little heavy. Of special interest are the doors and windows, in which the Classical reference disappears and only the basic geometric form remains with startling purity. The same quality is to be seen in the rear elevation of the buildings; the

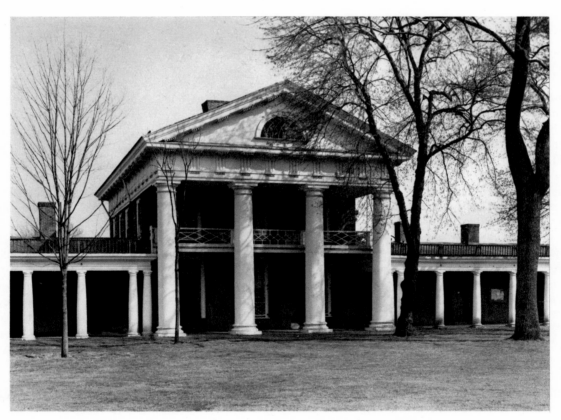

234 Thomas Jefferson. Pavilion IV, University of Virginia, Charlottesville. 1817–26

235 Thomas Jefferson. Serpentine wall, University of Virginia, Charlottesville. 1817–26

stolid red-brick arches look like a new kind of architecture, resembling the Roman use of arches in utilitarian building, but Roman power has given way to a modest and sober dignity. The free-form brick retaining wall (plate 235) has a special appeal for contemporary tastes; seen in the context of the total work, it is another example of Jefferson's rationalism, originality, and feeling for material. The Rotunda was the culmination of Jefferson's involvement with the Villa Rotonda, but he now moved beyond it to Palladio's own source, the Pantheon. The Rotunda is the badge of Jefferson's pilgrimage to Rome and perhaps his most professional achievement as an architect, but it remains a modest, domesticated, American version of architectural greatness.

FROM MONUMENTAL CLASSICISM TO GREEK REVIVAL AND LATER STYLES

Many of the foreign-born architects who helped form an American architecture in this period never attained success in practice and left little to show for their years here. George Hadfield (1764–1826) was a young architect of great promise, but Latrobe has left us a rather sad description of him: "He loiters here, ruined in fortune, temper, and reputation, nor will his irritable pride and neglected study ever permit him to take the station in art which his excellent taste and excellent talent ought to have obtained." The quality of that taste and talent is best seen in the Washington District Court, originally the City Hall (1820–26, plate 236). One of the finest and most impressive Monumental Classical examples, it has received curiously little attention. It has much the feeling of Latrobe, with its bold composition of big masses, the reduction of decoration to simplified entablature bands, recessed windows in arches, and even the recessed rectangular motif. The wing facades especially are handled with power and clarity. The clean-edged, simple masses at the corners enclose a loggia formed by two Ionic columns *in antis,* and the whole, raised on a massive podium, has an almost modern look.

Hadfield's Treasury Building (1798–99), which served as a model for many early government buildings, is now gone, as they are, but his remodeling of the Lee family mansion, Arlington, Va. (1820, plate 237), still survives. In Arlington the transition from Monumental Classicism

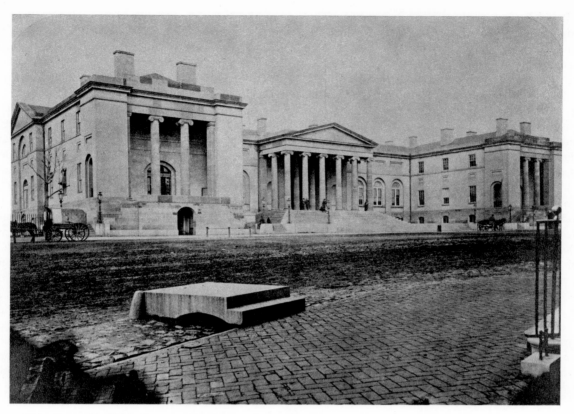

236 George Hadfield. City Hall, Washington, D.C. 1820–26

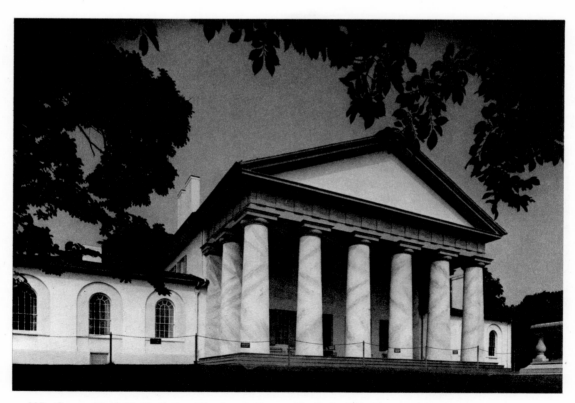

237 George Hadfield. Custis-Lee Mansion, Arlington, Va. Built 1803–04, central block 1817, columns 1820

to Greek Revival is achieved almost imperceptibly. The unadorned masses of the central block and wings are dominated by a giant portico of "archaic" Doric columns, rather too heavy in proportion and overbearing in scale for a house, but unquestionably imposing. More important, however, the portico no longer projects from the house block but now encompasses the whole in a temple form, shifting the roof axis from lateral to frontal and establishing the Greek Revival house type.

Like Hadfield, Maximilien Godefroy (c. 1770–after 1842) had a difficult and abortive career in the United States and left in 1819. Trained as a military engineer in the army of Louis XVI, he came to America in 1805 to teach "architecture, drawing, and fortification" at St. Mary's Seminary in Baltimore, where he designed in 1806–07 the Gothic Revival chapel (plate 368), discussed in Chapter 12. His major work was the Unitarian Church (1817–18, plate 238), in the same city, one of the great examples of Monumental Classicism, exhibiting all the hallmarks of the style, yet distinguished by unique features. The cubical shape of the building is modified only by the segment of dome that shows on the exterior, the three-arched pedimented loggia of the facade, and the cornice circling the building at the entablature level. The use of a loggia, rather than a projecting portico, and the precise relation of all the parts are reminiscent of Brunelleschi and fifteenth-century Italian Renaissance architecture rather than Roman. However, the bold handling of clean masses and the free use of Classical forms are even closer to the work of his fellow countryman, Ledoux. The interior (plate 239), now unfortunately altered, originally had the same large conception and direct execution. A simple but monumental space was achieved by the pure geometry of a coffered dome on pendentives, but here also the untrammeled use of traditional forms appeared in the elimination of the entablature. The delicate, incongruous Louis XVI ornament does not destroy the vigor of the solid masses and enclosed volumes.

The next generation of architects, all American-born except for John Haviland and William Jay, did their major work during the Greek Revival period. Some, such as Haviland and William Strickland, show the influence of Monumental Classicism in their earlier efforts; Robert Mills always retained a greater affinity with the more robust earlier style than with the later Greek elegance. Actually, it is often difficult to distinguish between the two styles, since the latter grew inevitably and imperceptibly from the former. In general, the Greek Revival is

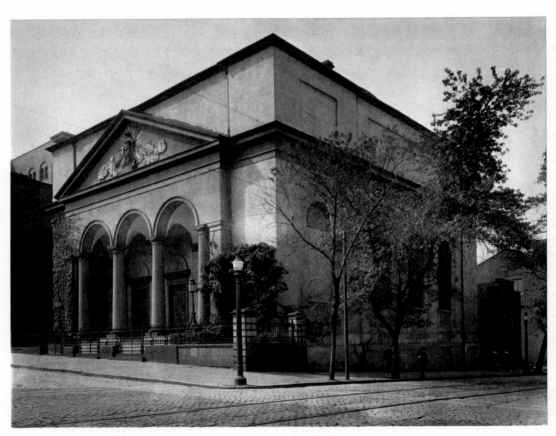

238 Maximilien Godefroy. Unitarian Church (Christ Church), Baltimore. 1817–18

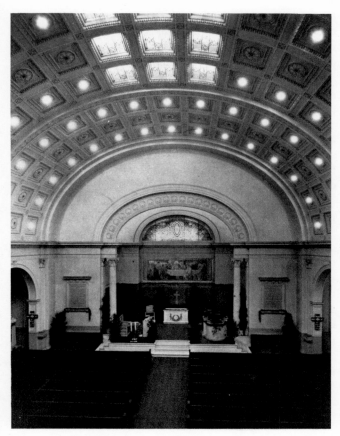

239 Maximilien Godefroy. Interior, Unitarian Church
(Christ Church), Baltimore. 1817–18

distinguishable from Monumental Classicism by (1) a
preference for Greek over Roman forms and propor-
tions, (2) the adoption of the Greek temple form, espe-
cially in domestic architecture, and (3) the use of the true
Doric order. Unfortunately, for purposes of identifica-
tion, not all these features always occur together, nor is
the presence of a single one an adequate criterion for
judgment.

Broadly speaking, Monumental Classicism is prepon-
derant and Greek Revival only tentative and sporadic
before about 1820, while Greek Revival emerges in
strength after that date and dominates until about 1850.
There is even some question whether they are not both
part of a single continuing and changing style, for ar-
chitects of both phases had a common concern with
rationality, simplicity, and clarity; with a free adaptation
of the past to the present; and with an open-mindedness
toward new materials and technology. It is also true that
the character of American life had changed and that the
Greek Revival began to express new cultural attitudes.
The earlier dedication to ideology relaxed into an opti-
mistic acceptance of prosperity; austerity was leavened
by a new grace. The difference between the two is one of
evolution rather than revolution.

MILLS AND STRICKLAND

Robert Mills (1781–1855) stands athwart the two periods.
In his intellectual dedication, inherited from Jefferson
and Latrobe, and his aesthetic austerity, an expression
of his own personality, he remained always more a Mon-
umental Classicist than a Greek Revivalist. Mills and
Strickland have always been coupled, for they were the
first professionally trained American architects, the major
architects of their generation, and both were students
and assistants of Latrobe and worked out of Philadelphia.
Architecturally they had much in common, most im-
portant the acceptance of engineering as an integral part
of American architectural practice. Otherwise they are
two faces to the same coin—Mills serious, practical,
blunt, perhaps even "stodgy"; Strickland adventurous,
inventive, and tasteful. The decade's difference in their
ages may explain Mills's absorption in the ideology and
form of Monumental Classicism and Strickland's ready
acceptance of the newer and more graceful mode. But
the usual denial to Mills of the refinement of taste at-
tributed to Strickland is somewhat overdone; the differ-
ence is more a question of style and basic personality than
aesthetic sensibility. Mills, seeking grandeur, permanence,
and integrity, often forgot the nuances of grace; Strick-
land, looking for grace, sometimes forgot principles.

From the outset Mills was serious and self-conscious
about architecture in relation to himself and the nation.
He prepared himself for this career while still an under-
graduate, when there were no courses in the subject. He
went on to work for Hoban and then for two years with
Jefferson, who recommended him to Latrobe; and he
assisted Latrobe on the Bank of Philadelphia and the
Baltimore Cathedral. No better training was available,
and Mills learned something about the Classic, a little
about the Gothic, and a good deal about masonry vault-
ing. His first independent effort was the Burlington
County Prison (1808) in Mount Holly, N.J., still in use.
Already the fundamental aspects of Mills's temperament
and practice can be seen in his careful study of penolog-
ical problems and the massive dignity of the design, in
which the Greek details are subordinate. His Sansom
Street Baptist Church (1808–09, plate 240), Philadelphia,
also shows his ability to handle new situations. The grow-
ing popularity of eloquent preachers, presaging the later
revival meetings, called for larger and different kinds of
churches to house the crowds that flocked to hear them.
Mills's solution was a circular auditorium-church which
could seat four thousand people, with a baptismal font
in the center, a pulpit at one end, and a stepped gallery
almost completely circling the interior. The exterior was
a spare cube relieved by recessed arches and a central
loggia with two Ionic columns *in antis*. The only rem-
iniscences of traditional church architecture are the se-
verely reduced geometric cupolas, rather ungracefully

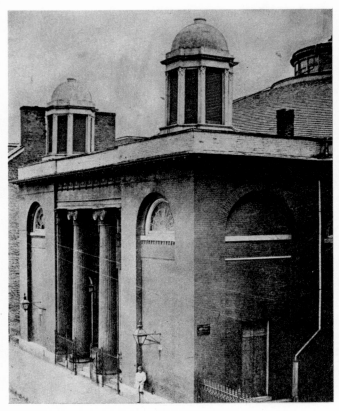

240 Robert Mills. Sansom Street Baptist Church, Philadelphia. 1808–09. Avery Library, Columbia University, New York. Gallagher Collection of Millsiana

marking the atrophied flanking towers. The Classical decoration of the interior was equally restrained and nonarchaeological. Mills later built other auditorium-churches in Richmond, Va., Philadelphia, and Baltimore.

Mills's Monumental Classicism can be seen in its purest form in the County Record Building (1822–27, plate 241) in Charleston. Compared with the original elevation rendering it reveals a particular facet of his artistic personality. The final structure is always more spare, more forthright, less ingratiating than his meticulous and beautifully detailed drawings. The Classical quotations and the decorative rhetoric seem to disappear in the face of the reality of building. In this case such particularly Greek details as the column fluting and the pediment were replaced by smooth columns and an eccentric parapet to give the building a starker and less archaeological look. The substitution of the right-angled winged staircase (plate 242) for the gracefully curved one in the drawing reinforces the appearance of directness and practicality. The fact that the structure has always been known in Charleston as the "Fireproof Building" is an indication of Mills's advanced structural thinking as well as the community's recognition of its functional purpose. Serviceability was always more important to Mills than architectural correctness. There is, however, at least in the original design, an obeisance to the growing popularity of the Greek mode.

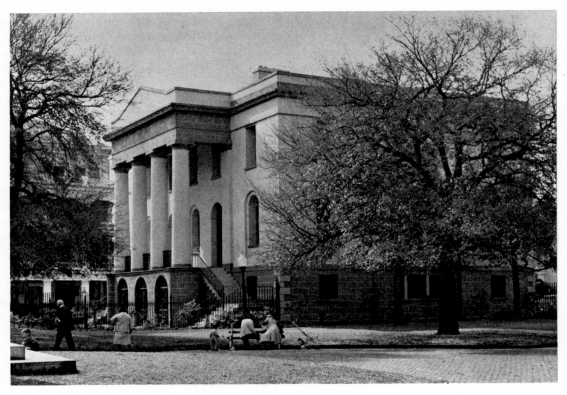

241 Robert Mills. County Records Building ("Fireproof Building"), Charleston, S.C. 1822–27

242 Robert Mills. Staircase, County Records Building ("Fireproof Building"), Charleston, S.C. 1822–27

243 Robert Mills. Washington Monument, Washington, D.C. 1836–84

A similar paring away of the superfluous occurred in his two famous monuments: the Washington Monument (1815–29) in Baltimore and the great Washington Monument or "Obelisk" (plate 243), designed in about 1836 and erected between 1848 and 1884 in Washington, D. C. In the Baltimore monument all the original finicky Classical decoration was deleted, and the unadorned column thrusts powerfully, even brutally, skyward. Mills had historic antecedents in the columns of Trajan and Marcus Aurelius in Rome, and he may well have known of the recently erected Napoleonic column in the Place Vendôme, Paris; however, the conception of a monumental shaft in the form of an obelisk for the Washington memorial had only the barest relationship to its Egyptian prototypes, and it would be difficult to say what connection with Solomon Willard's Bunker Hill Monument. In this instance, Mills eliminated the Doric oval of columns at the base, and the 500-foot shaft rises starkly and cleanly into the air, achieving the expression of power through size alone. When one considers the inherent difficulty in avoiding both bombast and triviality in the design of a monument for the first President, the Washington Monument is no small achievement. Mills's later work in Washington is discussed in Chapter 12.

Unlike Mills, William Strickland (1787–1854) found in Monumental Classicism primarily a point of departure. The son of a carpenter who worked as a "master mechanic" for Latrobe, Strickland showed a talent for drawing and became a student of Latrobe in his early teens. He received his major training from Latrobe from 1803 to about 1805, perhaps even later. Undisciplined and footloose, he left several times and was finally fired. After executing his first independent commission, the Philadelphia Masonic Hall (1808–11), in a not very convincing Gothic which had obviously been inspired by his teacher, he drifted out of architecture to become in turn a draftsman in the Patent Office, surveyor, painter, scenic designer in New York, and engraver. These activities, between about 1810 and 1818, prevented his participation in Monumental Classicism at its height, and his return to active practice, when he designed the famous Second Bank of the United States (1818–24, colorplate 18) in Philadelphia, was the first salvo in the Greek Revival. Only in the power and dignity of the barrel-vaulted central banking room (plate 244), which is curiously oriented on a lateral axis, is anything of the Monumental Classical style evident. The rest is Greek Revival. Strickland's later United States Naval Asylum

244 William Strickland. The banking room, Second Bank of the United States, Philadelphia. 1818–24

(1826–29), and United States Mint (1829–32), long since destroyed, both in Philadelphia, exhibit closer affinities with Monumental Classicism, though both have an elegant Ionic portico. The Naval Asylum (plate 245) is much more interesting in its plan than in its Classical detail; Strickland provided open balconies for all the rooms and tied the lattice-like structure of the wings and the imposing central portico into an unusually effective design, much more functional than revivalistic. Unlike Mills, who remained tied to his earliest experiences, Strickland shook them off with hardly a backward glance to move into a new era (see Chapter 12).

John Haviland (1792–1852), like Strickland, belongs properly to the Greek Revival, though his early work reveals the unmistakable influence of Monumental Classicism. Born and trained in England, Haviland went to Philadelphia in 1816 with Hugh Bridport, an artist, to open a school for architectural drawing, and in 1818 Haviland and Bridport published *The Builders' Assistant,* the first American handbook to include plates of the Greek orders. Haviland's First Presbyterian Church (1820) in Philadelphia was one of the earliest examples of the temple form, but the simple cubical structure devoid of ornament, the unfluted Ionic shafts, the plain geometry of the cylindrical cupola all bespeak an allegiance to Monumental Classicism. Much more original, though reminiscent of Latrobe, is the Deaf and Dumb Institute

(1824–25, plate 317). In both buildings Haviland is poised between two styles as in other work of those years, including the Eastern Penitentiary (plates 369, 370). Perhaps the most remarkable of his efforts of this period is the design for the Moody House (c. 1820, plate 246), Haverhill, Mass., which appeared in *The Builders' Assistant.* Its bold freedom and clarity of plan is matched by an equally daring and unconventional treatment of the exterior. The only reference to Classicism is in the paired Ionic columns *in antis*; the rest is pure geometry of startling originality. Haviland moved with the times and became one of the more prolific Greek Revival architects.

William Jay (act. c. 1817-24), an English architect active in Savannah, Ga., was a brilliant but isolated phenomenon about whom too little is known. His style, which had connections with Soane and the English Regency, was unusually polished for this country and gave unmistakable indications of moving toward the Greek Revival, but his surviving buildings are closer to Monumental Classicism. The Habersham House (1820), with its exquisite Greek Corinthian circular porch and pediment, is Adamesque in its delicacy but strikingly original in conception. Also attributed to him are the equally inventive and refined Scarborough House (c. 1820) and the Telfair House, now Academy (c. 1820). Jay's most important work was the Savannah Branch of the United States Bank (1819, plate 247), now destroyed.

245 William Strickland. United States Naval Asylum, Philadelphia. 1826–29

246 Moody House, Haverhill, Mass. c. 1820

247 William Jay. United States Bank, Savannah Branch, Savannah, Ga. 1819. From an engraving.
Georgia Historical Society, Savannah

It had a Greek Doric portico of six columns capped by a bold parapet, a Monumental Classical design of lucidity and power leavened by elegance of proportion and detail. Regrettably, an economic depression affected architectural activity in Savannah in the mid twenties, and Jay's career was curtailed. When prosperity returned in the forties, the newer Greek Revival came in full-blown.

In the sense that Neoclassicism was the first architectural style of the early Republic, it was naturally the first "American" style. But more than that, it was, at least in its Monumental Classical phase, self-consciously concerned with the ideological expression of American concepts, from Latrobe's "American orders" to Mills's dedication to establishing an American architecture. Americanism and Classicism were equatable, but Mills and Strickland as well as their mentor before them understood clearly that they were not interchangeable. In their own minds they were architects first, American architects second, and American Neoclassic architects finally. They were concerned above all with the standards of professional practice, the creation of rational, efficient, and permanent structures to satisfy public and private

needs, executed reasonably and in the most appropriate materials and the most advanced technology. And they achieved a remarkable level of architectural quality. But they were also concerned with expressing the "ethos" of America—a new world, a new society, a new culture, and a new era in the history of mankind. Their architecture expressed it with simplicity, power, and dignity.

These guiding principles carried over into the Greek Revival, and one should not underestimate the effect that the standards of skill established by the Monumental Classicists and the training of craftsmen under their direction had on the quality of American building during the next period. Their concepts of function, structure, and accommodation were passed on to and maintained by the best of the Greek Revivalists and hardly equaled again in the history of American architecture. Their pride in building was not limited to excellence of design but extended to engineering and workmanship. These men also built bridges, canals, waterworks, prisons, and hospitals, as well as the more traditional public buildings and houses, and the structures that still stand remain models of architectural integrity.

Spanish Colonial Architecture in California

In 1769, at the order of the Spanish Crown, military and missionary forces from Mexico advanced into Alta California. Under the zealous leadership of the Franciscan Fra Junipero Serra, father of the California missions, the first one was established at San Diego de Alcalá (1769). Eventually there were twenty-one, a day's journey apart, stretching from San Diego to Sonoma along 500 miles of the Camino Real. In a territory of peaceful, very poor, and, according to some authorities, rather backward Indians, the task of the Spanish missions in California was one of teaching and conversion rather than conquest and became, under religious administration, one of establishing centers for agricultural and craft development.

A California mission complex consisted of a *presidio,* or military establishment; a mission, or religious enclave; and a *pueblo,* or Indian quarter. The *presidio* was a fortified walled enclosure housing the *commandante* and as many as a dozen soldiers in offices, storerooms, guardrooms, and dormitories grouped around the four sides of a *plaza.* The mission, also a walled enclosure, was far more extensive, with one or more courts, including a church, with sacristy, baptistery, and, usually, a chapel, on one side, dominating the *plaza,* and around the other three sides workshops, storerooms, offices, cells for the *padre presidente* and perhaps two friars, kitchen, infirmary, guest rooms, and dormitories for Christian Indians and novitiates. The *pueblo,* outside the wall, was usually a cluster of nondescript adobe or thatched huts, of which none has survived.

Missions were self-sufficient communities—a reversion to medieval monasticism—largely feudal in character, directed by the friars and dependent on the peonage of the Indian population. During their greatest prosperity (1800–13), under the leadership of Padre Firmin de Lesuén, the missions were increasingly successful in agriculture, stock raising, and handicraft manufacture. Irrigation was improved, aqueducts were built, and new stone churches were erected. But the feudal power and

growing wealth of the missions found opposition in secular circles. In 1813 the government turned back some land to the Indians; then, in 1821, after Mexican independence from Spain, came Indian emancipation; and finally, in 1834, the missions were secularized. In less than a decade the wealthy, productive missions were gone, the buildings in ruin or decay, the Indians dispersed. When the Americans arrived in 1846, the glory of the missions was a thing of the past. However, of the original twenty-one, fourteen have been variously preserved, four are in ruins, and three have been "restored."

California mission churches fall somewhere between the provincial splendor of those in Texas and Arizona and the frontier simplicity of New Mexico. They have a rudimentary grandeur of scale and site; massive, solid walls with soft, stucco surfaces relieved by limited and restrained decoration; low-pitched roofs of red tile with broad projecting eaves; shaded *patios*; and arcaded *corredors* and *portales.* The tall, decorated *campanarios,* or bell towers, serve as picturesque accents to the low, horizontal bulk of the complex. The fabrics are of adobe, kiln brick, some stone, and roof tile; the basic structural element is the brick arch. There was little vaulting, and domes are scarce. The whole is an architecture that reflects with grace its limited technology, its rich heritage, and its benign climate—simple, charming, and spacious.

San Carlos Borromeo, Carmel, was founded in 1771 and became the central mission. There was no permanent church in Serra's day; the present church (1793–97), erected by Lesuén and under the direction of Manuel Estevan Ruiz, master mason from Monterey, was the most ambitious in California to that date. It is in many ways the finest of the mission churches, a bold but sensitive plastic design with a distinctly Moorish flavor. Its two asymmetrical towers flank an arched center section pierced by a beautiful quatrefoil window. In the interior a wooden vault was supported by three transverse stone ribs. The church was badly damaged in the earthquake of 1812 and restored in 1882.

248 Casa de la Guerra, Santa Barbara, Calif. 1819–26

249 *Corredor*, Casa de la Guerra, Santa Barbara, Calif. 1819–26

San Juan Capistrano (1797–1806, colorplate 19), in its ruined state the most legendary and picturesque, was founded in 1776. Built entirely of yellow sandstone with blue-gray sandstone trim by Isidoro Aquilar, master mason of Culiacán, it was the most ambitious of the mission churches, roofed with domes over three bays and the nave crossing and domical vaults over the transept and sanctuary. The exceptional carving of decorative details is probably by Aquilar, who is reputed to have been an Aztec. The church was destroyed in 1812 by the earthquake and never rebuilt.

Santa Barbara (1815–20), founded in 1786 and still functioning as a Franciscan establishment, is the best preserved and maintained of the mission churches. It is

built of sandstone, and the facade, outside the walls, is the only symmetrical example among California mission churches. The squat, square towers flank a pilastered Neoclassic temple center said to derive from a Spanish edition of Vitruvius.

San Luís Rey de Francia (1811–15), the largest in size, was founded in 1798. It was built of adobe and brick with a tile roof and molded-brick trim. The facade is asymmetrical with a single *campanario* resembling the squat towers of Santa Barbara. It is the only surviving example of a cruciform plan, with well-developed transepts, and it has a wooden octagonal dome over the crossing.

There were major *presidios* at San Diego (1769), Monterey (1770), San Francisco (1776), and Santa Barbara (1782), but the military was so minor in the process of pacification that the *presidios* never grew to importance, and none remains today. With the decline and secularization of the missions, the economy went over to private farming and stock raising. During the golden age of the Mexican *hidalgos* of the 1830s and 1840s, a domestic architecture evolved that was both gracious and informal, adapted to the environment and using local building technology, and it has had a telling influence not only on Californian but on all modern American architecture.

The only extant early Spanish domestic architecture in the United States is in California and dates from the short Mexican period and after the American annexation. Though they served different purposes, the *casa de campo* (farm house), including the *hacienda* (farm) and the *rancho* (stock ranch), and the *casa de pueblo* (town house), all were essentially the same one-story, adobe-and-wood structures with rooms on three sides around an open, often gardened, *patio*. Sloping tiled roofs supported by wooden posts or brick piers projected over covered *corredors*, or verandahs, facing the *patio*. Sometimes there were *corredors* on both sides of the rooms. Oriented for climate control and offering access to all rooms from the *patio*, such houses were ideal for outdoor living. Among examples of this type are the Casa José Antonio Aguirre (1825–30), San Diego, and the Casa de la Guerra (1819–26), Santa Barbara. The latter, built by José Antonio, the *commandante* and scion of a wealthy family, is a modest house but a fine example of the *casa de pueblo* (plates 248, 249).

Farther north, in the area of Monterey, San Juan, and Sonoma, a two-story type with verandahs developed in the 1830s and came to be known as the Monterey type. The two-story verandahs were supported by light wooden posts, and the balconies had railings. The ground floor accommodated the kitchen and living and service quarters, and the second floor, with access by exterior staircase, contained the bedrooms. The Thomas Larkin House (1834, plate 250), Monterey, is a classic example of the Monterey *casa de pueblo,* surrounded on three sides by a two-story verandah with a walled patio on the fourth. The gold rush of 1849 began the inundation of the Spanish colonial tradition, and the settlers who came from the East brought with them their own building types. Only in the twentieth century have California architects recognized the indigenous character and functional aptness of Spanish colonial architecture and begun to adapt it to modern usage.

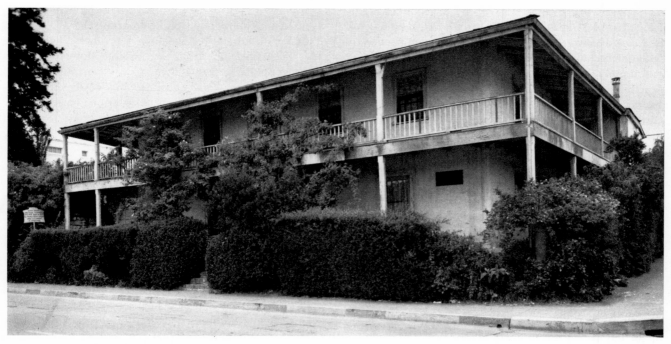

250 Thomas Larkin House, Monterey, Calif. 1834

CHAPTER EIGHT

Painting

Icons for a New Nation

American painters of the Early Republican period elude the Neoclassic label. They seem hardly to have been aware of Winckelmann's strictures concerning the primacy of intellect over emotion expressed in the dominance of drawing and sculptural form over color. Nor is there any evidence of a conscious acceptance of the superiority of the Neoclassic bas-relief type of composition over the freer Baroque and Rococo handling of space. American painting, like American architecture, was a specific response to particular conditions, but resulting in a quite different configuration. Early Republican architecture was dominated by a strong Neoclassic ideological content fostered by Jefferson and his coterie, and the federal government, followed by states and cities, supported the movement through direct patronage in its building program. Also, early Neoclassic architecture in its Monumental aspects was led by a group of highly trained professionals from abroad. Even a public not consciously aware of the ideological significance of Monumental Classicism could respond to its grandeur and dignity, perhaps because architecture is primarily a functional rather than expressive art in a way that the pictorial arts are not. But the same Americans could not easily identify with the Classical heritage in painting: mythology and history, about which they were largely ignorant, and nudity, which offended their religious and moral scruples. Neoclassicism, except in its fashionable aspects in decoration or costume and its purely formal aspects in architecture, was too intellectual and too remote for the common man. A poet or a professor might dream of America as a reincarnation of ancient Rome; a politician might, in a flight of rhetoric, compare the Potomac to the Tiber; and a merchant with pretensions to culture might hope that someday Boston would be the new Athens. But one would not expect an indentured servant to see himself as Aesop, a farmer crossing the Cumberland Gap into Tennessee to identify with Jason, or an immigrant adventuring across the seas to find a parallel in Odysseus. They had their own problems, needs, and desires to cope with in immediate and prosaic terms.

For most of them the pictorial arts were still a luxury and a mystery. Those who had the wealth and the desire for art were still almost totally committed to portraiture, the only "practical" art form; everything else was lumped under the general heading of "fancy subjects." The artists were alone in their yearning to break out of the bonds of face painting, except for the well-wishing of their intellectual compeers who wrote in journals and magazines and lectured rather grandiloquently about the cultural vistas of America. There was an undefined urge to culture, at least in a segment of the burgeoning society.

It is almost impossible to describe the chaos that was painting in those years. There were, in the great majority, the portrait painters, divided into several groups: First, the heirs to the Copley Colonial tradition, with painters trained like Charles Willson Peale, semitrained like Ralph Earl, or untrained like the Jennys brothers. Then there was Gilbert Stuart and the new fashion, along with all his imitators. The growing demand for portraiture could absorb even the inept, and ingenious devices and techniques were developed for speeding up the basically slow process of rendering a likeness by hand. Any extended survey of the endless and routine portraits of the early nineteenth century makes one rather grateful for the invention of the camera.

More interesting than the portraitists were those hopeful but tragic men who wanted to paint America's praises or offer her an art of grandeur, the painters of "fancy subjects" and the history painters—John Trumbull, John Vanderlyn, and Washington Allston. These found a solid wall of indifference, incomprehension, or sheer philistinism. It is not true to say that they were ill-equipped, except perhaps temperamentally, but in the United States they were stifled by narrow materialism, backbiting politics, picayune economies, and cultural immaturity. It is almost incomprehensible that the men who fostered so vital an architecture could turn their backs on Trumbull

and Vanderlyn, but the United States was just not culturally prepared for a "grand" style in painting.

Finally, there were the peripheral artists who were attempting to expand the range of pictorial expression within the normal limits of a middle-class society by landscape, genre, or still-life painting. The heroic and public art of history painting has been traditionally identified with authoritarian or aristocratic societies rather than more recent democratic and middle-class cultures, where the preference for the secular, personal, and informal picture has become dominant. Beginning in the seventeenth-century Protestant, republican, and mercantile-capitalist Holland, the smaller-scaled and more intimate picture—portrait, genre, still life, and landscape—supplanted history painting. The Early Republican United States was still not receptive to such subjects, except in the portrait, simply because the necessary cultural level of art collecting was a generation away. But tentative excursions in this direction were becoming more common, though very few artists were exclusively committed to any of these other genres and almost all were forced to gain a livelihood by portrait painting until 1820 or so.

Unlike architecture, American painting had not made its break from English hegemony, largely perhaps because of the continuing preeminence of Benjamin West in the eyes of young American painters. Although the English, through Gavin Hamilton and West, are usually credited with the earliest Neoclassic experiments in painting, this temporary excursion into archaeological Classicism was passé by about 1770 and certainly before the Revolution. England returned to its eclectic tradition that not only could accept Poussin and Rubens, Raphael and Titian, but insisted on their synthesis. Reynolds's alchemist search for the secret of Renaissance color seems to have imbued English painters with a strong preference for colorism in opposition to the Neoclassic emphasis on drawing and form. Despite West's earlier experiences with Neoclassicism and his continued theoretical deference to Winckelmann and Mengs, his style was more eclectic or academic than Classic. He owed more to Rubens than to Poussin and more to academic theory than to either. In England, unlike France, where the protean dominance of first David and then Ingres was enough to establish the rule of Classicism in the French Academy, the Classic influence was absorbed into the body of academic practice. West's style was painterly rather than sculptural, Baroque rather than Classical, in its conceptions of movement, space, light, and the expression of emotion. Strangely enough, just as his provincialism had earlier put him one up on the Classic Revival, his *retardataire* reminiscence of the Baroque and his academic bombast seem to have prepared him for Romanticism. Thus, all the young Americans who gravitated to England and to West came away with what might have appeared to them the ultimate in artistic rectitude and modernity,

but it certainly was not Classicism. Except for the abortive efforts of Vanderlyn (who studied in France), Neoclassic painting never gained a foothold in the United States.

PORTRAITURE

Portraiture during the Early Republican period divides itself into official and private, although the same artists were involved in both. The great demand after the Revolution for portraits of national heroes and statesmen created a body of official portraiture which is sometimes close to the intention of history painting and will be treated separately.

Charles Willson Peale (1741–1827) and Gilbert Stuart (1755–1828), the leading portraitists of the time, were not far apart in age and worked contemporaneously. Both had studied in England with West, neither was much influenced by him, and both had returned to America to work. However, Peale's formative years occurred before the Revolution, while Stuart's were spent during and after the War. Naive as Peale's style was before he went abroad, it was already firmly committed to the American realism of Copley, and although he returned a good deal more polished technically, he reverted to that earlier vision. Stuart, on the other hand, was completely formed by English portrait painting and practiced independently and successfully in London and Dublin before coming home. He has been compared with Reynolds and Gainsborough, and one of his paintings was actually confused with the work of the latter, but he is much closer in style to a younger generation of English portraitists: Romney, Raeburn, and Lawrence. Thus Peale, progressive and youthful as he always remained, exemplifies the culture of colonial America, moving into a new era but still rooted in the attitudes and values of an earlier day, while Stuart speaks of new horizons, new standards, and a new sophistication. Peale and his contemporaries played out their string before the end of the century, and after 1800 the field was left to Stuart and his imitators.

The personality of Charles Willson Peale is so ingratiating and his career so varied and fascinating that his stature as a painter can be lost in the sheer wonder of the man. He reflects something of the generative forces released by the Revolution. The universal genius of a Jefferson or a Franklin is matched by the universal talent of this humble craftsman, who, without much education but through constant interest and activity, achieved a remarkable level of competence in many fields. Apprenticed to a saddler as a child, Peale became in time harnessmaker, upholsterer, watch- and clockmaker, chaise and sign painter, silversmith, museum curator and lecturer, naturalist, taxidermist, archaeologist, scientist, inventor, dentist, experimental farmer, and, of course, painter in all branches of the art. He devised a set of porcelain false teeth, armatures for stuffed animals, a portable steam

bath, a smokeless stove, waxworks, a panorama, and an Eidophusikon (or "moving pictures"); and, in collaboration with Jefferson, a lifelong friend and fellow gadgeteer, he improved the polygraph. As a devoted patriot, he early became involved in radical politics, endangering his livelihood and, during the Revolution, his life. In the Pennsylvania Militia he rose to the rank of captain, on the whole reluctantly. "He fit and painted, and painted and fit," as a comrade-in-arms said, at Trenton, Princeton, and Valley Forge, finding time to paint miniatures of fellow soldiers and officers, including George Washington. At intervals he was back in the environs of Philadelphia, caring for his family, painting, and politicking for the Revolution. Afterward, just as he previously had painted banners and transparencies as propaganda for the cause, he helped in the erection of triumphal decorations to commemorate victory.

In 1782 Peale founded the first true museum in the country to house his portraits of Revolutionary heroes, and to these he added examples of natural history in 1786. In connection with the museum he learned to preserve specimens, arranged the first natural habitat groups, exhumed and reconstructed a mastodon, and lectured on the exhibits. In 1794 he founded the first artists' society in Philadelphia, the Columbianum (see Chapter 10), and in 1795 organized in its name the first art exhibition. In 1805 he helped found the Pennsylvania Academy of the Fine Arts and its art school, and, through necessity, became its first professional nude model. He did many things because he felt they had to be done or because he simply liked doing them, which left him little time for painting.

Peale was the best painter in the country between Copley's departure and Stuart's arrival, and not just as a fill-in; his paintings are interesting in their own right. His beginnings as a painter grew out of his craftsmanship and his omnivorous curiosity. He tried painting first on his own, producing a landscape and several family portraits, found that there was more to it than he had thought, bought *The Handmaid to the Arts* (Robert Dossie, London, 1758) on a trip to Philadelphia, gave John Hesselius a saddle for letting him watch while he painted, and so became a portraitist as well as sign painter. When debts forced him to flee Annapolis, he worked as an itinerant limner for a while and then, on a trip to Boston, stumbled on Smibert's studio and his paintings. Later he found Copley, who also let him watch while he worked and lent him a picture to copy. By now he had learned enough to satisfy his Maryland neighbors with portraits such as *Judge and Mrs. James Arbuckle* (1766, Collection Mrs. Walter B. Guy, Washington, D.C.), straightforward, naive, charming but still fumbling efforts more in the manner of Hesselius than Copley, which could yet impress the local gentry enough to send him abroad to study in 1767. From then on, though he remained devoted to craft, he became an artist rather than an artisan. Two years with West taught him the rudiments of a more

sophisticated style, as well as miniature painting, engraving, including mezzotint, and casting in plaster. He made his living in London as a miniaturist, exhibited at the Society of Artists, and was elected a member. He got rid of the accumulated Westian concepts of history painting in one last grand gesture in London, before his return in 1769, by painting an allegorical machine 8 feet high of William Pitt as a Roman Senator and executed a 2-foot engraving of it. After the financial failure of the project he attempted this kind of subject only once again, when he was carried away by sentiment at the ratification of the Constitution and painted a gigantic transparency typifying the genius of America. Then he settled down to painting the prosaic portraits his fellow Americans could understand and would pay for.

Peale's portrait style was rooted in the forthright realism of Copley. His *Mrs. Thomas Harwood* (c. 1771, plate 251) is strikingly close to Copley in its intensity of focus, feeling for material reality, and presence of personality. Though somewhat rigid in pose and less accomplished in handling than a Copley, it is, if anything, more sensuous in its pigment and warmer in feeling and has a greater immediacy of rapport between sitter and painter. Peale's *Family Group* (1773, with later additions 1809, plate 252) exhibits an adventurousness in composition and a complexity of psychological interplay which may have resulted from his European experience. The sharpness of outline

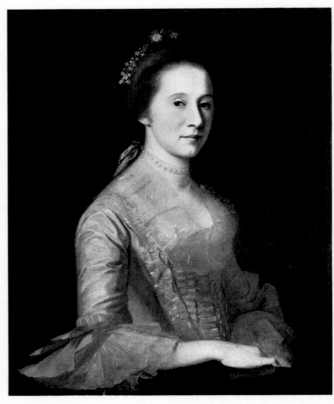

251 Charles Willson Peale. *Mrs. Thomas Harwood*. c. 1771. Oil on canvas, 31 × 24½". The Metropolitan Museum of Art, New York. Morris K. Jesup Fund, 1933

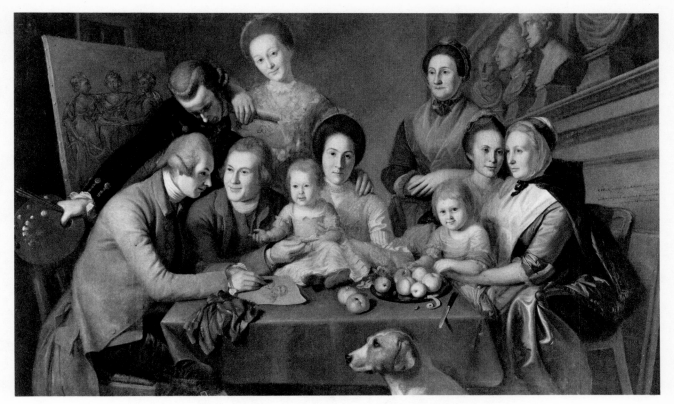

252 Charles Willson Peale. *Family Group (The Peale Family)*. 1773, with additions 1809. Oil on canvas, 56½ × 89½″. The New York Historical Society

and tightness of modeling are much like Copley's, but the sense of animation which pervades the composition, the sprightliness in expressions, and the general homely warmth of the scene are entirely Peale's. Although the figures are too crowded in the incompletely developed space and the actions of some are distractingly centrifugal, there are also passages of real achievement: the portraits of his brother, St. George, on the left, his wife, Rachel, in the center, and his mother on the extreme right; the beautifully handled still life on the table; and the remarkable characterization of the homely dog.

Peale's later serious efforts as a portrait painter, when he was not involved in the business of Washington effigies, the routine recording of the physiognomies of Revolutionary heroes, and the demands of the museum, are a culmination of Colonial portraiture. They reveal a new breadth in composition and sophistication in handling and, despite a recurrent difficulty in drawing, a heightened level of psychological penetration. Among such interesting portraits are those of *William Buckland* (1774–87, Yale University Art Gallery, New Haven), the Annapolis architect, and *John Philip de Haas* (1772, plate 253), Washington's quartermaster, in which Peale handles figures in clearly defined ambience and specific light with an inventiveness that goes beyond Copley in conception if not execution.

Peale's last great effort in portraiture, aside from the very late self-portrait, *Artist in His Museum* (1822, Pennsylvania Academy of the Fine Arts, Philadelphia),

and that of his brother James, the *Lamplight Portrait* (1822, Detroit Institute of Arts), was the double portrait of his sons Raphaelle and Titian, the *Staircase Group* (1795, colorplate 20). Conceived as a "deception," or *trompe l'oeil,* and set in a door frame with an actual wooden step at the bottom when exhibited at the Columbianum in 1795, it was Peale's supreme effort at the faithful rendition of nature. The composition of the two boys mounting the stairs and looking back into the room captures the reality of the moment so convincingly that it seems more a genre painting than a portrait. There is, surprisingly, no hesitancy in the conception and manipulation of mass, space, and light, all of which are managed simply and directly and not without sophistication. The complexities of light and shade are treated with great subtlety and, in the case of the younger boy who turns back around the corner, with appealing sentiment. The crisp, clear realism, different from Peale's earlier work in its increased sharpness of focus, emphasis on precision of outline, and purity of local color, is surprisingly similar to the French Neoclassicism of the period or perhaps the work of Wright of Derby, the English painter famous for his genre scenes by artificial light.

Peale's "gallery of heroes" portraits are more interesting as records of historical personages than as works of art, though occasional examples like the old *Benjamin Franklin* (1785, Pennsylvania Academy of the Fine Arts, Philadelphia) and the pouter-pigeon *John Adams* (c. 1791–94) or the dashing *John Paul Jones* (1781; both

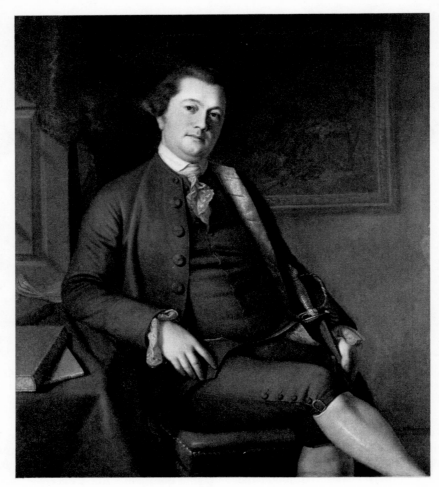

253　Charles Willson Peale. *John Philip de Haas*. 1772. Oil on canvas, 50 × 40″.
National Gallery of Art, Washington, D.C. Andrew Mellon Collection

Independence Hall Collection, Philadelphia) show acuity of characterization and sprightly shorthand rendering. Peale's painting efforts after the *Staircase Group* were rare, and interesting more for subject than quality. Throughout his life, even in his prime, he was an uneven and often slipshod painter, and one should remember him only at his best, as the humble, sympathetic but acute witness to the substantial worth of his Early Republican contemporaries.

William Dunlap, the "American Vasari," rarely missed an opportunity to draw a moral lesson from the lives of his subjects; Ralph Earl (1751–1801) rightfully earned Dunlap's opprobrium so far as drink was concerned, but he certainly did not deserve that mediocre painter's scorn of his art as being a travesty of Copley's. Earl, despite his shortcomings and unevenness, was a painter of unusual power and remarkable natural gifts. Only fairly recently have many of his works been rediscovered and his artistic personality reestablished, and still little is known of his life. He was born in Worcester County, Mass., and worked in western Connecticut. Leaving America because

of his Loyalist sympathies in early 1778, he was active in England until 1785, during which time he married an English wife without the formality of divorcing his American one and, according to his own account, which is open to doubt, studied with Reynolds, West, and Copley. He painted portraits in Norfolk and exhibited at the Royal Academy. On his return to the United States he was active in Connecticut and New York City. He died in Bolton, Conn., of "intemperance," according to Dunlap.

Earl's paintings before his English period are among the finest examples of the native American tradition stemming from Copley. At this point he must have been largely self-taught. One cannot know whether he had seen works by Feke or Copley and whether he was acquainted with the efforts of Connecticut artisan-painters such as William Johnston or Winthrop Chandler, from whom he could have learned nothing about technique. But there is a basic similarity of approach in the realism of his vision and that of Copley and the crude but vigorous images of the Connecticut limners. With all its

gaucheries, Earl's *Roger Sherman* (c. 1775, colorplate 21), is a more powerful image than any projected by either Copley or Peale. This staunch and rock-ribbed patriot, a member of Congress from Connecticut and the epitome of the hard-bitten New Englander, sits in his homespuns on a Windsor chair in an absolutely bare space which is yet the corner of a room. The man himself comes through as rigid and ungainly, but, then, John Adams once described Sherman as "stiffness and awkwardness itself." Earl has seemingly hacked a form out of solid substance, modeled the head, body, and hands with compulsive bluntness, so that they are insistently real. Yet his realism, unlike Copley's, is concerned not with detail but with bold and generalized forms almost abstract in their simplification. In a fundamental aesthetic sense this is not a naive picture, because the relationship between mass and space, interior pattern and frame, light and shade are managed with an unconscious subtlety that is a natural gift. There is also something uncanny in the psychological probity of this portrait. Though head and hands are painted crudely, the character and spirit of the sitter are immediately apparent. The spotting of the bright flesh in the face and hands, of the linen at the throat, and of a triangle of the open vest against the somberness of the brown, black, and earth red of the rest of the canvas reinforces in formal terms this startling and unforgettable image, unquestionably Earl's masterpiece. There are other early works which have something of the same compelling realism, such as the *Reverend Joseph Buckminster* (c. 1775–77, Yale University Art Gallery, New Haven) and the portraits of the Carpenter children, William and Mary Ann (1779, Worcester Art Museum), done immediately after his arrival in England but still in his American manner.

The English experience upset the naive balance of Earl's art without a compensating advance in sensibility or sophistication, except on the most superficial level. He picked up a bag of social symbols, paraphernalia, and manners which he grafted onto his native style with sometimes dispiriting results. Except for *Ann Whiteside Earl* (1784, Museum of Fine Arts, Amherst College), a portrait of his second wife which exhibits some of the English polish he was seeking, the many portraits he executed after his return to the United States are uncommunicative, frozen images of puppets dressed in unaccustomed finery, uncomfortably posed against painted stage sets. But there still is something arresting about such pictures as the Benjamin Tallmadge family portraits (1790, plates 254, 255), the *Chief Justice and Mrs. Oliver Ellsworth* (1792, Wadsworth Atheneum, Hartford), and the Boardman brothers (1789; *Major Daniel Boardman*, National Gallery of Art, Washington, D.C.; *Elijah Boardman*, Collection Mrs. Cornelius Boardman Tyler, Fairfield, N.J.). They have traded unassuming honesty for provincial pretense, but they also have, despite their psychological vacuity, an artistic distinction in color, pattern, and plastic volume. Of all the early American

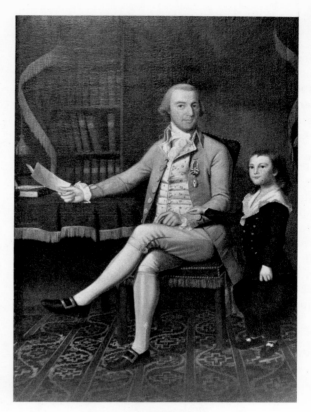

254 Ralph Earl. *Benjamin Tallmadge and His Son William.* 1790. Oil on canvas, 78¼ × 54½". Litchfield Historical Society, Litchfield, Conn.

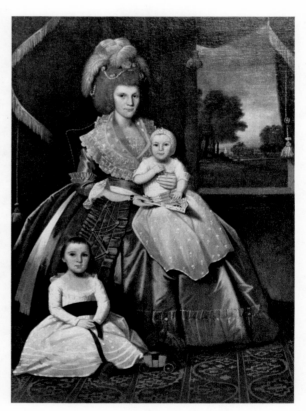

255 Ralph Earl. *Mrs. Benjamin Tallmadge and Her Children.* 1790. Oil on canvas, 78¼ × 54½". Litchfield Historical Society, Litchfield, Conn.

painters Earl appears the one most concerned with purely formal problems, even if on a fairly primitive level, and thus is especially appealing to contemporary tastes.

Earl was the most talented and best trained of an unusually interesting and active group of artisan portraitists working in the Connecticut Valley, beginning before the Revolution and continuing into the nineteenth century. All reflect some of the Copley manner in their blunt and even harsh realism. The style is, however, completely lacking in illusionism, depending for its effect on a fanatical concern with fact, a hard but crisp linearity, and a strong feeling for flat color pattern. Although a flattening of the three-dimensional art of Copley and Earl, it retains an essential dignity and psychological immediacy, and, in the very untutored literalness of rendering, the sense of realism is heightened. Of special interest is the frequent full-length or three-quarter-length figure in a specific and carefully depicted interior. Typical examples are the *Reverend Ebenezer Devotion* (c. 1770, plate 256), attributed to Winthrop Chandler, in which the meticulous rendering of the books on the shelves overwhelms the silhouette of the tightly drawn figure, and the *John Phillips* (c. 1793, plate 257), by Joseph Steward, with its unusual compositional use of a vista through two rooms into a landscape beyond. The latter shows a clear connection with Earl in the general composition, in the patterned floor (sure-handed even in its incorrect perspective), the gold-braided curtain with tassel (as in Earl's Tallmadge pictures), and the landscape seen through the window. A metallic precision in delineation is the hallmark of the Jennys brothers, William and Richard, who, in the incisive and immaculate linearity of their style, created some of the most striking early American portraits (plates 258–261). Working in New York was John Durand,

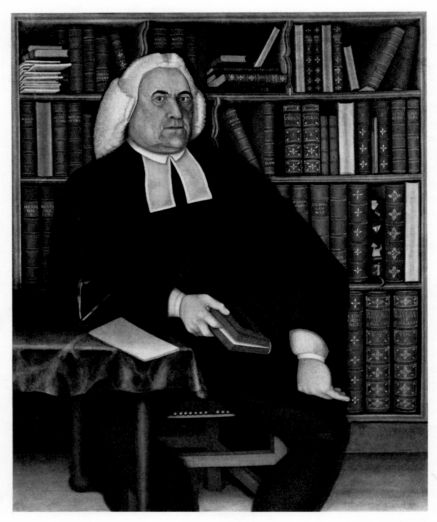

256 Winthrop Chandler (attrib.). *Reverend Ebenezer Devotion.* c. 1770. Oil on canvas, 54½ × 43½″. Devotion House, Brookline Historical Society, Brookline, Mass.

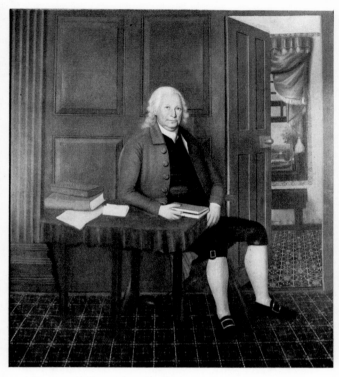

257 Joseph Steward. *John Phillips*. c. 1793. Oil on canvas, 78 × 68″. Courtesy of the Trustees of Dartmouth College, Hanover, N.H.

259 William Jennys. *Dr. William Stoddard Williams*. 1801. Oil on canvas, 29 × 24″. Heritage Foundation, Deerfield, Mass.

258 William Jennys. *Mrs. William Stoddard Williams*. 1801. Oil on canvas, 29 × 24″. Heritage Foundation, Deerfield, Mass.

260 Richard Jennys. *Elisha Bostwick*. 1799. Oil on canvas, 27½ × 20″. New Milford Historical Society, New Milford, Conn.

261 Richard Jennys. *Mrs. Elisha Bostwick.* 1799. Oil on canvas, 27½ × 20″. New Milford Historical Society, New Milford, Conn.

262 John Durand. *Children of Garret and Helena de Nyse Rapalje.* c. 1768. Oil on canvas, 50¾ × 40″. The New-York Historical Society

whose charming portrait of the Rapalje children (c. 1768, plate 262) is something of a throwback to the Hudson Valley painters of the early part of the century.

The artisan tradition continued in rural and frontier areas alongside the more sophisticated art of the major cities on the eastern shore. Well into the nineteenth century, even after the spread of photography, it maintained its vitality and its own artistic formulas even while responding to changing fashions. These painters, as well as the itinerant limners who followed settlers ever farther westward, were not isolated or eccentric "primitives" but part of an active production servicing a whole stratum of American society unable to patronize the leading artists. It is thus possible to see among them a clear and strong cohesion of style, as in the Connecticut group. Although not so apt to imitate stylish formulas as were studio-trained painters, they were quick to adapt basic artistic patterns to their own needs when and where they found them. They were actually an extension of the Copley, Peale, and Earl tradition to a broader economic, social, cultural, or geographic level. The relationship between the two levels in attitude, composition, and iconography is quite clear; only in the artistic transmutation of reality do they part company. The artisan's search for significant form may even make him more acceptable to modern taste than does the sophisticated painter's search for illusionism. It is something of an artistic curiosity that the artisan level during this period inadvertently produced the closest approximation in the United States of the international Neoclassic style in its clarity of form, restraint in movement and expression, controlled linearity of outline, precision in detail, and clean local color, avoiding, in the very nature of technical limitations, attempts at spatial, atmospheric, or coloristic illusion.

Except for Charles Willson Peale, the first group of American painters to study abroad—Matthew Pratt (1734–1805) and Abraham Delanoy, Jr. (about 1740–1790), with West in London, and Henry Benbridge (1744–1812), with Raphael Mengs in Rome—were not very productive or successful. They came home better equipped technically, perhaps, but emotionally less able than their more provincial brethren to face the rigors of American culture. Both Pratt and Delanoy ended as sign painters, and Benbridge, who moved to Charleston for his health, settled down to the undemanding task of filling Theüs's shoes. They may have brought home a new type of portraiture, the conversation piece; they certainly brought no revolutions in style.

Matthew Pratt had some modest gifts, including a feeling for color and pigment for its own sake. He went to London in 1764 after having studied in Philadelphia under his uncle, James Claypoole, a sign painter, and worked as a portraitist for six years in his home city and New York. He spent two and a half years in West's studio and then painted portraits in Bristol for eighteen months. It is therefore puzzling, considering the quality of some

few portraits like the *John Bush* (c. 1786–87, American Antiquarian Society, Worcester, Mass.), that he should have found it difficult to establish himself in Philadelphia as a portrait painter on his return in 1768. His signs were, according to contemporary accounts, extraordinary—possibly the finest ever done in this country. Pratt's failure, if such it was, may have been due to his own retiring nature. Peale described him as "a mild and friendly man, not ambitious to distinguish himself." The introspective poetic quality of gentle calm which pervades his most famous picture, *The American School* (1765, plate 263), would presuppose an artist of some sensitivity. Painted and exhibited in England at the Society of Artists while Pratt was still with West, it represents the latter's painting room. The picture has attained a special niche in the annals of American painting, for it breaks with the hieratic form of the posed portrait, is uniquely complex for Colonial portraiture, and is almost documentary in its depiction of the West studio with a group of young American artists resident at the time. Although no masterpiece, it has an unusually ingratiating charm and sweetness. It is effective in the simple geometry of its composition, the subtle study of light, and the sensitive handling of the two boys in the background but suffers from blatant inconsistencies in proportion and a naive rigidity in the major figures.

Obviously this painting shows no strong influence by West. It is closer in type and feeling to the informal portrait groups, or conversation pieces, produced by the lesser English painters of the period and in the United States by William Williams, whose similar group portraits in landscapes may have come from the same source. In certain ways Peale's *Family Group* belongs to the genre, as do Benbridge's *Gordon Family* (1771) and, later, William Dunlap's *The Artist Showing His Picture of a Scene from Hamlet to His Parents* (1788, plate 264), Joseph Wright's *The Wright Family* (1793, plate 265), and James Peale's *Self-Portrait with His Family* (1795, plate 266). Dunlap and Wright were also students of West, but of the next generation.

When Gilbert Stuart returned to New York in late 1792 or early 1793, he had been away for eighteen years and had achieved international renown. It was as something of a returning hero that he moved the next year to Philadelphia, then the capital of the United States, to become the unofficial painter to the republican "court." Philadelphia was then the gayest and most cosmopolitan of American cities, and its society had decided leanings toward aristocracy. The Washington administration had been "captured" by the Federalists, by wealthy mercantile and landed interests, and some of its adherents were even talking of monarchy and Washington as king. Stuart's

263 Matthew Pratt. *The American School*. 1765. Oil on canvas, 36 × 50¼". The Metropolitan Museum of Art, New York. Gift of Samuel P. Avery, 1897

264 William Dunlap. *The Artist Showing His Picture of a Scene from Hamlet
to His Parents.* 1788. Oil on canvas, 43 × 50". The New-York Historical Society

265 Joseph Wright. *The Wright Family.* 1793.
Oil on canvas, 38 × 32". The Pennsylvania Academy
of the Fine Arts, Philadelphia

reputation, his sophistication, and the natural elegance of his style were tailor-made for this new and ambitious "nobility," and he was an instant success. A Stuart portrait soon became a social cachet. That he was forced by his profession and his own improvidence to serve this pseudoaristocracy must have grated on his intelligence and sensibilities; that he was at the mercy of presumption and pretense certainly increased his irascibility. But he gave them what they wanted. When he became secure enough and crotchety enough, he turned away many whom he found overweening, unsympathetic, or uninteresting. In his time he had to paint too many potboilers, too many vapid or insipid or pompous faces, to get at those that mattered either historically, where he was not often successful, or psychologically, where he rarely failed. Stuart, as has so frequently been said, was a "face painter"; he could or would paint only faces, but at his best, when he found something in the sitter or perhaps in himself, the face reveals all that a face can.

Born near Newport, R.I., Stuart showed an early facility for drawing. He received some instruction from Samuel King, the local limner, and when Cosmo Alexander, a Scottish painter, settled temporarily among his fellow countrymen in Newport in 1769, he took the boy prodigy on a painting trip to South Carolina and in 1772 returned with him to Scotland. Unfortunately, Alexander

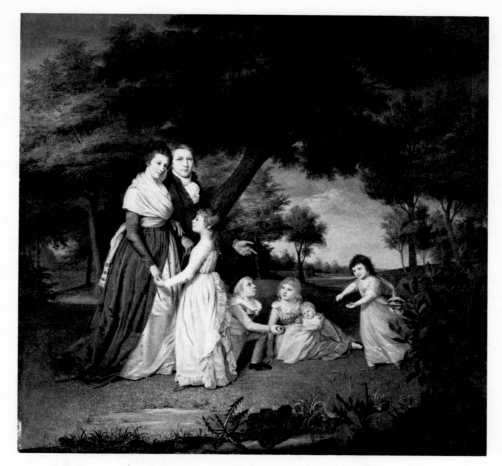

266 James Peale. *Self-Portrait with His Family*. 1795. Oil on canvas, 31 ×
32¾″. The Pennsylvania Academy of the Fine Arts, Philadelphia

died soon after, and the boy was left stranded to find his
way home alone. After some success as a portrait painter
in Newport, he sailed for London from Boston in 1775,
just before the Battle of Bunker Hill. After two years of
deprivation and neglect he swallowed his pride and wrote
to West, who took him in. From 1777 to 1782 he was
West's student and first assistant. Although Stuart re-
mained grateful for West's kindness, he had no high
regard for him as a painter or for history painting as a
métier and little sympathy with high-flown aesthetic
theory. He wanted simply to be a portrait painter.

Stuart portraits exhibited at the Royal Academy in
1781 and 1782 received such acclaim that he felt embold-
ened to set up for himself, but even though he had no
lack of commissions and charged fees exceeded only by
those of Reynolds and Gainsborough, his irresponsibility
in money matters and extravagances in living soon drove
him into debt and the danger of imprisonment. In 1787
he disappeared from London ahead of the bailiff and
turned up later in Dublin, where he again had unparal-
leled success. After five years as kingpin there, with a new
burden of mounting debts, he sailed home. He came
ostensibly to paint Washington's portrait, hoping that
the sale of engraved copies would solve his financial
problems. However, the call on his services was so great
that he put off that project until 1795.

Stuart learned little about portraiture from West. Al-
though he was shrewd enough to borrow from Reynolds
and especially from Gainsborough, for whom he had
great respect, he found what he was looking for by return-
ing directly to Van Dyck. However, he belonged to a new
generation of English painters who were moving away
from the courtliness and artificiality of the older genera-
tion toward a more personal style. He must have learned
something from Romney's informal and natural manner
but is closest to Raeburn, with whom he shares a direct-
ness and immediacy of both pose and execution. Raeburn
and Stuart both favored a direct application of pigment,
and Stuart's style, even more than Raeburn's, became
essentially impressionistic. Although he used a loaded
brush, the paint was applied thinly and unmixed, and his
touch was very light. The result is a vibrant, coloristic
surface that seems to capture the vivacity of living and
breathing beings. Stuart saw the face, not the environ-
ment, gesture, or costume, as expressive of the man, but
he loved the texture of such materials as lace, gold braid,
or brass buttons, and painted them with brilliance. His
faces are composed of a generalized but luminous flesh
tone built into an illusion of three-dimensional form. His
formula called for highlights on forehead, nose, lower
lip, and chin, with a sparkle of light in the iris, a glint of
moisture in the eye, and sharp but transparent touches of

shadow under the brows, nose, upper lip, and chin. Out of such limited means, handled with great subtlety, he achieved a palpable reality. Each stroke is an area of color as well as a definition of form. Depending on his mood or interest, the result was a routine likeness or an unforgettable personality. There is something almost magical in the way he could suggest a sense of vital being, and there is no significant change in style or genius between the *Self-Portrait* (1778, plate 267), done when he was twenty-three, and the *John Adams* (1823, Collection Charles Francis Adams, Boston), done when he was seventy-one, except for a deeper psychological insight and a loosening of touch, both simply the result of age and experience.

Just as Van Dyck had created the image of a Jacobean nobility, Stuart created the image of a republican society. Like Van Dyck, he was prestigious enough to give his clients what he wanted rather than what they might have preferred. Instead of social status and signs of wealth he gave them natural dignity, elegance, élan. He made them seem intelligent and interesting human beings, which may have been a reflection of his own personality rather than theirs. Stuart's reputation has suffered in modern times, because his style of surface painting and technical virtuosity was cheapened and fell out of favor, because his own production was uneven and the many superb portraits are lost in a welter of psychologically uninteresting although often well-painted official pictures, and because of the slipshod copies and routine and cursory efforts he turned out to make a living. As a face painter committed to the externalization of some inner spirit in the sitter, Stuart tended either to slough off details of background and costume or to standardize them. The result is an overwhelming monotony of repeated forms in his total

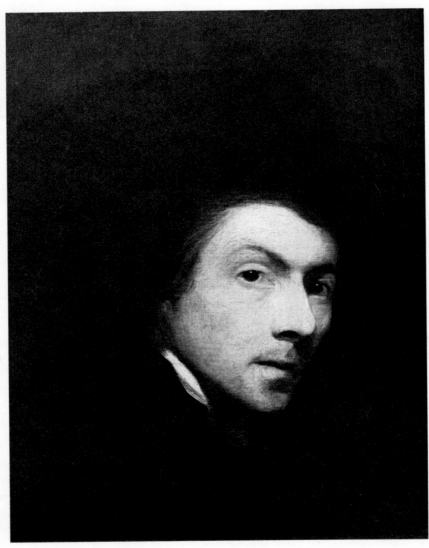

267 Gilbert Stuart. *Self-Portrait*. 1778. Oil on canvas, 16¾ × 12¾". Redwood Library and Athenaeum, Newport, R.I.

production. Added to this is the consistent restraint in emotional projection, the placidity of expression varying within the narrowest of ranges from serious introspection to the flicker of a smile. This combination of understatement and repetitive formula requires a conscious focus of attention on the face itself, and the judgment of excellence depends solely on the subtlety with which he has captured the elusive inner spirit.

Exceptional in character are the portraits of the Spanish ambassador, Josef de Jaudenes y Nebot (plate 268), and his wife, Matilda Stoughton (c. 1794), resembling state portraits in their formality and in the care with which they are painted, and exhibiting the range of his technical virtuosity. There is probably no greater portrait in his total oeuvre than the *Mrs. Richard Yates* (c. 1793, colorplate 22), which updates the whole American tradition of realistic portraiture. The old lady is seen with all the unremitting truth of a Copley, but the shrewd and quizzical expression is pure Stuart, transmitted in a momentary flicker of sight. Although he rarely used gesture, here the angularity of movement in her sewing hands reinforces the caustic glint in her glance. The whole is painted with a controlled fluency far beyond anything done so far in the New World. One might think that Stuart could never surpass the sheer brilliance of this picture, done at the height of his vigor and before he became careless, but, although age and dissipation eventually robbed him of some of his technical mastery, they seemed to deepen his psychological probity and emotional sympathies. His late *Mrs. Timothy Pickering* (c. 1816–18, private collection) is an exquisite study of aged beauty and lyrical mood, in which the lightness of his trembling touch imparts an impressionistic aura of luminosity. One of Stuart's last paintings, the unfinished *Washington Allston* (c. 1828, Metropolitan Museum, New York), stands as a kind of summation and ultimate purification of Stuart's vision. It is a face imbued with the Romantic conception of inspiration, immortal spirit expressed in the forms of mortal flesh.

WASHINGTON PORTRAITS

When Stuart returned to the United States to do a portrait of George Washington, he was entering the flourishing business of manufacturing likenesses of a popular hero whose fame extended far beyond the confines of the thirteen states. As the military leader in a gallant struggle against tyranny and then as president of a new democratic state, Washington had become a symbol for libertarians throughout the world, a romantic hero, the embodiment of "Roman virtue." European governments and private citizens, American states, cities, organizations, and individuals wanted paintings and prints of him. Aside from the monumental versions of his person in sculpture and painting, his appearance was immortalized in smaller

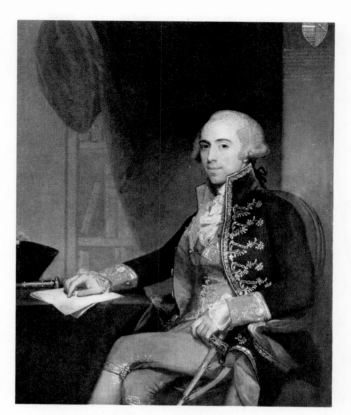

268 Gilbert Stuart. *Josef de Jaudenes y Nebot.* c. 1794. Oil on canvas, 50⅝ × 39¼". The Metropolitan Museum of Art, New York. Rogers Fund, 1907

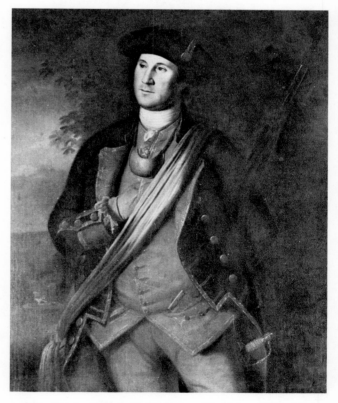

269 Charles Willson Peale. *George Washington.* 1772. Oil on canvas, 60 × 48". Washington and Lee University, Lexington, Va.

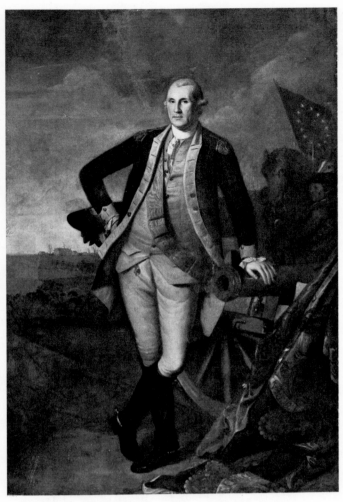

270 Charles Willson Peale. *George Washington at Princeton.* 1779. Oil on canvas, 93 × 58¼". The Pennsylvania Academy of the Fine Arts, Philadelphia

their colleagues. In this mass of Washingtoniana the representations rarely approach the inspiration of the man nor the quality of which the artists were normally capable. Thus the study of these portraits is more important in a historical than in an artistic sense, and less as portraiture than as an aspect of history painting.

The first of the Washington portraits, done by Charles Willson Peale, is the so-called "Colonial type" (1772, plate 269), depicting him as a colonel in the Virginia Militia during the French and Indian Wars. The rather wooden characterization of the youthful Washington is perhaps not entirely the result of Peale's artistic limitations, for the subject never seemed at ease in any of his portraits and was not naturally graceful in movement; indeed, the Washington image was partly one of unspoiled rustic dignity, of the farmer-statesman, the American Cato. In spite of its awkwardness, the portrait is solidly painted, colorful, completely honest even to the Colonel's corpulence, and witness to his physical power and stolid stubbornness of spirit, a quality that none of the later portraits capture. Peale had later done several likenesses, one at Valley Forge, as part of his gallery of famous Americans, and a bust for John Hancock (1776, Brooklyn Museum); but his first official commission for a Washington came from the Pennsylvania Council in 1779. Peale went to Trenton and to Princeton, where he had himself fought under Washington, to do sketches for the background. The outcome was the *George Washington at Princeton* (1779, plate 270), in which the Commander-in-Chief is shown standing, legs crossed, leaning on a cannon, with prisoners under guard in the background. As a heroic image it is rather ludicrous; the excessively lanky and disjointed Washington is caught uncertainly between dignity and friendliness. However, this "Continental type" was an immediate and complete success, and Peale made many replicas of it. He also did a somewhat similar full-length representing *Washington at Yorktown* accompanied by Lafayette and his aide, Colonel Tench Tilghman (1784, State House, Annapolis, Md.), commissioned by the Maryland Legislature in 1781. Both these pictures served as the basis for a Peale industry in Washington portraits. The client could have, according to price, full-, half-, or even bust-length versions; elements were interchangeable, and backgrounds could be varied to fit particular conditions or preferences. Replicas were produced by Peale himself, his brother James, or with the help of James and his own sons. The head of Washington in these two basic types seems close to the early "Colonial" portrait, but in 1787, at the Constitutional Convention, Washington posed for him again, and the bust likeness called the "Convention" portrait was the result, frozen in expression and heavy-handed in execution, the least successful of Peale's Washington repertory but variously copied. In 1795, after the success of the Stuart *Washington* threatened to cut into the family's monopoly, Peale asked Washington for a last sitting. The request

paintings, miniatures, engravings, and in representations on glass and china, clocks, mirrors, and wall plaques; it was printed on textiles and reproduced in porcelain figurines. Along with the American eagle, his head became the ubiquitous symbol of republican America long before his likeness graced our money, medals, and stamps. The earliest official representations were monuments by the foreigners Jean-Antoine Houdon, Antonio Canova, and Giuseppe Ceracchi (see Chapter 9), but painted versions by American artists were far more common, for the obvious reasons of cost, availability, and use. With time the authenticity of the likeness became increasingly important, and after his death the image "from life" took on added value. Since Washington posed only reluctantly, and, even had he enjoyed it, the demand would have been beyond endurance, such life sessions were rare and especially significant. To fill the clamorous demand, artists turned out copies of the originals, and those who had not been granted a sitting simply plagiarized the works of

was granted, and Charles turned up with his brother James and his sons, Raphaelle and Rembrandt, all of whom set up their easels and went to work. They were all then officially "life" painters of the great man. (Before this, in 1786, James had branched out on his own with *Washington and His Generals at Yorktown,* of which he made many copies.)

That Peale failed to achieve the heroic image is understandable, since he was by temperament and training ill-equipped to manage grandeur. John Trumbull was by training and avowed intention prepared for the challenge, yet his efforts were as disastrous as Peale's. Trumbull's earliest essay was a copy done in Boston in 1778 (Yale University Art Gallery, New Haven) of Hancock's Washington bust by Peale. In London in 1780 Trumbull painted from memory a full-length *Washington* against a background of West Point seen across the Hudson (Metropolitan Museum, New York). Since Trumbull had not had an opportunity to do Washington from life, the head is based on the copy he had done of the Peale por-

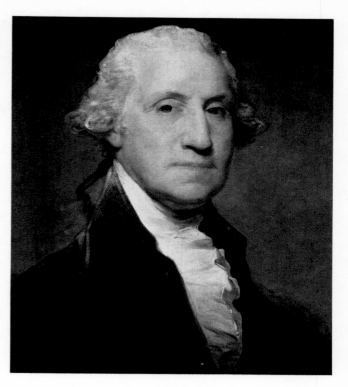

272 Gilbert Stuart. *George Washington.* 1795. Oil on canvas, 29¼ × 24″. National Gallery of Art, Washington, D.C. Andrew Mellon Collection

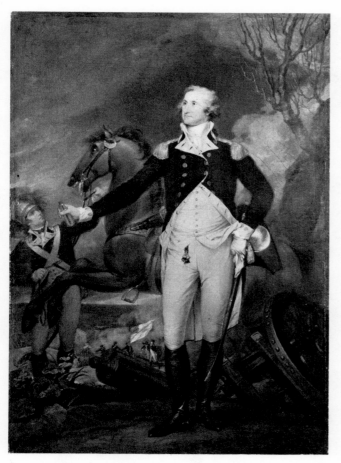

271 John Trumbull. *General George Washington Before the Battle of Trenton.* After 1792. Oil on canvas, 26½ × 18½″. The Metropolitan Museum of Art, New York. Bequest of Grace Wilkes, 1922

trait, but the rest is an effort at heroic conception. The dramatic sky, the exotic, turbanned black servant, and the horse are intended to add action, but the hero is thin and ineffectual in presence as well as in gesture, and the carefully and tightly painted forms are too small to carry a monumental theme. The likeness is not close to the more commonly accepted examples, but this was the Washington known to many Europeans, for it was engraved in England in 1781 and copied extensively abroad. Clearly more Romantic in feeling and more accomplished in execution is Trumbull's *George Washington Before the Battle of Trenton* (plate 271), done after 1792 for the City of Charleston and existing in several versions. Here the battle in the background, the denuded tree against a turbulent sky, the shattered cannon on the ground, the dragoon restraining the rearing charger, and the theatrical stance and gesture of the General are all elements that became the stock-in-trade of nineteenth-century Romantic military portraiture, and in that sense the painting is prophetic and interesting. But Trumbull did not manage to convey, as he had hoped, Washington's "military character in the most sublime moment of its exertion." The result is all pose and no action and lacks the movement and fire of a truly Romantic picture.

It took the antiheroic Stuart to achieve the image that has remained unalterable down to our own time, but it was the person and not the historical symbol that became the icon, for Stuart's own attempts at monumentality

also failed. The first sittings, in March, 1795, were something of a fiasco in human terms, although the so-called "Vaughan type" (plate 272), which came out of the sessions, was a creditable picture. Stuart was awed and completely nonplussed by the psychological fortress of Washington. He had perhaps expected that even Washington might be awed by the artist's reputation, but the sitter was not easily awed and certainly not by an artist. The "Vaughan" portrait, bust-length and completely free of any symbol of office, presents Washington as an individual and captures his stoniness, the expression of both his rigidity of personality and his monolithic strength of character. This quality in the man defeated Stuart's natural vivacity of spirit and lightness of touch; he was dissatisfied with the result, although, when it was exhibited in his studio in April, he received immediate orders for thirty-nine copies. Fifteen existing replicas are accepted as from his own hand. These vary slightly in detail: in the queue ribbon, the jabot, and the color of the background.

In 1796, through the good offices of Martha Washington, Stuart had another chance. According to Stuart's own account, talk about horses and farming stirred the great man into a semblance of animation; at any rate, the result, which pleased Stuart, is the "Athenaeum" portrait (plate 273). He never completed the background of that painting, nor of the companion *Martha Washington,* apparently in order to keep it as a model for copies. It became his potboiler, his "hundred-dollar bill," the price he charged for a replica when he was short of cash, and it is estimated that Stuart himself did some seventy versions. It was closer to the essential manner of Stuart than the "Vaughan" portrait, more fluent in handling, more animated in expression, infused with a vital spirit despite the disfigurement of the mouth due to Washington's new set of false teeth. But it lacks something of the forcefulness and dignity of the earlier portrait. It was a better Stuart but perhaps a worse Washington. However, it is the image that people accepted and still do.

The demand for a statelier and more official portrait

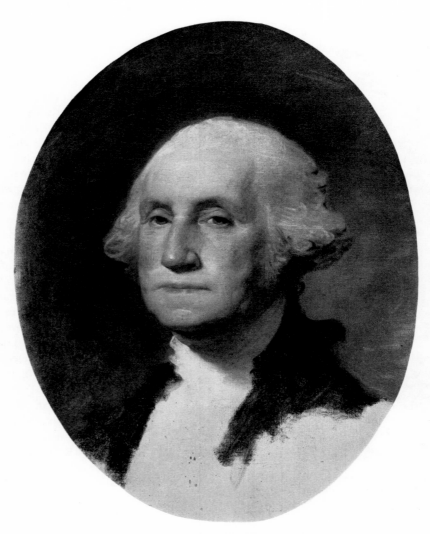

273 Gilbert Stuart. *"Athenaeum" Portrait of George Washington.*
1796. Oil on canvas, 39⅝ × 34½". Boston Athenaeum,
on deposit at the Museum of Fine Arts, Boston

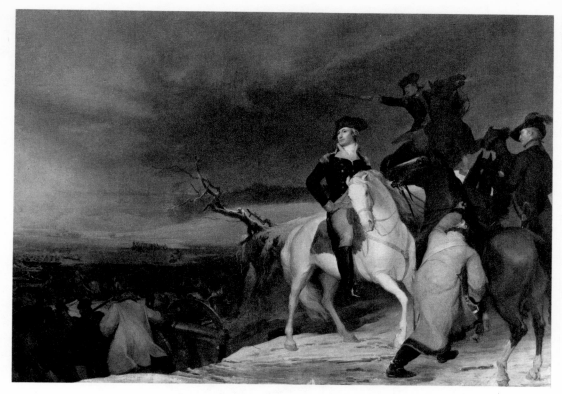

274 Thomas Sully. *The Passage of the Delaware*. 1819. Oil on canvas, 12′2½″ × 17′3″. Museum of Fine Arts, Boston. Gift of the owners of the Old Boston Museum

eventually led Stuart to attempt what he must have known was beyond his powers. The full-length portrait of Washington in his office was intended as a gift for the Marquis of Lansdowne, a famous English Whig, and is thus called the "Lansdowne" portrait. Although competently painted, it lacks any breath of animation; it is an uninspired and cluttered machine, a dismal failure. This did not, however, keep him from executing a number of copies. Knowing Stuart's acute critical intelligence and his capacity for self-evaluation, one wonders why in 1806, at the behest of the city of Boston, he tried another monumental portrait in the *Washington at Dorchester Heights* (Museum of Fine Arts, Boston). Here even the constrained competence of the "Lansdowne" is missing. The romantic animation he attempted was foreign to his nature, and the grotesquely distorted figure of the General is overshadowed by the rear end of the ungainly white horse. These were Stuart's only attempts at monumentality. By his very nature he was suspicious of hero worship and grandiosity.

Perhaps the finest painting in the Washington iconography, although it is more a historical picture than a portrait, is Thomas Sully's *The Passage of the Delaware* (1819, plate 274), commissioned by the state of North Carolina in 1818. The painting is Romantic without being melodramatic, heroic without pomposity, and, of all the representations of the General in military action, the only one to achieve credibility. In spite of such stock elements

as the gnarled tree branch, the rearing horses, and the rather theatrical gestures of the officers around Washington, there is a distinct sense of reality in the winter landscape and the action of the foot soldiers. It may not be painted with complete authority throughout; it was, after all, Sully's only effort at monumentality, and Washington seems somewhat remote from the scene, but the composition is original and the strong diagonal movement motivated and compelling.

A few other noteworthy representations of Washington should be mentioned. Joseph Wright, a gifted student of West who died young and is noted mostly as the designer of the first coins and medals for the United States Mint, painted a fine profile head in several copies. The Swedish painter Adolph Ulrich Wertmüller, who had achieved a reputation in Europe with his meticulous portraits of royalty and nobility, painted a *Washington* from life in 1794, convincing in its apparent verisimilitude but, as Rembrandt Peale so aptly observed, with a "German aspect."

The culmination of all the Washington worship is exemplified by the fanatical dedication of Rembrandt Peale to the cult of "Pater Patriae," which is what he called his last effort to achieve the perfect image, the "Porthole" portrait of about 1823 (plate 275). It is obviously an effort to achieve a deification by consensus—handsomeness, dignity, strength, will, and emotional fire. Set in a painted *trompe l'oeil* oval frame simulating cracked stone,

275 Rembrandt Peale. *George Washington* (the "Porthole" portrait). c. 1823. Oil on canvas, 36⅛ × 29⅛". The Metropolitan Museum of Art, New York. Bequest of Charles Allen Munn, 1924

it presents something of spiritual "deception" in its patent appeal to patriotism and hero worship. It never supplanted the Stuart "Athenaeum" in popularity, although Rembrandt spent the last thirty-five years of his life painting replicas and lecturing throughout the country on the true likeness of Washington, exhibiting his "Porthole" portrait along with copies of all the other well-known versions, and eventually billing himself as "the only living painter who ever saw Washington." The painter had achieved a final distinction through time itself. With the help of his wife, he produced some eighty copies of the "Porthole type."

HISTORY PAINTING

Unlike the portrait painters, who had only to compete in satisfying a demand, the history painters had to create a demand. They seemed convinced, although history belied them, that the nation's taste had matured enough to recognize history painting as the highest aspiration of culture, and that the United States had a special patriotic duty to memorialize the example of its struggle for in-

dependence and the rights of man to inspire the whole world. Schooled in European historical painting, men such as Trumbull and Vanderlyn declared themselves ready to immortalize the War of Independence—in Trumbull's own words, "the noblest series of actions which have ever presented themselves in the history of man." All they required was financial support, but this did not materialize, and the grandiose dream of a national historical art vanished. Their assumptions were wrong. The American public was not ready, and, even when art broke out of the tight frame of portraiture, it was not to history painting that it turned, but to more personal, intimate, and prosaic forms. The men who had counted on an enlightened cultural milieu and a nation grateful for their genius were sadly disappointed. Trumbull, Vanderlyn, and Allston found not so much opposition as lack of interest and lethargy, and their creative lives were tragically aborted, for they were the artists most firmly committed to history painting.

They were, however, not the first American artists who attempted to move beyond the confines of portraiture. West and Copley were among the leading European his-

tory painters at the end of the eighteenth and beginning of the nineteenth centuries, and it is really something of a wonder that so few of West's American students caught his enthusiasm. Pratt made some copies of mythological subjects and old masters, but only Peale, of the early students, tried a mythological subject on his own, the horrendous *William Pitt*. Only among his later students —Trumbull, Allston, and Rembrandt Peale—did West's influence become pronounced. By that time his Classical manner was long forgotten and the Romantic mode was in the ascendancy.

In background, experience, training, and talent John Trumbull (1756–1843) was particularly equipped to be the painter of the American Revolution. That he failed to achieve what he might have was as much the fault of his character as of historical circumstance. As the son of the Revolutionary governor of Connecticut, he had entrée to the highest circles of American politics and society; he knew Washington, Jefferson, and Adams; he fought in the Revolution as an aide to Washington and Gates; he studied with West and was befriended by David; he had a heroic project and passionate ambition. Yet, suspicious, cantankerous, self-centered, too quick to take umbrage, too intent on righting supposed wrongs, unforgiving and eventually bitter, he bickered away his chances at greatness. Trumbull expected a great deal from his country and his fellow countrymen, and when it was not forthcoming, he resentfully sacrificed his art for other paths to glory.

He was set on being a painter, but at his father's insistence he entered Harvard, where he maintained his interest in art. He took the opportunity to visit Copley and receive his criticism and advice and after graduation in 1773 taught school and did some painting. He joined the army in 1775 but resigned in a huff in 1777 because he felt he had been slighted in the dating of his promotion to colonel. He then rented Smibert's old studio in Boston and continued to paint until 1780, when he went to London with the hope of continuing his career, but after being imprisoned as a spy in reprisal for the Major André incident and bailed out by West and Copley, he was forced to return home. In 1784, however, he was back in London studying with West. Unlike Stuart, who was working there at the time, Trumbull was interested in history painting.

After an early essay in Classical mythology, *Priam Returning with the Body of Hector* (1785, Boston Athenaeum, deposited in the Museum of Fine Arts, Boston), Trumbull turned to contemporary history and his project for a history of the American Revolution. He was encouraged by West and later by David, who saw in him a fellow propagandist in the cause of liberty, and was assisted in the selection of twelve episodes by Adams and Jefferson, who took a continued interest in him and his project. During the next decade he worked in London, Paris, and the United States on sketches for the proposed

scenes and portraits from life of the participants. In 1789 he came back to America hoping to launch a subscription series of engravings after the sketches, but the response proved insufficient and he dropped the project in a mixture of pique and despair.

Turning his back on art, Trumbull accepted a post as secretary to John Jay in 1794 and was appointed one of the American Commissioners for the Jay Treaty in 1796. After a period in New York, where he painted portraits with indifferent success, and in London, he resumed his lobbying for government support of his old project in 1815. By this time Vanderlyn's backers were also active, but Trumbull's political support was more forceful, and in 1817 the Congress voted $32,000 as a commission for four of the paintings for the Rotunda of the Capitol. In the same year he was elected president of the American Academy of Fine Arts in New York. For the next decade he was something of a dictator on the American art scene, but his Rotunda paintings were not well received, and his authoritarianism drove the younger painters out of the American Academy. Trumbull spent his last years a rejected and bitter man. In 1831 he gave his paintings to Yale College in return for a life pension.

When Trumbull's paintings for the Rotunda were sent on tour to several cities before being put in place, there was a good deal of carping criticism, since he had made many enemies. The literal-minded found fault because some characters who had been absent at the signing of the Declaration of Independence were included and some who had been there were not, but the public had a right to its disappointment, because so much had been expected and the results were dull. Perhaps Trumbull's opportunity had come too late—the large finished paintings lack the fire and technical brilliance of the earlier sketches—but it may also be that he was not truly a monumental painter. The very qualities of passion and movement which characterize the sketches, achieved by fluent brushstrokes defining forms in a coloristic sparkle, could not easily be reproduced on a larger scale, where individual brushstrokes were lost in larger forms. Unfortunately, Trumbull, for ideological reasons, selected four scenes that were by their very nature difficult to dramatize, two of which were not among the original sketches. He thus had to supply two new compositions— *The Surrender of General Burgoyne at Saratoga* (c. 1816) and *The Resignation of General Washington at Annapolis* (c. 1817)— some twenty years after he had laid the project aside, and had to paint two others about thirty years after making the original sketches—*The Declaration of Independence* (1786–97, plate 276) and *The Surrender of Lord Cornwallis at Yorktown* (before 1797). None of the more exciting and dramatically inspired battle scenes—*The Battle of Bunker Hill* (1786), *The Death of General Mercer at the Battle of Princeton* (1787, plate 277), and *The Capture of the Hessians at Trenton* (1786)—was included in the commission, and Congress refused to allow Trumbull

276 John Trumbull. *The Declaration of Independence, July 4, 1776.* 1786–97.
Oil on canvas, 21⅛ × 31⅛″. Yale University Art Gallery, New Haven

to cover the four remaining panels of the Rotunda.

The eight original sketches (Yale University Art Gallery, New Haven), especially the battle pictures, and the small, almost miniature, portrait studies for the series are unquestionably Trumbull's finest work. The rest of his production—historical pictures, landscapes, and portraits—is inconsequential, at best routine and at worst unbelievably hard and dull. In portraiture, at least, one would have expected more, for his earliest portraits, before he went to England, were remarkably powerful, although still almost primitive in technique. His *Jonathan Trumbull and Family* (1777, Yale University Art Gallery, New Haven), in the tradition of Copley and quite close to Earl in its bluntness, indicated a unique and personal vision.

The major source of his style was clearly that of West, but the West of the eighties, when his proto-Romanticism was coming to the fore. West's Romanticism precedes the Romantic Movement proper by some thirty years, although it is not consistent in his work or in development. Trumbull avoided West's turgid religious pictures and went back instead to the *Death of Wolfe* (colorplate 14) as a starting point for his American history series. The influence of that picture is clearly seen in Trumbull's *Death of General Montgomery in the Attack on Quebec* (1786, colorplate 23). But Trumbull's sketches have a quality that does not derive from West, a truly light and painterly touch, a delicate vivacity that relates to the Rococo but is put to an entirely different purpose. Trumbull had transformed the studied academicism of West's historical tableaux into a vital representational style. The battle sketches are carefully thought through; coherently composed; full of movement, dramatic action, and emotion expressed in fluid, rhythmic paint passages of luminous, although restricted, color. These are authentic Romantic paintings presaging a brilliant future, but they remained the total and the end, rather than a beginning. The dainty little portraits have a delightful quality all their own, even more Rococo than the historical sketches, buoyantly spirited yet intelligently controlled, acute in characterization, and as charming as porcelain figurines. Seen against these assured, accomplished, and exciting youthful efforts, the rest of Trumbull's artistic life seems a sad anticlimax.

The life of John Vanderlyn (1775–1852) was artistically more frustrating and personally even more tragic than that of Trumbull, his archrival who closed so many avenues to him. But, as in the case of Trumbull, the circumstantial difficulties do not entirely explain the meagerness of his total artistic production. Vanderlyn's earlier life was as favored as his later was clouded. He was born in Kingston, N.Y., the grandson of the Hudson Valley limner Pieter Vanderlyn. As a boy he worked for Thomas Barrow, owner of an art-supply and print shop in New York, and studied for two years with Archibald Robertson, who ran a fashionable drawing school. A copy Vanderlyn made of a Stuart portrait of Aaron Burr brought him to the attention of that famous and powerful political figure, who saw in the boy a native genius to be fostered. Burr's patronage eased Vanderlyn's path in the early years, just as Burr's later disgrace made things difficult for the painter who had become so closely identi-

fied with him. Burr arranged for him to study with Stuart in Philadelphia for several months before sending him to Paris in 1796 to complete his schooling. Vanderlyn was thus the only American painter of the time to study in France, and, under the tutelage of François-André Vincent, a rival of David, he was trained in the French Neoclassic manner of precise draftsmanship and clear sculptural modeling.

Returning to New York in 1801, he did portraits of Burr and his daughter, and at Burr's suggestion went to paint several views of Niagara Falls with the hope of marketing engravings of this most famous natural wonder of the New World. These studies (Senate House Museum, Kingston, N.Y.), among the earliest representations of the falls, are straightforward records except for one in which the dominant form of a stark, dead tree presages the later development of Romantic landscape painting. Other studies of that period reveal a solid Neoclassic style with distinct Romantic overtones.

From 1803 to 1805 Vanderlyn was again in Paris. During this time he had his Niagara views engraved in London and was commissioned by Robert Fulton to paint *The Death of Jane McCrea* (1803–05, Wadsworth Atheneum, Hartford) to illustrate Joel Barlow's *The Columbiad*. Solidly painted in part, it remains a curious and ineffective mixture of Romantic violence in theme and restrained Classicism in handling. Vanderlyn stayed in Rome from 1805 to 1808, during which time he painted his *Marius Among the Ruins of Carthage* (1807, M. H. De Young Memorial Museum, San Francisco), exhibited at the Paris Salon of 1808, and was awarded a gold medal by Napoleon himself. The *Marius* is a typical Neoclassic academic machine with the right kind of moralistic theme, the correct emotion, and all the required archaeological details, but it completely lacks any freshness of feeling or observation, and, what is perhaps even worse in a Neoclassic work, any real elegance or refinement of drawing. While in Paris, Vanderlyn completed his *Ariadne Asleep on the Island of Naxos* (1812, colorplate 24), unquestionably his finest historical painting. Samuel Isham's apt description of the *Ariadne* as an example of Vanderlyn's French Neoclassicism, made many years ago, is still relevant: "An admirable piece of solid modelling, an academic study from the life, rather devoid of charm, the legs and feet being especially clumsy and inelegant, but executed with a faithfulness and capacity unknown in England." And certainly unknown in America. It was not only the standard of technical competence and the conception of theme, but the nude itself which was foreign to American experience.

On his return to the United States in 1815, the "gold-medal winner" did not receive the acclaim he had expected. Trumbull's return the same year further hurt his chances, and in 1817 he decided to try his fortune with a panorama based on sketches he had made of Versailles in 1814 (Senate House Museum, Kingston, N.Y.). Vanderlyn had probably seen the panorama that Robert Fulton showed in Paris (beginning in 1800), and possibly those of Robert Barker in his Rotunda in Leicester Square, London. The panorama promised well here,

277 John Trumbull. *The Death of General Mercer at the Battle of Princeton, January 3, 1777.* 1787. Oil on canvas, 20½ × 29⅞". Yale University Art Gallery, New Haven

since it was planned to have public appeal, combining the excitement of the theater and the cultural tone of the art exhibition. But Vanderlyn's panorama was not a success.

Recently restored to its original condition, this earliest extant American panorama, the only one by a recognized artist of stature, is stylistically unlike any other of Vanderlyn's works; presumably most of the actual painting was done from Vanderlyn's designs by assistants. From resemblance to theatrical scenery one can guess that the executants were scene painters. However, the figures have a verve and authenticity which makes their attribution to Vanderlyn likely, and the crisp clarity of the architectural rendering would indicate his close supervision.

He had taken a lease on a corner of City Hall Park, New York, and there erected a rotunda with borrowed money. Here he exhibited in 1819 *The Palace and Gardens of Versailles* (1816–19, plate 278). In adjoining rooms were also shown his *Jane McCrea, Marius,* and *Ariadne,* as well as his copies of old masters. He thought of the exhibition as a first step toward a national museum of art which would also help make his reputation. The panorama would attract the public, and the other paintings would elevate its taste. But the nude *Ariadne* created a minor scandal, which did not help Vanderlyn's public image, since the unfavorable publicity was used to his disadvantage by the Trumbull faction. In a puritanical society the nude was both excessively disturbing and titillating, and the case of the *Ariadne* was made doubly difficult because Vanderlyn was also exhibiting his copies of Titian's *Danaë* and Correggio's *Antiope,* and New York had just recently been scandalized by Jarvis's exhibition of Wertmüller's *Danaë,* a meticulously painted and excessively naked nude. Still, the prurient interest in nudity could prove profitable, and some artists tried to exploit the market. In 1811 Jeremiah Paul showed a 7-by-9-foot canvas of *Venus and Cupid* and an equally large *Adam and Eve,* advertised as having been "taken from live models," which outraged many, including William Dunlap, who later found Vanderlyn's *Ariadne* entirely moral in tone. In 1818 a Philadelphia museum charged twenty-five cents admission to a special room where one could see ten anatomical wax figures as well as paintings of nudes. There may have been some shock at such displays, but no longer did the nude have to be hidden as Robert Edge Pine had earlier had to hide his cast of the *Venus de' Medici,* to be shown only by appointment.

The failure of the Vanderlyn panorama was due to mismanagement and perhaps to the unexciting character

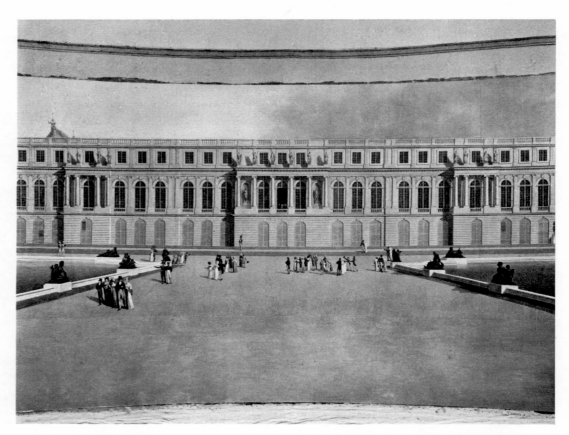

278 John Vanderlyn. Detail of panorama: *Palace and Gardens of Versailles.* c. 1819. Oil on canvas, 12 × 165′. The Metropolitan Museum of Art, New York. Gift of the Senate House Association, Kingston, N.Y., 1952

of the theme. The city canceled the lease in 1829, leaving Vanderlyn in debt and discouraged. He retired in frustration and bitterness to Kingston, where he spent most of the rest of his life in slow and solitary deterioration. In 1832 friends with political influence got him a commission from Congress to do a full-length *Washington,* and at long last in 1837 a commission for *The Landing of Columbus* to fill one of the Capitol Rotunda panels, but by that time the task was beyond Vanderlyn's technical capabilities. He took the money and spent two years (1842–44) in Paris supervising the painting of the commission. He seems to have done little more than design the picture; all the evidence points to its having been carried out by local French painters.

Vanderlyn's failure is a sad one, for he was an artist of real talent, as a few of his portraits reveal. If we had only his self-portrait (c. 1814, plate 279), we would have clear evidence of his capacities. It is his best work, worthy of comparison with portraits by students of David. It has all the Davidian precision in drawing, firmness in modeling, and enamel-like color. More than that, it is a sensitive and spirited evocation of character, one of the finest portraits painted by an American.

Though Washington Allston (1779–1843) belonged to the generation of history painters, he was also America's first truly Romantic artist. Like Trumbull, he was influenced by West's proto-Romanticism, but, arriving twenty years later, he became involved with West's later Romanticism rather than earlier historical themes and preferred characteristically Romantic subjects of mystery, foreboding, terror, or poetic reverie. Instead of Trumbull's positive heroicism there hovers over Allston's work a brooding sense of melancholy. The shift is fundamental, from an outer- to an inner-directed art, from a social to a personal statement, from reality to the imagination. As part of the first generation of nineteenth-century European Romantics, Allston was caught up in everything from the rediscovery of Rubens to the search for the indefinable. Even his life was a Romantic drama, and his failure was almost as complete as that of Trumbull or Vanderlyn. As the American sculptor William Wetmore Story wrote to James Russell Lowell years after the painter's death, "Allston [was] . . . stunted on the scant soil and withered by the cold winds of that fearful Cambridgeport." The "cold winds" have commonly been accepted as the cultural climate of America, but one wonders whether the too common failure of American genius can be so easily explained. The body of work that Allston left would indicate that he was something less than the genius his contemporaries thought him to be.

Allston was born to a socially prominent and wealthy South Carolinian family but was educated in New England, first in Newport, R.I., where he received some instruction in art from Samuel King, and then at Harvard, where he tried his hand at writing and painted several themes from a "Gothick" novel of Mrs. Radcliffe, *The*

279 John Vanderlyn. *Portrait of the Artist.* c. 1814. Oil on canvas, 25¼ × 20¾". The Metropolitan Museum of Art, New York. Bequest of Ann S. Stephens, in the name of her mother, Mrs. Ann S. Stephens, 1918

Mysteries of Udolpho, and Romantic scenes, including landscapes with horsemen and *banditti.* He was graduated with honors in 1800, and after a short sojourn in Charleston, left for London to follow a career in art. He studied at the Royal Academy under West and was impressed by the more fantastic art of Henry Fuseli and John Opie. In 1803 he met Vanderlyn and they went to Paris, where they saw the masterworks gathered by Napoleon at the Louvre and Allston took the time to copy from a Rubens. He settled in Rome in 1805 and became part of the Caffé Greco circle, which included his own friends Vanderlyn, Washington Irving, Coleridge, and Thorvaldsen, as well as such famous figures as Keats, Shelley, Turner, Von Humboldt, and Madame de Staël. This must have been heady fare for a young provincial, and Allston absorbed influences like a glutton—Classicism and Romanticism, the grand manner and the poetic mood, the glory of the past and the golden glow of the present, intellectual ideas and emotional impressions.

Boston, on his return in 1808, could not have been as exciting. After several years of painting portraits mostly of his own family, he returned to England. The following years, divided between London and Bristol, were his most productive, and he was establishing an enviable reputation as a painter in the grand manner when, in

1818, he decided to return to the United States. There must have been the still unfulfilled dream of greatness in his own land, the desire to play an important role in the promise that was America in those years after the War of 1812, when the stability of the government had been firmly established and a prosperous future seemed assured. It was no accident that Trumbull and Vanderlyn returned in 1815, and Allston in 1818, all with the same dream of glory. But the "Athens of America" did not live up to expectations. Although he was the center of an intellectual coterie whose adulation was untarnished by his lack of productivity, greatness eluded him. A subscription among friends and relatives to permit him to complete the great *Belshazzar's Feast* (1817–43, plate 280), a painting that he had brought unfinished from England, acted like an incubus rather than an inspiration. It seemed to drain him of decision and kept him from other things, and the more he worked, the less there was to see. In 1829 he abandoned the project only to take it up again in 1839, but it was left unfinished at his death. Allston lived in Cambridgeport from 1830 for the rest of his life in financial security, still revered as the embodiment of American genius but tragically unfulfilled.

Allston was neither decisive nor original as an intellect or an artist. He was essentially a derivative and eclectic painter, hoping perhaps for an eventual synthesis, yet achieving only reminiscences of others. His earliest affinities were with the West of *Death on a Pale Horse*, the terrorful fantasies of Fuseli, and the picturesque wildness of Salvator Rosa. Before his Roman period he produced at least one example of Romantic violence and terror, *The Rising of a Thunderstorm at Sea* (1804, Museum of Fine Arts, Boston), perhaps dependent on Claude-Joseph Vernet or Turner, but still a commendable effort by a young man and one of his most interesting pictures. *The Deluge* (plate 281), which was until recently ascribed to Allston and dated in the same year, has now been identified as a painting of the same title exhibited at the British Institution in 1813 by Joshua Shaw (c. 1777–1860), an English painter who settled in Philadelphia in 1817. The removal of the painting from Allston's oeuvre cleared up the knotty problem of stylistic discrepancies, for it tended to distort our conception of Allston's imaginative powers, but it also removes a fascinating work, one startlingly original in conception.

In Rome (1805–08) Allston, chameleon-like, reflected the current vogue of Italian Campagna painting practiced by an international group of artists resident there. His *Diana in the Chase* (1805, Collection Mrs. Algernon Coolidge, Boston) and the *Italian Landscape* (1805–08, plate 282) recall the more Classical and idyllic aspects of Romantic landscape painting as exemplified by Poussin

280 Washington Allston. *Belshazzar's Feast*. 1817–43. Oil on canvas, 12 × 16'. The Detroit Institute of Arts

281 Joshua Shaw. *The Deluge*. c. 1813. Oil on canvas, 48 × 65¾″. The Metropolitan Museum of Art, New York. Gift of William Merritt Chase, 1909

282 Washington Allston. *Italian Landscape*. c. 1805–08. Oil on canvas, 39 × 51″. Addison Gallery of American Art, Phillips Academy, Andover, Mass.

and Claude, rather than the *terribilità* of Rosa. A turn toward the grand manner of West appears in the work of his second English period (1811–17), when he painted most of his large historical subjects, among which were the notorious *Belshazzar's Feast,* just begun, and the *Elijah in the Desert* (1818, colorplate 25), completed in three weeks before he left for Boston. These historical paintings made his reputation, and they received honors and awards at English exhibitions, but they are, except for the *Elijah,* among his least interesting works. Dominated by Westian conceptions, they are pastiches of the old masters from Raphael to Rubens. The *Elijah* is at least a clear-cut, unadulterated variation on Salvator Rosa, but with a simple power and a harshness of form that is unlike the theatrical picturesqueness of the Italian artist.

On his return to the United States, he painted gentle Romantic dreams, except for an occasional reversion to the blood and thunder of his earlier Gothicism. The best of these, such as the *Moonlit Landscape* (1819, plate 283) and the *Flight of Florimell* (1819, Detroit Institute of Art), were done soon after his return. After 1821 and the *Belshazzar* commission there was not much left. Samuel Isham saw a basic weakness in Allston's art: "Allston erred, as West did, in trying to put into a picture emotions that were not pictorial. His contemporaries had the same emotions and understood. We do not, and it is as unlikely in his case as in that of West that posterity will ever renew its interest in his works." Posterity has a

renewed interest in both West and Allston, but largely for their influence or because of some accidental reference to contemporary taste, as in Allston's *David Playing Before Saul* (1805–08, Gibbes Art Gallery, Charleston, S.C.), a sketch which in its immediacy, passion, and lightness of touch is more convincing than most of his tortured epics.

Thus Allston, like Trumbull and Vanderlyn, remains incomplete—tantalizing in promise, heartbreaking in defeat, only occasionally rewarding in performance. Allston was important as a symbol, remaining throughout his life an image of excellence and a source of inspiration. He helped many aspiring artists to find themselves, but more than that his very being in America had significance. He was the first American artist in the modern sense—a man who worked not for material things but for some higher spiritual goal, who sought for universal values and aesthetic quality. It was an image close to the hearts of the next generation of Romantic artists, and his Romantic landscapes, both the sublime and the lyrical, helped open up new vistas in American art.

The failure of history painting was largely one of patronage. Since history painting, because of its scale and complexity, is a long and laborious process, artists must expect returns commensurate with their investment in time; when commissions and sales decrease, they are forced to look elsewhere for support or abandon the form altogether. During the eighteenth century, those who stayed with the genre turned to the public sale of engraved

283 Washington Allston. *Moonlit Landscape.* 1819. Oil on canvas, 24 × 35″. Museum of Fine Arts, Boston. Gift of Dr. W. S. Bigelow

284 Rembrandt Peale. *The Court of Death*. 1824. Oil on canvas, 11'6" × 23'5". The Detroit Institute of Arts

reproductions of painting as a source of income. This procedure was used with great success by Hogarth. After the middle of the century it was taken up extensively by history painters as an answer to the crisis of patronage. The development of the mezzotint gave added impetus to the growth of engraving as a reproductive technique. The rise of the middle class had shifted the center of artistic patronage from court and church to the public in general and the individual in particular. Many editions of historical prints returned handsome profits, but the inherent restrictions of the engraving in size and color, along with the diminishing returns that accompanied increased production, limited its possibilities.

The public exhibition grew out of this search for a new patronage. As early as 1781 Copley, who was trying to establish a reputation, exhibited his *Death of Chatham* in a rented gallery in competition with the annual exhibition of the Royal Academy, an action that did not endear him to his English colleagues, since it attracted more than twenty thousand spectators, cut into attendance at the Academy, and made him an estimated profit of five thousand pounds. In 1791 he showed his *Repulse of the Floating Batteries at Gibraltar* (1783–91) in a tent pitched with the King's permission in Green Park near Buckingham Palace, to which sixty thousand paid admission. So an American pioneered another new development in European art. In 1799 David followed suit by charging admission to the showing of his *The Sabine Women* in his atelier at the Louvre.

Both the public exhibition and the panorama tapped a new source of public interest. In some cases they were combined into a single show, as in Vanderlyn's exhibition at the Rotunda. Receipts from attendance and the sale of reproductions, if the exhibition were a success, could replace the more traditional patronage. It was a format more adapted to American cultural needs in its combina-

tion of spectacle, curiosity, entertainment, and enlightenment than the commission for a monumental decoration in a public building. But it had to be sold to the public, and this artists and impresarios did with verve, imagination, and acumen, revealing what must be a native American gift for publicity.

However, Vanderlyn's exhibition had not been successful, and the efforts at exploiting nudity had run into too much opposition, although not without profit. It was West again who hit upon the formula for success. In his old age he turned to the public for support, and the great religious sermons he painted and exhibited in London along with explanatory texts made him more money than he had managed as the King's painter. When the Pennsylvania Hospital asked for a contribution in 1816, he sent them his gigantic *Christ Healing the Sick* (c. 1811, Pennsylvania Hospital, Philadelphia), which, displayed in a specially constructed building (the picture being too large for the available walls), brought in twenty-five thousand dollars. Recognition that the American public would respond to religious subjects led to a chain reaction that continued for a half-century.

Perhaps the first to pick up the clue and certainly the most successful was Rembrandt Peale, with *The Court of Death* (1824, plate 284). Peale had done historical paintings after his return from Europe in 1810, but the experience of Wertmüller's *Danaë* restrained him from showing his *Jupiter and Io* (c. 1810–12), and when *The Roman Daughter* (c. 1810–12) was not well received, he abandoned painting, not to take it up again until *The Court of Death*. When completed, this 12-by-24-foot canvas was exhibited and sent on tour for thirteen months in churches, rented halls, and sometimes specially erected buildings, where it was seen by some thirty-two thousand people and earned the artist nine thousand dollars. It was billed as "The Great Moral Painting" and described in a

pamphlet designed to attract the masses by emphasizing that it was painted by a "native" artist; promising a new kind of allegory that anyone could understand, "painting by metaphor"; and proclaiming the potency of a "science" of painting applied to the noblest of purposes, "the expression of moral sentiment." Furthermore, it was described as of equal interest to all "ages and classes," thus excluding no potential customer, and as directed toward the removal of prejudices and terrors of death. One must recognize in this publicity the presence of an advertising talent well aware of the psychological factors in human motivation. The grandeur of the whole concept is demonstrated by the one hundred thousand colored engravings printed for sale at one dollar a copy. In the face of the advertising campaign, the painting is an anticlimax. Though carefully and well composed, it suffers from the Westian fault of overelaboration; each of the twenty-three figures is too active independently to become part of the whole, although individual elements are thoughtfully, even imaginatively, conceived and executed with competence. To modern eyes it may appear an academic contrivance. Even seen sympathetically, it vacillates pictorially between efforts at monumental power and meaningless rhetoric, and philosophically between the profound and the ludicrous. Still, for over a half-century people paid to view it.

At about the same time two historical pictures by Henry Sargent, *Christ Entering Jerusalem* and *The Landing of the Pilgrims,* were on tour. William Dunlap's experience as a theatrical entrepreneur had prepared him for such projects, and, beginning in 1822, he tried the circulation of such pictures in different cities. The first was a "copy" after a description of West's *Christ Rejected* (1814), which had been called "indubitably the greatest performance of modern times" when it was exhibited in London. In 1823 Dunlap added to the tour a copy based on a description and an outline engraving of West's *Death on a Pale Horse* and the next year an original composition, *The Bearing of the Cross.* In spite of declining receipts, he added a fourth item, *Calvary,* in 1828, and when the fifth, *The Attack on the Louvre* (1830–31), was a failure, he gave up with the remark that "nothing but novelty attracts our people." It is clear from Dunlap's account that history painting had become show business rather than art.

The truth of this statement is supported by the failure of Samuel F. B. Morse's *The Old House of Representatives* (1821–22, Corcoran Gallery, Washington, D.C.). The last of West's students to be imbued with the glamour of history painting, Morse tried to extend the limits of portraiture by painting this large scene containing the eighty-six members of the House of Representatives in night session. In an attempt at re-creating reality, he made portrait studies of each of the personages and reproduced Latrobe's architecture with absolute fidelity. The result is an impressive painting of a spacious interior in which

figures are subordinated to the total conception. Seen by lamplight, the splendid individual portraits as well as the magnificent room glow with warmth and color. It is, no doubt, the finest of these historical pictures, but its theme was undramatic, the portraits were too small to be recognized from a distance, and, even when identified by a key diagram, not of compelling interest. Most serious of all, it had no moral purpose. The quality of the painting and the honesty of its reporting were meaningless to a public that wanted sensation and entertainment even if in the guise of religious parables.

LANDSCAPE PAINTING

The more intimate and personal forms of painting—landscape, genre, and still life—later so common in American art, were, if anything, even more neglected than history painting. There was as yet no buying public large enough to support such activities, and the occasional excursions into them were usually by artists who were forced to make a living by portrait painting. However, the emergence of a tradition of landscape painting was discernible. The first post-Revolutionary interest in landscape appeared in the work of Ralph Earl, who seems to have preferred this form from his beginnings. In many of the portraits done after his return from England landscape vistas are unique in their homely truth and naive charm. They are American landscapes, not generalized or Romantic, but particular and descriptive. In his *Mrs. William Moseley and Her Son Charles* (1791, Yale University Art Gallery, New Haven) the Connecticut Valley landscape becomes an important part of the picture, although its relationship to the figures remains ambiguous. Much more significant is his *Looking East from Denny Hill* (c. 1800, plate 285), the first unequivocal landscape painting in America. Despite its obvious provincial shortcomings in composition and drawing, it reveals a combination of realistic observation of the New England countryside and a lyrical mood that presages the Hudson River School.

The native spark did not catch, but smoldered fitfully in a few isolated efforts. John Vanderlyn's drawings and paintings of Niagara Falls have been mentioned earlier. John Trumbull also did several views of Niagara (c. 1807–08), but they, like the earlier versions of Vanderlyn, are more like topographical records to be used as the basis for an engraving or a panorama.

Once more America was to receive a major impetus from abroad, this time through a group of English painters and engravers who arrived after the War of 1812. Though individually unimportant, they brought an English Romantic landscape style which was the foundation for the development of the Hudson River School. This style reflected at first the growing influence of Richard Wilson (deriving from Poussin, Claude, and the Dutch seventeenth-century landscapists) and Thomas Gainsbor-

285　Ralph Earl. *Looking East from Denny Hill.* c. 1800.
Oil on canvas, 45¾ × 79⅜″. Worcester Art Museum

ough, whose atmospheric rendering of nature led directly to the landscapes of Turner and Constable. A later group, involved with engravings of topographical views, transformed that art into an expression of more pictorial and Romantic values. The four who came in the first wave and were most influential—William Winstanley (act. c. 1793–after 1806), arriving before 1793; William Groombridge (1748–1811), by 1794; George Beck (1748/49–1812), the most thoroughly trained and most solid painter of the group; and Francis Guy (c. 1760–1820), in 1795—were all, except for Guy, derivative and pedestrian examples of the English manner, but they brought the reflection of a definite and consistent style of landscape painting. George Washington bought four landscapes from Winstanley and two from Beck for Mount Vernon, and Aaron Burr is said to have bought one from Groombridge—indication enough that there were no comparable native examples.

It was Guy, despite reported cribbings from other painters, who arrived at an original and personal style in his naively conceived and meticulously rendered cityscapes, which are almost genre pictures. His American experience seems to have expunged any memory of the picturesque, the ideal, or the artificial from these pictures, and we have instead the sprawling chaos of American urban life seen with literal accuracy and endearing charm. New York City in *The Tontine Coffee House* (c. 1797, New-York Historical Society) is a shambles of unmatched homely architecture and frantic human activity. All the rules of composition, Classical or Romantic, have gone by the board, and we are confronted by what appears to be an unpremeditated snapshot view. This vision was not accidental, for some twenty years later in *A Winter Scene*

in Brooklyn (1817–20, colorplate 26) the conception was refined in a Bruegelesque panorama of life. As in a Bruegel, however, the apparent ingenuousness hides an effective handling of complex formal spatial relationships as well as human incident. It may be coy and a little primitive, but it is masterly in the evocation of the ordinary, something quite foreign to the major artistic tendencies of the time.

Topographical prints, which had achieved a measure of popularity during the Colonial period, were in even more demand after the Revolution. Again, English artists were instrumental in raising not only the craft but the aesthetic level of such engravings. Philadelphia had become the publishing center of the United States in the post-Revolutionary period, which had seen a phenomenal increase in the printing and circulation of books and magazines, and most of the English engravers were attracted by the opportunities offered. William Russell Birch (1755–1834) was the earliest arrival, in 1794. A new standard of excellence was attained in his *Views of Philadelphia* (1798–1800), consisting of twenty-eight views of the city engraved after his own drawings. His *Country Seats of the United States,* 1808, exemplifies the transition from topographical reportage to intimations of Romantic mood. His son Thomas (1779–1851) assisted him in these projects but later branched out to become the leading marine painter of the period, establishing a genre that remained popular through the century. His most famous paintings, after which engravings were made, were inspired by sea battles of the War of 1812, *The United States and the Macedonian* (1813, plate 286) and *The Constitution and the Guerrière* (1813, Addison Gallery of American

286 Thomas Birch. *Naval Engagement Between the United States and the Macedonian, October 30, 1812.* 1813. Oil on canvas, 28 × 34½″. The Historical Society of Pennsylvania, Philadelphia

Art, Andover, Mass.), in which a new sense of dramatic action and Romantic atmosphere is apparent.

In 1816 two fine aquatint engravers migrated to Philadelphia, raising topographical landscape art to a superb level of craftsmanship: John Hill (1770–1850) and William James Bennett (1787–1844). Hill collaborated with Joshua Shaw on a series called *Picturesque Views of American Scenery*, issued in 1820. The prints, done after drawings by Shaw, introduce in landscape engraving for the first time the Romantic moods of turbulence and melancholy as aesthetic elements, clearly abandoning topography for expressive content. Hill's later collaboration with William Guy Wall (1792–after 1864) in *The Hudson River Portfolio* (1828), a series of aquatints after the latter's watercolor studies, and Bennett's nineteen splendid colored aquatints of American cities, issued between 1831 and 1838, rightfully belong to the next period of the full flowering of the Romantic landscape.

The landscapes of Washington Allston, already mentioned, introduced another tradition and achieved a standard of expressive power far beyond anything attained by the English landscape painters and topographical engravers. In his hands the landscape became a vehicle of emotional, philosophical, and artistic communication rather than a record of an event or a place with overtones of mood.

GENRE PAINTING

Genre and anecdotal painting, which were later to become so popular in American art, had not as yet found an adequate form of dissemination. The individual genre painting could find no buyers, and the occasional picture of that type was a sport rather than part of a developing tendency. When genre art eventually did achieve acceptance, it was through the mass medium of the colored lithograph. The first evidences of it are both sporadic and peripheral, as in signs such as Matthew Pratt's scene of a stag hunt with hounds and riders for Brown's Tavern in Philadelphia; in illustrations on business cards and handbills, which depicted activities in the crafts and trades; or as subsidiary elements in landscape engravings. The conversation piece moved in the direction of genre by introducing a natural interplay among individuals in a group, and this tendency became more marked in such pictures as Pratt's *American School* and Peale's *Staircase Group*. In a somewhat similar sense Peale's *Artist in His Museum* and, especially, *Exhuming the Mastodon* were intended partly as portraits and partly as records of activities but include genre aspects. The lively human elements in Guy's cityscapes, already mentioned, could easily qualify them as genre pictures.

The rare pure genre paintings are, on the whole, minor efforts. Among these is an early picture by Jeremiah Paul, Jr. (act. 1791–1820), a rather nebulous figure of whom Dunlap disapproved because of his intemperance. Paul's *Four Children Playing in a Street* (1795, Collection Arthur J. Sussel, Philadelphia), although sensitively painted, is oversentimental, reminiscent in theme of some of Murillo's more saccharine pictures of street urchins. At least one artist, John Louis Krimmel (1787–1821), seems to have specialized in genre subjects. Born in Württemberg, he arrived in the United States in 1810 and, after some attempt at portraiture, taught himself genre painting by copying in oils a print of the *Blind Fiddler* by the Scottish genre painter Sir David Wilkie. Among the few paintings he left before his untimely death by drowning, the most famous is *Fourth of July in Centre Square, Philadelphia* (1812, plate 287), which stems from contemporary French prints of fashionable Parisian life and, in spite of its artistic limitations, conveys a sense of elegance and vivacity. Less interesting perhaps in subject but more so artistically are Henry Sargent's two extant genre paintings, *The Dinner Party* and *The Tea Party* (both c. 1821–25, Museum of Fine Arts, Boston). Sargent had studied in London with West and served as an officer in the army before settling in Boston to paint mediocre portraits under the influence of his friend Stuart. He also painted several large religious scenes which did the exhibition circuit, but he is remembered best for these two unusual genre pieces. Although somewhat naive in execution, notably in the figure drawing, the compositions with many figures in a large space are remarkably well handled. Especially in *The Tea Party* (plate 288) there is a fine management of intricate space relationships, a subtle understanding of complex lighting effects, and a perceptive observation of the manners of social intercourse. Despite their dryness and limited color range, the paintings have a restrained animation and a refined Neoclassic elegance.

STILL-LIFE PAINTING

The still life had little currency in the post-Revolutionary period and was held in disdain by artists infected by the grand manner. Washington Allston, in attesting his deep passion for art, could say: "I cannot honestly turn up my nose even at a piece of still life"; and although Charles Willson Peale painted some, he thought them too simple for mature minds. But still lifes were being painted, and earlier Dutch examples were being offered for sale. The Columbianum exhibition in 1795 listed among its other works five still lifes attributed to Copley, examples by

287 John L. Krimmel. *Fourth of July in Centre Square, Philadelphia*. 1812. Oil on canvas, 23 × 29″. The Pennsylvania Academy of the Fine Arts, Philadelphia

288 Henry Sargent. *The Tea Party*. c. 1821–25. Oil on canvas, 64¼ × 52¼″. Museum of Fine Arts, Boston. Gift of Mrs. Horatio Appleton Lamb in memory of Mr. and Mrs. Winthrop Sargent

William Birch, a Miss Birch, and James Peale, and five still lifes and two "deceptions" by Raphaelle Peale. It seems almost as if still-life painting was for a while a monopoly of the Peale family.

One characteristic aspect of American still-life painting from the outset was a concern with the creation of an illusion of reality, a tendency toward *trompe l'oeil,* or, as the Peales called it, "deception." It is a common practice to sneer at such deception as catering to the most un-educated levels of taste, but the type has at least the sanction of antiquity. Roman artists had included bits of debris with cast shadows in the designs of mosaic floors. The still life has frequently lent itself to the display of the artist's magical power to deceive, with delightful as well as magnificent results, and, except for its more recent exploitation as a medium of purely formal, subjectless expression, its major concern has historically been with the realistic rendering of material objects. The very absence of animation or ulterior meaning has permitted the artist to study the structure, surface, texture, color, and illumination of physical bodies for themselves alone and thereby reveal a world of sensuous experience unadulterated by extraneous considerations. The unassuming and honest efforts of these early American still-life painters (plate 289) are a welcome relief from the pretense and rhetoric of the grand manner.

289 Charles B. King. *The Vanity of an Artist's Dream.* 1830. Oil on canvas, 36 × 30″. Fogg Art Museum, Harvard University, Cambridge, Mass. Gift of Grenville L. Winthrop

290 James Peale. *Fruits of Autumn.* c. 1827. Oil on canvas, 15½ × 22″. Private collection

James Peale (1749–1831), more retiring and less gifted and original than his brother, Charles Willson, was active as a miniaturist and portrait painter (plate 266). He is, however, best known for the still lifes that he continued to produce throughout his life. They follow what might be called the "Peale formula," a group of objects, mostly fruit and vegetables along with bowls and glasses, simply arranged on a table top and seen against a dark and undefined background (plate 290). The compositions are carefully ordered and, although they appear minutely rendered, are actually rather broadly painted. They are far from the elaborate and richly appointed still lifes of the Dutch seventeenth-century painters, closer to the simpler and more architectonic arrangements of Chardin, although neither so sensuous nor so sophisticated, and perhaps closest to the more naive still lifes of the Spanish school. James is often diffuse and overcomplicated in his compositions and somewhat hard and mechanical in painting, with an almost fanatical insistence on bright highlights.

Much in the manner of James, but both simpler and more subtle are the still lifes of Raphaelle Peale (1774–1825), the eldest son of Charles Willson. Raphaelle resembled his father in his divided interest in art and science, was more like his uncle James in his modest and retiring nature, and, unlike his aggressive younger brother Rembrandt, lacked a compulsive drive to succeed. Failing as a portrait painter, he was satisfied with painting still lifes. Whether he made a living at it is not known, but he seems to have drunk too much, suffered from gout in his

later years, and died too soon. Raphaelle's still lifes are less cluttered than those of his uncle, more carefully composed with a sense of classical balance. They are rendered with a crystalline clarity and have an air of dignity one does not expect in inanimate objects. He had a remarkable feeling for volumetric structure, which gives his most prosaic arrangements a challenging presence. Although his range was extremely narrow and he repeated many objects—wine glass, porcelain basket, cluster of raisins, sprig of leaves, cupcake with icing—the familiar objects are seen anew in different relationships, and each painting is a fresh experience. It is difficult to think of another still life with such modest elements treated with such consummate logic and restraint and achieving so imposing an impression as his *Still Life with Cake* (1822, plate 291). His most famous work, however, is a larger picture called *After the Bath* (1823, colorplate 27), which is ambiguous enough to have been often seen as a genre subject, a nude girl behind a sheet hung on a line. It is actually a deception, a painting or colored print of a nude hidden by a napkin pinned to a tape, the forerunner of the Harnett and Peto *trompe l'oeils* representing tape strips tacked to walls. But *After the Bath* is more than a prank; it is painted with a true feeling for form and a deep love of the medium. It is only the painting of a napkin or kerchief, but the conception of volume, the rhythmic interplay of shapes, the subtle study of light and texture are masterly. Very few of the more exalted paintings of the period can stand comparison with the authenticity of this unassuming work of art.

291 Raphaelle Peale. *Still Life with Cake*. 1822. Oil on panel, 9½ × 11½".
The Brooklyn Museum

Emergence of an American Sculpture

Unlike painting, which had undergone a half-century of professional development and produced a Copley who could take his place among his European peers, sculpture had not yet begun to break the bonds of anonymity in artisan production, the limitations of apprenticeship training, or the aesthetic confinement of the craft tradition. Native carvers did create works of artistic merit, but they were unequipped technically and aesthetically to meet the sudden demand for monumental official sculpture that arose with the founding of the new nation.

THE EUROPEAN IMPORTS

This demand was met first by placing orders abroad and then by attracting European sculptors, beginning in the 1790s. Only in the 1830s did local sculptors begin to replace foreigners as the creators of the heroic images of the new nation. Sculpture, even more than painting, was mobilized to supply the patriotic icons, for "imperishable stone" and the visual analogy with Roman bust portraits of Republican heroes made marble the preferred medium. In the first half of the nineteenth century every local politician, rural poet, and soldier seems to have had his physiognomy eternalized; the result was an awesome gallery of forgettable stone faces. The pattern of celebrating the heroes of liberty was begun as early as 1776, when the Continental Congress voted £300 for a memorial to Major General Richard Montgomery, killed in the raid against Quebec, the first notable casualty in the War of Independence. Through the agency of Benjamin Franklin, then American emissary in Paris, the French sculptor Jean-Jacques Caffieri (1725–1792) was commissioned to execute the monument. The cenotaph, with its Neoclassic conglomeration of symbols, including military trophies and emblems of liberty, was completed in 1778 but erected only in 1789 on the east-portico wall of St. Paul's Chapel in New York.

However, the first major monument of a Revolutionary hero was, naturally, of George Washington, whose face and form were endlessly proliferated in stone and bronze, as they were in painting. In 1784 the Virginia Legislature voted to honor its favorite son with a life-size memorial and, through Thomas Jefferson, offered the commission to Jean-Antoine Houdon (1741–1828), the leading sculptor of France. Accompanied by Franklin, Houdon, a man of strong libertarian sympathies, came to the United States with three assistants in 1785 to observe the President in the flesh. He did a life mask (Morgan Library, New York) and a terra-cotta bust (Mount Vernon, Va.) before returning to Paris, where he finished the clay model (1788) from which the marble was cut by 1791. The statue (plate 292) was installed in the Virginia State House in 1796. It is the most sympathetic of all the effigies of Washington, and the head is probably the finest portrait of him, but the figure is more a manikin than a heroic image. Houdon also produced a gallery of other American luminaries, including Franklin, Jefferson, Robert Fulton, John Paul Jones, and Joel Barlow, as well as a bust of Lafayette commissioned by the Virginia Legislature in 1781.

Among the more notable examples of Washington idolatry are the bust portrait by Giuseppe Ceracchi (plate 293) and the ill-fated Canova monument. In 1815, when North Carolina sought a sculptor to produce a statue of Washington, the Italian Neoclassicist Antonio Canova (1757–1822) was universally recognized as the greatest. Canova accepted the $10,000 commission and, without coming to the United States, used the Ceracchi bust as a model for the head and a Peale drawing for the body; his Washington was contrived in the guise of a seated Roman general writing on a tablet in flawless Italian, "Georgio Washington/Al Popolo degli Stati Uniti/1796/Amici e Concittadini" (plate 294). The monument was installed in the State House in 1821, where it was destroyed when the building burned nine years later.

In the 1790s the transfer of the United States capital to Philadelphia drew sculptors as well as painters and architects to that city. They came from many countries in Europe—John Dixey from Ireland in 1789, Ceracchi from Italy in 1791, Christian Gullager (Guldager) from

292 Jean-Antoine Houdon. *George Washington.* 1791. Marble, height 6'2" without base. Virginia State House, Richmond

293 Giuseppe Ceracchi. *George Washington.* c. 1791. Marble, height 31". Carolina Art Association, Gibbes Art Gallery, Charleston, S.C.

Denmark in 1798, John Eckstein from the court of Frederick the Great in 1794, and George M. Miller from Scotland in the late 1790s. There were also resident at the time several decorative stonecutters from Italy. The most famous of these professional sculptors to settle at least temporarily in the United States, Giuseppe Ceracchi (1751–1802) came to America with the vain hope of finding patronage for a projected $30,000, 100-foot high monument to Liberty. He was active in Philadelphia artistic circles during his stay, joining Peale and William Rush in the foundation of the Columbianum, and is known to have executed portrait busts of Jefferson, Franklin, Hamilton, John Paul Jones, David Rittenhouse, and George Clinton. But America was not ready for Ceracchi's sculptural dreams of grandeur, and he returned to Europe in 1795. Exhibition records show that Eckstein and Dixey also tried their hands at mythological and allegorical themes, but they found little patronage, although Dixey was commissioned to do a figure of *Justice* for the cupola of the New York City Hall (c. 1818) and another of the same subject for the Albany State House.

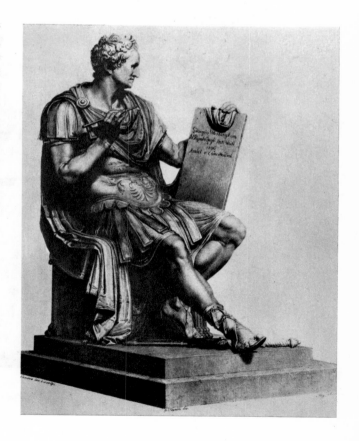

294 Antonio Canova. *George Washington.* 1820. Engraving after the original marble (destroyed), in North Carolina State House. State Department of Archives and History, Raleigh, N.C.

The construction of the Capitol at Washington in the early 1800s required architectural sculpture, and Latrobe sent to Italy for trained stonecutters. Giuseppe Franzoni (c. 1778–1815) and Giovanni Andrei (1770–1824), who came in 1806, did some sculptured allegorical subjects and ornamental carvings on the Capitol building before its burning by the British in 1814 destroyed most of their handiwork. They also worked in Baltimore on the Gothic detailing of St. Mary's Chapel (plate 368) and the pediment of Robert Cary Long's Union Bank (1808, plate 295). Franzoni is probably best remembered for the famous "corncob" capitals carved for the Capitol (plate 218).

After the War of 1812, reconstruction of the Capitol under Latrobe brought in a new group of Italian sculptors. Andrei returned from Italy with Carlo Franzoni (1789–1819), Giuseppe's brother, and Francesco Iardella (1793–1831), who was responsible for the "tobacco" capitals (plate 219). Carlo Franzoni is reputed to have done the lunette of *Justice* in the old Supreme Court chamber, and he executed the *Car of History* (1819) for the old House of Representatives, now the Statuary Hall. They were joined by Giuseppe Valaperta (?–1817), who had been employed by Napoleon on Malmaison, and

though he produced little beyond the frieze of the House of Representatives, he did discover near Baltimore a marble quarry heralded as the equal of any in Italy. More successful in obtaining commissions was Luigi Persico (1791–1860), who arrived in 1818 and, after working as an itinerant miniaturist and drawing teacher in Pennsylvania, went to Washington in 1825 to work under Bulfinch. He executed the east-front pedimental sculpture of the Capitol (1826, plate 296), statues of *War* and *Peace* for the niches under the portico (1829–35), and a group flanking the great stairs, called *The Discovery* (1846, plate 297), for which he was paid $24,000. The last was not well received, and by that time it was felt that such commissions should not go to foreigners. Enrico Causici, claiming to be a pupil of Canova, arrived in 1822 and also worked on the Capitol, carving two reliefs for the Rotunda (c. 1827) —*The Landing of the Pilgrims* and *Daniel Boone in Conflict with the Indians*—and a large plaster statue of *Liberty* (1825) for the House of Representatives. His best-known work, however, is the colossal cloaked figure of the General (plate 298) capping the Mills Washington Monument in Baltimore (1829).

All these Italian sculptors remained alien to America although they left their indelible traces on the nation's

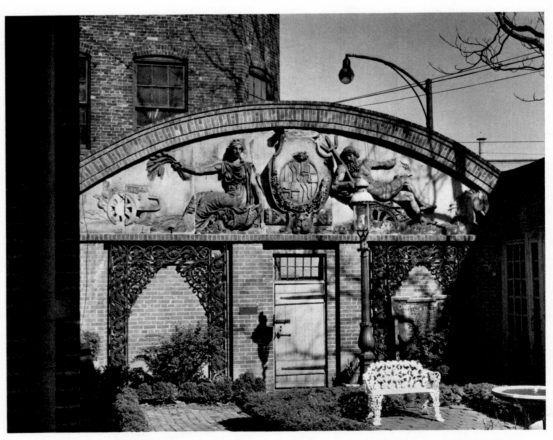

295 Giuseppe Franzoni and Giovanni Andrei. *Ceres and Neptune* (pediment from Long's Union Bank, Baltimore). 1808. Marble, height 60". The Peale Museum, Baltimore

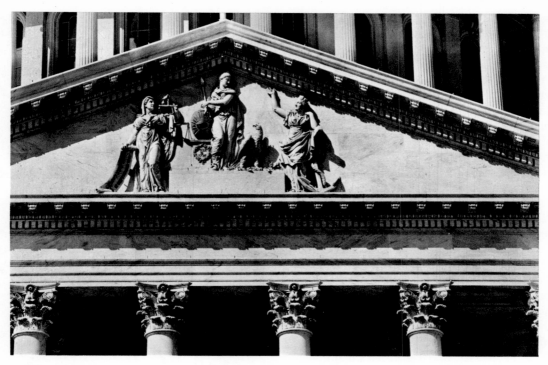

296 Luigi Persico. *Genius of America*. 1826. Marble, height 9′. East-front pediment, U. S. Capitol, Washington, D.C.

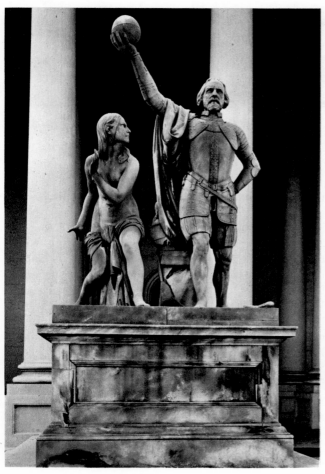

297 Luigi Persico. *The Discovery*. 1846. Marble. U.S. Capitol, Washington, D.C.

298 Enrico Causici. *George Washington*. 1829. Marble, heroic size. Washington Monument, Baltimore

capital. It is startling to realize how Italianate a production the early Capitol decoration was. Little in it related to American life or artistic taste, and it is not surprising that provincial lawmakers and the public consistently found them irrelevant. Though hardly remembered today, this group of itinerants had a telling impact on American sculpture in its formative years. Their Neoclassic vision established aesthetic norms and directed the first generation of American sculptors toward Italy.

However, the Italians were not the only foreign sculptors to work on the Capitol. Nicolas Gevelot, a Frenchman, seems to have been active in Philadelphia during the 1820s and produced a relief for the Rotunda, *Penn's Treaty with the Indians,* but otherwise gained little support for his projects, which included an equestrian statue of Washington. The Dresden-born Ferdinand Pettrich (1798–1872), who was trained by his father, court sculptor to the King of Saxony, and studied with Thorwaldsen in Rome, came to Philadelphia in the late 1830s. He was paid for executing two models of statuary groups projected for the west staircase of the Capitol, but they were never completed. Discouraged by his Washington experience, he left in 1843 for Brazil. Pettrich's major work in the United States was the heroic *George Washington* (c. 1840) for the New York City Customs House, the first bronze statue in this country.

THE NATIVE TRADITION

Expanding cultural horizons and a growing sophistication were reflected in an increased refinement of the crafts. Reliance was still on pattern books, but the standards in these had risen and they were more current in matters of changing taste. With time, the Neoclassic elements became dominant in them, though a strong Rococo strain continued as a provincial remnant. For artisan carvers such books remained the major source of both sculptural detail and figurative art, almost exclusively limited to ship figureheads and shop signs. Clusters of woodcarvers' shops were to be found in the ship-building ports of the eastern seaboard, notably in Boston and Philadelphia.

The Skillin brothers, John (1746–1800) and Simeon, Jr. (1756/57–1806), carried the long and illustrious line of New England woodcarvers into the postwar era. Little of their work remains, though there is ample evidence of their activities and standing in the craft. Woodcarvings attributed to the brothers exhibit a limited technical facility, aesthetic naiveté, and dependence on pattern books. *Plenty* (1793, plate 299), the only fairly well documented work of the Skillins and said to have been one of four garden figures done for Elias Hasket Derby's Salem mansion, has an amateurish charm.

Samuel McIntire (1757–1811), best known as carpenter, contractor, and architect, was also a woodcarver, though most of his work was in architectural and furni-

299 John and Simeon Skillin. *Plenty (Pomona).* 1793. Wood, height 55″. Peabody Museum of Salem, Mass.

ture decoration rather than sculpture. There are records of his having produced figureheads and ship carvings. As the bust portrait of *Governor John Winthrop* (1798, plate 300), based on a painted likeness, would indicate, McIntire was not at home in the figurative arts. He is remembered most for his decorative eagles and the medallion bust portraits of Washington, copied from Joseph Wright's profile portrait.

The culmination of New England figurehead carving is to be seen in the one surviving example of the work of Isaac Fowle (act. 1806–1843), nephew and apprentice to Simeon Skillin, Jr., and heir to the Skillin shop, a draped female figure (c. 1820, plate 301) that never crested the waves under a bowsprit, probably serving as Fowle's own shop sign. Excellently preserved, it offers a clear and unromantic record of figurehead carving at its height—robust, straightforward, and clean (one can only admire the proud tilt of the chin, the thrust of the strait-laced

300 Samuel McIntire. *Governor John Winthrop.* 1798. Wood, height 15½". American Antiquarian Society, Worcester, Mass.

301 Isaac Fowle. *Lady with a Scarf.* c. 1820. Wood, height 74". The Bostonian Society, Old State House, Boston

bosom, and the firm set of the foot and observe with interest the naturalism of the petticoat edge and the elastic ribbing in the shoe), yet naively derivative and fumbling in its forms. The "billowing" drapery bunches like hammered sheet iron, the foliated base is ornamentally illiterate, and the figure barely rises above wholesome stolidity. Yet, though she may not break away from pattern-book details, she is unquestionably an American woman of the day in spirit and dress.

Worthy of passing mention are the efforts of the Newburyport figurehead carver Joseph Wilson (1779–1857), who became involved about 1801 in the megalomaniacal eccentricities of "Lord" Timothy Dexter, a wealthy businessman who proposed to people the lawn of his mansion with near-life-size statues on towering pedestals of forty notables from history and the Bible, including himself. Intended to be in stone, they were done in wood and painted and were something of an attraction until most of them toppled during a hurricane in 1815 and disintegrated, except for fragments of one figure and the restored *William Pitt* (c. 1800, plate 302). Judging from this single example, Wilson was a maker of manikins rather than a sculptor.

Only one of the host of woodcarvers rose above the artisan level—William Rush (1756–1833) of Philadelphia, whose art was the climax and swan song of the craft. Rush worked under his father, a ship carpenter, and was apprenticed in 1771 to Edward Cutbush, a carver from London. Rush had hardly begun on his own when hostilities broke out, and in 1777 he was commissioned as an officer in the Philadelphia militia. After the war he returned to ship's carpentry and carving, rising to the summit of his craft and helping to make Philadelphia preeminent in figurehead production. According to a contemporary critic, "We should not forget how much we are indebted to his chisel, for the respectability abroad, already attached to our infant exertions in the Fine Arts. . . ." Rush's earliest work was done for the U. S. Navy as well as commercial shipbuilders, and he seems to have been in great demand. For the Navy he supplied ideas, drawings, and even recommendations for other carvers to execute, as in the case of John Skillin, who cut the

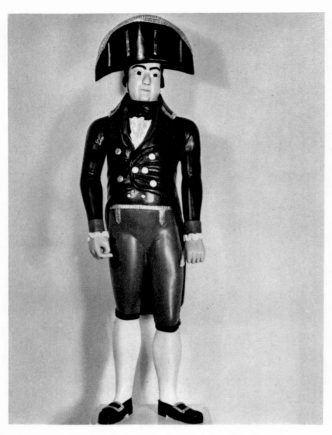

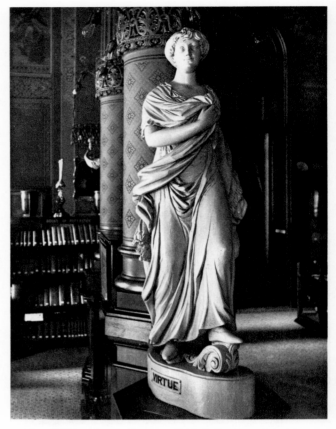

302 Joseph Wilson. *William Pitt*. c. 1800 (restored). Painted white pine, height 78″. Smithsonian Institution, Washington, D.C.

303 William Rush. *Virtue*. c. 1810. Painted wood, height 69½″. The Grand Lodge of Free and Accepted Masons of Pennsylvania, Philadelphia

Hercules (c. 1796) for the frigate "Constitution" after a drawing by Rush. Of all Rush's figureheads, only one, *Virtue* (c. 1810, plate 303), is extant, probably because, like the Fowle figurehead, it never went to sea. In fact, they resemble each other in their reliance on the same craft sources, though the Rush is more fluent.

In 1808, Rush moved beyond maritime carving with the over-life-size figures of *Comedy* (plate 304) and *Tragedy* (plate 305) for the Chestnut Street Theater. More ambitious and complex than figureheads, they still reveal a dependence on the woodcarving tradition, although there is evidence of more sophisticated models. The newly formed Pennsylvania Academy had already acquired casts of Classical statuary, but Rush seems to have been influenced more directly by Charles Taylor's *Artist's Repository or Encyclopedia of the Fine Arts* (London, 1808), a four-volume compendium of artistic theory and iconography, of which he owned a copy and to which he resorted for mythological and allegorical themes. As Henry Marceau has noted, many details in Rush's monumental work can be traced to engravings in the *Repository*. His naiveté and provincialism are reflected not only in his allegiance to the craft of woodcarving but also in his reliance on so ordinary a source. Such allegorical

works as his *Faith, Hope,* and *Charity* (c. 1811) for the Chestnut Street Masonic Temple, the *Wisdom* and *Justice* (1824) for the triumphal arch in celebration of Lafayette's visit, and *The Schuylkill Chained* and *Freed* (1828, plate 643) all suffer from these limitations. Despite an underlying sense of structure, the conceptions are stereotypes, and the translation of two-dimensional line into three-dimensional form is clumsy. Only the early *Water Nymph and Bittern* (1809, colorplate 28) manages to avoid pedantic formulas and retain a freshness of observation. The scandal of having a young Philadelphian beauty of good family pose in the nude has become a famous anecdote; yet there is no denying that the reality of a living body under the clinging wet drapery has a conviction not to be found in his other ideal figures. The stance may have been suggested by the *Medici Venus* and some details by the *Repository*, but the whole emerges as an original conception—aptly symbolic, both as a fountain group and in the selection of a native American bird; particular and naturalistic in proportion and form; and with a grace scarcely matched in early nineteenth-century American sculpture.

Rush entered the Washington portrait lists with a life-size wooden figure (1814, plate 306), of which he hoped to sell plaster casts. Placed in Independence Hall at the

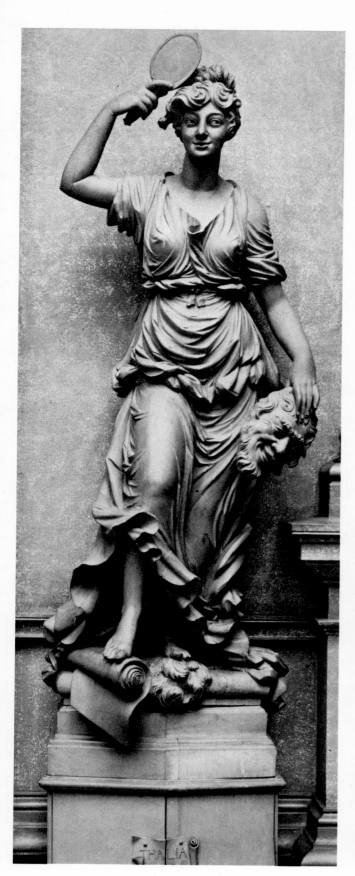

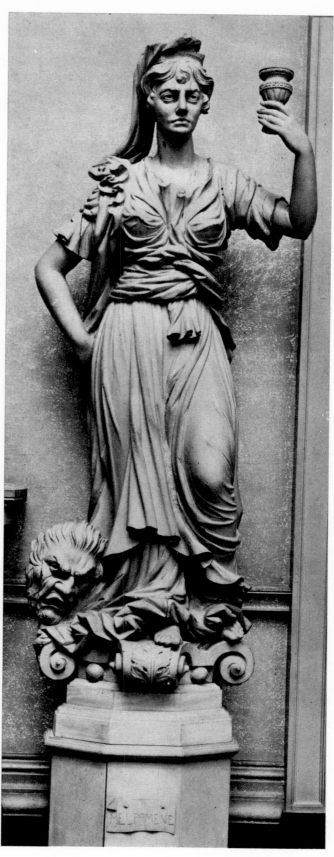

304 William Rush. *Comedy*. 1808. Wood, height 90½″. The
 Edwin Forrest Home, Philadelphia

305 William Rush. *Tragedy*. 1808. Wood, height 90″. The
 Edwin Forrest Home, Philadelphia

Emergence of an American Sculpture 217

time of Lafayette's visit, the work was purchased by the state in 1831 for $500. It is the apogee of woodcarving in America and in some ways one of the most satisfying of the monumental representations of Washington, depicting him as relaxed and human, though with great dignity. Unfortunately, the meaningless drapery cuts the figure in two and, with the clutter of iconographic paraphernalia, dissipates its underlying unity.

Rush is said to have learned to model and cast in plaster from Joseph Wright, and his earliest portrait bust is of Wright (before 1811, Pennsylvania Academy of the Fine Arts). Flaccid and indecisive, it lacks the literal realism of his later portraits. He could not have learned much beyond the process from Wright; his major influence seems to have come from the portraits left behind by Houdon, which exhibit the same attention to naturalistic detail and striving for the expression of personality. Although less suave in handling, Rush's *Captain Samuel Morris* (1812, Citizens of the State in Schuylkill, Philadelphia), in wood, resembles Houdon's *Voltaire* in its projection of Rococo *élan*. Actually Rush was closer to the Rococo spirit, even in his monumental works, than to the Neoclassicism of his time. Typical of his early portraits (1812–13) are the stolid *Dr. Caspar Wistar* and the forceful *Dr. Benjamin Rush* (both Pennsylvania Hospital, Philadelphia), and the handsome *Dr. Philip Syng Physick* (Pennsylvania Academy of the Fine Arts). Even the later, whimsical *Marquis de Lafayette* (1824, Pennsylvania Academy of the Fine Arts), done from memory, partakes of their unassuming honesty and directness. They are undeniably crude in handling and lacking in plastic distinction, as if Rush missed the glyptic quality of wood, with which he was so familiar. However, in the terra-cotta portrait of his young daughter, *Elizabeth Rush* (c. 1816, plate 307), he achieved a coherence of form appropriate to the material and a grace and charm that approach Houdon's vivacious little *Louise Brongniart*. Rush's most mature and convincing portrait is the symbolic "Pine Knot" *Self-Portrait* (c. 1822, plate 308), in which the forceful head, modeled with assurance, emerges from the bark of a *trompe-l'oeil* pine log.

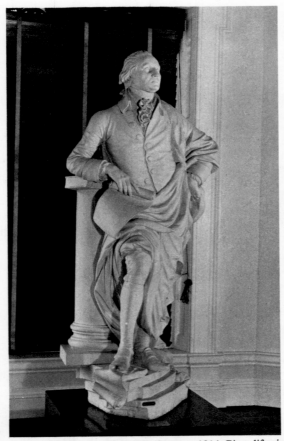

306 William Rush. *George Washington*. 1814. Pine, life size. Independence National Historical Park Collection, Philadelphia

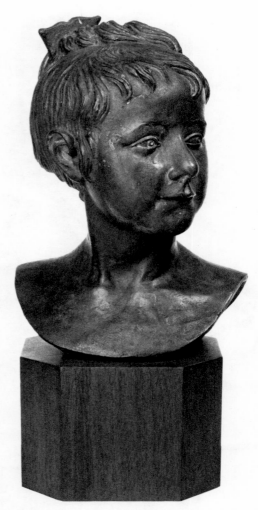

307 William Rush. *Elizabeth Rush*. c. 1816. Terra cotta, height 12½″. Philadelphia Museum of Art. Gift of Dr. William Rush Dunton, Jr.

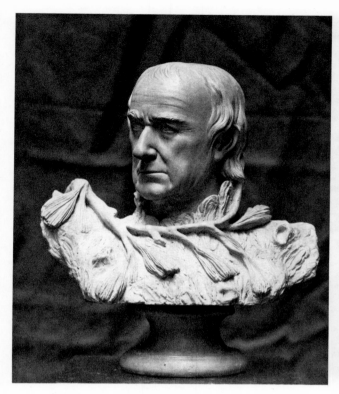

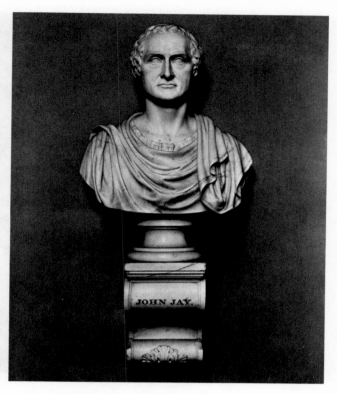

308 William Rush. *Self-Portrait* ("Pine Knot" portrait). c. 1822. Terra cotta, life size. The Pennsylvania Academy of the Fine Arts, Philadelphia

309 John Frazee. *John Jay*. 1831. Marble, life size. Supreme Court Room, U.S. Capitol, Washington, D.C.

At this point the native tradition in American sculpture had reached a level of accomplishment in the expression of realism comparable to that achieved by Copley before he left for Europe, though fifty years later. But at its very height this tradition was doomed by a growing sophistication in taste and a new generation of American-born artists who looked toward Europe for training and standards. By 1830 Neoclassicism was firmly established, and wood carving was relegated to the status of craft.

The apparent need for sculpture, reflected in large government commissions, and the impact of foreign sculptors led native artisans to begin in the 1820s to work in clay, plaster, and then stone. Also, actual examples of sculpture became more common through the works of immigrant sculptors and the growing collections of casts (see Chapter 10). Such collections included famous sculptures of the ancient world—the *Medici Venus*, the *Apollo Belvedere*, the *Laocoön*, the *Dying Gladiator*, the *Discus Thrower*, and the *Hermaphrodite*—as well as Greek and Roman bust portraits.

Except for Rush, who belongs to a different tradition and an older era, John Frazee (1790–1852), an artisan stonecutter, was the first American to venture into sculpture as such. Born in Rahway, N.J., of Scottish parentage, he spent his childhood in abject poverty, without education, and was apprenticed at fourteen to a bricklayer and

mason. As a stonecutter in Newark, he tried his hand at sculpture and in 1815 executed a funerary figure in stone for a son who had died in infancy. In 1818 he opened a tombstone business in New York with his brother. The John Wells monument in St. Paul's Chapel (1824), which includes a bust, apparently the first marble portrait cut by an American, has a decided Neoclassic tinge, but the bust of *John Jay* (1831, plate 309), the first commission given a United States sculptor, reveals a literal realism possibly related to the practice of taking life masks. As the first practicing American sculptor, Frazee received many commissions for portrait busts; in the early 1830s, for instance, he executed seven portraits of famous Bostonians for the Athenaeum. From 1834 to 1840 he worked on the New York Customs House, but he continued to produce funerary monuments and copies of busts in plaster and marble. He exhibited a project for a Washington monument at the American Art Union in 1848 but never actually did a full-length figure. He remained a portrait sculptor, clumsy, somewhat naive, but always direct, frank, and unpretentious.

Hezekiah Augur (1791–1858) began his sculpture career as a carver of ornamental parts for furniture in New Haven. The proceeds from an invention of a lace-making machine permitted him to devote himself to sculpture, and in 1825 he attracted the attention of Samuel F. B.

310 Hezekiah Augur. *Jephtha and His Daughter*. 1833.
Marble, height 44½″ and 36½″. Yale University Art Gallery, New Haven.
Gift of a group of subscribers, "the Citizens of New Haven," 1837

Morse, who encouraged him to work in stone. The portrait busts and ideal figures he produced were exhibited and gained him some reputation. The two separate figures comprising the *Jephthah and His Daughter* (1833, plate 310), his most famous works, are more interesting as indications of the achievement attainable by a self-taught native artisan than as formal statements. Augur took the step from wood to stone and into the Neoclassic world that Rush never did, but his work still suggests the tradition of woodcarving in its linear cutting, and its formal detail recalls pattern books. He never received more recognition than an order in 1834 for a bust of Chief Justice Oliver Ellsworth, which seems to have been the last work Augur did.

John S. Cogdell (1778–1847) of South Carolina, in his time a lawyer, legislator, and bank president, remained always something of an amateur as an artist. He took up painting as a hobby after visiting the studio of Canova in 1800. Cogdell, a friend of Morse and of Allston, did portrait busts and ideal figures that were widely exhibited and highly regarded, though he never received much patronage even in his home state. His busts were in a naturalistic vein, but his ideal pieces were more strongly Neoclassic in inspiration. His most ambitious work, the marble memorial to Mrs. Mary Ann Elizabeth Cogdell (1833, plate 311), is surprisingly close to contemporary

European Neoclassicism, predating comparable efforts of the American expatriates (see Chapter 14).

The portraits by John Henri Isaac Browere (1792–1834) belong in a special category, for, though their extreme naturalism is expressive of the taste of the period, the fact that they were basically life masks made them suspect as works of art even in their own day (plate 312). He had studied painting with Archibald Robertson in New York and spent two years studying sculpture abroad, where he probably learned to make life masks. After 1825 he traveled through the United States making life masks of famous men which he hoped would be cast in bronze for a national portrait gallery. The project never found the necessary support, but in 1828 he had accumulated enough examples to open his "Gallery of Busts" in New York. After his death, they were forgotten until early in this century. Browere's procedure was to incorporate the life mask in a bust portrait with toga-draped shoulders, thus approximating the "legitimate" sculptural portraits of the period.

Artists such as Frazee, Augur, Cogdell, and Browere form an intermediary phase of native sculptors emerging from craft traditions but not yet prepared to leave their culture for the international Neoclassic scene abroad (see Chapter 14).

Wax sculpture, like miniature painting in America,

remained essentially a minor art form, though it was quite common and fairly widespread. Small wax busts and profile portraits occurred as early as the eighteenth century. Patience Lowell Wright (1725–1786) of Bordentown, N. J., America's first female artist, turned in 1769 to wax portraiture as a means of livelihood after the death of her husband. Her work was well received, but in 1772 she left for London, where she established herself as a successful miniaturist in wax profile portraits. Her son, Joseph (1756–1793), who returned to the United States in 1782, had studied painting with West, but most of his work was in wax. He executed a bust of Washington that is now lost; however, a profile relief bust of Washington as a Roman crowned with a laurel wreath, done in 1784 in the Neoclassic manner, has survived (plate 313). The miniaturist wax technique served Wright well in designing the earliest coins for the United States Mint. Daniel Bowen (c. 1760–1856) also did wax portraits but was better known in connection with the wax museum which he operated in a series of cities. After the turn of the century several more skilled European artists practiced as itinerants, but wax portraiture declined, as did miniature painting, with the spread of photography.

312 John Henri Isaac Browere. *Bust of Philip Hone*. 1820s. Plaster, height 35″. The New-York Historical Society

311 John S. Cogdell. Memorial to Mrs. Mary Ann Elizabeth Cogdell. 1833. Marble. St. Philip's Church, Charleston, S.C.

313 Joseph Wright. *George Washington*. c. 1784. Beeswax, 6 × 5″. Henry Francis du Pont Winterthur Museum, Winterthur, Del.

CHAPTER TEN

Art Associations and Museums

In the Early Republic, there were clusters of artists working in all the major cities on the eastern seaboard. The growth of public interest in the arts was fostered by a new consciousness of nationhood, and art was identified with the highest national ideals. However, the roseate glow of a rising American interest in the arts was more wishful than actual. From the public response to panoramas and traveling exhibitions one can gather that the interest was focused mainly on sensation, entertainment, curiosity, or religion. There was as yet no evidence of any awareness of artistic quality, much less an interest in art for its own sake. The development of public taste in the United States has been slow, painful, and not always upward, but the first steps were taken at that time by the organization of the first art societies and museums. In Europe the differentiation between academies as artists' organizations and museums as public institutions run by and for laymen has always been perfectly clear. The mixture of the two in the United States created specific difficulties with unhappy effects on the history of both.

Academies in Europe had arisen as associations of artists to replace the outmoded medieval guild system. They were organizations that not only conferred honors and prestige on their members, thereby monitoring the artistic community, but also provided schooling for younger artists and facilities for exhibiting the work of members. Only the exhibition was a public function. On the other hand, public museums, as distinct from royal collections, which came onto the scene only after the French Revolution, were from the outset repositories of the art of the past. In the United States the two kinds of institutions and their functions were confused. So-called "academies" were dominated by laymen, although artists were always included, and were intended to function as public institutions rather than artists' organizations. It took some time before authorities and functions were sorted out and academies and museums emerged as distinct institutions.

According to William Dunlap, the earliest effort at establishing some sort of artists' organization was sparked by the omnipresent Charles Willson Peale, who,

as mentioned earlier, with the help of Giuseppe Ceracchi, tried to establish a school of art in Philadelphia in 1791, which unfortunately had only a short life. However, in 1794 Peale managed to organize his Philadelphia colleagues into the Columbianum, which almost immediately split into two factions, the native and the English artists, and died aborning, but not before the Peale group managed to set up an art school and hold the first and only exhibition in 1795. Then, in 1805, a new effort was made by a group of artists and laymen, and the Pennsylvania Academy of the Fine Arts was formed and chartered the next year. A building was erected in 1806, and in 1807 a collection of casts of Classical sculpture, chosen by the diplomat Nicholas Biddle in Paris, was installed. To this there was later added Robert Fulton's collection of paintings, including works by West, Allston, and Lawrence. However, in 1810 the artists, irked by the domination of the Academy by its lay members, founded The Society of Artists of the United States. Since the exhibition of casts and paintings at the Academy had proved successful, the organization offered its facilities to the Society for an annual exhibition. The first was held in 1811 and, though the Society was dissolved, the exhibition continued as a periodical event until 1969. The Philadelphia artists were not entirely happy with the arrangement but subsequently were never able to organize facilities of their own.

New York had not yet supplanted Philadelphia as cultural center of the nation, but there was enough artistic activity to lead to the formation in 1802 of the New York Academy of Fine Arts, which changed its name to the American Academy of Art with the granting of its charter in 1808. This organization, like its Philadelphia counterpart, was dominated by laymen. In 1803 it held its first exhibition of casts, selected by Robert R. Livingston, American Ambassador to France, at the "Pantheon," a museum of curios run by the painter Edward Savage. In the same year Vanderlyn was commissioned to purchase more casts abroad, but the response to the exhibition was so disappointing that the organization lost impetus, and, without a permanent home, its collection was put into

storage. After the war DeWitt Clinton made a valiant effort to resurrect it and in 1816 found quarters for the Academy in the old almshouse, which it shared with the Historical Society, the Lyceum of Natural History, and Scudder's Museum. The name was changed again, this time to the American Academy of Fine Arts, and in 1817 Clinton stepped down to permit John Trumbull to become president. Annual exhibitions were instituted and provisions made for students to draw from its casts. The first exhibition of works by its members was successful, but Trumbull, who treated the Academy as his private preserve and base of ambitious national operations, took the opportunity to sell a group of his own works to the Academy, depleting its treasury. Trumbull's dictatorial attitude, his jealousy of younger artists, and his general arrogance soon put the institution into a state of suspended animation, until the revolt of its younger members led by Morse in 1825 applied the *coup de grâce* and led to the formation of the National Academy of Design in 1826.

In New England, Newport's Redwood Library, founded in 1747, had by this time become a repository of paintings as well as books, and in 1807 Boston joined the cultural parade with the establishment of the Athenaeum as a library. Its collection later included paintings and the ubiquitous casts. The first loan exhibition of paintings, which numbered many redoubtable, if questionable, names of "old masters," was held in 1826. In the South, as early as 1786 a building was erected in Richmond to house an Academy of Fine Arts, but for lack of activity it was altered to serve as a theater. The South Carolina Academy of Fine Arts was founded in 1821, a building was constructed, exhibitions were held for a few years until interest lapsed, and the building was finally sold in 1831.

The public was obviously less interested in the elevating influence of art than it was in the curiosities that could be seen in the privately owned "museums" of the period. Peale's famous museum in Philadelphia, which included art as well as natural history, spawned many others like it. So long as Peale was in charge, a level of seriousness and quality was maintained, but it too, under his son Rembrandt, became something of a peep show. Many of Charles Peale's innovations in museum practice had to wait a century for adoption, and his dream of a national museum was lost in the wash of the public's fascination with curios. The stock-in-trade of these "museums" was a varied collection of oddments—natural history, waxworks, and paintings of topical, religious, or erotic interest. Rembrandt Peale was entrepreneur of one of the largest of them, an offshoot of the Peale Museum, in Baltimore, and his brother Rubens ran another in New York, which earlier had played host to the "Pantheon" and still had the John Scudder Museum. Appropriately enough, the Peale and Scudder museums were eventually combined by Phineas T. Barnum, who made the term "museum" synonymous with "sideshow." One of the earliest of these curio shops was also managed by a painter and retired minister, Joseph Steward, in the State House at Hartford, Conn. The frequent relationship of such museums with local government, even to the use of public property, indicates that they were considered of educational value. But despite the original intention of Peale and others, the museum rapidly lost its educational function to popular sensational interests and had to be reconstituted much later in a totally different context. The wide gap which existed between the artist and the public, between the grandiloquent statements and the truth of popular taste, is nowhere better seen than in the difficulties of the academies and the successes of the museums,

PART THREE

THE JACKSONIAN ERA

Art and Democracy

Although the pieces do not all fit neatly, and one would sometimes prefer 1820 as the terminal date of the Federal period, the election of Andrew Jackson to the presidency in 1828 is usually accepted as the beginning of a new cultural as well as historical era. The Federal period had continued into the nineteenth century as an extension of the eighteenth in its social organization, standards, and values, even though the colonies had been welded into a single nation. The old society on the eastern seaboard had remained as a stable balance between the mercantile economy of the North and the plantation economy of the South, with the West acting as a kind of safety valve. But by the 1820s, all the great Revolutionary figures who had dominated the scene during the Federal period were gone. The stability of the old world had vanished, class distinctions were blurring, and all sorts of new forces were rife under the impact of an expanding economy and technology. America was moving into the industrial age, and the economic, political, and social fissures appearing in the old structure were to become ever wider, culminating in the Civil War.

The continuing acquisition of western territory—Texas, the Oregon Territory, and various Mexican lands—opened the continent to exploration, settlement, and the exploitation of natural resources. An ever-increasing flow of settlers and speculators moved westward by raft and wagon, and later by steamboat and railroad. As early as Jackson's election, the West had already become a force in American society, demanding recognition of its interests equally with those of the North and the South. Jackson's election was supposed to redress the balance.

By now, however, the North had almost imperceptibly moved from commerce to industrialization, from artisan production to the factory system, from shipbuilding and trade to textile manufacturing and mining; and the control of economy and politics was passing from the older mercantile aristocracy to the new industrialists and bankers. Industrialism had also affected the South. The development of textile machinery and the invention of the cotton gin lowered the price of cotton and provided the means for satisfying the increasing demand. In the

South cotton now displaced the more balanced plantation economy of an earlier era. And slavery, which had been considered a disappearing evil, suddenly became a necessity. The great cotton plantations became agricultural factories, and economic and political leadership slipped from the hands of the humanitarian Jeffersonian agrarians of the "Old Dominion" into those of the "slavocracy" of the South Carolina "fire eaters."

The lines of interest were thus drawn and the battle was joined. The prize was the government of the United States. Social and political problems absorbed the attentions and activities of the American people, and for the first time in its history the United States turned its back on Europe and faced westward.

The election of Jackson as the champion of the common man was made possible by the establishment of universal manhood suffrage and the use of that new right by a coalition of the people of the West and the new proletarians of the North. Motivated by a social philosophy which combined Jeffersonian agrarianism and frontier egalitarianism, the Jackson administration set out to neutralize the political, and thus the economic, power of both Northern capitalism and Southern slavocracy. Although it did so only temporarily, it had a lasting effect on American culture. The rule of what its opponents called "mobocracy" established the first popular or mass culture and, for the first time in America, the distinction between a sophisticated and a popular taste.

This democratization was fostered by the spread of public education, by a great increase in the printing and publishing of books and illustrated periodicals, and in the arts by the mass circulation of prints and plaster statuary, increased exhibitions of art in the major cities, and traveling pictures, statues, and panoramas which penetrated more deeply into the hinterland. All this was accompanied by a growth of museums and art organizations in the newer cities of the nation, by the ubiquitous "lyceum lectures," and by the art unions, which during their short existence were the most effective means of spreading art among the general public. There is no question that the growing public interest in art as art, and

not exclusively as portraiture, resulted in an increased acceptance of other forms such as landscape, genre, and still life. For the first time also, sculpture became a viable and even popular art form, although its major functions were public rather than private until somewhat later in the period.

In turning its back on Europe and facing westward, America arrived at a new sense of identity, of nationalism, of "manifest destiny," both materially and spiritually. Cultural nationalism had gained momentum since the end of the War of 1812 and was given new direction by Jacksonian democracy. There was not only a growing optimism about the future of American culture but also an increasing insistence that art receive governmental support, as did other more material aspects of American life. From a purely practical point of view, art, it was said, was good for the economy, as the experience of Europe showed. On a more philosophical level, liberal attitudes based on Romantic thought had effectively reversed the older Puritan tenets. Instead of being immoral, art was an uplifting and civilizing experience, leading to virtue, even to God. Far from being the expression of despotism and decadence, art could truly flourish only in a democracy. Materialism was not enough; America would have to raise its spiritual sights to achieve true greatness. If public taste was low, then it would be educated, for the health of democracy depended on the practice of virtue and the practice of virtue on the education of citizens. There was also some unconscious agreement between Romantics and know-nothings that the "unspoiled" taste of the common man was inherently superior to that of the "decadent" dilettante. As for the inadequacy of patronage, democracy would create its own.

In the decades preceding the Civil War a cultural elite emerged, paralleling the growth of an altruistic social elite which was not antagonistic to cultural nationalism, but reinforced it with intellectual vigor, political and economic power, and social status. Out of the moral imperatives of Puritanism, the philosophy of transcendentalism, and a basic faith in democracy, the upper class of New England, especially, accepted the responsibility of social service and leadership in a changing world and played an important role in forming attitudes and opinions during those years. The Benthamite utilitarianism of these people generated a faith in rational planning and a dedication to social progress. They believed firmly that taste could be elevated, that people could be educated, that democracy was viable. These beliefs motivated the activities of such men as Charles Eliot Norton, Andrew Jackson Downing, and Frederick Law Olmsted, who had so much to do with influencing America's attitudes to art and environment. However, with all their altruism and social concern, they were, as members of an upper-class elite, fearful of the mob, of its violence and philistinism, and they counted on culture to serve as a civilizing force in society. Olmsted, the most profound and farsighted, felt that rational planning for the amenities of living, which included art, could make urban life stable and fruitful, in effect diffuse the inherent tension of class antagonisms. Norton, more pessimistic, eventually felt that the leveling factor in democracy would inevitably lead to conformism and shallowness.

CHAPTER ELEVEN

Romanticism

"Romanticism" is a term overused and misused, but Romanticism itself is a phenomenon that does not lend itself to easy definition or neat packaging. It defies limitation, remains impervious to logical explanation, and reveals itself repeatedly in paradox. In one of its many aspects it occurs as the dominant form of mid-nineteenth-century American art, a historical epoch which comparably eludes clear categorization. In the first half of the century the concurrence of Romanticism in painting and Neoclassicism in architecture and sculpture brings into question the very use of such terminology. Yet it is too simplistic to describe Neoclassicism as just another phase of Romantic revivalism and to see Neoclassicism and Romanticism either as inevitably antagonistic in a historical sense, as they were in nineteenth-century France, or as absolute polarities and thus mutually exclusive in a philosophic sense.

If one accepts the philosophic polarity of the Classic and the Romantic, the Apollonian and the Dionysian, the rational and the antirational, the intellectual and the emotional, one may see them as constants in the human condition and find their manifestations recurring in history. But it is dangerous and misleading to read one set of historical facts in terms of the patterns of another age without considering circumstantial differences. It is, however, possible to see as a single historical epoch the period of time stretching back from the present to the age of exploration. The development of science and technology, the decline of feudalism and the rise of capitalism, the emergence and consolidation of European nations and their imperial expansion into the newly discovered world, the increase in trade and population—all date back to the seventeenth century and in certain manifestations to as early as the sixteenth. The advent of the modern era brought profound changes in European society and culture. Depending on one's position and background, one saw in the future promise or disaster: an ever-expanding world of opportunity, conquest of the unknown, and exploitation of natural and human resources, all susceptible to solution and control by human intelligence and will; or the death of a stable world, society and standards in flux, the immensity of the universe and the insignificance of man, and the loss of faith in the face of materialism.

European dominion of the New World went hand in hand with the drive for human dominion over the natural world. This required the belief that man could cope through reason, that everything knowable was manageable, and that the universe was ultimately knowable. This positivist, optimistic, and aggressive attitude helped make the world of today. As against this there arose a doubting, pessimistic, contemplative frame of mind, repelled by materialism, unconvinced of man's perfectibility, and intrigued, saddened, even frightened by the ultimate mystery of life, the universe, and God. Whereas one side believed that the more one knew the closer one came to Truth, the other felt that the more one learned the more tantalizing became the ultimate unanswerable questions. In a cultural sense, these attitudes created an abstract antithesis out of man's natural duality—intellect as against emotion, reason against intuition, objective against subjective, and reality against dream. The line was drawn, and these became structured responses, styles of art. That they are now identified as Classic and Romantic is in many ways unfortunate, since both terms have other specific meanings in history and language, as well as overtones touching unconscious areas of preference or prejudice. It is perhaps more seriously misleading that the materialist, realist, positivist point of view should have been identified with the Classic, although natural enough, since Greek art in its Classic phase had many features in common with this later materialism, but every subsequent Neoclassic manifestation in style, regardless of its motivation or intention, even if Romantic, could so easily be misread. On the other hand, the common usage of the word "romantic" obscures the serious intent and profound significance of the movement as a whole, while its identification with pessimism and retreat from reality ignores its later development as a revolutionary force. For to be against "progress" is not always to be for "reaction"; it depends on what is being defined as progress. And in the nineteenth century, when "Realism"

was added to make a triad, the situation became even more confused.

Classicism and Romanticism are always with us. It is possible to see the evolution of their nineteenth-century manifestations in the art of our own time. In spite of all the modifications and variations that have occurred in the course of time, the fundamental opposition remains that between intellect and emotion in its many mutations, including its most recent incarnation, conscious and unconscious. And just as fundamental is the opposition of society and the individual. Why individuality should be the expression of intuition rather than reason is curious but understandable, since the logical structure of an ordered society and civilization seems the outgrowth of consciousness and rationality, while the individual and human personality seem the expression of the unconscious and the irrational. Perhaps because the psyche was so little understood, reason appeared a common experience while emotion was personal. We still consider that what we think is a manifestation of objectivity and what we feel is subjectivity. Romanticism's concern with the individual, with his personality, his unconscious, his subjectivity—in short, the particularity and whimsicality of his ego—is historically its most revolutionary and fruitful aspect, which helped establish the validity of direct sensuous experience and personal expression. By implication, it brought into question all universals, generalities, established ideals, dogmas, and traditions.

Transferred to art, the positivist attitude implied logical order, geometric structure, rationality, and clarity. Cultural positivism has usually returned for inspiration to, acknowledged allegiance with, or attempted a revival of Classical antiquity. Thus Neoclassicism emphasized clarity and restraint: ordered composition, measurable space, local color, and precision of line. Since the major source of such inspiration was Classic sculpture, Neoclassic painting seems perhaps too dependent on such sculpture in its immaculate outline and polished modeling, and especially on bas-relief in its planimetric treatment of space. Romanticism, on the other hand, sought the indefinable and the emotionally expressive. In composition it was intuitive, asymmetrical, and picturesque; in spatial definition naturalistic, fluent, even ambiguous; in color it strove for richness, luminosity, atmosphere, and mood. It was in color and the application of paint that Romanticism expressed itself most completely—in the very act of painting, in the brushstroke itself, implying an immediacy of feeling—rather than in line as a process of conscious control.

When Romanticism as a movement achieved the dominant position in nineteenth-century Europe, its forms proliferated and evolved in new directions. Its most radical aspect was a new positivism in response to specific historical conditions. The "failure" of the French Revolution was seen as the failure of reason, of the utopian ideals of liberty, equality, and fraternity that had cap-

tured men's minds. They had been betrayed in a series of steps from counterrevolution, Napoleonic dictatorship, imperial expansion, defeat, and a reactionary Bourbon restoration supported by the so-called "Holy Alliance." The revolutionary dream had been transformed into the reality of a new bourgeois society in its most blatant aspects—repressive capitalist consolidation, the worship of Mammon, exploitation, poverty, slums, industrial ugliness, and urban blight. The seemingly insoluble problems presented by the new society and the defeat of libertarian ideals were, in part at least, responsible for engendering a pervasive pessimism. In addition, the democratization of taste had lowered the level of culture to the tawdry and banal. The reaction to the "philistinism" of the bourgeoisie was a coalescence of aristocratic nostalgia for a departed elegance and disdain for the money-oriented *nouveau riche* with the more radical "bohemian" revolt against a culturally restrictive society. Romanticism thus became the expression of a cultured elite, paradoxically the language of both revolt and retreat, positive and negative, optimistic and pessimistic in an infinite variety of permutations and combinations depending on social position, political persuasion, or cultural preference. The past became symbolic of the heroic and the ideal in opposition to the commonness and materialism of the present. This attitude, supported by a growing historicity, led to revivalism, spawning a series of revival styles in architecture and decoration, and to a new concern for conservation and restoration. For the first time in history, for example, destroyed buildings such as the Houses of Parliament in London and the Hôtel de Ville in Paris were rebuilt in their original historical styles.

Inspired by a growing nationalism, Romantics sought for the origins of "race"—incidentally claiming a greater purity for the earlier state—in the ancient sagas, legends, and folk arts of the peoples of Europe. The impact of such interest is to be seen in the romances of Sir Walter Scott, the operas of Richard Wagner, the adaptations of folk tales by the brothers Grimm and Hans Christian Andersen, and the craft revival of William Morris.

Consonant with this concern with the past is the Romantic preoccupation with time, its inexorability, the mortality of man, the impermanence of his works, and the ultimate negation of all his efforts. In the visual arts, as well as the literary, the ruin was the most satisfying symbol of this poetic rumination on time. It provided evidence of man's temporary glory and inevitable defeat, the implacable power of time and nature, but at the same time it remained a remnant of the past for the present to contemplate. The Romantics had a great gift for transforming tragedy into sentiment.

Revulsion against the present, and especially against urban existence in a burgeoning industrialism, helped inspire the nineteenth-century retreat to nature. This new concept of nature as an emotional or aesthetic experience led to the efflorescence of nature poetry and landscape

painting, vacations in the country, travel in search of natural wonders, and English gardens and garden cemeteries. Once again Romanticism had transformed reality into a contemplative experience and experience itself into an aesthetic act.

The rejection of contemporary reality led also to fantasy, dreams, and the contrived world of literature. Literature became increasingly important for the visual arts as sensory experience was overlaid with philosophic significance, moral import, and poetic sentiment; and literature, like the past, was a repository of the heroic, the ideal, and the exceptional.

The Gothic Revival in architecture, which replaced the Greek in both Europe and the United States, reflected the Romantics' rediscovery of the Middle Ages as the antithesis of Classic antiquity. This was a confrontation in historical terms—faith and reason, spirituality and materialism, mysticism and reality, Christianity and paganism. The Romantic found in medieval architecture not its complex and logical structure but its sublime mystery, its picturesqueness, its endless world of individual detail. The Gothic presented an image for literature and painting that included, on a more popular level expressed so well in the "Gothick" novel, the feeling of violence, terror, mystery. Strangely enough, Gothicism, in spite of its religiosity, offered a world of darkness and fear as opposed to the open and joyful clarity of the Classic pagan world.

American Romanticism was influenced more by England and Germany than by France and was, in any case, different from the European in general in its provincialism and exceptionalism. Cultural ties with England still remained strong enough, especially in literature, for that country to continue as America's major contact with European developments. Interestingly enough, the Romantic movement in England showed its first signs concurrently with the rise of Classicism, indicating again the equally revivalist nature of both. The picturesqueness of the Romantic, in contrast to Classic formality, is to be seen as early as the 1720s in the poetry of John Dyer and James Thomson. Beginning shortly after 1714, the gardens at Stowe were redesigned by the English architect Charles Bridgeman in a new, natural, picturesque, and antiformal manner, the first of the English gardens which, as the *jardin anglais,* became the rage and swept the Continent. It included such "romantic" structures as grottoes, ruins, temples, and cottages, utilizing with amazing catholicity of taste Classic, Gothic, and even Chinese styles.

The Peace of Utrecht in 1715 made travel on the Continent safe again, and the grand tour as a ritual element in the English gentleman's education was launched, fostering a new interest in the past and its monuments as well as a taste for grandiose scenery. The English writers Horace Walpole and Thomas Gray went on a grand tour together in 1739—a crucial event in the history of Romanticism—and were greatly impressed by the magnificence and wildness of the Alpine landscape. It was a revelatory experience for both men. Gray played a major role in the evolution of Romantic poetry in England, and Walpole, after his return, began remodeling Strawberry Hill in 1752 as a sham Gothic building and in 1764 published *The Castle of Otranto,* progenitor of all subsequent "Gothick" novels. In America two Romantic literary figures followed suit. In 1836, almost a century after Strawberry Hill, Washington Irving had Sunnyside, a Dutch farmhouse near Tarrytown, N.Y., remodeled as his residence by Town & Davis in the Gothic manner, and in Cooperstown, N.Y., James Fenimore Cooper redid Otsego Hall, the family house, and the neighboring Christ Church in the same style.

Of unparalleled significance for the development of the Romantic movement were the works of the eighteenth-century French philosopher Jean-Jacques Rousseau, whose concepts of man and nature and the superiority of the "savage state" became fundamental to Romantic thought. His ideas found fertile soil almost immediately in Germany, which was, perhaps more than any other country in Europe, ready for a Romantic movement under any name. The impact of Friedrich von Schelling's philosophy was strongly felt in England, just as reciprocally the English Romantic novel and poetry deeply impressed the Germans. In the 1770s German intellectuals were swept up by the *Sturm und Drang* movement, which had its influence on both Goethe and Kant; it was the latter who expressed the principles of Romanticism most profoundly for the nineteenth century in his transcendental philosophy by his emphasis on the individual and intuition, as well as his espousal of fantasy over reason and the state of unrest over that of harmony. German Romanticism had its direct impact on America via Mme. de Staël, whose *De l'Allemagne* (British edition, 1813) fulsomely praised German literature, philosophy, and universities. Impressed by her account, George Ticknor, a graduate of Dartmouth, and Edward Everett, from Harvard, in 1815 enrolled in a German university, Göttingen. They were instrumental in the reorganization of educational practice at Harvard, and through them the transcendentalist circle around Emerson and Thoreau absorbed the influence of German literature and philosophy.

The American taste for the Romantic was fed by the popular English "Gothick" novels, especially those of Mrs. Ann Radcliffe, whose fame was immense. Allston was a devotee of Mrs. Radcliffe's spine chillers. The "blood-pudding school" of literature had its American exponents in Charles Brockden Brown, admired by Shelley and Poe; Robert Montgomery Bird; William Gilmore Simms; and on a somewhat higher plane, Hawthorne and Poe. In the Romantic tradition, though in different veins, were the good-humored picturesque "folk" tales of Washington Irving and the glamorized

versions of the noble savage and frontier life by James Fenimore Cooper. Given the differences among the arts, American Romantic painters covered a similar range of material and strove for similar effects.

In relation to European Romanticism, the American version revealed its provincialism in what can be seen as a regression in artistic standards as well as taste. The earlier Romantics, such as Allston and before him Trumbull and Vanderlyn and later Morse, were more sophisticated artists, European trained and oriented, striving for objectives that were beyond the society to which they had returned. The second generation consisted of painters who had almost all come out of more modest backgrounds, originally trained as craftsmen; others were self-taught or had only the most rudimentary instruction, but the audience to which they were appealing was not aware of such limitations. Foreign visitors noted with some surprise both the great number of artists and their presence in frontier towns, but they also remarked with some condescension on the low level of current taste. Of course, the traveler was judging popular taste against the standards of a more sophisticated culture, and one can question whether European popular taste was any more developed. But the level of American artistic production and the taste of its patrons was undoubtedly below the European. American art was affected by the leveling influence of democratization and westward expansion and fell prey to its own destiny.

Its destiny was manifest. A continent was before it. The adventure of exploration, conquest, exploitation was a Romantic epic in itself. The American artist was quite ready and happy to express the patriotic sense of his country's future, its wild and magnificent landscape, its beauty and plenty, its adventure, and its common activities. Unfortunately, the art on the whole did not do justice to the reality. There was nothing in it of the sweat and toil, the squalor and brutality, the danger, greed, and passion, the waste and death. American Romantic art did not consciously distort the truth, but it turned its back on the more unpleasant aspects.

There was during this period, perhaps more than at any other time in our history, a rapport between the artist and his public, a level of taste shared by almost all. Not until the advent of James J. Jarves was a critical evaluation of American art from a less insular cultural base even attempted. The dominance of public taste during this era fostered a sentimentalization of the more heroic and profound aspects of Romanticism, and genre and anecdotal art in particular descended to the level of the saccharine and the banal. But this is just as true of the popular anecdotal art of the Victorian era, in Europe as well as the United States.

CHAPTER TWELVE

Architecture

Eclecticism at Mid-Century

THE GREEK REVIVAL

The Greek Revival, which falls within the period from 1820 to 1845, shared with the earlier Neoclassic movement its basic intentions, aesthetic attitudes, and in some cases even a continuity of personnel. However, the Greek Revival was both more clearly oriented to a specific aspect of the past and more committed to it ideologically. Classicism was synonymous with rationality, order, stability, and moral virtue, and its architectural expression had dignity, simplicity, neatness, and vigor. It continued to have such implications during the Greek Revival, except that its overtones became more complex, reflecting the divergent attitudes emerging in American society. Characteristic of the Greek Revival is the fact that the Federalist banker Nicholas Biddle and the frontier Populist Andrew Jackson, mortal enemies in the profoundest ideological sense, both lived in Greek Revival houses, and that both houses were older structures to which facades had been applied. The Greek Revival came to mean different things to different people. To the abolitionist it signified democratic humanitarianism, and to the slaveholder a rationalization for slavery. The industrialist of the North could plan a textile town in which the mansion on the hill and the houses of his workers were all in the Greek mode. For the freeholder of the frontier it was the mark of civilization. But for all, whether conscious of the symbolic value or not, it was unquestionably American building. Never before or since has its ubiquity been equaled. From the monumental masonry structures of the large cities to the carpentry versions in backwoods settlements, America was committed to Greek forms. The very simplicity of the style seemed to lend itself to translation in wood, and even the provincial carpenter could achieve a naive but true dignity. In the hands of the professional the ancient vocabulary was capable of a forthright statement of simple power. And at no other time in its history has the United States matched the level of rational and humane planning for urban living that obtained then.

The significance of the Greek Revival in architecture can easily be distorted by too close a focus on its stylistic complexities or by moral or aesthetic judgments about revivalism in general. Arguments about the validity of revivalism are pertinent, but they can obscure its cultural relevance to the Jacksonian Era and its technological contributions to American architecture. Architectural historians are increasingly coming to see nineteenth-century architecture not as a denial of all the virtues modern taste subscribes to but as intellectually and technically fecund. This was an age of ferment and creativity in all fields. Nineteenth-century man faced a whole range of entirely new problems; the architect was no exception, and the American architect especially was confronted with herculean tasks in building for a modern society in a young nation in a new world. One could almost condone his simply borrowing security from the past, but the fact is that he borrowed, consciously and rationally, what he thought was the best that the past had to offer. He might choose Greek, Gothic, Romanesque, Egyptian, or any other mode, but the basic challenge was to build for a new kind of life. What the ablest architects had in common was a dedication to a functioning architecture, one which considered requirements, site, cost, technology, materials, and efficiency. Whatever one may think of the columns or crockets, the level of building, design, and craftsmanship were exemplary at least until the 1850s, when expanding industrialism, speculation, and exploitation began to transform objectives and standards.

The increased demand for all kinds of construction strained the resources of professional architectural practice. The well-trained émigré architects of the Neoclassic period were eventually replaced by native-born professionals who were not academically educated. There were

no architectural schools in the United States before the Civil War, and the most common route to professionalism was through apprenticeship to other architects, which provided technical competence but limited sources of inspiration or knowledge. Curiously enough, architects, unlike painters and sculptors, seldom traveled abroad and had no firsthand contact with the great monuments of the past except in reproduction. Thus the Greek Revival was a bookish architecture. At the beginning of the century most building, aside from large projects or government contracts, was handled by builders or carpenters who used the standard architectural books or went to architects for plans and drawings. The relation of the architect was then largely with the contractor rather than the client, and he usually furnished drawings at a set fee without supervising construction. By the thirties the architect was working directly for the client, although he often did no more than prepare plans and drawings to be carried out by the builder. By the mid-forties, the larger offices were performing all the functions of the modern architectural firm and were being paid on a percentage basis. It was during the Greek Revival period that the profession as distinct from the practice of architecture came of age. In 1836 the American Institution of Architects was organized, to be supplanted twenty years later by the present American Institute of Architects.

With population growth and urbanization, what were once minor became major problems. For example, prisons and hospitals, mentioned previously as new forms, were new only because earlier needs for such facilities were minimal. Now they were social necessities. It may seem surprising that so many prisons crop up in a discussion of the architecture of the period; it is not that American society had become so lawless but rather that the democratic humanitarianism of the period projected new concepts of penal correction. Expanding administrative functions, growing cities, and new towns required government buildings of all sorts, from state capitols to post offices. Under the supervision in sequence of Robert Mills, Ammi B. Young, and Isaiah Rogers, the Treasury Department erected post offices and customs houses throughout the country in staggering number and to a remarkable standard of efficiency in design. Also, the American concern with public education led to a proliferation of colleges even in frontier areas, where, before the land was cleared, the designation of college sites was often set. And what were once small town markets became large, permanent buildings; some cities boasted of arcades for shopping, a new form recently imported from Europe.

In domestic building the traditional "country house," continuing in urban as well as rural areas, saw more superficial but important changes in terms of greater convenience, increased specialization of function, and improved as well as new equipment. In the South, with the rise of great fortunes based on cotton, sugar, and slavery, the pattern of living approached the seignorial, and architecture responded with complexity of plan, magnificence of scale, and lavishness of decoration. In urban centers, industrial expansion and the enormous increase in population called for radically new types of housing. Just as important in its impact on American living was the beginning of the long process of conversion from a self-sufficient farm economy to an integrated pattern of urbanized existence. Mechanized agriculture, mass production and processing of food, and mass distribution, along with the increase in public services, revolutionized urban life. The new conditions were reflected in planned industrial towns, row houses, hotels; later they would spawn tenements and eventually housing developments. Some of these innovations occurred before the Greek Revival, many of them during it, and all saw an accelerated proliferation in the industrial surge of the fifties.

Revival architects were also progressive in their utilization of new materials and techniques. Solomon Willard, a Boston architect, devised the equipment for exploiting his find of local granite, with telling effect on commercial and industrial building. The great development of the wooden truss made possible the rapid erection of large-span railroad bridges. The "balloon frame," devised in the 1830s as a result of mass-produced and standardized lumber and cheap nails, revolutionized wooden-house construction. The development of the steam pump, gas lighting, and kitchen, bath, and toilet equipment had their obvious effects. Even central heating and cooling systems had abortive beginnings in those years: John Haviland's Egyptian Revival "Tombs" had central heating, and Mills installed an air ventilation system in the United States Capitol, although no one seems to know whether it was ever used. From Latrobe on until the advent of jerry-building in the post-Civil War period, the revivalist architects had a strong sense of integrity in the use of materials and the craft of building, as those structures which still remain attest. Beginning with Mills's County Records Building (plates 241, 242), the problem of fireproofing became an increasingly important consideration, and architects experimented with advanced methods, including the use of iron. Iron columns were first used as supports in England in the late eighteenth century, but, perhaps because of inadequate foundries, not until much later in the United States, where iron had its initial trials at the hands of revival architects. Young designed fireproof government buildings with cast-iron columns, brick vaults on wrought-iron beams, and iron in stairs, balconies, windows, doors, and door frames, all of which gave impetus to the development of prefabricated building materials. In the late thirties, cast-iron facades for commercial buildings were beginning to appear and would soon be widespread.

With all its functional innovations, however, nineteenth-century architecture still remained revivalist. Mills might write that his fundamental considerations were

"first, the object of the building; second, the means appropriate for its construction; third, the situation it was to occupy"; but the structures he erected were inspired by Greek models. Such forms were obviously not indigenously American, but then, what was indigenously American? The wigwam? In retrospect the preconditions for a nonrevivalist functional architecture seem to have already existed, and the intention was apparent even earlier in such men as Ledoux, Boullée, Soane, and Latrobe. It seems only one step from their stripped Classicism, with its functional integrity, to "modern" architecture, yet the step was not taken until many years later and under totally different conditions. Historic styles are more than expressions of rationality, if they are that at all; they are manifestations of ideological and cultural necessities.

The nineteenth was obviously a century in search of identity. For the first time in history art was thought of as expressing the nature of a people, the character of a society, its "genius," the significance of an ideology. But instead of discovering its forms in its functions, as eventually was done, the nineteenth century found them as analogues by historical example. Revivalism as an aspect of Romanticism was conditioned by two factors: first, a cultural uncertainty in the face of new situations and possibilities; second, the growth of historicity and an increased awareness of the past. To the earlier identification with the past was added a new objective evaluation, which led to a growing catholicity of taste. One could borrow, not only from Classical antiquity but from any time or place, whatever was pertinent to the present. Antiquity in itself took on a new cachet.

Neoclassicism had begun with Palladio and then rediscovered Rome. The image of Greek Classicism in literary guise or filtered through the aesthetics of later cultures did not have the more immediate visual presence of Italian Classicism ranging from Rome through the Renaissance. Not until the publication of *The Antiquities of Athens* (1762–1816) by James Stuart and Nicholas Revett did Europe make contact again with the architectural heritage of ancient Greece, and only at the turn of the century did Greek forms take their place in the Classical vocabulary—and then still largely as archaeological exoticisms. There was a copy of the first volume of Stuart and Revett in the Philadelphia Library by 1770, and Jefferson owned one also. Latrobe was clearly aware of Greek forms—he even referred to himself as a "bigoted Greek"—but such forms were not consistently or coherently used. As mentioned earlier, Greek details first appeared in American architectural handbooks with Haviland's *The Builders' Assistant* (1818). But the Greek orders were not accepted by Asher Benjamin until the sixth edition of *The American Builder's Companion* (1827). From then on Greek detail became more and more prevalent in his books, though rather independently and conservatively handled, as well as in those of Edward Shaw,

Chester Hills, and Minard Lafever, the most Grecophile of the handbook authors and the most influential in the spread of the Greek Revival on the vernacular level.

The actual use of Greek forms before Strickland's Second Bank of the United States, Philadelphia (1818–24, colorplate 18), is rare: Latrobe introduced the Ionic order in the Bank of Pennsylvania, also in Philadelphia (1798, plate 226), and the "archaic" Doric in some of the vaults under the Capitol, and before 1814 Mills employed a small Ionic porch in front and a grand Doric portico on the rear of the Brockenborough House, later the "White House of the Confederacy." The Greek style became increasingly common during the twenties, but it was not until the later years of that decade, when the Greek War of Independence aroused such sympathy in America, that the Greek Revival was properly launched. The image of a renascent ancient Greece was cast in the mold of Romantic sentiment by an amalgam of reverence for Classic antiquity, empathy toward a struggle for liberty, and Christian fervor against the infidel Turk. Hellenism became a fad; American children were named after ancient Greek heroes, and American towns after ancient Greek city-states. American women's fashions were influenced by Greek models, and Americans built in the Greek mode.

PHILADELPHIA AND WASHINGTON

Greek Revivalism became the national style by the 1830s, but Philadelphia, which had been at the heart of Monumental Classicism, had moved in that direction fully a decade earlier. Perhaps because its architects, Latrobe, Haviland, Mills, and Strickland, were more thoroughly trained and sophisticated, they were better prepared to accept the new forms. Philadelphia was still, though not to be much longer, the leading and most cosmopolitan city in the country, and it had in Nicholas Biddle—banker, ambassador, and dilettante—a champion of Greece and an arbiter of taste. Biddle's wealth, social position, and political influence made him a formidable figure in Philadelphia's intellectual life, and he wielded his power with aristocratic assurance. In *The Port Folio* (1814), he published George Tucker's *On Architecture*, the first defense of the Greek as the ideal form for America, and there is little question that he was responsible for the competition specifications for Philadelphia's Second Bank of the United States. Strickland's winning design resulted (except for the interior, plate 244) in the first true Greek Revival building in America (colorplate 18), predating the use of the Doric temple type of facade in other cities by a decade and the temple form by even more. The competition program called for a rectangular building faced in marble with "a portico on each front" to be "a chaste imitation of Grecian Architecture, in its simplest and least expensive form." Such specifications made the

temple form and even the choice of the Doric for economy all but inevitable, although in this case, as in most subsequent examples, the true Greek peripteral temple form was avoided and the Roman portico type used instead. Thus, what is Greek is mainly the detail in the orders and the decoration.

Latrobe had quit Philadelphia for Washington in 1807, though he maintained some contact with the city, and Mills departed in 1814. This left Haviland and Strickland in the twenties and thirties as the leading architects of Philadelphia. Strickland was the most Greek as well as the most graceful of the revival architects, but his dedication to the Greek manner did not prevent his using its formal elements with freedom and inventiveness. The most famous of his Philadelphia buildings, and his masterpiece, is the Merchants' Exchange (1832–34, plate 314), a singularly elegant and imaginative combination of disparate Greek elements. The rectangular block of the building is treated simply and broadly, almost completely devoid of decoration except for the strong horizontals of the cornice and a bold molding over the first story. His handling of the windows is unique; the large window areas divided into three vertical segments create a sense of spaciousness and establish a stately rhythm that carries to, yet contrasts with, the decorative elaboration of the curved facade. This semicircular facade with its *tholos,* or round-temple form, capped by a lantern which is an adaptation of the Choragic Monument of Lysicrates, is open to criticism from both purists and functionalists, but as sheer design it remains a masterly effort. The lower story of alternating large, simple windows and massive plinths serves as a solid base for the airy lightness of the freestanding Corinthian columns supporting a severely plain entablature, which in turn is enlivened by a lacy crown of acroteria.

Much less successful is Strickland's use of the Choragic Monument, again as a lantern, in the Tennessee State Capitol (1845–59), Nashville, in which the disparate elements fail to coalesce. The rectangular mass of the building, with Ionic porticoes at both ends and at the centers of the long sides, is handsomely done, but the lantern is blown up out of scale and raised on an incongruous, rusticated tower.

One of Strickland's pupils, Thomas Ustick Walter (1804–1887), active at first in Philadelphia, is best known for Girard College, the most archaeologically Classical of Greek Revival buildings, and the United States Capitol dome, an outstanding example of the revivalist bombast that was to dominate the post-Civil War era. He has been reviled unfairly for both; Girard College has been called a servile copy of a Greek temple put to an incompatible modern use, and the dome has been mocked as dishonest architecture because of its use of iron to simulate stone. But the idea of a Greek temple for Founder's Hall (1833–47) at Girard College was Biddle's, not Walter's. Walter had submitted a more Roman scheme to the trustees. An

314 William Strickland. Merchants' Exchange, Philadelphia. 1832–34

additional criticism of the ratio of length to width is also misdirected, since the dimensions were set by the financier's will. Given these conditions, Walter's achievement is impressive. The exterior is an academic copy, blown up in scale, of a Corinthian peripteral temple on a stylobate, but its elegant proportions, richness of materials, impeccable craftsmanship, and restraint in decoration create a monument of great dignity rather than a pedantic facsimile. In the lobby, the lavish materials are treated with unpretentious directness. Walter's real abilities are revealed in the interior rooms, where the unadorned cut-stone vaults and domes springing from massive piers result in an elemental architecture of unusual power. Behind the Greek colonnade is a functionally conceived structure executed with honesty and skill. In the four symmetrically flanking dormitory buildings, where there was no need for neo-Greek pretense, Walter produced pleasantly sturdy utilitarian constructions.

In his renovation of the United States Capitol (plates 315, 316) Walter enlarged the Senate and House wings (1851–61) and erected the great cast-iron dome (1855–65) which is now its distinguishing characteristic. Unfortunately, his work on the Capitol reflects not only the obvious needs of an expanding nation but the vulgarization of taste which accompanied it. It is not so much that he used cast iron in imitation of stone—there was no precedent for using this new material in a monumental building in any other way, and a dome on that scale could not have been built in any other material at that

315 U. S. Capitol, Washington, D.C. c. 1846. Daguerreotype by John Plumbe, Jr. Library of Congress, Washington, D.C.

316 Thomas U. Walter. Dome, U. S. Capitol, Washington, D.C. Completed 1865

time—but that the dome is undistinguished in design and crude in detail. Yet despite its aesthetic mediocrity and the fact that the modest dignity of the Thornton-Latrobe original has been overwhelmed in the great pile of sprawling masonry, the dome does, by its sheer scale, manage to unify the whole and dominate its environment in an impressive way.

The works of both Haviland and Mills have a certain robustness of form suggestive of Monumental Classicism even when they are at their most Greek in detail. Although Haviland used a Doric portico in the striking facade of the Pennsylvania Institute for the Deaf and Dumb (1824–25, plate 317), now incorporated in the Philadelphia College of Art, the clean cubical block of the wings flanking the recessed porch are reminiscent of Latrobe. Of his later work in the neo-Greek manner in Philadelphia, less is known. He designed the Philadelphia Arcade (1825–27, plate 318), demolished in the 1860s, and was probably responsible for many of the handsome squares and row houses of old Philadelphia. Like many of the Greek Revivalists, he reflected a growing eclecticism in the use of various styles, including the Gothic (plates 369, 370) and especially the Egyptian (plate 403), for which he seems to have had a predilection.

Mills never became entirely at ease in the Greek Revival. However, his Washington buildings from 1836 to 1842—the Treasury (plate 319), Post Office, and Patent Office—belong well within the period, though they are stylistically much closer to Rome than to Greece. True, the orders are knowledgeably Greek, pure Parthenon Doric in the Patent Office (now the National Portrait Gallery) and with a Hellenic grace in the Ionic colonnade of the Treasury, but this is not their significance. The importance of Mills at the time lies in the standards he established for governmental architecture by the integrity, efficiency, and accommodations of his structures. His plans are simple and rational; what they lack in inventiveness, they make up for in functional intelligence. As both engineer and architect, he made no distinction between construction and expression. His masonry and cement vaulting, the basic structural form of these buildings, was intended as efficient and permanent but also as expressive. Mills's masonry vaults survived a fire in the Patent Office in 1877, when Thomas U. Walter's later sections, constructed of a shell of masonry on an iron frame, crumbled. All the subsequent Classic Revival buildings, including those of the twentieth century, have not dimmed the austere dignity, the simple honesty and

317 John Haviland. Pennsylvania Institute for the Deaf and Dumb (now Philadelphia College of Art). 1824–25

power of his designs. As a Classic Revivalist, he borrowed from the past the language of his expression, even from the Greek when that became current, but as a Monumental Classicist, he employed it always in the service of what he considered to be a national architecture. "Go not to the old world for your examples," he wrote. "We have entered a new era in the history of the world; it is our destiny to lead, not to be lead."

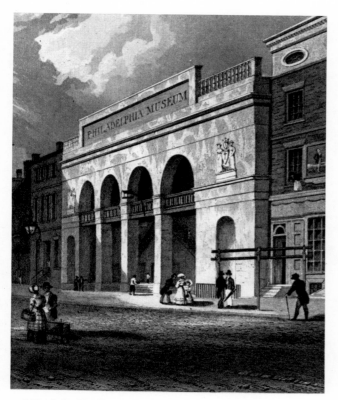

318 John Haviland. The Philadelphia Arcade. 1825–27. From an engraving by Fenner Sears & Co. Free Library of Philadelphia

NEW ENGLAND

New England as a whole and Boston in particular had been, during the Federal Period, under the conservative domination of Bulfinch, Benjamin, and their followers. But after Bulfinch's removal to Washington in 1817, rifts in the facade of Adamesque refinement became progressively more apparent. From 1815 to 1825 Boston was experiencing a period of intellectual ferment. The return of Ticknor and Everett from their studies in Germany enlarged cultural horizons, fostered a growing cosmopolitanism, and introduced a new Romanticism. The transcendentalist circle of Emerson, Margaret Fuller, Channing, Allston, and Greenough made Boston the hub of American philosophic thought and literature. Steeped in classical education, they endorsed the primacy of Classicism in art and architecture. Boston was thus fertile soil for the spread of the Greek ideal.

Three young architects—Parris, Willard, and Rogers —close friends and often collaborators, led Boston architecture from the Adamesque into the Greek Revival. Oddly, all three began as carpenters and came to architecture indirectly. Alexander Parris (1780–1852), of Portland, Me., practiced there from 1801 to 1809. His early work was clearly influenced by Bulfinch, although already distinguished by a striving for greater monumentality. Even many years later, his granite Unitarian Church (1828) in Quincy, Mass., was very much like Bulfinch's Lancaster church (plate 200) in design, except that the latter's light elegance was translated into a sober dignity. In a strangely retarded manner, it retains all the Georgian elements but stripped of their decoration and left in stark Classical nudity. After Portland, Parris spent some time

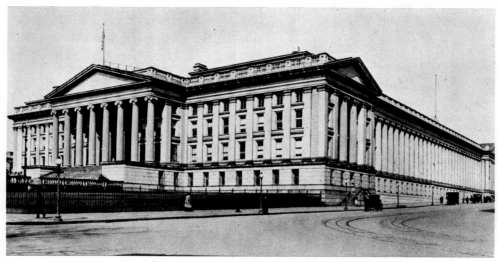

319 Robert Mills. Treasury Building, Washington, D.C. 1836–42

in Richmond, Va., where the presence of Latrobe had a marked effect on his style. His earliest important commission in Boston, the Sears House (1816, plates 320, 321), now the Somerset Club, was the first glimmer of a new kind of Classicism in that city so dominated by Bulfinch's refined Adamesque. Although it exhibits no obvious break from the Bulfinchian manner in its graceful bows, flat surfaces, and elongated windows, there is an added stateliness in its general appearance as well as its decorative detail, perhaps due in part to the use of granite. The Appleton-Parker Houses, which followed in 1818, also revealed his movement toward newer and more varied forms and freer invention. St. Paul's (1819–20, plate 322) on Tremont Street, with its starkly plain temple facade of unfluted Ionic columns, is clearly reminiscent of Latrobe and Monumental Classicism. Parris's most important and interesting work was the Quincy Market (1823–26, plate 323), a group of three long, shedlike buildings in Quincy granite, the central one with Doric porticoes on either end and the long line of the mass broken only by a simple central block capped by a shallow dome. There could be nothing more forthright, less archaeological, and yet so Greek Revival in essence than

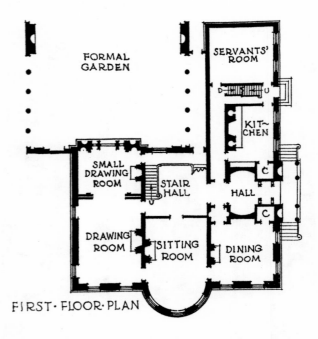

321 Alexander Parris. First-floor plan, Sears House (Somerset Club), Boston. 1816. From Hamlin, *Greek Revival Architecture in America*, 1944, fig. 10, p. 93

this market. Parris was a designer of vigor and originality, and it is regrettable in one sense that he turned to more utilitarian areas of construction and engineering, including the drydock of the Boston Navy Yard and the installations of the Portsmouth Navy Yard, of which he was Civil Engineer from 1848 until his death.

Solomon Willard (1783–1861) was an unusually talented architect and a man of wide interests, whose importance in the Boston group is not adequately reflected by his few extant works. Eccentric, gifted, and of independent mind, this man, who was in his time carpenter, woodcarver, sculptor, teacher, inventor, scientific farmer, and architect, was characteristic of the Bostonian radical intellectuals of his age. He studied architectural drawing and did architectural carving and models for Banner, Bulfinch, and Godefroy before he began to practice architecture independently in Boston in the early 1820s. His discovery of the Quincy granite quarries and his development of machinery to facilitate the cutting and handling of large slabs revolutionized Boston architectural practice and influenced building all over the eastern part of the country. The effect of his innovations can best be seen along the Boston waterfront (plate 324), in warehouses and commercial buildings constructed of great, rough-cut granite blocks, with monolithic slabs in the lower story, undecorated or with the simplest of anta capitals to indicate an awareness of the Greek Revival.

320 Alexander Parris. Sears House (Somerset Club), Boston. 1816

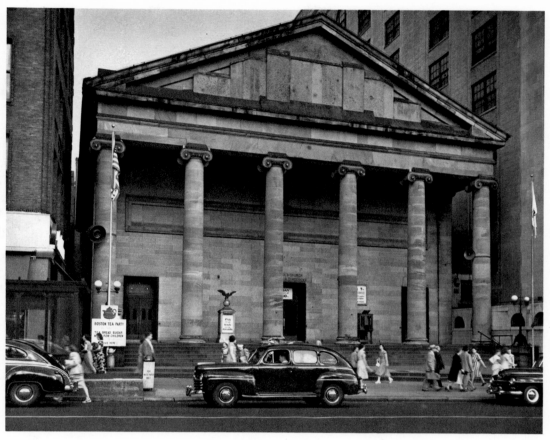

322 Alexander Parris. St. Paul's Church, Boston. 1819–20

323 Alexander Parris. Quincy Market, Boston. 1823–26

324 Boston wharf buildings. 1837

325 Solomon Willard. Suffolk County Courthouse, Boston. 1835. Courtesy The Bostonian Society, Old State House, Boston

In their directness and simplicity, their recognition of the primacy of function, they express the spirit, if not the insignia, of the style.

Of Willard's own work the obelisk of the Bunker Hill Monument (1825–43) is probably the most familiar, but the finest of his buildings, now destroyed, was the Suffolk County Courthouse (1835, plate 325), Boston. The plain, massive, three-story, granite block was unadorned except by simple horizontal bands at the roof and pedimental cornice lines and by the monolithic Doric porticoes on either end. As in all Willard's late work, the stripped structural masses project a bold and powerful presence, even more forthright and heavy than that of Mills. In some ways the works of Willard, as well as Parris, show a closer affinity to the Monumental Classical than to most of the more archaeological Greek Revival buildings of the period.

The most famous and prolific of the Boston group was Isaiah Rogers (1800–1869), whose successful career extended well beyond the Greek Revival. The son of a shipbuilder, Rogers spent the years 1820–21 in Mobile, Ala., where he won an architectural competition, and four years with Willard in Boston before entering independent practice in 1826. Rogers's reputation and the course of his architectural career were set by the success of his first important commission, the Tremont House (1828–29, plates 326, 327) in Boston, the first truly modern hotel. All the decorative details of the structure were neo-Greek, from the Doric unpedimented portico to the Ionic order used in the lavish dining room. However, it is not as a Greek Revival monument that it is most significant, although the simple, even austere dignity of its facade, handsomely executed in Quincy granite, is commendable, but in its revolutionary conception and rationality of planning. In one clean sweep Rogers transformed the eighteenth-century inn into the prototype of all subsequent luxury hotels. Functional requirements were planned with absolute clarity, and the various elements ingeniously disposed to fit the irregular site. Everything from basic convenience to the ultimate in creature comforts that modern technology could offer was supplied —a variety of public rooms ranged along the front on the ground floor; a sumptuous dining room on the same level, occupying the whole wing facing Beacon Street and serviced from below; one hundred rooms in suite or single arranged along straight corridors with easy access to stairways; and most spectacular of all, a row of toilets and bathrooms with running water.

Rogers was then commissioned to build New York's Astor House (1832–36), larger, more sumptuous, and

326 Isaiah Rogers. Tremont House, Boston. 1828–29. From an engraving. Courtesy The Bostonian Society, Old State House, Boston

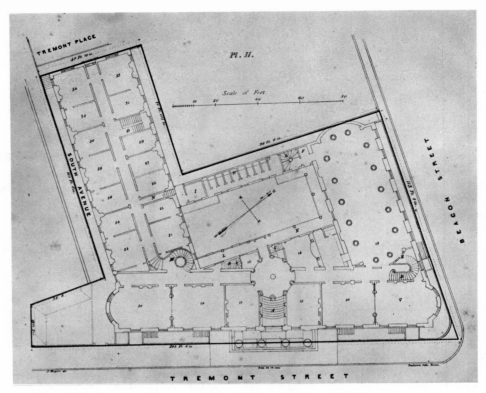

327 Isaiah Rogers. First-floor plan, Tremont House, Boston. 1828–29.
Courtesy The Bostonian Society, Old State House, Boston

technologically more advanced. For the first time water was pumped to a tank on the roof and running water could be supplied to every floor. From 1830 to 1865 he built almost all the major hotels in America: Bangor House (1832), Bangor, Me.; the Charleston Hotel (1839), Charleston, S.C., with its splendid Corinthian colonnade; the St. Charles Hotel (c. 1851), New Orleans; the domed Burnet House (1850), Cincinnati; the Galt House (c. 1865), Louisville, Ky.; and the 600-room Maxwell House (1859–69), Nashville, Tenn. In the later hotels of the fifties and sixties the changing taste toward a more vulgar eclecticism is clearly evident even in Rogers's work, but in his earlier years he made important contributions to the repertory of Greek Revival architecture: the sedately graceful Suffolk Bank (1834) and the much more opulent Merchants' Exchange (c. 1834–42), both in Boston and now destroyed. Of his work in New York (1834–42) the third Merchants' Exchange (1836–42), later the Customs House (its colonnaded facade now incorporated in the First National City Bank Building on Wall Street), was his most impressive achievement (plate 328). Harking back to his Boston past, Rogers built a granite Ionic stoa across the front of a magnificently simple cube. On the interior, the great domed rotunda with giant Corinthian columns and piers of unequaled Roman splendor was a fitting monument to the growing power of American finance. In his last years Rogers served as Supervising

Architect of the Treasury Department and completed the original Mills Treasury building, once again working in a manner close to the idiom of his youthful years.

Among the younger architects working in Boston during the Greek Revival, and there were many, Ammi Burnham Young (1798–1874) was the most noted and most successful. Born in New Hampshire, he is reputed to have been a student of Parris, and he did some early building in Vermont. His major work was the Boston Customs House (1837–47, plate 329), the culmination of the Greek Revival in Boston. This splendid old building has been preserved by incorporation as the base of the present Customs House. Built of Quincy granite, it is, in its compact, almost mathematical inevitability of design, a paradigm of academic Greek Revivalism. In it Young resolved two problems that seem to have haunted Greek Revival architects: how to break out of the restrictive bonds of the temple form, and how to combine a Roman dome with it. The powerful cadence of the Doric columns and the impeccable interrelationship of the four pedimented facades and the shallow dome make one feel, for once at least, that there really was no problem. During his tenure as Supervising Architect for the Treasury Department from 1852 to 1862, many new post offices and customs houses were built, and the standards of design and construction in government building attained a truly high level of excellence.

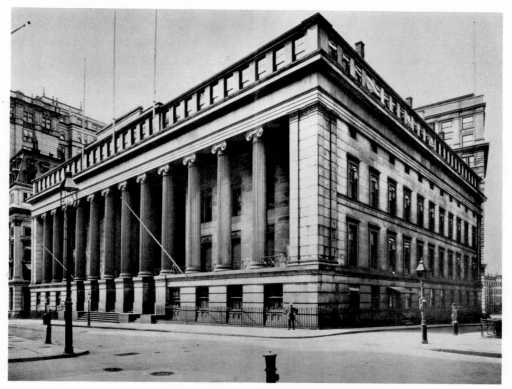

328 Isaiah Rogers. Third Merchants' Exchange, New York. 1836–42. From
American Architect and Building News, July 22, 1899

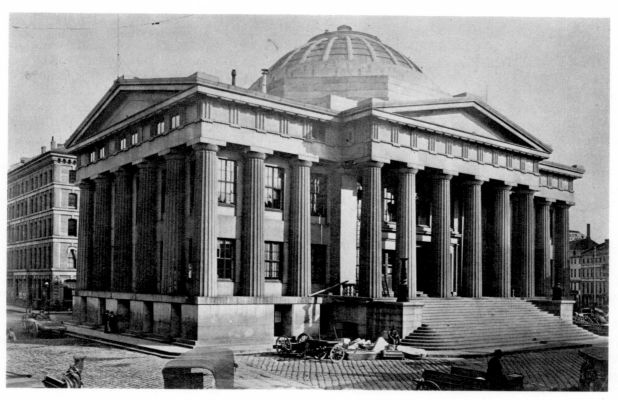

329 Ammi Burnham Young. Customs House, Boston. 1837–47. Courtesy The Bostonian Society, Old
State House, Boston

NEW YORK

New York came late to the Greek Revival, but when it did in the 1830s, it was with an unequaled richness and variety. After the opening of the Erie Canal connected the port with the western lands, New York became the leading commercial city of the Republic as well as its cultural center. New York's influence on the spread of the Greek Revival derived from two quite disparate sources. The first was the firm of Town & Davis, the largest architectural office of the time, whose leadership was exerted not only through the many buildings for which it was responsible but also through the many architects it trained. The second was Minard Lafever's handbooks. From monumental state houses to rural cottages, from the deep South to the Far West, the impact of New York was felt.

The long and successful partnership of Ithiel Town (1784–1844) and Alexander Jackson Davis allied two quite different personalities and talents—Town, entrepreneur and builder, and Davis, draftsman and designer. The contributions of each are difficult to disentangle. In Town's relationship with first Martin Thompson and then Davis, it was the partner who was usually given credit for the architectural design, but Town had designed a series of unusually interesting and advanced Greek Revival buildings before his partnership with either. He seems to have received his training in Boston, probably at Asher Benjamin's school, but his early works were done in New Haven, which he considered his home. Among them, besides a number of houses, were the Center Church (1812–14), still late Georgian; Trinity Church (1814–15), the earliest neo-Gothic building in New England; and the State Capitol (1827–31), the earliest Doric temple form in New England. He made a fortune as the inventor of the Town truss for bridges, traveled widely, and amassed the largest library of books and engravings on art and architecture in the country. In 1826 Town went into practice with Martin Thompson (c. 1786–1877) in New York. Their Doric Church of the Ascension (1828) on Canal Street, characterized by Lafever as the finest example of the Greek mode in the city, has always been credited to Thompson, but it may well be the result of Town's influence. Certainly Thompson's previous work, such as the U.S. Branch Bank (1822–24), the facade of which remains on the exterior of the American Wing of the Metropolitan Museum of Art, and the second Merchants' Exchange (1825–27), exhibits a conservative Classicism with an almost Georgian flavor. As a matter of fact, the Federal Style was still strong in New York, and it may be that the forcefulness of Town's personality and his scholarship were instrumental in breaking its hold. At any rate, by the time Davis was taken into the partnership in 1829, the supremacy of the Greek Revival was assured.

The early career of Alexander Jackson Davis (1803–1892) was entirely different from that of his older partner. He first worked as a topographic draftsman, depicting buildings and landscapes for engravers and lithographers. Even after he was established as an architect, he continued to sell designs and drawings to various clients and to other architects. His study of architecture seems to have been confined to an apprenticeship with Josiah Brady and to a stay in Boston during 1827, where he came into contact with its intellectual circle and was no doubt influenced by the Classical climate.

Of the various Greek Revival buildings designed by the partners either singly or together, very little now remains in New York—only the Old Customs House (1834–42), a fragment of La Grange (Lafayette) Terrace (1832–33, plate 344), and perhaps some unidentified commercial buildings. Gone are the prototypal Carmine Street Church (1831–32), the delicate little Bleeker Street Church (1831); and the almost Baroque, high-domed French Protestant Église du Saint Esprit (1832–34); and all their beautiful houses, including the elegant Brevoort (c. 1835) and the sumptuous John Cox Stevens (1845), as well as that pacesetting commercial structure, the Tappan Store (1829).

The Carmine Street Church, with recessed porch and two Doric columns *in antis* between two solid sections, established a type that was often copied. But their most important New York building is undoubtedly the Customs House, now the Federal Hall National Memorial, on the corner of Wall and Nassau (1834–42, plate 330). Although Town & Davis won the competition for the building and the exterior is the Doric temple they planned, the interior is not of their design. The authorities in charge questioned the proposed dome over the central rotunda projecting above the temple roof and called in a visiting English architect, William Ross, who planned instead a domed rotunda to be enclosed within the building. John Frazee, the sculptor, who was also a contractor and stonemason, was then employed as architect of the building, supervised its construction, and supplied the detailing and working drawings. The exterior is a faithful adaptation of the Parthenon. Much more impressive are Ross's skylighted, domed rotunda, and the powerful, shallow vaults on stunted Doric supports in the basement.

Many of New York's commercial structures built after the disastrous fire of 1835 in lower Manhattan were modeled on the Tappan Store, which was credited by Davis to Town. For the first time in New York granite piers were used on the lower floor, a practice Town as well as Davis must have recalled from their Boston experience. These simple and handsome buildings, many still standing, were built of monolithic granite piers with plain anta capitals carrying a broad granite architrave and, above, walls of granite or brick pierced by regularly spaced plain windows and capped by an equally modest cornice. Sturdy and unpretentious, they still have a power and grace which derive from Classic proportions.

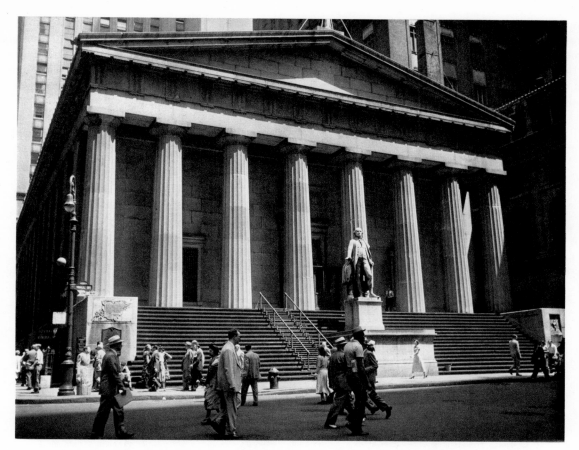

330 Town & Davis with William Ross and John Frazee. Customs House (later U. S. Sub-Treasury and Federal Hall National Memorial), New York. 1834–42

Town & Davis had an immense practice, extending south to North Carolina and west to Illinois. They designed state capitols for North Carolina, Indiana, and Illinois, and Davis was consultant for that of Ohio. They also built college buildings at Yale, the University of North Carolina, Davidson College, and the Virginia Military Institute. Most of the Town–Davis designs can probably be credited to Davis, and in most of them, before he turned to the Gothic, one can see his predilection for combining a Roman dome with a Greek temple, not always successfully, but establishing a type which became almost the hallmark of Greek Revival public building.

Just as Town & Davis exemplify the emerging conception of designer- rather than builder-architect, so Minard Lafever (1798–1854) represents the older craftsman or "mechanic" architect in the United States. It may be because he began as a carpenter in the Finger Lakes area of New York state and understood the needs and limitations of the provincial builder and craftsman that his architectural handbooks had such effect on the Greek Revival vernacular. In New England Asher Benjamin still reigned, but the rest of the country, down to the Gulf States and as far west as the Mississippi, was all Lafever territory, although his influence was much

stronger in rural and domestic building than in monumental public commissions.

Lafever's career as a practicing architect was overshadowed by the reputations of his more famous colleagues and by the success of his publications; also, fate has dealt harshly with his work, and none of the half-dozen of his extant buildings is in the neo-Greek mode. The first years in New York after his arrival about 1828 were spent as a draftsman for other architects. He actually came late to the Greek Revival, and his first and only documented building in that style was the First Reformed Dutch Church (1834–35), Brooklyn, long since demolished, a Greek temple type with Ionic octastyle porches on both ends. The modest St. James Roman Catholic Church (c. 1835–37), near Chatham Square, in the then popular Doric distyle *in antis* form, is often attributed to Lafever but is more probably one of the many examples of derivation from his published designs and details. The most notable Greek Revival structure connected with his name through local tradition is the eccentric, somewhat provincial, yet altogether charming Whalers' Church (1843–44) at Sag Harbor, Long Island (plate 331). This curious effort to wed the Greek to the Egyptian is a remarkably successful excursion into eclecticism. Whether

by Lafever or not, the freedom in adaptation and even invention of Greek forms characteristic of his handbooks is nowhere more apparent than in this bold Egyptianizing of the Greek. The battering of the sides and the increased scale and vigor of the ornament transmute the essentially Classical elements into a new, powerful, and exceptional statement. The Whalers' Church remains a sport. The Suffolk County Whaling Museum (1845–46, plate 332), formerly the Benjamin Huntting House, in the same town, is also often ascribed to Lafever, and it shares with the church such disarming localisms as the whalers' spade used as a symbolic decorative motif and

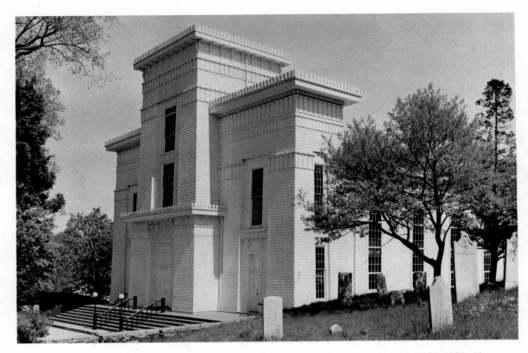

331　Minard Lafever (attrib.). Old Whalers' Church, Sag Harbor, Long Island, N.Y. 1843–44

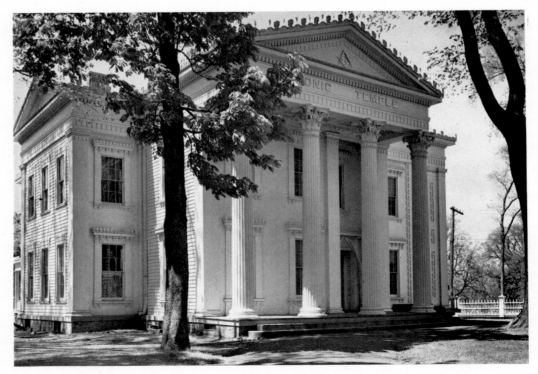

332　Minard Lafever (attrib.). Suffolk County Whaling Museum, Sag Harbor, Long Island, N.Y. 1845–46

a similar gigantism of ornament, approaching the more Baroque forms of the emerging Italian Villa style.

SPREAD OF THE GREEK REVIVAL

The phenomenal expansion of the United States from 1830 to the Civil War created a tremendous building boom. Towns grew into cities and new cities were founded. In the first half-century fifteen new states were added to the union. Capitols, city halls, post offices, customs houses, courthouses, churches, colleges, to say nothing of homes, had to be built—all during the period of the Greek Revival. No wonder that in the American mind the Classical orders and the temple form became synonymous with government, law, and order. One would expect the presence of professional architects in the large cities, or even in smaller ones, but architects were also practicing in what were scarcely more than frontier settlements. In discussing the Greek Revival in St. Louis, Talbot Hamlin mentions, without attempting to be exhaustive, ten architects by name, and this in a town with a population of under six thousand in 1821, when Missouri was admitted to the Union, and only about seventeen thousand by 1840. In 1837 the new town of Detroit boasted an architectural drawing school, and six men were listed in the directory as architects. Yet the demand for new buildings was so great that even the designs of local architects, supplemented by those of such national figures as Mills, Strickland, Walter, Rogers, Town & Davis, and others supplied by governmental agencies, were insufficient. Many commercial buildings and houses, as well as some of the more monumental edifices, remain anonymous, the work of builders and contractors depending on the handbooks. Throughout the country the standards of design and construction, whether in stone, brick, or wood, whether professional or not, were unusually high.

In New England, apart from the work of the Boston architects and of Town in New Haven, the most fruitful development of the Greek Revival occurred in Providence, R.I., where the activities of Russell Warren (1783–1860) and James Bucklin (1801–1890) are especially noteworthy. Warren's earlier efforts in a series of domestic buildings for wealthy shipowners of Bristol, R.I., were Adamesque, but his mature work, particularly that done in partnership with Bucklin, reveals a complete acceptance of the newer Greek forms. Among these were the Westminster Congregational Church (1828–29), with its stately octastyle Ionic portico, and the more interesting Providence Arcade (1828, plate 333). The only extant example of this newly introduced European type of en-

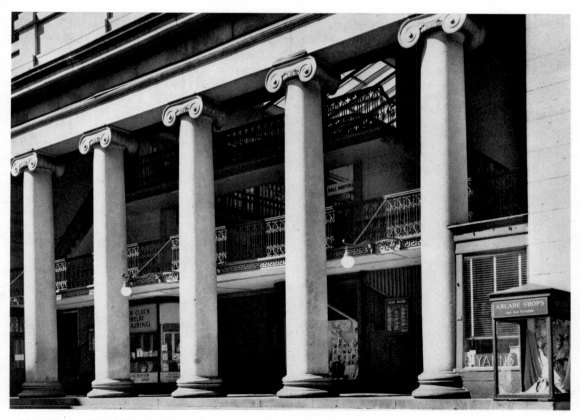

333 Warren & Bucklin. Providence Arcade, Providence, R.I. 1828

closed shopping center (cf. plate 318), the Arcade has two facades composed of granite Ionic columns and a very fine skylighted interior with side gallery railings of cast iron. Though academically faulty in the use of the Greek orders, it was noteworthy in its functional innovations and design, capable of standing comparison with similar buildings abroad. Bucklin by himself was also responsible for the handsome commercial block of Washington Buildings (1843, plate 334). Here red brick was combined with a lower floor and pedimented central pavilion of gray granite, curiously still conservative and reminiscent of Bulfinch, but with a dignity and aesthetic refinement characteristic of much of the commercial building of the period, soon to be lost.

Close to Washington, Baltimore had already attracted many first-rate architects—Latrobe, Godefroy, Mills, Ramée—who left it a heritage of fine building continued by the Robert Cary Longs, father and son. Richmond had works by Mills and Rogers, and many others were added during the height of the Greek Revival. Much of the South remained conservative and unresponsive to the new vogue until comparatively late. Still, Charleston had an unusual efflorescence of the Greek, even though it did not appear until the forties. Following a fire in 1838 a spate of Greek temples of increasingly archaeological erudition were erected there: Beth Elohim, the Hazel

Street Synagogue (1840), by the New York architect Cyrus Warner; the Hibernian Hall (1840) of Thomas U. Walter; and the Wentworth Street, or Second Baptist, Church (1842) by Edward Brickell White. Perhaps the most impressive of all was the magnificent Corinthian stoa on a one-story base in front of the Charleston Hotel (1838, plate 335), attributed variously to Isaiah Rogers and a German architect, Charles F. Reichardt.

After the Louisiana Purchase in 1803 an entirely new area of the continent was opened to settlement. The Mississippi waterway tied the Great Lakes to the Gulf of Mexico, and in the next half-century, with the rise in cotton and sugar production, it became a major trade route, with cities rising and flourishing all along the Mississippi River and its tributaries. New Orleans was the natural focal center of the new South. The older Creole population—Spanish and French—had its own developed patterns of life and modes of building which were then slowly absorbed into the fabric of American culture. The Americans and the Greek Revival took over and transformed but did not entirely obliterate the Creole heritage.

The Greek Revival in New Orleans properly dates from 1835, when James H. Dakin, who had studied with Town & Davis and then became a partner, joined his brother Charles and the Irish architect James Gallier, who had

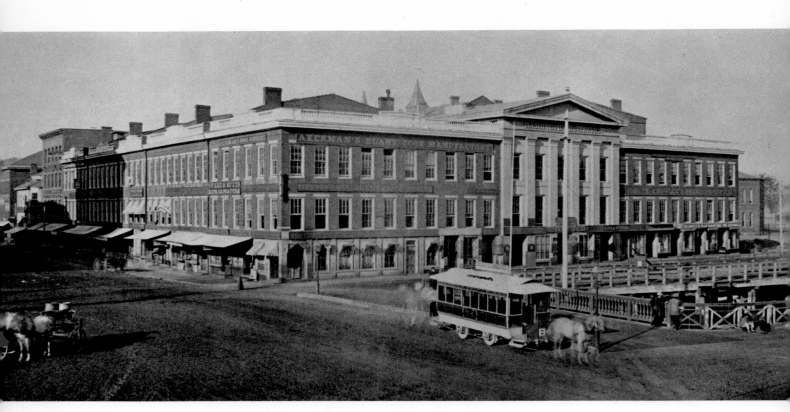

334 James Bucklin. Washington Buildings, Providence, R.I. 1843

335 Charleston Hotel, Charleston, S.C. 1838

336 James Gallier. City Hall, New Orleans. 1845–50

worked as a draftsman for Town & Davis and been a partner of Lafever for a short time. Separately and in concert they did much to change the appearance of New Orleans. The firm of Dakin, Gallier & Dakin was responsible for the great St. Charles Hotel (1834–36), burned in 1850, which had a magnificent rotunda and an exterior of Quincy granite. Also theirs was Christ Church (1835–37), but the most impressive of the Greek Revival buildings were the New Orleans City Hall (1845–50, plate 336) by Gallier, after the partnership had been dissolved, and the crude but powerful "Egyptian" Customs House (plate 337) by a local architect, A. T. Wood, begun in 1849 but not completed until after the Civil War.

French influence was strong along the Mississippi, where fur-trading posts had been manned by Frenchmen even under Spanish rule, and St. Louis, as one of these frontier outposts, was architecturally dependent upon New Orleans. The Continental Baroque is still apparent in the Vincentian Church (1827–39) at Perryville, but St. Louis was soon converted into a western station of the Greek Revival by a number of native as well as foreign architects. One of the finest churches of the period is the "old" St. Louis Cathedral (1830–34, plate 338) by the Edinburgh architect George Morton and the Pennsylvanian Joseph C. Laveille, although, in its bold cubical massing of almost bare architectural forms and its unacademic use of the Greek idiom, it is somewhat more reminiscent of Monumental Classicism. It is astonishing to find so much excellent and advanced building so far west—in churches such as the Second Baptist (1847) by Oliver Hart, from Connecticut; the Second Presbyterian (1839) by Lucas Bradley; and one of the last of the type, the Trinitarian Congregational (1859) by the Englishman George I. Barnett; in the simple yet monumental St. Louis Hospital (1831–37) by Hugh O'Neil, completed by Stuart Matthews in 1837; and the St. Louis Courthouse (1839) by Henry Singleton (to which an incongruous Baroque cast-iron dome was added in the sixties). Also worthy of mention are Stephen Hills's Old Capitol (1839–45), Jefferson City, and the first building of the University of Missouri (1840–41), Columbia, in which Greek Revival dignity is leavened by an uncommon grace.

The border states of Tennessee and Kentucky were settled even before the Revolution by the free highland farmers of Virginia and the Carolinas who had followed

337 A. T. Wood. Customs House, New Orleans. Begun 1849. Courtesy Tulane University Library. Hertzberg-Ricciuti Collection

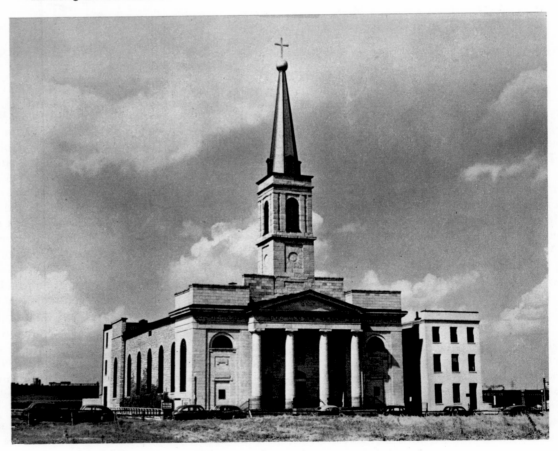

338 George Morton and Joseph C. Laveille. "Old" Cathedral, St. Louis. 1830–34

Daniel Boone through the Cumberland Gap. After the War of 1812 a new migration of wealthy land and slave owners moved into the river valleys and grasslands, while growing cities were populated by people from the North, so that these states remained divided in culture between the South and the North, and in social attitudes among the slaveholding landed gentry, the free soil farmers of the hill country, and the newly urbanized city dwellers. In its own way the architecture of the region betrays the cultural strains from which these various people came. In Tennessee the grandiose plantations, which were built rather late, are the most characteristic expression of the Greek Revival; but even here there often was a dependence on northern professionals such as Strickland, who was also responsible for a number of the major public buildings in Nashville, among them, of course, the Capitol, but also two quite remarkable churches, the severely monumental, Ionic St. Mary's (1845–47) and the comparable though "Egyptian" First Presbyterian (1848–51).

Kentucky was rather more fortunate in the native genius of Gideon Shryock (1802–1880), whose father, the builder-architect Matthias, had sent him to Philadelphia to study with Strickland. He was obviously an apt pupil, for his first major work at the age of twenty-five, the Old Capitol (1827–29), Frankfort, was, when one considers that it was practically on the frontier, notable both in its use of a refined Ionic temple form and in the com-

petence and clarity with which it was planned (plates 339–341). Shryock had an independence and a natural grace in design that, in spite of occasional provincialisms, made him one of the truly creative Greek Revival architects. Among his many other works are the Jefferson County Courthouse (1835–50), Louisville, which in its austerity and blocklike directness is more reminiscent of Mills than Strickland; and the unique facade of the Southern National Bank (1837), Louisville, recalling a Greek treasury rather than a temple (plate 342). The bank is perhaps the most Greek in feeling of all the Greek Revival buildings in this country, certainly the most Ionic in its delicacy and refinement of proportions and decoration, and although one might question the archaeological propriety of the battered antas, it is at least indicative of Shryock's unacademic turn of mind.

The Northwest Territory, out of which Ohio, Indiana, Illinois, Michigan, Wisconsin, and Iowa were formed, was settled largely by immigrants from the Northeastern and Middle Atlantic States who brought with them their own local building traditions. In Ohio the New England strain was especially strong, since many of the settlers came from Connecticut, which had even claimed the Western Reserve as its own. They seem to have carried their Asher Benjamins along with their Bibles. All Ohio's vigorous young cities—Columbus, Cleveland, Cincinnati, Dayton—had their churches, city halls, courthouses, post offices, and hotels in the Greek Revival style. Most

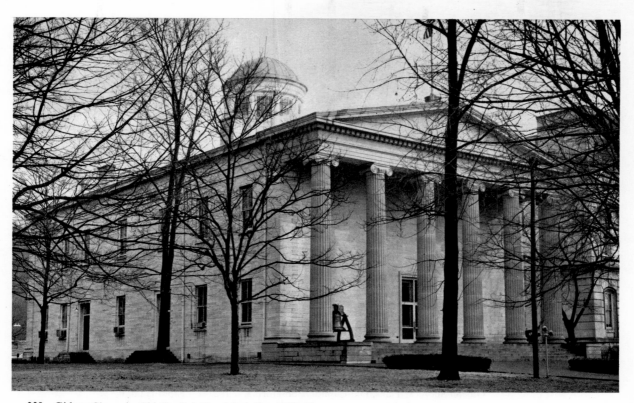

339 Gideon Shryock. Old Capitol, Frankfort, Ky. 1827–29

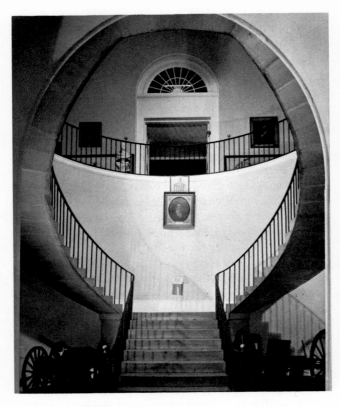

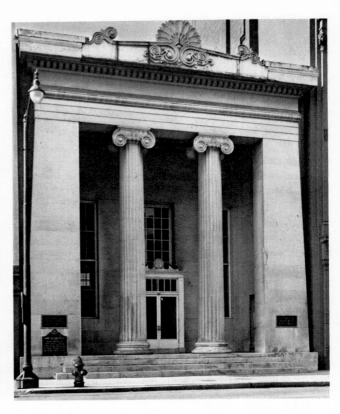

340 Gideon Shryock. Staircase, Old Capitol, Frankfort, Ky. 1827–29

341 Gideon Shryock. Southern National Bank, Louisville, Ky. 1837

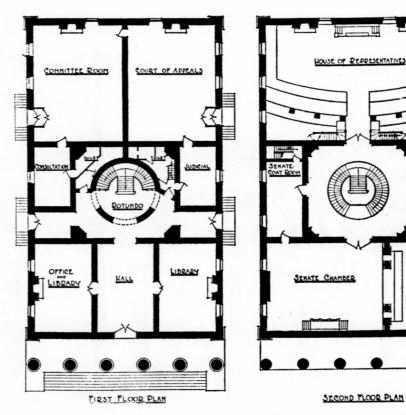

342 Gideon Shryock. Plans, Old Capitol, Frankfort, Ky. 1827–29. From Hamlin, *Greek Revival Architecture in America*, 1944, fig. 29, p. 245

impressive of all, and one of the major monuments of the period, is the State Capitol (1838–60, plate 343), Columbus, a work in which at least seven architects had a hand at one time or another. The rectangular block, with a recessed Doric porch on each of its facades, is unsurpassed in strength and dignity by even the best of Mills. Unfortunately, although the turret-like cupola over the rotunda is conceived with the same sense of monumentality, it is a complete anomaly in its place. Indiana eventually attracted its own array of local architects. Perhaps the finest of its Greek Revival buildings is the impressively simple Institute for the Blind (1851), Indianapolis, by Francis Costigan.

Throughout the country Federal buildings of excellent quality could be found in the most surprising places, from Stonington, Conn., which had a small Customs House possibly designed by Robert Mills, to San Francisco, where the impressive block of the United States Mint (1869–74), done under the supervision of Alfred B. Mullett, remains as the swan song of the Greek Revival in American public building.

DOMESTIC ARCHITECTURE OF THE GREEK REVIVAL

Despite an increase in the number of houses designed by professionals, the vast majority of domestic architecture was still produced by builders and carpenters who depended on handbooks for plans and details. Most of these guides were now published in America and written by Americans and were thus more immediately responsive to local conditions, practices, and tastes. As the repertory of Greek forms was expanded, it was always as a compendium of decorative details rather than as a system of Greek architecture. The decorative elements were thus seen out of context and as individual examples that could be used in free and varied combination. The American authors borrowed quite freely from European guides and architectural books, the most popular of which in this country were those of Peter Nicholson: *The Carpenter's New Guide* (1792) and *The Mechanic's Companion* (1825), both republished in various American

343 State Capitol, Columbus, Ohio. 1838–60

editions. Most of the Americans depended heavily on Nicholson for technical details of carpentry and construction. Among the other influential handbooks were Owen Biddle's *The Young Carpenter's Assistant* (1805) in its revised edition by Haviland, published in 1833; Edward Shaw's *Civil Architecture* (1831), the most thorough in a technical sense, and *Rural Architecture* (1843), whose designs of churches and houses were much imitated; and Chester Hill's *The Builder's Guide* (1834), the most eclectic in its borrowings. But it was Minard Lafever's three earliest works which had the greatest influence on vernacular architecture of the period: *The Young Builder's General Instructor* (1829), still crude and only tentatively Greek; *The Modern Builder's Guide* (1833), completely Greek and richly inventive; and *The Beauties of Modern Architecture* (1835), the climax of his mature Greek Revival style in beautifully executed plates. The general excellence of craftsmanship in the vernacular during the Greek Revival was due to the competence of its artisans, but the sophistication of design often found in the most remote regions is traceable to the handbooks in common use.

The development of the row house in the larger urban centers was one of the major contributions of the Greek Revival period, though they had appeared as early as Bulfinch's Tontine Crescent (plates 196, 197) in 1794. The row house, together with the ubiquitous grid plan, gave American cities their characteristic appearance, at least until the introduction, and final ascendancy in our own time, of the apartment dwelling. The growth of population in the larger cities made the freestanding house on its individual plot obsolete. Instead, whole blocks of contiguous houses were commonly erected by speculative builders to be sold to individual owners. The form as well as the process is open to obvious criticism. Attached houses on narrow plots present serious problems in planning and permit light and air to enter only from either end. The only practical solution is the basic plan of two rooms to a floor. Furthermore, speculative building can easily lead to a lowering of construction standards, monotony in planning, and a slighting of aesthetic considerations. It is therefore somewhat surprising that urban architecture of this period maintained so high a level, a circumstance which may be explained by the fact that such houses were built for the affluent, who insisted on certain standards and amenities, and by the integrity of the architects who designed them. With the social degradation of such buildings in our own time, it can be difficult to imagine that they once constituted luxury housing.

The finest houses were individually built, but the general acceptance of the standard city lot produced a standard form. Lot sizes varied in different places but were usually from 20 to 25 feet wide and approximately 100 feet deep, resulting in an inflexible narrow plan upon which very few interior changes could be rung. The ear-liest houses were two or three stories high; later ones, more commonly three or four, with a good deal of variation in attic and basement treatment. Individual cities produced characteristic types. Boston houses, for instance, were generally wider than those in New York or Philadelphia and thus capable of freer internal planning. New York houses usually had higher stoops and consequently a basement floor several steps below street level. In any case, variations on the basic plan of a hallway on one side and two rooms to a floor were severely limited. Indeed, Greek Revival town houses differed little in plan from those of the earlier Federal period and are distinguishable mostly in detailing. On the exterior almost the only change occurred in the door frame, which became clearly Greek in inspiration; in the interior, small-scale delicate ornamentation gave way to larger, bolder, simpler, and more clear-cut decorative elements in a rich new repertory of Greek forms.

In spite of their obvious drawbacks, planned units of entire blocks have at least the aesthetic advantages of order and dignity, and even the possibility of spaciousness and monumentality, as European experience has demonstrated. Unfortunately, this kind of urban planning did not take hold in the United States, and there are only a few fragments and some photographs to tell us what might have been. Among them are Aiken's Row, with its colonnaded porches, in Charleston, the Julia Row (1840) by James Dakin in New Orleans, both still standing, and a number of New York units long since destroyed—London Terrace (1845) on West 23d Street, by A. J. Davis; the De Pauw Row on Bleecker Street, probably by Samuel Dunbar; and on the same street Le Roy Place (1827), consisting of two rows of stone houses facing each other. The most splendid of all was La Grange (Lafayette) Terrace, New York (1832–33), attributed to A. J. Davis, originally nine houses, of which four remain (plate 344). Executed in Westchester marble, the original facade of twenty-eight elegant Corinthian columns two stories high on a rusticated stone base, with each entrance flanked by cast-iron candelabra lamps, could stand comparison with the finest in Europe. Even today, marred by neglect, renovation, and commercial signs, it adds a note of unexpected dignity to a drab and ugly stretch of urban decline.

Many row houses were erected by architect-builders for individual clients, and, within the given restrictions of cornice line and facade pattern, the client might introduce variations of detail, but the sense of unity and planning still obtained and imparted to such streets an air of quiet beauty. Only a scattered few are left—fragments of Washington Square in New York, Louisburg Square and streets on Beacon Hill in Boston, Rittenhouse Square in Philadelphia.

It is in city houses built on larger plots, similar to freestanding town or country dwellings, that the character of Greek Revival domestic design becomes most apparent.

344 Andrew Jackson Davis (attrib.). La Grange Terrace (Lafayette Terrace, Colonnade Row), New York. 1832–33

One of the finest examples in New York, where the Greek Revival had its richest urban domestic development, was the Brevoort (de Rham) House (1834, plate 345) by Town & Davis, unsurpassed in the restraint and elegant simplicity of its facade. The three beautifully proportioned bays were delineated with sharp-edged clarity, and there was a subtle interplay of raised and recessed flat surfaces from which all ornament had been eliminated. The spare geometry of the facade was echoed by the severe but gracefully slender windows, accented by the contained decoration of the cornice parapets defining the vertical bays, enriched by an ample doorway formed of Ionic columns *in antis* and an entablature crowned with a fine display of acroterial ornaments. The effusive decoration of the interior was in direct contrast to the chasteness of the exterior but with the same refinement in taste (plate 346). The Parish House (1848), New York, by R. G. Hatfield, is, like the Brevoort, now gone, but its plan (plate 347) can serve as an example of the variety of disposition possible even within the restrictive rectangle of the city house. Although it is perhaps more famous for its seven toilets and eleven tubs and washbasins, remarkable by any standard, these are not so indicative of the amplitude and graciousness of living as is the arrangement of rooms around the central oval stairwell and gallery.

The traditional house form had a rich and varied development during the Greek Revival, in the inventive modifications of the basic temple type by professional architects, as well as on the vernacular level in local adaptations. The pure temple type—a rectangular box with a columnar portico on the short side and a pediment continuous with the low-pitched peaked roof—like its counterpart in public buildings, was an adaptation of the Roman temple form which passed for Greek. Even the modified temple type, generally accepted as the Greek Revival paradigm, was never so widespread as it would seem. In actuality, the temple type evolved as a series of basic variations on a theme: the central pedimental block with symmetrical one-story wings, in which the temple form is the clearly dominant element; the two-story-wing type, in which the pedimented roof rising above the mass remains the major axis of the building; and a type in which the portico, and sometimes only a pavilion of building height, is added to the house block. The last is often indistinguishable from the Late Georgian houses that had giant columnar porticoes or pavilions, except in proportions or decorative features. These four forms, temple, one-story wings, two-story wings, and portico, were transformed by a series of secondary variations: the substitution of an entablature for the pediment, creating the appearance of a flat-roofed building; recessed

345 Town & Davis. Brevoort (de Rham) House, New York. 1834

346 Town & Davis. Parlor door, Brevoort (de Rham) House, New York. 1834

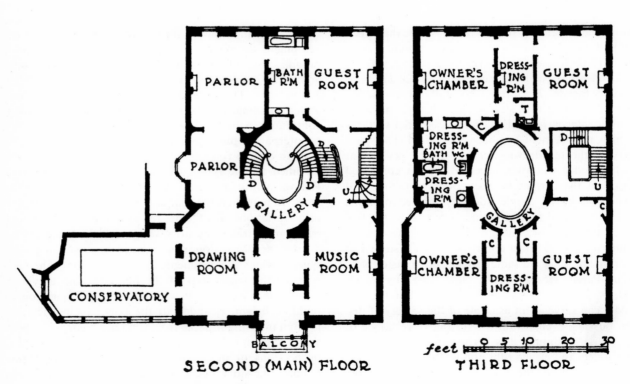

347 R. G. Hatfield. Plan, Parish House, New York. 1848. From Hamlin, *Greek Revival Architecture in America*, 1944, fig. 14, p. 129

instead of projecting porticoes, in which the columns are *in antis;* two-storied porticoes instead of the single giant order; and porticoes on the wings. The free use of such elements in various combinations and permutations resulted in a wide repertory of types. Except for the difficulty of admitting light into the attic area, the Greek Revival house was demonstrably adaptable to a variety of predilections and conditions.

The temple type found limited favor among home builders, as much perhaps because of its uncompromising formality as because of its functional limitations. Curiously enough, however, it found common use on the very lowest level of building, as in the modest one-story Kempf House, Ann Arbor, Mich., where it appears that the transition from frontier log cabin to Greek Revival temple needed only the addition of a portico on the short side. On a much more pretentious level are the Doric Ralph Small House (c. 1847), Macon, Ga., with corner antas and a low-pitched, sloping parapet capped by an acroterion rather than a full pediment; the Ionic Madewood (1840–48) in Louisiana, with two symmetrically flanking little one-story buildings of the same form but without the colonnade; and the Corinthian Samuel Russell House (1829–30), now part of Wesleyan University in Middletown, Conn., by Town & Davis. The finest and most imposing of the temple houses is Berry Hill (1835–40, plate 348), Halifax County, Va., which stands isolated on a sweeping greensward like a true Greek temple, balanced on either side by a smaller, one-story temple office, achieving an incomparable stateliness. The Starbuck-Codd House (1838, plate 349), Nantucket, Mass., is an astylar (noncolumnar) version of the temple type in which the colonnade is replaced by antas, and, as in many of the temple-type houses, the actual entrance is a small columnar porch on the side.

Totally different in appearance from the basic temple type is the house in which an entablature replaces the pediment, which can also be read as a cubical Federal Style house with a columnar portico across its facade. This type was popular in New England and especially so in the South. Two houses by Elias Carter of Worcester, Mass., the Levi Lincoln (1836) and the Simeon Burt (1834), are of this type, as is the splendid Elmhyrst (1833, plate 350), Newport, R.I., by Russell Warren, in which the four Ionic columns *in antis* form a recessed porch. Comparable variations in the South are two houses in Charleston, the Charles Alston (c. 1838) and the Roper (1845–50), which are not much more than Federal houses with applied columnar porticoes, the former in three stories, creating superimposed balconies in the typical Charleston mode, and the latter with a giant two-story order on an arcuated base. Of the same type, though more spacious, is the A. P. Dearing House (1856) in Athens, Ga., where the columns along the front turn the corner

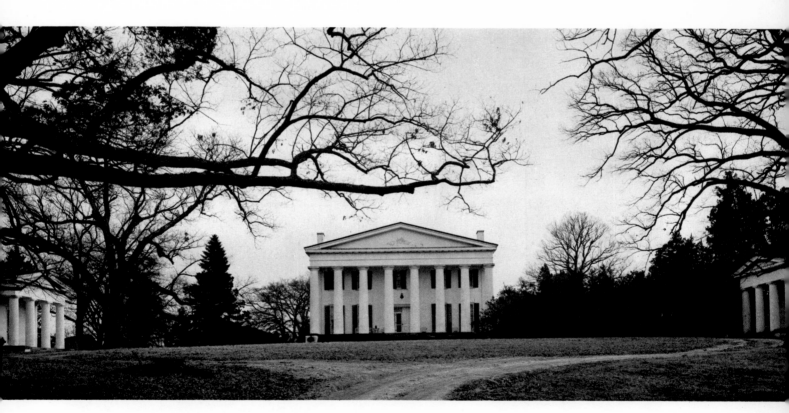

348 Berry Hill, Halifax County, Va. 1835–40.

Architecture: Eclecticism at Mid-Century 257

349 Starbuck-Codd House, Nantucket, Mass. 1838

and move partly down both sides in a T shape, producing the appearance of a peripteral colonnade (plate 351).

From a purely architectural view, the most interesting and pliable was the one-story-wing type, in which the interplay of cubical volumes on several levels and crossed axes offered a great variety of compositional effects. Many of the finest Greek Revival houses fall within this category. Some were the results of renovation in an effort to give a "modern" Greek look to older structures, such as Arlington (plate 237); Andalusia (c. 1835, colorplate 29), near Philadelphia by Thomas U. Walter for Nicholas Biddle, with its "Theseum" portico; and Andrew Jackson's home, the Hermitage (1835), Nashville, Tenn., in which a Corinthian colonnade of the entablature or stoa type was added along both long sides. Here, as in many houses of the period in areas where good carvers were unavailable, the leaves of the capitals are of cast iron. The one-story-wing type seems to have been a favorite device of Ithiel Town for some of his best houses, including his own (c. 1832) in New Haven. Town's Bowers House (1825, plate 352), Northampton, Mass., was one of the earliest and most striking versions of this form, in which the feeling of intersecting masses at different levels is clearly emphasized by the pedimented roofs on the wings as well as the central building. The cadence of the central Ionic colonnade is carried over into the pillared

350 Russell Warren. Elmhyrst, Newport, R.I. 1833

351 A. P. Dearing House, Athens, Ga. 1856

352 Ithiel Town. Bowers House, Northampton, Mass. 1825. Drawing by A. J. Davis. Society for the
Preservation of New England Antiquities, Boston

porches of the wings, creating a continuous columnar facade rich in geometric variation and subtle in its interplay of mass and space, light and shade, surface and detail. Of the many superb houses of the one-story-wing type throughout the country are Orton Plantation, Cape Fear River, N.C., completely remodeled in 1840, with its great Doric portico, and the stately Rose Hill, or Boody House (c. 1835), on Seneca Lake, Geneva, N.Y., with its wing porches, perhaps influenced by the Bowers House. A variation most common in rural areas, especially in Ohio, was an asymmetrical and patently less monumental form in which a single wing with a porch attached to one side forms an ell.

The two-story-wing type was also popular, probably because it was closer to the traditional "square" house and required only decorative innovations rather than serious alterations of plan or construction. In this sense the two-story-wing and portico types are similar, except that in the former the central pedimental form projects forward of the longitudinal mass of the building, and in the latter only the portico projects. In either case, the appearance of such buildings differed little from those of the Federal period, except in their use of Greek details. Of the two-story-wing type there are the Jenkins Mikell House (1853, plate 353), Charleston, one of the most im-

posing, with a giant Corinthian colonnade raised on a balustered base; the much more modest, wooden Ferris House, the Bronx, New York; and one of Town & Davis's New Haven houses, the Skinner, in which one- and two-story wings are combined in a fascinating composition of cubes.

By far the most popular in its varied forms all over the country was the portico type, which includes some of the most sumptuous of the great Southern plantations: Belo (1849), Winston-Salem, N.C., three stories high, with a giant Corinthian portico flanked by elaborate cast-iron balconies supported on one-story Corinthian columns; Stanton Hall (1851–57), Natchez, Miss., which has a portico balcony of cast iron; and the Old Governor's Mansion (1838) in Milledgeville, Ga., now President's House, Georgia State College for Women.

Somewhat more conservative is the Junius Ward House (c. 1856) near Georgetown, Ky., its Baroque treatment of Corinthian portico and doubled end pilasters giving a foretaste of the opulence to come. In other parts of the nation one could cite the Hadwen-Salter House (1844), Nantucket, which, though retaining the New England preference for wood, is so splendid in its sophisticated stateliness that it has been attributed to Russell Warren; the more monumental General Leavenworth House

353 Jenkins Mikell House, Charleston, S.C. 1853

(1838, demolished 1950), Syracuse, N.Y., built of stone with a dignified Ionic portico and an extensive service wing in the rear; or the even more monumental Charles M. Reed House (c. 1840?), Erie, Pa., attributed to William Kelly, an Erie architect, which because of its plastic richness and elaboration looks more like a public building than a domicile.

These basic types do not exhaust the range of Greek Revival domestic architecture. Some of its most interesting examples are exceptional, from the palatial Belmont (1850, plate 354), Nashville, Tenn., by Strickland, to local provincial types such as the ell-shaped houses with one-story side porches of western New York and Ohio. Belmont, though late in date and already reflective in interior decoration of the mid-century change in taste, is still Greek in its basic elements, but with a freedom of invention that makes it impossible to categorize. The great block is handled with breadth and delicate grace. The recessed porch of Corinthian columns *in antis,* the clean volume of the flanking bays, each with its elegant small porch of coupled columns at the corners, all capped by a bold but beautifully proportioned cornice, create a composition of unusual sophistication. Several southern plantations of this period could match Gaineswood (1842–c. 1860, plate 355), Demopolis, Ala., in scale and lavishness, but none surpassed it in aesthetic refinement and originality of conception. The completely free use of Doric detail in a complex pattern of cubical masses, columns, and piers may seem overwrought in a photograph, but the plan is surprisingly clear and logical. The imaginative use of balusters and urns and the delightful conceit of a Doric pergola seem much too informed for its reputed amateur architect, General Nathan Bryan Whitfield, the owner. More in the contemporary fashion of southern grandiosity was George K. Polk's, Rattle and Snap (1845), Maury County, Tenn., of which the overbearing facade of ten magnificent Corinthian columns would seem too much for a building twice its size. Less pretentious, more graceful, and altogether charming is the semicircular four-columned Corinthian portico of the Governor's Mansion (1842) in Jackson, Miss., by William Nichols.

The Alsop House (1832, plate 356), Middletown, Conn., variously attributed, is one of the most fascinating in its eccentricities of plan, its polychrome interior decoration, and, on the exterior, its *trompe-l'oeil* grisaille painting of statues in niches, painted decorative frieze under the projecting bracketed eaves,· and elegant iron porch and balcony, all suggesting a foreign rather than American origin. Whatever its provenance, it remains a

354 William Strickland. Belmont, Nashville, Tenn. 1850

355 Gaineswood, Demopolis, Ala. 1842–c. 1860

356 Alsop House, Middletown, Conn. 1832

357 Philip Hooker. Hyde Hall, Cooperstown, N.Y. 1833

unique example, in its very delicacy closer to Regency than to Greek Revival. In contrast, Hyde Hall (1833, plate 357), Cooperstown, N.Y., by Philip Hooker, the outstanding architect of Albany and upper New York state, is all robustness and unadorned simplicity, although it shares with the Alsop House a clean geometry of form. Built of stone, Hyde Hall is logically organized, clearly stated, completely unarchaeological and powerful enough to recall the best of Monumental Classicism. It is perhaps this very absence of academic vocabulary in such eccentric buildings that reveals the basic ingenuity and architectural soundness of the Greek Revival at its best.

The same inventiveness and freedom are to be seen even on the vernacular level, as in the Joseph Swift House (1840–41, plate 358), Vermilion, Ohio, now destroyed, a one-story farm house in which symmetrical projecting rooms on the front created an Ionic stoa, and a long colonnaded ell with a separate little building in the rear formed a garden court. Though plain almost to the point of severity, its functional logic and refinement of proportions gave the complex an air of modest distinction. The small, wooden James McAllister House (1839, plate 359), Tecumseh, Mich., is characteristic of a type Hamlin has localized in Michigan and called the "basilica." The pedimented long central "nave" block, with a recessed

porch formed by two slender Doric columns *in antis,* rises clearly above the side wings, which project to the portico line. The result is a structure of the utmost simplicity but, like the Swift House, distinguished by its rationality and unwavering clarity.

The so-called "Swedenborgian House" (1838, plate 360) in Cambridge, Mass., is a remarkable example of vernacular elegance, cleanly articulated, beautifully proportioned, and almost entirely devoid of stereotypical Greek Revival features. Built by a local builder, it was acquired by Jared Sparks, the historian, who lived in it while president of Harvard (1849–53), and later became the New Church Theological School. It was purchased by Harvard University in 1966 and is now used for faculty housing.

Architectural forms adapted to the peculiar climatic and cultural patterns of the South have been discussed earlier, in Chapter 4. During the Greek Revival the South identified itself programmatically, consciously, and emotionally with ancient Greece, where democracy had been supported by a slave population, and was therefore particularly receptive to Greek inspiration as a symbol of southern feudal splendor. The sumptuousness of certain plantation houses prior to the Civil War could be matched nowhere else in this country. John Andrews's Belle Grove

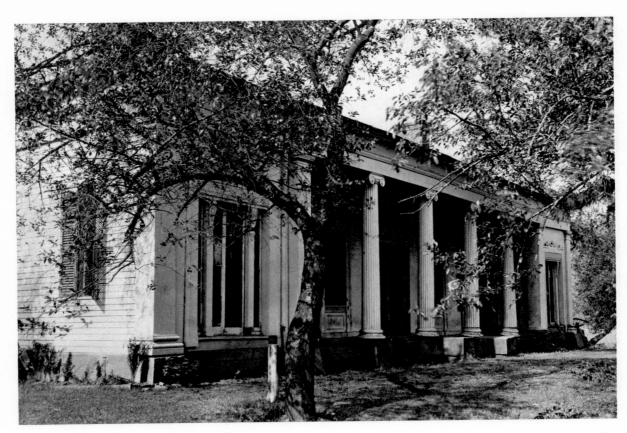

358 Joseph Swift House, Vermilion, Ohio. 1840–41

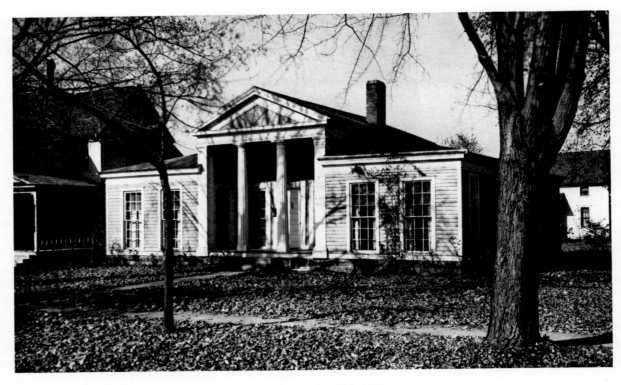

359 James McAllister (Adrian V. Yawger) House, Tecumseh, Mich. 1839

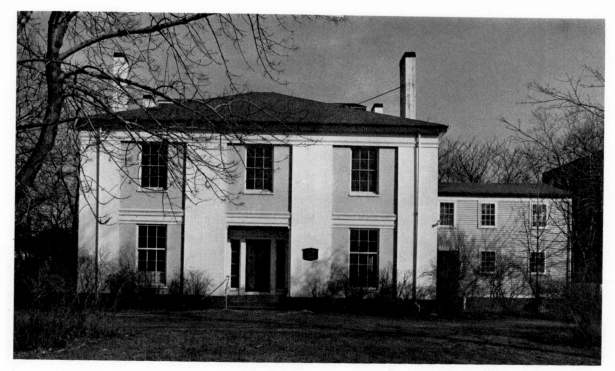

360 Swedenborgian House, Cambridge, Mass. 1845

(1857, plate 361), near White Castle, La., designed by the younger Gallier, had seventy-five rooms. Though still fundamentally Classical in inspiration, it reflected a growing eclecticism. This monumental pastiche of giant porticoes, extruding semicircular and cubical three-story bays and a two-story wing, was almost Baroque in feeling and less rational in plan than earlier Greek Revival mansions. Samuel Fagot's Uncle Sam Plantation (c. 1840–50, plates 362, 363), Convent, La., had seven major and forty minor buildings. Also in the same heart of the Louisiana cotton belt between Baton Rouge and New Orleans were John Randolph's Nottaway (1850), with its oval ballroom and Corinthian colonnade in the hallway, and Rosedown (1830), with a French formal garden and statuary.

Upriver, near Natchez, Miss., was Longwood (colorplate 30), the Moorish fantasy begun in 1860 by an architect and a crew of workmen from Philadelphia and never finished because of the Civil War. This octagonal extravaganza, which boasted a five-story central rotunda capped by a sixteen-sided cupola and an onion dome and porches framed by "horseshoe" arches, inspired by owner Haller Nutt's trip to Egypt to study cotton growing, was one of the last and most prodigal of southern antebellum plantation houses and indicative of the demise of the Greek Revival.

Local variations in southern architecture developed to cope with heat and humidity. Porches or piazzas and balconies or galleries, which provided shade for the interior and areas for outdoor living, had been common in

the South even during the Colonial period and simply took on Greek detailing. In a typical Charleston example, the Charles Alston House (c. 1845–50) follows the local pattern of orienting the short side to the street, with the addition of an elaborate cast-iron porch on the facade and a three-storied porch on the side. A comparable two-storied porch treatment is observable in the Forsyth House (c. 1848) in the Garden District of New Orleans.

To the common temple type and its variations, the South added a two-facade form with colonnades on front and rear, as at D'Evereux (1840, plate 364), Natchez, Miss., and a central form with a peripteral colonnade.

The plantation houses with peripteral colonnades seem to derive from an indigenous Creole tradition of building. The Hispano-American house type with projecting eaves forming a verandah on all four sides was common in the West Indies and may have come to the continent from there. The Ducayet House (plate 365), Bayou St. John, New Orleans, with its hipped roof and dormer windows and its two-storied verandah supported by Doric columns on the first floor and slender colonettes on the second, running around the four sides of the central core, is a prototype of the later Greek Revival peripteral house with its giant colonnade and cast-iron balconies. There was no change in functional intention, merely in stylistic expression. Among the most notable examples of this type are Oak Alley (1837–39) in Vacherie, La.; Dunleith (c. 1848, plate 366), near Natchez, Miss.; and Belle Helene (c. 1840), near Geismar, La., with square piers instead of columns.

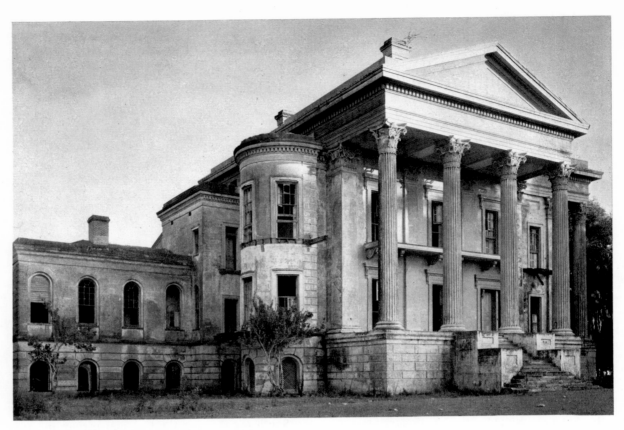

361 Belle Grove, near White Castle, La. 1857

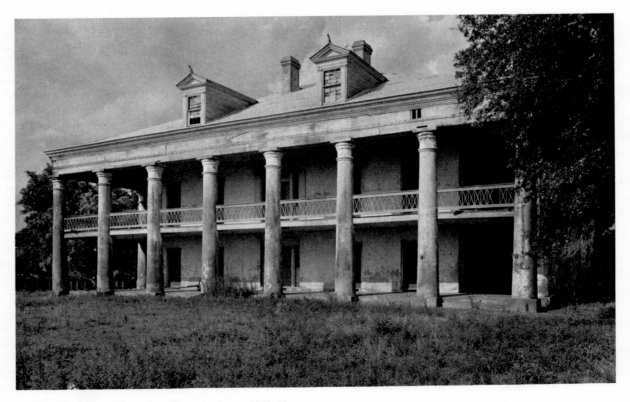

362 Uncle Sam Plantation, Convent, La. c. 1840–50

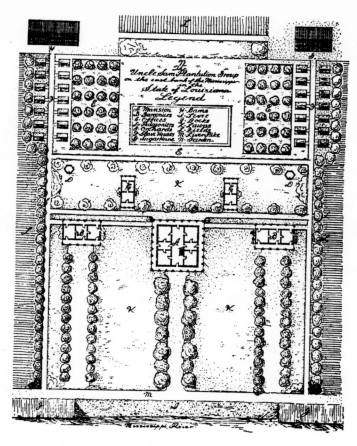

363 Plan of buildings and grounds, Uncle Sam Plantation, Convent, La. c. 1840–50. From Hamlin, *Greek Revival Architecture in America*, 1944, fig. 27, p. 232

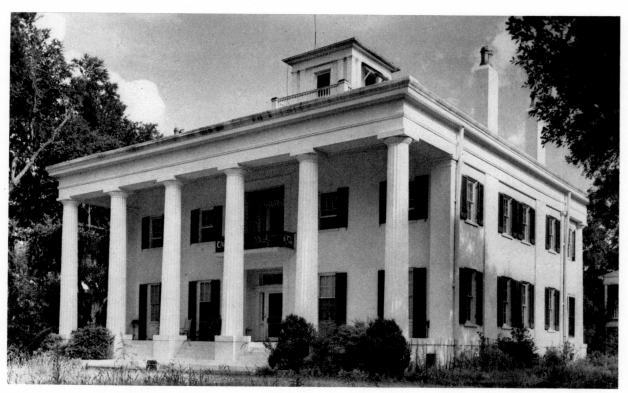

364 D'Evereux, Natchez, Miss. 1840

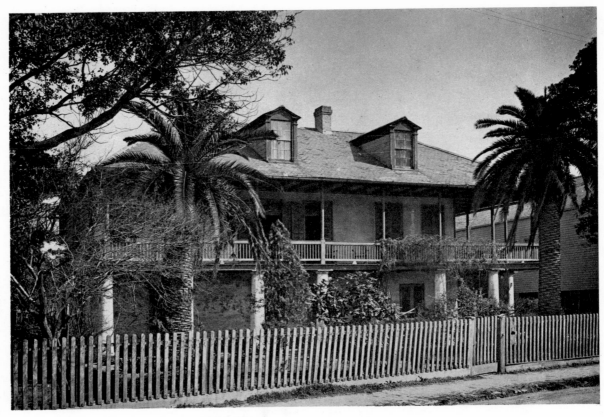

365 Ducayet (Pitot) House, Bayou St. John, New Orleans. Early 19th century

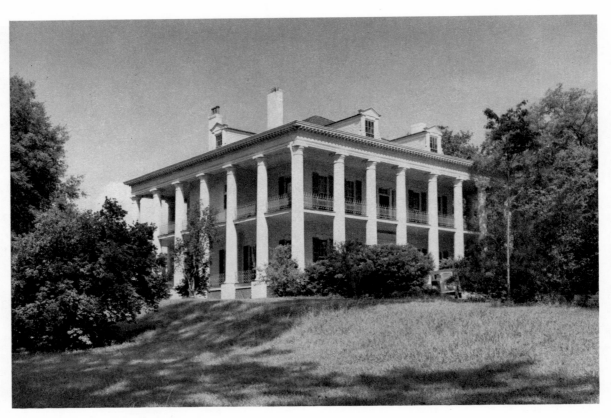

366 Dunleith, Natchez, Miss. c. 1848

Another Creole building type remained localized in New Orleans. The French town house of the Vieux Carré, remnant of another age and culture, never found currency, despite its charm and functional logic, because it was alien to the American population conditioned to English forms. In a narrow city lot, the two-story house was built close to the street line and over to one side; on the other a *porte cochère* or passageway led to a rear court and a stairway to the second floor. The ground floor consisted of a shop and storage room, and, beyond the staircase, a service wing with a porch toward the court formed an ell. On the second floor the front rooms spanned the width of the lot, the parlor in the front, bedrooms behind, and in the extension above the service wing, opening on to the gallery over the porch, were additional rooms for children or guests, the so called *garçonnière*. Compact and easily accessible, the house provided privacy, serviceability, and the pleasures of outdoor living within the city. Both functional and traditional, the type continued with many variations well past the middle of the century, changing at first only in the addition of Greek details or of the extravagant cast-iron porches, sometimes three stories in height, which give the Vieux Carré its special character. Later, under northern influence, the exteriors of Greek Revival town houses in New Orleans became almost indistinguishable from those of New York, except for their elaborate ironwork, but the basic Creole plan of *corps de logis,* or living quarters, *garçonnière,* and court was still maintained.

Much of Greek Revival architecture was simply keeping up with the latest fashion, dressing buildings with the current symbols of status and refinement, producing facades as false as the philosophy that instigated them, but at its best it produced building of a high order, functional in intention, inventive in conception, refined in aesthetic expression, and skillful in execution. And on the vernacular level the basic simplicity of the style lent itself to the techniques of carpentry in a way that resulted in buildings of honest and solid worth.

ECLECTICISM

By the mid-forties the fabric of the Greek Revival was becoming noticeably threadbare. In part, the original ideological inspiration that led to its dominance had lost force. Its leading architectural proponents had, from the beginning, been less single-mindedly committed to the style than was the general public, and with time they began to chafe at its restrictions. Now the very proliferation of Classical forms in architecture led to public surfeit with columns, plain walls, sharp edges, and white paint, and the Romantic preference for variety and the picturesque increasingly found the Classic style unexpressive. In opening the past to investigation, the Greek Revival made change and, eventually, eclecticism inevitable. Not only was there a new academic criticism of the free and unarchaeological use of Classical forms but also an increased questioning of the aptness of Classical architecture for all types of building and of the legitimacy of borrowing from the past.

But both critics and architects still found it difficult to think in terms other than those of historical styles adapted to American usage. In the first critical espousal of eclecticism, a writer in the *North American Review* of April, 1844, attacked both the Greek and the new Gothic revivals and suggested the study of more recent and fitting styles for America—the Renaissance and the native Colonial. Robert Dale Owens proposed that "in planning any edifice, public or private, we ought to begin *from within,*" but the statement was made in connection with a defense of the neo-Romanesque Smithsonian Institution. Horatio Greenough attacked the sham of revivalism with passionate rationality and urged: "Let us learn principles, not copy shapes . . . let us imitate them [the Greeks] like men, and not ape them like monkeys." He even, far in advance of his age, recognized the more truthful beauty he found in machines, clipper ships, and bridges and propounded an aesthetic of "functionalism" which architects would heed only generations later. His own sculpture, however, was still steeped in Neoclassicism, and his theoretical formulations had no discernible effect on architectural practice. The primacy of utility in architecture was preached by architects from the Classicist Latrobe to the eclectic Downing, but function in each case was neatly fitted into one or another historical style, or even a commingling of several. The connection between function and form could be seen only in terms of selecting the most appropriate and expressive style of the past with which to dress the function of the present.

Neither American nor European architecture was ready to leap directly into the twentieth century; it had still to find its way through the labyrinth of revivalism. And that historical process produced, apart from its more exuberant vagaries, a body of architectural monuments worth careful reexamination. This was a period of eclecticism in which architects used the past with what to them appeared as rational purpose. Different modes were acceptable at the same time, and individual architects designed simultaneously in a variety of styles. Theoretically, at least, the touchstone was appropriateness, not only functional but also symbolical. It is this latter aspect which makes an appreciation of the nineteenth century so difficult, conditioned as our taste is by the nonsymbolic nature of contemporary architecture. One can even discern a morphological pattern, although it was not rigidly adhered to: the Gothic especially but other medieval forms also were used for ecclesiastical buildings; prisons were castellated; armories were Romanesque; the Egyptian occurs most frequently in connection with cemeteries; Oriental forms were employed for exotic or ornamental effects; and the Italian Villa style was almost exclusively

confined to domestic architecture. Within this general picture of eclecticism one can note the growing and waning popularity of various styles—Italian Villa, Gothic, Romanesque, and, after the Civil War, the Second Empire—but none of them ever approached the earlier, almost complete dominance of the Classic. There was no neat sequence of revivals following the Neoclassic, but a complex interrelationship of different stylistic strands which, only in the unraveling, appear as separate movements. However, all were characterized by their anti-Classical concern with the picturesque. One of the most interesting and important aspects of this period was the development of the detached house or "cottage." In England, from late medieval times, and in America, from the earliest settlements through the nineteenth century, the individual house, rather than the Continental multiple dwelling, was the most prevalent form for both town and country. About 1800 in England the Romantic yearning for the picturesque, the natural, and the informal led, on the one hand, to the adaptation of the lowly "rustic" yeoman's cottage for middle-class houses or upper-class holiday retreats and, on the other, to the reduction of large, formal country mansions to more moderate-sized villas. America soon followed the English lead in a proliferation of eclectic picturesque forms. This development was the first evidence of our modern tide of desire to escape the difficulties of urban living, as well as an indication of the increasing middle-class affluence and the improvement of transportation, communication, and public services which made suburban living possible. Eclecticism permitted architects the uninhibited use of various historical styles in a single setting, as Nash had done in his Park Villages, London, begun in 1827, or as Downing had planned for Llewellyn Park, West Orange, N.J., the first of the suburban developments in America and a forerunner of the so-called "garden cities" of the twentieth century. The overriding concern was picturesqueness rather than consistency or archaeological accuracy. The most popular of the domestic modes and their variations were the Gothic and the Italian Villa (see below), which ran concurrently and were basically almost interchangeable, so far as plan and composition were concerned, although there seems to have been a preference for the latter in larger and more formal houses.

THE GOTHIC REVIVAL

Of all the post-Classic revivals, the Gothic was the most widespread and influential. The complete antithesis of the Classic in an abstract aesthetic sense, the Gothic was already established within Western tradition as its cultural foil. In English history the Renaissance had come late, and the Gothic had survived almost into the eighteenth century. Even great post-Renaissance English architects, including Wren, Vanbrugh, Kent, and Hawks-

moor, though steeped in Classical forms, were called upon to design in the Gothic manner, usually for ecclesiastical or related structures. These, however, were more survivals than revivals. Perhaps the earliest evidence of a Gothic revival occurred at the height of the Georgian with the publication of *Gothic Architecture, Improved by Rules and Proportions* by the brothers Batty and Thomas Langley in 1742. From then on it became common practice to introduce Gothic ornamental "fabricks," such as mock medieval ruins, into English gardens for Romantic effect. Eventually houses in imitation of the Gothic style, such as Strawberry Hill and its various later progeny, became increasingly popular. During this first phase, the Gothic was treated as a Romantic exoticism, a more or less playful conceit serving as a visual counterpoise to the serious Classical ideal. There was, therefore, no serious concern with understanding the style or re-creating an aesthetic based on its principles. However, the growth of taste for the "Gothick" eventually led to an increased awareness of England's medieval heritage and to archaeological study and restoration. Beginning with the first issue of Grose's *Antiquities of England and Wales* in 1773, the constant flow of literature on medieval architecture reveals a growing interest and sophistication culminating in the influential publications of Carter, Britton, Rickman, and the elder Pugin that laid the foundation for the Gothic Revival of the nineteenth century.

In England, the "Gothick" phase continued down to about 1820. America's cultural lag in this case was about twenty years, and, perhaps because of the absence of Gothic examples, the "Gothick" phase here had little importance and less quality. Architects committed to the Neoclassic occasionally worked in the Gothic. Even so confirmed a Palladian as Jefferson played with the possibility of a Gothic garden structure at Monticello, and Latrobe designed Sedgeley (1799), a house in the Gothic style near Philadelphia. Perhaps the earliest hint of Gothic usage in America, though in no sense a Gothic Revival building, was the second Trinity Church (1788–90), New York, by Josiah Brady, in a sort of Georgian Gothic out of Batty Langley. Even the first Trinity seems to have had some Gothic elements introduced into its Georgian matrix as early as 1737, during alterations.

After the turn of the century the Gothic became more common, especially for church buildings, and almost all the leading Neoclassic architects were involved. Latrobe's curious but elegant, stripped-down, almost Neoclassic Gothic alternate design for the Baltimore Cathedral (1805, plate 367) was not accepted. (However, there are two later Latrobe churches in the Gothic style, Christ Church, c. 1808, in Washington and St. Paul's, c. 1817, in Alexandria, Va.) In the following year, Godefroy submitted his plan for the Chapel of St. Mary's Seminary (1807, plate 368), in Baltimore, the first Gothic Revival church in America. Then in rapid succession came Gothic efforts by Bulfinch in the Federal Street Church

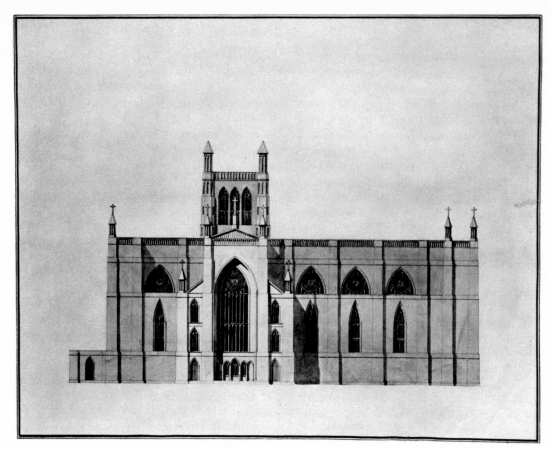

367 Benjamin H. Latrobe. Elevation for Gothic project, Baltimore Cathedral. 1805. Archdiocesan Archives, Baltimore

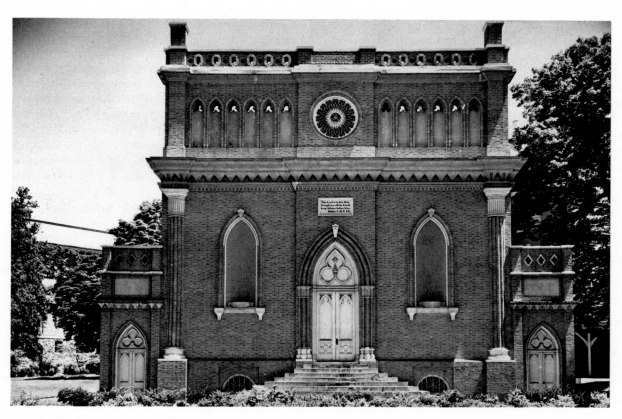

368 Maximilien Godefroy. Chapel of St. Mary's Seminary, Baltimore. 1807

(1809), Boston, and by Mangin in the first St. Patrick's (1809–15) on Mott and Prince Streets in New York, followed by Greene's St. John's Episcopal (1810–11), now the Cathedral of St. John, Providence, R.I., and Town's Trinity Church (1814), New Haven, Conn. They were, from the evidence available, Gothic only in decorative detail and essentially still Georgian in conception. Even Strickland's St. Stephen's (1822–23), in Philadelphia, was a heavy-handed, fortress-like structure, and, except for its pointed windows, more Monumental Classic than Gothic.

The Gothic also found its way into secular building—the Bank of Philadelphia (1807–08) by Latrobe and Mills and the Masonic Hall (1809–11), also in Philadelphia, by Strickland—but it was a Gothic of the most rudimentary character. Haviland's epochal Eastern Penitentiary (1821–37, plates 369, 370) was "castellated" Gothic in detail, but in its rationality of plan and spareness of form derived from Monumental Classical thinking. The selection of a brutal, dungeon-like design to house a penal institution reveals a symbolic intention at variance with the enlightened conception of the plan. The Gothic details are again simplified and almost primitive, the whole certainly not picturesque but conveying an oppressive sense of incarceration. Walter followed Haviland's lead in his Philadelphia County Prison (1829).

The Gothic continued as a peripheral style through the twenties and thirties without much advance in archaeological sophistication, interest in structural principles, or Romantic picturesqueness, and, to judge by the number of such buildings executed during that time, no increase in popularity. A group of granite churches in New England has some interest in relation to the Greek Revival churches of the same time, though the detailing is different. The ruggedness of the granite seems more medieval, at least in the Romantic sense, than Classical. The Gothic elements are limited to pointed windows, crenellations, quatrefoil openings, and simplified tracery handled in wood. Notable examples in this category are the Bowdoin Street Church, now St. John the Evangelist (1830, plate 371), in Boston, by Solomon Willard; St. Peter's (1837), Salem, attributed to Gridley J. F. Bryant; and the First Unitarian (1835), now the North Church (Unitarian), also in Salem, and also by Bryant.

The Gothic Revival of the forties was not much dependent upon these earlier "Gothick" examples. For America the publication of architectural books, rather than actual Gothic Revival buildings, eventually had a more telling effect, while new influences from England and a growing taste for the picturesque created the conditions for a more thoroughgoing neo-Gothic style. In England, with the increase of archaeological interest in national monuments, the Gothic Revival after 1820 also took on a decided nationalistic flavor, and with the acceptance in 1836 of Barry's Gothic design for the Houses of Parliament, its ascendancy was assured. The successive publications of Augustus W. N. Pugin, who worked with Barry

on the Houses of Parliament, were crucial in the transformation of the neo-Gothic from a picturesque minor mode into a programmatic style of Christian architecture. Pugin expressed his convert-Catholic zeal in *Contrasts* (1836), espousing a revival of Gothic architecture for its structural and liturgical character, rather than "immoral" copying of its detail. In *True Principles of Pointed or Christian Architecture* (1841), he argued that only a Gothic architecture could lead people into Christian ways and beliefs and inspire them to moral behavior. The neo-Gothic was thus provided with a rationale as principled as that of the Neoclassic.

Although the Gothic Revival in America was influenced by Pugin's thinking, similar attitudes found expression here at the same time. In 1836, Henry Russell Cleveland, in the *North American Review,* attacked Greek and Egyptian architecture as pagan and lauded the "architecture of Christianity, the sublime, the glorious Gothic." The symbolism of the Gothic as a Christian style supplanted the then-current political identification of democratic America with ancient Greece and Rome. More important was the publication in the same year of a small book by Bishop John Henry Hopkins, *Essay on Gothic Architecture,* which reflected contemporary English reform attitudes toward ecclesiastical building. Thus the Romantic taste for the picturesque joined with Christian piety to establish the Gothic in public favor.

The first and prototype of the full-fledged neo-Gothic churches was New York's third Trinity Church (1839–46, colorplate 31), by Richard Upjohn (1802–1878). It is also the first to look like a medieval building. Related to the Pugin ideal, it was conceived outside and inside (and the plaster vaults maintain the illusion) as a Perpendicular English parish church. Upjohn was neither a great nor an exciting architect but an honest and competent one, underrated today because of the very conservatism and fidelity to Gothic Revival principles which originally made his reputation. More than any of his contemporaries, Upjohn, as a dedicated churchman, subscribed to the Anglican reform program and its implementation in Episcopal circles in the United States. His convictions even led him to refuse to build in the Gothic style for nonconformist sects and to refuse to build at all for the Unitarians because they did not accept the divinity of Christ. It is therefore natural that he concerned himself more with liturgical problems and stylistic appropriateness of design than with picturesqueness for its own sake. Trinity, more than most of his output, reveals a visual reticence in its purely symmetrical plan and axial tower, a scholastic regularity in the repetition of elements, and a bareness, almost timidity, in ornamental detail. Despite its Gothic decorative elaboration, one is left with the impression of plain wall surfaces and cubical masses. The unremitting repetition of pointed windows, crenellations, finials, crockets, and thin ornamental bands gives the exterior a sharp, dry, cast-iron look. The interior,

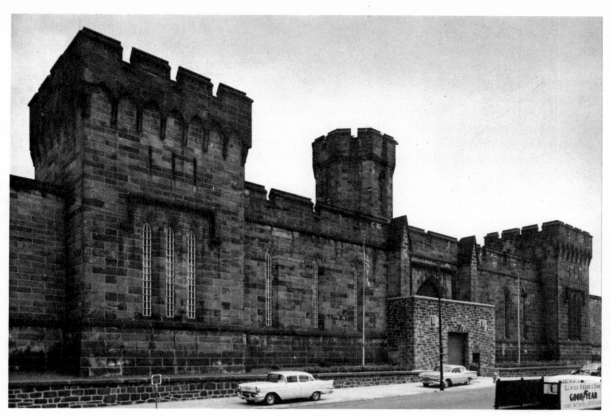

369 John Haviland. Eastern Penitentiary, Philadelphia. 1821–37

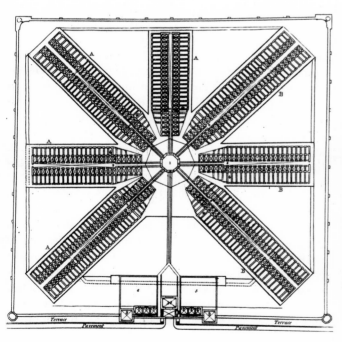

370 John Haviland. Plan, Eastern Penitentiary, Philadelphia. 1821–37. The Historical Society of Pennsylvania, Philadelphia

371 Solomon Willard. Bowdoin Street Church (St. John the Evangelist), Boston. 1830

though structurally false, is aesthetically coherent. On the whole, it is an informed version of the Perpendicular, if somewhat academically handled.

Born in England, Upjohn worked as a cabinetmaker before coming to the United States in 1829. In 1833 he undertook his first architectural commission, for the Isaac Farrar House (1833–36), now the Symphony House, Bangor, Me., still reminiscent of Bulfinch, though indicating an awareness of the neo-Greek. The Samuel Farrar House (1836), also in Bangor, is completely within the Greek Revival mode. But the year before, Upjohn had designed Oaklands (1835–36, plate 382) for R. H. Gardiner, Gardiner, Me., in the Gothic style, less a Tudor manor than a Georgian building with an outer skin of crenellations, mock turrets, clustered chimneys, and ornamental window bands. These early experiences presaged Upjohn's later eclecticism. Though he became the most famous designer of Gothic Revival churches, his oeuvre includes examples of the Italian Villa, Romanesque, Early Christian, and Renaissance styles.

Upjohn's Gothic churches, until 1844, were rigorously symmetrical, with a single axial tower at the front. Later, he seems to have bowed to the growing taste for the picturesque, treating the tower as an asymmetrical element and composing masses with an eye for the maximum pictorial effect, as in one of his major efforts, St. Paul's (1850–51), Buffalo, N.Y., completely gutted in 1888, but restored on the exterior to its original condition. His larger churches were as imposing and authentic as any of the time, though on the whole not very ingratiating. He is often seen to better advantage in his less pretentious projects, in small rural churches such as St. Mary's (1846–54, plate 372), Burlington, N.J. Here the single-aisled, cruciform plan, with a stubby tower and slender spire over the crossing, results in a modest, compact composition of rustic charm, echoed in the simple interior by a wooden-truss ceiling. After his experience with Trinity, where economic necessity forced him to use a sham vault, he usually employed the exposed wooden-truss ceiling, not only as a picturesque and archaeologically acceptable solution but as expressive of structural honesty consonant with current ecclesiological tenets.

Upjohn's churches in cities and towns along the Eastern seaboard from Bangor to Raleigh had an enormous effect on the propagation of the Gothic Revival. As a missionary activity, he designed without fee one church a year for a poor parish, and the demand for his services became so great that he published a series of such low-cost designs and instructions in *Upjohn's Rural Architecture* (1852), which inspired many small Gothic Revival churches erected by local builders. Perhaps the most interesting of these were the board-and-batten churches, of which his Trinity Church (1854, plate 373), Warsaw, N.Y., is typical. Board-and-batten construction was an indigenous form of carpentry sheathing in which boards were laid vertically and the joints covered by thin slats, or battens. Aside from being a simple and cheap method of building, the stripping had the aesthetic effect of enlivening the surface, emphasizing the vertical so dear to Gothic Revival taste. Reduced to the simplest masses, meager to the point of poverty, such churches still guilelessly recall their Gothic inspiration.

Upjohn's Trinity in New York City was followed almost immediately there by Minard Lafever's Dutch Reformed Church (1839–40, destroyed 1893), on the southeast corner of Washington Square, and James Renwick, Jr.'s, Grace Church (1843–46), nearby on Broadway. Sensing the change in fashion, Lafever turned from the Neoclassic and designed a series of churches in the Gothic Revival style. Although the Dutch Reformed was Perpendicular, perhaps in imitation of Trinity, Lafever seems to have preferred the Collegiate Gothic of King's College Chapel, Cambridge University, and in the three commissions that followed he employed that style. Almost all Lafever's ecclesiastical work in Manhattan, Brooklyn, and upstate New York is now gone. Only a handful remains. Of those in the Gothic manner, all of which are in Brooklyn, the Church of the Saviour, now the First Unitarian Church (1842–44, plate 374), on Pierrepont Street, is Collegiate; the Church of the Holy Trinity (1844–47), on Montague Street, is English Decorated with Flamboyant elements; and the Strong Place Baptist Church (1851–52), on Cobble Hill, is an Early English parish church with a Perpendicular interior. Lafever was a competent and fairly literate designer, and though he seems not to have lacked commissions, his clients were neither so high-church as Upjohn's nor so affluent as Renwick's.

James Renwick, Jr. (1818–1895), was born in New York City of wealthy, well-educated, and socially prominent parents. As early as 1813 his father, an engineer and professor at Columbia College, had proposed Gothic buildings for Columbia based on such English models as King's College Chapel. James Renwick, Jr., was graduated from Columbia in 1836 and turned to the study of engineering and architecture on his own. He first worked as a surveyor and civil engineer on the Erie Railroad, then as assistant engineer for the Croton Aqueduct, becoming clerk of works in the building of the Croton Distributing Reservoir (1839–43) at 42d Street and Fifth Avenue.

In the spring of 1843, Renwick submitted a plan in the competition for Grace Church, and, at the age of twenty-four, the self-taught architect was awarded the commission for New York's wealthiest and most fashionable church. Grace Church (plate 375), with its single axial tower, nave with flanking aisles under lower roofs, and English Perpendicular ornament, was an adaptation of Upjohn's Trinity, except that Renwick had retained the transept that Upjohn omitted and used white marble instead of brownstone. Though less monumental than Trinity, Grace Church is more tightly knit and more ele-

372 Richard Upjohn. St. Mary's Church, Burlington, N.J. 1846–54

373 Richard Upjohn. Trinity Church, Warsaw, N.Y. 1854

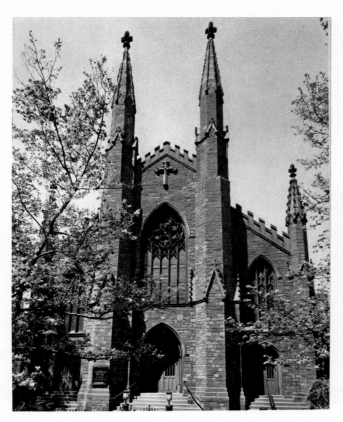

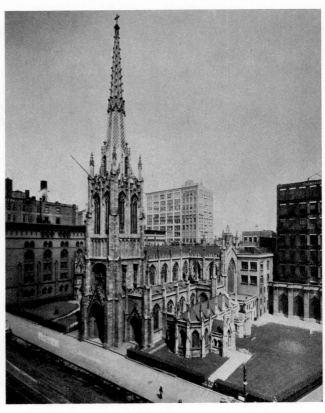

374 Minard Lafever. First Unitarian Church (Church of the Saviour), Brooklyn, N.Y. 1842–44

375 James Renwick. Grace Church, New York. 1843–46

gant in its building material and wealth of decorative detail. Like Trinity, Grace Church still had plaster vaults. Both were hailed as beautiful additions to New York, but Grace Church was the subject of some adverse criticism: Walt Whitman found the "showy piece of architecture" an un-Christian display of "vulgar ambition," and Philip Hone commented acidly about the cost of a pew and the gay and fashionable parishioners who came in their finery to be seen. Perhaps as a reaction against such criticism, Renwick turned to the Romanesque (see below) for his next work, the Church of the Puritans in New York and the Smithsonian Institution in Washington, D.C. With Calvary Church (1846–47), New York, he began to leave his more careful brand of eclecticism for a freer use of historical models. Its two symmetrical towers and three-part facade indicate that he was following in the direction of Pugin's complex and grand compositions at a time when Upjohn was edging away from Pugin toward the parish-church revival, as in his asymmetrical, more rural-looking Church of the Holy Communion (1846), New York.

The climax of Renwick's ecclesiastical work was probably the most important church commission of the century—St. Patrick's Cathedral, New York, in 1853. He had time to revise the plans carefully before the cornerstone was laid in 1858: the Cathedral was opened in

1879, and the spires were completed in 1888. St. Patrick's (plate 376) was the first church in the United States to embody clearly the influence of the French Gothic. Its large-scale triple doorways and double towers with tall spires resemble the Gothic Revival of the Continent more than anything English. Renwick was disappointed that the plan was reduced in execution: the stone vaults became plaster, the flying buttresses intended to support them were omitted, and the projected ambulatory with radiating chapels was somewhat squeezed. Nevertheless, in its interior, one does feel the soaring majesty of the Gothic.

Though he received important New York commissions, partly through family connections, partly because of the ingratiating character of his stylistic adaptations, Renwick was never one of the inner circle of contemporary architects. He seems to have been regarded as a dilettante and a snob and generally disliked. He lived a life of genteel culture, owned two yachts, and traveled frequently to Europe, where he collected art. Despite the personal abuse and critical vituperation he suffered, he was always stylistically *au courant* (he moved with the times into the Second Empire style; see Chapter 16) and technically advanced. His buildings show a genuine concern for functional planning and good lighting, heating, and ventilation.

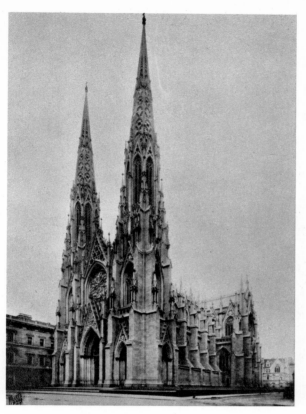

376 James Renwick. St. Patrick's Cathedral, New York. 1853–88

Another area in which the Gothic Revival found popular acceptance was in college building. It was then that the American collegiate identification with the architecture of the ancient English universities, Oxford and Cambridge, first emerged. The earliest of the neo-Gothic campus buildings and probably the earliest secular example of the style, New York University's first building on Washington Square (plate 377) designed by A. J. Davis in 1832 and completed by 1836, was inspired by King's College Chapel, Cambridge, in its central section, though much simplified. Aside from the elaborate central window, with its Perpendicular tracery flanked by blind polygonal turrets, the facade was rather bare and regular. The ranks of rectangular windows were enframed at their tops by simple moldings, and the roof line was ornamented with crenellations. What must have been in its day a Romantically picturesque departure seems in an old print a fairly staid and serviceable building. Davis, who made his reputation in the Greek Revival, worked simultaneously and just as fluently in a variety of manners. Quick-witted and sophisticated, he was the eclectic architect *par excellence*. He seemed to sense the winds of change almost before they had arisen, and the range of his production is amazing when one realizes that his designs were not simply modish but actually *avant garde*. In 1852 he designed Alumni Hall for Yale Univer-

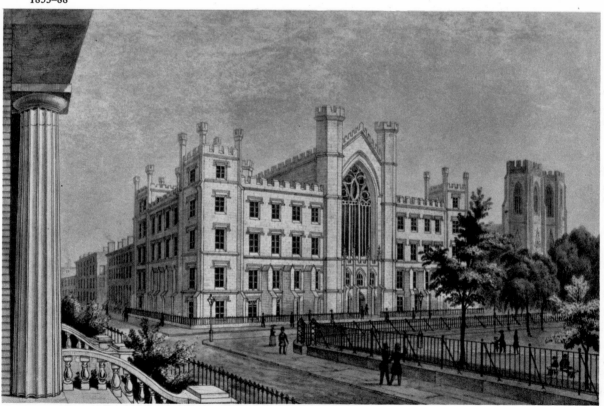

377 Andrew Jackson Davis. New York University, New York. 1832. From a print. Courtesy The Old Print Shop, Inc. New York

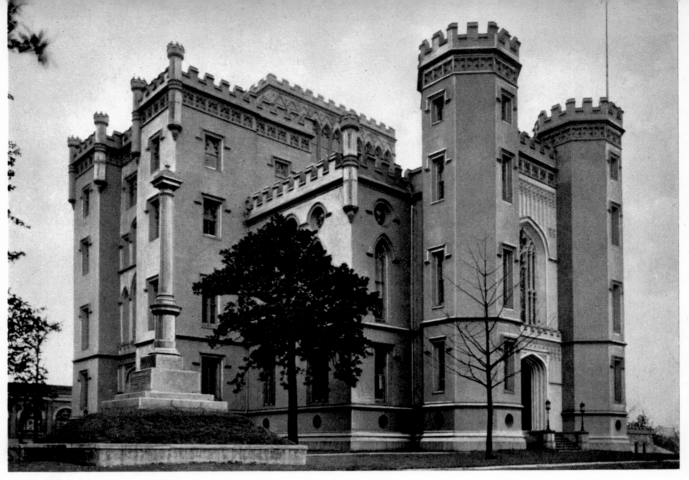

378 Old Capitol, Baton Rouge, La. 1847

sity, fortress-like and not very well proportioned. The castle style was better fitted for the buildings of the Virginia Military Institute, Lexington, begun in 1848, which have gone through too many vicissitudes to be judged except from Davis's original drawings.

Austin's Yale College Library (1842–44), now Dwight Chapel, was based on the Henry VII Chapel in Westminster Abbey, and Harvard had an earlier library building, also in the Gothic style, Gore Hall (1838). Upjohn did some college work in the medieval manner, but because of self-imposed restrictions it was not Gothic. Renwick designed a Collegiate Gothic building for the newly established Free Academy (1848–49), later the City College of New York, in red brick and compact form to minimize cost. Lafever's Packer Collegiate Institute (1854–56), in Brooklyn Heights, was also in red brick, with brownstone trim, but Tudor in style.

The ecclesiastical character of the Gothic inhibited its employment for secular building. Of all the state houses erected during the first half of the century, only Louisiana's in Baton Rouge (1847, plate 378) was neo-Gothic. The political and psychological identification of the Neoclassic with government was too strong to be affected by the new fashion. Isolated examples of other secular types, however, were done in the Gothic style. Town & Davis,

with the aid of Henry Austin, were responsible for the Wadsworth Atheneum (1842), Hartford, Conn.; Russell Warren designed the second Ocean House (1845, plate 379), a resort hotel in Newport; and in New York City Davis built a set of row houses behind a Gothic facade, the House of Mansions (1858, plate 380), an interesting counterpart to his Classical La Grange Terrace (plate 344). This rather smooth-faced, castellated mass, opposite what is now the New York Public Library, later served as Rutgers Female Seminary. The National Soldiers' Home (1852, plate 381), in Washington, D.C., was an unusually picturesque composition for that period, closer to the Victorian Gothic to come.

The Gothic Revival in this second phase, though archaeologically more sophisticated, remained a style of picturesque illusion or religious association. It was never as adaptable as the Neoclassic to contemporary building and, although it was widespread, never produced monuments of comparable interest or important structural innovations. One looks, not to the faint echoes of medieval cathedrals with their plaster vaults and emaciated ornamentation, but to the vernacular reduction of such forms to the techniques of carpentry or the picturesque inventions of the Romantic cottage, for the original contributions of American neo-Gothic architecture.

379 Russell Warren. Second Ocean House, Newport, R.I. 1845

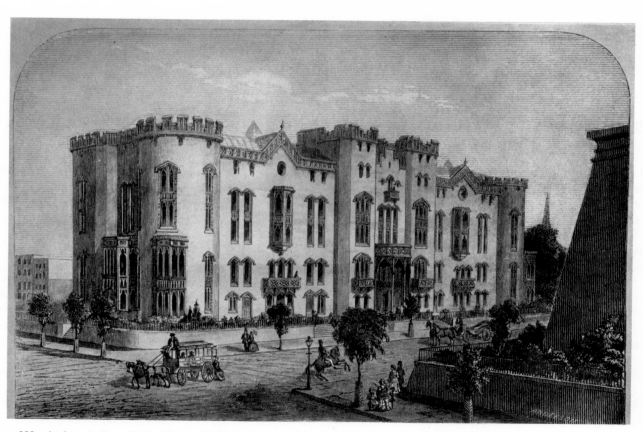

380 Andrew Jackson Davis. House of Mansions, New York. 1858. From an engraving. Museum of the City of New York. The J. Clarence Davies Collection

381 National Soldiers' Home, Washington, D.C. 1852

GOTHIC REVIVAL HOUSES

Because of the technical difficulties of carving elabo-
rate decorative details in stone, the Gothic was used most
frequently in modest wooden houses, but some impres-
sive mansions were built in the style. A. J. Davis was the
leading exponent of this aspect of the domestic Gothic,
and his Glen Ellen (1832), the Robert Gilmor, Jr., house,
near Baltimore, was probably the first of the Gothic Re-
vival houses. Much like Upjohn's first effort in Oaklands
(1835, plate 382), it was still rather tentative, blocklike,
rectangular, crenellated, and, except for the bay with its
fairly elaborate tracery and a corner tower of curious
design, not a very picturesque structure. It was the earliest
American reflection of the Scottish baronial style, which
had started with Abbotsford (1816), built for Sir Walter
Scott by Edward Blore, and had soon become a vogue
in England. Lyndhurst (plate 383), erected in 1838 in
Tarrytown, N.Y., was to become much more imposing
after the renovation begun in 1864, but it was already

picturesque in plan and elevation. Philip Hone, elegant
gentleman and opinionated diarist, a conservative by
nature and a Neoclassicist by prejudice, has left us a
description of the building in 1841 that is quite accurate:
"Mr. William Paulding's magnificent house, yet un-
finished, on the bank below Tarrytown . . . is an immense
edifice of white or gray marble, resembling a baronial
castle, or rather a Gothic monastery, with towers, tur-
rets, and trellises; minarets, mosaics, and mouse-holes;
archways, armories, and airholes; peaked windows and
pinnacled roofs, and many other fantasies too tedious to
enumerate, the whole constituting an edifice of gigantic
size, with no room in it." The details so maliciously enu-
merated are all there, but disposed in a composition that
was obviously foreign to Hone's Classical tastes. The
peaked roofs, turrets, finials, crockets, and tracery win-
dows were the recognizable signs of the Gothic Revival,
but more important from an architectural point of view
were the freedom of plan and the complex interrelation-
ship between solid and void forms, creating a picturesque-
ness of structure rather than of detail.

16 Spiral staircase, Gore Place, Waltham, Mass. 1805–06

17 Thomas Jefferson. University of Virginia, Charlottesville. 1817–26

18 William Strickland. Second Bank of the United States, Philadelphia. 1818–24

19 Isidoro Aquilar. Decorative carving, San Juan Capistrano, Calif. c. 1797

20 Charles Willson Peale. *Staircase Group*. 1795. Oil on canvas, 89 × 39½″.
Philadelphia Museum of Art. George W. Elkins Collection

21 Ralph Earl. *Roger Sherman*. c. 1775. Oil on canvas, 64⅝ × 49⅝″. Yale University Art Gallery, New Haven. Gift of Roger Sherman White, B. A., 1899

22 Gilbert Stuart. *Mrs. Richard Yates.* c. 1793. Oil on canvas, 31¼ × 25″. National Gallery of Art, Washington, D.C. Andrew Mellon Collection

23 John Trumbull. *The Death of General Montgomery in the Attack on Quebec*. 1786. Oil on canvas,
20¾ × 37″. Yale University Art Gallery, New Haven

24 John Vanderlyn. *Ariadne Asleep on the Island of Naxos*. 1812. Oil on canvas, 68 × 87″. The Pennsylvania Academy of the Fine Arts, Philadelphia

25 Washington Allston. *Elijah in the Desert*. 1818. Oil on canvas, 48¾ × 72½″. Museum of Fine Arts, Boston. Gift of Mrs. Samuel Hooper and Alice Hooper

26 Francis Guy. *A Winter Scene in Brooklyn*. 1817–20. Oil on canvas, 58¾ × 75″. The Brooklyn
Museum

27 Raphaelle Peale. *After the Bath*. 1823. Oil on canvas, 29 × 24″. Nelson Gallery-Atkins Museum, Kansas City, Mo. Nelson Fund

128 William Rush. *Water Nymph and Bittern.* 1809. Bronze, 91 × 33″. Courtesy the Fairmount Park Commission, Philadelphia

29　Thomas U. Walter. Andalusia, near Philadelphia. c. 1835

30 Longwood, near Natchez, Miss. Begun 1860

31 Richard Upjohn. Trinity Church, New York. 1839–46

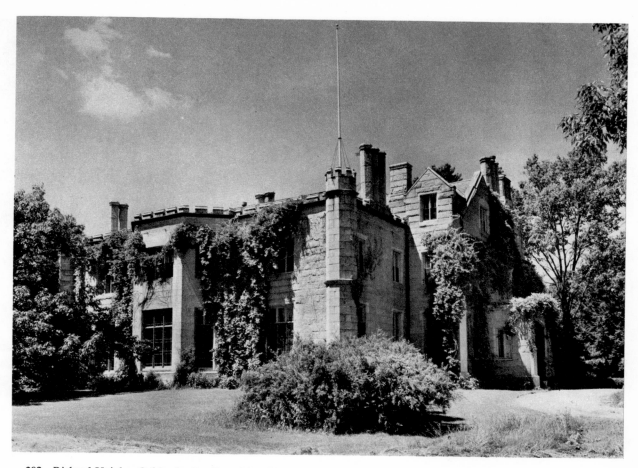

382 Richard Upjohn. Oaklands, Gardiner, Me. 1835

Davis designed many stone mansions in the Gothic mode, including Belmead (1845), Powhatan County, Va., which introduced the manorial Tudor Gothic to the South, but except for a few isolated examples, the Gothic Revival had little impact on Southern plantation architecture. Davis's most pretentious effort in the Gothic mode was Ericstan (1855), the J. J. Herrick mansion in Tarrytown, N.Y., a fake castle overlooking the Hudson River. More modest, more typical of neo-Gothic houses as a whole, and more charming than the larger stone mansions are his wooden cottages, such as the William Rotch House (1845, plates 384, 385), in New Bedford, and the board-and-batten Henry Delamater House (1844), in Rhinebeck, N.Y. Though exceptional in quality, they are standard examples of the rural cottage style in their picturesqueness of composition, steeply pitched roofs, extended eaves with verge- or barge-boards of elaborate scrollwork, trellised verandahs, bay windows, and clustered chimneys. Upjohn rarely used the Gothic for domestic building, but Kingscote (1841, plate 606), one of the earliest of Newport's palatial cottages, is Tudor Gothic in style, complex in plan, and entirely picturesque in composition.

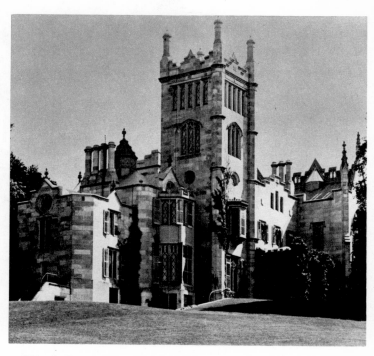

383 Andrew Jackson Davis. Lyndhurst, Tarrytown, N.Y. 1838 (remodeled 1864)

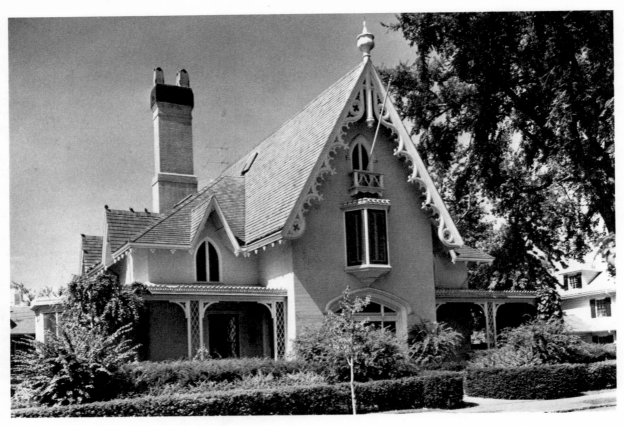

384 Andrew Jackson Davis. William Rotch House, New Bedford, Mass. 1845

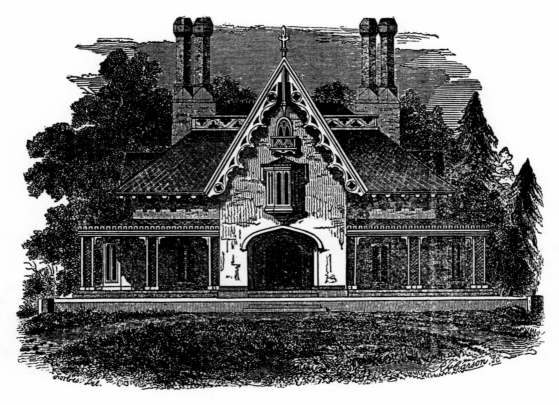

385 Cottage-villa in the rural Gothic style. From A. J. Downing, *The Architecture of Country Houses*, D. Appleton, New York, 1850, fig. 128

ROUND-ARCHED STYLES: ROMANESQUE AND RENAISSANCE

The historic compulsion of the Gothic Revival to move back in time from the Perpendicular to earlier phases of English medieval architecture led inevitably to the Romanesque. There is perhaps some tendency in concentrating on the later, Richardsonian Romanesque to overlook this earlier development. As a matter of fact, as Carroll L. V. Meeks has pointed out, if one groups the "round-arched" styles—the Romanesque and the Italian Villa—together, they add up as statistically more numerous than the "pointed" examples. At any rate, the Romanesque, also variously and loosely described at the time as Byzantine, Norman, or Lombard, was reserved almost exclusively for monumental building, while its counterpart, the Italian Villa, was almost exclusively employed for domestic architecture.

Upjohn, who reserved the Gothic for Episcopal churches, adapted round-arched styles for other denominations. Nonconformist sects consciously avoided the Gothic for the same symbolic reasons. The Romanesque lent itself also to the simpler, boxlike hall churches preferred by such Protestant groups as the Congregationalists, Methodists, Presbyterians, and Unitarians. The Congregational Church publication *A Book of Plans for Churches and Parsonages* (1853) contained designs by leading architects, including Upjohn, Renwick, and Austin, most of which were Norman and were described as the "Round Style." *Chapel and Church Architecture* (1856), by the Reverend George Bowler, also consisted mostly of Romanesque variants. The simplicity of forms and decoration in the Romanesque, the regularity of its fenestration, and its adaptability to brick construction made it preferable to the Gothic for utilitarian structures, schools, and institutions.

The earliest example of the Romanesque was Upjohn's Church of the Pilgrims (1844–46), Brooklyn, with a curiously shaped asymmetrical tower and a corbel table under the roof line that was Lombard in inspiration. His Bowdoin College Chapel (1845–55, plate 386), Brunswick, Me., was designed in a clearly Germanic vein. As a matter of fact, in the round-arched style Italian and German features were more evident than English. German cultural influence was exceptionally strong in the United States during this period, and the Germans, in search of a national revival style, had rediscovered their own great Romanesque tradition before the English accepted the Norman. This *Rundbogenstil* had its effect on American architecture not only through publications but also through the arrival in this country of Austro-German architects such as Leopold Eidlitz, Otto Blesch, Alexander Saelzer, and Paul Schulze. Eidlitz (1823–1908) had worked for Upjohn, but his first independent commission, executed in collaboration with Blesch, St. George's

Church (1846, plate 387) on Stuyvesant Square, New York, had Gothic spires rising from a Romanesque base with symmetrical towers. In the same year James Renwick designed the Church of the Puritans (1846), Union Square, New York, which was rather French in flavor, with roughly symmetrical towers, but of different heights and detail.

Church building in the Romanesque Revival style continued to be popular from the late forties down to the Civil War and then beyond. One can cite only a few characteristic examples: the Kent, Conn., Congregational Church (1848) by Henry Austin, a typical modest version; the Norman Congregational Church (1850), New London, by Eidlitz; the Central Congregational Church (1850–52, plate 388), Providence, by Thomas A. Tefft, with Germanic towers; the Union Methodist Church (1852–54, plate 389), St. Louis, by George I. Barnett, with its towering campanile; and the First Congregational Church (1857), Columbus, Ohio, by Sidney M. Stone, with an axial tower at the front.

The first monumental use of the Romanesque style in a public building was in the Smithsonian Institution (1847–55, plate 390), Washington, D.C. The building commission, under the direction of Robert Dale Owen, Senator from Indiana, after consulting such architects as Mills, Upjohn, Rogers, Young, and Walter, unanimously chose Renwick's two designs, one Gothic, the other Romanesque, but they preferred the latter. In *Hints on Public Architecture* (1849) Owen wrote of the "Norman" style that, in addition to having "the same variety as the Gothic . . . its entire expression is less ostentatious, and, if political character may be ascribed to Architecture, more republican." Indeed, the rich exterior effect was achieved by the massing of elements with very little carved detail. Despite its eight major towers and many chimneys of various shapes and sizes, the Smithsonian was designed to be flexible and cheap. The plan, with its museum and art galleries, lecture halls, laboratories, and library, was considered prior to the style of the elevation. Careful attention was given to lighting, access, public and private circulation, and fireproofing of parts of the building. The plan is actually symmetrical and the irregular, picturesque appearance quite dependent on the placement of the towers, which, one could even argue, were necessary for forge and furnace flues, freight elevators, and stairways. To Owen, who felt that "external form should be the faithful interpreter of internal purpose," the use of towers expressed the separateness of these functions and avoided encroaching on prime space. He hoped that the "Norman" would be considered an alternative to the Greek and the Gothic as a national style.

Although secular buildings in the round-arched style were fairly numerous, few remain today. Eidlitz's Springfield, Mass., City Hall (1854–55) was in the German Romanesque manner; and the Syracuse Court House (1856–67), by Horatio Nelson White, has a distinctly

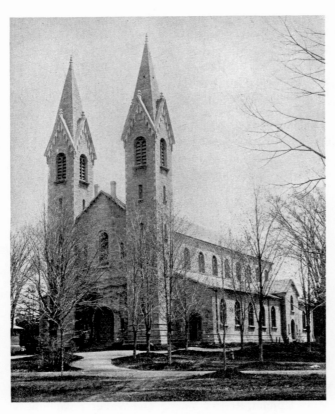

386 Richard Upjohn. Bowdoin College Chapel, Brunswick, Me. 1845–55

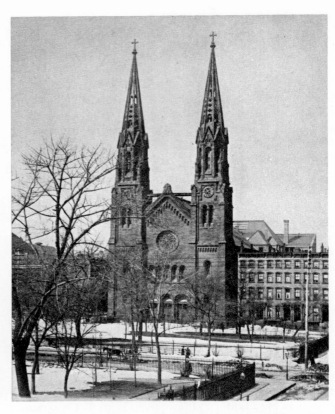

387 Leopold Eidlitz and Otto Blesch. St. George's Church, New York. 1846

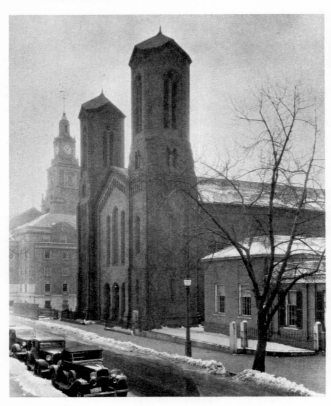

388 Thomas A. Tefft. Central Congregational Church, Providence, R.I. 1850–52

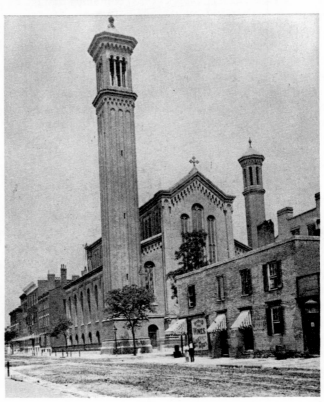

389 George I. Barnett. Union Methodist Church, St. Louis. 1852–54

390　James Renwick. The Smithsonian Institution, Washington, D.C. 1847–55

391　Thomas A. Tefft. Union Depot, Providence, R.I. 1848

"Anglo-Norman" look. The Astor Library (1849), on Lafayette Street, New York, was originally designed by Town in the Gothic style in 1843, but the actual building, for which Renwick won the competition, was apparently executed by Alexander Saelzer in 1859 and is less Romanesque than Italianate. Two large buildings in the Romanesque manner, both now destroyed, were St. Luke's Hospital (1856), New York, by John W. Ritch and the Union Depot (1848, plate 391), Providence, R.I., by Thomas A. Tefft (1826–1859). The latter, the finest of the early railroad stations in this country, was broadly conceived and executed entirely of red brick. The slender towers acted as a foil to the low, horizontal bulk of the structure, the open arcades to the solid masses of the major block and the octagonal end pieces. Aside from the decorative string corbels which added a delicate rhythmic pattern to the otherwise bare surfaces, the design depended boldly on the relationship of simple geometric volumes. This masterpiece of the early Romanesque Revival is all the more remarkable as the effort of a young architect who was still a student at Brown University.

Within the round-arched style the distinction between the various aspects of the Romanesque and the less

prevalent Renaissance Revival is often obscured. The neo-Renaissance mode, often called "Barryesque" after Sir Charles Barry, who led the revival in England, was introduced in this country by the immigrant Scottish architect, John Notman (1810–1865), who did the first Italian Villa houses. His Philadelphia Athenaeum (1845–47, plate 392) was the first and the purest of the early Renaissance Revival *palazzi,* which were to be popularized much later in the century by McKim, Mead & White. Upjohn adapted this style quite successfully for New York commercial buildings, first in the Trinity Building (1851–52), and then in the Corn Exchange Bank (1854), which was in some respects a prefiguration of Richardson's great Marshall Field Wholesale Store some thirty years later. The many post office and customs-house buildings designed by Ammi B. Young or under his direction also reveal the change in taste from the Neoclassic to the Italianate.

THE ITALIAN VILLA

The most revealing indication that the picturesque attitude was more important to eclecticism than any particular historical style, was the cohabitation of the medieval Gothic and the Renaissance Italian Villa in domestic architectural bliss. There was no significant difference in either plan or formal disposition but merely a variation in detail, and architects moved with ease from one manner to the other. The Italian Villa, an eccentric though not exotic style, was derivative of Classical and specifically Renaissance forms but, unlike the Barryesque Renaissance Revival, was not based on the major monuments or features of Renaissance architecture. Its inspiration was the rural and peasant architecture of Italy that appeared in the landscapes of Poussin and Claude. Among the major sources for American architects were G. L. Meason's *On the Landscape Architecture of the Great Painters of Italy* (1828); Pierre Clochard's *Palais, maisons et vues d'Italie* (1809), which consciously sought out the picturesque aspects of Italian architecture; Charles Parker's *Villa Rustica* (1832), which presented adaptations of such material for contemporary use; and "the Bible of the Villa style," J. C. Loudon's *An Encyclopedia of Cottage, Farm and Villa Architecture, and Furniture* (1833). In England, John Nash's Cronkhill (1802), with its round tower and picturesque composition of cubical masses of vaguely Classical derivation, was the first exercise in the style, and the rebuilding of Osborne House on the Isle of Wight for Queen Victoria in 1845–49 placed the royal stamp of approval on the mode. In America it may have developed independently, to some degree at least, out of the growing freedom of the late Greek Revival. After Downing's *Cottage Residences* (1842), all the American pattern books included the Italian or "Tuscan" Villa (plate 393), especially with

392 John Notman. Athenaeum, Philadelphia. 1845–47

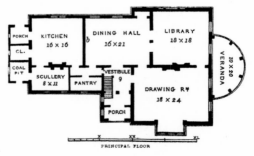

393 Villa in the Italian style. From A. J. Downing, *The Architecture of Country Houses,* D. Appleton, New York, 1850, fig. 119

heavy brackets under the eaves, in the repertory of house types, and it became a popular form in vernacular building. However, it had its major development in the larger, more palatial houses individually designed by architects.

These larger houses were usually built of stone or of brick surfaced with stucco, and the flat-walled, simple volumes produced a stateliness and formality entirely different from the rusticity and rich ornamentation of the neo-Gothic. Picturesqueness was achieved by an asymmetrical disposition of horizontal and vertical masses of irregular lengths and heights on varying axes and by the exaggeration in scale and increased plasticity of Classical ornament around window and door frames and in the heavy eaves brackets, decorative details which became the hallmark of Victorian architecture. The most obvious feature was the asymmetrically placed square tower, rising above the other, largely horizontal elements and capped by a roof that was almost flat and boldly extended. Italian Villa roofs were decidedly lower in pitch than those of the neo-Gothic. Characteristic also were roundheaded or rectangular windows in groups of two or three and roundheaded double doors or windows enclosed by arches. Interior moldings and ornaments were comparably Classical, large-scaled and coarse, entirely different from the intricate filigree of neo-Gothic decoration.

John Notman's modest and rather tentative Bishop Doane House (1837, plate 394), Burlington, N.J., is generally considered the earliest of the Italian Villas in America. Davis, with his remarkable prescience, had exhibited in 1835 a design for an Italian Villa which was more advanced than Notman's and comparable to English examples of the time. However, Notman's Prospect (1849, plate 395), Princeton, N.J., is a large, picturesque composition with a fine square tower. Most of Davis's Italian Villas date from the fifties, when the style reached its height, and though he did distinguished work in this mode, it seemed to restrict the more inventive side of his artistic personality. They are all handsome houses, well proportioned and impressive but, like Upjohn's, are rather conservative and reveal a strong inclination toward symmetry. Three of Davis's major villas—the Llewellyn Haskell (1851), Belleville, N.J.; the John Munn (1854, plates 396, 397), Utica, N.Y.; and the E. C. Litchfield (1854), Brooklyn, N.Y.—are similar in design, with a horizontal, two-story, main block, fronted by a picturesque pair of towers of disparate heights, one polygonal, the other square, but both placed more or less in the center without seriously intruding on the house mass.

Upjohn's more important domestic work was in the Italian Villa style, which he used with increasing boldness

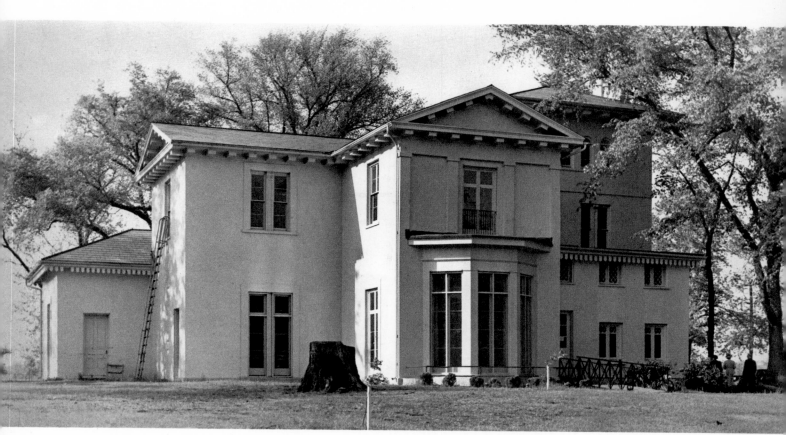

394 John Notman. Bishop Doane House (Riverside), Burlington, N.J. 1837 (destroyed 1961)

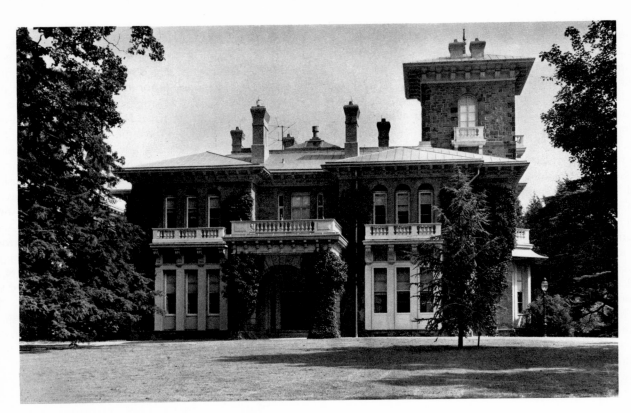

395 John Notman. Prospect, Princeton, N.J. 1849

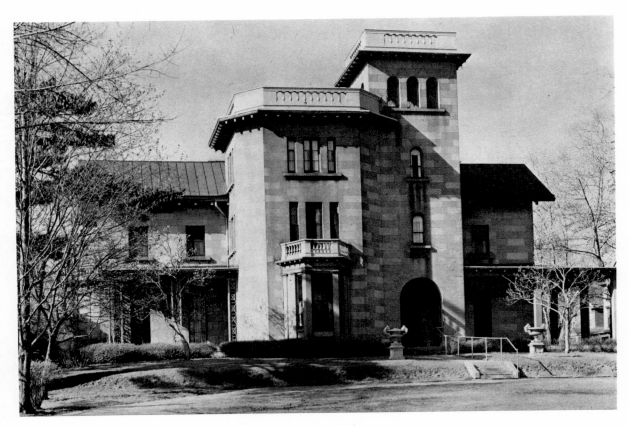

396 Andrew Jackson Davis. John Munn House, Utica, N.Y. 1854

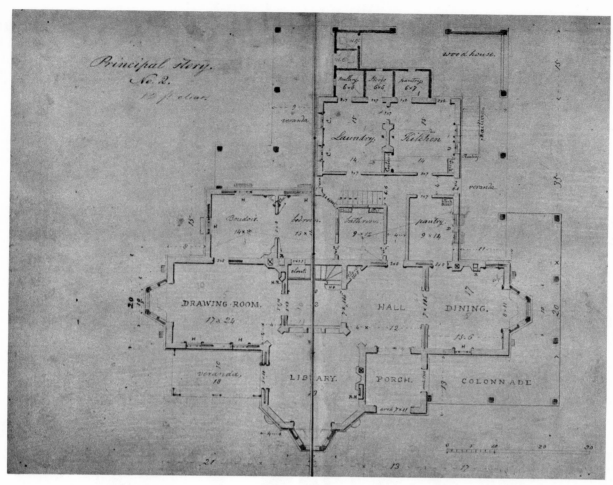

397 Andrew Jackson Davis. Plan, John Munn House, Utica, N.Y. 1854. Oneida Historical Society, Munson-Williams-Proctor Institute, Utica

into the sixties. The earliest is the blocklike Edward King House (1845–47, plates 398, 399), now the People's Library, in Newport, R.I., in which the entrance is flanked by a tower on one side and a projecting wing on the other to create a balanced composition. The similarity of wing and tower, except for height, reinforces the appearance of symmetry. The overscaled Classical trim contrasts with the clean wall surfaces, producing a pictorial richness that tends to obscure the basic conservatism of the plan. The C. Ely House (1852–54), now the Zollars' House Restaurant, in West Springfield, Mass., on the other hand, is stripped of decorative detail and exists as a freer, asymmetrical composition of clean-surfaced, sharp-edged masses. Upjohn's most imposing house in the Italian Villa style was the E. B. Litchfield House (1855), to be distinguished from the equally impressive E. C. Litchfield House by Davis, both of about the same date and both in Brooklyn. Here Upjohn returned, as if compulsively, to the symmetrical by placing the tower in the center of the facade, although other elements were treated asymmetrically and the decorative detail became excessively varied and profuse. He carried the Italian

Villa beyond its normal confines in his towerless John Stoddard House (1853–56), Brattleboro, Vt., and moved out of the orbit entirely and into the Barryesque Renaissance Revival with the Henry E. Pierrepont House (1856–57), Brooklyn, a blocklike, four-story Italian *palazzo*. This latter mode had only limited currency in domestic architecture during this period. A few examples were the Daniel Parrish House (1851–52, plate 400), Newport, R.I., by Calvert Vaux and the Tully D. Bowen House (1852–53), Providence, R.I., by Thomas Tefft.

Henry Austin (1804–1891), who did his most vigorous work in the two decades before the war in the Italian Villa style, handled it more picturesquely than did either Davis or Upjohn. Like them, Austin, as a protégé of Ithiel Town, had grown out of the Neoclassic into the eclectic and had tried his hand at a variety of modes, but he seems to have found the Italian Villa most congenial. His Norton House (c. 1849), New Haven, borrowed almost directly from Downing's *Cottage Residences* (Design VIII), was more open, more rustic, and less formal than houses in that style by Davis or Upjohn. Two of his later villas reveal an even fuller understanding and ex-

ploitation of picturesque possibilities—the Joseph Sheffield House (c. 1860), a remodeling of Ithiel Town's house in New Haven, and the Victoria Mansion, the Morse-Libby House (1859), Portland, Me. In the former he added two unequal towers, three wings, and a verandah, creating a complex, interlocking composition of horizontal and vertical elements. The latter (colorplate 32), perhaps the best-known of all the Italian Villas, is an excellent example of the lavish, stately town houses of the period. The asymmetrical composition of vertical tower and irregular horizontal masses, accented by boldly projecting eaves and enriched by a profusion of vigorously plastic ornament, forecasts the overwrought eclecticism of the postwar period.

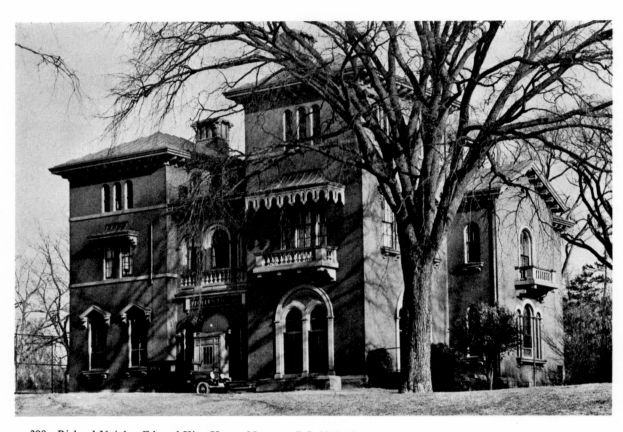

398 Richard Upjohn. Edward King House, Newport, R.I. 1845–47

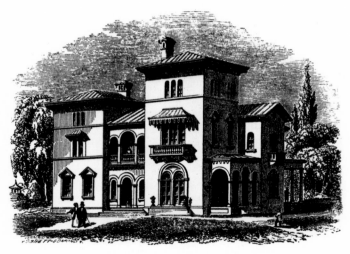

399 Villa in the Italian style. From A. J. Downing, *The Architecture of Country Houses,* D. Appleton, New York, 1850, fig. 143

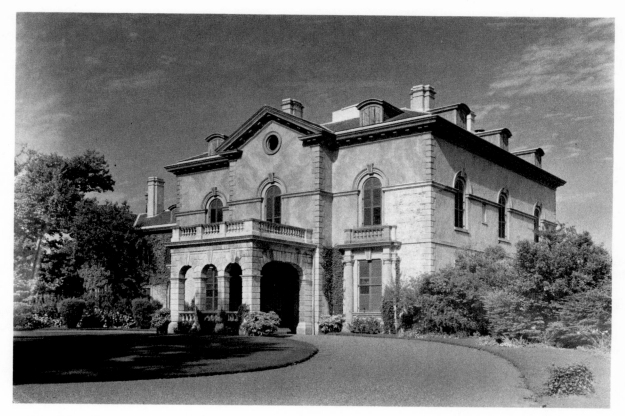

400 Calvert Vaux. Daniel Parrish House, Newport, R.I. 1851–52

EXOTIC STYLES

Among the less pervasive revival styles that added spice to the cuisine of the picturesque, the Egyptian was more frequently and seriously employed than the so-called "Oriental" (see below). Egypt, the most ancient of civilizations and the scene of Biblical history and Napoleonic adventure, had a Romantic aura as well as a certain immediacy. The Egyptianizing elements of the Empire style had already infiltrated the Neoclassic, especially in furniture and interior decor, but it comes as a surprise to find a serious, forty-page article on Egyptian architecture in the *American Quarterly Review* of 1829. Even more surprising are the more than sixty buildings in Egyptian style listed by Frank Roos, Jr., as existing in the United States before the Civil War. On the whole, however, the appropriateness of the style was considered limited. It was much favored for memorial monuments and, because of its association with death, for tombs and cemetery gateways. There was no real archaeological understanding of the style, however, nor any consistent use of its elements, which were treated freely and rather indiscriminately.

The first evidence of Egyptian influence occurred in the Baltimore Battle Monument (1815–25), a Roman fasces column rising on an Egyptian-style base, designed by Maximilien Godefroy. Solomon Willard introduced the popular obelisk form in the Bunker Hill Monument (1825–43), Charlestown, Mass., although several men claimed credit for suggesting the form, including Greenough, Parris, and Mills. Mills eventually dwarfed Willard's effort in the colossal Washington Monument (plate 243).

The earliest extant cemetery gateways in the Egyptian style are the iron-and-stone ones by Godefroy for Westminster Cemetery (before 1815), in Baltimore. Strickland proposed one for the Laurel Hill Cemetery in Philadelphia in 1836, and Walter designed a similar gate in the same year. There is a small but effectively picturesque gateway to the Old Granary Burying Ground (1840), Boston, by Solomon Willard, reproduced later as the Touro Memorial Gateway, Newport, R.I., and a larger one to the Mount Auburn Cemetery (1831, plate 401), Cambridge, Mass., by Jacob Bigelow. Henry Austin's gateway for the Grove Street Cemetery (1845, plate 402), New Haven, is typical of such designs. The gate is conceived as a pylon capped by a fluted cavetto molding bearing a winged solar disk with asps in the center. Tombs of the period also reflect the identification of the Egyptian mode with death.

Of the more conventional types of building in the Egyptian style, "The Tombs," officially the New York Halls of Justice (1835–38, plate 403), by John Haviland,

is probably the most famous. Here again the overtones of ancient law and timelessness must have played some role in the selection of the style as appropriate for a prison, though it is revealing that the public, with its own more ironic sense of symbolism, should have identified it with death. Also in the Egyptian manner were Haviland's New Jersey State Penitentiary (1832), Trenton, and Essex County Courthouse (1836), Newark.

One would not expect to find this style with any frequency in church buildings, but there are a few, notably the Sag Harbor Whalers' Church (plate 331) in which the Egyptian is fused with the Classic and translated into wood in an entirely original manner, and Strickland's much more conventional First Presbyterian Church (1849, plate 404), Nashville. The latter is exceptionally massive, with polygonal towers on square bases. It is rather Monumental Classical except in its detail—papyrus columns *in antis,* battered doors and windows, and cavetto moldings. In spite of the exotic interior decoration of Egyptian columns and wall painting, which creates the illusion of an Egyptian temple, the auditorium is a large, simple, open space. Strickland had also used the

Egyptian style as early as 1822 for the Mikveh-Israel Synagogue (1822–25), Philadelphia, which would appear to be the earliest attempt to find an appropriate style for synagogue architecture through identification with the Orient.

Among other scattered buildings that reflected the Egyptian fashion were the Pennsylvania Fire Insurance Building (c. 1839), Lancaster, Pa., one of the few commercial structures in the manner; the Medical College of Virginia (1844) in Richmond, by Thomas S. Stewart, in which an allusion to ancient medicine may have been intended; and the small Pearl Street Railroad Depot (1840), New Bedford, Mass., by Russell Warren, for which there seems to have been no symbolic reason. The simple, bold mass of the old Croton Distributing Reservoir (1841) by James Renwick, Jr., which occupied the present site of the New York Public Library at 42d Street, found acceptance even in the eyes of that astringent critic of revivalism, Horatio Greenough. Renwick had found in the gigantic battered walls of Egyptian building a structural form to express the function of a reservoir in the most forthright terms.

401 Jacob Bigelow. Gateway, Mt. Auburn Cemetery, Cambridge, Mass. 1831

402 Henry Austin. Gateway, Grove Street Cemetery, New Haven, Conn. 1845

403 John Haviland. New York Halls of Justice ("The Tombs"), New York. 1835–38

404 William Strickland. First Presbyterian Church, Nashville, Tenn. 1849

Both the Islamic and the Chinese modes were more fad than revival, purely exotic and generally playful rather than serious. In England the remodeling of the royal Brighton Pavilion under the direction of John Nash took on an Islamic cast and was completed as an extravaganza of bulbous domes, conical roofs, minarets, and horseshoe arches. After being received in it by the Queen, the great American showman, P. T. Barnum, not unmindful of the attendant publicity, had a palace in the style built near Bridgeport, Conn. Eidlitz claimed credit for the design of Iranistan (1847–48, plate 405), as it was called, an unimaginative, symmetrical building with irregular wings, covered with a filigree of Oriental detail and capped by five bulb domes. Eidlitz designed a variety of villas in the Oriental manner: Elk Hall (1851), Amelia County, Va., for William S. Archer and, in 1869, two houses for Llewellyn Park, one "Oriental" and the other "Moorish."

Oriental forms soon found their way into the American pattern books of the period, first in William H. Ranlett's *The Architect, A Series of Original Designs* (1847–49) and then in Samuel Sloan's *The Model Architect* (1852), which included several Oriental designs, one of which was the basis for Longwood (colorplate 30). Sloan, conscious of the anomaly of Oriental palaces in the New World, made a special effort to explain their particular features and adaptability to local conditions. Oriental designs had been recommended in architecture books for garden "fabricks" even in the Georgian period, but after the Civil War such structures became common for pleasure buildings in public parks. Notable among such are the Meadowport Arch (1868–70) in Prospect Park, Brooklyn, by Olmsted and Vaux, and the Music Pavilion (1872, plate 406) in Tower Grove Park, St. Louis, by David H. MacAdam. Also, the iron-and-glass Crystal Palace (1853–54, plate 407) in New York, designed by George Carstenson and Charles Gildemeister, differed from the London original in the addition of Islamic corner minarets and a somewhat Oriental dome.

Although the use of Oriental forms in commercial architecture was neither widespread nor noteworthy, at least two buildings in Charleston by Francis D. Lee deserve mention: the iron-and-concrete Moorish Fish Market and the sensitively handled facade of the Farmers' and Exchange Bank (1853–58, plate 408), with its horseshoe and cusped arches and alternating courses of light and dark stone.

Synagogue architecture was one area in which the Oriental seemed appropriate. The Romantic spirit had led other sects back to their ancient architectural forms, and Jewish communities were motivated by the same search for identity. There were no ancient synagogues to serve as models, however, and the Bible gives no clue as to the architectural style of Solomon's Temple. The closest the architects could come to an authentic form was the vaguely Oriental, and though the Islamic may not seem apt from our point of view, it appears to have satisfied people then. Examples include the Shaaray Tefila (1869), New York, by Henry Fernbach; the original Temple Emanu-El (1866–68), New York, designed by Eidlitz and Fernbach in a combination of the Gothic and the Islamic; and the Isaac M. Wise Temple, B'nai Yeshurun (1865–66), Cincinnati, by James K. Wilson, which in its effort to be archaeologically accurate included two minarets (plate 409).

European interest in *chinoiserie* was a fashion of long standing, though in its inception essentially a courtly taste. In Georgian England it became something of a rage in interior decoration, furniture design, and garden structures. The publication of *Designs of Chinese Buildings, Furniture, Dresses, Machines, and Utensils* in 1757 by Sir William Chambers was instrumental in popularizing Chinese forms in England and America. The Georgian Gunston Hall, Fairfax County, Va., and Miles Brewton House, Charleston, had interior details in the Chinese style, and American furniture faithfully copied "Chinese" Chippendale furniture. Although American trade with China in the nineteenth century created an interest in Chinese *objets d'art* and pattern books included designs

405 Leopold Eidlitz. Iranistan, near Bridgeport, Conn. 1847–48

406 David H. MacAdam. Music Pavilion, Tower Grove Park, St. Louis. 1872

407 George Carstenson and Charles Gildemeister. Crystal Palace, New York. 1853–54

408 Francis D. Lee. Farmers' and Exchange Bank, Charleston, S.C. 1853–58

409 James Keys Wilson. B'nai Yeshurun (Isaac M. Wise Temple), Cincinnati. 1865–66

of so-called "Chinese" villas and houses, the style had little currency except in pleasure buildings for gardens and public parks. Chambers's popular Great Pagoda in Kew Gardens, London, must have been the model for Haviland's delightful Pagoda and Labyrinth Garden (1828, plate 410), in Philadelphia, built as a place of entertainment. The only conventional building to reveal the Chinese influence was the very unconventional New Haven Railroad Station (1848, plate 411) by Henry Austin. Although described as "Italian," it was an incredible mélange of elements, including a central tower in pagoda form, one end tower in stupa form, and the other and largest of the three in a mixture that defies description. It was pulled down in 1874.

410 John Haviland. Pagoda and Labyrinth Garden, Philadelphia. 1828

411 Henry Austin. Sketch for New Haven Railroad Station. 1848. The Beinecke Rare Book and Manuscript Library, Yale University, New Haven, Conn.

A. J. DOWNING
AND COTTAGE ARCHITECTURE

More significant than the large mansions was the filtering down of "good" design to the level of middle-class suburban building through architectural handbooks. Such mid-century "house pattern books" included complete designs with plan, elevation, and landscaping, thus differing from the earlier "builders' guides," which were primarily concerned with building instructions and ornamental details. The house pattern books were intended for the general public rather than the craftsman and dealt with questions of taste rather than problems of construction. Their influence on taste in general was apparent, but it was in the vernacular that they had the greatest impact.

The picturesque cottage had its most persuasive advocate in Andrew Jackson Downing (1815–1852). Pattern books specializing in designs for villas and cottages had appeared in England early in the century and were soon common in America, at least among architects. The earliest American version, Davis's *Rural Residences* (1837), was rare, and Downing's books, beginning in 1841, swept the field. More than any other American, Downing gave domestic architecture of the period a coherent aesthetic and propagated its forms. A proselytizer rather than an originator, he published the designs of others as well as his own, especially those of Davis, with whom he worked in close collaboration. Downing began his professional life in landscape gardening, an interest revealed in the title of his first book, *A Treatise on the Theory and Practice of Landscape Gardening Adapted to North America . . . with remarks on rural architecture* (1841). In it he openly expressed his indebtedness to various English sources and especially to J. C. Loudon. He subsequently shifted his emphasis to architecture and refined his aesthetic theories in *Cottage Residences* (1842), the most popular and influential of his publications, continuing through five editions and thirteen issues down to 1887, and *The Architecture of Country Houses* (1850). He was also an active polemicist as editor of the *Horticulturist* from 1846 to his untimely death in the disastrous fire of the Hudson River steamboat "Henry Clay" in 1852. A posthumous collection of pieces was issued in 1853 as *Rural Essays*. Downing soon had many followers and competitors, but it was he who most effectively answered the Romantic urge for picturesqueness, the American concern with economy and efficiency, the pietistic need for moral sanctions, and the middle-class striving for taste and refinement.

Three principles underlay Downing's approach to domestic architecture—"Fitness or Usefulness," "Expression of Purpose," and "Expression of Style." Under "Fitness," he considered the plan for convenience in room arrangement; the orientation of the house in nature for picturesque appearance and view; its adaptation for family needs, maximum economy, and efficiency, including sanitary conveniences and labor-saving devices, the latter in response to the growing servant problem; and the selection of proper materials. "Expression of Purpose" had the specific meaning for Downing of "truthfulness." Here the influence of Pugin becomes apparent. "All beauty is an outward expression of inward good," Downing wrote, and it is clear that for him the house must express the notion of home, and the home was understood to be the basis of a moral society. However, Downing listed as the most expressive elements chimneys, windows, and porches—essentially the features that created picturesqueness and the interest of variety. By an act of legerdemain, taste had become an expression of morality. His antipathy to the white paint of the Greek Revival was not that it hid the "truthful" character of material, but that it clashed with nature, was therefore not picturesque. Up to this point, Downing wrote, one was dealing with building, not architecture, "only a useful, not a *fine art*." This was not entirely true, for his second principle had already introduced the concept of formal expression, without which "Expression of Style" would not have been possible. History could offer many appropriate faces—"Rural Gothic," "Italian," "Swiss," "Flemish," "Roman"—each appropriate to a particular image except for the Greek, which he dismissed as a "false taste" for "ambitious display." Downing warned that houses should imitate not the monumental aspects of historical styles but their humbler features. Thus good taste was modest taste; and again Romanticism had been domesticated.

Downing's theories were a curious mixture of realism and Romanticism, utility and picturesqueness, expressed in eclectic forms, but he made Romanticism a viable mode for suburbia and changed the character of the American house. If one strips away the homilies, one finds at the core of his writing a fecund source of ideas. His books, more than anything else, destroyed the hegemony of the formal, symmetrical, rectangular white house of the Neoclassic period and substituted the informal, asymmetrical, picturesque, harmoniously hued cottage of the Romantic era. The very principle of "Fitness" led naturally to freer planning, greater variety, richer and more inventive use of materials, and a closer relationship of house to nature and interior to exterior. Downing's own published plans were simple, rational, efficient, and economical, basically rectangular and not at all revolutionary. He did dispose rooms asymmetrically, but they were still essentially within the confines of the rectangle. The apparent spread outward and the variety of room shape were achieved by comparatively small excrescences: bay windows, verandahs, and balconies. These did more to create a picturesque exterior than to change interior spatial conceptions.

Curiously enough, considering his expressed preference for masonry as more permanent and status bearing, Downing's major contributions, aside from his impor-

tance as a propagandist, were his bracketed board-and-batten houses (plate 412). These were not original with him. Davis had published three board-and-batten house designs, one with brackets, as early as 1837 in his *Rural Residences*. But Downing made these elements his own and finally arrived at a style that expressed both materials and structure. His espousal of board-and-batten siding, extended eaves with supporting brackets, and light, stick-like porch structures was a recognition of the nature of wood and the method of construction. Here at last the

skeleton frame of the building was clearly expressed on the exterior. The thin skeleton construction of the balloon frame, which depended on the manufacture of cheap nails and mass-produced lumber, had first appeared in Chicago in 1833 and by the late thirties had spread through the prairie West, but the first publication of the method in an architectural handbook was not until 1855. The basic method of building in wood for Downing and his contemporaries was still heavy-timbered mortice-and-tenon carpentry. The skeletal pattern of both methods was

412 Small bracketed cottage. From A. J. Downing, *The Architecture of Country Houses*, D. Appleton, New York, 1850, fig. 9

essentially the same, however. Against his own predilection for masonry, Downing had come to accept wood as a native material and the "bracketed mode" as peculiarly fitted to North America, and Gervase Wheeler, the English architect who came to the United States in the forties and continued in Downing's tradition, recognized such features as indigenously American.

Downing's Romantic idealism also had a profound effect on environmental thinking. He saw beyond the house as a utility to the house as an aesthetic and even moral entity expressive of a total pattern of living. One may disagree with his dream of genteel domesticity and his *nouveau-riche* concepts of the cultured life, but that dream led him from the problems of the individual house to those of the suburban development and eventually of urbanism. A year before his death, he submitted to President Millard Fillmore a plan for the Romantic "ruralization" of Washington, D.C., and it was his influence on his protégé, Calvert Vaux, that helped form the conception of New York City's Central Park by Olmsted and Vaux, a plan that became the model for city parks throughout the country. It is a pity that Downing is remembered almost entirely as a purveyor of a quaint taste for the rustic, rather than as a serious, even a visionary, thinker on domestic architecture in an industrial society.

THE "EARLY IRON AGE"

While the Industrial Revolution had created new problems for building, it had also developed new materials and techniques to cope with them. The construction of factories, mills, commercial buildings, railroads, bridges, and roads, forms that have traditionally existed on the fringes of architecture, presented problems more economic than aesthetic. The major concerns were for speed of construction, efficiency of operation, and minimal cost, for profit rather than presence. Architecture was considered a frill, and utilitarian construction fell to engineers or simply to building contractors. It was during these years that the function of architecture as a combination of design and construction was fragmented. It is not accidental that architects, relegated to prestige building, worked in traditional materials and eclectic forms while engineers built industrial and commercial structures in new materials such as iron, which required advanced techniques, but in which style was at best an afterthought. The architect became a *couturier,* "dressing" structures that required a social image. Architecture suffered until this schism was healed in the latter part of the century, and aesthetic expression within new structural practices became possible.

The development of first cast and then wrought iron as a building material was a major contribution of the Industrial Revolution during the late eighteenth and early nineteenth centuries, but the evolution of its use in what Hitchcock has called the "Early Iron Age" was centered in England, technologically the most advanced country of the world, with some contributions from France. The American industrial plant was not capable until the 1850s of contributing to this historic process, and it was only late in the century that it assumed the lead in steel-skeleton construction. Before the middle of the century, American ingenuity had revealed itself in the development of the wood balloon frame, which supplanted the heavier mortice-and-tenon-jointed carpentry of an earlier period. Similarly, cast- and wrought-iron columns and beams were now to replace the heavier masonry construction. In both cases a lighter skeleton structure was achieved and prefabrication sped construction.

The inadequacy of America's iron production forced wood construction to its very limits. New and improved systems of wood trussing were invented to supply the demand for railroad bridges and factories, in which the ever-increasing open floor span to house larger and heavier machinery could no longer be supported by traditional post-and-lintel wood construction. With time, as metallurgical capacity increased, such ingenious but dead-end devices were supplanted by the newer iron technology, but America contributed little to the great germinal experiments of the first period of iron building, and produced no monuments to match the daring early bridges of Telford or Séguin; the radical innovations in iron-and-glass structures such as Rohault de Fleury's Jardin des Plantes, Paxton's Crystal Palace, or the sheds of so many European railroad stations, or the domed magnificence of Bunning's London Coal Exchange or Labrouste's two Paris libraries. In the United States cast-iron columns and, later, beams were increasingly used in large factories and mills to reinforce the load-bearing function of masonry and wood, but such elements were not generally visible. A few early examples attempted openly to integrate iron into the structural design: in Strickland's United States Naval Asylum (1826–29, plate 245) the slender iron columns supporting the balconies are an important element in the facade design; and the Providence Arcade (1828, plate 333) by Warren and Bucklin had stairs, balconies, and balustrades of iron and a roof of iron and glass. However, it was not before the fifties that Ammi Young began to incorporate iron features such as staircases, windows, and doors in his government buildings.

One major American contribution to iron architecture was the exploitation of the cast-iron building. James Bogardus (1800–1874), inventor and manufacturer of machinery, is usually credited with the development of this type of construction, although there is some question as to whether he invented it. At any rate, his activity in building such structures and the publication of *Cast Iron Buildings: Their Construction and Advantages* (1856) under his name, though ghostwritten, helped spread the system of prefabricated building throughout the country.

As early as 1829, Haviland had used cast iron instead of stone to face the brick walls of the Miners' Bank in Pottsville, Pa., but Bogardus called for self-supporting exterior walls composed of prefabricated columns and beams. It was similar in character to an iron building fabricated in 1839 by the Scottish engineer, Sir William Fairbairn, for re-erection in Turkey, which Bogardus may have seen while in England. In 1848, in New York, he began a four-story building with a cast-iron facade to house his own factory on Center Street, and completed two others there before it was finished in the following year—the five-story structure for John Milhau on lower Broadway, the first to be completed, and the "Cast Iron Building" (1848, plate 413) for E. H. Laing on Washington and Murray Streets, dismantled in 1971, which was erected in two months.

The ease with which the most elaborate and expensive carving could be duplicated in iron casting led to meaningless and often tasteless display and, at the same time, inhibited any search for new and more appropriate decorative forms deriving from other attributes of the material. Bogardus's Harper's Building (1854, plate 414), in an ornate late Renaissance mode supplied by the associated architect, John B. Corlies, reflects this mid-century taste. But in spite of its hackneyed ornament, the

413 James Bogardus. Edgar Laing Stores ("Cast Iron Building"), New York. 1848 (dismantled 1971)

414 James Bogardus and John B. Corlies. Harper's Building, New York. 1854. From an engraving by J. N. Allan. Museum of the City of New York

Harper's Building reveals certain features that were crucial for the later development of architecture. By relieving the wall of its load-bearing function, the first step toward iron-skeleton construction had been taken. The lightness of the iron members also opened the way for the wall surface to become a glass curtain. And finally, the modular character of prefabricated parts introduced an aesthetic element which would be understood more fully later: instead of a facade divided into component units, one has a facade created by the repetition of a given module. In this respect, at least, the Harper's Building was as significant a statement as the brilliantly revolutionary Crystal Palace. In the latter the module of the glass pane is not insistent enough to exist as a formal unit but becomes part of a larger screen of glass, while in the former the meaningless eclectic ornament reinforces the module as an expressive element of a repetitive design, a basic aesthetic concept in much contemporary architecture.

Bogardus's most radical conception, one which might have changed or accelerated the development of American architecture had it been executed, was his design for the New York World's Fair of 1853 (plate 415). Bogardus proposed an immense circular hall 1,200 feet in diameter and 60 feet high of standardized iron elements that could be reused after dismantling. The 300-foot central tower with an elevator was to serve both as an observatory and as the support for the suspended catenary-curved roof of sheet iron. This amazingly visionary yet practical plan was passed over for a copy of London's popular Crystal Palace.

Bogardus prefabricated many cast-iron buildings for other parts of the country, among them two in Baltimore —the Sun Building (1850–51, plate 416), after a design by

R. G. Hatfield, and another "Cast Iron Building" (c. 1870), now the Robins Paper Company Building. Other iron foundries followed his lead and from about 1850 to 1880 produced various cast-iron buildings that were once to be found in cities throughout the nation. Noteworthy among the New York examples is the Haughwout Building (1857, plate 417) at Broadway and Broome Street. The largest and one of the simplest in design, the old A. T. Stewart Department Store (1859–60), on Broadway, later Wanamaker's, designed by John W. Kellum, was destroyed by fire during its demolition in 1956. Some fine examples of the type were anonymous cast-iron facades of buildings along the St. Louis waterfront, which were removed to make way for the redevelopment of the area as the Jefferson National Expansion Memorial. One of these, the Gantt Building (1877, plate 418), indicates the capacity of the form for achieving a frank and elegant expression of structure. Except for the routine decorated cornice, the facade is a simple and beautifully proportioned cage of light colonnettes and severely plain horizontal members enframing the windows. The rationality of the design, the modular repetition, and the glass-curtain effect are all prefigurations of both the Chicago Style and the twentieth-century International Style.

The arguments for the superiority of iron as a building material included the belief that it was fire-resistant. However, although iron and glass will not burn, they melt under intense heat, and after a series of disastrous experiences Europeans became somewhat disillusioned with iron. This fact was not brought home to Americans until the great fires in Boston and Chicago in the seventies, and thus the "Early Iron Age" lasted longer in America than abroad. But the eventual submergence of iron building for at least a generation was due as much to

415 James Bogardus. Project for New York Industrial Palace, World's Fair of 1853. From B. Silliman and C. R. Goodrich, eds., *The World of Science, Art and Industry, Illustrated from Examples in The New York Exhibition, 1853–54*, G. P. Putnam, New York, 1854

416 James Bogardus after a design by R. G. Hatfield. Sun Building, Baltimore. 1850–51 (destroyed 1904)

417 Haughwout Building, New York. 1857

418 Gantt Building, St. Louis. 1877

the increasing taste for massiveness and plasticity, a taste at odds with the lightness, delicacy, and openness of iron-and-glass construction. The second phase of this evolution, which did not occur until the nineties, had to wait for a shift in taste as well as for the technological advances that made iron and then steel fireproof.

Some of the earliest and most radical developments in iron construction occurred in bridge building, which involved engineering rather than architectural skills. It is here that the split between engineer and architect becomes most clearly apparent, and although architects were often called upon as design consultants, as they still are, their activities were largely confined to the handling of masonry or decorative elements. Beginning with the earliest, the Coalbrookdale Bridge over the Severn in 1777 by Abraham Darby, the history of the iron bridge in England and France is a series of brilliant engineering feats, though the bridges themselves were often bedecked with eclectic ornament. They were attempts to adapt the static principles of masonry construction to the capabilities of iron, but a new direction was indicated by Telford's Menai Bridge (1819–24), the first great suspension bridge, and still the longest of the type in the British Isles. The principle itself was not new, but the substitution of iron chain for rope made it feasible for modern use. (James Finley had built several suspension bridges with iron chain in America, the first in 1801, and had patented the process in 1808.)

The Menai Bridge was hardly completed when Marc Séguin began a span over the Rhone which introduced the wire rope. But it was John Augustus Roebling (1806–1869) in the United States, whose career spanned the years from the "Early Iron Age" to the "Age of Steel," who brought the suspension bridge to magnificent maturity. Born in Germany, Roebling migrated in 1831 to Pennsylvania, the burgeoning center of the iron and coal industries. While working on the new Pennsylvania Canal, he developed a wire rope for hauling barges over mountain portages, and in 1841 devised a machine for spinning the cable; shortly afterward he improved the efficiency of the cable by binding the steel wires in parallel strands. The first of his suspension structures was an aqueduct for the Pennsylvania Canal (1844–45), followed by a bridge over the Monongahela River at Pittsburgh (1845–46). Roebling also built a bridge in Cincinnati and

419 John Augustus Roebling. Brooklyn Bridge. Begun 1869

a railroad bridge, no longer extant, at Niagara Falls. As the spans became greater, the problem of fabricating the cables became progressively more difficult, but Roebling's engineering genius was equal to the challenge and led finally to the commission for a bridge over the East River in New York. The Brooklyn Bridge (plate 419), his last and crowning achievement, and even today the paradigm of all suspension bridges, was begun in 1869 and belongs to the beginning of the "Age of Steel." Roebling was an engineer and not an architectural designer; the masonry towers of his bridges show a need, so characteristic of the time, to acknowledge some reverence for the architectural forms of the past. The sweep of roadbed and cable are pure engineering, creating a new form which has its own unquestioned aesthetic grandeur.

CHAPTER THIRTEEN

Painting for the Public

By and large, painting was appreciated for its literal naturalism and its subject matter, for the memories or sentiments it evoked, for the stories it told or the morals it drew, rather than for its more purely artistic qualities. The inexperienced could not be expected to respond to niceties of style, and their mentors in lectures and articles fed them a pretentious and unrewarding mess of outdated aesthetic generalities and moral precepts that were of no help in distinguishing the profound from the platitude or genius from mediocrity. Though the opportunity for a broader and more satisfying artistic expression was afforded the artists of this generation, the acceptance of popular levels of taste often limited their ultimate achievements.

Post-Stuart portrait painting was overwhelmingly mediocre, except for isolated canvases, and after the introduction of the daguerreotype became in imitation even more concerned with likeness. History painting had been effectively aborted by governmental lack of interest. The most important artistic developments during the period were the rise to dominance of landscape painting and the increasing interest in genre fed by their reproduction in color lithography. On the popular level the mass production of prints and the expanding use of illustrations in periodicals were influential developments.

THE ROMANTIC LANDSCAPE: THE HUDSON RIVER SCHOOL

Although landscape painting was influenced by and, to a great extent, dependent on popular taste, it was essentially expressive of a higher and more pretentious level of culture and society and had become the major vehicle for noble sentiment and ideal beauty. Reverence for nature (especially nature undefiled by man) being an important aspect of Romantic expression, the American landscape was in itself a Romantic experience; European travelers often came specifically to see the wonder and sublimity of nature in its original state.

The painters who established the tradition of a national landscape art emerged in the 1820s and became known, though they were never an organized group, as the Hudson River School. They were localized in the Hudson Valley, the Berkshires, the Adirondacks, and the White Mountains. Although they sketched out of doors, all except Asher B. Durand painted in their studios, so that many of their pictures are not actual records of specific locales but ideally organized compositions. In this respect they were well within the European tradition of Romantic landscape painting. Yet they are American in the character of the landscape and in a generally meticulous rendering of detail, due possibly to limited formal training, a background in engraving techniques from which many of them derived, and popular taste.

Romantic landscape painting may be divided into two major traditions—that of the sublime, the awesome, the wild and terrorful, characterized as *terribilità,* best exemplified in the landscapes of Salvator Rosa; and the lyrical, peaceful, more domesticated landscapes of Claude Lorrain. The distant view, the immense vista, and a general grandeur of scale were, however, common to both. Not until later in the century, with the rise of the Barbizon School in France, did a more intimate conception of nature become prevalent. The American landscape in its primordial state and large scale lent itself naturally to the former. Yet, except for the earlier landscapes of terror and mystery by Allston and the fantastic imagination of Thomas Cole, the Hudson River School avoided *terribilità*. Its glorification of the physical magnificence of the American continent had patriotic, religious, or philosophic overtones, but much of Hudson River School painting was concerned with the homier aspects of nature in its more benign character, implying simply richness and plenty.

This was a native school not only in subject but in training. Although most of its members traveled abroad, many did so after their careers had been launched and often after their styles had been formed. They were certainly aware of the older traditions of European landscape painting—of Rosa, Claude, the Poussins, and the Dutch—if not at first hand, then through engravings. Of more recent landscape painters, the influence of Richard Wilson was perhaps strongest, imported by a group of

minor English landscapists to Philadelphia in the early years of the century. The parallels between the American and German schools of landscape painting in attitudes, subject, and even handling are curious in that, although some of the Americans knew the Nazarenes as well as the German landscapists resident in Rome, no clear lines of influence can be drawn. But the Americans share with the Germans a national pride in the beauties of their native scenery and an overmeticulous attention to detail, although they never succumbed to the brooding melancholy that characterizes the German Romantics.

The inception of the Hudson River School is usually ascribed to the first exhibition of Cole's landscapes in New York in 1825, from which three were sold for $25 each to Trumbull, Durand, and Dunlap. During the early years of the century, there had been occasional efforts at landscape painting and a serious interest in the form on the part of Allston, as well as a definable (though minor) tradition established by the English émigrés in Philadelphia. Both Thomas Doughty and Thomas Cole were active in Philadelphia before they exhibited in New York. Thomas Doughty (1793–1856), born in Philadelphia, had left a secure livelihood in the leather business there in 1820 to become a landscape painter after only some limited independent experiments with oils and a few lessons in drawing. Yet in the same year he was listed in the Philadelphia directory as a "landscape painter"; was mentioned the following year by the well-known Baltimore patron of American art, Robert Gilmor, Jr., as having painted two views of his "country seat," a common source of revenue for incipient landscape painters in those years; and in 1823 exhibited eight paintings at the Pennsylvania Academy of the Fine Arts. In 1824 he was elected a member of the Academy. Doughty showed two landscapes at the first exhibition of the National Academy of Design in 1826, and they were highly praised. Two years later Asher B. Durand exhibited his first landscape, and with his addition to the roster the Hudson River School was launched.

Doughty continued to paint out of Philadelphia but traveled through Pennsylvania, New York, and New England in search of subjects. He had exhibited in Boston, settled there in 1832, advertising classes in oil and watercolor painting and drawing, and in 1834 held a major exhibition of forty-three paintings. In 1837 he made his first trip to England and then finally settled in New York in 1841.

Of the triumvirate of Doughty, Cole, and Durand, which dominated the early development of the school, Doughty was the most limited as an artist and the least interesting and skillful as a painter. He was the most dependent upon the earlier English tradition, and his work reveals many of its more obvious shortcomings—pedestrian composition, monotony of color tending toward the brown, and a niggling detail which led to the derogation "leaf painters." Still, Doughty was capable of

poetic statements about nature that could have come only from a deep love and understanding. *In Nature's Wonderland* (1835, plate 420) is typical of his unassuming art: sublimity reduced to a minor note by the unimaginative and almost tentative character of the composition; the stock figure of the Romantic wanderer dwarfed by the wilderness; and the fussiness of the brushwork which becomes a kind of surface embroidery contradicting the immensity of the natural vista. Yet the glow of light and the sense of silence create an authentic poetic mood.

By far the most interesting painter of the Hudson River School was Thomas Cole (1801–1848). In his grandeur of conception, imaginative fantasy, moral passion—even obsessive religiosity—he is closer to the turbulent heart of Romanticism than any of his contemporaries. Cole was born in England. He served an apprenticeship to a designer of calico prints and worked as a wood engraver in Liverpool before he went to Philadelphia. There he studied drawing at the Pennsylvania Academy, where he was much taken by the landscapes of Birch and Doughty. In 1824 he showed his first landscape at the Academy and in the following year exhibited in New York, where he had his first recognition.

Cole had probably begun painting landscapes during his wanderings either in Ohio or around Pittsburgh, but through the provident patronage of G. W. Bruen, a New Yorker, he managed a trip up the Hudson in 1825, the results of which made his immediate reputation. Most of his inspiration and thematic material came from the Hudson Valley around Catskill, but he did go on sketching trips through the White Mountains, to Maine, and to Niagara Falls. In 1836 he settled in the town of Catskill, where he worked for the rest of his life. His earlier works are much like Doughty's, rather straightforward glorifications of the American wilderness. *View of the White Mountains* (1827, plate 421), with its stock little human figure and splintered tree in the foreground, is typical. But a dramatic flair and Romantic passion, going far beyond Doughty or any of the later Hudson River School painters, may be seen in *Landscape with Tree Trunks* (c. 1827, Rhode Island School of Design Museum, Providence) or *Mountain Sunrise* (1826, Collection Alfred H. Barr, Jr., New York). Not only are the gnarled trees and jagged rocks more theatrically picturesque, but also they are painted with a nervous calligraphy that infuses them with a sense of the supernatural. Cole is the one American, at least before he began polishing his pictures to the level of banality, who was a painterly as well as a pictorial Romantic, who expressed with his brush, though not through color, the breath of experience, sensuous or spiritual.

Cole was by temperament attuned to the seventeenth-century *terribilità* of Rosa and had obviously absorbed it at second hand before he went abroad. His *Expulsion from the Garden of Eden* (1828, plate 422), even though not an original conception (it was based on an engraving

420 Thomas Doughty. *In Nature's Wonderland*. 1835. Oil on canvas, 24¼ × 30″. The Detroit Institute of Arts

421 Thomas Cole. *View of the White Mountains*. 1827. Oil on canvas, 25½ × 35″. Wadsworth Athenaeum, Hartford, Conn.

by John Martin illustrating *Paradise Lost*), indicates Cole's susceptibility to the apocalyptic vision which later became the hallmark of his art. The grandeur of nature is transformed by imaginative projection into a supernatural dream in which nature itself becomes the protagonist in a religious revelation and in which the incident of the Expulsion is lost in the vastness of God's creation.

Sponsored by Robert Gilmor, Jr., and already well established, Cole returned to England in 1829 and then traveled in France and Italy. However, in his allegiance to America and American scenery Cole deprecated his European experience as well as European art. Allston had relayed advice for Cole to study Turner, especially the drawings in his *Liber Studiorum*, as well as Claude, Titian, the two Poussins, and Rosa. Cole admired Turner and Wilson but considered himself a better painter than any of his English contemporaries; he expressed a preference for Claude and for Gaspard Poussin, although later, after his second trip in 1841, he added Titian, Correggio, the other Poussin, and the pre-Raphael Italian painters to the list; he found contemporary French painting "too bloody or too voluptuous"; and in Italy he sketched from nature instead of copying the old masters

and found contemporary Italian landscape painting inferior to the English or the German and even to the French. Yet after the trip abroad his paintings reveal a greater monumentality of both conception and scale, a preoccupation with moral sentiment, and a new concern with the past and Romantic attitudes toward the passage of time.

Immediately after his return he received the first of many commissions, the series of five pictures called *The Course of Empire,* (1833–36, colorplate 33) executed for Luman Reed, the New York merchant who was the most important of the early patrons of American art. This was followed by other series dealing with the same theme: *The Departure* and *The Return* (1837, Corcoran Gallery, Washington, D.C.) for William P. Van Rensselaer of Albany; *Past* and *Present* (1838, Amherst College, Amherst, Mass.) for P. G. Stuyvesant; and *The Voyage of Life* (1839, plates 423, 424) for Samuel Ward. Cole's deep involvement with these ideas derives from his reading of *Les Ruines; ou, Méditation sur les révolutions des empires* (1791) by the Comte de Volney, which did so much to popularize moral speculations on the death of civilizations. The thoughts of death which pervade Cole's work

422 Thomas Cole. *Expulsion from the Garden of Eden*. 1828. Oil on canvas, 39 × 54". Museum of Fine Arts, Boston. M. and M. Karolik Collection

423 Thomas Cole. Sketch for *The Voyage of Life: Old Age.* 1839. Oil on canvas, 25 × 39″. Collection Roy R. Neuberger, New York

424 Thomas Cole. *The Voyage of Life: Old Age.* 1840. Oil on canvas, 51¾ × 78¼″. Munson-Williams-Proctor Institute, Utica, N.Y.

are characteristic of the period; they found expression in sentimental novels and moralistic paintings, in the popularity of "mourning pictures," and in the new vogue for the garden cemetery, which combined interest in nature and death, as witness the founding of Mount Auburn in Cambridge, Mass., Laurel Hill in Philadelphia, and Greenwood in Brooklyn, N.Y.

In the five canvases of the *Course of Empire,* which may have been influenced by Turner's *Building of Carthage,* Cole describes the rise and fall of empires in symbolic terms from the Romantic wildness of the "savage state," to the Classical Poussinesque serenity of the "Arcadian or pastoral state," the fantastic splendor of "empire," the cataclysmic violence of "destruction," and the melancholy silence of "desolation." At this point the philosophic and literary elements have relegated both nature and art to secondary roles, and from here on Cole's work is hopelessly riven. He was convinced that what made a work of art great was the sublimity of its theme, an aesthetic fallacy that can be overcome only by the most sublime artistic ability, and Cole's equipment was inadequate. His allegorical works especially lack spontaneity of observation, smacking of studio contrivance. They are cluttered with literary detail and overpolished in execution, so that what is left is the sheer fantasy of invention to carry the image and too little artistic quality to raise it above the level of curiosity.

How much Cole lost in his search for moral and religious significance is to be seen in a comparison of the sketch for *Old Age* (1839, plate 423) and the finished picture in the *Voyage of Life* series (1840, plate 424). This sequence was the ultimate in his allegorical sermons, and the engraved version was the most successful set of religious prints to circulate in the United States. The mixture of fertility of imagination in detail and excruciating philosophic banality results, to modern eyes, in one of the more ludicrous comments on the destiny of man. The sketch, in its broad handling, vibrant touch, and evocation of a momentous vision, is convincing, but the puerile elaboration of the finished painting is cloying in its sentimental piety, except for the "surrealist" phantasmagoria of the palace of heaven, a gem of architectural fancy.

Much of the contemporary revival of interest in Cole is a condescending appreciation of the idiosyncratic and naive imagination of his allegories, so prophetic of Surrealist hallucinations, in preference to his more lasting contributions to landscape painting. Even while he was involved with subject pictures, he could produce so convincing a representation of the wilderness as *The Catskill Mountains* (1833, Cleveland Museum of Art), or so topographically accurate and almost unromantic a vista as *The Oxbow* (1836, Metropolitan Museum, New York). In later years his second European experience seems to have further enriched his response to nature. Typical are the picturesque grandeur of the *Landscape—Fountain of*

Vaucluse (painted in Rome in 1841, Metropolitan Museum, New York), so close to the early Turner, and the lyrical richness of *An Evening in Arcady* (1843, Wadsworth Atheneum, Hartford). As late as 1846 he could paint *The Mountain Ford* (plate 425), a paean to the American wilderness and a recapitulation of his own vocabulary—the infinite vista, the craggy heights, the dramatically gnarled and twisted trees, and the silence of a virgin land through which the tiny solitary figure on a white horse rides like some wandering hero from a Romantic tale.

When Asher B. Durand (1796–1886) exhibited his first landscape at the National Academy of Design, he was already over thirty and acknowledged as the leading engraver in the United States. Not until he was almost forty did he turn to painting as an occupation. Durand had been born in Jefferson Village (now Maplewood), N.J., and after some instruction in engraving from his father was apprenticed at sixteen to Peter Maverick of Newark, whose partner he became in 1817. When John Trumbull, in 1820, requested that Durand engrave his *Declaration of Independence,* Maverick in jealousy dissolved the partnership, but Durand on his own became very successful. Most famous after the large Trumbull plate was his engraving of Vanderlyn's *Ariadne.* He also reproduced Allston's *Spalatro* and engraved an illustration for Cooper's *The Spy.* He was much in demand as an illustrator, and many of the early Hudson River painters were popularized by his engraved copies in periodicals and "ladies' books." *The American Landscape,* an ambitious series of Durand engravings after various painters with accompanying text by Bryant, unfortunately had only one issue of six plates, but in 1834–39 Durand did engravings for the *National Portrait Gallery* of James Herring and John Longacre. Luman Reed, who commissioned him to paint a portrait of President Jackson and then all of Jackson's predecessors in office, encouraged him to give up engraving for painting. Durand worked first as a portraitist and even tried his hand at genre but, under the guidance of Cole, found his real vocation in landscape painting. Assisted financially by Jonathan Sturges, Reed's partner, Durand went abroad in 1840 accompanied by his students, John Casilear, Thomas Rossiter, and John Kensett. In London he expressed admiration for Claude, Rosa, and the Dutch painters; in Paris he showed his dislike for David and Neoclassicism; elsewhere he admired the scenery, especially along the Rhine and in the Swiss Alps. He returned to New York in 1841; was elected president of the National Academy, serving from 1845 to 1861; and in 1869 retired to his home town.

Durand's *Kindred Spirits* (1849, plate 426) is perhaps the most famous Hudson River School painting. Done in homage to Cole shortly after his death, it depicts that painter with the poet William Cullen Bryant. The whole is palpably contrived; and the posed figures, in both scale

425 Thomas Cole. *The Mountain Ford*. 1846. Oil on canvas, 28¼ × 40″.
The Metropolitan Museum of Art, New York. Bequest of Maria De Witt Jesup, 1915

426 Asher B. Durand. *Kindred Spirits*. 1849. Oil on canvas,
46 × 36″. The New York Public Library. Astor, Lenox
and Tilden Foundations

and strained formality, contradict the inherent majesty of
the scene. The hard, almost metallic precision of detail
also tends to diminish the intended emotional impact.
But Durand is here expressing his deeply felt sorrow in
Cole's terms, for it is essentially a Cole rather than a
Durand conception. Although much influenced by Cole,
especially in his early work, Durand was an artist of the
lyrical rather than of the sublime. His *Morning of Life* and
Evening of Life (1840, National Academy of Design, New
York) are reflections of Cole's allegorical subject matter,
just as his *Judgment of Gog* (1852, Chrysler Museum,
Norfolk, Va.) is an effort to match Cole's visionary
themes. However, Durand was too normal a person to
challenge sublimity; his true province was the bucolic.

Of all the American landscape painters, Durand is
closest to Claude. Like Claude, he sought the picturesque
and poetic aspects of nature rather than its wildness and
passion, but, unlike Claude's, his landscapes lack the
mythic details and nostalgic overtones, except for such
occasional examples as *Landscape—Scene from "Thana-
topsis"* (1850, Metropolitan Museum, New York), which,
as a programmatic picture, has exactly those literary
elements he usually avoided. Perhaps his greatest and
most characteristic painting, *Summer Afternoon* (1865,
plate 427), sums up both his dependence on Claude and
his own particular talent. Painted rather late in his career,
it indicates a turn to the more intimate landscapes of the

427 Asher B. Durand. *Summer Afternoon*. 1865. Oil on canvas, 22 × 35″.
The Metropolitan Museum of Art, New York. Bequest of Maria De Witt Jesup, 1915

428 Asher B. Durand. *In the Woods*. 1855. Oil on canvas,
60¾ × 48½″. The Metropolitan Museum of Art, New York.
Gift in memory of Jonathan Sturges by his children, 1895

Dutch. There is still the Claudian picturesqueness of composition, though the scene has become more commonplace. Behind the intimacy of the foreground stretches the limitless vista, and the scene is enveloped in a soft haze of silvery light. But the Claudian overtones of mythology or time have been replaced by contented cows in a rustic setting, and the mode has been transformed into a contemporary American experience.

In breaking the barrier of distance and ideality, Durand moved away from the Romantic to the realistic landscape of the immediate and the common. In *The Beeches* (1845, colorplate 34) the vista beyond becomes but a distant backdrop, and the focus is wholly on the literal transcription of the great beeches in the foreground. By moving closer into nature and observing its minute detail rather than merely embellishing the ideal with detail, Durand achieved a more realistic vision. The fact that, unlike the others, he painted directly from nature must have played a significant role. Yet, in the picturesqueness of composition, the retention of the infinite vista, and the poetic subject of shepherd and flock receding into the distance, the painting remains essentially Romantic. *In the Woods* (1855, plate 428), done ten years later, reveals an increasing interest in the more intimate and more natural aspects of landscape. The forest enclosure restricts one's vision almost entirely to the immediate foreground, and the disheveled underbrush involves the spectator in the intimate and particular details of reality. Durand had taken a most significant step toward the realistic landscape that his followers in the next generation would exploit.

Samuel F. B. Morse (1791–1872) belonged to both the Federal Period and the Jacksonian Era, but he left no appreciable impact on either. He was perhaps the finest artist of his generation and certain individual pictures are among the best and most interesting of the period, but he produced no lasting, coherent image of himself as an artistic personality. Even during his lifetime (and certainly after his death) his artistic stature was lost in his fame as the inventor of the telegraph. His failure was to fall short of the original goals he had set for himself or of maintaining them in the face of an unappreciative environment. Before Morse's graduation from Yale in 1810 he had dabbled in painting and produced a few miniatures, and then in 1811, after some parental objection, left with Allston to study art in England. In four years with West, but more strongly under the influence of Allston, whom he always considered his true master, he absorbed the passion for the "ideal" and the painting of history. His earliest attempts at history painting, the *Dying Hercules* (1813, Yale University Art Gallery) and the *Judgment of Jupiter* (1814, private collection), were still student efforts, derivative and in the Romantic tradition of West and Allston.

Returning to the United States in 1815, Morse found no demand for history painting on a heroic scale and set himself up as a portraitist with a studio in Boston, but he was forced to work as an itinerant in other parts of New England. From 1818 to 1821 he spent the winter season in Charleston doing portraits of superior quality, such as the very fine *Mrs. Daniel De Saussure Bacot* (1818–21, Metropolitan Museum, New York), but with only moderate financial success. In 1821 he was in Washington, working on his lone major effort at history painting in this country, the gigantic *Old House of Representatives* (1822, Metropolitan Museum, New York), which he vainly hoped would make his reputation and fortune. It was, however, a unique picture in many ways, not the least of which was its completely un-Romantic handling of a contemporary historical theme. Then in 1825 he was commissioned by New York City to portray Lafayette (1826, plate 429). The resulting full-length work, in its heroic conception, emotional fire, and spirited handling, is the finest Romantic portrait of the period. With such achievements in the field of portraiture, for which there was a market, it is almost incredible that Morse should not have gone on to a brilliant career, but he continued to eke out an existence, sometimes fairly close to starvation. He managed occasional landscapes, which are among the best of the period, and some family portraits such as that of his daughter, which has no peer.

Morse became involved with invention, and later with the daguerreotype; by 1837 he had abandoned painting forever. Although he belonged to the generation of the early Hudson River School painters, he differed from them in training and inclination. Solidly schooled in the major tradition of history painting deriving from West

rather than from the less prestigious English landscapists, he, nevertheless, produced several landscapes which belong within the general scope of the school and bear comparison with it. *View from Apple Hill* (c. 1828, plate 430), well within the early phase of Hudson River School painting, projects a realistic observation of more commonplace American scenery that would be taken up by the next generation. In this placid view of the Otsego Lake Morse seems to have avoided Romantic paraphernalia and painted a scene of rural felicity. Wood nymphs are replaced by proper American ladies, Classical architecture by the homely shapes of American houses and barns and a modern bridge, and the mythical chariot by a farm wagon. The rhetoric of the picturesque has given way to a flat vernacular statement of fact.

Curiously enough, Morse succumbed to the Romantic jargon of the period during his second stay abroad (1829–32), perhaps through the German landscapists he met in Rome, for his *Chapel of the Virgin at Subiaco* (1830–31, colorplate 35) is hardly American in either subject or

429 Samuel F. B. Morse. *The Marquis de Lafayette.* 1826. Oil on canvas, 96 × 64″. City Hall, New York. Art Commission, City of New York

430 Samuel F. B. Morse. *View from Apple Hill*. c. 1828. Oil on canvas, 22⅜ × 29½″. New York State Historical Association, Cooperstown

treatment. It belongs within contemporary European Romantic landscape painting in its touristic stereotypes of the picturesque, allusions to the past, and overtones of nostalgia. A handsome picture, painted with an assurance that his American contemporaries rarely achieved, it still is not so satisfying to modern tastes as the preliminary oil study (1830, plate 431), in which the immediacy of observation and broadness of handling are more acceptable than the polished finalities of the ultimate version. Aside from questions of taste, however, it is interesting to note the alterations that transformed the original visual experience into a statement of Romantic sentiment. The composition is expanded to convey a sense of spatial infinity, values are exaggerated to heighten the dramatic play of contrasts, and natural phenomena such as the golden glow on the distant hills and the tour de force of sunlight filtering through the mountain haze on the right are emphasized; but the inclusion of anecdotal elements converts the painting into a set piece of Romanticism—the elegantly dressed wanderer stopping to drink in the scene of a pretty peasant girl kneeling before the roadside shrine as shepherds vanish with their flocks over the crest. There is hardly a more Romantic picture in the annals of American landscape painting—and hardly one less Amer-

ican. Again Morse had contributed memorable examples to American art without visibly affecting its course.

Among other painters who were not primarily landscapists but whose work paralleled the Hudson River School, Henry Inman (1801–1846) offers a personal note. His few landscapes are more intimate than is usual, and the introduction of sentiment and even anecdote sets him somewhat apart. John Neagle (1796–1865) was, like Inman, primarily a portraitist, but he painted several landscapes of local scenery on the Schuylkill. In their looseness of handling, inherited from Sully, they look more English than American.

The landscape vogue spread wide in the cultural stream, affecting many provincial artists, penetrating to the artisan level, and finding a host of dabblers in amateur ranks. For the first time in America an art form had found ready acceptance in all strata of society. Among the lesser-known and more provincial landscape painters of the period was Alvan Fisher (1792–1863), a New England country-store clerk who had taken up portrait painting and even before 1820 had painted some fairly naive but charming landscapes. After a trip to Europe in 1825 he returned to Boston, where he continued to produce portraits, genre pictures, and landscapes in a semiprimitive

431 Samuel F. B. Morse. Sketch for *Chapel of the Virgin at Subiaco*. 1830. Oil on canvas, 8¾ × 10¾".
Worcester Art Museum, Worcester, Mass.

manner paralleling in conception and style the work of the more sophisticated Hudson River School painters. Of recognizable competence but still on the periphery of the Hudson River School were the occasional paintings done by topographical artists such as William Guy Wall (1782–1864) and Robert Havell, Jr. (1793–1878). The Irish-born Wall, who arrived in New York in 1818, is best known for his watercolor landscapes that served as the basis for the twenty aquatint engravings comprising the *Hudson River Portfolio* (1828) and his *Hudson River from West Point* (1826–32, Lyman Allyn Museum, New London), which reveals a professional competence in the English landscape style. Havell, the English engraver who had executed Audubon's plates, came to this country in 1839 and did a series of engraved views of American cities. His oil paintings are also topographical in character and extremely precise in execution, except for a few that have a slightly Romantic flavor.

The Romantic landscape tradition was carried well past the middle of the century by a middle generation between Doughty, Cole, and Durand and the later one of Church, Bierstadt, and Moran, which finally shifted the emphasis from the East to the newly opened West. This middle generation of Casilear, Cropsey, Kensett, and

Whittredge was ideologically and aesthetically so closely tied to the earlier group that they can easily be considered part of it. However, little of Cole's Gothicism was passed on to them; they were all Durand men and concerned with the idyllic and by this time more domesticated landscape.

John W. Casilear (1811–1893) had studied engraving under Peter Maverick and was a bank-note engraver for many years before he turned to landscape painting in 1854. His earlier works have some of the idyllic calm and silver tonalities of Durand, and in his *Lake George* (1857, Metropolitan Museum, New York) he resembles Kensett's more Romantic phase. Casilear continued in Durand's bucolic mode to the end of the century, becoming progressively more pastoral, more realistic, more pedestrian, and more bovine, until his foreground cows began to obliterate the distant hills of Romantic memory.

More than any others of that generation, Jasper F. Cropsey (1823–1900) continued unaltered the concept of the picturesque wildness and majesty of the American landscape, although even in his hands it showed signs of domestication. Trained as an architect, he left that career for landscape painting. His art was hopelessly outdated long before his death, but in one of his earlier works,

432 Jasper F. Cropsey. *Catskill Mountain House*. 1855. Oil on canvas, 29 × 44″. The Minneapolis Institute of Arts. The William Hood Dunwoody Fund

Catskill Mountain House (1855, plate 432), he produced a nobly conceived, strongly constructed, and crisply painted autumnal scene in the best tradition of the Hudson River School.

LUMINISM

Although Kensett and Whittredge began their careers as Hudson River School men, they transformed the style into something quite different—just as American, if not more so, more immediate, less pretentious, almost anti-Romantic—a new kind of naturalism. Deriving from the pastoral lyricism of Durand, they converted his idyllic Romanticism into a poetry of the commonplace. The pearly Claudian tonalities suggestive of an ideal time and place became the changing light of a specific moment and view, nondescript at times rather than heroic. There is a recognizable quality in their light that is neither traditional nor European, a light that many observers have noted as peculiarly North American; it has led some American art historians, including E. P. Richardson and John I. H. Baur, to postulate a school of "luminism" somewhere between the Romanticism of the Hudson River School and the realism of French Impressionism.

This is in many ways a useful definition of an identifiable tendency, comprising a variety of quite independent developments, rather than a coherent school or movement. If "luminism" is defined in the broadest sense as a new interest in the element of light rather than picturesque form and in the phenomenal character of a particular light rather than the generalized poetry of light, then it would include much of the work of Kensett and Whittredge among the Hudson River School painters; the pelucid seascapes of Salmon and Lane, deriving from a totally different tradition; the eccentric Heade or an occasional sport such as George Tirrell; and the sparkling early sketches of both Church and Bierstadt.

The emergence of this tendency in the fifties calls attention to the cultural change in American society in the decade before the Civil War. One might be justified in treating the period from about 1850 to about 1876 as a single cultural unit, except for the fact that the Civil War had its effects on the following decade and in some ways cut short some prewar tendencies.

Only very recently have the reputations of Kensett and Whittredge increased. Although both were popular and successful in their own day, their work was somewhat submerged in the mass of Hudson River School painting, and they continue to be seen by some as "minor" masters of the school. Perhaps our own taste in landscape, formed

by Impressionism in its preference for the anti-Romantic and the unpretentious, values their unassuming naturalism, fresh observation of reality, and laconic delight in the sensuous. It is difficult to say how much effect the camera had, but their paintings reveal a new interest in the momentary and the particular as opposed to the eternal and the general. Yet they continued to paint in their studios from sketches rather than directly out of doors, which may explain the studied character of their paintings but not their apparent spontaneity.

John F. Kensett (1816–1872) began as an engraver, first under his father, then under his uncle, Alfred Daggett. In 1840 he accompanied Durand to Europe and remained there for eight years, working and traveling. Back in New York late in 1847, he had already achieved a reputation on the basis of his landscapes sent from Italy to the National Academy exhibitions. Kensett's European experience was characteristic of a new American attitude toward study abroad that had begun with the earlier Hudson River School painters. American artists no longer went to London or even Paris to study with a particular artist; they went to Rome or Düsseldorf or traveled and worked on their own all over Europe.

Kensett, like Whittredge, never lost his feeling for the American landscape and, on his return, showed little influence from European sources. He found his subjects in the well-worn areas of the Hudson River School but extended the repertory to include the New England coast and the unromantic terrain of Long Island. He even traveled to the upper Mississippi and the mountains of the West. Many of his earlier landscapes are traditional in the Hudson River School manner (plate 433), striving for the picturesque and for the poetic statement. In these, at least, his training as an engraver shows in the precision of delineation and a meticulous sense of values. He always painted thinly and with a muted palette, but the sensitive and cool tonal relationships and the immaculate definition of the smallest areas re-create restrained yet personal moments of visual experience. More than any other artist of the school, Kensett reacted to the specific character of a site instead of imposing on it a set pattern or conception, so that he could achieve an almost mystic majesty in *Lake George* (1869, Metropolitan Museum, New York), a lyrical poetry in *River Scene* (1870, Metropolitan Museum, New York), or the prosaic naturalism of *The Shrewsbury River* (1859, colorplate 36). Most unusual and original of his works are the coastal scenes of New England and Long Island, in which the Romanticism is replaced by a straightforward record of land, sea, and sky, seen in a particular light and atmosphere. Such paintings as *Third Beach, Newport* (1869, plate 434) appear almost compositionless. All aesthetic effects are eschewed; all sentiments vanish except the bright sense of the open air and the pleasure of silence. These are Impressionist paintings but for their lack of high-keyed and broken color.

433 John F. Kensett. *The Mountain Stream.* 1856. Oil on canvas, 14 × 9¾″. Albany Institute of History and Art, N.Y.

Thomas Worthington Whittredge (1820–1910) went from a backwoods farm in Ohio to Cincinnati, where he first worked as a house and sign painter and then as a portraitist. His love of nature seems to have led him to landscape painting, and in 1849, with the backing of Nicholas Longworth and other patrons, he left for Europe, where he remained for ten years. After a short stay in Paris he went to Düsseldorf, met Emanuel Leutze, and incidentally posed for the figure of General Washington in Leutze's famous *Washington Crossing the Delaware* (plate 465). However, that German hotbed of fanatical detail and polish had no effect on his art. In Rome he became an habitué of the Caffè Greco. Like Kensett, Whittredge had been sending pictures back to the United States. When he was elected to the National Academy in 1861, his reputation as a landscape painter was already established. Also like Kensett, his years abroad had little effect on his style except for a minor hint of the intimate poetry of the Barbizon School and a felicity of color uncommon among his American colleagues. Whittredge shared Kensett's derivation from Durand but stemmed from Durand's more intimate and lyrical phase. His handling of paint was more fluent than that of either, and his vision was more informal and less romantic than

434 John F. Kensett. *Third Beach, Newport.* 1869. Oil on canvas, 11⅝ × 24¼″. The Art Institute of Chicago

Kensett's. His landscapes are broad, gentle, and pastoral, with an emphasis on the horizontal, on openness and quietude. Among his most interesting paintings are intimate woodland scenes such as *"I Come from Haunts of Coot and Hern"* (plate 435), which seem almost transcriptions from Durand except that the meticulous delineation of tangled forms is transmuted into a much more gentle and lyrical study of light. However, in his later work the real break with Hudson River School Romanticism occurs: in *Camp Meeting* (1874, colorplate 37), a simple scene given nobility by the musical cadence of the stately trees, the sparkling play of light and shade on the crowd, and the luminous glow suffusing the grove, all seen with a fresh eye; in *Old Homestead by the Sea* (1883, Karolik Collection, Museum of Fine Arts, Boston), a completely un-Romantic, uncomposed, unpicturesque, and unsentimental farm scene in which the poetry is confined to joy in the sensuous experience of light itself; or in *Third Beach, Newport* (c. 1870–80, plate 436), so much like a Kensett in its acceptance of the undistinguished coastal landscape of New England, dependent entirely on the sweep of beach, sea, and sky almost disappearing in the haze of the summer sun.

Among the lesser painters who fall within this second generation was Sanford Robinson Gifford (1823–1880), the first of the American landscapists to venture as far as Turkey and Syria. His major works fall within the traditional limits of the Hudson River School, but in his smaller sketches the "luminist" tendency is evident.

Quite apart from the central stream of Romantic landscape painting were seascape painters such as Robert Salmon and Fitz Hugh Lane. Their precise, factual depiction of boats, harbor installations, and shipping activities was completely un-Romantic, stemming from the English tradition of topographical description. The placidity, stereometry of form, geometric precision of detail, conventional rendering, and limpid light may well derive from Canaletto. It is a stylized naturalism based on acute observation of reality but expressed with an artisan's repetition of formula which, when well done, has a charm that transcends its props.

Robert Salmon (c. 1775–c. 1850), born in England, was trained and worked there before coming to America in 1828. In Boston he painted theatrical scenery and signs and executed some five hundred paintings of harbor views and ships from his studio on the Boston Wharf. In spite of repetition and formula, the intricate geometric patterns of masts, spars, and rigging against the sky and the luminous quality of cool light give them an air of minor but authentic poetry (plate 437).

Fitz Hugh Lane (1804–1865), of Gloucester, worked for some twenty years in Boston as a lithographer, rendering views of towns and buildings. Returning to Gloucester after 1847, he spent the rest of his life as a marine painter, retaining an artisan's respect for precision and literal transcription. He must certainly have known Salmon's marine views, for the two artists share a common interest in the intricacy of ships and rigging and in a clear and enveloping light. Lane's thin pigment lacks the impasto and subtle tonality of Salmon, and in some ways he was a less accomplished craftsman, but the very meagerness of paint adds something in openness of space, increased clarity of light, and spidery elegance of detail (colorplate 38). Neither Salmon nor Lane was a Romantic landscapist in the nineteenth-century sense, although one may read a Romantic flavor into their poetic sensi-

435 Thomas Worthington Whittredge. *"I Come from Haunts of Coot and Hern."* n.d. Oil on canvas,
12 × 21". Trinity College, Hartford, Conn. George F. McMurray Collection

436 Thomas Worthington Whittredge. *Third Beach, Newport.* c. 1870–80. Oil on canvas, 30½ × 50¼".
Walker Art Center, Minneapolis

437 Robert Salmon. *Ship Aground*. 1828. Oil on panel, 10½ × 14⅞″. Museum of Fine Arts, Boston. Gift of Miss E. E. P. Holland

tivity toward light. Both Salmon and Lane were meticulous and literal naturalists, reporters of fact, responsive to time, place, and circumstance, and restricted by their artisan backgrounds from making more than a minor comment upon experience.

The landscapes of Martin J. Heade (1819–1904) do not fit neatly into any of the categories of the period. He shared with most of the "luminists" a preference for the horizontal canvas, though his tended to be exceedingly wide, and an interest in light, though his was unusually dramatic. His art is something of a reversion to the mystery and terror of Allston, except that the foreboding appears as common natural phenomena. In *Approaching Storm: Beach near Newport* (c. 1860, colorplate 39) the lowering darkness of the sky turns the sea into an eerie sheet of phosphorescence and the deserted shore into a lunar landscape. The very neatness and hint of naiveté with which the waves seem almost embroidered on the surface of the painting and the primness of the ghostly white sails glowing out of the darkness add to the unearthly and "surrealist" sense of mystery. Even a commonplace holiday scene of sailing on a bay, with all its genre elements, as in *Thunderstorm, Narragansett Bay* (1868, plate 438), is transformed into a charade of panic, for the flash of lightning seems to freeze as it illuminates the people and boats in a vivid dream. The affinities of Heade's landscapes to Surrealism (or, more accurately, to Magic Realism), along with the naive elements in his technique, make them especially appealing to modern tastes, but they must be seen also as sincere efforts to

capture observed phenomena of nature, nuances of light, and quality of space. Heade's recent rediscovery has still left him an enigmatic personality and artist. Born in Lumberville, Pa., he spent some years in Europe (c. 1837–40) and after his return worked as a portrait painter. In 1863–64 he went to Brazil with an amateur naturalist, the Reverend James C. Fletcher, to do studies for a book on the hummingbirds of South America. The subsequent meticulously detailed paintings of birds and plants in high-keyed, almost lurid colors, aside from their scientific importance and accuracy, have been greatly admired for their high level of technical accomplishment, attention to minute detail, and, more recently, the very Victorian taste in subject and execution for which they were once execrated. Later Heade appears to have wintered in Florida, to have settled finally in St. Augustine (c. 1885), and to have continued painting, but he was forgotten long before his death.

George Henry Durrie (1820–1863), who made his reputation as a Currier & Ives artist, has suffered too long for this popularity. Although not one of the more important Romantic landscapists, he did, unconsciously perhaps but with unerring instinct, strike the dead level of American popular taste in landscape. That taste is still operative and possibly just as pervasive but now, as then, not fashionable. Durrie did what no other Hudson River painter had: he transformed landscape into anecdote and in that process humanized it (plate 439). The image that Durrie and others have projected is so much a part of

438 Martin J. Heade. *Thunderstorm, Narragansett Bay*. 1868. Oil on canvas, 32⅛ × 54¾″. Collection Mr. and Mrs. Ernest Rosenfeld, New York

439 George Henry Durrie. *Farmyard in Winter*. 1862. Oil on canvas, 26 × 36″. The New-York Historical Society

440　Currier & Ives (after a painting by George Henry Durrie). *Home to Thanksgiving.* 1867. Lithograph. Courtesy The Old Print Shop, Inc., New York

American mythology that a person raised in the desert of Arizona or in the heart of a city without experience of farm life may react to Durrie's *Home to Thanksgiving* (plate 440) with a twinge of sweet regret, as if it were a memory of his own past. Durrie's capacities as an artist could not transcend that commonness of subject from which one can move to universality as well as to banality. Though he composed well and compactly in an academic sense, his forms tend to softness, and his drawing is pedestrian rather than perceptive. His color, charming in the snow scenes, is devoid of that sensuous acuity and personal comment which characterizes the art of the "luminists."

THE EPIC LANDSCAPE: MANIFEST DESTINY

In contrast to members of the Durand circle, the somewhat younger, though approximately contemporary, Frederic E. Church and Albert Bierstadt converted the transcendentalism of Cole into a grandiloquent expression of "manifest destiny." They arrived at a style both popular and epic that seemed to fulfill the dream of an indigenous American art. Lofty in intention, grand in scale, and painstaking in execution, their painting of a new kind of spectacular scenery satisfied the yearning for the ideal as well as the concern with the literal.

No earlier painter in American history was so successful as Frederic E. Church (1826–1900). He was hailed as America's leading artist and, in England, as the supreme

landscape painter of his time, the heir to Turner. Church's earliest works reveal a strong dependence on Cole, with whom he lived and studied from 1844 to 1846, but by 1849, in *West Rock, New Haven* (New Britain Art Institute), he had almost imperceptibly moved over into the Durand camp. In this, as in similar paintings of the early 1850s—*New England Scenery* (1851, George Walter Vincent Smith Museum, Springfield, Mass.), *Scene in the Catskill Mountains* (1852, Walker Art Gallery, Minneapolis), and *Sunset* (1856, Munson-Williams-Proctor Institute, Utica, N.Y.)—Church had discarded Cole's Romantic compositions, set forms, and transfiguring light for a more naturalistic rendering of local scenery. He still retained a feeling for ideality and spatial grandeur, but his horizontal canvases were more bucolic and the handling of light descriptive rather than emotive, much in the manner of the "luminists." In his twenties he had shown himself to be an artist of rare talent with a strong sense of design, an original eye, and an enviable technique. However, after trips to Ecuador in 1853 and in 1857, motivated by his reading of the great German naturalist, Alexander von Humboldt, Church's interests turned from the lyric to the epic, which was henceforth to be his hallmark.

The root of Church's mature style was the memory of Cole's transcendental view of nature, grafted onto Humboldt's pre-Darwinian synthesis of science and imagination. Church also was much influenced by Turner, whose work he absorbed through engravings, and by the writings of Ruskin. The New World was for him the great arena of a cosmic drama and American destiny the

fulfillment of a universal plan. A turgid iconography expounded in elaborate brochures accompanied his epic landscapes, exhibited with great showmanship before awestruck multitudes who were as impressed by scenery as by art. The first in the series—*Niagara* (1857, Corcoran Gallery of Art, Washington, D.C.)—though an unqualified public success, was aesthetically ambiguous. Church attempted to capture on the oversized canvas the tremendous scale and power of America's greatest natural wonder in all its magnificence and in minutest detail. Brilliantly executed, the picture is compositionally flat; the artistic image, failing to rise to the drama of nature, remains a spectacular panorama, and one wonders how much Church owed aesthetically to the popular panoramas of the day.

In *The Heart of the Andes* (1859, plate 441), however, he achieved a coherent artistic vision that combined the spiritual and the scientific, the infinite and the particular, the distant and the immediate. Like all Church's epics, it was a carefully planned composition based on numerous, on-the-spot drawings and oil sketches. In a sense, Church reconstituted nature so that the spectator could vicariously experience the sensation of being there. To achieve the illusion of reality, the artist employed a series of devices—eliminating all evidence of the act of painting, establishing a panoramic vision, combining various perspectives, drawing the spectator into the foreground and by elevation transforming him into a disembodied, mobile eye. Church even advised that spectators examine the landscape through binoculars or a tube, in effect destroying it as a picture. Some critics felt that, though such piecemeal viewing might be successful as an experience, the painting as a whole lacked cohesion. *The Heart of the Andes* is a tour de force of spatial illusion, staggering in scale and detail, from the meticulous handling of foreground foliage to the towering mountains disappearing in the distant sky. Yet, with all its novelty and exoticism, it still recalls the Romantic landscape. *Cotopaxi* (1862, colorplate 40), on the other hand, finally captures the dramatic grandeur of New World nature. The conception is more titanic, the composition more imaginative, and the painting, now clearly Turnerian, more evocative.

After the Civil War, Church's cosmology slipped into the realm of the mystical, as if natural history were no longer adequate to express his transcendental vision. In *Aurora Borealis* (1865, National Collection of Fine Arts, Smithsonian Institution, Washington, D.C.), *Rainy Season in the Tropics* (1866, Collection J. William Middendorf, II, New York), and *The Vale of St. Thomas, Jamaica* (1867, Wadsworth Atheneum, Hartford), the striving for immensity became excessive, the influence of Turner more pronounced, the whole overtheatrical. With these works Church had completed his New World saga, and he turned as a traveler in time to a rediscovery of the past and ancient civilizations. For the first time he visited Europe and the Near East (1867–69), and among the fruits of that sojourn were *Jerusalem from the Mount of Olives* (1870, private collection), *The Parthenon* (1871, Metropolitan Museum, New York), and *The Aegean Sea* (c. 1878, Metropolitan Museum, New York), all rather disappointingly pedantic, though his powers as a painter had not really diminished. His New World grandiosity simply overwhelmed the human scale of the Old World, and he was forced to fall back on spectacular effects and Romantic clichés. In one magnificent effort—*Morning in the Tropics* (1877, plate 442)—Church tried to recapture his earlier cosmic vision but managed instead a kind of Wagnerian bombast, recalling the transcendentalism of Cole. By 1882, in *The Mediterranean Sea* (private collection), he had regressed even further back to the poetic reveries of Claude. Time and taste had passed him by, and it mattered little that he was incapacitated by a crippling rheumatic condition. He spent his last years at his mansion, Olana, among the accumulated relics of his travels and studies.

After almost a century there has been a recent revival of interest sparked by a reevaluation of Church's many oil sketches in the Cooper-Hewitt Museum, New York, and in the Karolik Collection (Boston Museum of Fine Arts), which reveal so many fine qualities—a startlingly fresh eye, a directness of observation, and a spontaneity and fluency in recording impressions—most of which were lost in the translation into cosmic rhetoric.

With all Church's adventurousness, he had never visited or painted the heroic landscape of the American West. It was Albert Bierstadt (1830–1902), born in Germany, who became the popular painter of the last frontier. Bierstadt had come with his family as a child to New Bedford, Mass., in 1832, but a growing interest in painting led him back to Düsseldorf in 1853 and later with Whittredge in 1856 to study in Rome. On his return to the United States in 1857, he painted in the White Mountains; in 1859 he accompanied a government-sponsored expedition led by Colonel Frederick W. Lander to map a trail across the Rocky Mountains to California. He returned East with a portfolio of sketches which served as the basis for those gigantic reconstructions of western scenery which made his immediate reputation. He undertook another trip West in 1863, traveling and collecting material through many states.

Bierstadt was obviously aware of Church's success and not above imitation, with the result that their works have been commonly lumped together. Both were explorer-artists who understood the appeal of their exotic subjects, and they shared a consciousness of public taste, no reluctance to please, and the showmanship to exploit their work. They had in common also a predilection for the epic vision, the panoramic view, and the outsized canvas. However, Bierstadt had no pretensions to profundity, nor were his paintings intended to have iconographic significance. He was a popular picture maker who had discov-

441 Frederic E. Church. *The Heart of the Andes.* 1859. Oil on canvas, 5'6⅛" × 9'11¼". The Metropolitan
Museum of Art, New York. Bequest of Mrs. David Dows, 1909

442 Frederic E. Church. *Morning in the Tropics.* 1877. Oil on canvas, 54¾ × 84⅛". National Gallery of Art,
Washington, D.C. Gift of the Avalon Foundation, 1965

ered that he could package the sublime for common consumption. Paradoxically, Bierstadt was technically both more sophisticated and less skillful than Church. Whereas Church with provincial fanaticism had actually attained a kind of perfection in rendering natural data, Bierstadt had absorbed the Düsseldorf formula and its devices, which he used without much question. He painted more broadly than Church or than the Hudson River School painters in general, which may have been why he seemed less American. In any case, his epic landscapes are best not in detail but in the long view, in their panoramic sweep, fabulous scale, and theatrical effects—exactly those elements for which he has been criticized. American critics, at least, have always thought more highly of Church's naturalism than of Bierstadt's sensationalism. However, such paintings as *The Rocky Mountains* (1863, Metropolitan Museum, New York) and the *Merced River, Yosemite Valley* (1866, colorplate 41) attempt to match the spectacular aspects of the western landscape, and, although Bierstadt's dramatic effects are rather transparent, with the sentimental touches of an idyllic Indian encampment, they manage to achieve a certain grandeur.

Although Bierstadt had a strong sense of composition, his drawing was erratic and undistinguished. With time his technique became more slovenly, his color disturbingly out of key; and, as he strove increasingly for narrative interest by introducing figures and animals, as in *The Last of the Buffalo* (1888, Corcoran Gallery of Art, Washington, D.C.), he fell into bathos. However, Bierstadt had great popular appeal and attained unprecedented success, commanding up to $35,000 for a single picture. He built himself a thirty-five room palace at Irvington-on-Hudson, where he lived and entertained like a potentate. But in 1882 the house was destroyed by fire, fashions in art had changed, and Bierstadt's fortunes declined. By 1889 a committee selecting works for the Paris Exposition could reject one of his paintings as no longer representative of American art, but there has been some recent revival of interest in Bierstadt's oil sketches and smaller paintings. Executed directly with a light and fluent touch, lively in color and luminous in tone, such sketches in their freshness are closer to the work of the "luminists" than to the ponderous epics that brought him fame.

The popularity of Church's epic paintings and especially Bierstadt's western panoramas seems to have fostered some specialization in Rocky Mountain and Pacific Coast scenery. Thomas Moran (1837–1926), born in England, spent a long active life in a production of western landscape paintings that was both prodigious and erratic. He came to the United States with his family in 1844 and was apprenticed to an engraver in Philadelphia, where he later also studied painting with his brother, Edward, and became an illustrator. Returning to England in 1862, he was greatly impressed with the work of Turner and became a life-long disciple. Back in America, he

signed on as official artist with a government expedition to Yellowstone led by the geologist Ferdinand V. Hayden in 1870. The watercolor sketches done then served as the basis for the chromolithographic illustrations of the expedition report published in 1876, and they established his reputation as a delineator of western landscape. He later accompanied another government expedition to Colorado. Two large paintings bought by Congress for the Capitol for $10,000 each—*The Grand Canyon of the Yellowstone* (1872, Gilcrease Institute, Tulsa, Okla.) and *The Chasm of the Colorado* (1873, U.S. Department of the Interior, Washington, D.C.)—are said to have been instrumental in establishing the national park system. At any rate, a peak in the Tetons was named after Moran. In his larger paintings he was rather prone to puff up his compositions, overstate his Turnerisms, invent detail outrageously, and, chameleon-like, change styles at will. His small watercolor sketches, the raw material for his large compositions, were his most satisfying efforts. Spirited, fluid, and gaudy in color, they reflect something of his ebullient temperament.

INNESS AND THE NEW LANDSCAPE

While George Inness (1825–1894) owed his beginnings to the Hudson River School and was a contemporary of its second generation, he stands somewhat apart from the traditional schoolmen, the "luminists," and the epic painters. He was a pivotal figure in the development of nineteenth-century landscape painting, straddling two eras, and although many of his colleagues lived along with him well into the last quarter of the century and continued the tradition of American naturalism, only Inness, responding to cultural changes, evolved a new and distinct style. His career can be divided into an early period running through the 1860s, in which he adapted the Hudson River style to his own artistic compulsions, aligning it with the mainstream of European landscape painting; and a late style, after his return from Europe in 1875, when he arrived at the poetic impressionism for which he became famous.

Inness was born near Newburgh, N.Y., of a well-to-do merchant family, but moved as a child to Newark, N.J. Afflicted with epilepsy, he was dismissed from school and, after various career failures, took up painting. For one month in 1845 he studied in New York with the French émigré painter, François Régis Gignoux, a student of Delaroche. Inness learned little or nothing from him but had begun exhibiting small landscapes and historical subjects that were well received as early as 1844 at the National Academy and the Art Union, which purchased his works regularly. From the start, he showed himself a person of independent mind and an unusual temperament, in part perhaps due to his illness. Passionately concerned with expressing himself, he struggled to combine

the sublime fantasies of Cole and the literal intimacy of Durand, checking them against Dutch and English engravings, without much success. In 1847 a patron enabled him to make the first of many European trips, and these experiences helped form his early mature style. Of all the American landscapists who traveled abroad, only Inness was so open to the art he encountered: first, the Romantic tradition of Claude, Poussin, and the Dutch, but then also more recent masters such as Constable and Turner, and his own contemporaries, Corot and the Barbizon School, and, finally, Delacroix. Borrowing from Europe has often been cited as a sign of American provincialism; in fact, the inability to react to the unfamiliar was the sign of provincialism in American landscape painting, whatever its virtues may have been. Inness made the first telling crack in the monolithic facade of American naturalism.

His earliest works were thin and tentative lyrical scenes in the manner of Durand, but in *The Old Mill* (1849, Art Institute of Chicago) the composition and handling are more European than American and the touch much broader than that of the Hudson River School. However, in *Lackawanna Valley* (1855, National Gallery, Washington, D.C.) he had worked his way through his borrowings to what was essentially his own vision—naturalistic but poetic, atmospheric rather than linear, coloristic instead

of tonal, panoramic yet not heroic, unpicturesque in composition, and painterly in touch. Though never closer to the "luminists" than in this painting, with its suffusion of natural light and air, he had begun to move in another direction, using a heavier impasto and brighter color. Inness settled in Medfield in 1859 and during the next decade painted the intimate landscape of eastern Massachusetts in the major canvases of his first style, to some his finest. Although he always denied any direct influence and thought of himself as self-taught, he had clearly absorbed the Barbizon manner. The earliest example of this style, *Delaware Water Gap* (1861, plate 443), retains the grand sweep of the Hudson River School, but, except for the rainbow, the scene has lost the Romantic overtones, and surface detail has given way to a painterly breadth of touch. The composition is not entirely resolved, but in *Harvest Time* (1864, Cleveland Museum) or *Delaware Valley* (1865, Metropolitan Museum, New York), one of the most expressive of this group, he achieved a new compositional cohesion, at once spacious and intimate. Inness's commitment to nature was reinforced by his deeply religious feelings for God, nature, and the act of painting. For him landscape painting was the expression of the totality of an emotion rather than physical detail. Thus, he sought an aesthetic harmony through unified palpable space, large massing of volumes,

443 George Inness. *Delaware Water Gap*. 1861. Oil on canvas, 36 × 50¼". The Metropolitan Museum of Art, New York. Morris K. Jesup Fund, 1932

broad handling of paint, and a symphonic use of color.

Inness's vitality, optimism, and emotional involvement were poured out in a paean of joy in *Peace and Plenty* (1865, colorplate 42), painted to hail the Union victory and projecting a dream of well-being expressed in the bounties of nature and conveyed in the sheer splendor of paint. Inness was no cosmic painter and he sought no hidden meaning in the universe. He once said, "The purpose of the painter is simply to reproduce in other minds the impression which a scene has made upon him. A work of art does not appeal to the intellect. It does not appeal to the moral sense. Its aim is not to instruct, not to edify, but to awaken emotion."

GENRE PAINTING: FROM FARM TO FRONTIER

Genre painting came into prominence during the Jacksonian Era as an expression of popular taste. Its appeal depends entirely on the viewer's recognition of ordinary life experience and an appreciation of the artist's skill in reproducing reality. Actually, landscape painting of the period was no less "real" than genre; but landscape painting expressed the ideal, the sublime, an abstract concept of beauty, whereas genre was concerned with "real" life.

Genre might not have developed so rapidly and spread so widely had it not been for the phenomenal growth of publication and illustration. Both art and writing about art were disseminated through a multitude of magazines such as *Harper's Weekly, Frank Leslie's Illustrated Weekly Newspaper, Gleason's Pictorial, The New York Mirror;* others directed more specifically at women: *Godey's Lady's Book, Graham's Magazine, Sartain's Union Magazine of Literature and Art;* and the gift annuals for women, with such appropriate names as *The Token, The Diadem,* or *Affection's Gift,* which mixed the lofty and the banal in the most indiscriminate enthusiasm, Emerson and Mrs. Lydia Sigourney, recipes for the moral life as well as pies, and a variety of illustrations. Among the visual material might be reproductions of well-known paintings, either old masters or modern American landscapes, reproductions of paintings especially commissioned or bought for the purpose and accompanied by "critical" reviews, or illustrations of the literary offerings. It was in such publications that many of the genre painters made their reputations and continued to find an important source of revenue.

Increased circulation of magazines and prints made the older forms of copper engraving obsolete. Steel engraving, wood engraving, and lithography became the mediums of mass reproduction in periodicals or as single sheets. But the most characteristic popular art form of the period was the hand-colored lithograph circulated in the thousands by many firms. The most notable of these was Currier & Ives, which commissioned genre subjects from many well-known artists and over a span of fifty years issued some seven thousand prints. Although they vary greatly in quality and at best are not memorable as art, they present a picture of American life in its variety, excitement, and color that the fine arts of the period generally fail to do. Reportage was one of the major interests, and prints described important news events and depicted noted personalities; naval battles were popular; disasters of all kinds were carefully detailed, as were occupational activities from picking cotton to hunting whales. Another category covered special interests: clipper ships, river boats, railroad locomotives, horses, prize fighters, or the events in which they were involved. Then there were the genre scenes, nostalgic, humorous, or sentimental aspects of eastern rural life: cider making, corn husking, or coming home for Christmas; and the more exotic, adventurous, or dramatic scenes of western frontier life: encounters with Indians, the dangers of hunting, or the wonders of the wilderness. These were apart from the more traditional subjects, religious themes and landscapes, which catered to more "elevated" tastes. Competition was keen, and although Currier & Ives advertised themselves as "printmakers to the American people," they had their rivals in J. Baillie, Sarony & Major, Thomas Kelly, and the Kelloggs, as well as the European firm of Goupil, Vibert & Cie., which published works by American artists.

Genre has had a long and varied history but has usually been considered a minor form of aesthetic expression, probably because it has most frequently been associated with lower levels of taste and pejoratively with the "middle class." And mid-nineteenth-century American art was unquestionably middle class. The Victorians preferred their Romanticism housebroken. Thus they transformed the Romantic's open world of experience into a closed world of homely virtues, moral sentiment, and humorous experience.

Genre and anecdotal art are capable of serious achievement, as witness Bruegel, Caravaggio, Rembrandt, Vermeer, Hogarth, Goya, Daumier, and Degas. They require the same artistic attitudes and skills as does history painting, except that the latter deals with the heroic. The basic requirements of figure painting are as necessary for both, and the iconography of one may be as complex as the other. But the iconography of history painting is more literary in that a specific and known story is illustrated, whereas the genre painter tells his own story in terms of the elements in the picture. Nineteenth-century anecdotal painters often could not resist an accompanying literary explanation in the manner of earlier history painters dealing with esoteric subjects. The genre painter has no traditional and time-tested themes to rely on nor a body of previous artistic examples in interpretation of such themes to emulate. His story is the product of his own observation of life.

Although genre and anecdotal art are sometimes in-

extricably related, genre is more concerned with man's common social relations and activities in a general sense, whereas anecdotal art has an additional narrative element which makes a humorous, moral, or philosophical point. Any human relationship may have anecdotal elements or overtones, and their mere presence is no mark of derogation, but an emphasis on them can lead to triviality. Anecdotal art is also often confused with illustration, since both are concerned with storytelling. However, illustration depicts a fragment of a literary sequence and is usually incomprehensible without knowledge of the context, whereas anecdotal art is self-contained. Such distinctions may seem like hairsplitting, but they are necessary for an understanding of what is often lumped together as genre painting.

Of all the American genre painters of the period William Sidney Mount (1807–1868) approached most closely Emerson's credo: "Give me insight into to-day, and you may have the antique and future worlds. . . . The meal in the firkin; the milk in the pan; the ballad in the street; the news of the boat; the glance of the eye; the form and gait of the body. . . ." This vision of the eternal relevance of the present and the lowly is expressed more simply and less romantically by Mount. It is a view of life limited by a particular frame of reference, the image of a genial, unhurried, uncomplicated rural existence. Few who found pleasure in his pictures ever bargained for a horse, eeled in quiet waters, or listened to a fiddler in a barn, but they all felt an empathy or nostalgia for this distant yet somehow immediate world of contentment. Mount's picture of the country life carefully avoided mention of work, hardship, or monotony. It was essentially an urbanized view of a rural Arcadia, and with it he struck a vein of sentiment in the American psyche which has been mined assiduously for more than a century by subsequent genre painters.

Mount was born and lived most of his life on Long Island in the kind of environment he depicted so well. He worked at first in New York City with his older brother, Henry, a sign painter, and attended the first classes in drawing organized by the new National Academy of Design in 1826. His early efforts were undistinguished portraits in a rather hard style and some not very promising religious pictures. Illness forced him to return to Long Island, where in 1830 he suddenly turned to genre painting. The choice, as well as the character, of his art is intriguing. The modesty of his work has perhaps obscured the fact that Mount practically alone created the form and character of a native American genre painting. Except for occasional genre pictures, David Claypoole Johnston (1799–1865) was his only predecessor in the field, and whether Mount knew Johnston's work is not very pertinent, since the latter was a satirist in the Cruikshank vein. More probable is Mount's connection with the tradition of English sentimental genre exemplified by Morland and Wilkie, the extremely popular prints of

whose works he could easily have seen. It is interesting that Allston advised Mount to study Ostade and Jan Steen, for it was exactly this Dutch and Flemish tradition of genre painting out of which the English school derives.

Mount's style is unusual and quite different from the meticulous polish of later genre painters influenced by Düsseldorf. In its thin glazes, transparent shadows, loaded lights, and limited color range, it is reminiscent of Rubens's oil sketches. Mount's technique developed from tight handling and overattentiveness to detail to a much broader and freer treatment without loss of precision. In content he moved from the anecdotal to genre, from the sentimental to the realistic, from genial humor to poetic introspection, although there is no absolute consistency in the sequence. In all his works, however, a careful attention to detail was necessary, because Mount was a storyteller and expected his audience to pick up the clues. The anecdotal element in his pictures varies from the obviously thematic and humorous—*The Long Story* (1837, Corcoran Gallery of Art, Washington, D.C.)—to the common incident that makes a point—*Bargaining for a Horse* (1835, New-York Historical Society)—or the simply colorful rustic activity of *Dancing on the Barn Floor* (1831, Suffolk Museum and Carriage House, Stony Brook, N.Y.).

News from California (1850, plate 444) is characteristic of Mount's maturer work, in which the anecdotal elements are part of a vignette of life rather than a short story. He sets the scene in the post office, the village's social hub as well as its contact with the outer world, since the picture's theme is the reaction to the Gold Rush, seen in terms of a single symbolic human incident. The posters on the wall offering enticements and passage establish the significance of the news being read out. As always, Mount's selection of actors is not haphazard, though intended to seem accidental, and the psychological expression of each is carefully studied, for he intends a cross section of reaction to the news. The focal point is the gentleman reading the news aloud, who by his affluence and superior smile dissociates himself from the common fever except as a spectator. The young couple reacts to the excitement of the moment, the promise of adventure and wealth. But, as frequently with Mount, the minor characters are more interesting than the major. In this case they are the three excluded from the ultimate adventure by circumstances—the small boy in wide-eyed ecstasy, the old man in hopeless regret, and the black in resignation. In this last Mount expresses a depth of understanding normally foreign to his world of sunny contentment.

As a matter of fact, Mount's treatment of blacks is unusual for the time in its awareness of the social problem. By the very nature of his art anything but an implied comment would have disturbed the harmony of his ideal rural world. But though that comment is unobtrusive and completely personal rather than political, he represents

444 William Sidney Mount. *News from California*. 1850. Oil on canvas, 21⅛ × 20¼″. The Suffolk Museum and Carriage House, Stony Brook, N.Y. Melville Collection

blacks as human beings and with dignity. In *Music Hath Charms* (1847, plate 445) the black who stands in deep meditation listening to the music outside a barn expresses both his essential humanity and his tragic separation from the white society in which he exists. The irony of the title, in its implication of soothing the savage breast, reveals Mount's intellectual consciousness, just as the heroic stature of the black woman in *Eel Spearing at Setauket* (1845, plate 446) discloses his emotional involvement. In such later works as these, anecdote has been reduced in favor of mood, and the material grain of things to the less tangible aspects of nature—light, atmosphere, and even heat and stillness. Mount leaves us, then, not simply with an incident but with a sense of the world in which it could occur.

By the time he painted the *Long Island Farmhouses* (1854–59, colorplate 43), the physical world has taken the center of the stage; the nondescript landscape tells the story in its homely but sturdy houses aged by time and weather, given form and character by their human use. The neighborly tree casts its delicate shadows on the house and the debris of living spills onto the land. All is enveloped in luminous golden tones, expressing the life of rural serenity that is Mount's hallmark. The anecdotal note of children at play is no longer necessary but included almost as an afterthought and hardly discernible.

Richard Caton Woodville (1825–1855) represents a somewhat different stylistic phase of American genre painting. He resembles Mount in his affably amused

attitude toward life, but his manner identifies him with the Düsseldorf School. Woodville was born in Baltimore of a relatively well-to-do family, was graduated from St. Mary's College, and had an opportunity to study Dutch and Flemish genre painting in the collection of Robert Gilmor before he left in 1845 for Düsseldorf, the world center for sentimental genre and anecdotal painting. Middle-class taste had so perverted this bastion of academicism that the ideal was equated with Victorian morality and the sublime with painstaking attention to detail.

Woodville was a talented painter and an apt student, and his limited output (due to an untimely death) can stand comparison with the best examples of the school. He spent most of his active career in Europe painting scenes of American life, which he sent back home for exhibition. Although meticulously accurate in the observation of manners and details of costume, as were all the Düsseldorfians, Woodville's works lack specific American flavor. They remain too obviously staged studio dramas, in which the details are right but the totality is unconvincing. Woodville is usually described as a better painter than Mount, and in technical proficiency he probably surpassed any of the other American genre artists of his time. He was literal about the form and the texture of things, and his canvases are carefully worked in gradations of tonality, harmony of color, and rich impasto. But this very addiction to the surface of the object often denies the importance of the picture's psychological content. One cannot tear one's eyes from a pitcher, when they should be focused on a face.

Woodville did have an aesthetic sensibility which went beyond the purely technical and a psychological perspicacity which was, however, too often cheapened by overstatement. His simplest painting remains his finest, *Politics in an Oyster House* (1848, colorplate 44), in which the limited and clearly defined cubical space contains the physical as well as the emotional interrelationship of the figures. Both the ambience and the types are well observed and rendered with restraint, although there is some self-consciousness about the gestures and expressions. One of his later paintings, *The Sailor's Wedding* (1852, plate 447), reveals both his strength and his failings. It is composed with almost stately dignity, as if it were a stage presentation, within the typical, limited, spatial box which is his trademark. The scenery and props have been carefully researched, all the actors carefully cast, costumed, and coached, and the director has thought of every detail; but the actors remain actors, more Dickensian than American, and all look as if they are trying to remember their lines. Woodville's ability to manage a large number of figures in a coherent light and atmosphere within a rational space is certainly no mean achievement for an American painter, but his insight into the personalities of his characters, the sincere feeling for material things, and the charm of his paint surface are

445 William Sidney Mount. *Music Hath Charms*. 1847. Oil on canvas, 17 × 21″. The Century Association, New York

446 William Sidney Mount. *Eel Spearing at Setauket*. 1845. Oil on canvas, 33¼ × 40¼″. New York State Historical Association, Cooperstown

447 Richard Caton Woodville. *The Sailor's Wedding*. 1852. Oil on canvas, 18⅛ × 22″. The Walters Art Gallery, Baltimore

not enough to overcome the contrivance of the conception and the pedantry of its elaboration. Except for the tangled group in the doorway, the painting, like all his work, lacks that sense of spontaneity essential for an effective genre style.

While Mount and Woodville walked with success on the sunny side of the American street, Blythe and Quidor found the shadowed side less hospitable. Both were eccentrics, in life as in their art unable to accept the American dream and therefore rejected. It has taken a century to discover Blythe and Quidor for the first time. David Gilmour Blythe (1815–1865) was both provincial and unique. His satirical art seems to derive from a lower stratum of caricature than that of David Claypoole Johnston, who was trained as an engraver under Francis Kearney in Philadelphia and, after setting up his own print shop there, ventured into lampooning local worthies. The outraged reaction of his subjects closed the normal outlets of distribution to him, and in 1821 he turned to the stage. In 1825 he went as an actor to Boston, where he again took up engraving and satisfied his predilection for satirical humor by publishing a periodical called *Scraps,* obviously inspired in both material and

style by Cruikshank's *Comic Almanack*. His humorous raillery at human foibles is much less astringent and accomplished than Rowlandson's or Cruikshank's, but it reflects that tradition in wryness of line and in attitude. His watercolor drawing *The Militia Muster* (c. 1829, plate 448) discloses a minor artistic talent but a perceptive wit, laced with good humor and completely without pretension. This level of satire was more acceptable, and Johnston had some success.

David Blythe was an artist of totally different disposition—satirical, certainly, but without Johnston's leavening sense of fun. His was an essentially misanthropic view of life. Blythe was born near the frontier town of East Liverpool, Ohio, and was active in Pittsburgh, where he seems to have learned portrait painting. He did some portraiture and woodcarving, painted a large unsuccessful panorama, which was cut up for stage scenery, and wrote verse. The premature death of his wife may be what led him to drink and general bitterness. He struck back at the world crudely but honestly, with a harshness foreign to the art of his time. Had Blythe had the technical equipment, he might have been a major figure in American art. From the evidence of his paintings he would seem to have

448 David Claypoole Johnston. *The Militia Muster*. c. 1829. Watercolor, 10¾ × 15″. American Antiquarian Society, Worcester, Mass.

been largely self-taught, for his drawing is ungainly and distorted, his modeling soft and unpleasantly pasty, his brushwork unsure. Yet his paintings exude a remarkable vigor, his exaggerations are descriptively and emotionally effective, and his very deficiencies seem to add an artistic dimension to the grossness of his people and the seaminess of their environment. In his view, life is an unrewarding struggle for mere existence, and this world of unadulterated ugliness is peopled by scoundrels, hypocrites, and nincompoops. The anger seething within him seems to explode in *Post Office* (c. 1863, plate 449), a picture of senseless incivility, vulgarity, and rapacity. Such violence seems too much for a genre picture, and perhaps he intended a larger indictment of the world in which he lived. Blythe is closer to Daumier in attitude and style than to any of his American contemporaries, but he had neither the Frenchman's genius nor depth of humanity. He remains a unique and authentic American talent, a welcome antidote to the general level of sentimental genre.

Blythe and Quidor were the only genre artists of their time to break out of the strict confines of realism into the realm of Romantic imagination. They were the only ones in whose work "Gothick" distortion of form was employed to heighten expression and, in that sense, were closer to the central tradition of Romantic emotionalism than to Victorian moderation. John Quidor (1801–1881) has left a body of work unique in its evocation of the macabre. In 1942 John I. H. Baur gathered sixteen of eighteen extant Quidor paintings for the first exhibition of the artist, at the Brooklyn Museum. They seem to have been painted over a lifetime in which Quidor had little or no recognition and during which he eked out a living as a painter of signs, banners, fire buckets, and panels for coaches and fire engines. He was not just an artisan; he

449 David Blythe. *Post Office*. c. 1863. Oil on canvas, 24 × 20″. Museum of Art, Carnegie Institute, Pittsburgh

had served a brief apprenticeship under John Wesley Jarvis and exhibited three pictures at the National Academy in 1828. But his was an unpopular kind of art, and he remained on the periphery of the New York art world.

Except for occasional religious paintings, the majority of Quidor's work was in illustration, and most of that was

based on Washington Irving's tales of Dutch New York. But the pictures are not illustrations in the common sense of accompaniment to a text and were never used as such. Quidor simply preferred to take his themes from literature, and his paintings can stand on their own as anecdotal or genre scenes. He transformed Irving's picturesque "folk" tales into burlesques of "Gothick" terror, walking a narrow line between prank and nightmare, amusement and fear. His was a wild humor teetering on the edge of madness. *The Money Diggers* (1832, colorplate 45) is a tableau out of the Grand Guignol, with twisted trees, jagged rocks, and batlike forms, all seen in an eerie firelight. A remarkable play of contrasts is created by brilliant flickering highlights and mysteriously threatening shadows. The robbers are swept into a spasm of action by a ludicrous terror, their grotesque forms galvanized in the lurid light. One expects to hear the sound of hideous laughter from the wings, for it is, after all, a ghost story. Yet it is too frightening to laugh at and too farcical to take seriously. As a painting, it is a notable achievement, knowingly composed, with all the dynamic action of the figures and writhing shapes of the landscape contained in

a unified complex in depth as well as on the picture surface. Though little appreciated, Quidor was one of the most sophisticated painters of the period, carrying on the Allston tradition of solid underpainting and subtle overglazing to create three-dimensional form in light and atmosphere, to which he added his own surface obbligato of "expressionist" brushwork and lively color. The earthy genre types and the transparent luminosity of his paint would seem to indicate some firsthand contact with Dutch and Flemish genre painting.

Quidor was entered as a portrait painter in the New York directory in 1827. After 1836 he was not listed for fourteen years, during which he seems to have taken to religious painting in the style of West. He returned to the directory from 1851 to 1868, and from this period date his later genre pictures, painted in translucent glazes of almost monochromatic color. The wildly prankish *Wolfert's Will* (1856, Brooklyn Museum) retains elements of his earlier style, but his *Voyage to Hell Gate from Communipaw* (c. 1866, plate 450) is more representative of this later phase in its cohesive tonality, absence of violent contrasts, and fluency of brushing, much more closely

450　John Quidor. *Voyage to Hell Gate from Communipaw.* c. 1866. Oil on canvas, 27 × 34″. Wichita Art Museum, Wichita, Kans. The Roland P. Murdock Collection

connected with Dutch and Flemish painting. However, these last works are equally infused with his demoniacal spirit, grotesqueries, and madcap humor.

George Caleb Bingham (1811–1879), more than any other artist of the era, expressed Jacksonian democracy in its western origins—its egalitarianism, adventurousness, and roistering vitality—even though his earliest genre scenes in the late thirties and early forties date from after the heyday of "Old Hickory's" power. As a genre painter he recorded the commonplace life of the frontier as he saw it in the vicinity of St. Louis, but in his heroic treatment of the ordinary and his conscious desire to depict the "social and political characteristics" of that society, he was as much a painter of history as of genre. He left a memoir of a time, a place, and a way of life unmatched in the annals of American art. The very limitations of his technique gave his paintings a crude and powerful simplicity consistent with his subject matter, and his unorthodox training led him somehow to sources which were unusual in his time but peculiarly cogent for what he had to say. It has often been noted that Bingham's compositional devices were based on Renaissance and Baroque concepts of heroic painting, something he must have learned from prints. It is amazing that he could adapt so successfully to his own idiom the essentials of a great tradition that had been thoroughly distorted by academic practice.

Bingham was born in Augusta County, Va., but was taken as a boy to Franklin, the major town in Missouri west of St. Louis, in 1819. Forced to help support the family after his father's death in 1823, Bingham first worked as a farmhand and was then apprenticed to a cabinetmaker in Boonville. Whether he received instruction from Chester Harding in those years is debatable. Bingham was described in an early newspaper account as having attained his skills "by means of his own unassisted application and untutored study." At any rate, he was drawn to art at an early age and, although he was interested in theology and law, turned to portrait painting in 1830. The West was so conscious of its cultural limitations that any evidence of achievement was rather effusively acclaimed, and Bingham's career eventually was colored by his status as Missouri's artist. His youthful portraits are clearly provincial and technically naive but, just as clearly, exceptional. His hard and precise linearity, strong sense of reality, and immaculate clarity of image seem like a throwback to such eighteenth-century limners as John Mare or the Jennys brothers.

Continuing success led Bingham to St. Louis in about 1835, but after two years there the call of greater cultural centers drew him to the eastern seaboard. His first contact with a sophisticated level of art came in 1838, when he spent three months in Philadelphia studying pictures at the Pennsylvania Academy. It may have been there that he saw his first genre paintings. However, he was soon back in Missouri, executing portraits, becoming involved in politics, and painting political banners. With the election of William Henry Harrison, for whom he had campaigned, Bingham moved to Washington in 1840 and for four years worked as a portrait painter with only moderate success. Before he left he must have completed the first version of the *Jolly Flatboatmen* (1846, Collection Senator Claiborne Pell, Washington, D.C.), which was bought along with three other paintings by the American Art Union, reproduced as the frontispiece of its journal in 1847, highly praised in the press, and engraved in 10,000 copies. Suddenly Bingham had a national reputation as "the Missouri artist" and the "western Mount," and soon print houses, European as well as American, were vying for his favor. During the years before his departure for Düsseldorf in 1856, he completed most of his significant genre paintings. After 1851 his production fell off as his compositions grew more complex and his execution more painstaking, and as he became more involved with the production and merchandising of his prints.

Except for *The Emigration of Daniel Boone* (1851, Washington University, St. Louis, Mo.), his one early venture into the heroic, and the paintings done after his stay in Düsseldorf, Bingham's genre themes dealt with life on the river and, later, the political scene. In his river subjects he avoided representations of labor or even vigorous activity, preferring moments of relaxation or amusement. His was no Romantic exaggeration of frontier adventure but, like Mount's bucolic view of eastern life, a pleasant and sunny version of western existence. In neither was the harshness of living alluded to. In *Fur Traders Descending the Missouri* (c. 1845, plate 451) two men in a dugout canoe drift downriver in the early morning haze; in *Raftsmen Playing Cards* (1847, City Art Museum, St. Louis) men while away the hours; in *Watching the Cargo* (1849, State Historical Society of Missouri, Columbia) three men are patiently encamped along the river's edge; in *Shooting for the Beef* (1850, colorplate 46) a group of frontiersmen engage in a contest in rifle marksmanship; only in *Jolly Flatboatmen in Port* (1857) is there any animated activity. But Bingham imbues such commonplace subjects with an uncommon grandeur.

Bingham learned to compose in the grand manner, using broad horizontal bands of space within which figures are solidly modeled and precisely placed and groups are arranged in stable pyramidal shapes. Every element is clearly defined and simplified. There are no accidental intrusions or ambiguities, though the transitions from part to part are not always successful. There is a strong sense of Classical order, reminiscent of Poussin, and an obvious dependence on a rudimentary geometric structure in which sharp-edged planks or slender poles and rifles play an insistent role. In his earliest paintings, such as the first *Jolly Flatboatmen* and *Fur Traders Descending the Missouri*, Bingham rather baldly centered his subject, leaving a border of space around the edges. In both

451 George Caleb Bingham. *Fur Traders Descending the Missouri.* c. 1845. Oil on canvas, 29 × 36½″. The Metropolitan Museum of Art, New York. Morris K. Jesup Fund, 1933

paintings the landscape serves as a backdrop, in the former remaining rather unimportant but in the latter becoming almost the dominant theme. The *Fur Traders,* in spite of its crude, hot color and oversharp contrasts of light and shade in the figures, remains one of his most satisfying efforts. The evocation of lyrical mood, the sheer loveliness of the river in a roseate haze, the delight in the sensuous aspects of the physical world were never again quite equaled in his work. The tenuous sense of space was obtained by atmospheric effects alone. *Raftsmen Playing Cards,* on the other hand, was not entirely a successful effort to break out of such spatial limitations by the compositional device of an asymmetric extrusion on the frame while maintaining the central focus.

Eventually Bingham gave up the centralized for a more fluent diagonal form in which a large foreground shape at one side balanced a small distant shape on the other, creating a plunging recession into space. *Watching the Cargo* (1849), *Shooting for the Beef* (1850), and *Fishing on the Mississippi* (1851) are all composed in this manner. The pyramidal groups exist as cubic masses in equilibrium with the open expanses of landscape backgrounds. In *Shooting for the Beef* the low-eye-level view produces a composition of foreground figures in monumental scale

contrasted with small background figures in a manner reminiscent of Piero della Francesca, and the powerful three-dimensional form of the seated figure in the central foreground, acting as a spatial barrier, recalls Giotto. The whole is tied together with striking geometric lucidity. The rationality and clarity of the composition, the solidly sculptured forms, the convincing illusion of space, the subtle echoing of shapes, and the overall sense of stillness and frozen time are notable achievements.

The election series, comprising the *County Election* in two versions (1851/52, City Art Museum, St. Louis, and 1852, Boatmen's National Bank of St. Louis), *Stump Speaking* (1853–54, also in Boatmen's National Bank), and *Verdict of the People* (1854–55, plate 452; another version, after 1855, Collection Richard W. Norton, Jr., Shreveport, La.), and perhaps *Canvassing for a Vote* (1851–52, Nelson Gallery–Atkins Museum, Kansas City, Mo.), occupied most of his artistic efforts for five years. Bingham was involved in politics all his adult life, and the election series is an expression of his faith in the democratic process at its grass roots as a fundamental social experience. In these paintings Bingham avoided any serious consideration of issues and, instead, recorded with good-humored raillery the human aspect of the

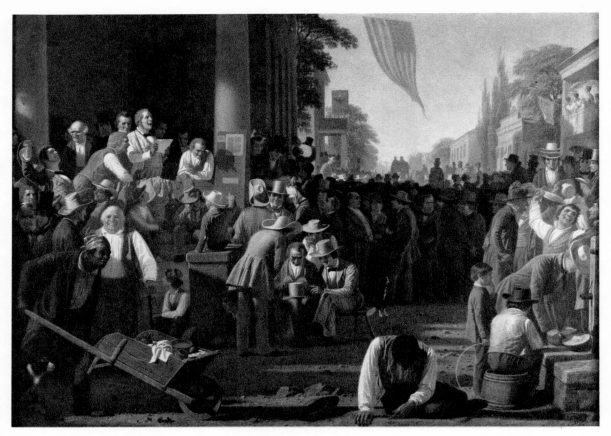

452 George Caleb Bingham. *The Verdict of the People.* 1854–55. Oil on canvas, 46 × 65″. The Boatmen's National Bank of St. Louis

political process. All types and social classes are included, except for women, for Bingham's was a man's world. All kinds of psychological responses are probed; from the pretentious to the irreverent, from the serious to the ludicrous, the whole range of festive activity is depicted. By this time he had attained a remarkable level of competence in handling large numbers of figures in composition. There is an unfaltering rationality in the way he organized the smaller elements into larger units and interrelated all in a coherent plan by means of alternate horizontal bands of light and dark masses receding in space. But the final image is synthetic, each object an independent entity coexisting among equals, for Bingham's vision was not sophisticated enough to translate the visual world into a unified experience of mass, space, light, and atmosphere. Evidently he planned his compositions down to the last detail, posed his figures and then made drawings of them, and finally transferred the drawings almost without alteration to the canvas. It is in his drawings (plate 453) in the St. Louis Mercantile Library Association that Bingham comes closest to visual experience. The figures, almost all single, are sharply observed, executed with bold fluency and control, describing the character, costume, and psychology of the subject with

remarkable economy of plastic means and a trenchancy of line which, except for an underlying lack of refinement, are close to Daumier.

Success fostered Bingham's self-esteem and led him to say to a friend, "In the familiar line which I have chosen, I am the greatest among all the disciples of the brush, which my native land has yet produced." It, no doubt, fired his ambition to test himself against the greatness of the past, and in 1856 he went to Paris, but the provincial in him was unsettled by the challenge of the Louvre, and he sought more congenial surroundings in Düsseldorf. There he identified wholeheartedly with its academic naturalism, seeing in it the reflection of his own aims and principles. For two years there he spent most of his time on two life-size portraits (later destroyed by fire) of Washington and Jefferson for the Missouri State Capitol and the *Jolly Flatboatmen in Port* (plate 454), in which the change in his style is almost imperceptible but disastrous. The technical subtleties he absorbed seem to have disturbed the cohesive force of his vision. Although based on earlier drawings, the figures in the painting have lost their authenticity; the composition is more fluent than any of his others, but it is also more academic; and while he learned to paint more suavely, the individual

453 George Caleb Bingham. Sketch of fur trader's son for *Fur Traders Descending the Missouri*. c. 1845. Pencil, brush, and ink wash heightened with white, 6⅞ × 10″. © The St. Louis Mercantile Library Association

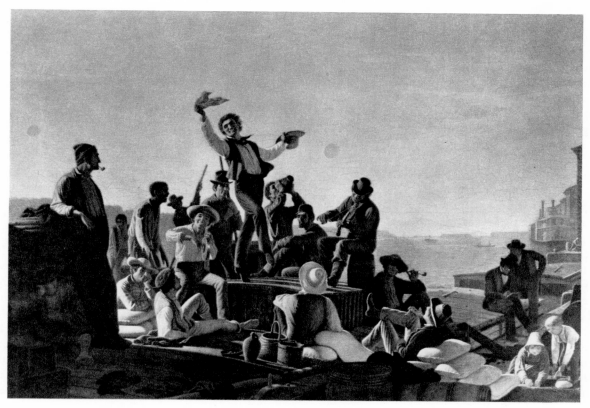

454 George Caleb Bingham. *Jolly Flatboatmen in Port*. 1857. Oil on canvas, 46¼ × 69″. St. Louis Art Museum

figures never coalesce into a unified whole. Bingham had obviously been moving away from his original inspiration even before he went abroad, and Düsseldorf merely reinforced the faults of his style.

On his return to the United States in 1859 he became progressively more concerned with projects for historical compositions and sought government commissions, without much success. His later years were devoted to politics and portrait painting, and though he remained a public figure, his achievements were soon forgotten. Some twenty-five years after Bingham's death Samuel Isham, in his then-authoritative history of American painting, dismissed him in a few lines: "Bingham produced rustic scenes in the style of Mount, and his 'Jolly Flat Boat Men,' engraved by the Art Union, may still be found hanging in old tavern barrooms; but his skill was not great." It took thirty more years, a growing interest in American art, and modern eyes to rediscover this unique and native genius.

THE WEST

The opening of the West had all the ingredients of a Romantic saga—primeval nature, an exotic aboriginal population, and the drama of adventure in the unknown. Even at the time there was an unusual self-conscious awareness of the epic dimensions and the historic import of the struggle. From the very beginning the New World had a fascination for the scientific student as well as the Romantic dreamer, and there was a sense of urgency, a historical understanding that the inevitable wave of civilization would destroy what had remained untouched for millenniums. Audubon felt that way about his birds, Catlin about his Indians, and even Bingham about the frontier life he loved so well. Intrepid artists—in some cases artists only by necessity—have left an invaluable record of a vanished world, although little of it is of enduring aesthetic value. This is, of course, not true of the work of the earliest of these men, the naturalist-artist John James Audubon (1785–1851), whose studies of American birds are inestimable ornithological records and artistic masterpieces at the same time.

Audubon was born in what is now Haiti, the illegitimate son of a French sea captain and a chambermaid. At four he went to France to live with his father in Nantes, where he received his education and his interest in nature was first encouraged. He may have studied briefly in the studio of Jacques-Louis David, as he later claimed, but whatever he learned was scant. In 1803, to avoid conscription in Napoleon's armies, Audubon came to the United States, and by 1808 he had married and moved to the frontier in Kentucky, where he kept store until his bankruptcy in the panic of 1819. From his arrival in this country he had observed and drawn birds, and this passionate avocation was fired in 1810 when the

Scottish immigrant artist Alexander Wilson (1766–1813) walked into Audubon's store in Louisville, seeking subscriptions for his *American Ornithology* (1808–13), the early volumes of which Audubon saw and admired. Not until 1820, however, when he was thirty-five, did Audubon set out down the Mississippi on a flatboat to record the birds of the New World for his own projected publication. That year his work as a taxidermist at the Western Museum of Natural Science in Cincinnati had brought him into contact with more scientific naturalists and made him aware that among his drawings were many species of western birds Wilson had not seen. Perhaps, too, he felt that his own renderings could surpass Wilson's somewhat brittle and prosaic, but precise and knowledgeable, works. Audubon's scientific training was acquired mostly on his own; as he said, he was not a "learned" naturalist but a practical one.

The Mississippi Valley was a flyway for migratory birds, and for the next six years New Orleans was the base of Audubon's operations. During this time his wife taught school to support the family while he contributed by doing chalk portraits and teaching drawing, French, music, dancing, and fencing. In 1824 he visited Philadelphia, hoping to find support for his publication, but the scientific and artistic communities there remained loyal to Wilson. After another year and a half of intensive labor, Audubon left for Europe, where his drawings and stories of personal experience in the wilderness captivated the English, Scottish, and French. Acting as his own publisher and salesman, he managed to keep just ahead of the creditors while, for the next twelve years, he and his family worked out of London. There the engravers Robert Havell and Robert Havell, Jr., reproduced his drawings in their original size on copper plates by a combination of etching, aquatint, and other processes. The prints were then colored by hand.

Audubon returned periodically to America to gather more material, improve on his drawings, and solicit further subscription. The four elephant folio volumes of 435 colorplates were issued between 1827 and 1838 under the title, *The Birds of America;* the accompanying text, *Ornithological Biography* (1831–39), in five volumes, was published in Edinburgh. The publication was deservedly successful. Audubon had devised a method of wiring a recently shot bird into a lifelike position and placing it before a background ruled off in small squares. He depicted his birds in a variety of actions, from flying or swimming to scratching a wing, attacking prey, warding off enemies, or feeding their young, all seen from eye level. Some of the more unusual poses are intended to reveal the special markings of a species. One of Audubon's particular gifts was the ability to capture the personalities of different kinds of birds. Often his portrayals are unified by drama: a mockingbird nest threatened by a rattlesnake, or a group of partridges attacked by a hawk. Assistants, among them his son John Woodhouse Audu-

bon, usually painted in the background of appropriate branches or terrain. Sometimes more generalized backgrounds would be left to the Havells or to Audubon's other son, Victor.

Audubon's intentions were scientific, and his obsession was to describe every bird in America faithfully in detail, habitat, and color, and as close to size as possible. The necessities of scientific accuracy and the restrictions of the format often led to brilliant formal solutions. *The Great Blue Heron* (1821, colorplate 47) is a case in point. The spindly creature is contorted to fill the prescribed space with an elastic but awkward grace that is both true to the species and exciting as pure design. In the flattening of form, emphasis on silhouette, and relationship of shape to frame, there is a striking resemblance to Japanese painted screens. One can find similarities also in the acuteness of observation and precision in handling detail, the hard elegance of line, and the delicacy of color. Audubon had gradually developed a painting technique using watercolor, pastel, ink, oil, egg white, and even scratching on the surface to simulate textures with an exquisite fidelity to nature. And although the Havell engravings are remarkable in themselves, they lose much of the vivacity and quality of the original paintings, of which The New-York Historical Society owns almost all.

Audubon returned to the United States in 1839 and two years later embarked on a project of depicting the mammals of the continent. In 1843 he traveled up the Missouri to Fort Union, gathering specimens, but when his sight failed in 1846, it was left to his son, John Woodhouse, to complete *The Viviparous Quadrupeds of North America* (1845–48). Audubon spent his last years quietly in a home he had built on the Hudson.

Unfortunately, other documentors of the West had none of Audubon's genius, although Catlin showed the same fanatical devotion. Catlin and Eastman, at least, had long and close contact with the western lands and Indians; most of the others were only itinerant observers. Some went west attached to government expeditions, but many of the artists who braved the wilderness did so on their own, out of a consuming interest in the subject or in connection with smaller, private expeditions whose intention was usually publication.

In general the American attitude toward the Indian before the nineteenth century had been unequivocal—the only good one was a dead one. By 1830 the Indians had either been brutally exterminated or driven beyond the Mississippi, and in the vastness of the western plains they no longer posed an immediate obstacle or threat. In their remoteness they could even be thought of in Romantic terms, as examples of natural man, even as heroic and tragically doomed. Their exoticism in appearance and mode of existence added to the Romantic interest, and there was some anthropological and ethnographic interest in their customs. Travel in Indian country was not especially dangerous, since the tribes tended to honor their treaty commitments, and travelers did not find it difficult to live among them, as the literary and visual evidence seems to indicate. Not until the white man began to move westward again did the period of Indian Wars end the short interlude of peace. After the annexation of California and the discovery of gold in 1848, the inevitable urge toward unification of the continent led to a national policy of extermination. Meanwhile those who were interested could collect their data.

The earliest representation of North American Indians during the sixteenth century, by Jacques Le Moyne and John White, had shown them as curious mutants of an antique norm, no more accurately than the animals in a medieval bestiary. Although Europe continued to be fascinated by the strange New World, American colonials were too busy dispossessing Indians to think of them either Romantically or scientifically. In distant London, Benjamin West might call upon an old memory to re-create a gallery of protagonists for his historical dramas, but Gustavus Hesselius's portraits of two chieftains of the Delawares (plate 153) were probably the first and possibly the only authentic records of Indians during the colonial era. It was not until 1824 that government authorites, recognizing the imminent disappearance of the Indian, instituted the recording of likenesses of visiting tribal dignitaries to Washington and the frontier capital of St. Louis. Thomas L. McKenney, chief of the newly formed Bureau of Indian Affairs under the War Department, hired a number of artists for this purpose, among them Charles Bird King, James Otto Lewis, Henry Inman, George Cooke, Peter Rindisbacher, and A. Ford. All but a handful of these portraits, along with a mass of Indian material, were destroyed in the fire of 1865 in the Smithsonian Institution. However, 120 of them had been reproduced in the three folio volumes of the *History of the Indian Tribes of North America* (1836–44) by McKenney and Hall, and a set of copies of the vanished paintings by Henry Inman exists in the Peabody Museum at Harvard University.

The procession of venturesome artists who recorded their experiences in the West had begun with the somewhat nebulous figure of Joshua Shaw, an English landscape painter and topographical artist. Shaw seems to have traveled on the Ohio, possibly as far as the Mississippi, in about 1820, and left a series of interesting drawings of river boatmen. Another Englishman, Samuel Seymour (act. c. 1796–1823), joined Major Stephen H. Long in an expedition to the Rockies in 1819–20. The first in a line of explorer-artists attached to government missions, he journeyed in 1823 as far up the Mississippi as Prairie du Chien in Wisconsin Territory, where he painted Indians and landscape views, which, although now lost, were reproduced as lithographs in 1825. James Otto Lewis (1799–1858) was also in Prairie du Chien in 1825 as a government artist to paint the Indians, but his efforts, too, remain only in lithographic reproduction in

his *Aboriginal Portfolio* (1835–36). Peter Rindisbacher (1806–1834), a Swiss immigrant who had come to Lord Selkirk's utopian colony on the Red River in 1821, arrived at Fort Snelling in Minnesota from Canada in 1826 and did watercolors of the Winnebago and Fox tribes. He settled in St. Louis in 1829 and, like Lewis, painted portraits of Indians for the government. None of these early Indian painters produced works of more than historic or ethnographic interest, nor did they achieve public renown. Although not much more accomplished as an artist, George Catlin became and has remained identified in the public mind as *the* Indian painter through his long years of devoted study, the authenticity of his observations, the great body of his production, and most of all his publications and the impassioned espousal of the Indian cause in his traveling exhibition and show. Made up of paintings, Indian costumes, and artifacts, and, at times, troupes of live Indians, the whole managed with great showmanship, the show toured the United States and Europe for fifteen years.

Born in Wilkes-Barre, Pa., George Catlin (1796–1872) practiced law in the surrounding area before turning to miniature and portrait painting in 1821, after which he plied that trade in Philadelphia, Albany, Richmond, and Washington for almost a decade. He had been captivated by the sight of a group of Indians in full regalia in the streets of Philadelphia and, years later, wrote: "The history and customs of such a people, preserved by pictorial illustrations, are themes worthy of the lifetime of one man, and nothing short of the loss of my life shall prevent me from visiting their country, and of becoming their historian." By 1830 he was in St. Louis doing portraits of Indians, and two years later he started out with an American Fur Company party taking the first steamboat up the Missouri 2,000 miles to Fort Union. Catlin spent almost eight years among the Indians, was the first artist to penetrate the Far West, and amassed close to six hundred paintings, which he assembled as his traveling "Indian Gallery." His *Letters and Notes of the Manners, Customs, and Condition of the North American Indians* (1841) went through many editions and, aside from its ethnographic value, became a source book for artists who had never seen a live Indian. Conscious of the red man's doom, Catlin had made good his vow that through his art, phoenix-like, they "may rise from the 'stain of a painter's palette.' " His lack of training may actually have been a boon, for a sophisticated artist might have found the conditions under which he had to work too difficult, and those who came later and were trained could not help seeing in set formal patterns. Still, Catlin's paintings lack the intrinsic interest to match the fascination of the subject as Audubon's did. This is not to say that he lacked talent; despite his shortcomings he had an artist's eye for the dramatic sight or moment, for composition, pattern, and linear movement. His scenes of Indian life (plate 455), though often not much more than shorthand nota-

tions, are full of vivacity, and though they call for further elaboration, the basic elements are suggested.

His landscapes have the same rudimentary character. Topographical rather than Romantic, they record the most spectacular scenery with laconic spareness, the large forms rendered with what can only be called "aesthetic frugality." Catlin's reference to "stain" might even have been deliberate, for his basic manner is in staining the canvas with a minimum of pigment. His miserliness with paint may have been dictated by his insistence on painting on the spot and the necessity of carrying a minimum of equipment. Catlin worked directly and very rapidly, and in his pictures there is practically no drawing in the sense of delineation of form. In completing his paintings, Catlin did not rework them but added detail to the original sketch, thus retaining a freshness of execution and immediacy of observation. Perhaps the most effective of his works are his portraits, in which he often captured in the simplest terms the native pride and common humanity of his Indian subjects underneath their exotic trappings (plate 456).

In 1846 Catlin offered his "Indian Gallery" to the government, which he hoped might purchase the collection when he was forced to disband the exhibition in 1852, but it was not acquired by the Smithsonian Institution until 1879, after his death. Disillusioned and discouraged by his country's treatment of his beloved Indians, Catlin traveled and painted among the tribes of South and Central America from 1853 to 1857, took a trip up the western coast to the Bering Sea and Siberia, after which he settled in Brussels. He returned to the United States in 1870 and died in Jersey City in 1872.

Seth Eastman stumbled onto an interest in Indians through his career as an army officer in Indian country. The very nature of his relationship with the tribes must have colored his personal attitude toward them, but his sketches show the same kind of objective recording as do Catlin's. As with Catlin, his training was limited and his technical equipment hardly superior, although his later works, based on the earlier studies, show an increased command of the medium and an obvious concern with formal elements. Unfortunately, the results are less authentic, more contrived and romanticized. Eastman's effort to convert the raw material of his experience into an artistic statement is apparent in such a painting as *Squaws Playing Ball on the Prairie* (1849, plate 457), in which the carefully composed pattern of silhouetted figures seen in the slanting rays of the setting sun captures with Romantic sentiment the feeling of tribal life, a moment of carefree action, and the immensity of open prairie and sky.

Eastman was born in Maine, was graduated from West Point in 1828, and was assigned to the western frontier at Fort Crawford (Wisc.). The earliest of his drawings dates from 1829, a year before Catlin first went west. He was transferred in 1830 to Fort Snelling (Minn.) taught drawing at West Point from 1833 to 1840, and served again at

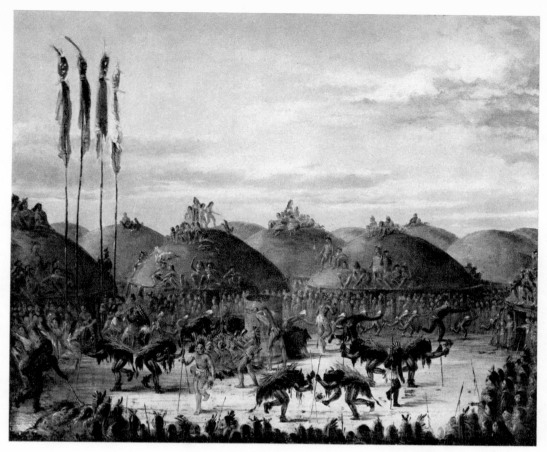

455 George Catlin. *Bull Dance*. c. 1832–36. Oil on canvas, 22⅝ × 27⅝″. National Collection of Fine Arts, Smithsonian Institution, Washington, D.C.

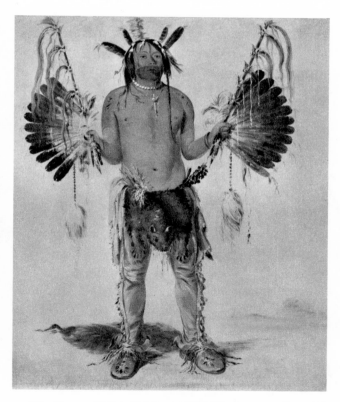

456 George Catlin. *Old Bear*. 1832. Oil on canvas, 29 × 24″. National Collection of Fine Arts, Smithsonian Institution, Washington, D.C.

Fort Snelling until 1848. His paintings and the illustrations for both his wife's *American Aboriginal Portfolio* (1853) and Henry R. Schoolcraft's six-volume study, *Information Respecting the History, Condition, and Prospects of the Indian Tribes of the United States* (1851–57), were based in part on his sketches in the years spent among the Sioux and Chippewas.

For the Swiss artist Charles (Karl) Bodmer (1809–1893) the Indians were only an incident in a long life of artistic activity. He came to America with the Prussian officer and naturalist Maximilian, Prince of Wied-Neuwied, in 1832. In the following spring, just one year after Catlin, they made their way to Fort Union on the same steamboat, the "Yellowstone," and by keelboat beyond to Fort McKenzie, where they spent over a month. They wintered downstream at Fort Clark, near the villages of the Mandan Indians. By the end of 1834 they were back in Europe preparing the publication of Maximilian's *Reise in das innere Nord-Amerika in den Jahren 1832 bis 1834* (1839–41); Bodmer executed the watercolors and many of the eighty-one handsome colored aquatints that were made from them (plate 458). Though still only in his early twenties, Bodmer had been solidly trained as an artist in Zurich and Paris. His observations were accurate enough, but his formal experience colored his vision, and his Indians are dramatic actors in a fascinating theatrical performance. Correctly costumed, they move through

457 Seth Eastman. *Squaws Playing Ball on the Prairie.* 1849. Oil on canvas, 24 × 34″. Peabody Museum, Harvard University, Cambridge, Mass.

458 Charles (Karl) Bodmer. *Bison Dance of the Mandan Indians.* 1839–41. Aquatint after original water-color, 12 × 17⅛″. Joslyn Art Museum, Omaha, Neb. Northern Natural Gas Company Collection

their paces with predictable savagery and violence, but the bodies and the repertory of poses are recognizably out of the French Academy, and the blatant colors of a primitive people are transmuted into the acceptable harmonies of the salon.

Alfred Jacob Miller (1810–1874) was equally well schooled. Born in Baltimore, he studied with Sully in Philadelphia and later in Paris at the École des Beaux-Arts. He might have persisted as a modest portraitist had he not met an adventurous Scotsman with a wild dream of decorating his family castle with paintings of Indians. In 1837 Miller accompanied Captain William Drummond Stewart to the Rockies and made watercolor sketches of landscapes and Indian life. After spending two years in Scotland (1840–42) completing a series of large oil paintings for Stewart, Miller returned to Baltimore and to portrait painting but continued to reproduce Indian paintings from his original sketches on demand. These, as well as the Stewart paintings, are of little consequence, but the small watercolor sketches of that one summer are aesthetically perhaps the most satisfying works in the genre. They are charming studies, sensitively seen and rendered with verve. Miller recorded mass in space, movement, the sparkle of color, the quality of light and atmosphere. There is an air of remoteness about the sketches, as if he were not psychologically involved but just passing through, as he was, and putting down what he saw. As a result, they are less specifically Indian and more generally pictorial, a quality reinforced by the alien character of his style, which owed so much to contemporary French Romantic painting.

Like Catlin and Eastman before him, John Mix Stanley (1814–1872) had a long and varied career as a documenter of Indian life. The wagonmaker from upstate New York went to Detroit in 1834, where he was active first as a sign painter and then as a portraitist. In 1838 he made his first foray into Indian country, traveling up the Mississippi, and later found his way to Arkansas and New Mexico and as far west as California and Oregon. His studies of life among the Creeks, Seminoles, Cherokees, Choctaws, Blackfeet, and Apaches were exhibited in the East, but of the 152 pictures of forty-three different tribes deposited at the Smithsonian all but five were destroyed by fire. Stanley was also a photographer, and much of his work was based on camera records. His later efforts at reconstructing his vanished works are overly sentimental and rather heavy-handed. He is best remembered for his Romantic landscapes, the first to deal with the scenery of the great West.

Charles (Karl) Wimar (1828–1862), the last of the Indian painters, went to St. Louis from the Rhineland in 1843. Bitten by the Indian bug at an early age, Wimar dedicated his short life to the immortalization of a vanishing race and a childhood dream. He served his artistic apprenticeship assisting the panorama painters centered in St. Louis and made his initial trip into Indian country in 1849. Having saved enough money, he went to study at Düsseldorf in 1852, returning to St. Louis in 1856. Much of the last few years of his life was spent traveling and painting the Indian scene. Although profoundly involved with the Indians and a serious student of their ways, he came too late to see them with the objectivity of some of his predecessors. They appeared to him through a veil of Romantic sentiment and a frame of Düsseldorfian pedantry. His striving for grandeur emerged as pomposity, the dramatic as stagy, and emotion as sentimentality. The fault was not so much in himself but in his time and his training: the one prevented him from seeing honestly and the other from recording freshly.

Three of the Indian painters, Catlin, Bodmer, and Wimar, have left us versions of the same subject reflecting differences in attitude as well as in style. Catlin's *Bull Dance* (c. 1832–36, plate 455) is a reporter's account ingenuously recording the size and nature of the houses surrounding the dance area, the number and disposition of the audience, the pattern of the dance, and the costuming of the dancers. There is no evidence of artistic vision coloring ethnographical data, except insofar as Catlin had a particular though limited aesthetic vocabulary. Bodmer, in his *Bison Dance of the Mandan Indians,* which exists only in the aquatint version (plate 458), has isolated a dramatic group of dancers, each of whom is differentiated in costume, movement, and psychological expression. Each figure is precisely delineated, and all are woven into an intricate and picturesque pattern against a vaguely defined group of observers in the background. The emphasis is on the exoticism of the incident and the emotional ferocity of the actors. The locale and the totality of the scene have been supplanted by a set of emotive symbols. Wimar in *The Buffalo Dance* (1860, plate 459) returns to a total scenic concept, in which figures, buildings, and space are logically organized and carefully studied, but the whole is now bathed in Romantic sentiment. The ceremony is seen by firelight; figures are illuminated by its flickering radiance or hidden in smoke or shadow. The whole smacks more of the studio than the open plain, and one has the nagging suspicion that it depends more on Catlin than on personal observation.

By this time an objective picture of Indian life had become a thing of the past. The Indian, as he was being exterminated, was being transmogrified into a mythological symbol, the cruelly implacable but doomed foe of the heroic white man—a Romantic image fostered through the various media of popular art down to our own time without much modification. One of the earliest and most popular exploiters of the frontier subject was Charles Deas (1818–1867), whose melodramatic scenes of the perils of the West engraved after his paintings were almost comic in their exaggeration. Deas was a well-trained and competent painter who had made something of a reputation in New York as an artist of humorous genre before spending seven years in St. Louis painting

459 Charles (Karl) Wimar. *The Buffalo Dance*. 1860. Oil on canvas, 24⅞ × 49⅝". St. Louis Art Museum

pioneer life. In *The Death Struggle* (1845, plate 460) the last moment of fright in all its realistic detail is more ludicrous than compelling. In a similar popular Romantic idiom were the paintings of Western subjects by William Ranney (1813–1857) and Arthur Fitzwilliam Tait (1819–1905), reproduced in engraving and lithography.

HISTORY PAINTING

Although the ideological basis for government-supported historical painting was strong during the Jacksonian Era, its development was limited by the continuing provincialism of American taste, the lack of tradition and the inadequacy of American artists in history painting, and the sectional rivalries and narrow materialism of American legislators. Congress seemed to have washed its hands of art patronage after the negative reception of Trumbull's murals, but continued pressure to complete the remaining four panels of the Rotunda led in 1834 to the passage of enabling legislation. After much maneuvering by politicians and artists, the assignment was made to four artists: John Vanderlyn, Robert W. Weir, John G. Chapman, and Henry Inman. Only Vanderlyn had some conception of what history painting could be, and none of them had ever faced the problem of mural decoration, unless one includes Vanderlyn's panorama in this category. They were all essentially easel painters—Inman was even something of a miniaturist—and the result was inevitable. The paintings were not conceived nor did they ever function in the space they occupied as heroic compositions. Inman, perhaps fortunately, never got beyond the stage of a sketch for the *Emigration of Daniel Boone to Kentucky* before his death in 1846, and subsequent politicking for this commission turned up an unknown

460 Charles Deas. *The Death Struggle*. 1845. Oil on canvas, 30 × 25". Webb Gallery of American Art, Shelburne Museum, Shelburne, Vt.

Midwestern candidate, William H. Powell. But the Rotunda area was now at least filled by Vanderlyn's *Landing of Columbus* (1842–44), Weir's *Embarkation of the Pilgrims* (1837–40), Chapman's *Baptism of Pocahontas* (1837–42), and Powell's *Discovery of the Mississippi River by De Soto* (1848–53).

The proposed building of two new wings to the Capitol in 1850 opened the question of government patronage of art again. To avoid any hint of political influence, supervision of construction and decoration was handed over to Captain Montgomery Meigs, an Army engineer. From 1853 to 1859, when he was replaced by a new administration interested in the patronage, Meigs performed his duties with the strictest honesty and economy, although somewhat arbitrarily. It should be said in his defense that he tried to learn and even sought advice. Although the sculpture done under Meigs for the Capitol is not one of the bright spots in American art annals, his selection of Thomas Crawford, Randolph Rogers, and Hiram Powers for the commissions was defensible (see Chapter 14). But his designation of Costantino Brumidi, an émigré Italian painter, to decorate the interior of the Capitol was questionable artistically as well as politically. Impressed by Brumidi's ability to paint in fresco and his willingness to work cheaply on a per diem basis, Meigs was apparently overcome by the cost effectiveness of the situation. Thus introduced, Brumidi worked for the government for over twenty-five years and covered in fresco, which Meigs considered "in the long run a cheaper substitute for wallpaper or whitewash," committee rooms, corridors, and the new dome of the Capitol with a repertory of academic decoration—wreaths, garlands, cherubs, and allegorical figures, and, what was perhaps even more shocking, with American historical subjects which were the sacred province of American painters. The artistic community was outraged and, in the first concerted national movement in art, met in convention at Washington on March 20, 1858. A request to Congress for appointment of an Art Commission to supervise governmental patronage of the arts produced enabling legislation, and in 1859 President Buchanan appointed three artists to serve: the sculptor Henry K. Brown, the portrait painter James R. Lambdin, and the landscapist John F. Kensett. The failure of the Commission's report in 1860 to stir any action has been blamed on its own shortcomings. More telling reasons could be found in the basic Congressional antipathy toward cultural patronage, the growing political tensions produced by the approaching Civil War, and the fact that most American artists were less interested in government patronage or monumental commissions than in providing a growing middle-class public with a less heroic and more personal product in portrait, landscape, genre, and still-life painting. The failure of governmental patronage was thus not crucial to the development of art except in the area of history painting.

Aside from Allston, whose last years were sterile, and the handful who painted pictures for the Capitol, very few artists were concerned with history painting during the middle of the century. Of these the most interesting was William Page (1811–1885), a complex and often paradoxical figure. He fascinated and repelled his contemporaries, was equally revered and denounced, and

achieved at the time more of a reputation than his work merited but eventually even less recognition than it deserved. Page was the one true heir to Allston's romantic transcendentalism, more concerned with the "soul" of art than with its material character, yet the most sensuous painter of his generation, a poetic mystic who became a Swedenborgian, a speculative but erratic theorist, and an inveterate experimenter in the techniques of painting. A brilliant conversationalist, who seems to have mesmerized aspiring young artists and literary notables in Boston and Italy from Emerson to the Brownings with his discourses on art, he is remembered today for only a handful of pictures that have escaped the consequences of his eccentric technical procedures. Most of his works have darkened or deteriorated beyond recognition, and many have simply disintegrated. But the few that remain have an authentic poetic Romanticism and a painterly richness that sets Page apart.

Born in Albany, Page went to New York while still a child and is reputed to have won an American Academy prize in drawing at the age of eleven. He became a student of Morse and was in the first drawing class of the National Academy, winning a silver medal at the first annual exhibition of the Academy in 1827. However, he decided to study for the ministry and spent several months at Phillips Academy in Andover, Mass., and then went to Amherst. He returned to art as a portrait painter in Rochester in 1831 and, after spending several years in both New York and Boston, left for Europe in 1850. For ten years Page was an important figure in the English-speaking art circles of Florence and Rome. Back in New York in 1860, he spent his last years working on paintings begun abroad and occasionally received portrait commissions, but although he was elected President of the National Academy in 1871, he was increasingly neglected.

Page inherited from Allston not only a predilection for traditional Biblical and classical subjects but also a consuming interest in traditional technical procedures, which led him in quest of the secrets of Venetian color, especially the luminous color of Titian. He developed a complex method of underpainting and successive layers of glazing that produced a textural richness and coloristic glow unique in its time. The most striking of his historical pictures is *Cupid and Psyche* (1843, plate 461), one of the few works of the period in which Romantic sentiment is expressed with poetic intensity in painterly rather than literary terms. This is the first painting in America in which nudity is seen not through a veil of conventional artistic or literary allusion but as a freshly observed experience. Yet it remains an idealized and lyrical statement of sexuality, not a realistic one. The glowing warmth of the flesh against the brooding darkness of the landscape evokes a mood of poetic sentiment rather than a physical actuality. All Page's subject pictures have this sense of Romantic timelessness and melancholy, of idealized emotion. Even *The Young Merchants* (1842, colorplate 48),

461　William Page. *Cupid and Psyche*. 1843. Oil on canvas, 10¾ × 14¾″. Private collection. Courtesy Kennedy Galleries, New York

though a genre rather than a history painting, is removed from the specifics of time and place—the rhetoric of genre painting—and transmits a sense of poetic reverie. The young street vendors as well as the objects are real enough, but Page's concern with composition, form, light, atmosphere, color, and paint surface creates an aesthetic texture which lessens the importance of the actual incident and material objects and evokes a generalized mood. In spite of his occasional inadequacies and eccentricities, Page was the most sophisticated painter of his generation, and it is only recently that those qualities which his contemporaries only vaguely sensed have been recognized and his stature as an artist has been reexamined.

A good deal of Page's activity was directed toward portrait painting, much of which has stood up better than his imaginative painting because it was less experimental. His portraits are among the finest and least conventional of the time, and even in his official portraits a sense of artistic distinction and psychological insight is evident. Among the best of these is the impressive *John Quincy Adams* (1838, Museum of Fine Arts, Boston), in which the strong sense of reality and meticulous attention to fact reinforce the imposing dignity of that crabbed old statesman. Much more than a standard likeness is the

Mrs. William Page (1860–61, plate 462), a portrait of his third wife. The dark, almost spaceless figure is silhouetted against the lighter backdrop of a simplified landscape with the ruined mass of the Colosseum, but the bold contrast of formal elements is softened by the luminous glow of color. It is reminiscent in composition and feeling of the early Romantic Italian portraits of Ingres, and in its own more modest and provincial manner is a sensitive and warmly appealing portrait.

The other history painters of the period had neither Page's adventurousness nor his aesthetic sensitivity, although some, like Daniel Huntington (1816–1906) and Henry Peters Gray (1819–1877), were similarly involved with a search for ideal beauty in the art of the past. In their day their paintings passed for elevated and refined taste. In 1849 the Art Union paid its highest price for Gray's *Wages of War* and the following year exhibited a Huntington retrospective of 130 paintings, an honor never before tendered a living American artist.

After attending Yale and Hamilton College, where he met and was encouraged by the portraitist Charles Loring Elliott, Huntington studied under Morse and, later, Inman. In 1839 he went abroad with Gray and spent a year painting in Florence and Rome, where he developed a style that was a pastiche of Raphael, Correggio, and

462 William Page. *Mrs. William Page.* 1860–61. Oil on canvas 60¼ × 36¼″. The Detroit Institute of Arts

463 David Huntington. *Mercy's Dream,* 1850. Oil on canvas, 90¼ × 67½″. Corcoran Gallery of Art, Washington, D.C.

especially Titian. His *Mercy's Dream* (plate 463), painted in several versions, the earliest in 1841 (Pennsylvania Academy of the Fine Arts, Philadelphia), and *Christiana and Her Family Passing Through the Valley of the Shadow of Death* (n.d., also Pennsylvania Academy), both taken from Bunyan's *Pilgrim's Progress,* were extremely popular for a time and much reproduced. They combined ideal beauty, the old-master look, and sentimental piety in a manner that was more naive and retardataire than comparable academic painting in Europe but was apparently attractive to Victorian sentiment in America. Less idealizing and closer to anecdotal tastes in history painting was his *Lady Washington's Reception,* or *The Republican Court* (1861, Brooklyn Museum), which became one of the most popular prints of the time.

Henry Peters Gray's subject pictures are even more clearly Titianesque than Huntington's, with the addition of some Poussinesque stiffening. A Gray such as the

Greek Lovers (1846, plate 464) or the *Judgment of Paris* (1861, Corcoran Gallery, Washington, D.C.) is an exercise in memory, with every form, gesture, and detail somehow reminiscent of, though not literally copied from, his sources, but such echoes of greatness in all their sincerity are banal. Even Samuel Isham found these history painters "hopelessly of another age, with other methods and other ideals."

Emanuel Leutze (1816–1868) exemplifies a more contemporary kind of history painting, which strove not for the lofty ideal and the old-master manner, but for a particularization of history through naturalism of detail and modernity of technique. This current ran through European nineteenth-century painting, in the work of Paul Delaroche in France and Wilhelm von Kaulbach in Germany, for example, or, somewhat later, of the Pre-Raphaelites in England. Perhaps the major center of this kind of Victorian, middle-class, anecdotalized history painting was Düsseldorf, where Leutze studied, taught, and spent most of his active life. He was born in Württemberg, Germany, was taken to Fredericksburg, Va., as a child, and in 1841 went to Düsseldorf. There he became something of an institution and a *pater familias* to the

464 Henry Peters Gray. *Greek Lovers*. 1846. Oil on canvas, 40⅛ × 51½″. The Metropolitan Museum of Art, New York. Gift of William Church Osborn, 1902

465 Emanuel Leutze. *Washington Crossing the Delaware*. 1851. Oil on canvas, 12′5″ × 21′3″. The Metropolitan Museum of Art, New York. Gift of John S. Kennedy, 1897

466 John Singleton Copley. *Watson and the Shark*. 1778. Oil on canvas, 71¾ × 90½″. National Gallery of Art, Washington, D.C. Ferdinand Lammot Belin Fund, 1963

many American students who gravitated to the city after 1849, when Americans were introduced to German painting with the opening of the Düsseldorf Gallery in New York. Leutze painted his famous *Washington Crossing the Delaware,* now destroyed, and also a larger version in 1851 (plate 465), which was brought to America for exhibition and engraved. Instantaneously and universally successful, it has remained an integral part of American mythology. It exists uneasily between nobility and banality, neither so heroic as patriotic sentiment would see it nor so insipid as aesthetic judgment would make it. Seriously conceived, well composed, and painted with broadness and spirit, it does not fail either as image or as illustration but only in the most profound aesthetic sense as a work of art. Compared with Copley's *Watson and the Shark* (plate 466) or Géricault's *Raft of the Medusa* (plate 467), it lacks the former's emotional intensity, compelling

even with its naive errors, and the latter's heroic realism.

In 1859 Leutze settled permanently in the United States, and Congress, shortly after, commissioned him to paint *Westward the Course of Empire Takes Its Way* for the new Capitol extension. A picture with no redeeming features, completely disorganized in composition, slipshod in execution, and garish in color, *Westward* lacks even the popular imagery of the *Crossing.* At about the same time Congress commissioned several other historical paintings for the extension: James Walker's *Battle of Chapultepec* (1857–62) for the West Staircase of the Senate Wing; William H. Powell's *Perry's Victory on Lake Erie* (1865–75), an enlarged version of a painting he had done for the Ohio State Capitol, for the East Staircase; and two large landscapes by Albert Bierstadt: the *Discovery of the Hudson River* (1874) and the *Expedition under Vizcaino, Landing at Monterey, 1601* (1875).

467 Jean-Louis-André Théodore Géricault. *The Raft of the Medusa*. 1818–19. Oil on canvas, 16'1¼" × 23'5⅞". The Louvre, Paris

THE DECLINE OF PORTRAITURE

The demand for portraiture in the first half of the nine-teenth century increased as the middle class grew in numbers and affluence. Until the Civil War it remained the most important and stable source of income for the majority of artists. Even the spread of photography, at least at the beginning, had little effect on the stability of the portrait market. While the photographic portrait put an effective end to miniature painting, the large-scale, colored oil painting still carried status, and portraits based on photographs even increased the production of painted portraits. But, as a taste for a more varied range of subject painting developed, fewer artists of stature turned to portraiture. The result was a proliferation of mediocre, largely routine, almost indistinguishable like-nesses with neither character nor artistic interest. Eventu-ally the influence of the camera produced a mechanical repetition of pose, expression, and finish, so that the painted portrait looked like the tinted photograph which was originally intended to imitate the painted portrait.

The first generation of nineteenth-century portrait painters came out of the elegant tradition of Stuart, though some, like Sully, lived on into the sentimental decades of the Victorian era. All the larger cities and

most of the smaller ones had their local coteries of por-traitists, and many of the lesser centers were also serviced by well-known painters who visited the South in season or itinerants who followed the settlers to the western frontier. Boston was dominated by Stuart, of course, but it also had Henry Sargent, and James Frothingham (1786–1864), a minor echo of Stuart, and the young Samuel F. B. Morse before they moved to New York. Aside from the artists of loftier pretensions from Trum-bull down, the New York market was dominated in these years by Jarvis and the team of Waldo and Jewett, whose products varied from solid competence to slipshod hack-work. Sully, undoubtedly the best portrait painter of his generation, was active most of his long life in Philadel-phia. Rembrandt Peale worked in Baltimore, as well as Philadelphia and New York, and Charles Bird King painted in Washington, D.C., for many years, while lesser artists filled the steady demand for portraits throughout the country, leaving a staggering gallery of faces with little historic and less aesthetic significance.

Thomas Sully (1783–1872) was a painter of talent, so-phistication, and charm, who produced about two thou-sand portraits and five hundred "fancy" pictures. Too many of these were potboilers, but enough of them have quality to raise him above the ruck of journeymen face painters. The best of them, and most are relatively early,

exhibit a fairly solid technical ability, a native elegance, a lightness of touch, and a Romantic sense of mood which is both pensive and sweet, although the sweetness with time became rather sentimental. Sully had a varied and not very easy early life, during which he absorbed many different influences. He went to Charleston from England as a child, then moved to Richmond, where he received some training in miniature painting from his brother, Lawrence. He seems to have worked for Jarvis for a short time in New York and in 1807 was in Boston, where he was befriended by Stuart, who permitted him to watch as he painted and offered him some criticism. The Stuart influence is especially strong in his early career. Sully is the only portrait painter who retained something of Stuart's fluency of manner and elegance of touch, qualities reinforced by his trip to England in 1809, when he was impressed by the Romantic virtuosity of Sir Thomas Lawrence. In 1810 he settled in Philadelphia, where he remained, except for professional visits to other cities and a second trip to England in 1837–38, during which he painted his famous *Queen Victoria*.

Characteristic of Sully's earlier style is the solidly im-

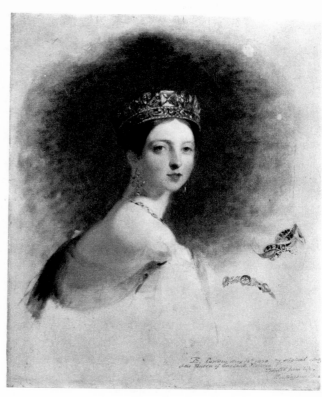

469 Thomas Sully. *Queen Victoria*. 1838. Oil on canvas, 36 × 28¼". The Metropolitan Museum of Art, New York. Bequest of Francis T. S. Darley, 1914

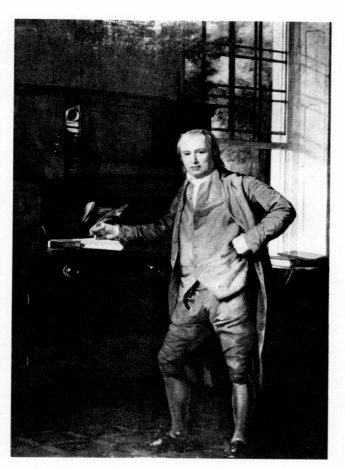

468 Thomas Sully. *Samuel Coates*. 1812. Oil on canvas, 8'9" × 6'3". Pennsylvania Hospital, Philadelphia

pressive *Samuel Coates* (1812, plate 468), combining a straightforward rendering of personality and a new sophistication in the handling of an unusual, even daring composition for the time and place. The full-length figure in a spacious interior bathed in both light and air is well realized and painted with grace and assurance. His later portraits are more floridly Romantic and earned him the designation of the "Lawrence of America." With time he became more superficially fluent and spirited in his brushwork in the manner of the English master but without the latter's brilliance. The *Queen Victoria* oil sketch (1838, plate 469), painted from life, has a light and airy elegance that is lost under the weight of sentimental pomposity in the full-scale version (Collection Arthur A. Houghton, Jr.).

In comparison with Sully, his contemporaries were as determinedly pedestrian as their sitters were middle class. Aristocratic airs and psychological vitality had given way to the staidly sober and the conventionally pretty. Although John Wesley Jarvis (1780–1840) was an unexpected early bohemian, a charming, roistering *bon vivant* and wit, he painted hard, precise portraits with solid competence and only rare flashes of inspiration. Later his style loosened up a good deal, and occasionally, as in the unfinished portrait *Alexander Anderson* (1815, plate 470),

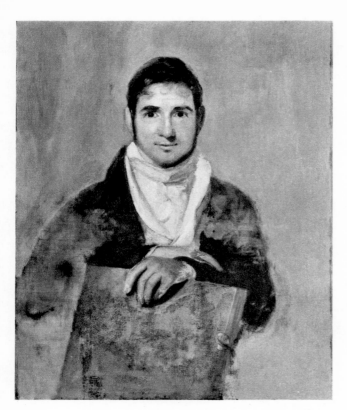

470 John Wesley Jarvis. *Alexander Anderson, M.D.* 1815. Oil on canvas, 34 × 27″. The Metropolitan Museum of Art, New York. Gift of Robert Hoe, Jr., 1881

Aside from John Neagle (1796–1865), who was influenced by his father-in-law, Thomas Sully, and falls between the two generations, the succeeding group of portrait painters turned from the loose brushwork of the Stuart-Lawrence tradition to a tighter and more polished style, presaging the photographic vision of the mid-century. Neagle was an uneven painter and is remembered almost exclusively for the famous portrait of *Pat Lyon at the Forge* (1826–27, plate 471), unusual for the time in its genre-like depiction of the blacksmith working at his craft, a conception expressly demanded by the affluent but democratically minded client. The intended humility is transformed into theatricality by the Romantic though somewhat limp bravura of Neagle's version of the Stuart manner. It is almost as if Longfellow's "Village Blacksmith," of whom Pat Lyon was the prototype, were running for public office on the Populist ticket.

Chester Harding (1792–1866), in age at least, stands, like Neagle, between the two generations, but since his introduction to painting was belated, he is identified with the younger men. Harding's life was a typical American rise from rags to riches. After an early life spent at hard

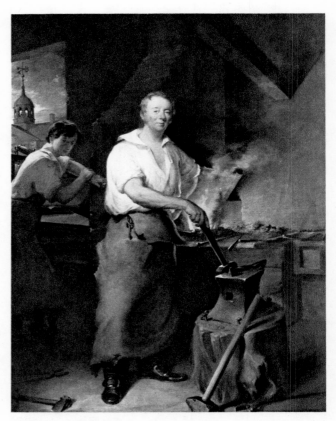

471 John Neagle. *Pat Lyon at the Forge.* 1826–27. Oil on canvas, 93 × 68″. Museum of Fine Arts, Boston, on loan from Boston Athenaeum

Jarvis's flashing spirit comes through. He was essentially a face painter and often collaborated with others in turning out a finished product—from 1802 to 1810 with Joseph Wood (c. 1778–1830) and later with Henry Inman, who served as an apprentice from 1814 to 1822. Such partnerships were common, indicating the routine factory production of portraits to meet the demand. With Jarvis doing the face and hands and Inman the background and costume, they could turn out a portrait a day.

The most successful partnership of the time was that of Samuel Lovett Waldo (1783–1861) and William Jewett (1789/90–1874), who collaborated from about 1818 to 1854. Waldo, the face painter of the pair, was born in Connecticut, went to England in 1806 with introductions to West and Copley, and studied at the Royal Academy. He set up shop in New York in 1809 and took in Jewett, also from Connecticut, as a student in 1812. As with Sully, Waldo's style was based on the later manner of Stuart and influenced by that of Lawrence. In his own earlier work he reveals a decided if somewhat limited talent and a perceptive eye for character. However, the joint efforts of Waldo and Jewett are routinely competent portraits of sober citizens, somberly dressed and formally posed, without much psychological or artistic impact.

farm labor on the western frontier, he became an artisan painter and, after picking up the rudiments of portraiture from an itinerant, traveled through the hinterlands in search of sitters. He was successful enough to establish his family in the East and in 1823 to finance a trip abroad. Even in London he met with success, and on his return to Boston in 1826 his popularity continued unabated. Over a thousand portraits bear witness to his industry, though the products of his brush rarely rise above the level of the flattering yet faithful likeness.

Henry Inman (1801–1846) was generally considered the best portrait painter of his day, but his sentimentalized, prettified, and highly polished pictures now have minor interest as records of the questionable taste of another era. Born in Utica, N.Y., he began his career under Jarvis at an early age and set up independently in New York in 1823. After several years (1831–34) in Philadelphia as the partner of Cephas G. Childs in a lithography firm and as a portrait painter, he returned to New York, where he worked for the rest of his life, except for a short trip to England in 1844. Inman was not much interested in portraiture, considering it only a livelihood, but he was too successful at it during most of his career to abandon the trade for some higher artistic ideal. His innate talents were scarcely challenged, and much of his work in genre as well as portraiture wallows in sentimentality, but the small *Self-Portrait* (1834, colorplate 49), executed in a single sitting to demonstrate his procedure, is rich in painterly qualities so rare at the time: immediacy of attack, a feeling for pigment as an element of expression, and a sensitivity to the realities of light and texture rather than the formulas for their re-creation.

Even more than those of Inman, the works of Charles Cromwell Ingham (1796–1863) exploited the taste for sentimentality and high finish. Born and entirely trained in Dublin, Ingham migrated to America in 1816 with a technique of complex glazing in bright colors and meticulous rendering of detail which brought him instant success. He became an important figure in the New York art world and for almost fifty years turned out a succession of simpering porcelain dolls in elaborate costume and decor (his mannerisms did not lend themselves well to male portraiture). Many of his sentimentally anecdotal portraits of females today appear either ludicrously mawkish or delightfully camp. The *Amelia Palmer* (c. 1829, plate 472), perhaps his masterpiece, is both but, in spite of its cloying sweetness and artificiality, is somehow fresh and ingenuous.

In the second quarter of the century styles in portraiture were quite varied. Trumbull and Vanderlyn were still active to a certain degree, and Stuart's style was carried on by a host of provincial imitators. The younger generation of more literal painters, born about the turn of the century, were well launched, to be followed toward the middle of the century by a new group which clearly showed the influence of the camera and which carried

472 Charles Cromwell Ingham. *Amelia Palmer*. c. 1829. Oil on canvas, 68 × 53½". The Metropolitan Museum of Art, New York. Gift of Courtlandt Palmer, 1950

well into the second half of the century, when portrait painting as a profession declined sharply.

The portraits of Charles Loring Elliott (1812–1868) illustrate this evolution most clearly: the early ones of the thirties influenced by Stuart, then those of the forties in the Inman manner, and finally during the last years of his life an increasing dependence upon photography, even to copying directly from photographs. Elliott, born in upper New York State, the son of an architect, went to New York City, where he was advised against becoming a painter by Trumbull, who seems to have made a practice of dissuading all aspirants from entering the field. But he drew from casts at the Academy and studied with Trumbull and for a short time with Quidor. After some ten years as an itinerant in upstate New York, he returned to the city about 1839, becoming after Inman's death the leading New York portraitist. His technique was solid, his eye for likeness phenomenal, and his insight into character superior to that of any of his contemporaries. Although uneven, the best of his earlier works are modest but competent and revealing studies. An almost fanatical attention to detail led in his later portraits, dependent on photographs, to dryness and a deadly mechanical precision.

By far the most successful of this generation of portrait painters was George Peter Alexander Healy (1813–1894), who achieved an international reputation and painted many outstanding personalities of the time, from Lincoln to King Louis-Philippe. Healy's immense popularity can be explained in part by his personal charm, his ability to produce a flattering likeness, and the speed of his execution, but also by the new phenomenon of "official" taste, which seemed to demand a standardized, noncontroversial, even "nonartistic" product. Since the development of photography, public figures have rarely been painted by major artists, but by specialists in painting public figures. Healy went from Boston to Paris in 1834, studied with Baron Gros for a short time, and knew Couture very well. His style was thus in the French academic tradition rather than American, a mixture of Ingres and Victorian Romanticism. Healy lived in Paris for many years, but he traveled constantly between the continents, painting an incredible number of portraits. Though lacking in inspiration, he was an extremely competent craftsman, capable of handling a full-length figure in space with dignity and often with some power. He was, in short, a respectable painter for a society devoted so wholeheartedly to respectability.

CHAPTER FOURTEEN

Images in Marble and Bronze

The efflorescence of American sculpture during the Jacksonian Era is one of the strangest chapters in American art. In 1816 North Carolina could find no native sculptor equipped to execute a monumental statue of Washington. The closest approach to the heroic was the Rush *Washington* (plate 306), done two years earlier, which went begging. In 1820, John Trumbull advised the young Frazee that "nothing in sculpture would be wanted in this country for yet a hundred years." Yet scarcely more than six months after the destruction of the Canova *Washington* at Raleigh, an American, Horatio Greenough, was commissioned to do a monumental statue of Washington for the Rotunda of the Capitol, and by the mid-thirties three leading sculptors of the period, Greenough, Crawford, and Powers, the first of a long list of expatriates, were working in Italy.

Why this sudden interest in an art that had so long been ignored? Demand certainly played a part; the munificent sums paid as commissions also must have been important. But why such high prices and ready approval when commissions for painting were so restricted? Greenough received $20,000 for his *Washington,* Powers $19,000 for a bronze of Daniel Webster for Boston, Crawford $53,000 for his work on a Washington monument in Richmond, and Mills $50,000 for one in the capital. Even with the cost of materials and labor, the money paid was substantial. Was it because sculpture appeared more tangible and permanent than painting, or, like architecture, more official? On a cultural level, sculpture, especially in white marble, was closer to the dominant Neoclassic taste. Sculpture was also more clearly an expression of America's political identification with the Classical past than was the more private and personal Romanticism of painting.

The Classical style, set by the foreign sculptors and the architects who hired them, was both the accepted art of the present and the most revered art of the past. Given this unanimity, the subsequent direction and attendant dilemmas of American sculpture are understandable. In fact, the dilemma of American culture, the accommodation of the common with the ideal, is nowhere more pronounced than in sculpture. Riven by the extremes of a provincial and plebeian naturalism and an aristocratic Classical idealization, by an artisan aptitude and the loftiest of aesthetic theories, by a hard-headed Yankee shrewdness and the imputed spirituality of art, it often found reconciliation in a delusive sentimentality. If, in the few years it took to learn the rudiments of his craft, a country boy or urban artisan became an international figure in art, how could he distinguish between common sense and ideas, between reality and art, between mechanics and aesthetics? Perhaps sculpture attracted so many mechanical and literal-minded men because it is so close to technology, so concerned with the alteration of material in a physical sense. Nor is it accidental that while their contemporaries were inventing the cotton gin, the apple parer, and the bridge truss, so many American sculptors developed mechanical devices for executing statuary. To many of them sculpture was strictly manufacturing a product to please the public.

Within the Neoclassic mode, sculptors who remained in the United States were in general more naturalistic and less stereotyped than their compatriots working in Rome or Florence, because they were farther removed from the Neoclassic source and they did their own carving. The expatriates chose to work in Italy not only because it was the home of Classicism and fine Carrara marble was cheap but because expert stonecutters could be hired at a pittance. The truth is that most American sculptors were incapable of carving their own works. Many created little more than the original clay model, which was then cast in plaster, pointed up, and finally cut by Italian craftsmen. They believed that the original idea was all and that execution was routine and wasteful of time and genius. If they produced copies of their works without aesthetic qualms, it was perhaps because the originals were no more than copies. What they did not realize is that the high level of available craftsmanship reduced all their works to the same polished inanity. It is as if the production of all the American expatriates were the creation of a single anonymous hand. Nathaniel Hawthorne had a more perceptive eye than his artist friends when he noted

473 Robert Ball Hughes. Model for George Washington equestrian monument. 1834. Plaster, height 35½". Society for the Preservation of New England Antiquities, Boston

474 Robert Ball Hughes. Model for *Nathaniel Bowditch*. 1846. Plaster, height 63". Boston Athenaeum

in *The Marble Faun,* a fascinating account of the expatriate world, that somehow the promise of the model was always lost in the execution.

By contrast, of all the sculptors who migrated to the United States, only the London-born Robert Ball Hughes (1806–1868) went through the process of artistic naturalization. Trained at the Royal Academy and in the studio of Edward H. Baily, he won several prizes before going to New York in 1829. He worked also in Boston and Philadelphia during the 1830s, finally moving to Boston in 1840. He had some early recognition, being more accomplished than the self-taught local competition, but never achieved financial success or great status. He may have suffered discrimination in favor of the emerging native talent and may have been personally improvident and untrustworthy. Still his career seems to have been dogged by fate. His project for a colossal Washington monument for the Bowling Green park in New York got no further than the proposal; the plaster group of *Uncle Toby and the Widow Wadman* (1833–34), taken from Sterne's *Tristram Shandy,* is now lost; his famous *Alexander Hamilton* (1834), done in marble for the New York Merchants' Exchange, was destroyed by fire; the George

Washington equestrian monument in Philadelphia, for which he did a remarkably spirited model (1834, plate 473), did not materialize; and the same model was rejected for Union Square, New York.

Hughes remains a somewhat enigmatic and tragically distorted transitional figure who might have led American sculpture out of the confines of Neoclassicism, even though he was schooled in that tradition. In his portraiture there is a strong sense of reality rather than Neoclassic ideality. In spite of toga and stylized hair, the bust portrait of *John Trumbull* (1834, Yale University Art Gallery, New Haven) exhibits an unusual concern for the particular and a forceful expression of personality. In a similar vein, he broke with convention in representing for Mount Auburn Cemetery the life-size seated figure of *Nathaniel Bowditch* (1846) in modern dress, a straightforward, almost literal conception that is the most impressive of his extant oeuvre (plate 474). In his years in America he had difficulty making a living, even when sculptors were receiving munificent government commissions and fees for marble copies of their works cut by Italian craftsmen. His impact was transitory, and he is now almost forgotten.

EXPATRIATES: THE FIRST GENERATION

Horatio Greenough (1805–1852), the first to harken to the siren call of Neoclassicism and settle in Italy, does not fit the common expatriate pattern. A proper Bostonian, educated at Harvard and a product of transcendentalism, a friend of Emerson and a disciple of Allston, a handsome man and a brilliant conversationalist, he moved with grace in the highest social and intellectual circles at home and abroad. He was as sophisticated an intellectual as American culture produced at that time. He had become interested in sculpture early in life and consciously dedicated himself to it as a career. His early training was rudimentary, mostly technical, but he had the new casts at the Boston Athenaeum to copy and Washington Allston to talk to. In 1825 he left for Rome, where he joined the painter Robert Weir. Encouraged by Thorwaldsen, to whom he had a letter of introduction, he settled down to drawing from the antique in the galleries and the nude at the academy and to working in his studio. He produced a number of portrait busts and his first ideal piece, *Abel* (1826), which was sent home for exhibition and was praised by Allston. In 1827 he was stricken by what was called the "Roman Fever," probably malaria, and forced to return home. Having recovered his health, he spent the next year seeking portrait commissions in Boston, Baltimore, and Washington, where his connections led to portraits of the President, John Quincy Adams, and the Chief Justice, John Marshall.

Greenough went back to Italy in 1828 to have his plasters done in marble at Carrara and then settled in Florence amid the growing American colony. He shared an apartment with Thomas Cole and met James Fenimore Cooper, who, intent on fostering the cultural elevation of the United States, commissioned Greenough to execute a group based on the singing *putti* of Raphael's *Madonna del Baldacchino*. The *Chanting Cherubs* (1828–30, now lost) was the first major work in marble by an American and was exhibited in several cities. Its reception was mixed and disturbing. The artistic concepts which attracted Cooper and Greenough were still foreign to the American public, which could react with such shock to the nudity of the infants that they had to be draped and was disappointed that they did not actually sing. The contradiction between elitist aesthetics and popular taste tore at the heart of Greenough's beliefs, for he was a sincere democrat who had faith in common sense and in the ultimate cultural sovereignty of the public. He could never reconcile his own standards with those of the mass nor understand why his noblest conception, the *Washington,* became an object of ridicule.

Nevertheless, the *Chanting Cherubs* established Greenough's reputation as the premier American sculptor. Through the urging of Cooper and Allston and the intercession of Daniel Webster, Greenough was commissioned by Congress in 1832 to execute a statue of Washington for the Rotunda. The clay model of the colossal *George Washington* was finished in 1835; then followed the long process of production from plaster casting to cutting in stone, and the finished marble (plate 475) was finally set in place in 1841. Based on the lost *Olympian Zeus* of Phidias, reconstructed in a publication of Quatremère de Quincy in 1800, the heroic figure of Washington is nude to the waist, drapery covering the legs and hanging over the right upper arm. However informed Greenough's rationale, it should have been obvious that the American public would not accept its mythic hero partially wrapped in a sheet, regardless of his imposing mien. The unexpected nudity may have blinded the public to the power and dignity of the conception, but in a more profound sense the work fails because the insistent naturalism of the head, based on the Houdon portrait as specified in the contract, contradicts the almost abstract nobility of the rest of the figure. It *is* an imposing figure, canonical in proportion, simple and majestic in its mass. It is also surprising that, with all his careful study of conditions, Greenough should have misjudged the harshness of the light in the Rotunda. He asked to have the statue moved outdoors, with even more disastrous results. In the expanse of the Capitol grounds it lost its scale, was soiled by weather and pigeons, collected puddles in the lap, and in general looked uncomfortable.

475 Horatio Greenough. *George Washington.* 1840. Marble, height 12'. Museum of Science and Technology, Smithsonian Institution, Washington, D.C.

Greenough was also commissioned in 1839 to do a group to balance Persico's *Discovery* (plate 297) for the Capitol staircase. *The Rescue,* which represented the "heroic" struggle between the white settlers and the "savage" aborigines, occupied his last years and was erected after his death by Clark Mills, who has been blamed for ineffectively assembling the individual figures into a group, for which Greenough left no instructions. On balance, in spite of a serious commitment to his art and his pioneering efforts, Greenough's sculpture remains unimaginative in its naturalism and pedantic in its Classicism. Only his *Washington* attains artistic stature. He might have done better in some other field, for he had a first-rate intelligence, and his theoretical writings on art, published just before his death as *The Travels, Observations and Experiences of a Yankee Stonecutter,* under the pseudonym of Horace Bender, are more important contributions than his sculpture. As Emerson observed, "Horatio Greenough . . . was far cunninger in talk than his chisel to carve. . . ." Greenough's proposition of the fundamental significance of *function* in the creation of form, though little noted at the time, is one of the most trenchant and generative aesthetic statements of the nineteenth century.

Greenough was joined in Italy by Thomas Crawford (1811/13–1857) in 1835 and Hiram Powers (1805–1873) in 1837. Powers, of lowly origin, out of the Middle West, and with a mechanic's background, was to become America's most famous sculptor. Originally from Vermont, he moved as a boy to Cincinnati and, after his father's death, worked in a local clock and organ factory. He had taken up sculpture as a hobby and received basic instruction in modeling and casting from Frederick Eckstein, who had settled in Cincinnati. The combination of skills led to his employment in 1828 at Dorfeuille's Western Museum, first as supervisor of the mechanical section and later in the arrangement of wax-work tableaux. His earliest sculptural efforts prompted Nicholas Longworth, the patriotic Maecenas of Cincinnati artists, to finance a trip to Italy for him. Powers got only as far as New York, but there he must have seen real sculpture before returning to Cincinnati.

In 1834 Longworth supplied the backing for a move to Washington, where Powers was an instant success with his *Andrew Jackson* (c. 1835, plate 476). In spite of its Neoclassic toga, the bust is realistic without being literal, revealing a search for personality, and achieving a simple dignity. In Washington Powers modeled likenesses of various famous personages in American politics, among them Marshall, Calhoun, Webster, Van Buren, and John Quincy Adams. After adding others in New York and Boston, he moved to Florence in 1837 to have the portraits cut in stone and remained there the rest of his life.

Greenough helped Powers get established and even commissioned portraits of himself and his wife. Before long Powers emerged as one of the leading portraitists of

476 Hiram Powers. *Andrew Jackson.* c. 1835. Marble, height 34½". The Metropolitan Museum of Art, New York. Gift of Mrs. Frances V. Nash, 1894

the time, highly esteemed by Thorwaldsen and Greenough, and is said to have produced some one hundred fifty busts, commanding as much as $1,000 for a marble. His Italianate style was obviously affected by Greenough and Neoclassicism, and his portraits became more idealized and polished. How much of this was due to Italian cutters is hard to say, but the portraits are also imbued with a Romantic spirit, characterized by Wayne Craven as "Byronic," to be found earlier in the work of Greenough and, later, other expatriate sculptors.

For a sculptor, as for a painter of that period, portraiture was an inferior occupation, except in a monument. Powers graduated from the portrait to the ideal bust with the *Ginevra* (1838, Cincinnati Art Museum), well received, though it had not the success of his *Proserpine* (1839), of which more than a hundred copies were made at $400

477 Hiram Powers. *The Greek Slave.* 1847. Marble, height 65½". The Newark Museum, Newark, N.J.

apiece. Despite meager training in anatomy, he began to work on ideal figures as early as 1838, and *The Greek Slave* (plate 477), undertaken in 1843 and the first of his figures to be carved in marble, made his reputation as America's Michelangelo. Exhibited at the Crystal Palace in London in 1851, it was bought by an English lord for $4,000. Six copies went at the same price, a smaller replica also sold well, and *The Greek Slave* grossed $23,000 on its tour of the United States. The fabulous success of this routine adaptation of the *Medici Venus* was a triumph of shrewd Yankee merchandizing, which included an advance man, promotional literature, and the proper clerical endorsements. Selling a life-size marble female nude to prudery-ridden America when women were padded, corseted, and ruffled to resemble mobile fortresses took persuasion by means of political sympathy, Christian morality, and a large dose of sentimentality. Represented as a pathetic captive of the infidel Turks, the chained girl in her nudity became a symbol of inviolable Christian virtue. Without the libretto she remains an ungainly and bloodless manikin. Powers tried to mine the vein of nudity with a series of ideal female figures, none of which matched the popularity of *The Greek Slave,* though the *California* (1858, plate 478), elegant, enigmatic, and almost sexless, for which William B. Astor paid $7,500, is a more intriguing figure.

Powers's growing international reputation finally brought him monumental commissions—the *John C. Calhoun* (c. 1845), an over-life-size figure of the legislator in Roman toga, which was destroyed by fire, and the bronze *Daniel Webster* (1858, Boston State House) in modern dress, a frozen, pompous effigy which was much criticized, especially for the great man's baggy pants. Finally, in 1859 Powers was awarded his only major government commission—the over-life-size marbles of *Benjamin Franklin* and *Thomas Jefferson,* erected in 1863, the former in the Senate and the latter in the House, for which he received $25,000.

Embalmed in the encomiums of an international reputation, Powers continued to produce portraits and echoes of his ideal sculpture long past their time, and the glamour of his name was faded before his death. Though he acted his role of authentic genius for American visitors and the world in general, he remained always a Yankee in Italy—provincial, hard-headed, practical, and narrow-minded. He equated art with mechanics, and there was little in his work that rose above the level of cliché.

If "manifest destiny" demanded an American culture hero as symbolic evidence of the westward course of civilization, it found Thomas Crawford personally, though hardly artistically, a more fitting object of idolatry than even Hiram Powers. Of modest background, personable, talented, happily married to a woman of breeding and wealth, surrounded by influential friends, Crawford was more successful in his short career than any other American sculptor of the time. He was hailed

478 Hiram Powers. *California.* 1858. Marble, height 71″. The Metropolitan Museum of Art, New York. Gift of William B. Astor, 1872

as a "Grecian genius," compared with Phidias, and nominated to inherit the mantle of Canova and Thorwaldsen. But with all the acclaim, there is little in his voluminous output that seems worth a second glance.

Born in New York City of Irish parentage, Crawford was apprenticed to a woodcarver in 1827 and continued his studies at the National Academy by sketching from its casts. In 1832 he found employment with the stone-cutting firm of Frazee & Launitz, and it was Robert Launitz, a student of Thorwaldsen, who had the greatest formative influence on Crawford and sent him to Rome in 1835 with a letter of introduction to Thorwaldsen, who accepted him as a student. Crawford, the first American sculptor to settle in Rome, became the most dedicated of American Neoclassicists. His first works, however, were portraits ordered by traveling Americans, among them that of *Charles Sumner* (1839, plate 479), the brilliant orator and later senator from Massachusetts, who became his devoted friend. The polished elegance of its Byronic Neoclassicism is typical of his portraits of that period and almost identical with those of Greenough and Powers at the same time.

Like his compatriots, Crawford was soon immersed in projects for ideal themes and in 1839 began work on the *Orpheus and Cerberus* (plate 480), which was to make his reputation. Through the efforts of Sumner, the *Orpheus,* carved in stone in 1843, was exhibited in Boston in 1844 and received with rapturous enthusiasm. The statue was accompanied by a scenario that appealed to Victorian sentimentality—ill-starred lovers, death, fidelity, resurrection, grief, mystery, and beauty—and an iconographic description of every detail, gesture, and implied emotion. It was the first nude male statue, though fig-leafed, to be shown in the United States, but clothed in such piety that it could hardly offend. In fact, it is a rather pedestrian variation on the *Apollo Belvedere,* only one of many ideal subjects that came from Crawford's teeming mind in the early forties—Neoclassic, saccharine, and banal. In spite of the proselytizing of Sumner and Crawford's wife, daughter of an influential New York family, he received no important commissions until he won the competition for the *Washington Monument* (plate 494) in Richmond in 1849. Then followed an avalanche of commissions: the *Beethoven* for the Music Hall in Boston (1853); the Senate pediment and portal sculptures (plates 481, 482); and in 1855, the colossal *James Otis* for Mount Auburn Cemetery, the *Armed Freedom* that tops the dome of the Capitol, and the bronze doors of both the Senate and the House of Representatives. The remaining years of Crawford's life were spent in feverish activity, preparing sketches and models, executing figures in clay, supervising their casting in plaster or in bronze or their carving in stone, working on ideal themes.

Much of Crawford's work was left unfinished at his death, some to be completed by other sculptors. Even so, he accomplished an incredible amount. Considering the

32 Henry Austin. Morse-Libby House (Victoria Mansion), Portland, Me. 1859

33 Thomas Cole. *The Course of Empire: Destruction.* 1833–36. Oil on canvas, 39 × 61″. The New-York Historical Society

34 Asher B. Durand. *The Beeches.* 1845. Oil on canvas, 60⅜ × 48⅛″. The Metropolitan Museum of Art, New York. Bequest of Maria De Witt Jesup, 1915

35 Samuel F. B. Morse. *Chapel of the Virgin at Subiaco*. 1830–31. Oil on canvas, 30 × 37″. Worcester
Art Museum

36 John F. Kensett. *The Shrewsbury River*. 1859. Oil on canvas, 18 × 30″. The New-York Historical Society

37 Thomas Worthington Whittredge. *Camp Meeting*. 1874. Oil on canvas, 16 × 40¾″. The Metropolitan Museum of Art, New York. Lazarus Fund, 1913

38 Fitz Hugh Lane. *Schooners Before Approaching Storm*. 1860. Oil on canvas, 23½ × 28″. Private collection, New York

39 Martin J. Heade. *Approaching Storm: Beach near Newport.* c. 1860. Oil on canvas, 28 × 58¼″.
Museum of Fine Arts, Boston. M. and M. Karolik Collection

40 Frederic E. Church. *Cotopaxi.* 1862. Oil on canvas, 48 × 85″. Collection John Astor, New York

41 Albert Bierstadt. *Merced River, Yosemite Valley*. 1866. Oil on canvas, 36 × 50″. The Metropolitan
Museum of Art, New York. Gift of the sons of William Paton, 1909

42 George Inness. *Peace and Plenty*. 1865. Oil on canvas, 77⅝ × 112⅜". The Metropolitan Museum of
Art, New York. Gift of George A. Hearn, 1894

43 William Sidney Mount. *Long Island Farmhouses.* 1854–59. Oil on canvas, 21⅞ × 29⅞″. The Metropolitan Museum of Art, New York

44 Richard Caton Woodville. *Politics in an Oyster House.* 1848. Oil on canvas, 16 × 13″. Walters Art
Gallery, Baltimore

45 John Quidor. *The Money Diggers*. 1832. Oil on canvas, 16¾ × 21½″. The Brooklyn Museum. Gift of Mr. and Mrs. A. Bradley Martin

46 George Caleb Bingham. *Shooting for the Beef*. 1850. Oil on canvas, 33½ × 49¼″. The Brooklyn Museum

47 John James Audubon. *The Great Blue Heron.* 1821. Watercolor, 36 × 25⅜". The New-York Historical Society

48 William Page. *The Young Merchants*. 1842. Oil on canvas, 42 × 36″. The Pennsylvania Academy of
the Fine Arts, Philadelphia

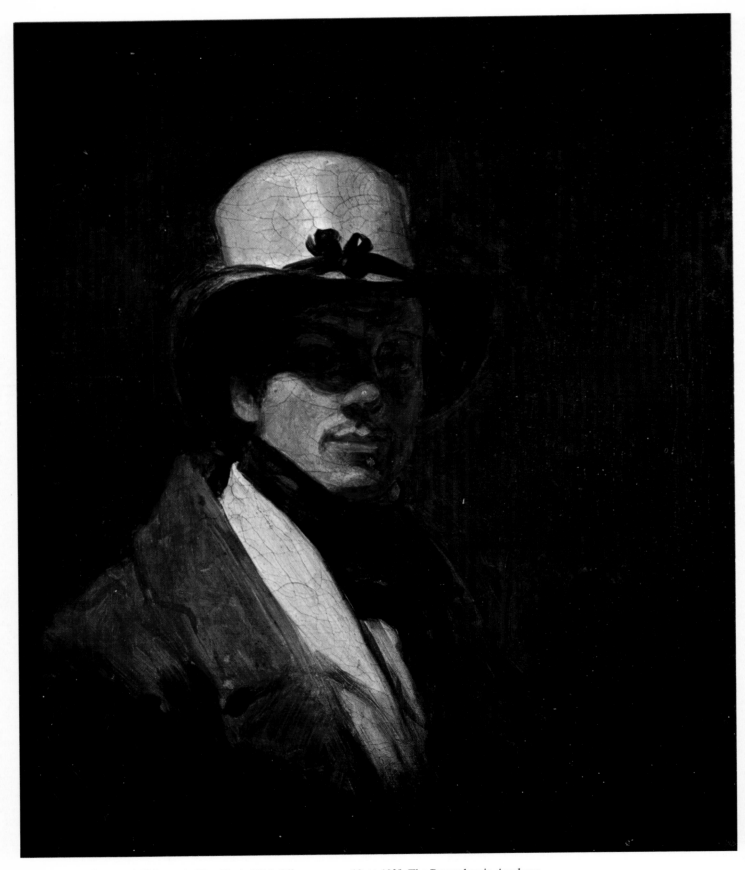

49 Henry Inman. *Self-Portrait (Top Hat)*. 1834. Oil on canvas, 13 × 10¾″. The Pennsylvania Academy
of the Fine Arts, Philadelphia

479 Thomas Crawford. *Charles Sumner*. 1839. Marble, height 27″. Museum of Fine Arts, Boston. Bequest of Charles Summer

480 Thomas Crawford. *Orpheus and Cerberus*. 1843. Marble, height 67½″. Museum of Fine Arts, Boston, on loan from Boston Athenaeum

481 Thomas Crawford. *The Progress of Civilization*. 1855. Marble, width 60′. Pediment, east front, Senate Wing, U.S. Capitol, Washington, D.C.

482 Thomas Crawford. Senate doors. 1855 (executed by William Rinehart, 1863–65). Bronze, height 14'. East entrance, Senate Wing, U.S. Capitol, Washington, D.C.

course in the United States. Only Greenough was an authentic Neoclassicist; the rest—Powers, Crawford, and their later followers—were Victorians and academic eclectics. Greenough, who sensed the underlying principles of the Classic Revival, was led in the end to expose their perversion. For the others, the Classic tradition was merely a repertory of antique exemplars to be plagiarized or adapted to a national mythology or a Victorian sentimentality. Though they set a level of academic training and professional practice in sculpture, the dead hand of tradition managed to stultify the development of American sculpture for almost half a century.

SECOND-GENERATION EXPATRIATES

For the American sculptors who worked in Italy in the forties and fifties, the visual experience of Classical statuary was still the dominant note, even if the content had changed. It is curious that, surrounded as they were with Renaissance and Baroque sculpture, there should have been so little conscious response. When American sculptors finally reacted to the Baroque, it was not through firsthand experience in Rome but via the neo-Baroque Beaux-Arts style that emerged in Paris during the Second Empire. The second-generation Neoclassicists were essentially academic eclectics who mixed modes without the slightest unease, blindly and happily convinced that they were working in the purest vein of Classical principles.

Their art was Victorian in its pseudo-cultural pretensions, its literal naturalism, its ideality, and its Romantic penchant for the mysterious and the exotic, along with a puerility of imagination, emotional triviality, and pious sentiment. Made for a public that confused art with literature and form with reality, it was clothed in poetic allusion and rendered with prodigious detail. Its creators lived a charade of artistic dedication while turning out a marmorean commodity with all the efficiency of industrial producers. In opting for Italy, because it was culturally satisfying and because materials, living, and labor were cheaper, the second generation, unlike their predecessors, who had come to discover an art form, removed themselves from their native land without cutting their cultural ties, for it remained their market. They simply ignored the life and problems of America, though their handiwork peopled the parlors of the nation.

During the forties Florence continued as the American expatriate center. The Cincinnatian Shobal Vail Clevenger (1812–1843), aided by Nicholas Longworth, arrived there in 1840. The son of a poor weaver, Clevenger had been apprenticed to a stonecutter and then worked with David Guion, carver of funerary monuments. Largely self-taught, he began doing portraits in the early thirties and in 1837 left for the East, where he soon became the lead-

heroic scale of his ambition and the fertility of his imagination, it is difficult to understand the banality of his production. He transformed Neoclassicism in his American monumental commissions into a routine academicism, performing his duties conscientiously but without inspiration.

Whatever the shortcomings of the first generation of expatriates as sculptors, they gave America its first international recognition in the field and solidified the dominance of Neoclassicism. All of them had come to the style late in its history and thus projected it beyond its normal

ing portrait sculptor in the country, since Greenough, Powers, and Crawford were already in Italy. In Washington Clevenger made, among others, bust portraits of Clay and Webster, of which many replicas were sold; then in Boston, Philadelphia, and New York he added a roll call of eminent Americans. Once in Italy, he began having his plaster busts cut in stone. A trip to Rome in 1841 led to his only essays in the ideal, *Lady of the Lake*, a bust based on the Walter Scott poem, and a full-length *Indian Chief*, both now lost. Clevenger contracted tuberculosis and died at thirty-one on the way home. The *Indian Chief*, of which a line engraving was published, was a novel American subject, though based on Classical sources. Clevenger's reputation rests on his portrait heads, most of which were done before he went abroad. Doggedly realistic and without pretense, they are strong and simple characterizations of personality with an almost Roman Republican austerity (plate 483). He was, on balance, more American in his naturalism than Neoclassic.

Though Henry Kirke Brown (1814–1886) belongs with the American-oriented sculptors of the period, he was for a short period, 1842–46, an expatriate and a convert to Neoclassicism. Brown began his artistic career as a portrait painter in Boston after studying with Chester Harding. Then, making his way to Cincinnati, he became part of the group patronized by Longworth. His friendship with Clevenger led to an interest in sculpture, and on his return to Boston he abandoned the brush for the chisel. The competition in Boston may have influenced his move to Albany, where he did portraits in sculpture and paint successfully enough to finance a trip abroad. In Florence he set to work cutting his own busts in stone, which was unusual, and, to signalize his loyalty to American art, began the *Indian Boy* (1843), which he maintained had "as much historical interest and poetry as an Apollo or Bacchus." At the end of that year, after moving to Rome, he was converted to the antique and to ideality. The crowning "treachery," as he himself put it, was to transform the *Indian Boy* into a Neoclassic *Idolino*, and the Victorian sentiment and elegance of his *Ruth* (1845, plate 484) was a successful enough mixture to call for two copies. By then Brown's work was indistinguishable from that of his compatriots in Italy. In 1846 William Cullen Bryant, sitting for his portrait, persuaded the sculptor to return to America and lend his genius to further its cultural destiny. Brown came back to pick up the lost thread of the American subject in a sequence of Indian themes.

In the fifties Chauncey B. Ives, who was well on his way to recognition, and the young Randolph Rogers moved to Rome, and although the Florentine circle was joined by Joel T. Hart in 1849, John A. Jackson in 1853, Thomas Ball in 1854, and, at the end of the decade, William Rinehart, Florence ceased to be the hub of American Neoclassicism. Most of Hart's late ideal works are lost, and his reputation rests on his naturalistic por-

483 Shobal Vail Clevenger. *Josiah Lawrence.* 1837. Plaster, height 21″. Cincinnati Art Museum. Gift of Lawrence Minor

traits; Jackson was primarily a portraitist, though he produced a few ideal themes after about 1860; and Ball, in his first Italian stay, was equally involved with portraiture. Rome remained the stronghold of Classicism almost to the end of the century, by which time the style was dead. Only Crawford and Richard Greenough had worked there in the forties, but the new decade saw the arrival of many others.

Richard Saltonstall Greenough (1819–1904) had been in Florence in 1837 to visit his older brother, Horatio, and to study art, but illness forced him to return to Boston. In the following decade, he gained a modest reputation as a portrait sculptor and decided to return to Italy, this time Rome, where he became a mainstay of the American circle from 1848 to 1853, and then again from the mid-1870s to his death. Greenough was a true eclectic, combining elements of different styles in a single work or changing styles for different occasions. His portraits are typically Victorian in their mix of idealism, naturalism, and mindless detail. He turned out his quota

484 Henry Kirke Brown. *Ruth*. 1845. Marble, height 56". The New-York Historical Society

of Classical themes, but also an American subject in the Italianate manner, the *Shepherd Boy and Eagle* (1853, Boston Athenaeum). His reputation established, Greenough returned home in 1853 as Boston's most eminent sculptor to execute the $20,000 commission for a statue of *Benjamin Franklin* (plate 485). Completed in 1855, it was cast in bronze and erected in front of Boston's City Hall the next year. This was followed by a life-size marble of *Governor John Winthrop* for Mount Auburn Cemetery. The *Franklin* is naturalistic and humane, the benign head in deep thought, the rotund torso balanced on chunky legs; and, though the detail is fussy, the figure has a homely dignity. The *Winthrop* seems consciously archaistic, a costume study in which the personality is lost in a mass of detail. It was executed in Paris, where Greenough had settled in 1856. He remained there through the early 1870s, but his work was not appreciably different from that of the Americans in Rome, evidence that academic eclecticism was by then a firmly established "international" style. His *Carthaginian Girl* (1863, plate 486) is typical of the ideal female nudes of the period, though it recalls the *Venus de Milo* rather than the *Medici Venus*. When Greenough returned to Rome, Victorian Classicism was already moribund, but he continued to work within the limits of his earlier experience, unaware that in the *Circe* (1882, plate 487) he had produced a caricature of all that Victorian sculpture had been.

Out of the same milieu as the Greenoughs came William Wetmore Story (1819–1895). Born in Salem, Mass., he was, as the son of an Associate Justice of the Supreme Court, destined for the legal profession upon graduation from Harvard. Though he showed an early interest in literature and the arts, he was surprised, after the death of his father in 1845, to be asked by the memorial committee to execute the portrait statue for the monument. Thus his career as a sculptor began precipitously with a major commission. To fulfill the assignment, he traveled through Europe in 1847, worked on the model in Rome in 1848–49, and then gave up law to settle permanently in Rome in 1851. The completed *Justice Joseph Story* (1853), now in Mount Auburn Cemetery, is hardly a memorable work, and, although he later achieved an enviable reputation, he was never more than competent as a sculptor. From all accounts, he was a cultured gentleman of wide interests—poet, essayist, biographer, and musician, the center of an intellectual coterie which he enthralled by his brilliance and charm. Yet all the riches, the happy family, the talents, the illustrious friends, the popular success did not add up to genius. Story's art is in some ways the Victorian exemplar—more literary than sculptural, Romantic in mood and Classical in form, exotic in subject and literal in rendering. As Henry James noted, Story appealed not to "the aesthetic sense in general, or the plastic in particular, but the sense of the romantic, the anecdotic, the supposedly historic, the explicitly pathetic," concluding that "he was

485 Richard Saltonstall Greenough. *Benjamin Franklin*. 1855.
Bronze, life size. City Hall, Boston

486 Richard Saltonstall Greenough. *Carthaginian Girl*. 1863.
Marble, height 51″. Boston Athenaeum

487 Richard Saltonstall Greenough. *Circe.* 1882. Marble, height 54½″. The Metropolitan Museum of Art, New York. Gift of Misses Alice and Evelyn Blogler and Mrs. W. P. Thompson, 1904

not with the last intensity a sculptor." Story's success with his *Cleopatra* (1869, plate 488) and *Libyan Sybil* (c. 1861) was due, again according to James, to the ability of penetrating "the imagination of his public as nobody else just then could have done." The handling in the *Cleopatra* is tight and rather prissy, full of calculated detail which does not add up to the menace of the "smooth and velvety tiger" that Story described in a poem on the same subject. His Cleopatra is a New England matron seated magisterially aloof, revealing a single breast in an absent-minded rather than erotic manner. The brooding tension is dramatically more telling in the *Medea* (1868, plate 489), although the emotional intensity implied in the upper half is in contrast to the Classical calm of the lower, a handsome paraphrase of Roman statuary. Yet we may underestimate Story's art because the allusions are no longer convincing. His better efforts have a seriousness, a conscious intellectuality, and an unconscious psychological ambivalence that may be worth looking at freshly. Granted his dependence on

Classical models, one is still impressed, if also repelled, by the academic rigor of his solutions and the logic of his forms. The latter part of his life was increasingly devoted to portraiture and monuments, none especially noteworthy.

After moving to Rome, Chauncey Bradley Ives (1810–1894) had a series of popular successes with ideal female figures based on literary or mythological themes—a *Pandora* (1854, Virginia Museum of Fine Arts, Richmond), a *Rebecca at the Well* (1854), of which twenty-five copies were sold, and the *Undine* (1855, plate 490), a blatantly suggestive figure of a young nymph seen through a clinging wet veil, a tour de force of technical virtuosity in carving. It was part of the gimmickry of the expatriate group to amaze the populace with illusionistic effects which, of course, were executed by their Italian assistants. The *Undine* was one of a long succession of nude or semi-draped female statues that had a special appeal for a Puritan-dominated society in which eroticism was permissible only in the guise of white marble.

Benjamin Paul Akers (1825–1861) had his major success with *The Dead Pearl Diver* (1858, plate 491), typical of the pathetic subjects so dear to Victorian hearts. Its popularity was attributable equally to a mawkish sentiment about death and to a childish delight at the details of sand, fish net, and sea shells, all carved in stone. Considering that Akers had copied Classical sculpture in the Vatican galleries, the *Diver* is remarkably free of the antique in conception and form. In this vein of bathos *Nydia* (1859, plate 492) by Randolph Rogers was probably supreme in the number of copies purveyed in its day. He had adapted it from the Hellenistic *Old Market Woman* in the Vatican, but the sentiment was consonant with the purple prose of Bulwer-Lytton's *The Last Days of Pompeii,* from which it derived. Rogers (1825–1892) was one of the most successful sculptors of his generation; his

later *Lost Pleiad* (1874–75) rivaled the *Nydia* in popularity and sales, and both the *Nydia* and *Ruth* (c. 1850–55) were still held in high esteem at the Centennial Exposition of 1876. On the basis of *Ruth* Rogers was commissioned to execute the bronze doors of the Capitol Rotunda in 1855. Based on the Ghiberti "Gates of Paradise," the "Columbus" doors (plate 493) are among the first indications of an interest in the Renaissance that continued in Rogers's later monuments. Rogers wrote that he was "not willing to acknowledge that an American of the nineteenth century cannot produce a work equal to that of any Florentine of any period." The bronze doors fall somewhat short of the boast. Derivative in conception and composition, they are academic, dry, and often clumsy in detail.

In 1857 Rogers was asked to complete Crawford's

488　William Wetmore Story. *Cleopatra.* 1869. Marble, height 56″. The Metropolitan Museum of Art, New York. Gift of John Taylor Johnston, 1888

489 William Wetmore Story. *Medea*. 1868. Marble, height 76½″. The Metropolitan Museum of Art, New York. Gift of Henry Chauncey, 1894

490 Chauncey Bradley Ives. *Undine Receiving Her Soul*. 1855. Marble, height 61″. Yale University Art Gallery, New Haven, Conn. Gift of Mrs. Alice A. Allen

491 Benjamin Paul Akers. *The Dead Pearl Diver*. 1858. Marble, 28 × 67″. Portland Museum of Art, Portland, Me.

492 Randolph Rogers. *Nydia*. 1859. Marble, height 55″. The Metropolitan Museum of Art, New York. Gift of James Douglas, 1899

493 Randolph Rogers. "Columbus" doors. 1855–59. Bronze, height 6′8″. East entrance, Rotunda, U.S. Capitol, Washington, D.C.

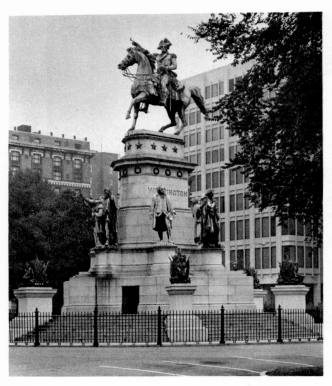

494 Thomas Crawford and Randolph Rogers. Washington Monument, Richmond, Va. 1849–57

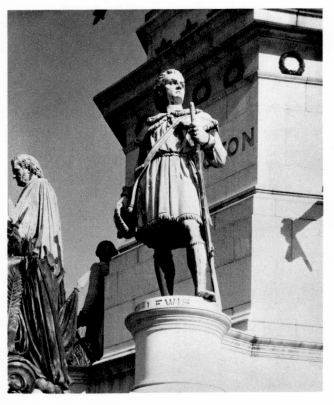

495 Randolph Rogers. *Andrew Lewis.* 1861. Bronze, heroic size. Washington Monument, Richmond, Va.

unfinished *Washington Monument* (plate 494) in Richmond, which occupied him in part through the Civil War. Rogers had the Crawford plasters cast and executed the *Andrew Lewis* (plate 495) and *William Nelson,* as well as the six seated allegorical figures and military trophies around the base. The heroic standing figures are among his finest efforts, straightforward, even brusque, reminiscent of Crawford's simplistic forms. The more fluent plastic quality of the seated female figures is also unusual in Rogers's work. However, like many of his fellow expatriates, Rogers shed the Neoclassic in his monumental commissions, becoming fussy about detail and surface. After the war, Rogers was one of the busiest of war-memorial designers, executing colossal and pedestrian sculptural confections for Cincinnati, Providence, and Detroit.

The most dedicated to the Classic tradition among the second generation was William Rinehart (1825–1874), who had begun his career as a stonecutter in Baltimore. He studied art at the Maryland Institute of the Mechanic Arts, and his earliest works brought him the support of William T. Walters, the wealthy collector who made it possible for Rinehart to go to Italy and remained his patron. During the first two years in Florence (1855–57) Rinehart was occupied almost entirely with ideal subjects, but American in theme, based on Indian and frontier life; then, after a short stay in the United States, he settled in Rome in 1858. His first major work, commissioned by Walters, *Rebecca,* or *The Woman of Samaria* (1859–60, Walters Art Gallery, Baltimore), affirmed his allegiance to the Classical ideal, though neither it nor his other works avoids the Victorian pitfalls of sentimentality and naturalistic detail. One of his most popular works was the *Sleeping Children* (1859–60) for Greenmount Cemetery, Baltimore, of which he did some twenty versions (plate 496). The maudlin sentiment aroused by plump and helpless babes carved in stone was one of the common emotional excesses of the period satisfied by a host of Victorian sculptors. Crawford's *Babes in the Woods* (1851, plate 497) is, if anything, even more tear-provoking than Rinehart's.

In 1861 Rinehart was asked by Crawford's widow to finish her husband's Senate and House doors of the Capitol. Put into plaster in 1866, they are no more inspiring than those of Rogers—simpler, more emblematic, but equally routine in composition and dry in modeling. Rinehart's greatest success came with two late ideal works, *Clytie* (1869–72, Peabody Institute, Baltimore), one of the most popular of the female nudes, and *Latona and Her Children* (1871–74, plate 498). The *Clytie* is a vapid academic pastiche, but the *Latona* reveals a transformation of Classical models into a completely Victorian conception, sentimental and overly detailed, but with a frank sensuousness of form that is rare with American Neoclassicists.

No account of American sculpture in Italy would be

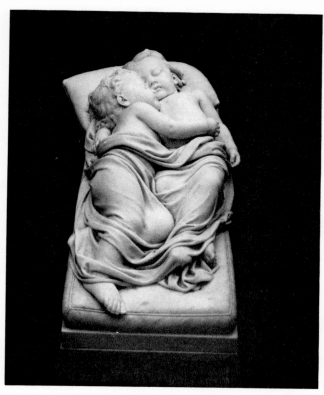

496 William H. Rinehart. *Sleeping Children*. 1868. Marble, height 17″, width 20″, length 34″. The Maryland Institute, Baltimore

complete without mention of the women sculptors, condescendingly dubbed by Henry James "The White Marmorean Flock," who were part of the circle in Rome. It is difficult to explain why so many women were attracted to sculpture at this time, though their preference for Rome over the United States, where their activities would have been considered eccentric, is understandable. Perhaps they reflected the movement toward the emancipation of women in the early nineteenth century. In any case, Rome saw the arrival during the fifties of Harriet Hosmer (1830–1908), Margaret Foley (c. 1820–1877), Louisa Lander (1826–1923), and Emma Stebbins (1815–1882) and, in the next decade, of Edmonia Lewis (1845–?) and Anne Whitney (1821–1915). None was any better or worse than the general run of male academic eclectics, and they produced their quota of undistinguished ideal figures, monuments, and bust portraits.

"Hatty" Hosmer achieved her notoriety largely through her picturesque personality and winning charm rather than any apparent sculptural virtues. She became a colorful fixture of international society in Rome, an intimate of writers, artists, statesmen, tycoons, and kings, many of whom bought her works. Raised unconventionally by her widowed father, she developed an early passion for sculpture and fought her way against prejudice to learn the

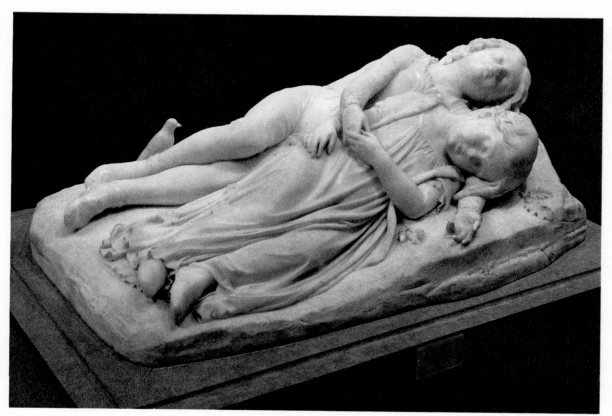

497 Thomas Crawford. *Babes in the Woods*. 1851. Marble, 34½ × 48½″. The Metropolitan Museum of Art, New York. Gift of the Honorable Hamilton Fish, 1894

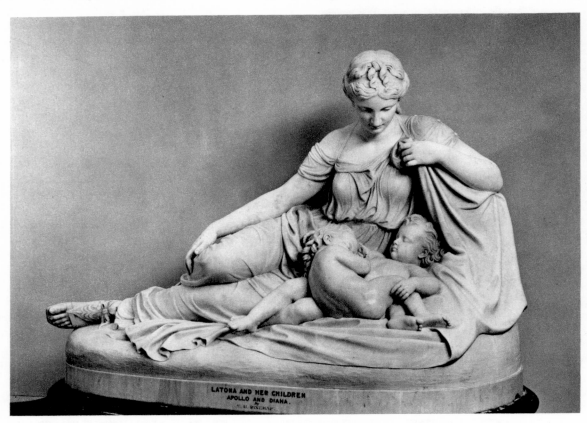

498 William H. Rinehart. *Latona and Her Children, Apollo and Diana*. 1871–74. Marble, height 46″. The
Metropolitan Museum of Art, New York. Rogers Fund, 1905

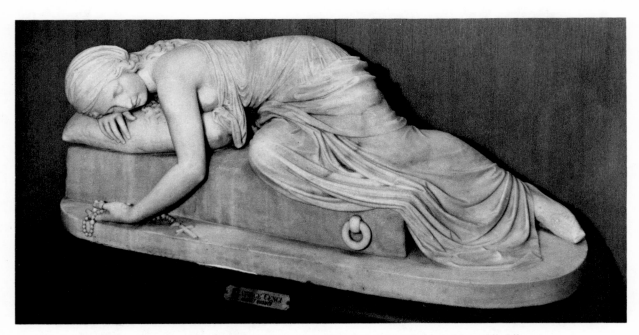

499 Harriet Hosmer. *Beatrice Cenci*. 1853–55. Marble, 24 × 60 × 24″. © The St. Louis Mercantile Library
Association

rudiments of the craft. She went to Rome in 1852 to study and work with John Gibson, the leading English Neoclassicist. Her first recognition came with *Oenone* (c. 1855), a sentimental, anatomically flaccid, Neoclassic nude, but her reputation was made by a series of maudlin set pieces, *Beatrice Cenci* (1853–55, plate 499), a literary tearjerker, and then, hitting the mother lode of cuteness, *Puck* (1856, plate 500) and *Will-o'-the-Wisp* (c. 1858, private collection, Piermont, N.Y.), which helped support her for years. Unsatisfied with popular acclaim, she attempted the heroic in a huge *Zenobia* (1858), which enjoyed a successful American tour and was sold along with two replicas, and accepted a commission from Missouri for a statue of *Senator Thomas Hart Benton* (c. 1862). Cast in bronze during the Civil War and erected in St. Louis in 1868, the colossal figure was anachronistically still depicted in Roman dress. She continued to produce ideal academic Neoclassic figures and commissioned portraits until the middle 1870s, when she turned her attention to mechanics and the problem of perpetual motion. Though she lived into the twentieth century, her art falls within the framework of Victorian academic eclecticism.

THE NATIVE SCHOOL

Given the cultural nationalism of the period, it is surprising that there was no greater fuss over the expatriation of American sculptors. But there was great pride in the international reputations of the expatriates as reflecting a maturation of American culture, and the Italianate group was actually not so divorced from the American milieu as would at first appear. They exhibited extensively in the United States, enjoyed critical acclaim in American journals, found most of their market among Americans here or traveling abroad, received more than their share of public commissions, and appealed to popular taste. Only later was the distinction between them and the so-called "native" sculptors emphasized, and that distinction has been exaggerated, for the native sculptors on the whole were motivated by similar cultural and aesthetic imperatives. It was more in the critical reviews, where the American themes were lavishly commended, rather than in the works themselves, that the distinction between the expatriate and the native was evident.

Except for William Rimmer, who received little recognition in his lifetime, Erastus Dow Palmer (1817–1904) was the only native sculptor to concern himself primarily with ideal themes. Palmer began as a small-town mechanic, having left school before he was twelve and become a carpenter and then an expert patternmaker in Utica and Albany. Inspired by a cameo portrait, he taught himself to carve shell and was fairly successful in his new profession until failing eyesight forced him to work on a larger scale. He found almost instant acceptance with his first ideal bust, an *Infant Ceres* (1849), a

500 Harriet Hosmer. *Puck*. 1856. Marble, height 28". National Collection of Fine Arts, Smithsonian Institution, Washington, D.C.

portrait of one of his daughters, shown at the National Academy of Design. In 1856 he was invited to exhibit a dozen of his works in New York and later in Boston, thus establishing his reputation as one of America's leading sculptors. Comparison of the *Indian Girl* (1853–56, plate 501), his first full-length figure, with similar Italianate statues reveals no striking differences. It seems neither more American nor more faithful to nature. Also known as "The Dawn of Christianity," its American theme is just as literary, moralistic, and sentimental as that of Powers's *Greek Slave*, Story's *Cleopatra*, or Richard Greenough's *Carthaginian Girl*. Its mixture of piety and Romanticism has a Neoclassic maiden in the guise of an Indian girl gazing at a missionary cross, purportedly found during her forest wanderings, which leads to Christian stirrings within her soul. Victorian taste for the anecdotal was just as endemic on this side of the ocean as the other, and the only statuary precept available to Palmer or any other native sculptor was Neoclassic. Palmer may have thought that his sole teacher was nature, but his very conception of the role of the artist as revealing the ideal in nature was essentially Neoclassic.

His *White Captive* (1859, plate 502), the finest of the mid-century ideal nude female figures, in its simplicity, proportions, and graceful *contrapposto,* is close to a Clas-

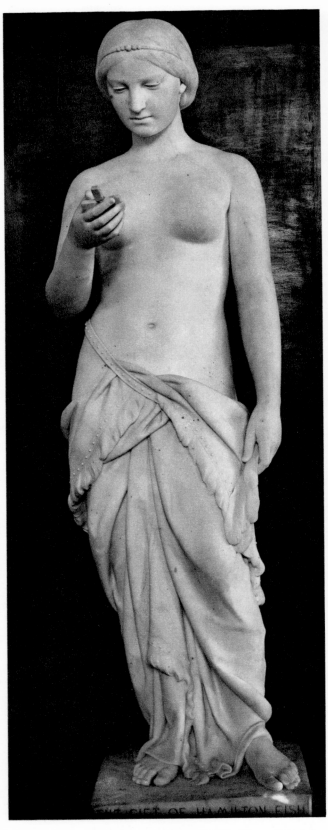

501 Erastus Dow Palmer. *Indian Girl (The Dawn of Christianity)*. 1853–56. Marble, height 59½″. The Metropolitan Museum of Art, New York. Gift of the Honorable Hamilton Fish, 1894

502 Erastus Dow Palmer. *The White Captive*. 1859. Marble, height 66″. The Metropolitan Museum of Art, New York. Gift of the Honorable Hamilton Fish, 1894

sic canon, if not the *Medici* or *Melian,* then the late Hellenistic *Cyrenean Venus,* with its softly rounded, stockily proportioned, youthful configuration. Palmer more nearly approached the Classic perhaps because he did go back to nature and redistilled an essence. The one element in the statue that is un-Classical (but not necessarily, therefore, American) is the head, which is typically Victorian. Rare for America at that time, the marble indicates a restrained response to the calls of the flesh. But *The White Captive* was saddled with a script to match any Victorian morality screed. An American maid, captured and bound by "savage" Indians (a rather sudden reversal of the Romantic view of the aborigines in Palmer's *Indian Girl*), is sustained in face of the "grinning brutes" by her Christianity. Still, the lovely, introspective figure manages to rise above the forgotten literary allusions and achieve plastic validity.

In 1857 Palmer submitted a model for the pedimental sculpture of the new House Wing of the Capitol, which was rejected. He continued to work modestly in Albany, turning out portraits and rather pious ideal works. *Peace in Bondage* (1863, plate 503), an allegorical relief inspired by the Civil War, gained him some international repute and is one of the finest sculptures of the period. Elegantly Neoclassical but without mannerism, suffused by a sense of reality yet not literal, it has a sincere lyricism unequaled in its day. In 1873 he finally went abroad in connection with a commission from New York State for a full-length statue of *Robert Livingston* (1874), destined for the Capitol's Statuary Hall. It is an impressive bronze, well executed, though overnaturalistic in detail. Palmer lived into the twentieth century, but he quietly slipped from the sculptural scene in the last quarter-century of his life.

Palmer's Albany studio was an efficient production unit, employing American stonecutters, among them, Launt Thompson and Charles Calverly, who became sculptors on their own, which may have something to do with the difference in texture of Palmer's marbles from the Italian-cut works of the expatriates. His talent was modest but authentic. He was satisfied with the limits of his gentle vision, and within them he was a sensitive observer and a skilled craftsman. He had raised the level of native sculpture and demonstrated that it was not necessary to study abroad.

The most original sculptor of the mid-century, William Rimmer (1816–1879), was an enigmatic personality who belongs to the tragic band of aborted talents that dot the pages of American art like reproaches. Barely a half-dozen of his sculptures are extant, just enough to make the works of his contemporaries pale into insignificance. He never received the support necessary to keep him active as a sculptor, but he seemed only sporadically engaged in sculpture as an occupation. Like Audubon, Rimmer lived with the unsubstantiated belief that he was the son of the lost Dauphin. His father, a cobbler who

503 Erastus Dow Palmer. *Peace in Bondage.* 1863. Marble, 30⅛ × 25½". Albany Institute of History and Art, N.Y.

died a drunkard, seems to have been a cultured man who raised his family in the legend of their royal descent, teaching William, the eldest, the prerogatives and obligations of his destiny, and setting the psychological conditions which made it impossible for the son to adjust to his environment. The unrevealable secret bred both arrogance and insecurity, a belief in his own superiority and a persecution complex, that stayed with Rimmer all his life. Both father and son eked out a living, moving constantly in fear of discovery, from Liverpool, where William was born, to Canada, to Maine, to Boston.

At about fourteen the young Rimmer, possibly inspired by local stonecutters, carved a statuette in gypsum, called *Despair* (c. 1830, plate 504), unique in American sculpture of the period and unbelievable for someone so young. It is possibly the first nude figure done in the United States and, despite some awkwardness, a direct expression of emotion without the paraphernalia of Neoclassic allegory. It seems to embody his father's life and to predict his own. Does the hand covering the mouth repress a secret or an anguished cry, or are the two related? Does the other hand clutching the leg seek assurance in the physical reality of self in face of some insupportable vision? The sense of terror, pain, and hopelessness expressed in this small figure must have

504 William Rimmer. *Despair.* c. 1830. Gypsum, height 10″. Museum of Fine Arts, Boston. Gift of Mrs. Henry Simonds

come out of some deep recess of the boy's being and was to remain the essence of his life and work.

One might expect a brilliant career from such beginnings, but Rimmer abandoned sculpture for some thirty years, drifting through such odd jobs as sign and scenery painting, doing pictures for neighboring Catholic churches and portraits at $5 to $20 each. After marriage, he settled in Randolph, Mass., where he earned his living as a cobbler, with an occasional portrait thrown in. Then, through the friendship of a local doctor, he acquired enough knowledge to practice medicine. During this period there is mention of only one work, a portrait of his daughter, cut directly in stone. In 1855, he moved to East Milton, where he doctored the quarrymen's families and was finally invited to join the Suffolk County Medical Society. He lived in poverty, in deep depression over the death of the last of his three sons, and in intellectual isolation.

In 1858, at forty-two, Rimmer was influenced to return to sculpture by the wealthy Bostonian patron of the arts, Stephen H. Perkins. His first mature work, as a tribute to Perkins, was a *St. Stephen* (1860, private collection), carved directly in granite. As in all his work, the inner turmoil of the spirit is expressed in the outer form, a far cry from the placid academic stereotypes of his contemporaries. Exhibited in Boston, it was favorably noted but found no buyer. But Perkins maintained his faith and advanced Rimmer the money to begin the life-size *Falling Gladiator* (1861, plate 505). Curiously, Rimmer never conscientiously tried to learn the rudiments of the sculptor's craft. Although he was a brilliant anatomist, he knew nothing about the preparation or maintenance of clay or an armature to support it, so that sections collapsed or broke away. Nor did he know how to cast it in plaster when it was finished. Something of a curiosity while it was in process, the *Gladiator* was not taken seriously by Bostonians, who already had their roster of famous sculptors. Dr. Rimmer always remained an eccentric amateur to them. But Perkins persevered and, in 1862, took a cast with him to London, where it received good notices; to Paris, where it was attacked as a cast from a live model; and to Florence, where it received the commendation of the French sculptor, Jules Dupré. Though it helped spread Rimmer's reputation, it was buried in the storeroom of the Cooper Union Museum until Daniel Chester French arranged to have it cast in bronze in 1906. The *Gladiator* is not only a consummate display of anatomical knowledge but also the representation of a being wracked by pain. The Neoclassic reminiscences, also present in Rimmer's drawings, are closer to the Romantic fire of Blake and Fuseli than to the elegant ideality of Canova and Thorwaldsen.

Isolated and unappreciated, Rimmer was a sculptor of Romantic agony in a garden of conventional beauty. His art harks back to Delacroix and Géricault and parallels the sculpture of Daumier, Barye, and Rodin. The late works, the small bronzes of *The Dying Centaur* and the *Fighting Lions* (plate 506), both 1871 (plaster originals, Museum of Fine Arts, Boston), most clearly reflect the artistic purpose and the nature of the man. Albert T. Gardner described *The Dying Centaur* (colorplate 50) as a symbol of Rimmer's own life: "a wild pagan creature, half man, half myth, sinking to the earth, with amputated arm stretching its handless stump to a pitiless Puritan sky."

With his return to sculpture in the early 1860s, Rimmer began to lecture on anatomy in Boston and was very successful, and from 1864 ran his own school. Unfortunately this occupation kept him in those years from concentrating on his art. He was apparently a brilliant teacher, and, with the publication of *Elements of Design* (1864), his fame spread beyond the Boston environs. Peter Cooper offered him the directorship of the School of Design for Women in New York, and he served suc-

505 William Rimmer. *The Falling Gladiator.* 1861. Bronze, height 63". Museum of Fine Arts, Boston. Gift of Miss Caroline Hunt Rimmer, Mrs. Adelaide R. Durham, various subscribers

506 William Rimmer. *Fighting Lions.* 1871. Bronze, 16½ × 24". The Metropolitan Museum of Art, New York. Gift of Daniel Chester French, 1907

cessfully in that capacity for four years, until a disagreement with the trustees led to his resignation in 1870. Back in Boston, he returned to lecturing on anatomy at the School of the Museum of Fine Arts, the Worcester Technological School, the Yale School of Fine Arts, and the National Academy of Design. In 1877 his monumental *Art Anatomy* was published. In all, Rimmer had received only two public commissions, the *Alexander Hamilton* in 1864, now on Commonwealth Avenue, Boston, which seemed to surprise him, though the $5,000 fee was half of what would have been given to another; and *Faith* (1875) for the Plymouth Monument, for the 9-foot model of which he received $2,000 and which was garbled

in the cutting. The clay model of the *Hamilton* was done in eleven days, and the committee was far from pleased by the mottled gray Quincy granite figure completed in 1865. After Rimmer's death, Boston had a twinge of conscience, held an exhibition of his work at the Museum of Fine Arts, and then forgot him. It is clear in hindsight that Rimmer's art belongs to the mainstream of European mid-century naturalistic sculpture, rather than to the provincial backwater of academic Neoclassicism in Rome.

The "Rogers Groups," so popular in the United States during the second half of the nineteenth century, were the sole province of John Rogers (1829–1904) and a uniquely American phenomenon—a successful union of art, industry, and commerce. These parlor ornaments reproduced in plaster and priced from $3 to $25 sold some eighty thousand copies during the life of the company Rogers established. They had no exact counterpart in Europe, though their ultimate derivation may have been from mass-produced European porcelain figurines. Rogers was exploiting a growing American market for cheap statuary then being supplied by the cabinet busts and ornamental figures manufactured and hawked in the streets by Italian plaster workers whose pirating of popular subjects led American sculptors to patent statues for reproduction. Considering their popularity, it is surprising that the Rogers groups had no competition, for as counterparts of genre painting reproduced in Currier & Ives prints, they appealed to a plebeian taste, while sharing with all Victorian art a predilection for the literary, the morally didactic, and the sentimental. As ascerbic a critic as Jarves found them more honest and satisfying than the pomposities of the Neoclassicists.

Rogers came to sculpture as a mechanic and an amateur, but out of a cultured New England family in financial decline. He studied "practical subjects" in high school and then worked as a machinist in New England and the Middle West, puttering all the while at modeling clay figure groups that amused and impressed his friends. Then, an economic recession having led him in 1858 to consider sculpture as a profession, he went to study abroad, where, through Greenough and Story, he was introduced to Paris and Rome. From the beginning this level-headed Yankee knew that neither Italy nor the art being produced there was for him, though he could learn from it. After his return, he sent a small genre group called *The Checker Players* (1859, plate 507), the second of four he did of the subject, to a church bazaar, where it won immediate acclaim. He followed it with *The Slave Auction* (1859, plate 508), a topical subject of potential appeal. Wasting no time, he opened a studio in New York and began producing plaster casts of *The Slave Auction* from gelatin molds. When shops refused to handle the group for fear of offending pro-southern customers, he arranged to peddle them in the streets. The operation launched the "Rogers Groups," and in the ensuing years he issued a series of propaganda pieces highly extolled by Union partisans, including President Lincoln, as well as scenes depicting the lighter side of military life. After the war he turned to a good-humored kind of genre in the vein of his *Checker Players,* a three-dimensional equivalent of the paintings of Mount and Bingham, along with occasional social themes. Among his earliest trial pieces had been subjects from literary sources, and beginning in the 1870s such groups appeared frequently.

508 John Rogers. *The Slave Auction*. 1859. Plaster, height 13¼". The New-York Historical Society

507 John Rogers. *The Checker Players*. 1859. Plaster, height 8¼". The New-York Historical Society

509 John Rogers. *Weighing the Baby*. 1876. Plaster, height 21". The New-York Historical Society

Whether the topic was social, genre, or literary, the groups were essentially the same—anecdotal accounts rich in detail, local color, and human interest. Rogers had no illusions about what he was producing but was serious about it, never aspiring to loftier goals. He was a natural storyteller and a skillful craftsman. As a genre sculptor, he attempted to create a segment of life as truly as he could, though, as an anecdotalist, he had a tale to offer as well. His art was not dependent on an accompanying text but on the common experience of the audience. Each group is like a scene from a play, so that almost inevitably he turned to illustrating dramatic excerpts.

As Rogers developed, his observations became more acute and his handling more assured; his control of the medium improved rapidly, and he attained a remarkable descriptive facility. He never attained the heroic, but in the finest of the genre groups, like *Coming to the Parson* (1870, colorplate 51), the most popular of his works, selling some eight thousand copies, or *Weighing the Baby* (1876, plate 509), he re-created rural life with warmth, nostalgia, and genial humor.

In formal terms, Rogers was conservative and deceptively simple. He had a strong plastic sense and emphasized the underlying structure of a form even when it was overladen with detail. He managed also to hold the action to a definable architectonic unit with a surprisingly complex interrelationship between volume and void. In addition, Rogers was an excellent portraitist, as the heads in the groups or in an occasional bust, such as the *William Cullen Bryant* (1892, New-York Historical Society), would indicate. Also, his work is generally known only through the plaster groups, which naturally lost a good deal in the reproduction. The bronze casts of the originals, from which the molds were taken (the New-York Historical Society has a large collection of them), reveal a much sharper definition of forms and richness of surface.

MONUMENTAL STATUARY

The bread-and-butter activity of American sculptors remained the portrait: busts of individuals or public figures, often reproduced in numbers, and public monuments commissioned by a city, state, or the nation itself. The proliferation of such works continued the Early Republican concern with establishing national heroes. The models were the Greek philosophers, Roman emperors, and antique bust portraits, even to the retention of ancient costume.

The specialists in the field of commissioned monuments were Henry Kirke Brown, Clark Mills, and Thomas Ball. The scale of such monuments, and especially the exigencies of the equestrian statue, inevitably led to the replacement of stone by bronze as the preferred material. The effect of the change was important, first, in that it freed the sculptor from the ubiquitous stonecutter and allowed him to express himself directly (not always the advantage it seems), and, second, in that it cut the tie with the white marble of antiquity and all it symbolized, signaling a new beginning and a search for new directions. The struggles of these first "bronze-age" sculptors with the problems were direct, practical, almost technological, and unpretentious, in comparison with those of the academic eclectics.

When Henry Kirke Brown returned after four years in Italy, he was eager to revert to the American subject. He spent the next several years programmatically dedicated to furthering a native art and immersed himself in the Indian theme, sketching Indian settlements and working on sculptures from the studies. One of these, the *Aboriginal Hunter* (1846), distributed as a premium by the American Art Union, was extremely successful. The bronze statuettes, produced in his own studio foundry, were among the first cast in this country. Brown's major Indian piece was the larger-than-life-size *Indian and Panther* (1849–50, plate 510), a Romantic depiction of the heroic aborigine, in the fashion of James Fenimore Cooper, before the

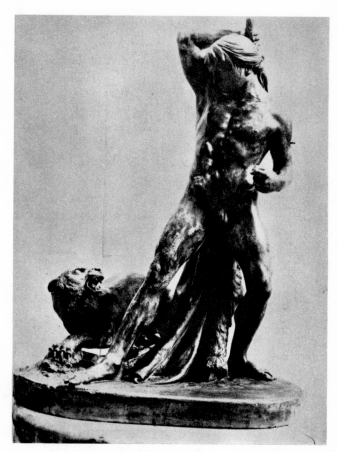

510 Henry Kirke Brown. *Indian and Panther*. 1849–50. Bronze, height 7'. Whereabouts unknown

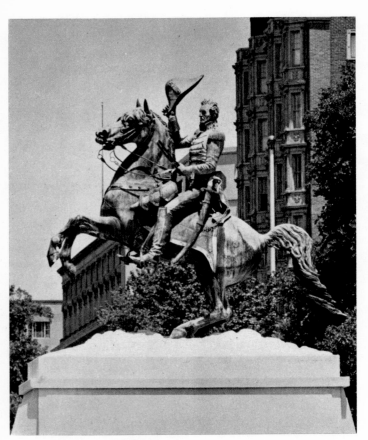

511 Clark Mills. *Andrew Jackson.* 1848–52. Bronze, over life size. Lafayette Square, Washington, D.C.

Washington is the finest equestrian statue of that period; the Crawford, with its rather frenetic horse, is a disorganized group, and the dashing *Jackson* by Mills is more impressive as engineering than as an artistic conception. Brown's *Washington* has something of the grandeur of the *Marcus Aurelius* in Rome, which he must have known, but is even closer to the vigor of Verrocchio's *Colleoni* in Venice. There is a nice balance between the calm, imperious Washington in his regimentals, seated rather stiffly, and the stride of the spirited stallion. This was the high point of Brown's career, combining a routine naturalism with an emotional verve in a way which he never managed again.

Spanning two periods, Brown responded more than any other sculptor of his time to the change from Neoclassic ideality to American naturalism, from marble to bronze; and, as one of the first of the American monument makers, set a standard, supplying guidance to such younger sculptors as John Q. A. Ward and Larkin Mead, who had worked as his assistants.

Unlike Brown, Clark Mills (1815–1883) was self-taught as a sculptor. His father had died while he was still a boy, and he spent his youth wandering and working at odd jobs, until he was employed in New Orleans as a foreman in a plaster and cement factory. He moved on to Charleston in 1837, learned to be an ornamental plasterer, and in the early forties began to do life masks, for which he developed a new procedure. He adapted the masks into portrait busts and soon had many customers. In 1845 he tried his hand at stonecutting in a portrait of Charleston's favorite son, *John C. Calhoun* (City of Charleston), and he devised his own methods. Though rather crude, his work attracted some attention, including that of John Preston, who invited him to Columbia to do several portraits and then subsidized a stopover in Washington on the way to Italy. But Mills happened to meet Cave Johnson, the Postmaster General and chairman of the Jackson Memorial Committee, and found himself with the commission to execute an equestrian statue of General Jackson (1848–52, plate 511).

Mills had certainly never seen an equestrian statue and scarcely any full-length figures except the Houdon *Washington* (plate 292) and the Greenough *Washington* (plate 475). He had never done anything but a bust portrait. There had been many unfulfilled projects for equestrian monuments, from the one of Washington voted by Congress in 1783 and earmarked for Houdon to Crawford's model, which was accepted by Richmond in 1849, a year after Mills received his commission. Such a statue was, thus, an innovation in America, but Mills decided on a rearing horse, both forelegs off the ground, a conception that had few successful precedents anywhere, and he could have seen them only in engravings. In view of Mills's training, the execution and casting of the *Jackson* was no small achievement. He solved the problem of the rearing horse by radically shifting the center of gravity

"noble savage" became the "savage brute." It was also stylistically one of the earliest departures from the static quality of Neoclassicism, introducing a new dynamic movement.

By 1850 Brown was well on his way to becoming the leading sculptor working in the United States, and his Brooklyn studio was busy with a series of projects: the *De Witt Clinton* (1851–52) for Greenwood Cemetery, Brooklyn, one of the first large bronzes cast in the United States; the *Angel of the Resurrection* (c. 1852) for the Church of the Annunciation in Brooklyn; and the colossal equestrian *Washington* (1853–56, colorplate 52) for Union Square, New York. Brown's *Washington* had been recently preceded by two other commissions for equestrian monuments, the *Jackson* of Clark Mills in 1848, and the Crawford *Washington* for Richmond in 1849. Brown had seen the *Jackson* in process when he began the plaster model of his 14-foot-high horse and rider in a special studio. It took eighteen months to complete and almost two years more for the bronze casting and the erection on a granite base. Aesthetically, the Brown

and balancing the forepart on the hind legs and tail. He built his own foundry; learned to cast bronze; and, in spite of some disasters, including a crane break, a burst furnace, and having to cast the horse six times before he got an acceptable result, he managed to complete the group late in 1852. It was erected in Lafayette Square, opposite the White House, and the public and press were ecstatic. Congress voted him an unheard-of $20,000 bonus in addition to the $12,000 in the contract and almost immediately appropriated $50,000 for the long-deferred equestrian statue of Washington, for which Mills was awarded the commission. He had become the official sculptor to the Congress.

In 1853 he was asked to assemble Greenough's newly arrived *Rescue* group. He built a larger studio and foundry to handle his increased activities, including orders from New Orleans and Nashville for replicas of the *Jackson* monument and a bronze statuette of it. Though a gale destroyed his studio and the foundry burned, he completed the *Washington* and cast the colossal Crawford *Armed Freedom,* which was placed atop the new capitol dome in December, 1863. But at the height of his phenomenal success, government support ceased, apparently because he was suspected of dishonest practices in handling the metal assigned to him. The rest of his life was spent under a cloud, and he produced little except a statue of Chief Justice Chase, in connection with a nebulous project for a Lincoln monument. Mills's reputation rests on the *Jackson*; the *Washington,* erected in Washington Circle in 1860, is a timid and lack-luster affair. The *Jackson,* with all its almost archaic awkwardness, is a daring conception. Though not a distinguished monument, it captures a great deal of Jackson's challenging spirit and personality.

Slightly younger than Brown and Mills, Thomas Ball (1819–1911) came to sculpture late, after an indifferent career as a painter, so that most of his monument sculpture postdates the Civil War. He was born in Charlestown, Mass., the son of a signpainter who encouraged his artistic interests, but after his father's death he was forced to work at odd jobs. Employed as a museum clerk, he tried cutting silhouette portraits and painting miniatures, which were exhibited with some success, and drifted into painting as a profession. Dissatisfied with his progress, he turned to sculpture with the aid of John C. King, a Boston sculptor. Ball's interest in music inspired him to do a cabinet bust, from photographs, of the singing sensation of that day, Jenny Lind, the "Swedish Nightingale." Its reception was encouraging, and he did a flourishing trade in replicas before it was pirated by Italian plasterers. However, he continued to work in cabinet size and sold the reproduction rights to his full-length statuette of *Daniel Webster* (c. 1853) for $500. To further his career he spent three years (1854–57) in Florence, executing portraits and experimenting with ideal themes without much distinction. He was apparently untouched by Neo-

classicism. In Boston again, he produced the small, full-length *Henry Clay* (1858, plate 512), one of his finest works—lean, precise, with a kind of elegant simplicity, naturalistic without being fussy, and animated by the febrile temperament of the little southern gamecock.

At about the same time he began a model of an equestrian *Washington* (plate 513), which was well received when exhibited at the Athenaeum, and after a subscription fund was raised, he was offered the commission. Like Mills, Ball had never done a life-size figure before he undertook the colossal equestrian monument. Devising his own armature on a turntable, and his own procedures,

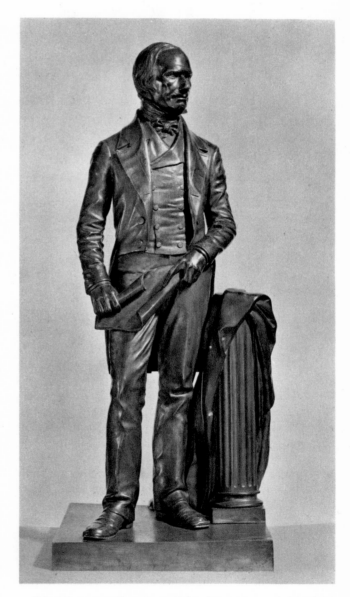

512 Thomas Ball. *Henry Clay.* 1858. Bronze, height 31½". North Carolina Museum of Art, Raleigh. Gift of Mr. and Mrs. Robert Lee Humber

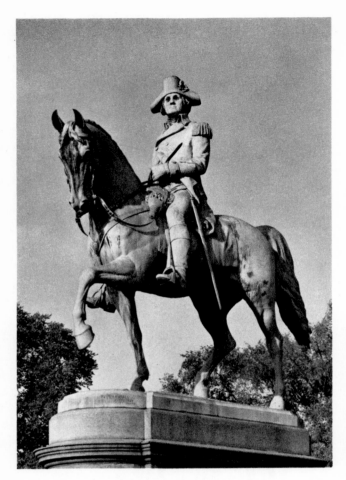

513 Thomas Ball. *George Washington*. 1858–61 (cast 1869). Bronze, height 16′. Public Gardens, Boston

greeted with general acclaim. They did not think of themselves as superior to the public; they were interested not in raising its aesthetic quotient but in giving it what it wanted.

PORTRAITURE

Most sculptors depended on bust portraits for a living, and there seems to have been an inexhaustible number of insignificant people eager to have their likenesses in plaster or stone. A gallery of nineteenth-century portrait busts can be one of the more numbing experiences in art. All seem to come from the same hand, the same eye, the same

514 Joel Tanner Hart. *Henry Clay*. 1846–59. Marble, life size. State House, Richmond, Va.

he completed the plaster of the 16-foot group in 1861, but, with the war, bronze was needed for cannons, and it was not until 1869 that it was cast and erected in the Boston Public Gardens. It has a clean look, a calm dignity, and is altogether the finest of his monuments, though it lacks the bravura of the Mills *Jackson* or the verve of the Brown *Washington*. Ball had a long and distinguished career after the war, working out of Florence, but the work of his prime years was already retardataire, like that of most sculptors of his generation. Unfortunately, after the Civil War many official commissions were awarded to men of reputation who had been reared in another age and were incapable of creating an art pertinent to a new era.

In contrast to the expatriates, who were concerned with aesthetic theory, the first generation of native monument makers was essentially pragmatic, and though they may have thought of themselves as artists, acted more like entrepreneurs, manufacturers, or engineers, creating a specific product to fill a given need. Unlike Greenough or Crawford, none of them had any difficulty with either patron or public; on the contrary, their works were

brain, and over the later ones hovers the unmistakable pall of the photograph. Naturalism has been perverted into mechanical transcription. One can scarcely differentiate between the native and the expatriate, except that the works of the latter, cut by Italian craftsmen, have a softer and more polished surface, while those of the former, often cut by local workmen, are somewhat harsher, more insistent on detail, and more photographic.

It was common practice for portraitists to take their plaster busts to be carved in marble in Italy, and some, like Joel Tanner Hart (1810–1877) and John Adams Jackson (1825–1879), stayed there to do portraits of visiting Americans. Hart, the Kentucky stonemason turned sculptor, spent ten years in Florence supervising the carving of his *magnum opus*, a full-length *Henry Clay* (1846–59, plate 514), though much of his interest was directed toward the development of a pointing machine. Hart was a sort of primitive literalist, and the *Clay* has a wax-work realism. After 1860 Hart devoted himself to ideal themes and writing poetry, leaving unfinished at his death the *Woman Triumphant* (destroyed by fire, 1897). Jackson, the first American sculptor to study in Paris, spent the last two decades of his life in Florence. Though he did an occasional ideal piece, he remained primarily a portraitist.

At home the native sculptors were also busy supplying the demand for bust portraits. There was an unusual concentration of sculptural activity in Cincinnati and Boston. In the 1830s Powers, Clevenger, Brown, Edward Augustus Brackett (1818–1908), and John Crookshanks King (1806–1882) were all in Cincinnati. Then Powers left for Italy, and in 1839–40 both Clevenger and Brown were working in Boston. They were followed by King in 1840 and Brackett in 1841, both of whom settled permanently in Boston, joining Henry Dexter (1806–1876), the most popular and prolific of the local practitioners, whose project for a portrait gallery of all the presidents and incombent state governors was interrupted by the war; Hughes, just returned for good from Philadelphia; and the young Richard Greenough, entering the profession. Bostonians seem to have had a special affinity for the marmorean art, and the American colonies in Florence and Rome were almost Boston outposts.

The South, continuing provincial in matters of art, had few of its own sculptors, depending on itinerants. Mills's success in Charleston, with his first halting essays, is an indication of the paucity of talent available. Hart was a special favorite in his home state and Virginia. But Alexander Galt (1827–1863), who spent many years in Florence, became *the* sculptor of the Confederacy. Washington, D.C., naturally attracted many portraitists to do busts of political personalities. Horatio Stone (1808–1875), originally from New York, settled in the capital and had an active career as a portrait sculptor.

In the Middle West, Thomas Dow Jones (1811–1881) continued the tradition in Cincinnati; James Wilson Alexander MacDonald (1824–1908) was active in St. Louis

515 Leonard Wells Volk. *Abraham Lincoln*. 1860 (cast 1914 from model of 1860 from a life mask of 1860). Bronze. life size. The Metropolitan Museum of Art, New York, Gift of Theodore B. Starr, 1914

before the war; and Leonard Wells Volk (1828–1895), who began his career in St. Louis and spent several years in Rome, became the leading sculptor in Chicago. He executed many monuments and portraits after the war but is probably best remembered for his portrait bust of Abraham Lincoln (plate 515), done in 1860; the pre-bearded likeness, used so frequently by subsequent delineators, has become the accepted image of the youthful Lincoln. Though based on the life mask Volk made at the time, it is one of the first evidences of a break from the dryness of academic eclecticism and literal naturalism. It captures the psychological quality of the man in more fluent terms, presaging the style that was to become dominant in the next generation.

CHAPTER FIFTEEN

Patronage

The Art Union

No other period in American history has witnessed such concern with native art and such support for the native artist. It was the first time that the wealthy began collecting art to any appreciable extent, and on the eve of the Civil War there were private collections in most of the major cities. Although tradition was strongly in favor of old masters, limitations in wealth prevented the formation of important collections of this type. Most contained "fakes," copies, or lesser examples of favored artists and periods. On the other hand, the rise of cultural nationalism had created a climate for contemporary American art and for landscape and genre painting. Men of new wealth, especially in New York, became staunch champions and friends of contemporary artists, joined with them socially, as in the formation of the Sketch Club and the Century Association, or for the establishment of artistic organizations or institutions. They commissioned artists as well as buying their works. Some, like Luman Reed, Thomas J. Bryan, William Aspinwall, and Marshall O. Roberts, opened their collections to the public.

New York had become the art capital of America and by the late 1850s was supporting a flourishing artistic community, the largest concentration of artists, the most active patrons, art galleries, auction houses, and exhibitions. The first chink in the all-American armor, with a hint of things to come, occurred when Goupil, Vibert & Cie., supporting the International Art Union in opposition to the American Art Union and exhibiting French art, and the Düsseldorf Gallery, showing German art, opened for business in 1849. However, only after the Civil War and the Centennial Exposition of 1876 did American art succumb to the European competition.

The incredibly successful American Art Union was the most important instrument in the spread of American art in those years. Organized in 1842 in New York after the failure of the Apollo Association during the depression of 1839–41, it was dedicated to the nationalization, democratization, and propagation of American art to the widest possible audience. The Union held exhibitions, bought works and issued engravings which were distributed to members, and published two journals, the *Bulletin* and *Transactions,* among the first art magazines in this country. A five-dollar fee entitled a member to an engraving, the publications, and a chance in a yearly lottery of winning an original work of art. Agents throughout the country, designated "honorary secretaries," solicited subscriptions, and the total membership in 1850 was over 16,000, widely spread across the nation. Original works of art distributed rose from thirty-five in 1842 to 3,300 in 1850, and the Union disseminated in its ten years of existence 150,000 engravings and some 2,400 paintings by more than 250 American artists. As articles in the *Bulletin* indicate, the intention of the Union was to foster American over European art, to educate the artist toward satisfying the public, and to elevate public taste. Presumably it did all three with some success. The Union attracted most of the leading artists to exhibit, and from its purchases it can be deduced that the selection was representative, though the higher-priced works were avoided in order to increase the number to be distributed.

However, circumstances combined to cut short the Union's life at its height. In 1851 the management overextended its purchases beyond its expected subscription income, and the jealousy of some artists led to a legal suit. The Union was declared an illegal lottery by New York State and was forced to liquidate most of its assets to pay its debts. It continued as an exhibition gallery for a while, then transferred its remaining works and funds to the New-York Gallery, which comprised the former Luman Reed Collection, later to become part of The New-York Historical Society.

The success of the American Art Union during its life led to the formation of similar but less durable associations in Philadelphia, Boston, and Cincinnati. The spread of popular interest in art continued, and museums, gal-

leries, or art associations were established in Cleveland, then the leading cultural center in the West, St. Louis, Pittsburgh, and New Orleans; and artists found patronage in many others. Through it all, the position of the American artist, both socially and financially, had greatly improved. But even before 1860 there were indications that there was a growing taste for other than contemporary American art, and some collectors were buying European art and old masters. August Belmont began to add examples of the Barbizon School to his collection in 1857, long before they became popular. James Jackson Jarves's amazing collection of Italian primitives was turned down by the Boston Athenaeum and finally sold to Yale University for far less than its value in 1864. In the same year, Thomas J. Bryan gave his collection of French, Flemish, German, and Spanish old masters to The New-York Historical Society after it had been rejected by the Pennsylvania Academy of Art.

PART FOUR

CIVIL WAR TO 1900

Reconstruction and Expansion

The changes in America during the Jacksonian Era were as nothing compared with those that followed the emergence of the United States as a modern industrial nation after the Civil War. This transformation, deeply rooted in the antebellum world, altered the very nature of American society by the turn of the century. In 1860 the United States was still largely agricultural, since westward expansion had outstripped industrial growth in the northeast, but the scales were soon tipped in the other direction. In the next decade industrial production had doubled, and by 1900 the United States had become the leading industrial power in the world.

This climb toward economic preeminence had begun in the North during the war, which had stimulated large-scale manufacturing, exploitation of natural resources, extension of railroads and telegraph, investment banking, foreign commerce, and the mechanization of agriculture. By 1900 twelve new states had been added to the union; the population had increased from about 30 million to about 76 million, of whom 15 million were immigrants; the land mass was consolidated; and the frontier had finally disappeared. Unprecedented natural resources were available for development—rich mineral deposits, unmatched river networks for navigation and power, limitless timber, and the fertile plains for agriculture.

Even before the Civil War, the American capitalist had become aware that commerce offered more limited and less stable wealth than did production and had begun to move from mercantile to industrial capitalism, a process greatly accelerated after the war. New industries expanded eventually into giant corporate bodies and trusts. Cities grew in size, and towns became cities as the flood of workers from rural America and Europe migrated to industrial areas to form a new proletariat. The need to feed an ever-increasing industrial population both here and abroad led to the cultivation of large tracts of land and a growth of industries to supply farm machinery and to process and package products. Industrial, agricultural, and commercial complexes were tied together by new canals, new roads, and an ever-expanding railroad system. The 30,000 miles of railroad track in 1860 were almost doubled in a five-year period after the war, and by 1900 the United States had 200,000 miles, more than all Europe. In the words of Henry Steele Commager, "In

the generation after Appomattox the pattern of our present society and economy took shape. Growth—in area, numbers, wealth, power, social complexity, and economic maturity—was the one most arresting fact."

However, America's physical expansion has its less positive side. Propelled into the race for wealth and power, the nation had not the time, inclination, or wisdom to question its course or to understand its new problems —equitable distribution of wealth; control of the power inherent in capital; adjustment of political democracy to an undemocratic economy; recurrent depressions; widespread unemployment and labor strife; urban blight; declining farm income with increasing agricultural production; despoliation of natural resources; assimilation of immigrants; accommodation of older agrarian and mercantile capitalist political institutions to a new industrial and finance capitalism; and the national stance in foreign policy. Such problems are still with us, but the second half of the nineteenth century was more openly a battlefield for contending interests. Gone was the earlier altruistic idealism of an intellectual elite that conceived of a national destiny based on moral principles and individual responsibility deriving from the philosophic and political thought of the Enlightenment. It was replaced by a narrow materialism, a concern for personal advantage, and a belief in the new Darwinian concept of the "survival of the fittest" as translated into social doctrine by Herbert Spencer. It was argued that government must not interfere in the process of social evolution but permit untrammeled competition to achieve "natural selection." In effect, however, the new *laissez faire* attitude of the national government in the post-Civil War period allowed powerful economic interests to gain undue advantages. At no time in our history was the government as "shot through and through with partisanship, privilege, and corruption" as it was during the Grant administration.

The war had spawned countless war millionaires, "robber barons," "captains of industry," and "masters of capital." After the war railroads were subsidized by Congress to the tune of $64 million in loans and 131 million acres of land in grants, liberally supplemented by state and local inducements for railroad service. Peddling of influence, contracts, and jobs; bribery and fraud; extravagance and waste at public expense; and outright

thievery of public lands, resources, and funds—all were common in Washington as well as in state and municipal governments. It was the industrial and financial North that harvested the major fruits of victory; the agricultural West was thrown a bone, while the prostrate South was stripped of economic and political power. The Republican Party, in absolute control of the government, was dedicated to the support of industrial and financial interests. Before the end of the century the steel, oil, and railroad trusts loomed like colossi in the economic landscape, and behind them all was the almost limitless financial power centered in the New York banks. As against this, the small farmer, faced with low prices and dear money, found subsistence difficult. The urban worker, beset by competition from immigrant and even contract labor, economically disenfranchised, found little government protection for his efforts to organize. Class distinctions were now entirely based on wealth, and ruthless exploitation of labor led to class warfare toward the end of the century. Similarly, antipathy between the rural and the urban became more pronounced.

At the same time cultural nationalism declined as the older, ideological dream of American destiny became an individualistic, competitive drive for power and wealth, which, being both new and transitory, had to be conspicuously displayed. The *nouveau riche* industrial and financial tycoons, whose origins usually were humble and whose rise to fortune was frequently shady, were less tasteful than extravagant and less knowledgeable than acquisitive. The shortest and surest road to social and cultural standing was the assumption of European aristocratic trappings. During the "Gilded Age," American millionaires began to emulate both the manner and scale of princely existence, building fake palaces, châteaux, and castles and forming "old master" collections.

In an even more profound sense culture had been affected by the transformation of America through its phenomenal growth into a pluralistic society. New York, Philadelphia, and Boston had become metropolises, concentrating great populations and intense financial and commercial activity. Urban and rural populations were differentiated by occupation, ethnic origin, mode of life, and even thought, and both were more stabilized. Although social and geographical mobility has continued to play an important historical role, the earlier fluidity between town and country and between settled areas and the frontier had already become less usual.

Immigrants settled to some extent in the free lands of the West, but most gravitated to the cities, swelling the slums and changing their ethnic and cultural character. Until 1890 the majority of immigrants still came from northern Europe, but then the great influx of peoples from central and southern Europe began. Since Americanization took time, the alienation of the native rural and immigrant urban populations was intensified, and in the cities the juxtaposition of immense wealth and abject poverty exaggerated class antagonisms. In different parts of the country people of different ethnic origins, engaged in different and specialized occupations, and belonging to more precisely circumscribed classes, lived, acted, and thought differently, and it had become difficult to define an American destiny equally meaningful for all.

In outgrowing its earlier naive cultural positivism, America did not suddenly become mature. Instead, it entered a period of adolescent uncertainty, brashness, and philistinism. The passion for material acquisition began to alienate its own intellectual class, including its artists. The tasteless extravagance of the *nouveau riche* was matched by a "know-nothing" philistinism of the rural masses, who saw in culture the evils of cities, the effeteness of the arts, and the decadence of wealth. In this new anti-intellectual environment, the status of the artist deteriorated.

The oversized landscape spectaculars of a Church or a Bierstadt still found buyers, but in general American artists no longer found patronage simply because they were American. Even the most untutored of robber barons was aware that European art carried more social cachet than the local variety; if he could not afford authentic old masters, he bought second-rate examples, fakes, or contemporary European academic works. In addition, bread-and-butter portraiture had finally been undermined by photography. The distinction between "fine" and "popular" art became sharper as class interests and tastes diverged. Popular art became increasingly anecdotal and sentimental, and the fine arts took on the guise of gentility. The crude, aggressive, and vital character of American society found no adequate expression, except perhaps in its architecture, the artless nature of industrial construction, the flamboyant extravagance of eclecticism in commercial building, and finally in the genius of the Chicago School.

Not for the first time, but in somewhat different context, American artists found their environment unsympathetic. A new sophistication about aesthetic standards led Whistler and Cassatt to expatriation, and a new kind of seriousness toward creative integrity led Eakins, Ryder, and Blakelock to work here against the grain of current taste. The dislocation of art that emerged after the Civil War became more pronounced with time, as it did in nineteenth-century Western culture in general. In that sense, at least, the American artist exhibited a growing sophistication, though the deep-seated provincialism of his culture remained a dominant force. Unable to cope with the crude vitality and the disturbing problems of contemporary life, American culture slipped into a stultifying respectability from which it did not emerge until the beginning of the twentieth century. Few voices were attuned to the raucous sounds of industrial expansion; few even conceived of expressing the raw power of that experience. Much of the art of the time was a false facade behind which the harsh realities of life were hidden.

CHAPTER SIXTEEN

Architecture

The Battle of Styles

The architecture of the nineteenth century as a whole, and of the second half specifically, has commonly been described as an epic struggle between the forces of reaction expressed in eclecticism and those of progress embodied in functionalism. It has been seen not only as an aesthetic but as a moral dilemma of modern man facing a changing world with outworn traditions and conceptions. Much has been made of the alienation between engineer and architect, between function and expression, between reality and illusion. This is essentially a picture colored by hindsight. No doubt the nineteenth was a troubled century, but hardly more so than our own. In architecture, the late nineteenth century was an exuberantly vital and productive era, fascinating in its failures as well as in its successes, full of monstrosities and abortions but also of productive progeny.

What was once seen as a single undeviating line of development from Darby's iron bridge over the Severn to the International Style no longer seems an adequate description of nineteenth-century architecture. Recent historians have done much to redress this imbalance and rediscover those aspects of eclecticism which had either an important influence on the mainstream or aesthetic validity in their own right, leading us to see the nineteenth century afresh in its own terms, as part of our cultural heritage, not as a simplistic confrontation between reaction and progress or between tradition and new technology. The separation between architect and engineer in the latter half of the century was real enough, but architects were not blind to advances in technology or uninterested in engineering as related to building. Many had engineering training, some even made important contributions to building technology, and every large architectural firm had its engineer. However, the gap between the purely utilitarian construction of bridges, railroads, canals, dams, or factories and that of traditional structures such as public buildings, churches, schools, libraries, museums, or dwellings had become irreconcilable. Architecture and engineering had become distinct and specialized professions that could in some circumstances operate symbiotically but would henceforth go their separate ways. Not only were the engineering demands in many new kinds of building now beyond the capabilities of most architects, but the very nature of the industrial complex and the demands of individual clients fostered such a division of labor. Many kinds of construction were thought of as purely engineering; railroad engineers were expected not only to handle the laying of lines but also to design bridges, service installations, and train sheds.

It was in the gray area between what was normally thought of as engineering on the one hand or architecture on the other that aesthetic confusion occurred. Architects and engineers alike were interested in both aesthetic and practical solutions, as the literature of the period reveals, though the contradictions took many decades to resolve. The problem showed itself clearly in the railroad station, where the train shed was entrusted to the engineer and the station building itself to the architect. Commercial architecture in general teetered between utility and public presence. To be profitable the commercial building had to be serviceable and economical, but it often had to appeal to aesthetic taste as well. The ornateness of the building was directly related to the status consciousness of the client. Some of the most lavish of the early skyscrapers were for banking and insurance companies eager to project a public image of wealth and stability.

Building activity fell off with the financial depression of 1857, and the decline naturally continued through the Civil War, even though Lincoln insisted on continuing the renovation of the Capitol building as a symbolic gesture. But the postwar boom fostered public and private building on an unprecedented scale. Four years of fratricidal war had had remarkably little effect on taste. Revivalism in architecture continued uninterrupted. The urge toward increased picturesqueness, greater plasticity, and even gigantism, which had already been evident in the fifties, now came into full flower. The postwar period is characterized not only by a new level of extravagance but also by a freer eclecticism, with an uninhibited and often misguided mingling of elements from various historical sources. The result was at times a new and exu-

berant originality and at others a provincial pastiche, labeled aptly enough the "General Grant Style," since its life span coincided with the General's term as President from 1868 to 1876.

From the end of the Civil War to the Philadelphia Centennial Exhibition in 1876, American taste accepted with equanimity two distinct revival styles, the Victorian Gothic, which was distinct from the earlier Gothic Revival, and the Second Empire, derived from Napoleon III's revival of the French Classic Baroque of Louis XIV. On the face of it, no two modes could be more disparate: the one medieval, towered, pointed-arched, asymmetrical, and polychromed; the other Classical-oriented, mansard-roofed, round-arched, symmetrical, ordered, and, at least in its origins, essentially monochromatic. Yet, somehow the two were converted to a common aggressively plastic picturesqueness expressive of the brash adventurism of the period itself. The styles were operative concurrently and even interchangeably, within a general recognition of the Gothic as a more churchly manner and the Second Empire as a courtly manner. Thus, churches and, by what one may assume was logical extension, schools, libraries, and museums were normally Gothic, while governmental and commercial buildings, or anything intended to appear palatial or luxurious, were more frequently Second Empire. Naturally, hotels were clothed in Second Empire opulence, whereas in such ambiguous types as the railroad station aesthetic confusion reigned and almost any style was acceptable.

THE SECOND EMPIRE

The so-called "Second Empire" style was practically decreed by Napoleon III to bolster his imperial intentions. His first architectural gesture was the extension of the Palace of the Louvre connecting it with the Tuileries, and the "New Louvre" (1852–57) set the pattern for the international Second Empire style; its neo-Baroque was an eclectic variation on themes from the old Louvre, but with even more pronounced plasticity. The new vogue spread with amazing rapidity, partly through architectural publications and travel, but also because burgeoning urban societies needed a unifying, standardized, expandable, and essentially undemanding style which still carried the recognizable cachet of status and power. The open-ended repetition of arches and columns, even in a variety of combinations, was no particular strain on the architect, who was rendered almost unnecessary, on the client, who was relieved of problems of taste, or on the builder, for whom the limited ornamental vocabulary was a boon. Curiously, the more flamboyant and more original neo-Baroque style of Charles Garnier's Paris Opera (1861–74), which has become the very symbol of Second Empire extravagance, had practically no influence in this country.

The American version of the Second Empire, perhaps because it derived from engraved illustrations, remained always dryer, harder, and almost austere, its basic exuberance expressed in an imaginative, at times fantastic, elaboration of elements rather than lushness of surface. While the vogue in the sixties was reinforced by the popularity of Napoleon and the Empress Eugénie, the architectural influence came not directly from France but through England, where the style had found early and even official acceptance. However, prefigurations of the mode had appeared in the United States before the war. The most characteristic feature, the mansard roof, named after the seventeenth-century French architect Jules Hardouin-Mansart, occurs as early as the fifties in a few isolated examples which seem in context almost a logical outgrowth of the Italian Villa style rather than a new importation. The newly immigrated, French-trained Danish architect Detlef Lienau (1818–1887) used what may be the earliest mansard roof, as well as French dormers, in a house for Hart M. Shiff (1850, plate 516) in New York City. A rather rudimentary version of the French style, it predates the official revival in Paris. Lienau continued to use it interchangeably with the Italian Villa for more formal and palatial structures, as in the white-marble terrace or row houses he built for Mrs. Colford Jones on Fifth Avenue, between 55th and 56th Streets, New York City, in 1869.

Strangely enough, Richard Morris Hunt (1827–1895), the outstanding eclectic architect of the period, who had returned in 1855 fresh from the Ecole des Beaux-Arts and had actually worked on the New Louvre, showed little interest in the lushness of this new style, although he did employ the mansard roof in his early work. Henry Hobson Richardson (1838–1886), also trained at the École a decade later, showed some influence from the major mode in Paris but never became seriously involved with it. Thus the two leading and most sophisticated architects of the period, who had a firsthand acquaintance with the style, had little to do with its promulgation on these shores.

James Renwick, whose early work had been in medieval revival modes, tried his hand at the Second Empire style in several buildings before the war. Though the results were fairly simple, rather provincial, and not very elegant, they were original and indicative of an awareness of the new manner. The earliest of these, Charity Hospital (1854–57, plate 517), now the main building of Riverside Hospital on Welfare Island, New York City, is a severe, barracks-like structure in gray stone, though it originally struck some as being too palatial for its purposes; its restrained use of trim and quoins in lighter stone, simplified mansard roofs of purple slate, and a formal facade with a central and two symmetrical end pavilions were consciously Second Empire in inspiration. In 1859 he designed a Second Empire building to house the Corcoran Gallery, now the Renwick Gallery (colorplate 53), Wash-

516 Detlef Lienau. Hart M. Shiff House, New York. 1850

517 James Renwick. Charity Hospital, Blackwell's Island, New York. 1854–57. From an engraving. The New-York Historical Society

ington, D.C. It was executed in red brick with brownstone trim, and although it was obviously a monumental effort, the result was still a somewhat muddled and provincial reflection of the New Louvre. Renwick's Main Hall at Vassar College (1860, plate 518), near Poughkeepsie, N.Y., indicates a continuing provincialism, but it also reveals a more independent use of borrowed materials. The building, commissioned by the brewer Matthew Vassar to imitate the Tuileries, is a four-story red-brick block, enlivened by a central and end pavilions capped by mansard roofs. A far cry from its prototype, it is nonetheless a building of some vitality in its own right. Also, for a college it was advanced in amenities as well as construction, with fireproofing, the first central heating of its kind, and even an attempt at soundproofing. Although Renwick's buildings are comparatively early examples of the style, they were probably not very influential in its eventual spread.

It was the Boston City Hall (1862–65) by G. J. F. Bryant and Arthur Gilman that set the pattern for a long

518 James Renwick. Main Hall, Vassar College, Poughkeepsie, N.Y. 1860. From a print. Courtesy Vassar College

519 State, War, and Navy Department Building, Washington, D.C. 1871–88. From a photo of c. 1880. Library of Congress, Washington, D.C.

series of governmental buildings in the Second Empire style. Most Federal building during the General Grant era was in the manner and was executed under Alfred B. Mullet, Supervisor of Architecture for the Treasury Department. Arthur Gilman, as consultant, probably had more to do with the design. The old State, War, and Navy Department Building (1871–88, plate 519), now the Executive Office Building, in Washington, D.C., was the major effort of this team and remains one of the prime examples of the style. It has served for so long as a model of bad taste that modern eyes can scarcely see it in its own terms, as a coherent, insistently plastic mass with a distinct personality. It owes perhaps more to the inventiveness and rather naive sensibility of the architects than to its European models. The reduction in scale and fanatical repetition of elements transformed a grandiose style into one of matchstick fantasy.

The Philadelphia City Hall (1871–81, plate 520), designed by a local architect, John McArthur, Jr., has been equally denigrated, perhaps because of the ungainly, out-of-scale tower capped by a gilded statue of William Penn, which was added more than a decade after the building was finished. The immense, square-planned mass of the block itself is a faithful and knowledgeable variation on the New Louvre, well proportioned, boldly scaled, and richly plastic, combining picturesqueness and monumentality in the largest and finest example of the Second Empire in this country. Too frequently the Second Empire style deteriorated into meaningless ornamental bombast, as in that fantastic pile of masonry that once stood in City Hall Park, the New York Post Office (1868–75), whose very extravagance seems to reflect the staggering list of architects, from Renwick to Hunt, who were involved with it. Lesser examples of the type still stand in towns and smaller cities throughout the country, their pretensions somewhat deflated, the splendor grown shoddy, but with a remnant of dignity that makes the plastic and neon brashness of their more recent neighbors seem barbaric. Most of the larger and more important examples have been destroyed, such as the Cook County Buildings, Chicago; the Municipal Buildings, San Francisco; and the original Grand Central Station, New York.

The Second Empire style was short-lived. In governmental building, at least, it seems to have come to a sudden halt, perhaps because of the national revulsion against corruption in the Grant administration, with which both the style and the buildings themselves were identified. Certainly not many buildings in the style postdate the panic of 1873, and many begun earlier were revamped after it had passed out of favor, for instance, the New York State Capitol (plate 537). Although the Second Empire was never a major manner in American architecture, two of the earliest skyscrapers in New York City, Post's Western Union Building (1873–75) and Hunt's Tribune Building (1873–75), both sported mansard roofs.

520 John McArthur, Jr. Philadelphia City Hall. 1871–81

For urban houses the style became common in the late 1850s and remained popular through the mid-1870s. Classical detailing, French dormers, and mansard roofs characterized many of the row houses of the period in Boston, where Bryant and Gilman were active, and in New York, with Lienau and Hunt. The Stuyvesant Flats (1869–70), one of the earliest apartment houses in New York City, was an unusually restrained example by Hunt. The style had perhaps its most successful and telling effect in suburban domestic architecture, where its sculptural qualities pleased the picturesque taste of the times. The lush treatment of detail reinforced an already strong tendency in that direction apparent in the Italian Villa style, but its most important contribution to the vocabulary of the picturesque was the mansard roof in its many variations. It was freely substituted for, and even combined with, the earlier pointed Gothic or flat Italian Villa roofs. Calvert Vaux, in his *Villas and Cottages* (1857), had included such French details as the latest fashion. Seen first in more formal houses of masonry construction, the new style became amalgamated into vernacular wooden building and even appeared later in the Shingle Style. Many houses in Newport, R.I., built during that period in both masonry and wood, attest to the popularity of the mansard roof. Beaulieu (1856–59, plate 521), a formal mansion in red brick built for the Peruvian ambassador,

521 Beaulieu, Newport, R.I. 1856–59

522 Showandasee (the Train Villa), Newport, R.I. 1869

523 United States Hotel, Saratoga Springs, N.Y. 1875. From a photo of 1920

is an excellent example of the more monumental and palatial type, whereas Showandasee, the Train Villa (1869, plate 522), incorporates mansarded masses with the more indigenous open porches.

The great resort hotels of the period were among the most original confections of Second Empire style. Improvements in travel, especially the development of railroads, led to a phenomenal growth of mountain and seashore resorts. Splendid hostelries of gargantuan proportions were built in the Catskills, Saratoga, Newport, and Atlantic City. Nothing else quite exemplified the social pretensions and essential instability of the General Grant era as did those giant tinderbox fantasies. They managed to translate the masonry pomposities of the Second Empire style into elaborate, airy, frivolous wooden extravaganzas. Economics, time, and fire doomed the delightful dinosaurs to extinction. Gone are the Grand Union and the United States hotels in Saratoga Springs (plate 523); the mansarded Hotel Brighton in Coney Island; the Queen-Anne-cum-Oriental Cresson Mountain House in Pennsylvania; and the many that stretched along the Boston North Shore from Rockport to Swampscot. Only a few crumbling relics can still be seen in such places as Cape May, N.J., and Block Island, R.I.

VICTORIAN GOTHIC

The Gothic Revival continued into the postwar era, although its character was radically altered. The newer, so-called "Victorian Gothic" was the achievement of a new generation influenced by John Ruskin, whose *Seven Lamps of Architecture*, lauding the English Gothic, was published in 1849; even more influential was his *Stones of Venice*, 1851–53, in which he shifted allegiance to the Italians. Although both works, as well as G. E. Street's *Brick and Marble in the Middle Ages* (1855), were phenomenally successful here, their impact was not felt much before 1860. The Victorian Gothic, like the Second Empire, was short-lived; absorbed eventually by the Romanesque, it produced few notable monuments.

Gothic achieved a new level of Romantic imaginativeness in its Victorian phase. Earlier Puginian concepts of structural "truth" and archaeological accuracy were replaced by a new compositional and decorative freedom given "ethical" support by Ruskin. By placing more emphasis on craft than on structure, Ruskin opened up a new range of decorative possibilities. Every inch of the surface became expressive through color, texture, and ornament. Ruskin's particular preference for Italian

Gothic polychromy and his basically Romantic concern with the picturesqueness of both detail and mass produced an often indigestable richness. Victorian Gothic was less a revival style than an imaginative pseudo-Gothic manner in which medieval details were manipulated for picturesque effects. The new freedom had an important influence on the development of American architecture, though it had no first-rate practitioners, except for Richardson, who converted it to Romanesque, and Frank Furness, who made of it an idiosyncratic personal style.

Ruskinian influence is first discernible in the banded pointed arches of the Nott Memorial Library (1856–76, plate 524), begun by Edward T. Potter, set in the center of the otherwise Neoclassic campus at Union College, Schenectady. However, the Victorian Gothic lent itself most readily to ecclesiastical architecture. The earliest example is St. John's Chapel (1867), Episcopal Theological School, Cambridge, Mass., by Ware & Van Brunt, and for at least a decade most churches were executed in that manner. The First Church, Unitarian (1865–68), Boston, by Ware & Van Brunt, was a rather timid effort compared with their later *magnum opus* and apogee of the style, Memorial Hall (1870–78, plate 525), Harvard University, a difficult building to accept, but not an easy one to ignore. Too large to be charming, not good enough to be important, it was long singled out as a prime example of bad taste, perhaps because of its scale but more be-

524 Edward T. Potter. Nott Memorial Library, Union College, Schenectady, N.Y. 1856–76 (photographed before completion)

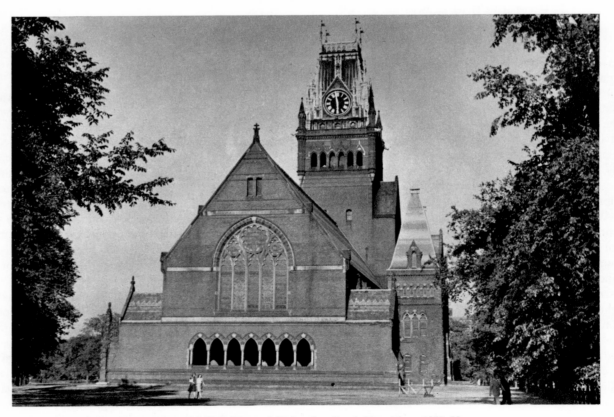

525 Ware & Van Brunt. Memorial Hall, Harvard University, Cambridge, Mass. 1870–78

cause the style was out of fashion. If anything, it is rather too refined and pedantic for its age, not daring enough to transcend its revivalist limitations. Still, it remains an imposing structure of well-organized masses composed into a picturesque whole. It runs the Ruskinian gamut, from plain walls to filigreed spires, banded courses, polychromed tiles, richly textured and varicolored masonry, through an extensive repertory of window, roof, and finial forms. The interior wood-trussed ceiling is a splendid example of the Gothic roofing that began with Upjohn's earliest churches. Yet, strangely reticent and harsh in detail, it lacks the sensuosity or fantasy that might have brought it to life. There is neither the subtlety nor power to carry the composition to an inevitable climax in the tower, as Richardson was doing in Trinity.

Richardson is so completely identified with his mature Romanesque manner that it is difficult to think of his earlier Gothic essays except as a prelude to his later work. He was one of the earliest and, in spite of his youth, for a short time one of the most sophisticated practitioners of the Victorian Gothic. Though small and fairly unassuming, both his Unity Church (1866–68), Springfield, Mass., and Grace Episcopal Church (1867–68), Medford, Mass., indicate an obvious familiarity with publications on English High Victorian Gothic. His mature style owed much to this earlier experience with the picturesque and the textural richness of materials.

The Potters, Edward T. and William A., were among the most successful exponents of the Victorian Gothic. The South Congregational Church (1872, plate 526), Springfield, Mass., by William is more imposing, more lavish, and more obviously High Victorian than Richardson's earlier example in the same city. The complex interplay of geometric volumes, the rich display of decorative elements, and the variations in texture and color are handled with competence and a sense of style. Edward's Harvard Church (1873–75) in Brookline, Mass., exhibits a similarly rich polychromy and a use of native materials for pictorial effects. On the other hand, New Old South Church (1874–77), Boston, by Cummings & Sears, with its awkward detailing and blatant color, exemplifies the provincialization of a style which lent itself so easily to vulgarization.

The Gothic never adjusted easily to modern secular functions, partly because it was not medieval secular forms that were imitated. Victorian Gothic emphasized the eccentric and the picturesque, contrary to the demand of bureaucratic and commercial functions for regularity. However, fashion can be strong, and some picturesque, turreted piles with dungeon-like interiors serving secular needs were built. The National Academy of Design (1862–65, plate 527), New York City, designed by Peter B. Wight, was the first to exhibit clearly Ruskinian Venetian Gothic influence in its obvious paraphrasing of the Doge's Palace and its unprecedented use of polychromy. Ruskin's identification with the style may have influenced its use

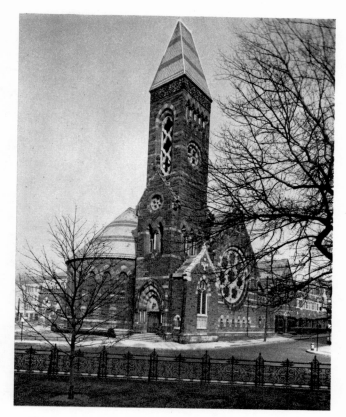

526 William A. Potter. South Congregational Church, Springfield, Mass. 1872

for art museums, as in the old Boston Museum of Fine Arts (1876–78, plate 528), by John H. Sturgis and Charles Brigham, and the still extant wing of the Metropolitan Museum of Art (1878–80) by Calvert Vaux and J. Wray Mould. Academic institutions continued the preference for the Gothic, as already noted in Nott Memorial Library and Memorial Hall. Yale University has two quite disparate versions of the Victorian Gothic: the overwrought Yale Divinity School (1869), by the French-trained Richard M. Hunt, working in a style for which he had little feeling; and Farnum Hall, begun in the same year, by the German-trained Russell Sturgis, in which there is unusual restraint and sophistication in the combination of plain wall surfaces and Gothic decorative detail. The most famous Gothic examples of the railroad station (see below, *The Railroad Station*) are gone.

A monumental failure, in the confusion of tongues typical of the period at its worst, is the Connecticut State Capitol (1873–78, plate 529), Hartford, by Richard M. Upjohn. It is expressive of the Victorian age in sheer scale, in the oppressive weight of the masonry mass, and in its striving for both the grandiose and the picturesque. However, the nondescript symmetrical block is overladen with the kind of mechanical ornament which eventually vitiated much of neo-Gothic architecture, and the whole is capped by an incongruous dome.

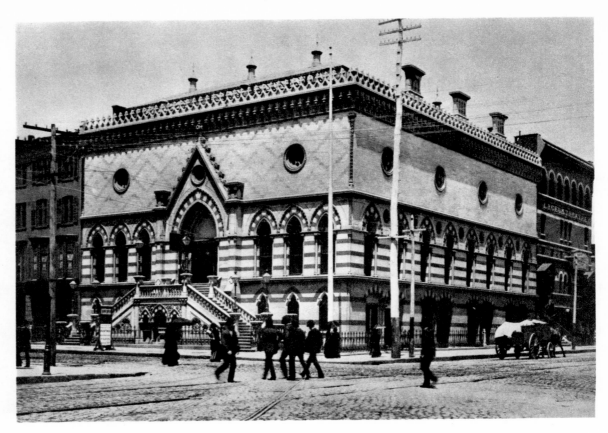

527 Peter B. Wight. National Academy of Design, New York. 1862–65. From a photo of c. 1888. The New-York Historical Society

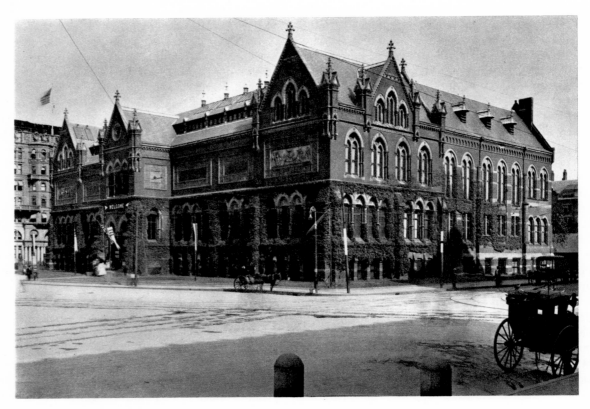

528 John H. Sturgis and Charles Brigham. Old Museum of Fine Arts, Boston. 1876–78

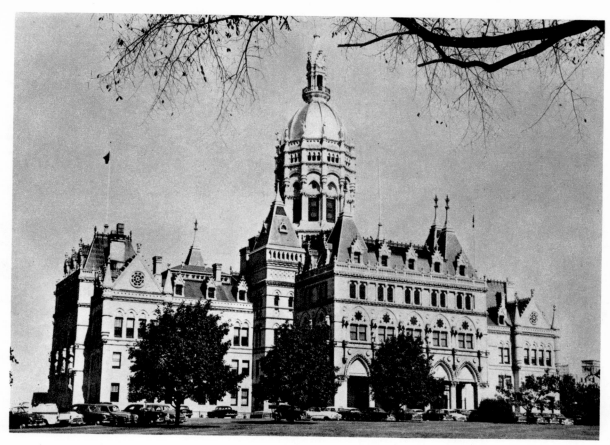

529 Richard M. Upjohn. Connecticut State Capitol, Hartford. 1873–78

Frank Furness (1839–1912), who worked in Hunt's office before opening his own in Philadelphia in 1867, fits somewhere within the Victorian Gothic but not comfortably. An architect of brutal power and perverse originality, he seemed for a long time the epitome of General Grant vulgarity. His first important commission, the new Pennsylvania Academy of the Fine Arts (1872–76, colorplate 54), planned for the Centennial Exhibition, was a Ruskin-inspired mélange of materials and textures —rusticated brownstone, dressed sandstone, pink granite columns, red and black brick. This capriciously irreverent use of traditional forms seems entirely personal, though a connection with Viollet-le-Duc can be adduced. The Guarantee Trust and Safe Deposit Company (1875, plate 530), of brick, black and gray stone, and tiles, was also strongly Ruskinian in its striped, interlaced, pointed arches, with a twin-tower facade reminiscent of Viollet-le-Duc, but here again there are personal inventions, as in the transformation of the mansard roof into a new parapet form and the introduction of proto-Art Nouveau decoration, which was to influence Louis Sullivan.

The harsh, aggressive granite mass of the Provident Life and Trust Company (1876–79, plate 531), later the Philadelphia National Bank and recently demolished, was Furness at his best, brutally frank in an age of pretense, programmatically irreverent toward tradition but never ignorant, searching for a new style that would match and transcend the past. He failed, but it was a heroic failure before which much of the thoughtless revivalist architecture of the time pales. Furness designed several other banks in Philadelphia, among which the Penn National (1882–84), now destroyed, was Richardsonian in character but with an angular brusqueness and a singular lack of charm, and the National Bank of the Republic (1883–84, plate 532), powerful but erratic in design, also gone. The narrow facade offered the strange appearance of two distinct buildings in violent opposition, but actually the architectural elements, which ranged from the eccentric to the bizarre (a half arch over an entrance), were very carefully and tightly composed, and the interior was a model of unadorned spatial simplicity. Furness's major commission in the 1890s was the massive enlargement of the Broad Street Station (1892–93, plate 593), now destroyed, which contained the largest single-span train shed in the world. Although the interiors of the station were interesting and unusual in decoration, the exterior was an inchoate mixture of styles. His later work became increasingly conservative, and his memory

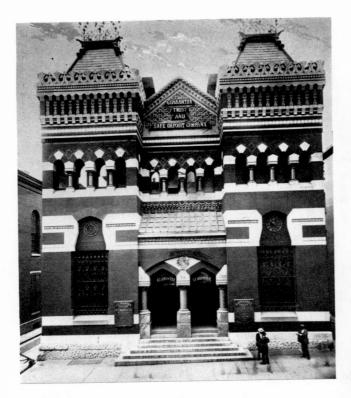

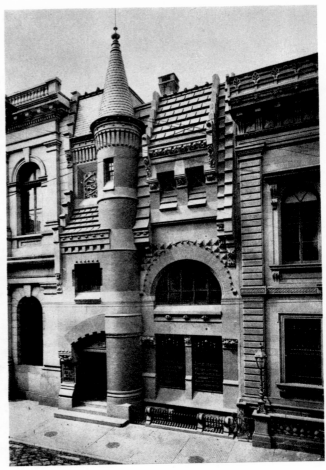

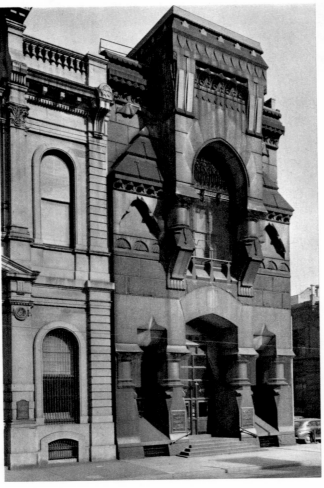

530 Above left: Frank Furness. Guarantee Trust and Safe Deposit Company, Philadelphia. 1875

531 Below left: Frank Furness. Provident Life and Trust Company, Philadelphia. 1876–79 (destroyed)

532 Above right: Frank Furness. National Bank of the Republic, Philadelphia. 1883–84 (destroyed)

was kept alive until recently only by the respect and affection of Louis Sullivan, who had worked with him briefly in 1873.

In domestic architecture the Victorian Gothic influence was felt in the continuing picturesqueness of vernacular wooden building, achieving its culmination in the indigenous development called the Stick Style, which is discussed in a separate section below. Some more pretentious mansions of the period were more clearly Victorian than the earlier Gothic Revival castellated mansions or rustic cottages, more picturesque, and richer in detail. A whimsical example of the type was designed for the great humorist Mark Twain by Edward T. Potter. The Mark Twain House (1874, plate 533), Hartford,

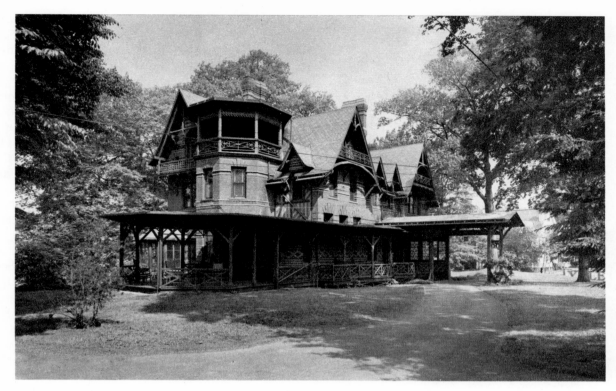

533 Edward T. Potter. Mark Twain House, Hartford, Conn. 1874

Conn., now a public shrine to his memory, is a delightful extravaganza of gables, towers, chimneys, Stick Style porches, a porte cochère, and a "pilot house" verandah, where the writer could recall his early years on Mississippi riverboats. Random ashlar, patterned brick, diapered roof tiling, and wooden lattice work are only a sampling of the profusion of materials, textures, and colors used in its execution.

RICHARDSON AND THE ROMANESQUE

No American architect ever dominated the age in which he lived so completely as did Henry Hobson Richardson (1838–1886). Louis Sullivan's masterpieces said more to the future than to his own time, and Frank Lloyd Wright's undeniable influence both here and abroad was as an individual rather than as the center of a movement. Richardson made a style which became that of his time. It has been called the Romanesque Revival, though it could perhaps more accurately be called "Richardsonian," as Henry-Russell Hitchcock has suggested. Richardson was a giant, in physical size, personality, and talent, and his earthy robustness, tempered by an unusually sophisticated taste, was expressed directly in his buildings. He was ideally equipped to express the vigor, materialism, ruthlessness, and pretension of his time, yet

he did not accept its standards. He tried to raise them to his own level and his clients responded by accepting his image of them; the "robber barons" were happy to become "merchant princes." The hallmark of Richardson's style was quality—in design, materials, and workmanship—and quality symbolized money, security, and status.

In addition to serving his clients well, Richardson created a monumental architectural style and played a major role in the transformation of domestic building. In one respect he must be considered retardataire: he avoided the technological challenges of his age, continuing to build in an older tradition, though on a level it had never achieved before in this country. Yet before his death he left to the next generation in his Marshall Field Wholesale Store a standard for commercial building which conditioned the development of the skyscraper in Chicago.

Richardson came from a wealthy Louisiana family, and something aristocratic and southern remained in his personality although he lived all his adult life in the North. He attended the University of Louisiana and then Harvard before going to Paris in 1859 to study architecture under Louis-Jules André at the École des Beaux-Arts. During the Civil War he remained in Paris, where he worked in the atelier of Théodore Labrouste, brother of the more famous Henri, and possibly with J. I. Hittorf on the Gare du Nord. When Richardson settled in New York in 1865, he was a soundly trained professional steeped in the French academic system. He exhibited an

a corner tower reminiscent of an Italian *campanile,* but most striking of all is the outsized sculptural frieze by Frédéric-Auguste Bartholdi, running in a continuous band around the square tower under an arcade at the top, a conscious modernism on Richardson's part.

Immediately thereafter, Richardson won the competition for Trinity Church (1872–77, colorplate 55), Boston, which established his reputation. Trinity is in many ways derivative from the earlier church, except that it is larger and, because of the truncated triangular plot on Copley Square, had to be modified to a central plan. Richardson met the challenge of the site by designing a building in the round that offered a variety of picturesque views, not all equally satisfying. The massing of parts is intricate but beautifully articulated into a composition of robust grandeur. The pink Milford granite in random ashlar with Longmeadow brownstone trim reveals the Victorian Gothic bias, but, as the work proceeded, Richardson, never a drafting-room architect, showed a growing interest in archaeological accuracy and in the French Romanesque, especially of the Auvergne, evident in the detailing and polychrome decoration of the apse. The most controversial aspect of the edifice is its central tower, borrowed from the Old Cathedral of Salamanca by Stanford White, then working for Richardson. Though perhaps too pedantic in detail and somewhat flamboyant in comparison with the rest, the tower is not uncharacteristic of earlier Richardson designs or unfitting, for its richness carries the simpler lower masses to a soaring climax. The interior is as English as the exterior is Mediterranean, with its magnificent double-curved, wood-trussed ceiling, later transformed into a barrel vault. The use of stained glass was also responsive to contemporary English practice. Richardson hired William Morris and Burne-Jones to do the north transept windows, but he entrusted the rest of the interior decoration to his old friend John La Farge (see Chapter 17). Trinity, of all his buildings, was most dependent on archaeological quotation, not only in White's tower but also in his own reliance on H. A. Revoil's *Architecture Romane du Midi de la France* (1868–73). Trinity was selected by architects, in a poll taken by the *American Architect and Building News* in 1885, as the finest building in America. Four other Richardson buildings made the first ten, indicating his personal dominance as much as the popularity of the Romanesque.

Richardson's first official commissions were handled with mixed results. The Town Hall (1879–81), North Easton, Mass., was a charming minor effort, almost a parody of his own picturesque eclecticism. The New York State Capitol (1875–81) entailed transforming a Second Empire design by the English architects Fuller and Laver, with Leopold Eidlitz as his partner. The exterior is a disappointment, dry, rather formal, and pedestrian. Only in the interior, in the Executive Chamber (1880), the Court of Appeals Room (1881), and especially the grand

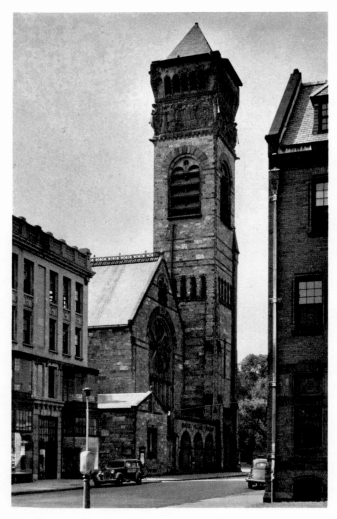

534 Henry Hobson Richardson. Brattle Square Church, Boston. 1870–72

immediate affinity for English High Victorian Gothic sources, as may be seen in the Hampden County Court House (1871–73) and the North Congregational Church (1872–73), both in Springfield, Mass., and the State Hospital (1872–78), Buffalo, N.Y. Richardson's earliest Romanesque manner was only a change in vocabulary.

His first mature work and his first Romanesquoid building was the Brattle Square Church (1870–72, plate 534), now the First Baptist Church, Boston, one of his most successful and charming efforts and already authentically Richardsonian. The Roxbury puddingstone, richly colored and roughly textured, is laid in irregular courses; the detailing, part French Romanesque and part English High Victorian Gothic in inspiration, is handled with freedom and imagination; and the geometric volumes of the building are composed with unusual clarity and power. The T-shaped plan is original, as is the use of

Senate Chamber (1875–81, plate 535) were Richardson's feeling for space and his virtuosity with exotic materials given free range.

The Allegheny County Buildings (1884–88), Pittsburgh, were Richardson's outstanding government project, just as Trinity was "his" church. They are related to the New York State Capitol in the use of a rather unpleasant, light-gray, rusticated granite, coloristically cold and neutral; in the steeply pitched slate roofs; and in the meaningless dormers. The major courthouse facade, with its huge central tower, is commonplace in conception and mechanical in detailing, but Richardson's genius comes through in the impressive massing of geometric volumes; in the compelling rhythms of the fenestration in the quadrangular interior court (plate 536); in the primitive power of the masonry itself; and, perhaps most of all, in the threatening sense of incarceration projected by the jail compound (plate 537). Analogy with the engravings of Piranesi is obvious, for both have the same superhuman scale, dramatic power, and projection beyond reality into the realm of imaginative creation.

Richardson had several opportunities to design academic buildings, and although the very early Worcester (Mass.) High School (1869–71) was something of a disaster, the two he later did for Harvard are among his finest buildings. Austin Hall (1881–83, plate 538), the later and more monumental of them, is more recognizably Richardsonian and, with Trinity, his most richly decorated work. Located near the newly completed Memorial Hall, it seems to have been intended as competition to the latter's Victorian splendor. Richardson pulled out all the stops, from picturesque massing and Syrian arches to lavish polychromy and carved Byzantine ornamentation. However, he did himself in, for opulence in decoration is no substitute for clarity of design, and Austin Hall is better in its parts than in the whole, more satisfying in the asymmetrical picturesqueness of the rear than in the formalism of the facade. On the other hand, the commission for Sever Hall (1878–80, plate 539), to stand in the Yard among the older red-brick buildings, presented him with a new frame of reference, forced him to modify his vocabulary, and resulted in an architectural gem unique

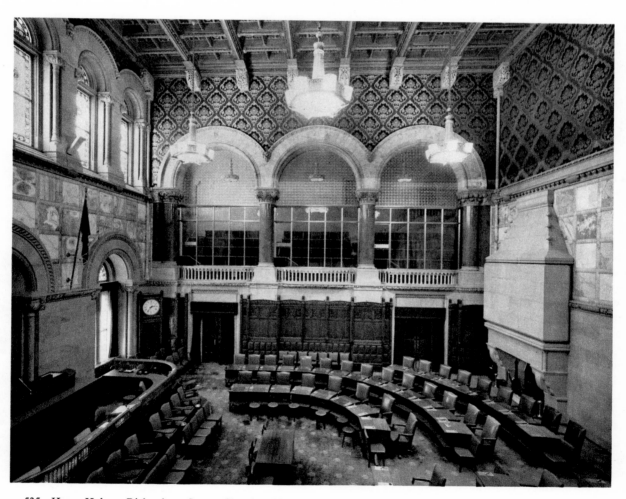

535 Henry Hobson Richardson. Senate Chamber, New York State Capitol, Albany. 1875–81

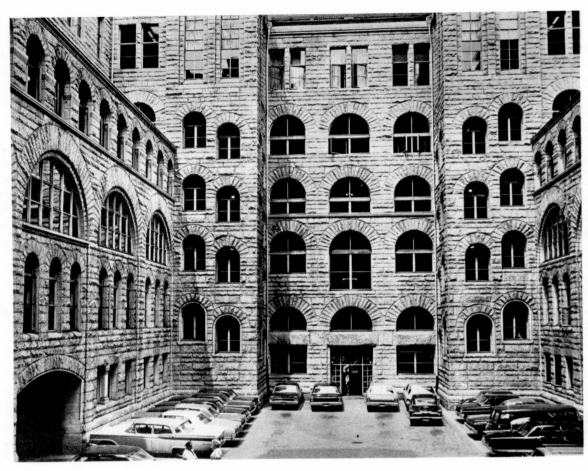

536 Henry Hobson Richardson. Courthouse court-
yard, Allegheny County Buildings, Pittsburgh. 1884–88

in his oeuvre. Using a beautiful pinkish-red brick with
matching carved brick ornament, he built a simple, sharp-
edged, clean-planed rectangular block relieved only by
the subtlest of design variations, the most elegant pro-
portions, and the most exquisite detailing. It is a mono-
chromatic shell-like form with curtain walls pierced by
bands of clustered windows. Criticism of Sever Hall's in-
terior planning ignores the then current level of school
design, to which it was in no way inferior. Its fenestration,
at least, was far in advance of its time.

One of Richardson's important functional contribu-
tions was in the development of the library; he designed
five between 1877 and 1883. He did not accept traditional
formulas, as in so much of his other work, but examined
freshly the needs of the small public library in terms of
storage, service, and circulation, and his planning has
the rationality and organization one would expect from
his French training; the picturesque grouping of exterior
volumes and window bands expresses directly the neces-
sary disposition of interior spaces and lighting needs.
The earliest of these, the Winn Memorial Library (1877–
78), Woburn, Mass., is the most Victorian in conception
—richly textured, profusely ornamented, with poly-

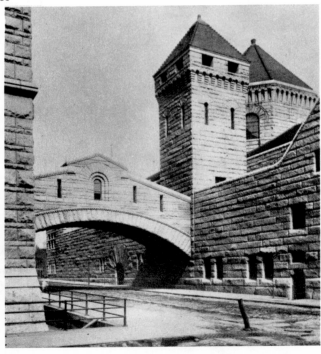

537 Henry Hobson Richardson. Jail wall and bridge, Al-
legheny County Buildings, Pittsburgh. 1884–88

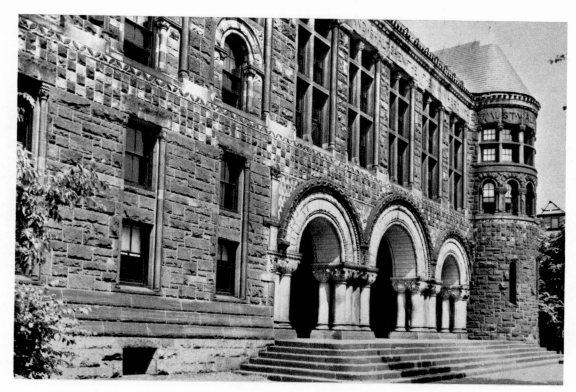

538 Henry Hobson Richardson. Austin Hall, Harvard University, Cambridge, Mass. 1881–83

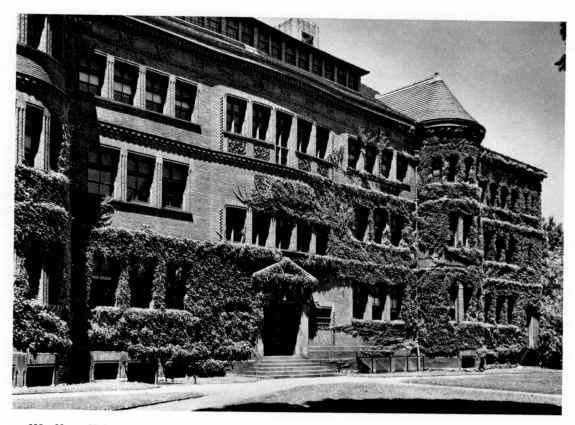

539 Henry Hobson Richardson. Sever Hall, Harvard University, Cambridge, Mass. 1878–80

chrome banded arches. The composition includes a baptistery-like building joined by a harsh segmental arch to massed gables and a flamboyant tower. Though the juxtaposition of elements is cleverly handled, the result is overanimated and diffuse. The introduction of window bands and the window wall were significant innovations that may have been derived from the "Queen Anne" style with which Richardson had been experimenting (see *The Shingle Style,* below). Much more unified in plan and simplified in execution is the Oakes Ames Memorial Library (1877–79), North Easton, Mass., where he retained the picturesqueness of the silhouette but achieved a more compact and forceful massing of parts. Here also he first introduced the heavy so-called "Syrian" arch that was to become a Richardsonian trademark. Though smallest in scale, the Crane Memorial Library (1880–83, plate 540), Quincy, Mass., is Richardson's most coherent and succinct statement in the library form. The building is a simple rectangular mass under a broad and gently sloping tiled roof, enlivened by the softly swelling curves of three eyelid dormers. The simple facade is dominated by an asymmetrically placed gabled pavilion enclosing a band of small interlaced-arch windows above the massive void of the Syrian entrance arch, which is flanked by a small stair turret, all that remains of the earlier picturesque tower feature. The longer left flank of the facade contains only a narrow horizontal band of windows under the eaves, balanced on the shorter right flank by a vertical window wall. The ascetic geometry of the facade composition is relieved, perhaps unfortunately for modern taste, by the random ashlar masonry, rough-cut, polychrome, and fortress-like in its massiveness.

Although Richardson lived during the great era of railroad expansion and had close connections with railroad magnates, he never built one of the great railroad terminals of the age. However, in his small suburban stations for the Boston and Albany Railroad he achieved a paradigm of Romantic rusticity wedded to socioeconomic security. He devised a functional unit that included shelter, platform canopy, and porte cochère; arranged the elements with freedom and inventiveness; and clothed them in his own version of the rural picturesque. The fundamental character of materials, stone as torn from the earth, wood as hacked from the tree, or brick baked in a primitive kiln, is felt in the finest of the small stations, such as those at Auburndale (1881) or Chestnut Hill (1883–84). His desire to join elemental materials with rudimentary functions is expressed also in the apt yet styleless character of the two bridges he did for the Fenway in Boston in 1880–81.

Richardson's station buildings seem to prefigure the prairie houses of Frank Lloyd Wright, and are closely allied with his own domestic architecture in the Shingle Style. For example, the Ames Gate Lodge (1880–81, plate 541), while it is a house, is related in form to the railroad stations. It is the most extreme example of Richardson's

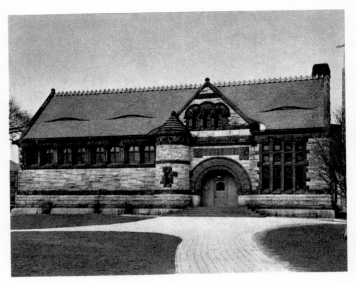

540 Henry Hobson Richardson. Crane Memorial Library, Quincy, Mass. 1880–83

quest for an aboriginal architectural expression, conveying a sense of fortification and gateway and, in its battered tower, random boulders, bold arch, and molded roof, constituting a remarkable piece of abstract sculpture.

Richardson's last major opus, the Marshall Field Wholesale Store (1885–87, plate 542), Chicago, was historically his most important building, for it came at a time when Romantic eclecticism was frittering away its dying energies in irrelevant elaborations on antiquated ideas and a younger generation of technologically oriented builders was floundering without aesthetic direction. Undoubtedly, the projection of his personality with such force and cogency on the Chicago scene at that time was a catalytic element in the emergence of a modern American architecture. It took some time before the younger architects could understand the message, but eventually it had its effect, and the Chicagoans began to produce not merely buildings but an architectural style.

Richardson had already done a good deal of commercial work, including an early proto-skyscraper, the American Express Building (1872–73) in Chicago; the Western Railroad Offices (1867–69) in Springfield, Mass.; and a project for the Equitable Insurance Building (1867) in New York. The Marshall Field Store was, as in all his work, the result of previous experiment, trial and error, and ultimate purification. It had its precursor a decade earlier in the Cheney Block (1875–76, plate 543), now the Brown-Thompson Store, in Hartford, Conn. This basically simple, rusticated mass with banded round arches is related to earlier English commercial building, though the Romanesque detailing is clearly Richardsonian. The ordered plan is subtly asymmetrical without any material disturbance of the interior function or the reg-

541 Henry Hobson Richardson. Ames Gate Lodge, North Easton, Mass. 1880–81

542 Henry Hobson Richardson. Marshall Field Wholesale Store, Chicago, 1885–87

543 Henry Hobson Richardson. Cheney Block, Hartford, Conn. 1875–76

544 Henry Hobson Richardson. Ames Building, Boston. 1886–87

ularity of fenestration. Picturesqueness is limited to slight variations in facade spacing; asymmetrical treatment of the height and roofing of the towers at either end, calling for a vertical extension of one cluster of windows; and a similar asymmetrical handling of two ground-level gables rationalized by using the larger to cap the off-center entrance. There is an unusual balance between Romantic eclecticism and functional necessity, and in its clarity of design and boldness of execution the Cheney Block is hardly a breath away from the Marshall Field Store, but it remains revivalist.

In the Marshall Field Store revivalism was almost completely expunged; only its traditional masonry construction and the echo of an older style relate it to the past. The round arches and rusticated masonry seen in the context of a square block capped by a flat cornice are not so much Romanesque as reminiscent of the Florentine palaces of the Renaissance or, perhaps, simply of fundamental masonry forms inherited from the Romans and applied to a contemporary function with frankness and clarity. Richardson used iron columns as interior supports but self-bearing masonry for the exterior walls. He accepted the cage without bowing to its rigid geometry. It

was his vision and his vocabulary that dictated the use of round arches, rusticated masonry, horizontal window bands to express regularity, and vertical bay divisions to emphasize weight and structure. It was his taste that insisted on the subtleties of modulation in proportion, rhythm, and texture, the changing forms and cadences of the windows, the all but imperceptible gradation in masonry courses and rustication, the variations in horizontal and vertical spacing and in window frames and divisions. The exterior of the Marshall Field Store was the embodiment of an artistic personality working at the limits of capacity with honesty toward materials. It did nothing to advance the technology of steel-skeleton construction, but it was an authentic example of architecture in any terms. Its destruction to make way for a parking lot was an act of cultural vandalism.

Where Richardson might have gone is problematic, for the evidence of the posthumous Ames Building (1886–87, plate 544), Boston, is equivocal. Even if one thinks of the more forward-looking elements as his own and the retarded as by others, the fact remains that it shows no significant advance in construction. Both the increase in window area and the frank use of metal in the spandrels

indicate at least some influence from his Chicago experience, though the latter seems more an acceptance of the new material's decorative rather than its structural potential. Like Moses, Richardson was never to enter the promised land, but he did lead the way.

RICHARDSON'S FOLLOWERS

Richardson's style never led to a Romanesque revival in the academic sense of a return to historical sources. What remained for a short span, not much beyond the 1880s, was an imitation of his Romantic picturesqueness. He had many followers: men who had worked intimately with him, like McKim and White; independent figures unsettled by the force of his vision, like Sullivan and Root; or the many Western architects who may have seen his work only in magazines. During the eighties there was a plethora of buildings, public and domestic, that rang all the changes on the picturesque silhouette, the massive wall, the rusticated masonry, and other quirks of his style. Too often they were only uninspired imitations, and so many have been demolished that one can hardly reconstruct a history in extant buildings. The subsequent reaction of academic eclecticism, with its sharper definition and lighter texture, engendered a taste that found the Richardsonian Romanesque elephantine, forbidding, and aesthetically obsolete.

The Richardsonian Romanesque was more popular in the West than in the East, and more so in Boston than New York. Richardson left New York before his style had matured, and in the early 1880s the academic eclecticism of Hunt and McKim, Mead & White was already in full swing. Of the better-known New York architects only Bruce Price was Richardsonian in his domestic buildings. William A. Potter did three churches in the manner, of which the Holy Trinity (1888), now St. Martin's, in Harlem is still standing. The gargantuan cathedral of St. John the Divine by George L. Heins and C. Grant La Farge, begun in 1891 and still incomplete, has gone through so many building stages that it can hardly be called Richardsonian today. Richardson's presence in Albany seems to have had some effect on the All Saint's Episcopal Cathedral (begun in 1884, never finished), by a local architect, Robert W. Gibson, in association with Richardson. Richardson also submitted a design for the Buffalo Public Library and Art Building (1884–87), but the commission went to Cyrus L. W. Eidlitz, who executed a competent Richardsonian paraphrase (plate 545).

In Boston, where Richardson had his office and where some of his major works were visible, the impact of his style is apparent in the architecture of Peabody & Stearns, Van Brunt, and especially Shepley, Rutan & Coolidge, who were heirs to his practice, completed his unfinished projects, and continued to build extensively in his manner with fanatical archaeological accuracy. The New London Public Library (1890, plate 546) is so faithful to Richard-

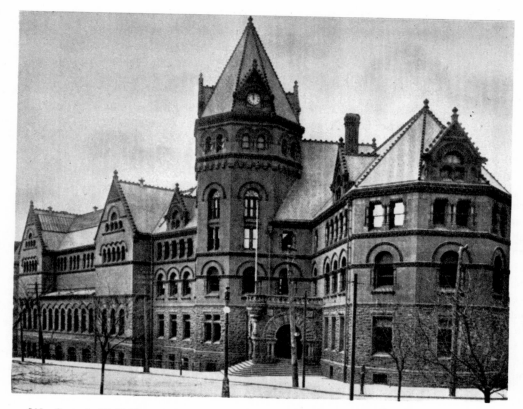

545 Cyrus L. W. Eidlitz. Public Library and Art Building, Buffalo, N.Y. 1884–87

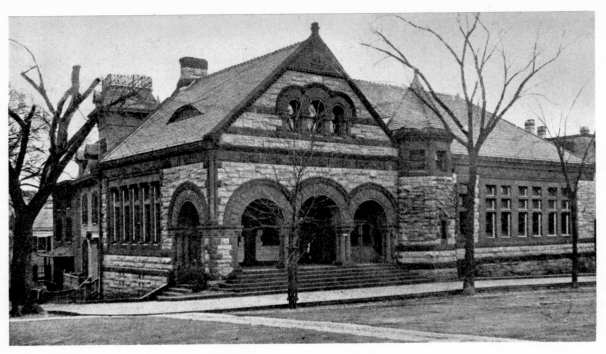

546 Shepley, Rutan, & Coolidge. Public Library, New London, Conn. 1890

son's models that the architects seem to have acted as surrogates of the departed master.

Richardson's activity in Chicago had a profound effect on Western public building and, perhaps, even more so on the domestic. Burnham & Root did at least six major Richardsonian public and commercial buildings between 1884 and 1891, of which only The Rookery (1885–86) remains. Adler & Sullivan's Standard Club (1887–88) is also gone. Of all the Chicago firms, Cobb & Frost were the most deeply committed to the Richardsonian Romanesque, but only the Newberry Library (1892) is still extant. S. S. Beman's Grand Central Station (1888–89, plate 591) completes the meager list.

The Twin Cities—Minneapolis and St. Paul—have been more fortunate. The Richardsonian influence was especially strong there in the eighties, and a fairly large number of buildings by Leroy S. Buffington, Long & Kees, and E. Townsend Mix, among others, have survived.

It is difficult to assess the contributions of the enigmatic and tragic designer Harvey Ellis (1852–1904) to the spread of the Richardsonian Romanesque in the West. Did he design the buildings he rendered so brilliantly for the many architects who employed him? Unquestionably he had a remarkable flair for Richardsonian picturesqueness and an extremely fertile, though not profound, creative imagination. Ellis was never the architect of record; but if he is to be credited with such Richardsonian buildings as the Germania Bank Building (1890, J. Walter Stevens), St. Paul, Minn.; Pillsbury Hall (1887, Leroy S. Buffington), University of Minnesota, Minneapolis;

the Mabel Tainter Memorial (1889, plate 547, Leroy S. Buffington), Menomonie, Wisc.; and the residential street gates (1893, Eckels & Mann) and the Compton Heights Water Tower (1893, George R. Mann), St. Louis, Mo., then he must be considered one of the prime forces in Midwestern architecture of that period. The Noyes Brothers & Cutler Building (1886, J. Walter Stevens), Minneapolis, closer to Louis Sullivan's Walker Warehouse than to Richardson and two years earlier, is a structure of which any architect could be proud. But Richardson's importance as an influence was not on the Romanesque revivalists; it was on the architects he inspired to be themselves, McKim, White, Sullivan, and Wright. Ellis was not one of them.

Stanford White, designer rather than builder, facile draftsman, had much in common with Ellis, including a fertile and imaginative intelligence and a pictorial vision. He designed at least one original masterpiece in the Richardsonian manner—the First Methodist (now Lovely Lane) Church (1882–86, plate 548) in Baltimore—for McKim, Mead & White. The massing of the elliptical auditorium, the surrounding rectangular buildings, and the nine-story tower is brilliantly conceived and beautifully executed in random ashlar. There is something archaic about the battered tower, in which White follows Richardson in his search for primeval forms, but it is not at all Richardsonian in appearance or detail. Montgomery Schuyler, the great proselytizer for the Richardsonian Romanesque, found it both too "rude" and too pictorial. White, in one creative leap, had moved beyond Richardson to something original but without progeny.

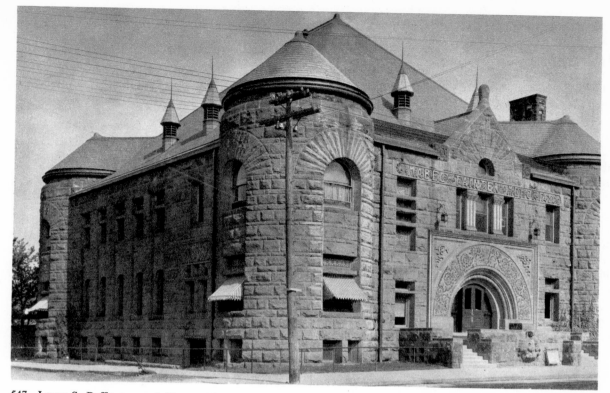

547 Leroy S. Buffington and Harvey Ellis. Mabel Tainter Memorial, Menomonie, Wis. 1889

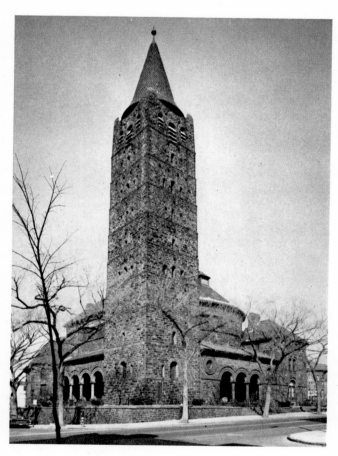

548 Stanford White. First Methodist (Lovely Lane) Church, Baltimore. 1882–86

It must have been inspired by medieval fortress towers, but there is nothing quite like it again before the emergence of twentieth-century European Expressionism.

THE RISE OF THE SKYSCRAPER

When Louis Sullivan spoke of an office building as "a proud and soaring thing," he was looking beyond utility to the symbolism of the skyscraper as an expression of the modern world. The skyscraper is the major contribution of nineteenth-century America to the architectural repertory and a development out of specific conditions of urban-industrial-commercial society. Despite earlier technological advances, the office building had remained tied to the traditional urban palace form. Not until the commercial building was forced skyward by post-Civil War population concentration and increased real estate values and became, in effect, the "skyscraper" did it take on an autonomous character.

The history of the skyscraper is not a rational, step-by-step solution, either technological or artistic, of a set problem. If one sees the skyscraper as the expression of modern technology, then the steel skeleton defines the type, and its structural development and artistic expression describe its evolution. But steel-skeletal construction was merely one means of achieving the socioeconomic unit called the skyscraper; many of its architectural forms were evolved independently of such construction, and the skeletal form is so flexible that it is capable of a variety of aesthetic solutions.

The office building as a form began in the first half of the nineteenth century. After the Civil War, buildings in the larger cities, even the tallest, were not more than four or five stories in height. Though there was increasing pressure to exploit the value of centrally located real estate by building higher, clients were reluctant to rent space above the comfortable limit of human vertical mobility. The answer was the elevator. Hoists for goods were in common use in warehouses before the middle of the century. The Bunker Hill Monument had a steam-operated passenger elevator by 1844, and in New York the Haughwout Store in 1857 introduced for the first time in an urban edifice the passenger elevator developed by Elisha G. Otis. The Equitable Life Assurance Building (1868–70, plate 549), New York City, designed by Gilman & Kendall with George B. Post as engineer, was the first office building planned with an elevator; it contained five stories, was 130 feet high, and was an immediate financial success. It soon had competitors, and older buildings added elevators and additional stories. The "elevator building," the first designation of the tall building, thus had its inception in the commercial metropolis of the country, New York. In spite of the panic of 1873, two major elevator buildings were begun in that year: the Tribune Building (1873–75, plate 550), nine stories and 260 feet high, by Richard M. Hunt; and the Western Union Building (1873–75, plate 551), ten-and-a-half stories and 230 feet high, by George B. Post.

There were other aspects of commercial building in which significant advances had been made earlier, specifically in the use of metal. With the development of fireproof tile between 1860 and 1870, further advances in iron construction were made possible. These early tall buildings were generally erected in what might be called "mixed media": exterior self-bearing and partially floor-bearing masonry walls and interior construction of combined wrought- and cast-iron and masonry, usually brick. With variations and ingenious refinements, this remained the basic method of skyscraper construction in New York until about 1890.

549 Gilman & Kendall with George B. Post. Equitable Life Assurance Building, New York. 1868–70. Courtesy The New-York Historical Society

550 Richard M. Hunt. Tribune Building, New York. 1873–75. From an engraving. Museum of the City of New York. J. Clarence Davies Collection

THE CHICAGO SCHOOL

551 George B. Post. Western Union Building, New York. 1873–75. From an engraving. Museum of the City of New York

Apart from technological problems, the skyscraper had to be adjusted to an environment of traditional architecture in the city's center. Commercial buildings had conformed to current modes, but the increase in horizontal as well as vertical scale imposed new problems. A French château did not adapt convincingly to a ten-story office building. Eclecticism became ludicrous when mansard roofs and dormer windows were perched on palisades of masonry and glass or when columns and arches were pasted in layers over the same cliffs. Architects were aware that new functions demanded new forms, but the evolution of style is the result of a historical process, not merely of rational thought. Although New York introduced the tall commercial building, it had little to do with either the technological or the aesthetic evolution, perhaps because its established architects were committed to eclecticism or because its clients were primarily concerned with the expression of wealth and status. The Tribune and the Western Union contained no technological innovations, and their designs were fumbling and ungainly even by eclectic standards. For the further development of the skyscraper one must turn to Chicago.

In retrospect Chicago seems to have been particularly fitted for skyscraper development through a congruity of circumstances—its phenomenal economic growth, its less entrenched and more adventurous capitalism, and the group of youthful and stylistically uncommitted architects then becoming active. In forty years Chicago had grown from a frontier village to become the teeming center of a voracious Western economic expansion. The crude and ugly commercial encampment of industrial installations and flimsy wooden slum dwellings was almost demolished overnight by the great fire of 1871. One third of its property evaluation was destroyed and one third of its people were homeless. Chicago obviously had to be rebuilt, and its architects had an unprecedented opportunity to build from scratch. For the next two decades Chicago experienced a building boom which created the developed form of the skyscraper and the so-called "Chicago Style."

The Chicago School in its heyday produced almost exclusively commercial structures—office buildings, warehouses, stores, factories, hotels, and apartment houses. Most of these were erected in the constricted area of the Loop, where land was expensive. The economic pressures to build vertically, inexpensively, and rapidly, and to conserve space were the overriding considerations in the "functional" direction that the Chicago School took. The slab form, cage construction, modular regularity, and undifferentiated space are economically rather than socially functional. New York architects achieved verticality by mechanical refinements in existing technology; Chicago moved toward the rationalization and transformation of the process itself.

Chicago architects were more pragmatic than those of New York and less tied to tradition, their response to function, materials, and technology more direct. Their theoretical speculations may not have been profound, but such architects as Sullivan and Root sought an expressive form for a new kind of function and structure. Crucial in this connection were the writings of Viollet-le-Duc, whose *Entretiens,* translated by Henry Van Brunt, was published in Boston in 1875. Although he was generally thought of as an archaeologist and revivalist, his credo that the nature of structure determined the character of all architecture left a deep impression on nineteenth-century functionalist thinking. He could envision the possibility of an iron skeleton encased in masonry, and Leroy Buffington credited his own idea for a system of metal framing to Viollet-le-Duc. In addition, Sullivan found in Darwin's evolutionary theory an exposition of the rationality of nature and organic growth that reinforced his own thinking and practice. John Root translated the writings of Gottfried Semper, the German architect, and Dankmar Adler quoted him frequently, for

Semper saw every technical product as "a resultant of use and material" and style as "the conformity of an art object with the circumstance of its origin and the conditions and circumstances of its development." The older American functionalist theory of Greenough was thus reiterated and given new substance.

The intimate connection among its architects must have had something to do with the rapid evolution of the skyscraper in Chicago. They were a competitive but closely knit group, and innovations by one were immediately utilized by the others. The Chicago story begins with Major William LeBaron Jenney (1832–1907), who was the *pater familias* of the group and the first to arrive at iron skeletal construction. Jenney was an engineer with little pretension to architecture, which he left mostly to younger members of his firm. Born in New England, trained as an engineer in Paris, he served as an engineering officer in the Union Army and in 1868 opened an office in Chicago. In 1872 he built an unprepossessing but straightforward commercial building, the Portland Block, with cast-iron interior supports. In 1879, in the First Leiter (now the Morris) Building (plate 552), he began to approach skeletal construction and to suggest the glass-enclosed cage. The interior construction was standard, with iron columns and wooden beams, but the exterior brick wall piers were non-load-bearing and could thus be reduced in thickness.

553 Adler & Sullivan. Borden Block, Chicago. 1879

552 William Le Baron Jenney. First Leiter (now Morris) Building, Chicago. 1879. Courtesy Chicago Historical Society

In the same year, Louis Henri Sullivan (1856–1924), who had just joined Dankmar Adler, designed the Borden Block (plate 553), the first important aesthetic statement of the Chicago School and the embryonic indication of his own style. That the building had probably the first isolated pier foundations may be of interest to historians, but, more important, the exterior design, unlike the haphazard facade of Jenney's Leiter, reveals an architectural intelligence at work. The wall was opened by doubling the bays and by reducing the width of piers and the intermediary cast-iron window mullions. Except for the horizontal banding between some stories, the vertical members were emphasized, each bay was terminated by a decorated tympanum form, and the whole was capped by a projecting cornice.

Sullivan was the greatest architect, the leading theoretician and propagandist, and the most interesting personality of the Chicago School. Born in Boston, he studied architecture and engineering at M.I.T. and the École des Beaux-Arts and came away with a contempt for architectural schooling and eclecticism and a great respect for engineering. He was the only one of the Chicago group

who had formal architectural training. Though he later credited his architectural awakening to his work with Frank Furness in Philadelphia and Jenney in Chicago in 1873 before he went to Paris, his academic background in architecture may have been what differentiated him from the others. After his arrival in Chicago in 1875, he held a variety of architectural jobs before joining Adler in 1879 and becoming a full partner in 1881. From the beginning, Sullivan was the designer and Adler the engineer and businessman of the firm.

Dankmar Adler (1844–1900) was born in Lengsfeld, Germany, and went to Detroit as a boy. He had some academic education before becoming an apprentice draftsman in the architectural office of E. Willard Smith. He arrived in Chicago at the age of seventeen, worked with Augustus Bauer, joined the Union Army in 1862, and returned to architectural practice in Chicago in 1866. Adler was a brilliant engineer and an acoustical expert, and whatever structural innovations the firm contributed were undoubtedly due to him. But the firm of Adler & Sullivan was more important to the stylistic than to the technological development of the Chicago School.

Sullivan's architectural evolution was personal and somewhat apart from the mainstream of the Chicago School, though he designed some of its major monuments. In his early work (c. 1880–85) he contributed directly to the evolution of the glass cage which became the trademark of Chicago. His early facades, though wide-ranging in decorative detail, were the most coherently organized and consistently open. As a youth Sullivan must have seen the Jayne Building in Philadelphia (plate 554), begun by William Johnston in 1849 and finished by Thomas U. Walter in 1850, for his Rothschild Store (1881) is reminiscent of that curiously premature, eight-story "skyscraper." The decoration in the Jewelers Building (1881–82) seems almost a throwback to Furness, and the Revell Building (1881–83) is a variation on the Borden Block, but all indicate Sullivan's efforts to open the wall to glass and accent the vertical bearing members. In 1884, in the Ryerson Building, Sullivan first introduced the bay window, which became one of the features of the Chicago School; and in the same year his Troescher Building (plate 555) made the most complete early statement of the glass cage. The latter, despite ornamental confusion, presents a beautifully proportioned facade, with isolated thin masonry piers emphasizing the vertical and with wrought-iron I-beams as spandrels opening the wall to glass. The ingredients of his later work were already apparent here.

In comparison with Sullivan's buildings during these years, the Montauk Block (1881–82, plate 556) by Burnham & Root, often cited for its frankness of statement and simplicity of design as the first expression of the Chicago School, was a fairly uninspired blowup of a standard warehouse of the period. The windows were small, and the emphasis was still on masonry. The regu-

554 William Johnston and Thomas U. Walter. Jayne Building, Philadelphia. 1849–50

larity of its window spacing and the ten-story horizontal repetition showed no revolutionary advance over cast-iron buildings except in the removal of ornamental details, and what remained was undistinguished. Technologically, however, the building offered the first floating raft foundation, consisting of iron rails embedded in concrete, which became standard in the marshy soil of Chicago, and the first complete fireproofing with hollow-tile flooring and fire-resistant beam envelopes.

The key monument in the technological evolution of the skyscraper was Jenney's Home Insurance Building (1883–85, plate 557), the first completely metal-framed building. Skeletal construction consists of a metal frame on which the wall serves as a skin and is not self-supporting. There were many steps in the final achievement of this system. Some of Bogardus's cast-iron buildings may have been of a skeletal construction, and Buffington ar-

555 Adler & Sullivan. Troescher Building, Chicago. 1884

556 Burnham & Root. Montauk Block, Chicago. 1881–82. Courtesy Chicago Historical Society

557 William Le Baron Jenney. Home Insurance Building, Chicago. 1883–85

558 Burnham & Root. The Rookery, Chicago. 1885–86

rived at a solution earlier, though only theoretically. Even Jenney's achievement has been questioned, but it is generally accepted as the first recorded example. Resting on a raft foundation adopted from Burnham & Root, the nine-story metal cage (two stories were added in 1891) was of iron for the first six and steel for the remainder. Unfortunately, the skin did not live up to the revolutionary character of the skeleton. Typical of Jenney design, it was a layer cake of ornamental detail. It seems that the skeletal construction was hardly a conscious aim, for the Home Insurance Building had no immediate effect and was absorbed rather haltingly and piecemeal into Chicago building practice.

For instance, The Rookery (1885–86, plate 558) by Burnham & Root was of traditional masonry construction with granite columns and brick piers on the exterior, but it had a complete iron-skeleton system in the interior court (plate 559). Nothing reveals more clearly the aes-

thetic and even structural confusion of the period than the massive, castle-like, Richardsonian exterior, designed before the Marshall Field Store was built, and the light, cagelike metal scaffolding of the open interior court. Lit through a glass skylight, with ornamental detailing added by Frank Lloyd Wright in 1905, the court of The Rookery remains one of the finest examples of a feature which became common in early skyscraper design. John Wellborn Root (1850–1891), who was responsible for The Rookery, was, like Sullivan, an intellectual, theoretically minded, aesthetically oriented architect. Born in Lumpkin, Ga., he went to school in England, where he exhibited an early interest in architecture. After his return, he received a degree in engineering from New York University and worked first with Renwick and later with John B. Snook, who was building New York's Grand Central Station. He went to Chicago in 1871 and entered the office of Carter, Drake & Wight, where he met Daniel

559 Burnham & Root. Interior court, The Rookery, Chicago. 1885–86

Burnham, with whom he formed a partnership in 1873. Root, the designer of the firm, had a brilliant but short career; Daniel Hudson Burnham (1846–1912), the organizer and "impresario," though now generally underrated and even maligned, had a long and influential one. Burnham was born in Henderson, N.Y., and taken as a child to Chicago in 1855. Though unsuccessful as a student, he had an adventurous early career, including a stint in Jenney's office and a political fling, before settling down to architecture, first with Gustave Laureau and then with Carter, Drake & Wight.

In 1886, the comparatively new firm of Holabird & Roche designed the Tacoma Building (completed 1889, plate 560), which finally arrived at the glass cage as the expression of skeletal construction. Carl W. Condit, who has written extensively about the Chicago School and building technology in general, stated: "In its functional characteristics [it] was the most advanced design of its time." The completely rationalized metal skeleton structure contained many engineering innovations, including the stabilization of the subsoil by means of pumped concrete and the first use of rivets instead of bolts to tie the frame together. However, the Tacoma Building also expressed clearly for the first time the interior skeleton and transformed the exterior wall into a curtain of glass.

560 Holabird & Roche. Tacoma Building, Chicago. 1886–89

Holabird & Roche had refined standard building procedures and borrowed stylistic elements such as the oriel windows from Sullivan's earlier efforts, but the result was something new. Neither the lack of sophistication in design nor the piddling ornament can hide the daring simplicity of the conception.

Holabird & Roche, the least famous and colorful of the Chicago School, were its most consistent exponents, producing the largest number of good buildings, and some of the best, over the greatest period of time without deviating much from the manner they first set in the Tacoma Building. Except for a few examples, they showed no brilliance as designers nor much sophistication and often seemed committed to superficial decoration. William Holabird (1854–1923) was born in American Union, N.Y., and spent two years at West Point before going to Chicago in 1875, where he began his apprenticeship as a draftsman for Jenney. The partnership with Roche was formed in 1883 and lasted for forty years. Very little is known of the early life of Martin Roche (1855–1927) except that he was born in Cleveland, was taken to Chicago two years later, and after finishing school worked in Jenney's office until he joined Simonds and Holabird in 1880.

Meanwhile, the aesthetic impact of Richardson's newly finished Marshall Field Store set the Chicago School off on a somewhat tangential, though not unproductive, course. Sullivan especially had to work his way painstakingly through its suggestions. The Standard Club (1887–88), perhaps because it was not a commercial building, was closer to the earlier picturesque Richardson than to the simple power of the Store block. In the same year Adler & Sullivan were presented with their largest commission, the mammoth Auditorium Building (1886–89, plate 561), a combined office, hotel, and theater complex. The ten-story block with a tower of seventeen, the largest building in the country, was still of traditional masonry construction and a magnificent testimonial to Adler's engineering genius. It established the firm's reputation, but Sullivan's exterior, an ill-digested version of the Marshall Field Store, which had impressed both architect and client, was an ungainly gray elephant. Perhaps out of sheer frustration Sullivan lavished on the interior of the hotel and theater (plates 562, 563) all the brilliance of his unique decorative gifts. However, in the Walker Warehouse (1888–89, plate 564), Sullivan finally made peace with the older master and found himself again. In a set piece, he consciously stripped away historical reminiscences and produced an unhesitatingly frank storage building, cleanly geometric in character, unornamented, and precise in definition. It had the same architectural presence, the same refinement of proportions, and the same sense of inevitability as the Marshall Field Store, but it was a modern building.

The design of the Richardson store was reflected in many Chicago buildings, but its most telling and unob-

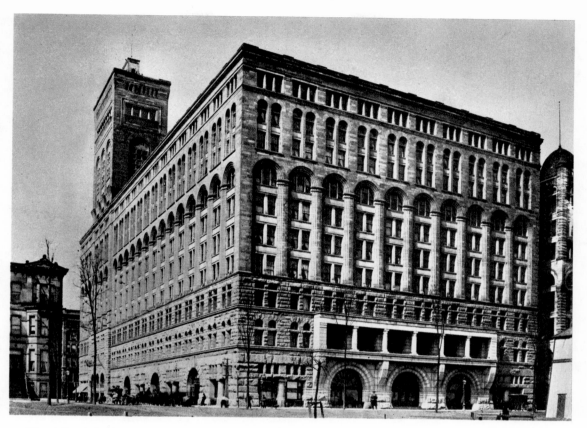

561 Adler & Sullivan. Auditorium Building, Chicago. 1886–89

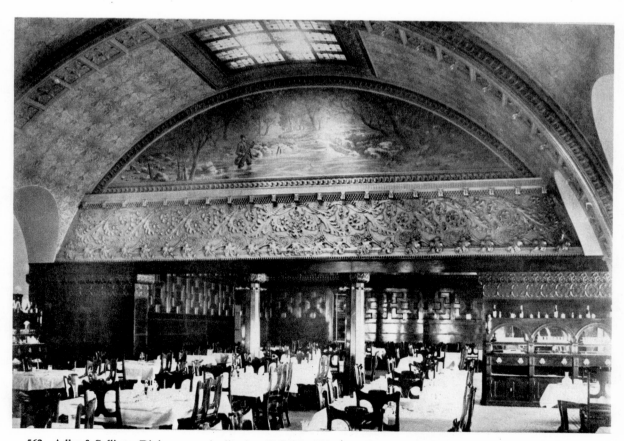

562 Adler & Sullivan. Dining room, Auditorium Building, Chicago. 1886–89. Courtesy Chicago Historical Society

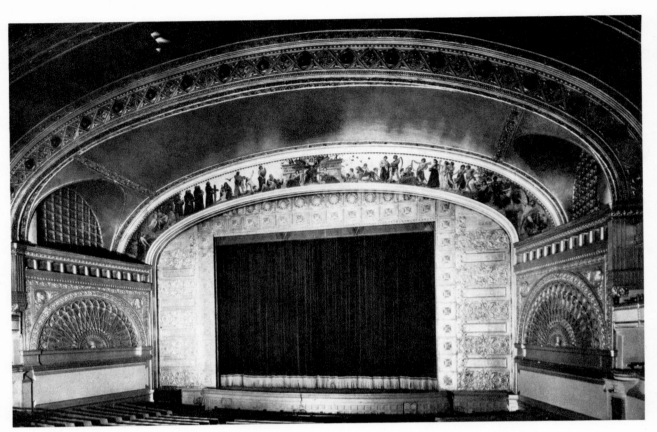

563 Adler & Sullivan. Theater, Auditorium Building, Chicago. 1886–89. Courtesy Chicago Historical Society

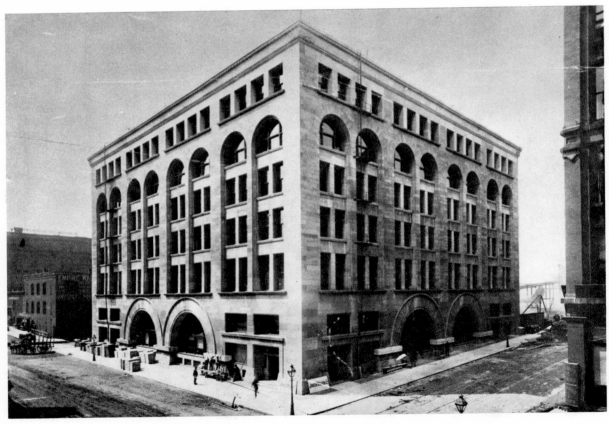

564 Adler & Sullivan. Walker Warehouse, Chicago. 1888–89. Courtesy Chicago Historical Society

trusive effect was on the Second Leiter Building (1889–90), in which for the first and only time Jenney produced a clear and powerful statement in formal terms to match his engineering abilities. It is far from being a distinguished design, but it is an honest and foresighted one. He took the monumental, ordered Richardson block and opened it up to glass. He expressed the equilibrium of skeletal construction more clearly than it had been done before. Even his continuing allegiance to an impoverished catalogue of decorative detailing cannot hide the basic logic of the structure.

Richardson's influence seems to have been strangely disturbing to Burnham & Root. Although they had shown an interest in Richardsonian Romanesque as early as 1882 in the Chicago Club and again in The Rookery, it became dormant until the last year of Root's life. In 1890–91 he designed the Great Northern Hotel, only slightly Richardsonian, and the Woman's Temple and the Masonic Temple, both blatant examples of Romantic eclecticism. This is all the more mystifying, since the firm had made major contributions to the Chicago School in the previous two years, the Rand McNally and the Monadnock Buildings.

The Rand McNally (1888–90, plate 565) was the first by Burnham & Root to have a complete skeletal frame and the first in which the frame was entirely of steel, but the exterior was somewhat disappointing in its ornamental fussiness. In contrast, the Monadnock (1889–91, plate 566) is an example of formal purity and structural conservatism, both in part the result of circumstances. The client appears to have preferred safe-and-sound masonry construction to new building techniques and to have insisted on absolute simplicity of design. Thus Burnham & Root, who were simultaneously producing a steel-skeleton building, executed in the Monadnock what was essentially a replica of the type in masonry. And Root, dedicated to the importance of ornament in architectural expression, was forced to create a masterpiece without decoration. Covering half a narrow block, the Monadnock is a sixteen-story slab, two bays wide and five long. The rest of the block was completed with scrupulous fidelity to the original in 1893, by Holabird & Roche, in what was by then acceptable skeletal construction. The building exists today in excellent condition. Interior loads are supported by iron columns, but the brick bearing walls rest on a ground floor of smooth cut stone 72 inches wide which curves inward and is echoed by the reverse curve of the parapet, the whole forming a giant "I." The oriel bays give the slab an air of lightness which contradicts the masonry construction, but the windows are comparatively narrow, revealing its structural limitations. The narrow plot permitted outside exposure for all the offices flanking a single hallway with a central stairwell. Logical in plan, beautifully executed, and memorable for its simplicity and power, the Monadnock Building still remains a paradox, an architectural tour de

565 Burnham & Root. Rand McNally Building, Chicago. 1888–90

566 Burnham & Root. Monadnock Building, Chicago. 1889–91

force in which an avant-garde form camouflaged a traditional structure.

On the other hand, the Reliance Building (1893–95, colorplate 56) projected itself uncompromisingly and daringly into the future. It seems to belong, except for its oriel windows, more to the twentieth than the nineteenth century and is considered by many to be the masterpiece of the Chicago School and its most germinal building. Charles B. Atwood, Burnham's assistant after Root's death, is credited with the design. The Reliance, a ten-story glass tower, was first designed and built as a four-story structure and was certainly not so striking as it appeared when six identical stories were added in 1895. The basic concept derives directly from the Tacoma Building (plate 560). The oriel bays, the neutral cage, and the dominance of glass are all refined to emphasize the lightness of construction and openness of surface. The unobtrusive character of the horizontal bands separating the stories, the thin vertical struts that divide the glass panes without creating window framing, and the faceting of the oriel bays, which destroys any inherent planar wall surface, create the impression of a prismatic glass tower. The open-faced, transparent-skinned effect of the Reliance Building has hardly been surpassed, except through the present-day illusionistic use of glass for horizontal bands. One can cavil only about its undistinguished ornament, which happily seems to disappear under certain light conditions. The oriel type became very popular with Chicago architects and was frequently employed in skyscraper design— for example, by Adler & Sullivan in the Stock Exchange Building (plate 569)—but none achieved the purity and coherence of the Reliance.

A few years earlier Adler & Sullivan were engaged in a project for St. Louis, the Wainwright Building (1890–91, colorplate 57), which was destined to establish the dominant skyscraper mode in America until well into the twentieth century. In this building Sullivan arrived at a personal synthesis and opened a different avenue of skyscraper design. He was by then ready, as he himself said, to advance "beyond the building of the speculator-engineer-builder" and reveal "the hand of the architect." In the Wainwright the skeletal structure takes a columnar form with base, shaft, and capital, which Sullivan explained in retrospect as best expressing the function of the skyscraper. The first two floors (the base) are designed to accommodate stores and public offices; above, the shaft contains a series of identical floors with modular office units; and topping the whole is the capital, which hides the terminus or return of the utilities complex originating in the basement. Thus the base is spatially open and expansive in treatment, the shaft an undifferentiated repetition of modules, and the capital an elaborate decorative mask. So far the form expressed the utilitarian and structural function of the building, but Sullivan's conception—"form follows function"—included another ingredient, the "emotional" expression

of the building's nature, or social function. For Sullivan an organic architecture was the product not only of historical, social, and material conditions peculiar to a given time but also of the ideals, aspirations, and needs of the people. A skyscraper, he wrote, "must be every inch a proud and soaring thing, rising in sheer exultation [so] that from bottom to top it is a unit without a single dissenting line." The Wainwright rises from a simple, wide-windowed base of red Missouri granite and brown sandstone, straight up through red-brick piers with recessed decorated spandrel panels of red terra cotta, to a luxuriant top-story frieze in the same red terra cotta, ending in a bold projecting cornice. However, in order to achieve a sense of organic unity, verticality, and cubical mass, he was forced to belie the skeletal structure. There is no structural reason for the emphasis on the corner piers, for the introduction of alternate piers containing no metal bearing members, nor for the cornice and frieze with its bull's-eye windows lost in exuberant foliage. By emphasizing verticality and mass, Sullivan introduced a stylistic counterpoise to the emergent Chicago concept of cage and openness.

It is one of the accidents of history that Sullivan's skyscraper style was not better represented in Chicago. There his Schiller Building (1891–92), now the Garrick Theater Building, was obviously derived from the Wain-

567 Louis Sullivan. Guaranty (now Prudential) Building, Buffalo, N.Y. 1894–95

wright but unfortunately exaggerated its least promising aspects. Standing next to the Borden Block, which carried so many kernels of this later style, the Schiller Building can almost make one regret the course that Sullivan had taken. His other masterpiece in this manner, the Guaranty Building (1894–95, plate 567), now the Prudential, was built in Buffalo. It is almost a twin of the Wainwright, with minor but significant stylistic variations. The building appears lighter because the entire skin is of terra cotta and the corner piers are greatly reduced, and more vertically accented because the piers are spaced more closely. The result is both more cagelike and more open, in spite of the attenuation of the piers and the smallness of the windows. The elaborate arched entrances seem an intrusion in the rectilinearity of the two lower floors, and the remarkably premonitory "pilotis" that open the ground floor are rather awkward. Depending on taste, one may either regret or admire the brilliant efflorescence of decoration, especially on the frieze and cornice, so uniquely Sullivanian, but certainly the reduction of the cornice and the interrelation of arched bays and round windows under it improved the scale and elegance of the building.

That was as far as Sullivan was to go with verticality, except for the Bayard Building (1897–98, plate 568), later the Condict, in New York, which was essentially only a facade. One step beyond the Guaranty, it makes no pretense that the wall is anything but a glass skin. In it, Sullivan returned to the openness of the Chicago Style, to his own earlier Rothschild Store, and perhaps even to his memory of the Jayne Building, in Philadelphia. Unlike those, its decoration is not Gothic but authentic and flamboyant Sullivanian Art Nouveau, even to the winged figures under the cornice. Its ornament was difficult for many to accept even in its own day, but two of the finest architectural critics of the time, Montgomery Schuyler and Russell Sturgis, both felt that if metal architecture were to develop a style, this was the direction it would take.

More expressive of skeletal construction and more central to the Chicago School than either Sullivan's vertical shaft or the oriel type was the neutral cage, which reached its apogee after the Columbian Exposition of 1893. The cage form was inherent not only in metal framing but also in the nature of commercial buildings. It was already discernible in the early Boston granite warehouses, in the cast-iron buildings of Bogardus, and in the least pretentious of Chicago warehouse buildings, where space, light, and economy were paramount. Skeletal construction simply made such objectives more attainable. The reduction in weight achieved by metal framing allowed increased height, the reduction of wall surface permitted more glass area and thus better lighting, and the reduction in structural elements made for greater flexibility in the use of interior space, while the lower cost and speedier construction were decided eco-

568 Louis Sullivan. Bayard (later Condict) Building, New York. 1897–98 (photographed 1934)

569 Adler & Sullivan. Stock Exchange Building, Chicago. 1893–94

Architecture: The Battle of Styles 455

nomic advantages. Unfortunately, the taste of the client or the architect led to the masking of the simple grid with superfluous ornament, particularly in more pretentious structures. The cage was already fighting its way toward expression in such early examples as Sullivan's Troescher Building in 1884 and was almost achieving fulfillment, except for a rash of pilasters, in Jenney's Second Leiter Building in 1889. Perhaps the design consciousness exhibited in other forms was needed before the cage could emerge in the late 1890s as the ultimate expression of commercial architecture by the Chicago School.

In the sequence of this evolution one must begin with Sullivan's Stock Exchange Building (1893–94, plate 569). A confusing building within his development, executed between the Wainwright and the Guaranty, it contained a curious amalgam of motifs, almost as if he were trying to adapt his style to that of Chicago. The arcaded lower floors and entrance were reminiscent of the Transportation Building (1893, plate 586) he had just completed for the Fair, alternate bays of oriels were added to his own shaft form, and the whole was capped by an incongruous

570 Holabird & Roche. Marquette Building, Chicago. 1894

columned stoa and an ungainly cornice. But, along with Adler's introduction of the caisson foundation, the Exchange also boasted the first example of the classic Chicago window. The skeletal structure called for a wide window area to fill the space between piers, but, given the standard narrow form of the sash window, an aesthetic solution was slow in emerging. It was Sullivan, accepting horizontality for the first time, who devised the large stationary central pane with flanking narrow sash windows, treated as a unit precisely recessed and framed in a narrow decorative band. It was to become a hallmark of the Chicago School.

Holabird & Roche almost immediately employed a variant of the Chicago window in the Old Colony and Marquette Buildings, both completed in 1894. In the latter (plate 570) the central horizontal pane was divided vertically in two with a distinct loss of elegance in proportion, but the building itself was the first to state the cage theme unequivocally. Although the impact is blunted by unnecessary banding, an excrescence of ornament toward the top, and a classical cornice, the horizontal module is carried through three stories of the base and eleven of the shaft. A more refined version of the cage occurs in the Studebaker Building (1895, plate 571) by Solon S. Beman. In its facade, for the first time, the spidery thinness of the skeleton is completely revealed and the wall becomes a glass skin. One can only regret the delicately handled but needless Gothic detailing.

The cage type finally achieved jewel-like perfection in a series of small buildings erected at the turn of the century, the Gage Group (1898–99) and the McClurg Building (1899–1900). The former (plate 572) consists of three attached buildings, two adjacent and identical in design by Holabird & Roche, one of two bays and six stories and the other three bays and seven stories; and the third by Sullivan, of three bays and eight stories, with four added in 1902 by Holabird & Roche without altering its character. The exquisite ensemble is hardly matched for airy grace and elegance. The proportions vary slightly and show subtle refinements: Holabird & Roche's somewhat sturdier and more vertical, Sullivan's lighter and more horizontal. They have borrowed Sullivan's window, and he has accepted their cage. Aside from the commonplace cornices reflecting a carelessness in ornamental detailing which defaced some of their finest buildings, Holabird & Roche here produced frank examples of an architecture of steel and glass. In contrast, Sullivan's facade may appear fussier, but it is also more subtle. The proportions and the delicacy in detailing are superior. He handled the emphasis on the central bay more frankly and successfully. He also achieved greater lightness and horizontality by devising a new kind of window with a band of translucent glass above clusters of narrow vertical panes. Certainly his cornice is a more fitting climax. Only in the ornament does the purity of intention seem contradicted. The small decorative elements in the horizontal bands are

questionable, but the elaboration of the ground-floor framing and the floral explosions above the vertical piers are Sullivan at his exuberant best.

Holabird & Roche's masterpiece, the McClurg Building (plate 573), now the Crown, is a gem of facade design. Like their Gage buildings, it is without decoration except for a more appropriate cornice; the piers and window mullions have become thinner and the Chicago windows more horizontal, creating an integrated cage in perfect equilibrium.

The Carson, Pirie, Scott Store (plate 574), often described, with reason, as the culmination of the Chicago School, is Sullivan's last major work and his masterpiece. The nine-story, three-bay unit on Madison Street just off State was erected in 1899. In 1903–04 Sullivan added a larger section twelve stories high, with three bays on Madison and seven on State. D. H. Burnham & Co. completed the State Street block in 1906 with the addition of five bays. However, the building remains a unified whole because the original Chicago window module was maintained throughout. The only break in the cagelike block is the round section that turns the corner. Here Sullivan contrasted a vertical accent with the pronounced horizontality of the rest. The two lower floors are treated as a unit, with large display windows framed in lavish metal decoration. Above, the walls rise sheer and unadorned for nine stories. The top-floor windows are recessed behind the revealed piers, which support a bold

571 Solon S. Beman. Studebaker Building, Chicago. 1895

572 Holabird & Roche and Louis Sullivan. Gage Group, Chicago. 1898–99

573 Holabird & Roche. McClurg Building, Chicago. 1899–1900

574 Louis Sullivan. Carson, Pirie, Scott Store, Chicago. 1899 (extended 1903–4, 1906)

but lightly scaled and simple cornice. Unfortunately, the tenth floor has been remodeled and the cornice replaced by an ungainly parapet. The entire building above the second floor is sheathed in thin terra-cotta tile, the windows are cleanly recessed and delicately framed, and the only ornament is a continuous reticent banding at window sill and lintel, emphasizing the horizontal. The metal frame is nowhere else more logically expressed nor with such sophistication in scale, proportion, and nuance. Here Sullivan had made his final choice the horizontal, managing it with the same artistry as he had the vertical, but with greater clarity.

Sullivan's decoration is a problem only if one attempts to reconcile it with the functional logic of the metal skeleton or with the purist taste of the later International School, which he prefigured. He was a man of his own time, a contemporary of such Art Nouveau architects as Horta, Gaudi, Guimard, and Mackintosh, who saw ornament as an organic element of architecture. Sullivan's ornament was neither a careless afterthought, like that of Jenney or Holabird & Roche, nor an archaeological quotation, like that of the revivalists. He seems to have

arrived at it comparatively early and independently, though perhaps with some influence from Viollet-le-Duc and more directly from Frank Furness. He was inspired by Gothic, Celtic, and Oriental art, but also by Darwinism and Asa Gray's *Botany* (2d ed., 1874), where he sought principles of natural growth as the basis for a new and nonhistorical language of ornament. There is in his decoration, as in Art Nouveau in general, a tension between movement and organization, between the naturalistic and the abstract, and between flatness and plasticity. The ornament is confined to bands, as in the Transportation Building, or explodes out of its confines, as in the Carson, Pirie, Scott Store. The forms may resemble foliage or Celtic interlaces. They may remain part of the surface or serve as a contrast to its flatness. Among his finest decorative efforts were two small tombs, the Getty (1890) in Graceland Cemetery, Chicago, and the Wainwright (1892) in Bellefontaine Cemetery, St. Louis. The Getty (plate 575) is a simple cube with a boldly projecting flat cornice and a kind of Syrian arch framing the metal gate. The Wainwright (plate 576) is a mosquelike structure with a dome on a cube. In both cases the Oriental

575 Louis Sullivan. Getty tomb, Graceland Cemetery, Chicago. 1890. Courtesy Chicago Historical Society

576 Louis Sullivan. Wainwright tomb, Bellefontaine Cemetery, St. Louis. 1892

577 E. Townsend Mix. Interior court, Guaranty Loan (now Metropolitan Life Insurance) Building, Minneapolis. 1888–90

578 George H. Wyman. Interior court, Bradbury Building, Los Angeles. 1893

influence—Persian and Islamic—is marked, but the style is completely Sullivanian: simple geometric volumes defined with great precision, flat wall surfaces, and rich ornament severely restrained within bands.

A brief but delightful byway in the development of the metal frame was the arcade, or interior light court, mentioned in connection with The Rookery (plate 559) in Chicago. One of the earliest buildings to use this form was the Palace Hotel (1874–75) in San Francisco, designed by John P. Gaynor and destroyed in the earthquake of 1960, with not one but three interior courts lit by skylights of iron and glass. Perhaps the most remarkable example of the iron-framed arcade was the six-story octagonal court of the John Shillito Store (1878), Cincinnati, by James W. McLaughlin, which was later demolished. The Cleveland Arcade (1888–90) by John M. Eisenmann and George H. Smith had an unusually handsome iron-truss frame. Of the office buildings with such interior light courts, the Chamber of Commerce Building (1888–89) in Chicago, by Baumann & Huehl, also now gone, was the first in which the metal frame had no masonry elements, and the court was surrounded by a beautiful web of open ironwork. However, two excellent examples remain: the Guaranty Loan Building (1888–90, plate 577), now the Metropolitan Life Insurance, in Minneapolis, by E. Townsend Mix, which contains a twelve-story fantasy in iron under a skylight, with elevators running open and floors of glass; and equally spectacular in its lacelike intricacy, the interior court of the Bradbury Building (1893, plate 578), Los Angeles, by George H. Wyman. In them one can observe a conscious effort to exploit structural form for decorative purpose.

NEW YORK SKYSCRAPERS

New York architects continued through the 1880s to build in mixed media. Some unpretentious warehouses, such as the De Vinne Press Building (1885, plate 579) by Babb, Cook & Willard, were simple in design and straightforward in execution. This red-brick building is in a retarded, round-arched style but handsome enough in its simple dignity to stand comparison with contemporary Chicago efforts or Richardson himself. New York, however, was committed to Beaux-Arts eclecticism, and there were few serious efforts to grapple with an original style of commercial building. McKim had shown some interest in the problem, and his first effort, the Goelet Building (1885–86, plate 580), in its regularity of fenestration and repetition of stories, expressed frankly the character of an office building. The same can be said for the two skyscrapers he designed and built for the New York Life Insurance Company in Omaha and Kansas City (plate 581) in 1888–90. The vocabulary was Classical and

the aim monumentality, but the handling revealed an architectural intelligence and sophistication hardly matched at the time by the structurally oriented Chicagoans.

The first use of Chicago skeletal construction in New York occurred in the Tower Building (1888–89), and the architect, Bradford Lee Gilbert, had difficulty getting the plans approved by the board of examiners; but the structure was no taller than earlier New York skyscrapers, and its facade was particularly undistinguished. Not until the mid-nineties did steel skeletal construction become common in New York. George B. Post had come close to skeletal construction in the New York Produce Exchange (1881–84), recently demolished, which enclosed a skylighted open space 144 by 220 feet and 47 feet high surrounded by offices. Post's Pulitzer (or World) Building (1889–90, plate 582), twenty-six stories and 375 feet with its Renaissance dome, still had masonry bearing walls 9 feet thick at the base, though the interior load was carried on an iron-and-steel frame. However, the Manhattan Life Insurance Company Building (1893–94) was fully framed in iron and steel with a concrete caisson foundation; the twenty-story American Surety Building (1894–95), by Bruce Price, had a complete steel skeleton, as did the twenty-six-story St. Paul Building (1886–88), by Post.

On the whole, New York architects were conservative in both design and construction and seem to have been less driven to efficient low-cost structural systems than the Chicagoans. Aside from a mania for height, New York's main contribution to the skyscraper was the development of the tower as opposed to the Chicago flat-topped block or shaft. Even the earliest tall buildings in New York tended toward elaboration of terminal elements, and the spire eventually became characteristic of the New York skyline and symbolic of the skyscraper itself. At the turn of the century the Park Row Building (1897–99, plate 583) by R. H. Robertson, with its thirty stories, had won the title as tallest building in the world and was then considered to have reached the ultimate height possible. Unfortunately, the technological achievements of such colossi were not adequately expressed, for the ubiquitous Beaux-Arts quotations on the surface were both structurally and visually irrelevant, and, perched so far above the street, the crowning glories assembled from architectural textbooks became meaningless.

THE COLUMBIAN EXPOSITION AND "IMPERIAL CLASSICISM"

When Chicago was chosen by Congress in 1890 to be the site of a world's fair, its architects hoped to impress their more prestigious eastern colleagues. Burnham & Root had envisioned a colorful mélange of picturesque

579 Babb, Cook & Willard. De Vinne Press Building, New York. 1885

580 Charles F. McKim. Goelet Building, New York. 1885–86.
Courtesy Museum of the City of New York

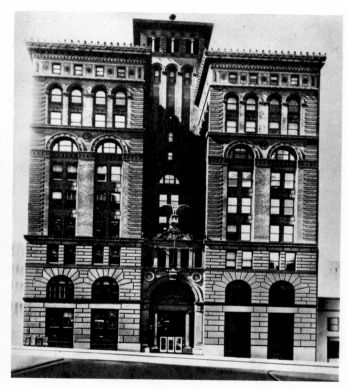

581 Charles F. McKim. New York Life Insurance Building,
Kansas City, Mo. 1888–90

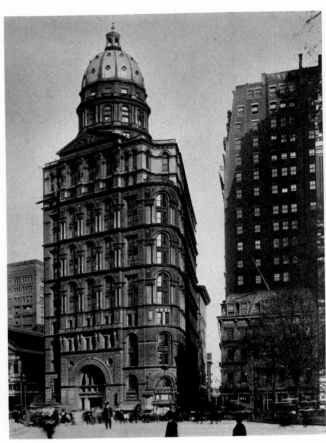

582 George B. Post. Pulitzer (World) Building, New York. 1889–90. Courtesy The New-York Historical Society

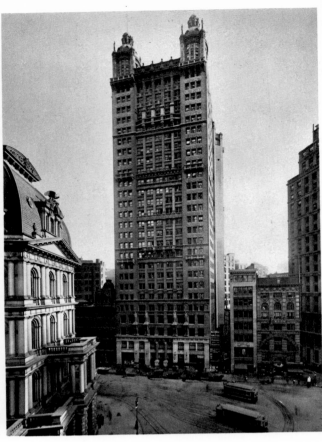

583 R. H. Robertson. Park Row Building, New York. 1897–99 (photographed 1912). Courtesy Museum of the City of New York. Underhill Collection

eclecticism—an indication of their stylistic provincialism. There is no evidence that the Chicagoans hoped, as Sullivan later maintained, to apply a new functional style to the monumental plaster buildings of the Fair, for at that time there really was no discernible Chicago manner. Root, who died shortly after the opening of the planning conference in January, 1891, might have withstood the combined eminence of the easterners, but that is dubious; nor would the retardataire Romantic eclectic manner of the buildings he was designing at that time have been any more appropriate than what was chosen. In any case, the easterners prevailed when a unified plan and style was agreed upon. The choice of "Classicism" was predictable, for the Beaux-Arts manner, as an outgrowth of the Second Empire, had become the international fashion and practically *de rigueur* for world's fairs.

The World Columbian Exposition of 1893, popularly known as "The White City," was a symbol of America's entry into the mainstream of international culture, parallel to that in economics and politics. Siegfried Giedeon has called it the manifestation of "mercantile classicism," and James Fitch labeled its products "imperial symbols."

The false facades of "The White City" can also be seen as symbols of self-deception. This whipped-cream architecture hid crises of unprecedented scale—financial panic, class warfare, and urban degradation. It was a time of collapsing railroad empires, bank closings, agricultural depression, unemployment, and the march on Washington by Coxey's Army. It was also a time of open struggle between labor and capital, the Haymarket bombing, the Homestead massacre, and the Pullman strike. Cities were exploding with mass immigration, strangling in civic corruption, their poor sunk in filth and disease. The World's Fair and "mercantile classicism" in general did not advertise such difficulties. Sullivan and the Western Populists might rail against the East and Wall Street, against the evils of cities and capital, but the establishment was calling the turn and hiring the architects. Columns and cupolas, cupids and cornucopias were expected to hide the crude facts of reality.

But the Fair was also a dream shared by America as a whole. Perhaps it was no better than we deserved, but it was not really so bad as it has been painted or plastered. MacMonnies' Columbian Fountain (plate 584) might be

hard to match, but more recent expositions have also had their quota of artistic disasters. The Columbian Exposition was approached by its architects and artists with more than ordinary seriousness. They were looking forward, perhaps naively, with great confidence in America's innate greatness, goodness, and grace to the new century, the American century. One might think it arrogant, if it were not so touching, that Augustus Saint-Gaudens could exclaim to Daniel Burnham, "Look here, old fellow, do you realize that this is the greatest meeting of artists since the fifteenth century?" But it was the first time that a group of American artists—architects, sculptors, and painters—had been called together to plan something. They conceived with rationality and grandeur, and the result, despite the plaster confections, was a vision of order and amplitude, culture and cleanliness to stand against the reality of urban boom and blight. No American city had a plan or even adequate restrictive regulations, except for Washington, where an architectural undergrowth by this time had already obscured L'Enfant's original grand design. The "city beautiful" was to have some effect in the next century, in zoning regulations and in formal planning for civic centers. There is no question that a generation of people came away from the Fair with an image of what a city could be.

The basic plan of the Fair was the work of the great landscape architect Frederick Law Olmsted and his young partner, Henry Codman, who converted the marshy wasteland of Jackson Park along the lake front into a complex of lagoons, canals, ponds, islands, and piers. The major buildings were sited around a formal axis of lagoon and canal. Those awarded to the "visitors," around the lagoon with a great Court of Honor at one end, were to be in the "Classical" style, white, naturally, and with a common cornice line. This portion of the Fair, which gave it the name "The White City," included Richard M. Hunt's conglomerate Administration Building (plate 585), McKim, Mead & White's Agricultural Building with a Pantheon dome, Van Brunt & Howe's Electricity Building, George B. Post's Manufacturers and Liberal Arts Building, and Peabody & Stearns's Machinery Hall, called the largest building in the world. At the Peristyle end of the lagoon was Charles Atwood's Fine Arts Palace, considered the most beautiful building at the Fair, with a facade literally copied from a Prix de Rome project. All these were "Classical" only in the broadest Beaux-Arts sense, a free adaptation of Renaissance and Baroque, Italian, French, and Spanish models.

In other sections of the Fair architectural styles were more varied, including replicas of buildings from exotic lands. Notable among the major non-Classical examples were the Romanesque Fisheries Building of the Chicagoan Henry Ives Cobb and the famous Sullivan Transportation Building (plate 586), a simple, shedlike, arcaded

584 Frederick MacMonnies. Columbian Fountain. 1893. From *Dedicatory and Opening Ceremonies of the Columbian Exposition,* Stone, Kastler & Painter, Chicago, 1893. Courtesy Forbes Library, Northampton, Mass.

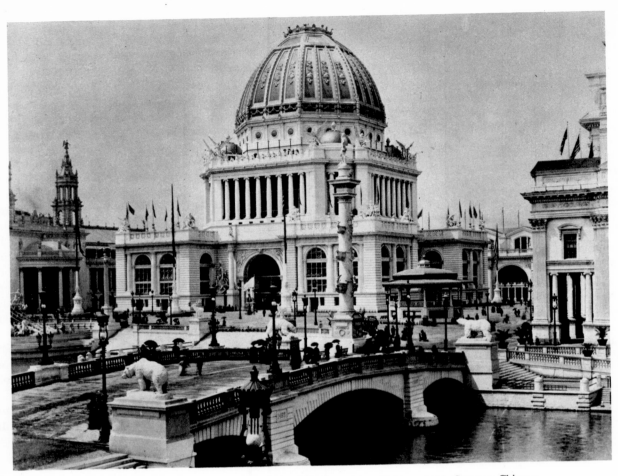

585 Richard M. Hunt. Administration Building, Columbian Exposition, Chicago. 1893. Courtesy Chicago
Historical Society

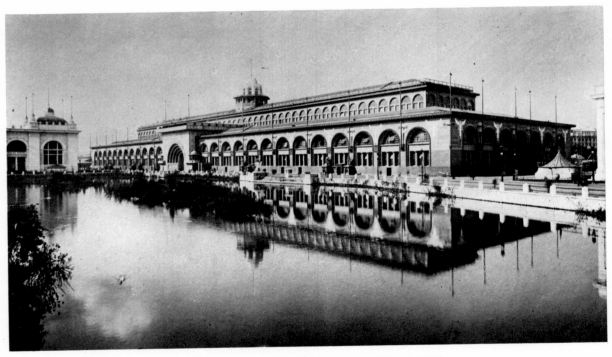

586 Adler & Sullivan. Transportation Building, Columbian Exposition, Chicago. 1893

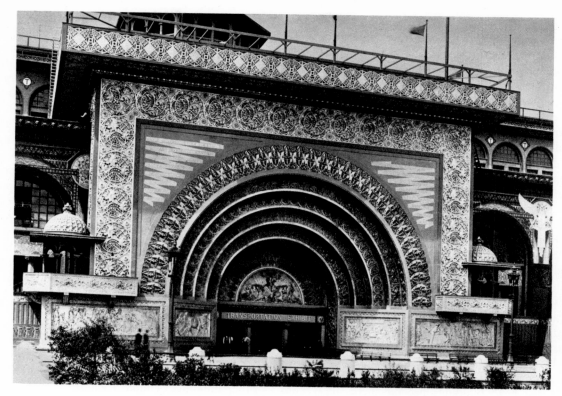

587 Adler & Sullivan. "Golden Door," Transportation Building, Columbian Exposition, Chicago. 1893

structure. With its "Golden Door" (plate 587) flanked by Islamic pergolas, sparkling in its colorful, Orientally inspired Art Nouveau decoration, the latter was more a carnival delight than an important architectural expression, and no less a structural lie than any of the Beaux-Arts examples. In this battle of taste the Chicago School would seem to have lost or capitulated, for the Beaux-Arts tradition was to remain dominant in American architecture for some time, but it may be more accurate to view the struggle as between the old picturesque eclecticism and the new "imperial Classicism." Chicago "functionalism" was as yet pertinent only to commercial architecture and still had its course to run.

THE RAILROAD STATION

Although the railroad was a product of the nineteenth century and the railroad station had no antecedents, attempts to accommodate it to the past were common. The problems of the station were not only technological but also functional and expressive. Its functions divide fairly clearly into the handling of trains and the handling of people, the train shed for one and the concourse for the other; and this basic divergence conditioned the architectural solutions. The major technical problem was the train shed, for, with increasing traffic, the size of the enclosure grew and the technical means of spanning it de-

veloped from wood to iron to steel, from truss to tied arch to pure arch. The great metal-and-glass balloon sheds toward the end of the century were among the triumphs of engineering and the visual glories of the age, but this form became obsolete at the apogee of its development, first through the invention of the Lincoln Bush shed, then the butterfly shed, and finally the electrification of railroads.

While the train shed was a comparatively straightforward engineering problem, the station building presented others that were more complex. Its utilitarian functions became more varied as the range of services increased, and it had an expressive function which had to be discovered. Set in the city center, it was a privately owned building of a quasi-public character, intended both to attract the public to rail travel and to advertise the wealth and stability of the railroad empire. There was a persistent notion that the station was both symbolic, as the gateway to the city, and utilitarian. Aesthetically it was torn between a display of monumentality and a revelation of the train shed behind the facade. As early as mid-century the shed enclosed within the station building appeared in such great European examples as the Gare de l'Est (1847–52) in Paris and King's Cross Station (1851–52) in London, but stations in the United States lagged behind those of Europe until after the Civil War. By then the railroad station had moved into a new phase of monumentality, and in America it was fully committed

to eclecticism well into the twentieth century. At the same time the shed had been separated from the station building, because increased traffic and services made inclusion in a single structure impractical. The station, housing a grand concourse, new services, and often a hotel complex, became a multistoried building that masked the shed completely.

Before the Civil War, railroad capital was invested in functional aspects of service rather than passenger comfort, and the stations were therefore fairly modest and in frontier areas quite primitive. In larger stations the sheds were built of wood trusses, and the buildings that housed them were designed in the revivalist styles of the period (e.g., plates 391, 411), the most popular being the round-arched Romanesque and Italian Villa types.

The prosperity of railroads after the Civil War was reflected in the growing opulence of the station building. Increasing traffic and competition fostered ever larger spans, and iron began to replace wood in shed trusses. America followed Europe in the development of the great metal-and-glass balloon sheds, but, curiously enough, as the shed and station functions became progressively separated, and the engineering of the shed construction reached new heights of daring and even elegance, the head buildings became increasingly conservative and eclectic. The expressive material became stone rather than iron.

New York's first Grand Central Station (1869–71) was the earliest of the great stations. As in all these, the engineering and architectural functions were distinct. Designed by Isaac C. Buckhout, the shed (plate 588), 200 feet wide and 600 long, was then the largest interior space in the United States and second only to the Capitol as a public attraction. The arches, tied below ground level, sweeping in an arc across the width of tracks, were inspired by London's newly completed Victorian Gothic St. Pancras Station, the wonder of Europe, but Grand Central's arches were round rather than pointed. The exterior (plate 589), by John B. Snook, a somewhat provincial Second Empire in the front and nondescript in the rear, did nothing to reflect the majestic expanse of the interior. Boston's Park Square Station (1872–74) by Peabody & Stearns was the first to imitate St. Pancras's pointed-arch metal vaults, and appropriately the exterior was in High Victorian Gothic. Also Gothic were the Baltimore & Potomac Railroad Depot (1873–77), by Joseph M. Wilson, in Washington, D. C., and the Union Passenger Station (1875–77), by Ware & Van Brunt, in Worcester, Mass., of which only the tower remains.

In the eighties the Richardsonian Romanesque replaced the Victorian Gothic in station architecture as in other buildings. Unlike Richardson's own stations, described earlier, which tended to be small and almost domestic in scale, some were monumental. Two by C. L.

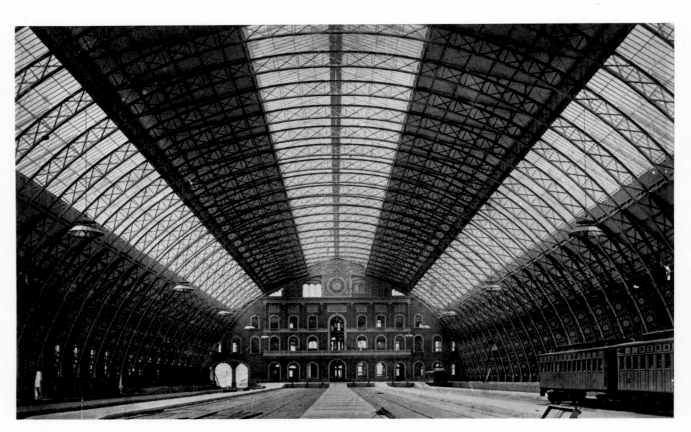

588 Isaac C. Buckhout. Train shed, first Grand Central Station, New York. 1869–71

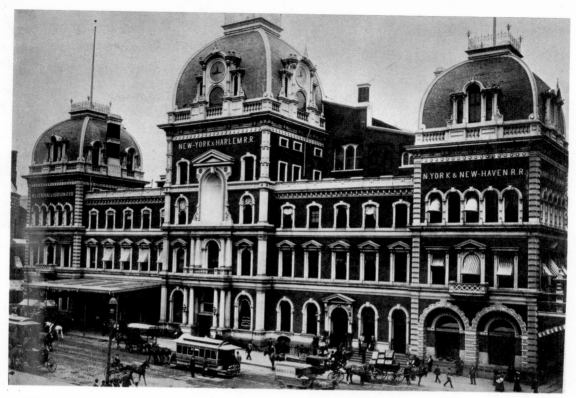

589 John B. Snook. First Grand Central Station, New York. 1869–71

W. Eidlitz had a rather Swiss flavor, especially in the towers: the Michigan Central Station (1882–83) in Detroit and the Dearborn Station (1883–85, plate 590) in Chicago. Also noteworthy are the Union Station (1886–89) in Indianapolis, by Thomas Todd; the Chicago and Northwestern Station (1889) in Milwaukee, by Charles S. Frost; and the Union Depot (1889) in Detroit, by Isaac S. Taylor.

Although influenced by the Richardsonian Romanesque, Solon S. Beman's Grand Central Station (1888–89, plate 591), Chicago, reflects architectural developments in that city. Chicago's Grand Central shed did not match the earlier one in New York, but many soon did. The Reading Street Station (1891–93, plate 592) in Philadelphia surpassed it with a span of 256 feet, the largest single-span shed still in operation, but this was almost immediately outdone by Furness's Broad Street Station (1892–93, plate 593), also in Philadelphia, with a span of 300 feet, 108 feet high, the largest single-span train shed ever built. Even this did not equal in interior space two buildings at the Chicago Fair—Machinery Hall, 390 feet wide and 741 long; and the Manufacturers and Liberal Arts Building, 385 feet wide and 1,400 long.

Increasing train traffic doomed the single span and led the train shed into a last phase of gigantism before its demise. Only a few multiple-span sheds were built, among them Union Station (1891–94, plate 594) in St. Louis, by Theodore C. Link and Edward D. Cameron,

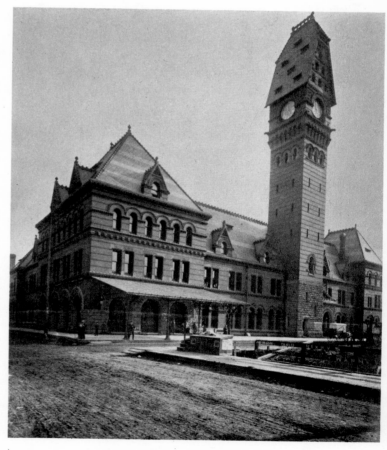

590 Cyrus L. W. Eidlitz. Dearborn Station, Chicago. 1883–85 (photographed 1880s). Courtesy Chicago Historical Society

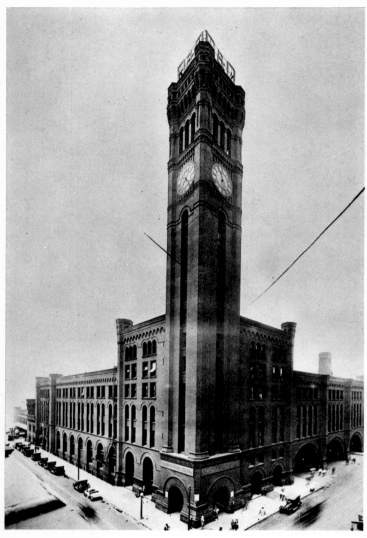

591 Solon S. Beman. Grand Central Station, Chicago. 1888–89

592 F. H. Kimball. Reading Street Station, Philadelphia. 1891–93

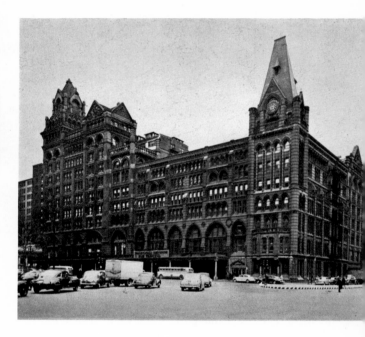

593 Above and below: Frank Furness. Broad Street Station and train shed, Philadelphia. 1892–93 (destroyed)

with George H. Pegram as engineer: and South Station (1896–99) in Boston, by Shepley, Rutan & Coolidge, with J. R. Worcester as engineer. The St. Louis station, with its five-span vault covering an area 601 feet wide and 700 long, was for a while the largest depot in the world. The head building is retarded Richardsonian in manner, huge in scale and compositionally not entirely coherent, its grand interior concourse clearly derivative from Sullivan. Stations like these became white elephants, economically and technologically outmoded. In the twentieth century the railroad station was to become an enclosed plaza with circulation in all directions leading to tracks underground, and the harbinger of the new architectural type was the temporary railroad terminal of the Chicago Fair (plate 595), with its three arched portals, which initiated a new era of Classical splendor.

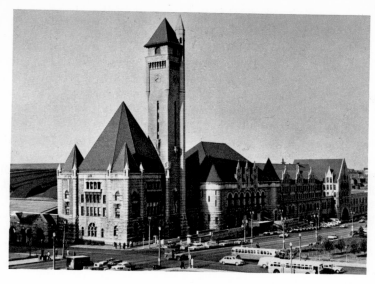

594 Left and below: Theodore C. Link and Edward D. Cameron with George H. Pegram. Union Station and train shed under construction, St. Louis. 1891–94

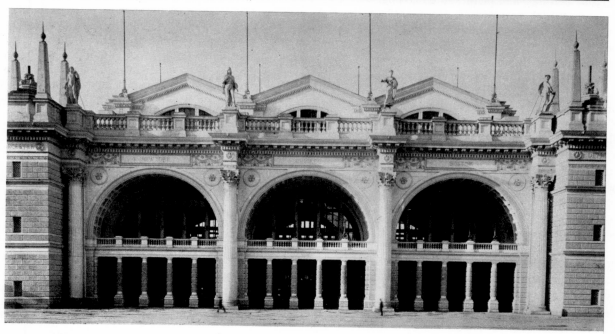

595 Charles B. Atwood. Railroad Terminal Building, Columbian Exposition, Chicago. 1893. Courtesy Chicago Historical Society

DOMESTIC ARCHITECTURE: STICK AND SHINGLE

After the Civil War the efforts to solve the critical need for mass housing were sociologically inadequate and architecturally undistinguished. However, the extra-urban private house, for the middle and upper classes, had a spectacular architectural development from Richardson through Wright, and the vernacular of wooden building underwent a transformation and efflorescence in the so-called "Stick" and "Shingle" styles. Both grew out of revivalism but evolved as original and indigenous forms—less spectacular than the contemporary development of the skyscraper but important and germinal in their own field. In the end, in spite of eccentricities and excesses, they introduced a new inventiveness into domestic architecture—freedom of plan, shape, massing, and use of materials.

The apparent source of the Stick Style was the revealed skeleton of wood construction in the cottages of Downing and Wheeler and their concern with the picturesque and its proliferation of exterior forms. In addition, there were two new foreign elements—the Swiss chalet and Elizabethan half-timbering—popular picturesque types in the Romantic cottage styles of Europe. Downing, following English pattern books, had included the Swiss chalet in his canon of acceptable modes, as had Cleaveland and Backus in *Village and Farm Cottages* (1856). The Swiss chalet and the Stick Style had in common: exposure of the skeletal structure for decorative ends, a profusion of extruding elements—gables, overhangs, balconies, porches, exposed rafters, diagonal braces, and jigsaw cutting—and picturesque massing.

Gervase Wheeler's Olmsted House (1849) in East Hartford, Conn., reproduced in his *Rural Houses* (1851), though Gothic in inspiration, was in many ways a prefiguration of the Stick Style. The Hamilton Hoppin House (1856–57) in Middletown, R.I., by Upjohn, with its schematized structural elements on the exterior, was another step in the same direction.

Even earlier, in 1854, Leopold Eidlitz had designed the Willoughby House (plate 596) in Newport, R.I., as a Swiss chalet. The house is composed on a cross-axis, on several levels, expanding outward with a delightful fantasy of carpentry forms. Nothing in the purely American development of the Stick Style predates the Eidlitz design, reproduced the same year in John Bullock's *The American Cottage Builder*.

Richard Morris Hunt, who was most famous for his later palatial buildings, played an important role in the development of the Stick Style. According to Vincent Scully, who invented the term "Stick Style" and has written extensively about it, Hunt's wooden cottages, with their open interiors and their skeletal treatment of exteriors, were his best and most "American" works.

Scully feels that they were rooted in the Romantic "rustic" architecture of Europe, as exemplified by the picturesque *pavillons* that Hunt had seen in the Bois de Boulogne. He views Hunt's masterpiece in the style, the J. N. A. Griswold House (1862–63, colorplate 58), now the Art Association, Newport, R.I., as a combination of medieval half-timber, French rustic, and American framing. One might add Swiss chalet to this catalogue, but the result is a new and fascinating kind of domestic architecture: rich in spatial relationships, juxtaposing void and solid, vertical and horizontal; proliferating shapes, textures, and carpentry forms; and creating a concatenation of geometric elements that seem to answer some interior functional conception. It is, however, still a somewhat cubical structure without the spidery lightness and filigreed elaboration that characterized the full-blown Stick Style.

Probably no single locale has so great a collection of fine Stick Style houses as Newport, which became the summer showplace of the rich in the postwar era. Among leading examples are the King Covell House, formerly the residence of N. H. Sanford, and the Thayer Cottage, both built in 1870, which combine Stick Style framing with mansard roofs. Reminiscences of Elizabethan half-timbering are to be seen in the Thomas Cushing House (1870), an example of intricate yet clear articulation of skeletal elements, and the Nathan Mathews House (1871–72) by Peabody & Stearns, perhaps consciously conceived as Elizabethan revival with a first story of brick and a superstructure in half-timber. The George Champlin Mason House (1873–74) is a splendid example of the style, open in plan, with board-and-batten sheathing and jigsaw ornamentation. Lastly, the Mrs. Loring Andrews House (1872) is the style gone wild. It is perhaps in this final phase that the style is best remembered—the matchstick fantasies of piled gables, spindly turrets, peek-a-boo dormers, and trellised porches, most specimens of which have fallen victim to fire, decay, economy, and changing taste. There were many buildings of the type at the Centennial Exposition in Philadelphia in 1876, notably the New Jersey State Building, by Carl Pfeiffer, a veritable dictionary of Stick-Style vocabulary.

By almost unanimous agreement, the perfect exemplar of the style is the Jacob Cram, now Mary Sturtevant, House (1871–72, colorplate 59) in Middletown, R.I., by Dudley Newton. It combines an airy grace and playfulness with a clear-cut utility and rational planning, expressed in a brilliant interrelationship of geometric forms, light and shade, and textures. The interior seems to extrude into porches, gables, and overhangs in an organic yet structural way. Though the interior plan was not so fluid as it seemed, the exterior, at least, bore promise of the architecture of Wright, Maybeck, the Greenes, and their progeny.

An addendum to the Stick Style was the Travers Block (c. 1875, colorplate 60) by Hunt in Newport, not far

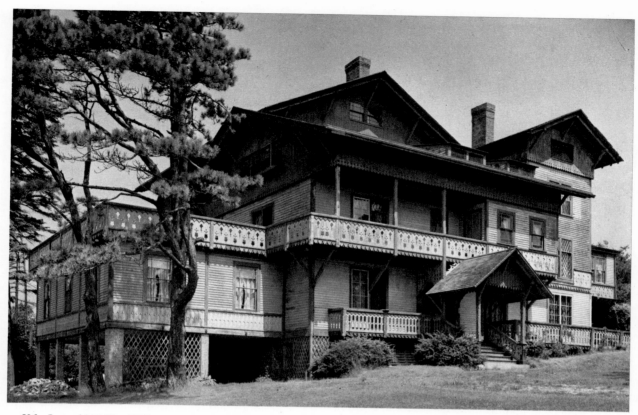

596 Leopold Eidlitz. Willoughby House, Newport, R.I. 1854

from the Casino, for which it creates an interesting foil. Built of brick with heavy chamfered half-timbering, it is rather awkward in scale and bulky in proportion. Inspired by the Stick Style, the block moves back into Elizabethan antiquarianism, transforming structure into decoration, but it is probably the first suburban shopping center designed as a unit. The Stick Style was fairly short-lived, extending not much beyond the early 1870s, and it had little effect on other American architecture. However, it prepared the way for the Shingle Style and offered a welcome interlude of imaginative improvisation.

In some basic aspects the Shingle Style was inspired by the English Queen Anne. Beginning in the 1860s, Richard Norman Shaw led a revolt of young English architects against the tyranny of the High Victorian Gothic and the revivalism of "great" styles. He substituted the more modest Elizabethan cottage, whose homier virtues were romanticized by touches of quaintness and a profusion of materials and detailing. The features of the Queen Anne, or perhaps more accurately the "Shavian," style are evident in Shaw's Leyes Wood in Sussex (1868–69, plate 597), a key monument in the evolution of the mode. Half-timbering masking brick, hung tiles, barge-boarded gables, clustered chimneys, leaded casement windows, mullioned bays, and pronounced eaves—all reinforced the picturesque massing of architectural elements. More important than this sentimentalized antiquarianism were the domestic scale, the free plan, and the radical innova-

tion that Hitchcock has described as the "agglutinative" interior, in which the rooms cluster around a central hall with an elaborate staircase derived from the medieval great hall.

Meanwhile, Richardson in the United States seems to have arrived at a comparable point at approximately the same time. His houses of the late sixties and early seventies, including his own Arrochar (1868) on Staten Island, were in the Stick Style, but a house project (c. 1870) for Richard Codman, which never materialized, shows the first evidence of a Shavian type of hall. (Richardson could not have seen a Shaw plan before than of Hopedene in 1874, but published examples of earlier stages of the hall plan were available to him.) In the F. W. Andrews House (1872–73), Newport, R.I., no longer extant, his interior plan was freer than that of any English models, and the porches around the central mass were certainly un-English; but the exterior indicated Shavian influence, despite a textural mixture of shingle and clapboard in place of the English tile and brick. Almost at once, in the William Watts Sherman House (1874–76, colorplate 61), Newport, though still referring to the Queen Anne, Richardson transformed the Stick into the Shingle Style by stretching, as it were, a skin over the structural elements. The surface was swept clean, freeing it for textural enrichment, and the building masses were simplified. Much of the decoration and detailing is due to Stanford White, who also enlarged the house in 1881; later it was further

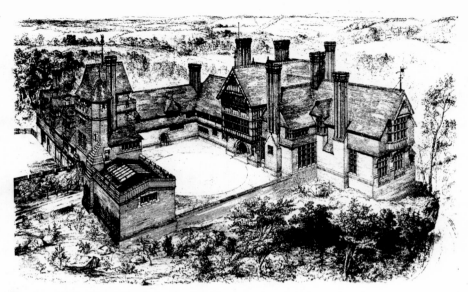

597 Richard Norman Shaw. Leyes Wood, Sussex, England. 1868–69.
From *Building News,* March, 1871

expanded by Dudley Newton. The exterior, perhaps re-flecting White's antiquarianism, is an Americanized ad-aptation of a Shavian manor house with a lower story of granite and brownstone and an upper of cut shingles, grouped and banded casement windows, and half-timber with decorated plaster on the gable front. But it is the highly articulated interior volumes of the hall-staircase-fireplace complex that are Richardson's major contribu-tion to the Shingle Style and the architecture of the detached house.

The new style answered a deep-felt cultural need. It was natural for Americans to turn from the difficulties and ugliness of industrial society and political corruption to the nostalgic vision of a rural and virtuous colonial past. Colonial architecture offered an image of simplicity, amplitude, security, and attachment to the soil, espe-cially in its seventeenth-century phase. This interest was reinforced by the Philadelphia Centennial Exposition, which fostered a recapitulation of American history and a reassessment of the American ethos. The English buildings in Queen Anne style erected for the Centennial and the "New England Kitchen of 1776" vied in popu-larity, and articles in architectural magazines not only equated the Queen Anne with the Colonial but called for an "American" architecture founded on the Dutch and Puritan past.

Prototype Colonial buildings such as the Fairbanks House (plate 11) were obviously compatible with the emerging Shingle Style in such features as the central stack, extrudent plan, and clapboard or shingle exterior surfaces. In the Shingle Style the use of shingles for sheathing may have been motivated by either of two concurrent factors: The single was a cheaper, more rustic,

and less formal material in the Colonial period and might imply a kind of Romantic humbleness. Also, it acted as a scale in a continuous skin that could stretch and un-dulate, as opposed to the linearity and mechanical preci-sion of a clapboard surface.

There is a span when Queen Anne, Colonial revivalism, and Shingle Style all seem to coalesce. One group of American architects assimilated the antiquarian pictur-esqueness of the Shavian Queen Anne manner without understanding its more radical aspects and never matured into the Shingle Style, achieving instead an accommoda-tion of the Stick Style and the Queen Anne. Among these were A. F. Oakey, Henry Hudson Holly, whose publica-tions had a wide effect on anonymous builders, Potter & Robertson, and William A. Bates. Another group fol-lowed the Colonial strand (see following section). Still a third group finally arrived at a synthesis that is, properly speaking, the Shingle Style—American without being revivalist—after groping in the 1870s through the rem-nants of the Stick Style and the picturesque byways of the Queen Anne.

It was Richardson, returning to domestic architecture in the eighties, who turned his back on antiquarianism and, in a series of wooden cottages, unequivocally estab-lished the hallmarks of the Shingle Style: interior open-ness and flow of space, bold and simple composition of exterior volumes contrasting with the sheltering voids of porches, lightly scaled woodwork recalling the Stick Style, and a stretched skin of rough shingles. Among these cottages were the Dr. John Bryant House (1880), Cohasset, Mass.; the Percy Brown House (1881), Marion, Mass.; the M. F. Stoughton House (1882–83, plate 598), Cambridge, Mass.; the Walter Channing House (1883–

84), Brookline, Mass.; and the F. L. Ames Gardener's Cottage (1884), North Easton, Mass. The unostentatious Stoughton House, impressive in its gracious interior (though much altered over the years) and in the simple massing of its exterior elements, became a much emulated model. Richardson's stone houses of the eighties show a stylistic influence from his work in shingle and are no less satisfying, although sometimes more apt to include antiquarian reminiscences. The R. T. Paine House (1884–86), Waltham, Mass., in which he used stone and wood in a completely nonhistorical manner, contains a brilliant central hall and staircase characteristic of Richardson at his best (even without the interior-decorating genius of Stanford White)—complex yet comprehensible, fluid and still contained, monumental without being oppressive. The Shingle Style house became common in resort towns, especially along the eastern seaboard, where its informal, rambling picturesqueness implied a closeness to soil and sea and harked back to the colonial past.

Kragsyde, the G. N. Black House (1882–84, plate 599), in Manchester-by-the-Sea, Mass., is perhaps the masterpiece of Peabody & Stearns in the Shingle Style, a sprawling complex of varied shingled shapes on a rough stone base, cleverly composed, but rather fussy. Lamb & Rich, though given to picturesque detailing, produced some handsome houses of restrained composition, such as Sunset Hall (the S. P. Hinckley House, 1883), Lawrence, L.I., extremely simple in its long, almost unbroken mass

and with a wonderful open porch along three sides. William Ralph Emerson shed his earlier Shavianisms to become one of the most inventive and picturesque of the Shingle Style architects, executing in the early eighties a series of houses distinguished by imaginative planning, expressive use of materials and forms, and sensitivity to light and space. The Hemenway House (c. 1883), Manchester-by-the-Sea, Mass., exemplifies his rich yet delicate treatment of materials in the juxtaposition of a heavy, rough stone base and light, wooden geometric shapes above. Perhaps the most restrained and simplest in conception of all were the houses of John Calvin Stevens of Portland, Me. He utilized rough stone and shingle much in the manner of Richardson but with even less affectation, transforming the Colonial vernacular almost imperceptibly into something modern. In the James Hopkins Smith House (1885, plate 600), Falmouth Foreside, Me., Stevens employed traditional materials and forms to create a new kind of architectural environment for leisure living. In contrast, the houses of Wilson Eyre, Jr., of Philadelphia are antiquarian and English in character, less Shavian than Elizabethan. The Richard L. Ashurst House (c. 1885, plate 601), Overbrook, Pa., in spite of its revivalist half-timbering, exhibits a mastery of Shingle Style elements in the fluid treatment of space, the bold organization of geometric volumes on the exterior, together with a strong predilection for horizontal composition.

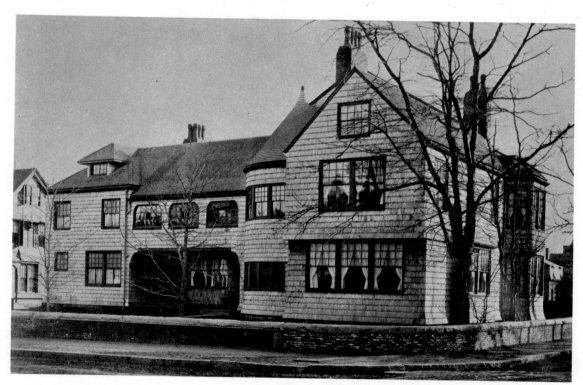

598 Henry Hobson Richardson. M. F. Stoughton House, Cambridge, Mass. 1882–83. From G. W. Sheldon, *Artistic Country Seats,* D. Appleton, New York, 1886–87, Vol. I

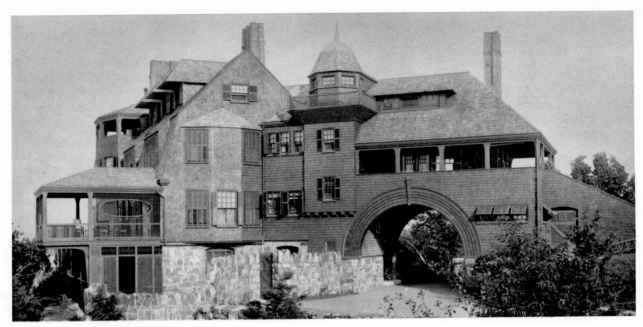

599 Peabody & Stearns. Kragsyde (G. N. Black House), Manchester-by-the-Sea, Mass. 1882–84. From
G. W. Sheldon, *Artistic Country Seats,* D. Appleton, New York, 1886–87, Vol. I

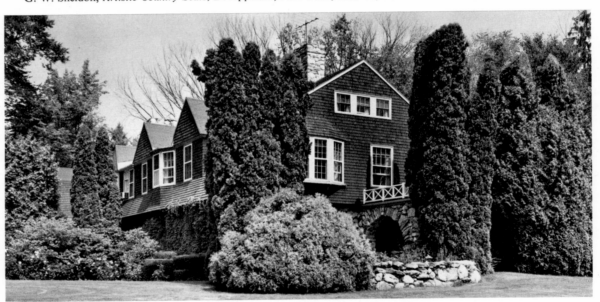

600 John Stevens. James Hopkins Smith House, Falmouth Foreside, Me. 1885

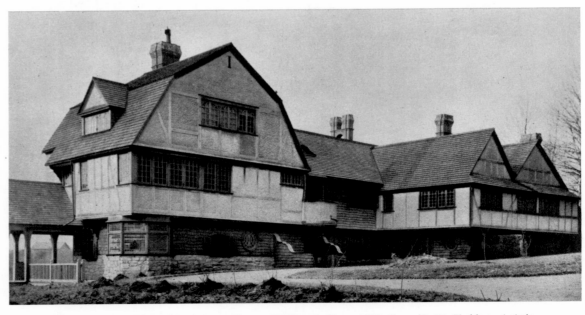

601 Wilson Eyre, Jr. Richard L. Ashurst House, Overbrook, Pa. c. 1885. From G. W. Sheldon, *Artistic
Country Seats,* D. Appleton, New York, 1886–87, Vol. I

The most unpredictable and radical of the younger men working in the style was Bruce Price, voracious in borrowing and exuberant in invention, who, as late as 1884, could produce so monumental a design as the George F. Baker House (plate 602) in Sea Bright, N.J., composed with forthright vigor but still with a dose of antiquarianism. It was in the smaller cottages built for Tuxedo Park, N.Y., that Price's most germinal work was done. He adapted the open, organic planning of the Shingle Style to a more compact design, emphasizing the geometric order of the elements disposed on a cross axis around a central fireplace. Price's exteriors were somewhat eccentric and aggressive, their geometric shapes showing little accommodation to the natural setting. The Pierre Lorillard House (1885, plate 603) is a curious and unexpected symmetrical design of two massive brick chimneys flanking a powerful, low, rough stone entrance arch. The balancing horizontal balconies over open porches appear almost cantilevered in space, suggestive of Frank Lloyd Wright, as is the skillful exploitation of solid and void. More traditional but just as daring in the free use of elements is the William Kent House (1885).

The firm of McKim, Mead & White contributed greatly to the flowering of the Shingle Style in the early eighties, when it built summer cottages, mostly at Newport, for social-register clients. Stanford White had been

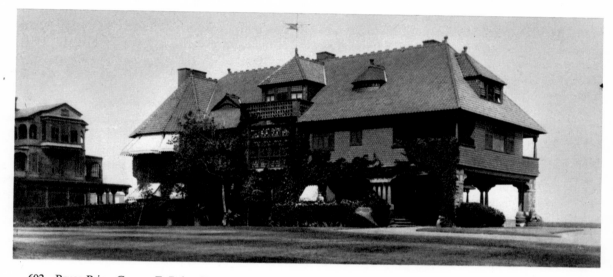

602 Bruce Price. George F. Baker House, Sea Bright, N.J. 1884

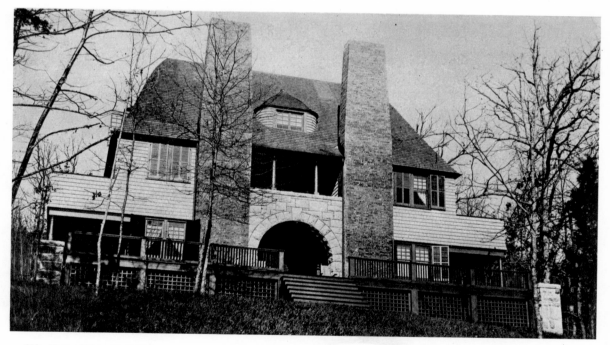

603 Bruce Price. Pierre Lorillard House, Tuxedo Park, N.Y. 1885. From G. W. Sheldon, *Artistic Country Seats*, D. Appleton, New York, 1886–87, Vol. II

in on the style from its inception as an assistant to Richardson, and in his new association he grew in subtlety, especially as an interior designer. In those years he produced some of the most exquisite interiors in American architecture. Charles F. McKim had been with Richardson before White, but had during the seventies shown an early interest in reviving the Colonial, turning to the Shingle Style only at the end of the decade. The Newport Casino (1879–81, colorplate 62) was the first major work of the firm in the style and one of three important clubhouses designed by them, the others being at Short Hills, N.J. (1882–83), and Narragansett Pier (1881–84). The facade of the Newport Casino is a rather unprepossessing symmetrical block, with a lower story of Roman brick containing shops flanking an arched entrance surmounted by three large bays shingled and capped by gables; it is essentially reticent, Colonial in flavor, with a transformed Palladian window in the center gable. In contrast, the back, facing the court, is a Romantic fantasy of a Tudor set, done freely in stone, brick, and shingle. For modern taste, the most exciting aspect of the building is in the piazzas surrounding the court, undoubtedly designed by White. One sees a confection of spatial grace and airy lightness, combining a memory of the spindly Stick Style with the geometric purity of Japanese woodwork—a tour de force in the manipulation of exterior space through wall-less structural elements and latticed screens. Unfortunately, the major portion of the more monumental Narragansett Casino has been destroyed. The part that remains is remarkably Richardsonian and picturesque.

The firm was much more successful in smaller cottages than in the more palatial Shingle Style houses. There is a kind of false modesty in the Victor Newcomb House (1880–81), Elberon, N.J., and Southside (1882–83, plate 604), the Robert H. Goelet mansion in Newport. They demonstrate that it is impossible to achieve monumentality out of the rustic or to maintain domesticity in the face of the grandiose. The former is reminiscent of the Casino and the latter a complex pile of cottage elements blown up out of proportion. However, both are skillfully handled, and their interiors are magnificently planned and detailed, although the great hall and staircase of the Goelet house are too baronial for the mode. On the other hand, such modest houses as the Samuel Tilton (now Louis Hobbs) House (1881–82) and the Isaac Bell House (1882–83), Newport, R.I., are among the most satisfying in the genre. The latter (plate 605), especially, has an incomparable lightness of treatment both inside and out, a marvelous fluidity of spatial relations, and an unfaltering sense of scale and proportion. The presence of Stanford White is strongly felt, particularly in the elegant Japanese-inspired interiors, such as he must have seen at the Centennial Exposition, but the borrowed elements were adapted to Western living with singular understanding and taste. The dining room of Kingscote (plates 606, 607), Upjohn's Gothic Revival villa in Newport, remodeled by White in 1880–81, is a brilliant example of White's handiwork, a ravishing interior as fine as anything produced here or abroad at the time. Notable are the pervasive sense of space and light, the rhythmic restraint of an imposed geometric module, the continuity of wall and window bay through shape and light value, the horizontal band cornice that ties the room together and adds to its height, and the muted opulence of materials and faultless detailing.

On a less pretentious level, the Skinner House (1882)

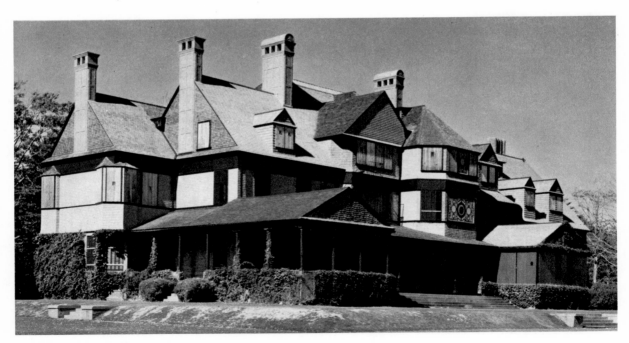

604 McKim, Mead & White. Southside (Robert H. Goele House), Newport, R.I. 1882–83

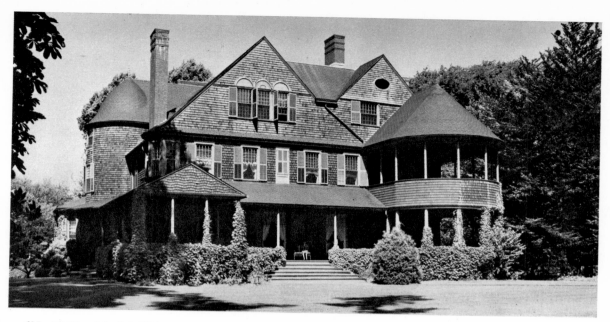

605 McKim, Mead & White. Isaac Bell House, Newport, R.I. 1882–83

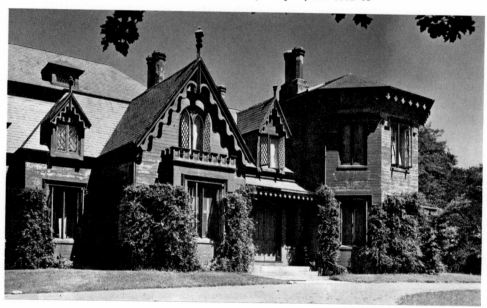

606 Richard Upjohn. Kingscote, Newport, R.I. 1838

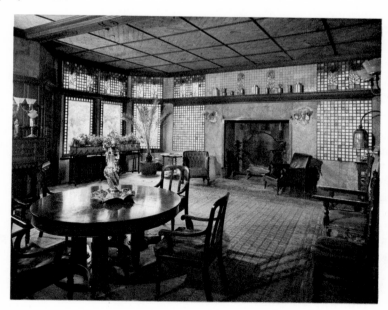

607 Stanford White. Dining room, Kingscote, Newport, R.I. Remodeled 1880–81

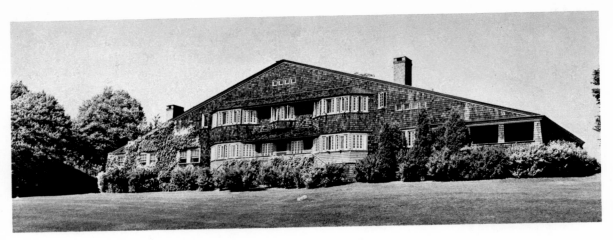

608 McKim, Mead & White. William Low House, Bristol, R.I. 1887

is remarkable for its reduction of the Shingle Style cottage to a compact unit and simple vernacular form. Such houses became standard for anonymous builders through the nineties in the suburbs and small towns, especially along the eastern seacoast, where a good many still remain. The Shingle Style house was introduced to Chicago in the mid-eighties by J. Lyman Silsbee, and eastern architects were building it as far west as Colorado Springs and Pasadena. However, the style had become passé by 1885, submerged by the Colonial and Classical reactions.

The catalogue of Shingle Style cottages would be incomplete without mention of McKim, Mead & White's William Low House (1887, plate 608), Bristol, R.I., a swan song, recapitulating some of the finest aspects of the style in its magnificent simplicity, its sense of belonging to the terrain, and its taut shingled skin over subtly undulating volumes, but also revealing a new kind of imposed order in the grand sweep of the roof enclosing the entire mass and the symmetry of the gabled facade. Though without antiquarianism, it reflects McKim's search for a more formal order in the Colonial past.

Wherever Shingle Style cottages can still be found, their shingles silvered by the sea or retaining their original earth-color stains, they are among the most precious remnants of our architectural history.

CLASSICAL REACTION AND ACADEMIC ECLECTICISM

As the practice of McKim, Mead & White increased in the mid-1880s, the domestic architecture of the firm became more standardized. The demands of their clients for more palatial homes led to a more formal and monumental manner. Their first break from the modest Shingle Style was the Charles J. Osborn House (1884–85), Mamaroneck, N.Y., a baronial château with Norman towers. At the same time the Charles T. Cook House (1885), Elberon, N.J., was still essentially a cottage, but with an

overlay of Colonial Georgian elements. McKim and his partners were returning to an earlier interest in the Colonial style current in the seventies and to the memory of the trip they had taken through New England in 1877, rediscovering and sketching Colonial houses. Homestead, the Appleton House (1883–84, plate 609), Lenox, Mass., is clearly antiquarian in intent, with Georgian detail on the exterior and eighteenth-century woodwork on the interior. The clapboard walls act like flat screens, and the whole is sharp-edged and unpicturesque in profile. However, the house does not look Georgian; Palladian motifs are freely applied without reference to a formal canon, and the plan (plate 610) is disposed on an eccentric broken axis. The new Classical reaction became evident in two Newport houses: the H. A. C. Taylor House (1885–86), in the Georgian style; and the Commodore William Edgar House (1885–86), in the Adam style.

Perhaps the dynamics of revivalism eventually had to arrive at academic eclecticism—the scholastic codification of historical styles—but it required a certain sophistication on the part of American architects to accept architecture as largely a matter of taste. By this time most architects were college graduates, and many had studied abroad at the École des Beaux-Arts. Formal training was further advanced by the establishment of architectural curricula at the Massachusetts Institute of Technology in 1866, followed by Illinois (1870), Cornell (1871), Columbia (1881), and Harvard (1890). In addition, the availability of European architectural journals and the founding of the *Architectural Review and American Builders Journal* in 1868 accelerated the transmission of information and style influences.

It is ironic that just when the basic environmental problems of the nineteenth century were reaching the point of crisis, when an explosively expanding industrial and urban society was fumbling for viable forms, architecture should have become so committed to fashion. There was no hint of governmental concern and none on the part of the capitalists, who were involved in a kind of im-

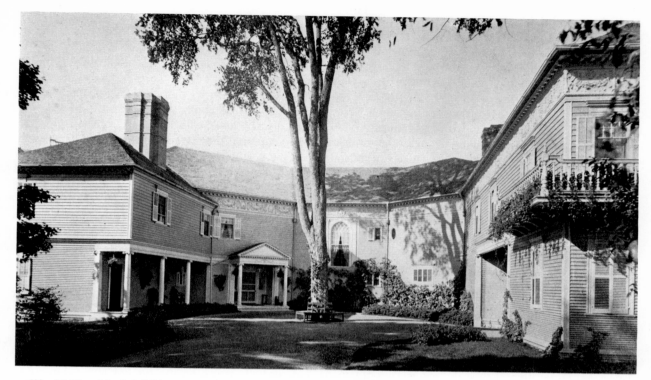

609 McKim, Mead & White. Homestead (Appleton House), Lenox, Mass. 1883–84

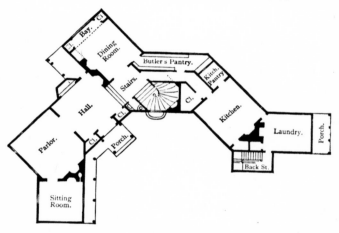

610 McKim, Mead & White. Plan, Homestead (Appleton House), Lenox, Mass. 1883–84. From G. W. Shelton, *Artistic Country Seats,* D. Appleton, New York, 1886–87

perialistic expansion of their own within the nation itself. In such an ambience the role of architecture, with all its new sophistication, became cosmetic.

Academic eclecticism of the end of the nineteenth century and the beginning of the twentieth has not unjustly been called an expression of "imperialism," but it is rather strange that during those years not much important public building, even on an "imperial" level, was being done—certainly nothing so fundamental as urban planning. The major architectural activities were in industry, where building was still left to engineers; in commerce, where the new tall urban structures were shoddily

tailored in historical modes; and in the mansions of the "robber barons," where the scholarly resources and elegant taste of the best architectural firms were employed.

The panic of 1873 and the depression that followed curtailed building in general, and it was not until the end of the decade that a new wave of construction began. Between 1879 and the next financial crisis in 1893 the magnificent palaces of America's moneyed peerage arose —in New York along Fifth Avenue between 50th and 79th Streets, called "Millionaires' Row"; and in Newport, R.I., where they summered. The possessors of this new wealth, made in real estate, railroads, steel, and banking, gravitated to New York, the hub of the financial world, and set up a local *Almanach de Gotha,* "The 400." "Everyone" now had money in great quantities, but social status had to be fought for, and the house, its location, scale, and cost (effectively displayed through art) took on strategic value.

In discussing what he termed the "Parvenu Period" (1860–80), T. E. Tallmadge noted that "a man who lived behind a brownstone front often did business behind a cast-iron front." Some of the most powerful of the new millionaires before 1880 were satisfied with brownstones by speculative builders. Among them were Astor, Morgan, Rockefeller, and Gould; William H. Vanderbilt, constructing two great mansions in competition with his sons, William K. and Cornelius II, still insisted on brownstone against the advice of the contractor, Herter Brothers, who suggested black and red marble. It was a distinct

break from tradition when A. T. Stewart had John Kellum design the so-called "Marble Palace" (1864–69), a white mansion in the Second Empire style. But when Richard M. Hunt built the William K. Vanderbilt Residence (1879–81, plate 611) as a château in the style of François I at a cost of $3 million, the four-story mansion of gray limestone with a blue slate roof and copper cresting set a new standard for palatial town houses.

Hunt was the most thoroughly trained and sophisticated architect working in the United States, but in spite of his success, his artistic development had been erratic until, with the Vanderbilt house, he came into his own. Steeped in the Beaux-Arts tradition, he was eminently equipped to furnish his clients with authentic versions of European aristocratic architecture. His own preference was for the style of François I, misleadingly called "French Renaissance," transitional from late Gothic with elements of the Italian Renaissance, and best seen in the châteaux of the Loire Valley. Combining the picturesque and the stately, exuberant but refined, expansive but orderly, the style seemed to fit Hunt's architectural personality and to offer his clients a symbol of status and culture. The Vanderbilt mansion was princely in every respect, revealing its cost in scale, materials, craftsmanship, and taste. It was perhaps overdecorated but so

skillfully managed and so knowledgeable a pastiche that it avoided pomposity. It established Hunt as the architect of "Society" and the style as his.

The Vanderbilt house found immediate imitation in George B. Post's even more expensive mansion (1880–94) for William K.'s brother, Cornelius Vanderbilt II, which was less ebullient, in keeping with its dependence on a later, more Classical phase of the style. But Hunt had captured the market for French châteaux, supplying in the next decade versions in New York City for Henry G. Marquand (1881), Elbridge T. Gerry (1891), and Mrs. William Astor (1893–95), all now demolished. The château, however, was not really a town house, and the François I style was not a facade architecture. It needed space in which to expand. Given the opportunity, Hunt built some of the grandest palaces for the new peerage, among them Ochre Court (1888–91) for Ogden Goelet, in Newport, and Biltmore (1890–95) for George W. Vanderbilt, near Ashville, N.C. Ochre Court (plate 612) was the first American imitation of European regal residences set in gardened parks, like Chenonceaux and Versailles. It is a rather academic rendering of a French Renaissance château, cold and characterless, its tremendous bulk crowding the limited space, but its interior exudes an almost unreal splendor, with a theatrical three-

611 Richard M. Hunt. William K. Vanderbilt Residence, New York. 1879–81

story hall effusively decorated in plaster and paint. In Biltmore (colorplate 63) Hunt finally achieved an "authentic" replica of a great French château, prodigal in scale, meticulous in detail, set in a spacious landscaped estate, about which he could say in truth, "the mountains are in scale with the house."

With all its charm and *élan,* the style of François I was not easily adaptable to large-scale public or commercial building and remained almost exclusively a vehicle of conspicuous consumption. Imperial eclecticism found its chief expression in the more serious, hieratic, and mon-

umental styles of the Italian Renaissance and Beaux-Arts Classicism, as espoused by the younger firm of McKim, Mead & White. In 1882 they had designed one of the few Richardsonian town houses in New York for Charles L. Tiffany, but the Henry Villard Houses (1883–85, plate 613) cut their last ties with Romantic eclecticism. White's original plan had called for some Richardsonian rustication, but Joseph M. Wells, an important figure in the firm, insisted on a smooth facade and an authentic Renaissance palace derived from the Cancelleria in Rome. The large brownstone complex, disposed around a three-

612 Richard M. Hunt. Ochre Court, Newport, R.I. 1888–91

613 McKim, Mead & White. Henry Villard Houses, New York. 1883–85

sided court and occupying an entire block along Madison Avenue, is impressive in its simple, declarative monumentality. Perhaps the serious stateliness of the style or its symbolic reference to the mercantile nobility of the Renaissance made it seem closer to the image of imperial power and to the American Classical tradition than did the frivolous François I manner.

However, McKim, Mead & White preferred the neo-Georgian for domestic building, and the neo-Renaissance was not established as the dominant mode until the nineties. In 1889 George Post had designed a New York town house for Collis P. Huntington in the Italian Renaissance

manner, and in 1892 the style reached its climax in two great Newport mansions built at the same time (1892–95) for the Vanderbilts by Hunt. The "Marble House" (plate 614), originally for William K. Vanderbilt and bought by O. H. P. Belmont, was a grandiose, though pedantic, neo-Palladian palace. The Breakers (plate 615), constructed for Cornelius Vanderbilt, equally Palladian and much like the late Renaissance palaces of Genoese merchant princes, suffers from gigantism and scholasticism, as if Hunt, striving for grandeur through size alone, had lost his sense of scale and ended in bombast. Still, it expresses the pretensions of America's ruling oligarchy in

614 Richard M. Hunt. "The Marble House," Newport, R.I. 1892–95

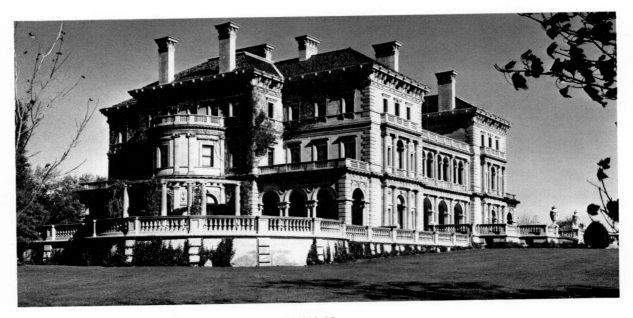

615 Richard M. Hunt. The Breakers, Newport, R.I. 1892–95

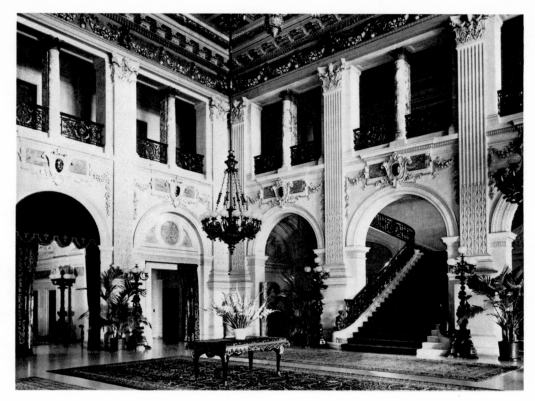

616 Richard M. Hunt. Reception Hall, The Breakers, Newport, R.I. 1892–95

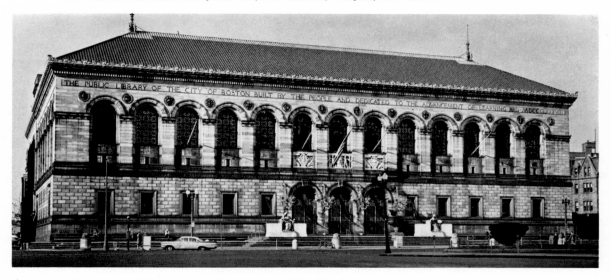

617 McKim, Mead & White. Public Library, Boston. 1887–98

sheer size and quantity, in lavish materials and decoration (plate 616), even in its avid borrowing from the past.

The megalomania continued well into the twentieth century, as did its handmaiden, "imperial Classicism," though with less distinction. Clark's Folly (1898–1904), the residence of Senator William Andrews Clark, counts only in terms of size, numbers, and cost. This trivial monster in the Beaux-Arts French neo-Baroque—a seven-story, white granite structure on a steel skeleton, containing more than 120 rooms, a theater, swimming pool, four art galleries, and several dining rooms—was

erected at a cost of $7 million. It was rivaled by the Charles M. Schwab Mansion (1902–06) on New York's upper West Side—a French Renaissance château set in a park of thirty city lots with seventy rooms and forty baths, a swimming pool, gymnasium, art gallery, and chapel—costing $8 million.

McKim, Mead & White had used Renaissance arches in the Goelet Building (plate 580), but their major work and the prime monument in the neo-Renaissance style during the late nineteenth century was the Boston Public Library (1887–98, plate 617), their first commission for a

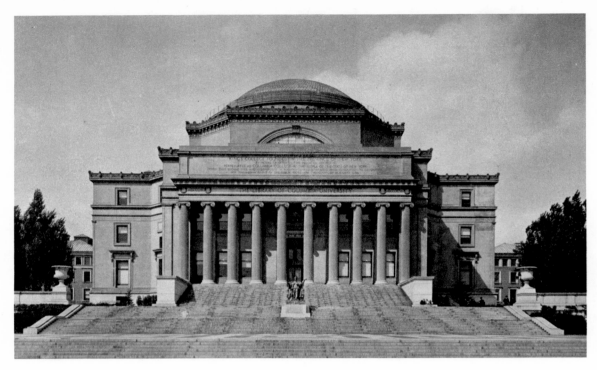

618 McKim, Mead & White. Low Library, Columbia University, New York. 1895–98

large public building. The project was challenging; it confronted them with their architectural origins, for the Library, on Copley Square, was to face the great Richardson Trinity (colorplate 55), on which both McKim and White had worked. To complete the site one must visualize also the High Victorian Gothic New Old South Church by Cummings & Sears on the north and the then Museum of Fine Arts (plate 528) by Sturgis & Brigham on the south side of the square. It took courage to counterpoise so positive, simple, and intellectually deliberate a structure against the picturesque mass and sensuous texture of Trinity and the animation of its neo-Gothic neighbors. The long, flat facade, Italianate and Classical, is unusually reticent, although not so austere as the Bibliothèque Sainte-Geneviève (1843–50), Paris, which may have inspired it; the Boston Library facade is lighter, more animated, and somewhat more decorative. In both the composition is repetitive rather than symmetrical in conception. However, the center of the Boston Library facade is emphasized by a three-arched loggia with sculptured panels above, which is not only more ceremonious but also more inviting than the small door of the Sainte-Geneviève. McKim, Mead & White insisted on the finest materials and craftsmanship and hired the best artists available as collaborators. Saint-Gaudens, French, and MacMonnies did the sculpture; and Puvis de Chavannes, the most highly regarded French mural painter, Sargent, and Abbey were commissioned to decorate the interior. The building reveals an architectural intelligence quite

different from that of Richardson but impressive in its own right, although there may be some legitimate complaint about its functional efficiency.

The Library established McKim, Mead & White as the leading architectural firm in the nation and, to accommodate the demands on their services, they became the first "corporate" architectural office. Even earlier the practice of such architects as Hunt and Richardson had grown too extensive for a single man to handle even with assistants. With McKim, Mead & White it had become so vast that the partners could not manage even the design, so that the "office" took over the bulk of routine commissions, and anonymous production became the normal practice. It is said that Joseph Wells refused a partnership in the firm because he would not sign his name to so much inferior work. Most of the enormous output that flowed from the office to the time of White's death in 1906 and McKim's retirement in 1908 was, except for churches, in the "imperial Classic" mode, and rather dull. The firm did a good deal of college work, including Columbia, New York University, Harvard, Radcliffe, the U.S. Military Academy, and the restoration of Jefferson's Rotunda at the University of Virginia. McKim became involved with restoring national monuments: the White House, the old Customs House in New York, and the L'Enfant plan for Washington, D.C. The Low Library at Columbia University (1895–98, plate 618) is one of the firm's most successful ventures in imperial grandeur, a neo-Roman domed mass derived from the Pan-

theon. They also produced a series of clubhouses, among them, in New York City, the rather lush Century Association (1889–91) by White and the seignorial University Club (1900, plate 619) by McKim, the ultimate and, perhaps, the purest statement of the neo-Renaissance, a citadel of social status in the immaculate guise of an early Florentine Renaissance *palazzo,* reminiscent of the Palazzo Riccardi in its vigor, imposing scale, magnificent materials, and assurance in detail.

619 McKim, Mead & White. University Club, New York. 1900. Courtesy The New-York Historical Society

FRANK LLOYD WRIGHT

Frank Lloyd Wright (1869–1959) has often been described, rightly or wrongly, as the greatest architect of the twentieth century (and twentieth-century architecture would be unthinkable without him), but he belonged essentially to the nineteenth. His individualism, moral conviction, and unorthodoxy (characteristics, even virtues, of nineteenth-century New England) were absorbed during his childhood in the vigorous intellectual climate of his family, and later through Emerson, Thoreau, and Whitman via the rhapsodic prose of Louis Sullivan. Raised in Wisconsin, he was deeply attached to the frontier, and he felt that "the real American spirit . . . lies in the West and the Middle West." Perhaps this identification with the West and with the past was responsible for his anti-urbanism. Although he produced some individual masterpieces in twentieth-century urban architecture, he will be remembered more for his revolutionary transformation of the private dwelling and the brilliant changes he played on that form.

Despite his nineteenth-century "romanticism," Wright's early work in the nineties prefigured the twentieth-century. He was committed to an "organic" architecture that grew from within outward, in which, as in medieval architecture (and here his, as well as Sullivan's, dependence on William Morris is clear), form is a response to function. In his project for a house in a prairie town (1900, plate 620), published in the *Ladies' Home Journal* in 1901, he finally broke open the "box" that had enclosed domestic architecture. From Downing through Richardson to Wright, the free plan evolved into its twentieth-century incarnation, in which interior and exterior were interpenetrating and walls were screens and not barriers. Even as early as this Wright showed the sensitivity to materials that all great architects have and a sensuousness reminiscent of Sullivan and Richardson that only a few are given.

620 Frank Lloyd Wright. Design for Prairie House. *The Ladies' Home Journal,* XVIII, No. 3, February, 1901

In 1885 Wright went to work as an apprentice to a local contractor-builder and soon after began attending classes in engineering at the University of Wisconsin. After two years he left for Chicago, where he entered the office of the architect J. Lyman Silsbee. Wright's first work under Silsbee, the Hillside Home School (1887) in Spring Green, Wisc., was a family affair commissioned by Wright's aunts and designed in the provincial shingle style. Later that year Wright was hired by Sullivan to work on the ornament of the Auditorium Building (plate 561), and in 1888 he was given responsibility for the domestic work of the firm. One of the earliest of his houses, his own (1890), in Oak Park, though an unpretentious shingled cottage on the exterior, introduced what were later to become benchmarks of his style—rooms merging within a continuous space and a "utility core" that was at the heart of his later radial plans.

The most important of the early commissions for Adler & Sullivan was the Charnley House (1892), Chicago, a formal, *palazzo*-like, geometric block of four stories in Roman brick. It is closer to the Neoclassicism of McKim than to the asymmetry of Sullivan, though the influence of the latter is to be seen in the horizontal banding, projecting eaves, Art Nouveau ornament, and balcony loggia. Here, and in the Winslow House (plate 621) in River Forest, Ill., the following year, Wright's first independent commission after breaking with Sullivan, he projected a new kind of nonhistorical, modern Classicism unlike the revivalism of McKim, Mead & White. Both houses share an abstract formalism in composition, immaculate sharp-edged flat surfaces into which windows are punched, an emphasis on the horizontal through banding and boldly projecting eaves, an elegance of proportion, and a preference for the Classical square window. One is impressed by the organization and rhythmic order of all the elements, perhaps not yet entirely under control in the Charnley, but simplified and completely formalized in the Winslow. In 1893 Daniel Burnham saw Wright's project for a library and museum for Milwaukee and was so impressed by its polished Classicism that he offered him four years of study at the École des Beaux-Arts and two at the newly established Academy in Rome to prepare him for a place in the firm. However, in spite of the enticement, Wright turned his back on "imperial Classicism."

Toward the end of the century Wright had fought his way out of formalism and symmetry to a freer and original expression. The important ingredients of his "prairie" style are apparent in the project for the River Forest Golf Club (1898–1901, plate 622): the intimate, almost mystical, relationship between building and site; the open, fluid, self-generating plan; the horizontality and spacious-

621 Frank Lloyd Wright. Winslow House, River Forest, Ill. 1893

ness; the floating roof planes; the natural materials; the banded fenestration. The Japanese flavor, stemming from his contact with Japanese architecture at the Columbian Exposition, is very strong, as it is in the two houses he did in Kankakee, Ill., in 1900, for B. Harley Bradley and Warren Hickox, prototypes of his "prairie" house of the next century. Though the mingling of "Tudor" and Japanese elements is rather curious, the plan and composition of volumes are already Wrightian. It was not accidental that by 1900 Wright should have gathered together all the strands in the evolution of the "cottage" and woven them into the fabric of a modern house.

622 Frank Lloyd Wright. Perspective and plan, River Forest Golf Club, River Forest, Ill. 1898–1901. From Frank Lloyd Wright, *Buildings, Plans and Designs,* Horizon Press, New York, 1963, plate 17

CHAPTER SEVENTEEN

Painting

The Gilded Age

The effect of the Civil War on culture was not cataclysmic. In the postwar decade the euphoria generated by peace, the preservation of the union, and, in the North, victory, fostered the illusion of national continuity. For a time the art world was still dominated by the prewar generation, but a younger generation was beginning to move in other directions. The young men who went abroad to study sought new schools and new artistic gods. In a cultural sense, 1876 was more significant as a date than 1865, not because it marked the completion of a century of political existence, but because it saw the end of the Grant administration and the Centennial Exposition in Philadelphia. In spite of disillusionment, the country began to adjust to new perspectives. The Exposition serves as a key to the next period, for the great Corliss engine that dominated Machinery Hall, symbolizing America's technological advances, proved more impressive than a century of American art displayed in a thousand works. Though the selection of European art was hardly more imposing, doubt about American achievement was strongly felt.

So, after a long reign of nationalist isolation, the arts turned again to Europe. Even during the postwar decade, American artists and collectors were revealing a heightened sophistication, a dissatisfaction with insular standards and limitations. Artists were going abroad to study at an earlier age, when they were more susceptible to influence. The day of Düsseldorf was over, and Paris and Munich became new meccas for American students. Paris was preeminent, with young artists coming from all over Europe and America for what were essentially cram courses. Entrance to the École des Beaux-Arts was competitive and difficult, but professors did accept nonmatriculated students in their ateliers; however, such students did not undergo the rigorous academic training of the Beaux-Arts curriculum. One might also study with an independent master or enroll, as most did, in the Académie Julian, specifically organized to accommodate the hordes of foreign students. Here, though space was at a premium, one could work at will and receive criticism

from Beaux-Arts masters hired to perform that function. Aside from the joys and advantages of living in Paris and visiting and, perhaps, working in the Louvre, this was inadequate training. Few had the opportunity or insight, as did Hunt, Inness, Whistler, Cassatt, and Sargent, to study for any length of time or make a meaningful connection with French art. The majority collected a particular bag of tricks, assumed the artist's mien, and returned to a culture which had suddenly become unreceptive. Many who could not make what they had learned fit their native environment found it more congenial to live and paint abroad. Those who came back brought mannerisms alien to American eyes and memories. Undigested borrowings from various European sources gave American painting of the late nineteenth century an air of eclecticism. American painting in its new sophistication had become part of an international style of academic art without national or aesthetic relevance.

On the other hand, Winslow Homer and Albert Ryder seem to have been unaffected by their foreign contacts, and although Eakins studied with and revered Gérôme, the fountainhead of so much academic insignificance, he also found something more in Spain. Beginning with William Morris Hunt, some Americans reacted to more vital aspects of European art. Hunt and after him Robert Loftin Newman gravitated to the Paris atelier of Couture, which was an indication of some awareness. Couture was a painter of remarkable talent and an important teacher who numbered Manet among his students during the 1850s. Also, during those years La Farge spent several weeks in Couture's studio, and Whistler copied a study of a head by Couture. Hunt eventually transferred his allegiance to Millet, bought many of his works, and was instrumental in introducing the Barbizon School to this country. Meanwhile, Inness in his trips abroad had discovered Corot, Rousseau, and the Barbizon landscape painters. Although Whistler was nominally a student of Gleyre, he met Courbet and Manet and became one of the group of dissidents later to be called the Impressionists. Some years after, Mary Cassatt, through her friend-

ship with Degas, became a member of the circle. It is some reflection on the character of American culture and of some importance for the development of American art that Whistler and Cassatt remained expatriates and that their experiences were exceptional. On the whole, what America got of European art was second-rate.

Artists returning from study abroad found no ready buyers, for, though collecting had expanded with increased wealth, the majority of *nouveau riche* collectors bought the fashion of the period, from Bouguereau to Meyer von Bremen, Meissonier, or even Corot, rather than their American echoes. Very few knew about the avant-garde artists who were to become the great masters of the period. The richer and wiser collectors began to invest in the more stable currency of the old masters, and it was in those years that the collections of J. P. Morgan, Henry Walters, Benjamin Altman, Isabella Stewart Gardner, John G. Johnson, and Henry G. Marquand were begun, and that Mary Cassatt advised her friends, the Havemeyers, as well as the Stillmans, Whittemores, and Vanderbilts, to buy the Impressionists.

Art interest and activity expanded greatly in the post-war period, as witness the establishment of museums, art institutions, and art schools and the increase in the number of collectors, dealers, and artists. Taste was wide enough, or perhaps confused enough, to accept a broader range of expression than previously. Painting, like architecture, had become eclectic. But within this great span of uninspired picture making, the major trends and developments in American painting are not much different from those in Europe and they even exhibit historic (if we include the expatriates) or parallel connections with the central stream of French avant-gardism. One can isolate two main currents in post-Civil War painting, Realism and Romanticism, with Realism as the dominant stream, not in terms of statistics or acceptance but importance. The new visual Realism grew out of the literalism of the Hudson River School and the popular art of the genre painters; the new Romanticism transformed the transcendental philosophy of the Hudson River School into the personal expression of poetic feeling.

REALISM

Beginning with the Renaissance, the preoccupation of Western painting has been the representation of reality, and philosophic speculation in art has been largely about its relation to nature. The continuing reference to nature, through shifting attitudes and styles, may be the aesthetic equivalent of Western man's concern with the conquest of the physical universe. In the nineteenth century, as the scientific understanding and control of nature accelerated, art evinced a new preoccupation with physical reality. The troubling question, and a crucial one for the twentieth century, is why at the very end of the nineteenth an ambiguity about the relationship of art and nature turned the course of art in other directions. However, for the last half of the century, at least, Paris was the arena in which the artistic conquest of reality took place.

The key figure in the rise of a new visual Realism was Édouard Manet, who faced the major problems and arrived at germinal solutions. He was not alone nor uninfluenced in his efforts; Courbet struck the first blows for Realism against the preconceptions of both Classicism and Romanticism, but his Realism, despite its revolutionary impact, was rooted in a provincial naturalism. Although Manet was profoundly moved by Courbet, he returned to the tradition of Hals and Velázquez to free himself from both the tyranny of the literal and the last vestiges of Romanticism. The new photographic image may have reinforced Manet's growing preference for flatness and silhouette, but the lighter, "natural" color was his own contribution. Thus, the configuration of Manet in relationship to Courbet, to the past, and to the future (Impressionism and Postimpressionism), is the template against which all peripheral Realist developments, including the American, should be matched. In such a context one can see more clearly the avant-garde role that Whistler, in his relationship with Courbet and Manet, played in the emergence of visual Realism as well as the historic importance of his break from it. Cassatt's adherence to Impressionism and her expatriation appear more normal. Sargent is no longer to be dismissed as a society portraitist but seen as a Realist, somewhat eccentric, though related to the Manet configuration through Carolus-Duran, through his interest in Spanish painting, and, perhaps even more important, through his connection with the tradition of visual Realism via the collateral English line from Van Dyck to Lawrence. Homer, on the other hand, was exceptional in his lack of connection with the historical sources of visual Realism, but evolved in an independent parallelism to Manet and early Impressionism. Eakins, like Leibl in Munich, though retardataire, is related to Courbet, and to Manet through a comparable interest in Spanish painting. Finally, Harnett and the other *trompe-l'oeil* painters, as well as the genre painters of the period, are retardataire in their adherence to the Düsseldorf school. All this is no criticism of the quality of American Realist painting or of its relevence to American life; it merely sets it within the context of Western painting as a whole.

THE EXPATRIATES:
WHISTLER, CASSATT, SARGENT

Since it was common for American artists to study, travel, and even live abroad permanently as far back as the eighteenth century, it is rather curious for historians of American art to have singled out Whistler, Cassatt, and Sargent as *the* expatriates. Except for Copley and

West, who were colonials, and the sculptors who worked in Europe largely for reasons of craft, the earlier expatriates were inconsequential as artists. These three are a big chunk of American (or non-American) art, so that they are usually honored for their international eminence and slighted for their purported irrelevance to American art and life. In fact, all three thought of themselves as American and had more pertinence for American art than is commonly thought.

The expatriation of James Abbott McNeill Whistler (1834–1903) began when he was taken at the age of nine to St. Petersburg to join his father, a retired Army engineer then supervising the building of the railroad to Moscow. His early aristocratic schooling in Russia and his later visits to England, where his half-sister had married Sir Seymour Haden, did not prepare him for life in Pomfret, Conn., to which the family moved after Major Whistler's death in 1849. He spent three years at West Point and, after a short stint in the U.S. Coast and Geodetic Survey, where he learned engraving, went to Europe in 1855, never to return. Although he retained strong ties with America and was often nostalgic and sharply defensive in the face of English criticism, in a moment of annoyance he said, "I do not choose to have been born in Lowell, Massachusetts."

In Paris, Whistler entered the studio of Charles-Gabriel Gleyre and settled down to concentrated bohemian living. He seems also to have worked, and in 1858 he published the first of his etchings, the *French Set.* He had made many friends, including Fantin-Latour, who introduced him to Courbet. His earliest mature efforts show a strong influence from the leader of the Realist movement, and his first major painting, *At the Piano* (1859, Cincinnati Art Museum), rejected by the Salon, was highly praised by Courbet. Though modest, it is a remarkable picture, as advanced as anything being done by his avant-garde contemporaries. *The Music Room* (1860, Freer Gallery, Washington, D.C.), in compositional pattern, framing, and sense of arrested movement, predates the use of similar devices by Degas. In a sense, he had already made his mark among his peers when he moved to London, where he lived for the rest of his life. In Wapping-on-Thames, he did a series of paintings of life on the river, of which *Wapping* (1861–64, colorplate 64) is probably the most famous, a picture of unusual promise and originality, though clearly out of Courbet. In contrast, *The Coast of Brittany* (1861, Wadsworth Atheneum, Hartford), the first of his seascapes, may have anticipated Courbet's later paintings of the sea, begun when both artists worked at Trouville in 1865. At Wapping, Whistler also began the *Thames Set,* which established his reputation as an etcher. In 1863 *The White Girl* (1862, colorplate 65), rejected by both the Royal Academy in London and the Salon in Paris, was exhibited at the famous Salon des Refusés, where, along with Manet's *Le Déjeuner sur l'Herbe,* it was the butt of ridicule. On the other hand,

it brought him the praise of avant-garde critics and artists, and he was at this time equally accepted by the Courbet entourage and by the younger Realists led by Manet in Paris and the Pre-Raphaelites around Dante Gabriel Rossetti in London—often acting as a kind of ambassador between the two.

Also during the early 1860s in Paris Whistler became interested in Japanese art and began to buy Japanese prints and blue-and-white porcelain, for which he started the vogue in London. *The White Girl* and subsequent paintings placed him on the threshold of Impressionism, but a trend away from the main direction of Realism soon became evident, first, in his continuing concern with Japanese art and, second, in his growing involvement with subtle nuances of visual phenomena. His early preoccupation with Oriental art parallels that of the Impressionists and is expressed more in exotic and colorful Oriental paraphernalia than in an adaptation of its design principles. *The Lange Lijzen of the Six Marks* (1864, Philadelphia Museum), *La Princesse du Pays de la Porcelaine* (1864, Freer Gallery, Washington, D.C.), and *The Golden Screen* (1864, also Freer Gallery) are almost entirely Western in their naturalistic effects, although the last introduces a new interest in pattern. With the Peacock Room (plate 623), the fateful project he executed for the London home of Frederick R. Leyland in 1876–77, he entered a new and decorative phase of *japonnoiserie,* revealing a flair for interior decoration, in which he became a seminal figure.

Those years also saw a turn toward the subjective, tonal impressionism that was to be the hallmark of his style. Instead of the more objective recording of nature in dazzling sunlight which occupied the French Impressionists, Whistler sought the evanescent, crepuscular moments in which mist shrouded the ugly banks of the industrialized Thames and created a mood of gentle mystery. *Old Battersea Bridge* (1872–73, plate 624), one of the early "nocturnes," combines Japanese composition with a blue tonal haze out of which hulking shapes loom indistinctly, lights of gold twinkle from the opposite shore, and a bursting rocket speckles the sky.

In the late sixties Whistler was torn between fidelity to nature and internal aesthetic order. In an impassioned letter to Fantin in 1867 he renounced Courbet and "that damned Realism" and cried, "If only I had been a pupil of Ingres!" The next years saw only the slight and tentative experiments in composition and color, involving friezes of women in a mixture of Greek and Japanese details, undertaken as a decorative project for Leyland but uncompleted. However, when he began to paint seriously again in the early seventies, he had arrived at his mature style. In the next fifteen years he painted his most famous portraits, beginning with the *Portrait of the Artist's Mother* (1871, Louvre, Paris) and followed almost immediately by the *Thomas Carlyle* (1872–73, plate 625). In them, he stated a new credo: that aesthetics takes

623 James A. McNeill Whistler. The Peacock Room. 1876–77. Oil and gold on wood, canvas, and leather. Freer Gallery of Art, Smithsonian Institution, Washington, D.C.

624 James A. McNeill Whistler. *Nocturne in Blue and Gold: Old Battersea Bridge.* 1872–73. Oil on canvas, 29¾ × 21″. The Tate Gallery, London

precedence over reality, either objective or emotional. It was also then that he began to retitle pictures, without reference to subject, as "symphony," "arrangement," "nocturne," "harmony," in accordance with musical practice. The *Mother* was called *Arrangement in Gray and Black, No. 1* and the *Carlyle, Arrangement in Gray and Black, No. 2.* Physical reality has been subordinated to a compositional format emphasizing flatness, silhouette, rectilinear spatial balance, and tonal harmony, much of which is derivative from Japanese art, although without the Oriental detail of earlier works except for the curtain in the *Mother.* It is difficult to approach the *Mother* freshly, since it has been so overexposed; but in spite of some feebleness in drawing, Whistler's most obvious failing, it is an exquisitely composed picture, capturing something of the ineffable balance of Japanese art. The more moving portrait of Carlyle, seated in pathetic grandeur, is handled with greater assurance and less sensitivity to formal relationships. Restrained as both portraits are in statement, their revolutionary aesthetic significance was appreciated only later in the century.

Other notable portraits of these years include: *Harmony in Gray and Green: Miss Cicely Alexander* (1873, Tate Gallery, London), *Mrs. F. R. Leyland: Symphony in Flesh Color and Pink* (1873, Frick Collection, New York), *Arrangement in Black, No. 3: Sir Henry Irving as Philip II of Spain* (1876, Metropolitan Museum, New York), *Arrangement in Black and Brown: The Fur Jacket* (1877, Worcester Museum); and, among his finest "moonlights":

625 James A. McNeill Whistler. *Arrangement in Gray and Black, No. 2: Thomas Carlyle.* 1872–73. Oil on canvas, 67¾ × 56½". Glasgow Art Gallery and Museum

Nocturne in Black and Gold: The Falling Rocket (c. 1875, colorplate 66) and *Cremorne Gardens, No. 2* (c. 1875, Metropolitan Museum, New York). After years of ridicule and neglect Whistler was in demand for portraits, had commissions for decorations, and his works were beginning to sell. Then, in a series of catastrophes, his world crumbled. His altercation with Leyland over the decoration of the Peacock Room led to a rupture in relationship, reduction of fee, and bitterness. *The Falling Rocket,* exhibited at the Grosvenor Gallery, was singled out for derision by John Ruskin, who attacked Whistler viciously for his "cockney impudence" in asking "two hundred guineas for flinging a pot of paint in the public's face." Whistler's suit for libel became a *cause célèbre,* and though he technically won the case with the judgment of a farthing, press and public reactions were unfavorable and financially damaging. The trial expenses forced him into bankruptcy and the loss of his new home, the White House (1878), designed by E. W. Godwin and decorated by Whistler, in itself an important aesthetic monument of the period.

Whistler left for Venice in 1880 to do a series of etchings commissioned by the Fine Art Society. From then on his energies were directed largely to etching, lithography, pastel, and watercolor, which in scale and intimacy lent themselves more readily to the nuances and ephemeral effects he sought. In the early 1880s, regaining some of his patronage, he executed the last of his important portraits: *Arrangement in Black: The Yellow Buskin: Lady Archibald Campbell* (1883–84, Philadelphia Museum); *Arrangement in Flesh Color and Black: Théodore Duret* (1882–84, plate 626); and *Arrangement in Black: Pablo de Sarasate* (1884, Carnegie Institute, Pittsburgh). Ironically, as his production decreased, recognition and honors accumulated, his work was exhibited in many international exhibitions of avant-garde art, and in 1891 Glasgow bought his *Carlyle* and the Luxembourg his *Mother.*

Whistler continued to fight the battles of the progressive movement on his own terms. He had entered the early struggle for Realism, but his lasting significance was anti-Realist, in his espousal of aestheticism and art for art's sake. His "Ten O'Clock" lecture of 1885, repeated many times, published, and translated into French by Mallarmé, was the manifesto for a new movement in European art, the anti-Realism that motivated Post-impressionism, Symbolism, Art Nouveau, aestheticism, and much of twentieth-century art. Yet, Whistler has not received his due, perhaps because his achievement never equaled his promise, or because, in leaving Paris, he became peripheral to the vital center, or because his work often seems incomplete as a natural result of his search for the moment, for the one total spontaneous statement. Sometimes, as in the *Duret,* all the parts fall into place and we have a superb portrait comparable to those of Manet; at others they drift into a vaporous suggestion of something yet to happen. His failure was due not to frivolity or laziness, for he produced a formidable output in various media, but to a lack of profundity. He had talent, intelligence, wit, shrewdness, superb taste, and great perspicacity, but his art suffered from fundamental weaknesses in training, lack of discipline, and an unwillingness to deal with his deficiencies, for he was arrogant, self-indulgent, cantankerous, and pretentious. Yet perhaps no artist of his generation outside the mainstream of French painting had so great an impact.

In contrast, the career of Mary Cassatt (1844–1926) was modest and her influence negligible, though her effect on American taste through the important collectors she advised was profound. She was born in Allegheny City, Pa., to parents of wealth and culture. She studied briefly at the Pennsylvania Academy and then in Parma and settled in Paris in 1873. Like many progressive painters of the time, she was "self-taught" in museums rather than academies, traveling extensively in France, Italy, Spain, Holland, and Belgium, and, like most of them, she returned to the visual realism of Hals, Velázquez, and Rubens, as her earliest works attest. However, her palette was already becoming lighter before she met Degas, who invited her to join the Impressionist

627 Mary Cassatt. *Reading Le Figaro*. c. 1883. Oil on canvas, 39 × 31″. Private collection, Haverford, Pa.

group in 1877. From then on his influence was obvious in her work, beginning with the gouache *Self-Portrait* (1878, Collection Mr. and Mrs. Richard Proskauer, New York), and continuing through such paintings as the *Woman and Child Driving* (1879, Philadelphia Museum), *Five O'Clock Tea* (1880, Museum of Fine Arts, Boston), and *A Woman in Black at the Opera* (1880, also Museum of Fine Arts, Boston). From Degas she borrowed liberally: his momentary vision, though she never achieved his spontaneity; his compositional devices; his color range and texture; even his subjects. But with it all she remained herself. Aside from being somewhat more heavy-handed, she tended also toward greater three-dimensionality and sweetness of expression. In her pastels she more nearly approached his lightness of touch and grace in movement. Occasionally, as in *Reading Le Figaro* (c. 1883, plate 627), she made a more personal and powerful statement, closer to the realism of Courbet and Manet, the two other contemporary painters she revered.

In 1890 Cassatt and Degas together visited the exhibition of Japanese prints at the École des Beaux-Arts and were deeply impressed. The Japanese influence is most marked in the series of ten color prints (mixed media including drypoint, aquatint, and soft-ground etching on three plates) executed by Cassatt in 1891, in which,

James A. McNeill Whistler. *Arrangement in Flesh Color and Black: Théodore Duret*. 1882–84. Oil on canvas, 76¼ × 35¾″. The Metropolitan Museum of Art, New York. Wolfe Fund, 1913

though patently imitative, she successfully adapted Japanese stylistic elements to Western subject matter. The Japanese emphasis on line, flat pattern, and compositional arrangement was more fully assimilated in such paintings as *The Bath* (1892, colorplate 67), in which Impressionism, Japanese art, and her own warmth of sentiment coalesce.

During the nineties, at the height of her powers, her painting became more forceful, more personal, stronger in outline, and more three-dimensional. She seems to have settled on the woman-and-child theme as her personal subject, treating it with a tenderness that is foreign to the Impressionist mode. At the turn of the century Cassatt moved from the linearity and flat pattern of her earlier work to an overall play of color and a fusion of tone, unfortunately accompanied by an increasing sentimentality. With failing eyesight, her work began to deteriorate, and by World War I she could not continue painting. Though she was not a major artist, her reputation has suffered unduly by comparison with the work of more gifted Impressionists.

Of the three expatriates, John Singer Sargent (1856–1925) has probably sustained the greatest decline in esteem, but his reputation was always largely popular rather than informed. A leading society portraitist of his time, he was subsequently dismissed as superficial and facile. Facility had become suspect, so that he is now denigrated for the very gift that made his reputation. Sargent was born in Florence to American parents, and his early years were spent in leisurely travel through Europe. He studied first in Rome and then at the Accademia in Florence before entering the studio of Carolus-Duran in Paris at eighteen. No radical, Carolus-Duran was a solid painter, inspired by the same sources of visual realism that influenced Manet, and Sargent received a thorough technical grounding. Immensely talented, he learned quickly, but his earliest works were slick rather than original.

However, after a trip to Spain and Holland in 1879–80 and a serious study of Velázquez and Hals, his style gelled suddenly into precocious maturity. His *Mrs. Charles Gifford Dyer* (1880, plate 628) is a moving psychological study as well as a brilliant bit of painting. *The Pailleron Children* (1881, Collection M. Robert B. Pailleron, Paris) is startling in its naturalism and its emotional tenseness. The environmental clutter is reminiscent of Carolus-Duran, but a new objective reality in the figures, possibly from his interest in Velázquez, is more closely related to the English portrait tradition. There is even a curious affinity in some of Sargent's later portraits with the American tradition of Copley and Stuart.

It is interesting that Sargent had visited the Centennial Exposition, where he could not have missed the American paintings. At any rate, within the mainstream of visual Realism, he continued the English, rather than the

628 John Singer Sargent. *Mrs. Charles Gifford Dyer.* 1880. Oil on canvas, 25⅝ × 17¼″. The Art Institute of Chicago. Friends of American Art Collection

French, tradition of portraiture both in its painterly virtuosity and in its occasional courtly vapidity. Characteristic is the *Daughters of Edward Darley Boit* (1882, colorplate 68), perhaps his closest brush with greatness. Daring in conception and composition, lucid in execution and in the handling of light and space, capturing the vibrancy of the children and the total ambience, it nevertheless fails to move one deeply, perhaps because the recording eye chose chic over aesthetic probity, or because the scale was too large and there are too many empty areas. In contrast, perhaps his most famous portrait, *Madame X* (1884, plate 629), is in the French vein of Carolus-Duran, classical in pose and solidly painted. This likeness of Mme. Pierre Gautreau, a society beauty, mingles a flair for style and social elegance in the sheer *élan* of the figure with an unexpected and disturbing fidelity to physical reality. Mme. Gautreau and her family were ostensibly outraged by the shocking décolleté when the portrait was exhibited at the Salon, but they may have been equally upset by the vanity and the hint of

629 John Singer Sargent. *Madame X (Mme. Pierre Gautreau)*. 1884. Oil on canvas, 82⅛ × 43¼". The Metropolitan Museum of Art, New York. Arthur H. Hearn Fund, 1916

there was no further development in his style. His willingness to please led to a succession of exquisitely groomed manikins of fashion—glossy, empty symbols of social position turned out with a technical dispatch that is somewhat repellent, as in *Mrs. Hugh Hammersley* (1893, Collection Mr. and Mrs. Richard E. Danielson, Groton, Mass.), but he was also capable of a penetrating character study such as *Mrs. Asher Wertheimer* (1904, Tate Gallery, London) or *Henry G. Marquand* (1897, Metropolitan Museum, New York). Given the infatuation of wealthy Americans for the trappings of English aristocracy, Sargent's manner naturally spawned a school of American society portraitists, which included J. Carroll Beckwith, John W. Alexander, Irving R. Wiles, and Cecilia Beaux and found an echo even in Robert Henri.

Contemporary taste seems to value Sargent's watercolor sketches over his formal portraits. They were at first his travel notes, but he turned to watercolor painting more seriously about 1910. His watercolors have an uncanny visual accuracy and a technical brilliance that is almost unequaled, yet they reveal that Sargent had very little to say.

With all his innate talent, his sound training, his total technical equipment, Sargent never achieved greatness. Although he was a dedicated craftsman, repainting a head a score of times to get it right, his superficiality betrays the absence of artistic compulsion. Still, he was capable of reacting almost instinctively to the challenge of a sitter or a situation; of capturing the nuances of light and air; or even of attempting daring aesthetic effects, although he never seemed to carry them far enough. And he did catch something of the truth because he painted what he saw—class, pretension, pomposity, vacuity, physical fact without fanaticism, and timeliness. Few painters have recorded so accurately the style, appearance, and dress of a period as an aspect of characterization.

NATIVE REALISM:
HOMER, EAKINS, JOHNSON

Although Winslow Homer (1836–1910) was the same age as Whistler, there could hardly be a sharper contrast in both personality and relation to American art than between the Yankee recluse and the cosmopolitan aesthete. Yet their art had points of contact and some common interests. Both began as realists, but whereas Whistler became part of an international "new movement" in art, Homer was the culmination of an older native school of genre painting. However, Homer's work was neither so local or naive as it may appear at first glance, and one must suspect that neither was he. One of his closest friends when he had a studio in New York was John La Farge, no country bumpkin, and since the early 1870s

vulgarity that Sargent, perhaps unconsciously, revealed. Annoyed by the resultant hubbub, he withdrew the portrait, left the French art scene, and shortly afterward settled permanently in London. He was before long an internationally famous portraitist.

His mature portrait style was oriented to society and fashion—fluent, elegant, and dramatic, expressed in elongated forms and bravura brushwork, replete with aristocratic reminiscences of English portraiture from Van Dyck to Lawrence. Frozen into a position of success and affluence, he avoided challenges and problems, and

Homer had owned a copy of Chevreul's book on color, so important to the Impressionists, and called it his "Bible." He was successful from the outset, recognized as the most "American" of American artists. It would seem that everything that can be said about him has, yet his art continues to reveal new aspects as his reputation grows.

Homer was born in Boston to an old, middle-class New England family. He spent his youth in Cambridge in fairly rural surroundings, which may have had some effect on his later attitudes toward life and art. A decline in family fortunes forced him at nineteen to accept an apprenticeship with a Boston lithography firm, where he worked for two years. In 1857 he began contributing illustrations, on a freelance basis, to *Ballou's Pictorial* in Boston and the new *Harper's Weekly* in New York. Homer's illustrations were chiefly genre scenes based on his own experience, the elegant, fashionable world of Boston and New England rural life. Like Mount before him, he recognized the popular interest in rural nostalgia and depicted the pleasant rather than the onerous features of farm life. Within a short time he had established himself as the country's leading illustrator, a skillful draftsman with a distinct style—fashionable, vivacious, and aesthetically novel. In 1859 he moved to New York and continued freelancing, producing the same kind of genre scenes, though now of New York life, more elaborately and with increasing skill.

Harper's illustrations were printed from wood-engraved blocks, then the common method of reproduction in periodicals. Since wood engravings were not cut by the artists, there was no impulse to use the process for its own ends. Artists submitted drawings in all kinds of media, which were then transferred to the block, or drew directly on the block, as Homer usually did. The results were often crude because of the limitations of the craftsmen or of the craft. Only Homer, of all the illustrators of the period, recognized the capacities of the wood block and exploited them—line, pattern, and black-and-white contrast—and his graphic art had a power and vitality unequaled by his competitors.

During the Civil War Homer did scenes of the conflict based on various assignments—with the Army of the Potomac outside Washington in 1861, with the Peninsular Campaign in 1862, with Grant in Virginia and at the Siege of Petersburg in 1864, and covering Lee's retreat to Appomattox in 1865. Many of the drawings were done on the spot and even on the block, but most were executed in his studio in New York. He had little to report of the fighting itself; his concern was with the life of the soldier in leisure and boredom, peripheral but revealing, jovial rather than serious. Homer kept a tight rein on sentimentality, but he satisfied the emotional needs of civilians at home. His is the most complete picture we have of wartime activity, though he could not match the documentation provided by photographers such as Matthew Brady.

After the war Homer turned seriously to painting. He had studied drawing in Brooklyn and at the National Academy and had taken a few painting lessons from a little-known painter of French origin, Frédéric Rondel, in 1861. He began exhibiting at the National Academy almost immediately and was elected an associate in 1864 and a full member a year later. Homer was largely self-taught and his painting technique remained simple, the paint applied directly and opaque, comparable to the manner of Impressionism. In other respects he was no novice; he came to painting with a full repertory of illustrator skills: the ability to tell a story, compose a scene with many figures, capture a gesture, characterize an individual, suggest movement, describe light, and define mass in space. He also had a remarkable eye and a native feeling for design. His earliest paintings show some hesitancy in handling but a strong sense of reality and a remarkable feeling for light. He was oblivious of schools or manners, although *Pitching Quoits* (1865, Fogg Art Museum, Cambridge, Mass.) relates to Gérôme and the military paintings of Meissonier and Détaille. *The Veteran in a New Field* (1865, plate 630) is an original, direct, and irreducible moment of reality, revealing the qualities which would inform his art for the rest of his life—sharpness of observation, elimination of nonessentials, economy and aptness of rendering, a feeling for flat pattern rather than space.

Prisoners from the Front (1866, plate 631) deals with the most relevant topic of the times, peace rather than war, humanity rather than ideology. It was an illustrator's painting, describing characters, clothes, and gestures with accuracy and economy and telling its story without excessive rhetoric or emotion. Exhibited at the National Academy that year, it was the success of the show. Though Homer was hungry for recognition, this was not the kind of success he wanted. He turned back to the stricter naturalism of *The Veteran* in *The Morning Bell* (1866, plate 632) and *Croquet Scene* (1866, colorplate 69), the masterpieces of his early years. In them the sensuous feeling for light and color, the appearance of things in a particular light at a precise time, creates the illusion that one could hear the sounds and smell the aromas of that instant. Few artists have caught a given moment of physical reality with such accuracy. But Homer also saw things freshly, unexpectedly, and in a conformation of pattern that was completely his own. His sense of design differentiates him from the Impressionists and makes one think of Japanese prints, as in the cant of the wooden bridge that cuts a dominant diagonal through *The Morning Bell* and the distinct rhythmic spotting of figures against the dark ground in *Croquet Scene*. There is much in the latter that is close to early Monet, in which light is on its way to becoming the syntax of vision, but for Homer it always remained the delineator rather than the disintegrator of form, even though form flattened into silhouette.

Late in 1866 Homer went to Paris, where two of his

630 Winslow Homer. *The Veteran in a New Field*. 1865. Oil on canvas, 24⅛ × 38⅛″. The Metropolitan Museum of Art, New York. Bequest of Miss Adelaide Milton De Groot, 1967

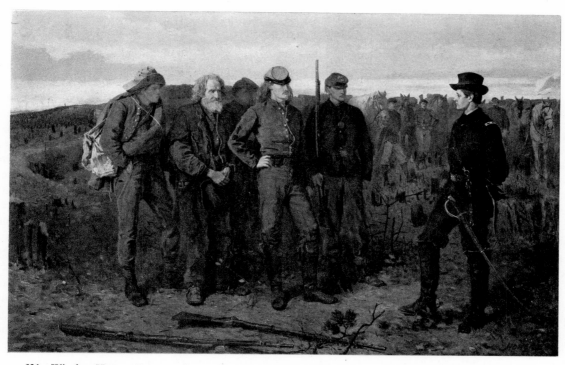

631 Winslow Homer. *Prisoners from the Front*. 1866. Oil on canvas, 24 × 38″. The Metropolitan Museum of Art, New York

paintings, including the *Prisoners* (associated by a French critic with the work of Gérôme), were being exhibited at the Exposition Universelle. His alleged imperviousness to foreign influence has been questioned by Albert Ten Eyck Gardner, who was convinced that Homer's art was transformed by assumed contact with the work of Cour-

bet and Manet on exhibition outside the fairgrounds and with Japanese prints in the Japanese Pavilion. However, all the features in Homer's art that Gardner finds derivative from these sources were apparent in work he had already done and can be posited as independent, parallel developments out of the native tradition of naturalism

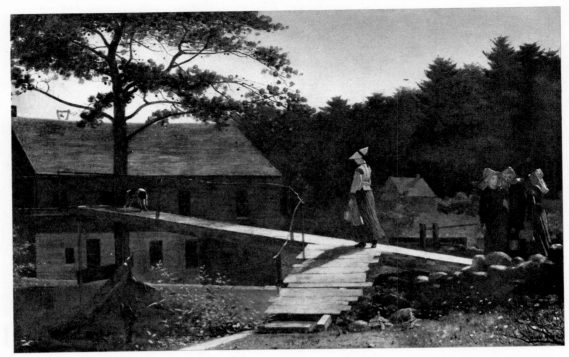

632 Winslow Homer. *The Morning Bell*. 1866. Oil on canvas, 24 × 38¼". Yale University Art Gallery, New Haven, Conn. Bequest of Stephen C. Clark

in American genre and "luminist" landscape painting. As for the Japanese influence, American interest in Japan was earlier and stronger than the European, and Homer might have seen Japanese prints in Boston or later through La Farge. At any rate, even American reviewers in the seventies found startling affinities in subject, decorative qualities, and color between Homer's paintings and Japanese prints.

On his return, Homer took up freelance illustration again and continued painting summer-resort and rural genre scenes in the White Mountains, Long Branch, N.J., the Adirondacks, and Gloucester. In these pictures of the seventies he came closest to the Impressionists' attitude and aesthetic, sharing with them themes of pleasant holiday activities—bathing, boating, picnicking, and riding—peopled mostly by fashionable women. Unlike the Impressionists, except for Degas, he subordinated landscape to people, and a narrative element in many of his pictures is, again except for Degas, foreign to the Impressionists. He continued also the native genre tradition of nostalgia for childhood in a rural setting. Among his most appealing pictures are scenes of children in school or at play, full of homely sentiment unexpressed. His work abounds in moments which must be sought out, since he consciously avoided the literary and the sentimental, as in the boy athwart the prow of the catboat in *Breezing Up* (1876, plate 633), suffused with sun and air and filled with a joy that unites him with the universe. Homer could move from the fashionable decorativeness of *Long Branch* (1869, Museum of Fine Arts, Boston),

so reminiscent of Boudin, and the polished anecdotalism of *High Tide* (1870, Metropolitan Museum, New York) to the simple naturalism of *Bridle Path* (1868, Clark Art Institute, Williamstown, Mass.), but, today at least, the most successful seem those in which the literary and decorative elements were restrained. In *The Country School* (1871, plate 634), as in all the post-Paris paintings, the color is higher in key, perhaps because French painting was brighter than American and the French experience led to an increased interest in the phenomena of light. The room is flooded by a golden light filtered through fluttering translucent curtains. The light is handled with such sensitivity that it is almost palpable, faithful to details of reality in a way that never interested the Impressionists. But the picture is also concerned with the human experience—the buzz of boredom, frustration in the teacher, small heartbreak in the tearful child and his sympathetic friend, and a common desire to break out into the sun. In few pictures has Homer so successfully mixed naturalistic fact with implied sentiment.

Homer took to serious painting in watercolor during the summer of 1873 in Gloucester, inspired perhaps by an exhibition of English watercolors at the National Academy that spring, and suddenly found a perfect vehicle for his naturalism. Following his wash drawing for illustrations, Homer's Gloucester watercolors are essentially drawings in color, many of which were translated into wood engravings for *Harper's*, perhaps his finest illustrations. He found the medium so congenial that he used it thereafter to sketch from nature, and many of his oils

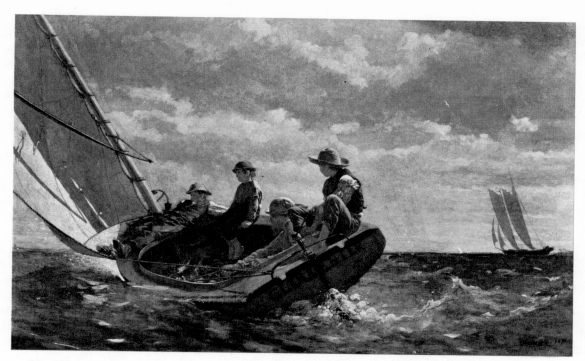

633 Winslow Homer. *Breezing Up*. 1876. Oil on canvas, 24⅛ × 38⅛″. National Gallery of Art, Washington, D.C. Gift of the W. L. and May T. Mellon Foundation, 1943

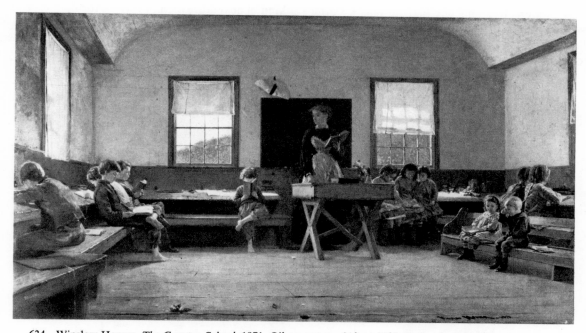

634 Winslow Homer. *The Country School*. 1871. Oil on canvas, 21⅜ × 38⅜″. St. Louis Art Museum

are derived from such studies, but he also found it increasingly a mode of expression to rival his more monumental works in oil. His oils became more studied and formal as his watercolors absorbed his instinctual response to nature. His control of the medium grew prodigiously from the tentative linearity of the first Gloucester sheets, through the sprightly costume pieces com-

prising the so-called "Shepherdess series" (1878), to the Ten Pound Island, Gloucester, watercolors of 1880, in which the translucent washes began to sing through the spidery lines of his drawing (colorplate 70).

In 1875 Homer revisited Petersburg, Va., and in the next two years did a series of paintings on black themes. These are remarkable in their truth of observation, sym-

pathy for the people, and monumentality of treatment and unusually free of caricature, stereotype (sometimes noticeable in his Civil War illustrations), exoticism, or condescension. He reported the blacks' poverty in *A Happy Family in Virginia* (1875, Collection Edward A. Hauss, Century, Fla.), admired their color and vitality in *The Carnival* (1877, plate 635), and paid homage to their race in *The Cotton Pickers* (1876, Collection Mr. and Mrs. James C. Brady), his most monumental composition up to that point. He did not always skirt sentimentality, for, with all his reticence, he was obviously moved by their condition and humanity.

In 1876, at the age of forty, Homer was a successful artist, extremely well represented at the Centennial Exposition, his pictures selling quite well at modest prices; yet the critical response to his work was ambivalent. Reviewers differed violently as to whether his qualities were virtues or failings. The very Americanism of his subjects, the freshness of eye, the originality, vigor, and reality of his art were found disturbing, ugly, crude, too colorful, and lacking in finish—in short, inartistic by Victorian standards.

In 1881 Homer went to England, where he settled for the next two years near Tynemouth on the North Sea to paint the life of the fisher folk and especially their women. The watercolors and oils that he finished after his return are a complete departure from his earlier work. A new heroic element had entered his art in the majestic figures of these hardy women, enveloped in the gray light and rain-filled air, standing tall and resolute against the lowering skies or raging sea. Influenced perhaps by English watercolors, his became more finished and three-dimensional and lost their freshness, sparkle, and transparency. While Homer had increased his artistic powers and attempted more demanding themes of dramatic action and emotional expression, the compositions are too formal, the heroics seem contrived, the expressions banal. He was probably reacting to a basic change in American taste from the homely and native to the grandiose. (At approximately the same time Eakins also abandoned genre painting for portraiture.) And Homer's English paintings brought him closer to the artistically acceptable and earned him the greatest acclaim and financial awards he had yet received.

After his return, he moved to Prout's Neck, on the rocky, windswept, and sea-battered coast of Maine, where he spent the rest of his life in increasing isolation from society and communion with the elements. In the following years his pictures of men and the sea won him recognition as America's leading painter. In them, the dominant female theme gave way to a masculine world of physical activity and danger, the endless struggle of the Banks fishermen against an implacable ocean. Dramatic action transformed the genre subject into a new kind of adventure picture with all the heroicism of history painting. He carried over from his Tynemouth studies the portentous cold gray tonalities and the studied compositions, but he had recaptured his original naturalism

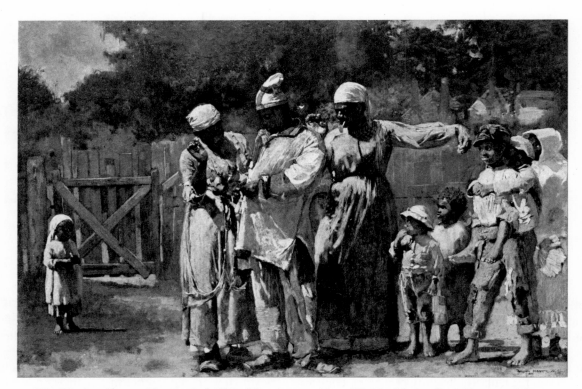

635 Winslow Homer. *The Carnival*. 1877. Oil on canvas, 20 × 30″. The Metropolitan Museum of Art, New York. Lazarus Fund, 1922

of observation. *The Herring Net* (1885, Art Institute of Chicago) and *Eight Bells* (1886, Addison Gallery of American Art, Phillips Academy, Andover, Mass.) are most successful just because the epic theme is underplayed and the physical elements are recorded with freshness and accuracy, so that one can recapture the blue iridescence of the moonlight, the feel of the fog, and the movement of the swell.

Homer's regained naturalism was fostered by his watercolors of those years, through the new and brilliant color of his Caribbean sketches, begun in 1884 with a visit to the Bahamas and Cuba and continued, with the addition of Florida, almost to the end of his life; and the more somber but equally brilliant studies of the north woods in the Adirondacks beginning in 1889 and Quebec in 1893. In these he achieved a mastery of the medium never equaled even by Sargent. His impressions were set down with breathless speed, effortlessly, and with great control, capturing the tropical sunlight as no one else ever has but avoiding instinctively the too obvious beauty of the environment. Never was his brushwork more fluid or his color more translucent. If the Caribbean studies were the acme of his work as a watercolorist, his northern hunting and fishing scenes were more studied and complete as pictures. He brought all his knowledge as a woodsman and all his skill as an artist to create a new world in American art, focused on the total physical, emotional, and visual experience. These too were adventure pictures, but the holiday version of man against nature. The Adirondack watercolors are almost photographic in detail, in a rich, sonorous, though limited and somber range of color. The Canadian paintings are freer, full of movement in both action and brush, the color more varied and striking.

Beginning in the early nineties, as he became more immured at Prout's Neck during the long winters, his interest in the sea itself continued to grow until man seemed to recede and the battle of the elements became the drama. These scenes were painstakingly studied over years, recorded with great fidelity, carefully composed for dramatic as well as decorative effect, simplified to bare essentials, and painted with broadness and a surface fluency more like Sargent's than his own. Paintings such as *Northeaster* (1895, plate 636) and *Early Morning after a Storm at Sea* (1902, Cleveland Museum of Art) have an elemental power and simplicity that none of his earlier work had, but they have lost much of the naturalistic detail that made the latter so immediate and revealing. The seascapes generated a school of imitators who painted rocks, waves, and spray *ad nauseam* without ever capturing Homer's surging vitality.

At his death, Homer was generally thought of as America's greatest painter, largely because of his sea epics; subsequently his less pretentious genre pictures were rediscovered and his reputation as a major American artist has, if anything, increased. Contemporary taste prefers the freshness and intuitive grace in his earlier work and his watercolors to the muscularity and drama

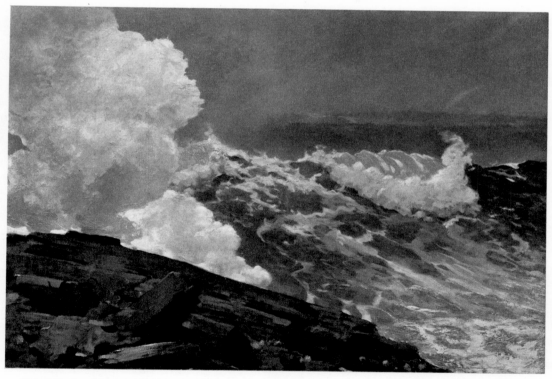

636 Winslow Homer. *Northeaster*. 1895. Oil on canvas, 34¾ × 50¼″. The Metropolitan Museum of Art, New York. Gift of George A. Hearn, 1910

of the later. Homer's artistic life was in a sense a struggle between an inherent naturalism and compulsions toward the monumental, as influenced by changing taste, the decorative, which was a personal predilection, and the anecdotal, a result of his experience as an illustrator. At times he achieved a synthesis of such disparate elements; at others, unfortunately, he was misled beyond his depth. Thus the disappointment of the Tynemouth paintings, the posturing of the figures in *Undertow* (1886, Clark Art Institute, Williamstown, Mass.), the ultimate banality of *The Gulf Stream* (1899, Metropolitan Museum, New York), or the irresolution of *Kissing the Moon* (1904, Addison Gallery of American Art, Phillips Academy, Andover, Mass.). On the other hand, the striving for formality adds power to many sea pictures; his decorative feeling is strikingly successful in *The Fox Hunt* (1893, plate 637), the most Japanese of his paintings; and his gift for storytelling imparts an added dimension to *The Wreck* (1896, Carnegie Institute, Pittsburgh).

When Thomas Eakins (1844–1916) came home from his studies in Europe, he was optimistic about his future, ready to settle down in his community, where his roots were deep, and paint, as he felt himself equipped to do. After some success, at least in esteem, the cultural milieu of Philadelphia began to close in on him, and, almost before he could understand the situation, he was forced into bitter isolation. Perhaps no other city would have been more hospitable, for he was something of a radical artist for his time. Though he was heroic in maintaining his integrity in a hostile environment and fortunate in the

financial support of his father, his art could not but be affected by the attrition of neglect.

The only son of the close-knit family of a writing master, Eakins had a normal boyhood and was an excellent student and artistically gifted. After high school he enrolled in 1861 at the Pennsylvania Academy, where he studied drawing from the antique, and took anatomy courses at the Jefferson Medical College. In 1866 he went to Paris, was admitted to the École des Beaux-Arts, and became a student of Jean-Léon Gérôme. These years were fateful for Eakins, for Beaux-Arts training, and that of Gérôme in particular, was founded on drawing, the painstaking delineation of form, as the basis of painting. His own rational, scientific, and mechanical predilections were reinforced by this discipline and he proved an apt pupil, but he learned little about painting. In his three years in Paris he remained unaware of the revolutionary stirrings in French art. He expressed his admiration of such academicians as Fortuny, Regnault, Bonnat, and his own master, but made no comment on Courbet or Manet, whom he later admired, as he did Degas, and who were closer to his own Realist intentions.

Eakins must have sensed that his training was incomplete, and when he discovered Velázquez and Ribera on a visit to Spain in 1869, he knew he had found his course and remained to study for six months. He struggled to find himself in his first major effort, begun in Spain, *A Street Scene in Seville* (1870, plate 638). Compared with the facility and virtuosity of Sargent's *El Jaleo* (1882, plate 639), done at the same age and under the same

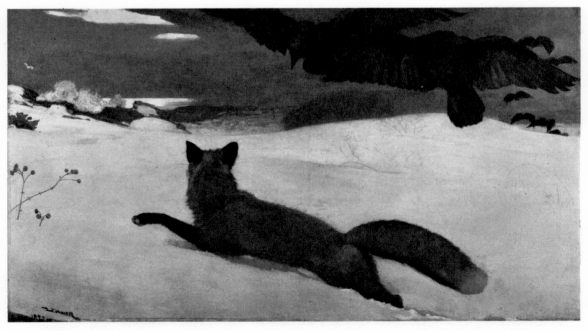

637 Winslow Homer. *The Fox Hunt*. 1893. Oil on canvas, 38 × 68″. The Pennsylvania Academy of the Fine Arts, Philadelphia

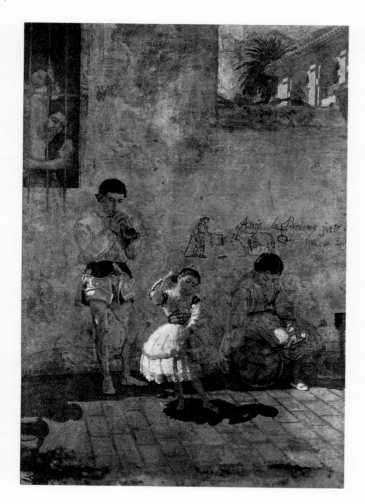

Spanish influence, its fumbling naiveté is touching in its sincerity. It is as if he were trying to rediscover the entire tradition of visual Realism, and the intensity and dedication of his effort resulted in a remarkable progress toward maturity. Within a year his style was formed, not to change substantially for the rest of his life. It was really two styles: one, original, American, and in the direct line of "luminism," which he used in his outdoor sporting pictures; and the other, confined to his indoor genre pictures and portraits, more traditional and charged with emotional empathy, closer to Rembrandt than Velázquez, and to the Munich School than to Courbet or Manet. He belongs in this aspect, as least, to a subsidiary and provincial phase of nineteenth-century Realism.

Eakins had a deep interest in outdoor life, and many of his early paintings deal with rowing, sailing, and bird hunting. These sporting pictures parallel those of Homer, but unlike Homer, who was a naturalist trusting his eye to record the appearance of reality, Eakins was a Realist with strong scientific preoccupations who had always to prove that what he saw was true. Hence the preliminary perspective and anatomical studies and the dependence on photographic evidence to reinforce visual experience. *Max Schmitt in a Single Scull* (1871, colorplate 71) is a striking innovation in the history of Realism as well as

638 Thomas Eakins. *A Street Scene in Seville.* 1870. Oil on canvas, 62¾ × 42″. Collection Mrs. John Randolph Garrett, Sr., Roanoke, Va.

639 John Singer Sargent. *El Jaleo.* 1882. Oil on canvas, 91¼ × 137″. Isabella Stewart Gardner Museum, Boston

American genre painting. It may have affinities with Impressionism in its nontraditional approach to the physical world, even with "luminism" in the handling of light and atmosphere, but it projects a new kind of vision, photographic in inspiration or influence, concerned with objective recording without reference to theory, memory, or sentiment. Other artists of the nineteenth century had employed photographic detail to heighten the illusion of reality, but, except for Degas, Eakins was the first to grapple with the aesthetic of photographic vision, the stop-action moment of eternity. The *Max Schmitt* is modern in the unquestioning acceptance of the mechanical elegance of the bridges, American in its cool, limpid light. But the contradiction between the sharp focus of studied detail and the immediate impression of visual experience creates an aesthetic ambivalence—a kind of frozen animation—and a poetic quietude that Barbara Novak feels to be peculiarly American. A comparison of Eakins's *Starting Out after Rail* (1874, plate 640) with Homer's *Breezing Up* (plate 633) reveals Homer as almost Romantic in contrast. It also reveals the still traditional and intuitive unity of Homer's vision, lacking the complexity, originality, and aesthetic sophistication in Eakins that transformed the experience into something beyond the representation of reality.

Eakins's early interior subjects were essentially genre paintings and in most cases also portraits of family members and friends, except for the monumental *Gross Clinic,* the allegorical *William Rush,* and a series on colonial themes. They are, on the whole, more conventional, dark and somber in tonality, rather brooding in character, simple and fairly formal in composition, and more akin to mid-century Realist painting in Europe. But they too reflect, if in a lesser degree, his search for the essence and the reason of reality. One can almost feel in them the bulldog nature of the man, worrying the problem, never satisfied, and starting anew. Frequently the by-products of his search turned out to be notable works of art. One can cite the *Margaret in Skating Costume* (1871, Philadelphia Museum of Art), in its painterly sensuousness and psychological depth one of the most tragic portraits in the history of art; or the little girl in the plaid dress in *Home Scene* (c. 1871, plate 641), a brilliant and surprising flash of vision unequaled and unrepeated in his oeuvre; or the cubical intensity of the *Baby at Play* (1876, Collection John Hay Whitney, New York); or the complete conviction of *The Pathetic Song* (1881, Corcoran Gallery, Washington, D.C.), a culmination of the early indoor genre paintings.

Despite Eakins's commitment to Realism, he was not entirely satisfied with commonplace genre subjects. He was driven by an image of "bigness" in art—the epic, the profound, the timeless—which he sought, like Courbet, in the reality of contemporary life. *The Gross Clinic* (1875, plate 642) is his first and most successful effort to find a heroic realism in his time and make it stand up

640 Thomas Eakins. *Starting Out after Rail.* 1874. Oil on canvas, 24 × 20″. Museum of Fine Arts, Boston. Charles Henry Hayden Fund

against the monumental art of the past. Like Rembrandt's *Anatomy Lesson,* which obviously inspired it, it is a group portrait, representing Dr. Samuel David Gross performing an operation and lecturing to students at the Jefferson Medical College. Aside from the theatrical clutching hand of the patient's relative at the left, it was intended as an objective record of the event. Eakins could never understand why the painting was socially unacceptable, but it had created a scandal when first exhibited in a private gallery, been rejected at the Centennial, although five of his works were shown, and finally hung in the medical section. Regardless of the quality of the painting, it was the uncompromising truth of a few square inches of blood that was repellent. In fact, the blood is still shocking; it is as real and unaesthetic as it ever was. The picture itself is Eakins's most impressive work. Dr. Gross is probably the most compelling single figure in American painting, worthy of the best in nineteenth-century portraiture. The leonine head, Rembrandtesque in its depth of character and humanity, and the bloody hand, cruelly factual, dominate the composition and establish a dramatic tension that even the distraction of the operation itself—cluttered, overlighted, and routinely painted—and the hovering wraiths of students in the background cannot destroy. It is really history painting of the first order rather than genre.

50 William Rimmer. *The Dying Centaur*. 1871. Plaster, height 22″. Museum of Fine Arts, Boston.
Bequest of Miss Caroline Hunt Rimmer

52 John Rogers. *Coming to the Parson*. 1870. Plaster, height 22″. The New-York Historical Society

51 Left : Henry Kirke Brown. *George Washington*. 1853–56. Bronze, height 13½′. Union Square, New York

53 James Renwick. The Renwick Gallery (formerly Corcoran Gallery), Washington, D.C. 1859

54 Frank Furness. The Pennsylvania Academy of the Fine Arts, Philadelphia. 1872–76

55 Henry Hobson Richardson. Trinity Church, Boston. 1872–77

56 Burnham & Root. Reliance Building, Chicago. 1893–95

58 Richard M. Hunt. J.N.A. Griswold House (now Art Association), Newport, R.I. 1862–63

57 Adler & Sullivan. Wainwright Building, St. Louis. 1890–91

59 Dudley Newton. Jacob Cram (now Mary Sturtevant) House, Middletown, R.I. 1871–72

60 Richard M. Hunt. Travers Block, Newport, R.I. c. 1875

61 Henry Hobson Richardson. William Watts Sherman House, Newport, R.I. 1874–76

62 Right above: McKim, Mead & White. Interior court, Casino, Newport, R.I. 1879–81
63 Right below: Richard M. Hunt. Biltmore, near Asheville, N.C. 1890–95

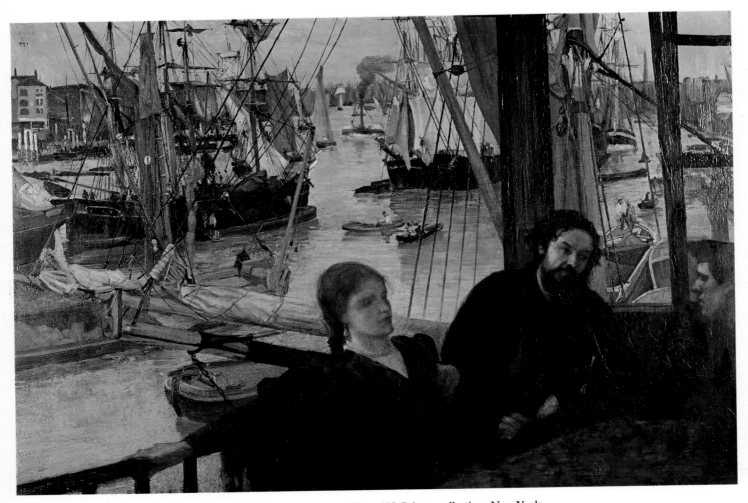

64 James A. McNeill Whistler. *Wapping*. 1861–64. Oil on canvas, 28 × 40″. Private collection, New York

65 Right: A. McNeill Whistler. *The White Girl*. 1862. Oil on canvas, 84½ × 42½″. National Gallery of Art, Washington, D.C. Harris Whittemore Collection

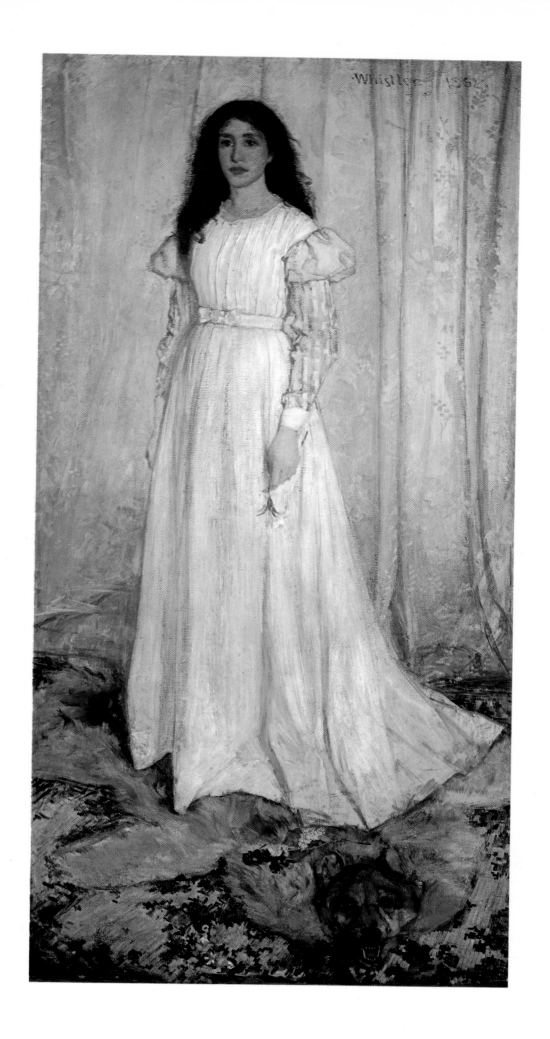

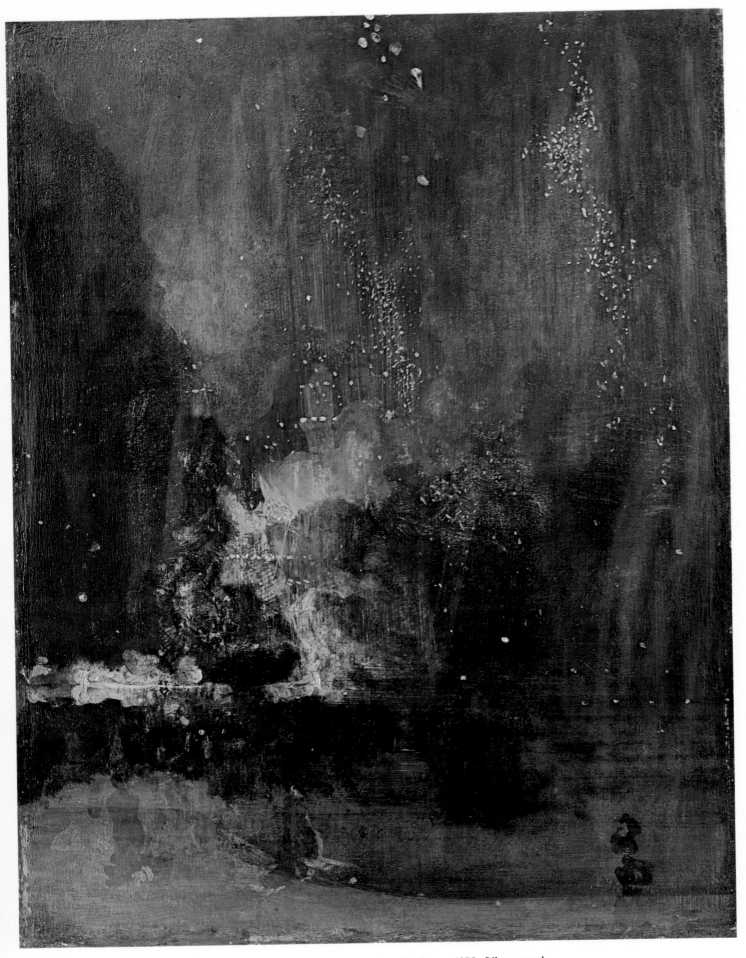

66 James A. McNeill Whistler. *Nocturne in Black and Gold: The Falling Rocket*. c. 1875. Oil on panel, 24¾ × 18⅜". The Detroit Institute of Arts

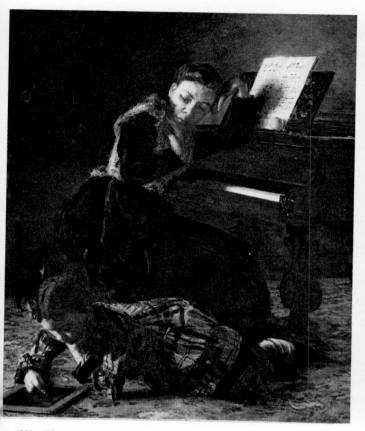

641 Thomas Eakins. *Home Scene*. c. 1871. Oil on canvas, 22 × 18¼". The Brooklyn Museum. Dick S. Ramsay Fund and Others

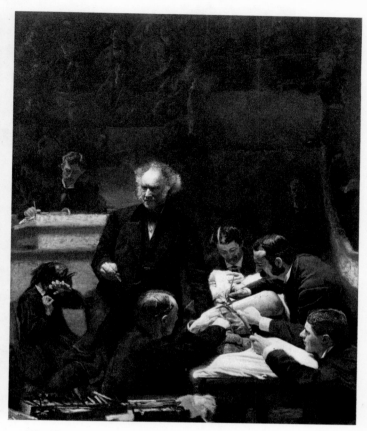

642 Thomas Eakins. *The Gross Clinic*. 1875. Oil on canvas, 96 × 78". Jefferson Medical College of Philadelphia

On the other hand, in *William Rush Carving His Allegorical Figure of the Schuylkill River* (1877, plate 643) Eakins transformed a history subject into a genre painting. The story of the early Philadelphia sculptor who sought a model to pose nude for him had symbolic meaning for Eakins, and he used it later as an image of his own struggle against puritanism. The painting shows him at his imaginative and painterly best. In all his work there is no more sensuous painting than that of the buxom nude and her clothes scattered on the chair. The frankness of the naked (a word he preferred to "nude") model is far removed from the erotic ideality of Gérôme and completely new to American painting. Still in his thirties, Eakins had already established himself as the greatest painter in the United States, although hardly anyone knew it, least of all the art world of Philadelphia. He had no patrons and few champions except for Fairman Rogers, a director of the Pennsylvania Academy, who commissioned him to paint the sparkling little *Fairman Rogers Four-in-Hand* (1879, Philadelphia Museum of Art) for a fee of $500, the highest Eakins had received up to that time. Almost his only income came from teaching. In 1876 he took over the life classes at the Academy and reorganized the antiquated curriculum around the study of the nude and anatomy to make it the most

progressive art school in the country. He was appointed director of the school in 1882, but his demanding procedures and radical methods aroused opposition, and the display of a completely nude male model in a mixed class led to his dismissal in 1886. Loyal students rallied to his support and organized an independent art school, but Eakins refused to assume leadership in the fight, though he taught there without fee, and it collapsed after several years.

During this time Eakins continued to paint genre pictures: a series of more pastoral scenes of shad fishing at Gloucester, N.J., in the early 1880s; and even one pure landscape and some "Arcadian" studies, his only excursions into mythology. Of the same period is *The Swimming Hole* (1883, plate 644), Poussinesque in its classical structure and serenity, but the contemporary note of visual objectivity is obviously dependent on the camera. This is a rare example in which he permitted himself the luxury of using the nude, for he would not paint it out of realistic context, and it was hardly ever in context in Philadelphia.

His dismissal from the Academy school seems to have driven him further into himself. He abandoned the painting of the life around him, which as a Realist he believed to be the goal of art, to express his own melancholy in-

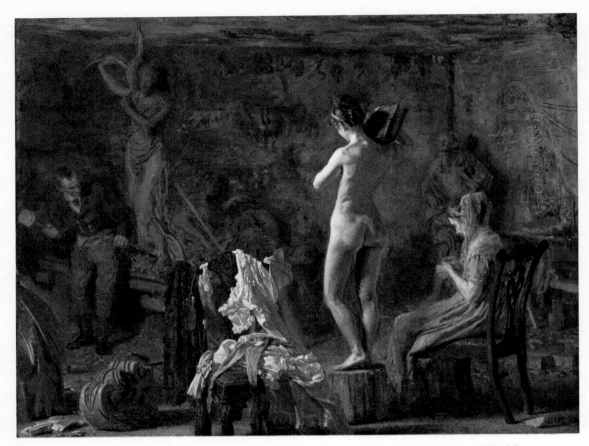

643 Thomas Eakins. *William Rush Carving His Allegorical Figure of the Schuylkill River*. 1877. Oil on canvas, 20⅛ × 26½″. Philadelphia Museum of Art. Gift of Mrs. Thomas Eakins and Miss Mary A. Williams

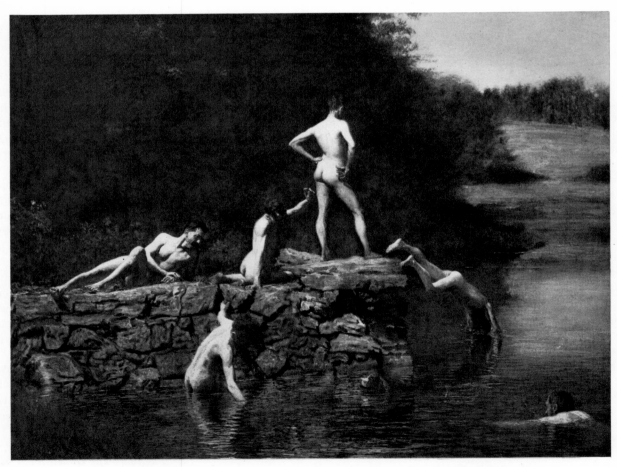

644 Thomas Eakins. *The Swimming Hole*. 1883. Oil on canvas, 27 × 36″. The Fort Worth Art Museum

trospection. From 1884 on, his major work was in portraiture with few exceptions, notably the boxing pictures done in 1898–99, which failed to recapture the freshness and truth of his earlier genre paintings, and the reprise of the William Rush theme in 1908, almost as an ironical coda to his life as an artist. Though these portraits express his courage and humanity, they are rather conservative, and quite a few seem unfinished or finished without the sitter; others as if he had lost interest. Very few were commissioned, and some, especially in his later years, seem to have been done largely from photographs. Among

646 Edouard Manet. *Philosopher with a Hat.* 1865. Oil on canvas, 73¾ × 42½″. The Art Institute of Chicago

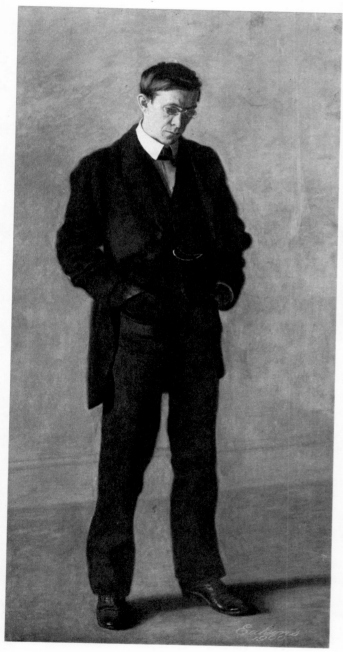

645 Thomas Eakins. *The Thinker: Louis N. Kenton.* 1900. Oil on canvas, 82 × 42″. The Metropolitan Museum of Art, New York. Kennedy Fund, 1917

the late portraits are some in which the subjects seem strangely cataleptic and the technical handling has deteriorated into rigidity. However, there are superb portraits, among them *The Thinker: Louis N. Kenton* (1900, plate 645), a full-length portrait of his brother-in-law, which can stand comparison with the suave aestheticism of Whistler's *Théodore Duret* (plate 626) or Manet's brilliant paraphrase of Velázquez in his *Philosopher with a Hat* (plate 646). Although they are remarkably similar in many respects, the Eakins appears almost provincial in its primary concern with the sturdy honesty and warm humanity of the subject. Part of Eakins's misfortune was that he was not only aesthetically retardataire but also his attitudes toward reality and the subject matter of art had become unfashionable. Equally indicative of his

interest in character rather than aesthetics are the impressive *Professor Leslie W. Miller* (1901, Philadelphia Museum of Art) and the more loosely handled, almost Sargentesque *John McLure Hamilton* (1895, Wadsworth Atheneum, Hartford, Conn.), and *The Dean's Roll Call* (1899, Museum of Fine Arts, Boston). One of his greatest, if least ingratiating, portraits is that of *Mrs. William D. Frishmuth* (1900, Philadelphia Museum of Art), who sits formidable and frozen, enveloped in darkness, amidst the priceless debris of her collection of musical instruments. It is a haunting and disjointed picture, large in scale and conception, yet painstaking in detail, and though it is painted with magnificent authority, there seems to be no relationship between the artist, the sitter, and the instruments.

It would appear almost as if the less recognition he received, the more he strove to achieve in each picture, and the paintings grew larger and the conceptions more monumental. A case in point is *The Agnew Clinic* (1889, plate 647), originally commissioned as an individual portrait by students of the famous surgeon, Dr. D. Hayes Agnew. Eakins requested permission to paint the huge canvas at no increase in the agreed price of $750, the largest fee he ever received. As a pendant to the earlier *Gross Clinic,* it reflects changes in medical practice as well as in Eakins's art. The antiseptic dress of the participants and the evidence of improved technology are

reinforced by the cold white glare of the illumination, in sharp contrast to the improvisatory air and almost theatrical aura of *The Gross Clinic. The Agnew Clinic* is a more daring composition, isolating the doctor in profile from the attending figures, and lighting them all with the same clinical intensity. Although painted with vigor, the tableau around the operating table is neither cohesive nor compelling, and the frieze of shadowy observers forms a spaceless backdrop unrelated to the central action. Only the brilliant portrait of Dr. Agnew comes across with power and conviction.

The smaller and the less formal portraits are often more satisfying, perhaps because Eakins allowed the innate warmth of his nature to show through, as in the pensive *Miss Amelia C. Van Buren* (1889–91, plate 648), painted with a wonderful feeling for weight and texture, luminous in the ivory skin tonalities. Such portraits are documents of emotional involvement, psychological probing, and affection. No American portraitist has ever approached the poignancy of *Addie* (1900, Philadelphia Museum of Art), *Mrs. Thomas Eakins* (c. 1899, Hirshhorn Museum and Sculpture Garden, Smithsonian Institution, Washington, D.C.), and the *Self-Portrait* (1902, National Academy of Design, New York); or the romantic intensity of *Signora Gomez D'Arza* (1902, Metropolitan Museum, New York), the rollicking earthiness of *Walt Whitman* (1887–88, Pennsylvania Academy of

647 Thomas Eakins. *The Agnew Clinic.* 1889. Oil on canvas, 74½ × 130½″. University of Pennsylvania, Philadelphia

648 Thomas Eakins. *Miss Amelia C. Van Buren*. 1889–91. Oil on canvas, 45 × 32″. The Phillips Collection, Washington, D.C.

the Fine Arts, Philadelphia), the tender sweetness of *Mrs. Letitia Wilson Jordan Baker* (1888, Brooklyn Museum), or the total revelation of what may be his greatest portrait, that of his wife and their dog, Harry, in *Lady with a Setter Dog* (1885, plate 649). The last is exceptional in the relationship of the figure to its setting, the high-keyed color, the almost miniaturist yet broad treatment of surface, and the skillful handling of interior light and atmosphere. The vulnerable and appealingly fragile lady remains one of the unforgettable images in American art.

Only late in life did Eakins receive recognition in honors, awards, and critical appreciation. In 1902 the National Academy elected him an associate and two months later a full member. Perhaps more tragic than neglect was his own failure to fulfill his dreams and potential. No artist was better equipped through native genius, training, and broad interests to meet the challenges of a changing world. His being an American and a provincial actually freed him from allegiance to a revered artistic past, and his interest in science opened vistas for him that no one had yet explored. As a Realist he had all of turbulent, colorful, brutal, ugly America to paint. The environment may have aborted his natural tendencies and rejection driven him back into portraiture when it was a declining art form. In any case, his art was bent

from its original inclination, even frustrated, and it took dogged courage and a sense of his own worth to keep it alive and fruitful.

The long career of (Jonathan) Eastman Johnson (1824–1906) encompassed the transition from pre- to postwar American paintings. Johnson went to Boston from rural Maine at sixteen to learn lithography and after two years returned home as a crayon portraitist, practicing also in Boston, Cambridge, and Washington with marked success before going to Düsseldorf, where he shared a studio with Leutze for several years. Dissatisfied, he visited London during the exposition of 1851, then settled in The Hague to paint portraits and study the great Dutch masters, and went on to Paris, where he seems to have worked with Couture.

When Johnson returned to the United States, he had a bag of styles that he never completely sorted out: the meticulous detail and sentimentality of Düsseldorf genre; the dark, rich luminosity of the Dutch; and the broad, painterly style he learned from Couture. He painted Indians and frontier life around Lake Superior, worked as a portraitist in Cincinnati and Washington, and finally settled in New York City by 1858. In the next two decades he was largely occupied with genre themes, many of which were issued as prints. Johnson belongs among the mid-century sentimental genre artists catering to popular taste, and he shares their obvious faults. But he stands somewhat apart, first, in that he was a better painter, and, second, in that he could move beyond their limitations into the realm of emotion and also share the objective naturalism of Homer and Eakins.

The *Old Kentucky Home, Life in the South* (1859, plate 650) was a full-dress presentation of a topical theme which, in its sentimental anecdote, must have fostered the myth of the benevolence of slavery. It is a sly picture both ideologically and aesthetically, pandering to popular political attitudes and taste, carefully plotted, and painted in a mixture of Düsseldorf detail and Dutch homely warmth, but rather loosely composed, overanimated, and fairly obvious. Johnson was also capable, however, of unaffected sincerity and broader handling, as in *Husking Corn* (1860, Everson Museum of Art, Syracuse, N.Y.), which continues the tradition of Mount. Even more clearly *Not at Home* (1872–80, plate 651) reveals his ability to manage a genre subject with a minimum of anecdote. The matter-of-fact recording of reality —of interior space, light, and atmosphere—is worthy of the Dutch little masters.

In the 1870s, without abandoning genre, he produced a series of paintings in Nantucket which he thought of as "finished sketches," approximating the straightforward naturalism of Homer, who may have influenced him. *In the Fields* (1875–80, plate 652) has the same directness of observation and shorthand notation of physical fact with a somewhat more sophisticated and sensuous feeling for pigment. These small sketches are both a summation of

649 Thomas Eakins. *Lady with a Setter Dog (Mrs. Eakins)*. 1885. Oil on canvas, 30 × 23″. The Metropolitan Museum of Art, New York. Fletcher Fund, 1923

651 Eastman Johnson. *Not at Home*. 1872–80. Oil on academy board, 26½ × 22¼″. The Brooklyn Museum

650 Eastman Johnson. *Old Kentucky Home: Life in the South.* 1859. Oil on canvas, 36 × 45″. The New-York Historical Society

652 Eastman Johnson. *In the Fields.* 1875–80. Oil on board, 17¾ × 27½". The Detroit Institute of Arts. The Dexter M. Ferry, Jr., Fund

653 Eastman Johnson. *The Hatch Family.* 1871. Oil on canvas, 48 × 73⅜". The Metropolitan Museum of Art, New York. Gift of Frederick B. Hatch, 1926

"luminist" tradition and precursors of Impressionism. The larger, more finished *Corn Husking at Nantucket* (1876, colorplate 72) and a replica, *Corn Husking Bee* (1876, Chicago Art Institute), though more Romantic and picturesque, reflect his new interest in naturalism, in the suppression of anecdote, and in the free handling of paint.

After 1880 Johnson turned from genre to portrait painting. An earlier "conversation piece," *The Hatch Family* (1871, plate 653), is one of the most revealing

documents of Victorian America. All his Düsseldorf skill is used in a new way to capture the texture of upper-class life. The Victorian ideal is embodied in its bourgeois attitudes, in the mixture of wealth and implied social status of the room, the dress, and the carriage of its inhabitants, with a familial cosiness expressed in anecdotal interplay that is psychologically revealing and sentimental and so right that it could hardly have been intentional. The love of material things is almost palpable, as is the feeling of health, well-being, and security. Even the obvious posing of the figures reflects the formality of Victorian gentility.

In *The Funding Bill* (1881, plate 654), a portrait of two old men seated in conversation, Johnson achieved a psychological penetration and painterly richness worthy of the finest of Eakins's portraits. The memory of Rembrandt comes through strongly in the deep, warm shadows, the somber opulence of color, the solid modeling of form, and the character of the men. At his best Johnson deserves to be ranked alongside Homer and Eakins, for he grew with the times, even if haltingly, moving from sentimental storytelling to naturalistic genre and from face painting to the heights of characterization.

THE MUNICH SCHOOL: DUVENECK AND CHASE

While Eakins had arrived at a style parallel to that of Munich through independent development, a group of American painters led by Frank Duveneck and William Merritt Chase transmitted the Munich manner directly and with marked impact through teaching. In the 1870s American art students, many from the Middle West and with German backgrounds, were attracted to Munich, which had displaced Düsseldorf as the leading German art center and was even considered by some to be the "art capital" of Europe. Its Royal Academy boasted skillful and successful academicians—Karl von Piloty, Wilhelm von Kaulbach, Wilhelm von Diez, and Arthur von Ramberg, among others. However, in 1869 the first international art exhibition held in Munich presented an array of foreign art, both conservative and radical, including even Manet, and many young Munich painters and students were greatly impressed by Courbet, whose visit helped galvanize the Realistic circle around Wilhelm

654 Eastman Johnson. *The Funding Bill.* 1881. Oil on canvas, 60½ × 78¼″. The Metropolitan Museum of Art, New York. Gift of Robert Gordon, 1898

Leibl (1844–1900). The Leibl Kreis became a vital artistic center for a time, though, except for Leibl and his closest friends, Wilhelm Trübner (1851–1917) and Karl Schuch (1846–1903), its adherents were not distinguished. Leibl, like Manet, sought the sources of Realism in Spanish painting and Velázquez, but he was even more profoundly influenced by Dutch and Flemish painters—Hals, Rubens, and Brouwer. The choice of commonplace subjects, loose and spirited brushwork, and dark, limited tonal range became the hallmarks of the Munich School. This young group of radical Realist painters influenced the American students arriving in the early seventies.

Frank Duveneck (1848–1919), of German extraction, was born in Covington, Ky., and in 1862, while still a boy, had begun to work at painting and decorating for churches in Latrobe, Pa., Quebec, and Covington. In 1867 he joined William Lamprecht, a German-trained decorator, and in 1870 left to study in Munich under Wilhelm von Diez. However, he soon came under the influence of the Leibl Kreis and intensified their fluent brushwork and dark tonality into a personal style. Duveneck worked rapidly and wetly from dark underpainting into light with broad, squarish brushstrokes, defining form vigorously. His color range was restricted and conceived tonally, the pigment applied with a decided impasto. In the Hals-like *Whistling Boy* (1872, plate 655) Duveneck's style is already set, confident, fluent, expansive, capturing the moment and suggesting through bold surface planes the underlying structure. The portrait *Professor Ludwig Loefftz* (c. 1873, Cincinnati Art Museum), in its technical proficiency and intuitive feeling for character and expression, is worthy of Trübner, if not so penetrating as Leibl.

After three years in Munich, Duveneck returned to Cincinnati and worked for a while in the Middle West. He showed five paintings at the Boston Arts Club in 1875, and when he received the critical accolade of William Morris Hunt, the local arbiter of taste, Duveneck became an overnight sensation, appreciated for his felicitous combination of old-master appearance with an accomplished modern European manner. He may have been the first American painter to be appreciated for his style rather than what he was painting. However, he did not stay to exploit his success but returned to Munich, where he set up his own school, attracting many American students who came to be known as the "Duveneck Boys." Duveneck was a popular teacher, for he taught a formula for capturing the appearance of reality in purely painterly terms. In time his own painting became less concerned with the real world and more with set pieces such as *Turkish Page* (1876, plate 656), a studio contrivance which displays his virtuosity in handling materials but remains essentially meaningless. With all his gifts, Duveneck really had little to say, but he did have flashes of insight and power, in spite of a tendency to fall into the

655 Frank Duveneck. *Whistling Boy*. 1872. Oil on canvas, 28 × 21½". Cincinnati Art Museum

manner of one of his old masters. Inspired by Rubens or perhaps Van Dyck, the *Woman with Forget-Me-Nots* (1876, Cincinnati Art Museum) is moving and solidly painted. *The Cobbler's Apprentice* (1877, Cincinnati Art Museum), one of a series of studies of working boys deriving from Hals, is startlingly close to Manet in its broad, flat tonal rendering. *Francis Boott* (1881, Cincinnati Art Museum), the portrait of his father-in-law, while reminiscent of Tintoretto, is impressive in its own right; and the portrait of his wife, *Elizabeth Boott Duveneck* (1888, colorplate 73), is surprisingly straightforward, carefully done, without the bravura of his earlier style, and closer to Whistler than one would expect.

In 1879 Duveneck left Munich with his students for Italy, where for the next two years he divided his time between Venice and Florence. His response to the Italian climate and environment was marked; the brown tonalities gave way to a higher-keyed and more colorful palette, the sharp edges of his brushing were smoothed over, the impasto became thinner, and the sentiment turned sweeter and less masculine. Also, he took to landscape painting—light, airy, and subtly toned views of Venice—and experimented with etching. After 1885 he worked in both Paris and Florence but, following the death of his wife, returned in 1889 to Cincinnati, where he taught for

656 Frank Duveneck. *Turkish Page.* 1876. Oil on canvas, 42 × 58½″. The Pennsylvania Academy of the Fine Arts, Philadelphia

the remainder of his life at the museum art school. In those thirty years he ceased to be an important influence.

William Merritt Chase (1849–1916), who proved a greater force in American painting of that period, also came from the Middle West. Born in Williamsburg, Ind., he moved with his family to Indianapolis, where he studied with a local portrait painter who was so impressed with his talent that he sent him on to New York. After a short stint at the National Academy of Design, he set up as a painter in St. Louis and before long found patrons willing to finance his study abroad. German connections probably led to the choice of Munich, and he enrolled at the Academy in 1872, studying with Alexander Wagner and then under Piloty and Leibl. For a while he shared a studio with Duveneck and during 1877 worked in Venice with him and John Twachtman. A gifted and facile student, Chase learned the Munich manner so well that he was offered a position at the Academy, but he returned instead to the United States to begin his career as the most popular and influential teacher of the period. Peripatetic and indefatigable, he taught at various times at the Art Students League, the Brooklyn Art School, the Chicago Art Institute, and the Pennsylvania Academy of Design; established his own Chase School, which became the New York School of Art; and offered private classes in his studio. He also taught summer ses-

sions at Shinnecock, Long Island, and at Carmel, Calif., and took groups abroad.

Chase became the image of the successful artist—gregarious, socially polished, and politically adept. He dressed elegantly, wore a monocle on a black ribbon and a boutonnière, kept a white wolfhound, and had a black servant who wore a robe and a red fez. He served for ten years as president of the Society of American Artists, was a member of the prestigious "Ten," was elected to all the artistic societies, and received countless national and international honors and awards.

Chase soon dropped the murky palette of the Munich School but retained its slashing brushwork and animated surface. He absorbed influences like a sponge—along with Munich's preferred old masters, contemporaries such as Whistler, the younger Sargent, Fortuny, Boudin, Manet, and even the Impressionists—but he achieved an eclecticism all his own, superficial perhaps, yet light, airy, brilliant, and curiously honest in his response to the visual world. The *Lady in Pink* (1886, Collection Margaret Mallory, Santa Barbara) is clearly derived from Whistler's *White Girl,* and his portrait of *James A. McNeill Whistler* (1885, Metropolitan Museum, New York) is a take-off on the latter's manner but nonetheless a fine picture. *Hide and Seek* (1888, Phillips Collection, Washington, D.C.) is a daring and delightful paraphrase of

657 William Merritt Chase. *Lady with the White Shawl.* 1893. Oil on canvas, 75 × 52". The Pennsylvania Academy of the Fine Arts, Philadelphia

Sargent's Boit children (colorplate 68), while the *Lady with the White Shawl* (1893, plate 657), in a more serious vein, can stand comparison with Sargent in his less patrician mode. Chase could do so many things with such dexterity, elegance, and style that he is now often dismissed as an artistic butterfly with more shimmer than substance.

In the less pretentious genre scenes and landscapes his qualities as a painter are most apparent. From the interior scenes of the early eighties (*The Tenth Street Studio,* Art Museum, St. Louis; *In the Studio,* c. 1880, plate 658), with their picturesque clutter, spatial and atmospheric rightness, and surface glitter, to the Shinnecock paintings of the nineties, bathed in an all-pervading light, reducing form to color (*Hall at Shinnecock,* 1893, Collection Margaret Mallory, Santa Barbara; *At the Seaside,* c. 1892, Metropolitan Museum, New York; *Shinnecock, Long Island,* c. 1895, colorplate 74), his strength lay in the direct and sensuous response to visual data. Such later studies reveal his growing interest in sunlight and a consequent heightening of palette until it was substantially Impressionist in range. There is something beguiling about these small pictures, perhaps too facile for profundity but essentially honest in observation.

Chase's style was an amalgam of the deft brushwork of Sargent, Impressionist color, and a Whistlerian feeling for pattern, and through the medium of his teaching it became at the turn of the century almost the American manner.

658 William Merritt Chase. *In the Studio.* c. 1880. Oil on canvas, 28½ × 40¼". The Brooklyn Museum. Gift of Mrs. C. H. De Silver, in memory of her husband

Painting: The Gilded Age 531

GENRE PAINTING

In the postwar era serious collectors turned from anecdotal paintings of American life to subjects considered more elevated and artistic. In the 1880s both Homer and Eakins turned from genre painting in response to a general evolution in art away from the literary to the visual, in which genre painting lost its specialized and essentially lower-class identification to become part of the mainstream of painting. Well-known painters sometimes did genre scenes just as they did portrait, landscape, or still-life paintings. This is as true of Whistler, Cassatt, and Sargent as of Homer and Eakins. Much of the work of the American Impressionists deals with scenes of everyday life, and so does that of many Romantic artists of the period. The whole genteel tradition at the end of the century is also largely concerned with human activity, though within a new upper-class frame.

On the other hand, the great increase in popular periodicals and the advance in reproductive techniques fostered anecdotal art and illustration. Thus the older genre tradition continued and even expanded as a popular form that has, rightly or wrongly, been differentiated from the so-called "fine arts." Certainly much of artistic interest has been produced in illustration and in commercial art in the past century, but their contributions can be treated only tangentially here.

There still were a number of artists who continued in the prewar tradition of Mount and Bingham, and of Woodville and the Düsseldorf manner, and are now largely ignored. One of these, Thomas Waterman Wood (1823–1903), born in Montpelier, Vt., made his reputation on New England rural scenes. Wood studied in Boston and spent three years in Paris before returning to a career as a portrait painter in Nashville, Tenn., and Louisville, Ky. In 1867 he settled in New York, where he spent the rest of his life as a genre painter, serving as president of the National Academy from 1891 to 1899. Most of Wood's painting is rather weak, at times almost naive, and fairly obvious, but at his best, as in *New England Country Store* (1873, plate 659), he displays a sharp eye for detail, a pleasant humor, and some skill in handling a complex interior space. A much more accomplished painter of rural scenes was John Whetton Ehninger (1827–1889), who was born in New York City, graduated from Columbia College, and studied in Düsseldorf with Leutze and later in Paris with Couture. He was a successful illustrator but also painted genre subjects in the Düsseldorf manner, with polished competence and a foreign cast. *The Turkey Shoot* (1879, plate 660), one of his most ambitious efforts, exhibits a studious attention to detail from clothes to expression, but everyone looks rather more *bürgerlich* German than rural American, though it was painted in Saratoga.

By far the most popular genre painter of the period

659 Thomas Waterman Wood. *New England Country Store*. 1873. Oil on canvas, 36 × 41". New York State Historical Association, Cooperstown

660 John Whetton Ehninger. *The Turkey Shoot*. 1879. Oil on canvas, 25 × 43½″. Museum of Fine Arts, Boston. M. and M. Karolik Collection

was British-born John George Brown (1831–1913), whose sentimental, sad-eyed bootblacks and newsboys made his name a byword and produced an income in the neighborhood of $40,000 a year. Brown had studied in Newcastle and Edinburgh and worked in London before emigrating to the United States in 1853. Settling in New York, he continued his studies at the National Academy at night. He brought with him the highly polished, anecdotal style of English Victorian academic genre painting, but his early efforts in this country show a marked influence from Homer's rural genre scenes, though in a more anecdotal and sentimental vein. They have a sweet charm and are executed with skill. *The Music Lesson* (1870, plate 661), startling in the context of the stereotyped "J. G. Brown," is a quite respectable example of English genre, reminiscent of Holman Hunt's *Awakening Conscience,* and one of the few American paintings of the period to show any connection with the Pre-Raphaelites. Equally unusual is his *Longshoremen's Noon* (1879, plate 662), depicting a group of workers in what appears to be a political discussion during their lunch hour. It is a seriously thought out picture, well composed, and painted with great attention to physical detail, ethnic characterization, and expression, in keeping with the literary tenets of anecdotal art. Although rather obvious and cliché-ridden, it is one of the few paintings of the time to recognize the existence of an industrial working class, with its immigrant composition, and the "labor problem." However, Brown's little pictorial "Horatio Algers" became so popular that he spent most of his life supplying the demand. Ironically, at a time when Eakins could not find a market, J. G. Brown earned $25,000 in royalties for a chromolithograph given free with tea.

Another popular genre painter was Edward Lamson Henry (1841–1919), whose rural scenes were full of anecdotal activity and excess sentiment. He is best remembered, however, for *The 9:45 Accommodation, Stratford,*

661 John George Brown. *The Music Lesson.* 1870. Oil on canvas, 24 × 20″. The Metropolitan Museum of Art, New York. Gift of Colonel Charles A. Fowler, 1921

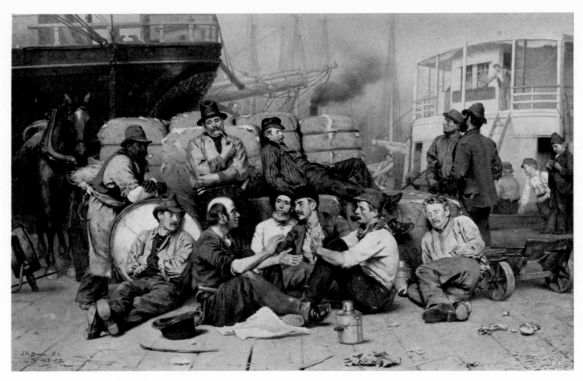

662 John George Brown. *Longshoremen's Noon.* 1879. Oil on canvas, 33¼ × 50¼". Corcoran Gallery of Art, Washington, D.C.

Connecticut (1867, plate 663), a lively and observant rendition of a new phenomenon in American life, the suburban railroad. The handling of incident and human interest is managed with a raconteur's skill and humor, but it is raised a cut above the usual by an air of authenticity in reportage and a pleasant sensitivity to light and environment.

Thomas Hovenden (1840–1895) was born in County Cork, Ireland, and came to the United States in 1863. He studied at the National Academy and later in Paris with Cabanel. After painting in Brittany, he returned to America, a well-trained academic genre painter with a style that retained its European flavor. His classical composition and scrupulous detail are closer to Woodville than to Mount or Homer, and his farmers look rather like French peasants. *Breaking Home Ties* (1890, plate 664), combining morality, sentiment, and careful painting, was one of the most popular pictures of its day. Quite distinct from his other work is the attempt at historical painting in *Last Moments of John Brown* (1881, Metropolitan Museum, New York), where a touching dignity comes through the sentimental and the painstakingly trivial. Of comparable interest is Hovenden's treatment of the blacks in *Their Pride* (1888, plate 665). Here for the first time is a glimpse of emancipated urban blacks, quite distinct from the usual depiction as slaves or exotica, and although the incident of the family proudly observing the young girl in her new finery is sentimental, the picture states without condescension that "Black is beautiful."

The Civil War offered an opportunity for reportage and genre painting that was exploited by such artists as Homer and Johnson, but most of the work produced offers little beyond documentary interest. The magazine illustrations do not equal the camera records, and the genre pictures are mostly trivial. A minor exception is the work of Conrad Wise Chapman (1842–1913), son and pupil of the Romantic painter John Gadsby Chapman, who returned from Italy to fight for the Confederacy. In Charleston he executed a series of small pictures, essentially sketches, done with a clarity and painterly touch that recalls the "luminists."

Done years after the war was over, the paintings of Julian Scott (1846–1901) recapture events of the northern side with unusual credibility and directness, close to the earlier war sketches of Winslow Homer. Black life in the South continued to have appeal as an exotic subject, though most examples followed sentimental and humorous stereotypes. The Wilmington painter Jefferson David Chalfant, better known for his *trompe-l'oeil* still lifes, did some black genre themes, gently sentimental in feeling, but more interesting for his rendering of interior clutter. Memorable more as records are the naively intense pictures of southern life by William Aiken Walker (c. 1838–1921).

Westward expansion after the war led to a renewed interest in frontier life. Magazines carried illustrations dealing with the migration of settlers, the building of railroads, life on the plains, Indian wars, and the new American mythical hero—the cowboy. Little of this ma-

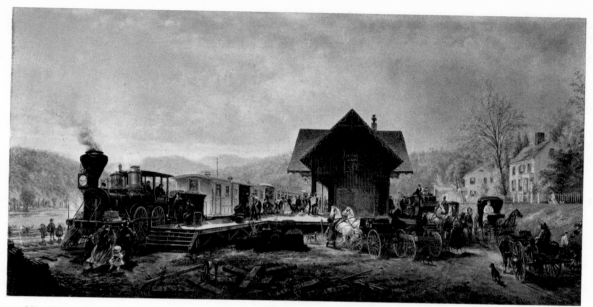

663 Edward Lamson Henry. *The 9:45 Accommodation, Stratford, Connecticut*. 1867. Oil on canvas, 16 × 30⅝″. The Metropolitan Museum of Art, New York. Bequest of Moses Tanenbaum, 1937

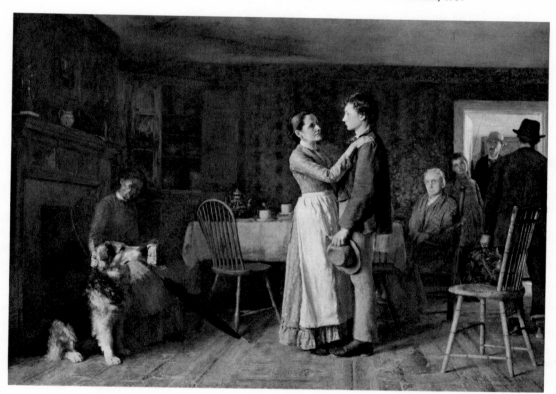

664 Thomas Hovenden. *Breaking Home Ties*. 1890. Oil on canvas, 52⅛ × 72¼″. Philadelphia Museum of Art

terial found its way into painting, remaining as popular illustration, though the distinction is perhaps arbitrary, since the originals were often paintings. Because they were done for reproduction, they were frequently cursory in execution, barren in texture and color, chiefly concerned with popular appeal, and superficial in observation and significance.

The attempts of Samuel Colman (1832–1920) to record the stately Conestoga wagons moving over the plains seem hardly adequate to immortalize such stirring scenes. However, some aspects of life in the West had more than adequate coverage by a host of illustrators, fostering an image of adventure in a world of cowboys, troopers, and Indians. Among the most famous of the artists of the

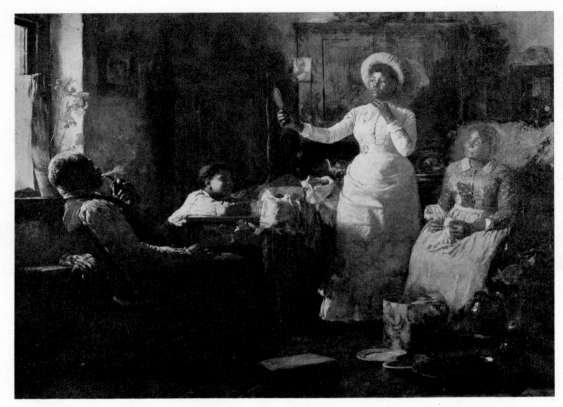

665 Thomas Hovenden. *Their Pride.* 1888. Oil on canvas, 30 × 40″. Union League Club, New York

West were Frederic Remington (1861–1909), Charles Marion Russell (1864–1926), and Charles Schreyvogel (1861–1912), all of whom achieved their greatest renown after the turn of the century. Remington and Russell were primarily illustrators and depicted contemporary life on the range, although the cowboy as they had known him was rapidly disappearing. Schreyvogel worked entirely for reproduction and was in a sense a historical painter dealing with military life and Indian wars of the past. All of them were interested chiefly in adventure. Remington, a good draftsman with an excellent knowledge of equine anatomy, was most effective in projecting dramatic action, and his gifts as a writer helped make him the most famous of the group. Russell had spent most of his life in the West and worked for some years as a cowhand, so that his detail is usually more authentic, though they all prided themselves on accuracy. All three also treated similar subjects in sculpture (see Chapter 18).

The English-born Arthur Fitzwilliam Tait (1819–1905) was a popular painter of adventure and wild-West subjects which were spread through reproduction by Currier & Ives and probably had much to do with creating the romantic vision of frontier life. An excellent craftsman, he told his story with skill and with just the right mix of truth and fantasy. Of those who recorded the roistering life of California from the Gold Rush to the San Francisco earthquake only Charles Christian Nahl (1818–1897) is worthy of mention. German-born and -trained, he went to New York in 1849 and soon after made his way to San Francisco, where he worked as a portrait painter. His genre scenes of mining-camp life capture something of the rough masculine violence and humor with robustness and convincing detail, except that they seem to have been seen through the eyes of a Düsseldorfian.

In retrospect, the popular genre painters and illustrators said little that was profoundly revealing about American life in the late nineteenth century. At best their work was minor and nostalgic; at worst, falsely sentimental. For exceptional work one has to look to non-genre painters or an occasional artist such as Charles Caleb Ward (c. 1831–1896), who somehow avoided the pall of sentimentality. Ward, a Canadian, was active in New York City for some years. He had a feeling for aesthetic qualities beyond anecdote and sentiment, and his most famous painting, *The Circus Is Coming* (1871, plate 666) reveals a unique and fresh vision influenced by the camera rather than the accumulated clichés of genre painting. One is struck at once by the conviction of the wooden houses plastered with posters, the stance and dress of the figures, the very quality of light, as well as the pattern of forms and relation of elements that reveal more than explicit anecdote. Of comparable interest is *Duane Street,*

New York (c. 1878, plate 667) by Louis Comfort Tiffany (1848–1933), better known for his work in stained glass and as America's foremost Art Nouveau designer. Most of his paintings, small oil sketches, deal with exotic subjects. This view of slum life is rare for that time and is painted with freshness and verve, much in the mode of Chase.

Another little-known artist deserving of attention is Henry Alexander (1860–1895), whose work does not fit neatly into any category. He painted people in interiors with great quantities of equipment rendered with the fanatical attention of a *trompe-l'oeil* painter. Although the figures are not up to the quality of the inanimate objects, the total view, as in *The Laboratory of Thomas Price* (c. 1887, Metropolitan Museum, New York), is a unique record of a specialized activity rendered with startling reality. Born in San Francisco and trained in Munich, Alexander worked in New York and his native city before his untimely death. Unfortunately, all the works collected for a memorial exhibition in San Francisco in 1906 were destroyed in the earthquake.

Little of the dramatic impact of industrial development in the late nineteenth century is reflected in art. Neither the industrial plant and landscape nor the role of labor in production seemed picturesque or heroic enough. American culture turned to the West for its mythical hero, to the Romantic image of natural man, the cowboy in a primitive confrontation with his physical environment. One

666 Charles Caleb Ward. *The Circus Is Coming*. 1871. Oil on canvas, 10⅛ × 8″. The Metropolitan Museum of Art, New York. Bequest of Susan Vanderpoel Clark, 1967

667 Louis Comfort Tiffany. *Duane Street, New York*. c. 1878. Oil on canvas, 27 × 30″. The Brooklyn Museum. Dick S. Ramsay Fund

finds only scattered references to labor and usually inferentially, as in Brown's *Longshoremen's Noon* (plate 662). Much more impressive is *Steelworkers—Noontime* (c. 1882, colorplate 75) by Thomas P. Anshutz (1851–1912), pupil and assistant of Eakins at the Pennsylvania Academy and the artistic bridge between nineteenth-century Realism and the Ash Can School. However, neither painting deals with what might be labor's heroic implications but with a moment of leisure. The Anshutz, at least, composed with an almost Poussinesque Classicism and drawn with a studious attention to anatomy, conveys a physical sturdiness which borders on the heroic without destroying the immediacy of the particular and the prosaic. Though it suffers from a too obvious posing of figures and a sometimes niggling concern with detail, the quality of the light modeling the bodily forms imparts to it an uncanny sense of reality.

Rare in American art are the industrial themes of John F. Weir (1841–1926), the elder brother of J. Alden and the son of Robert W. (1803–1889), who had himself done a remarkable genre painting, *The Microscope* (1849, plate 668), curiously reminiscent of the eighteenth-century scientific genre studies of Wright of Derby. John studied with his father and later briefly in Europe, returning in 1869 to become the first director of the newly organized Yale School of Fine Arts. *The Gun Foundry* (1866, Putnam County Historical Society, Cold Spring, N.Y.) and *Forging the Shaft* (1877, colorplate 76) were remarkable for the time at which they were executed. Weir caught the drama of the industrial scene in the titanic scale of the foundry and its apparatus and the belching furnace fire illuminating in sharp chiaroscuro the action of the dwarfed workmen. In one youthful probe Weir had touched on a central aspect of American life that was never really followed up.

STILL LIFE AND TROMPE L'OEIL

Still-life painting found limited acceptance in the latter part of the century, appealing neither to the sophisticated taste for the sublime, the grandiose, and the aesthetic nor to the popular taste for the sentimental and the anecdotal. Yet in the postwar period there was a remarkable efflorescence of *trompe-l'oeil* still-life painting by William Michael Harnett, John Frederick Peto, John Haberle, and a host of lesser-known artists. If still life was considered a minor art form, then *trompe l'oeil* was clearly lower-class. Dismissed by the critics as "imitative" art,

668 Robert W. Weir. *The Microscope.* 1849. Oil on canvas, 30 × 40". Yale University Art Gallery, New Haven, Conn.

it scrabbled for existence on the fringes of the art world. Few of its patrons were art collectors as such, and its practitioners—except for Harnett, who found survival difficult—never made a living at their art; some were part-time painters and even amateurs.

Alfred Frankenstein, in his dedicated efforts to reconstruct this forgotten chapter in American art, has discovered a surprising list of personalities who had the patience and sometimes the skill to paint *trompe-l'oeil* pictures in the last decades of the nineteenth century. That an entire school of *trompe-l'oeil* painting should have developed in America at that time is curious, though not unexplainable. There was, first of all, a tradition of *trompe l'oeil* established by the Peales in the early part of the century and in Philadelphia, where Harnett and Peto originated. Then, the popular taste for verisimilitude continued unabated, in spite of the increasing elevation of taste. The *trompe-l'oeil* still-life painters picked up and revitalized a tradition that was a half-century dead and exploited as never before the desire to simulate the appearance of physical things, but at a time when such imitation was no longer considered to be art. The more convincing the illusion, the more suspicious the reaction of the cognoscenti. *Trompe l'oeil* was simply a "deception."

Whether Harnett and his fellow deceivers went back to the local version of the Peales or to its sources in seventeenth-century Dutch still-life painting is not clear. By this time the opportunity for studying the past through photographic reproduction had reduced the insularity of those artists who did not study abroad. However, whatever its origins and sources of influence, *trompe l'oeil* developed along unmistakably American and late nineteenth-century lines. By its very nature *trompe l'oeil* has never been entirely serious; it has always been seen as artistic sleight-of-hand and therefore lighthearted, frivolous, and even humorous, as tricks should be. The *trompe-l'oeil* painters accepted the limitations of their craft as prestidigitators, and their public, unlike the critics and the cultural elite, judged them not as artists but as painters with marvelous skill. Much of what was produced is worthy of consideration, infinitely superior to the bloodless vapors of the cultured and the pomposities of the *nouveau riche*. It remains, if one reads it correctly, popular art in the most profound sense.

The most successful artist of the group was the Irish-born William Michael Harnett (1848–1892), who worked for a decade in Philadelphia and New York as an engraver on silverware while attending night classes at the Pennsylvania Academy and later at Cooper Union and the National Academy before becoming a painter. Harnett spent the years from 1876 until his departure for Europe in 1880 in Philadelphia, and his earliest exhibited works, still lifes rather than *trompe l'oeil,* are in the tradition of the Peales. In Philadelphia, at least, the still-life form was still alive in the work of surviving members of the Peale

family and in a more elaborate manner in that of John F. Francis (1808–1886), also a Philadelphian, whose still lifes cover a limited range of objects but are treated in a pleasant, personal, high-keyed palette and with a strong feeling for plastic form. Harnett might also have known the work of the German émigré painter Severin Roesen, who came to this country about 1848 and worked in Williamsport, Pa., from 1858 to his death in 1871. Most of Roesen's still lifes contain elaborate displays of fruits or flowers in the manner of the lesser Dutch still-life painters, executed rather naively and in painstaking detail. Simpler examples are more closely akin to Harnett's in composition and even in the choice of objects.

Harnett's dependence on the Peales is apparent in the borrowing of their simple grouping of fruit, vegetables, and other objects on a horizontal shelf-table against an undefined and usually dark background. These are traditional still lifes, but the impulse to intensify the palpability of the real is visible in the compositional device of elements overhanging or projecting beyond the ledge and in the rather naive application of pigment in relief to such details as nail heads, which he abandoned after the Philadelphia period. Harnett may also have derived from Raphaelle Peale the conception of the currency picture; that is, if a deception listed as *A Bill* painted by Peale in 1795 actually represented a banknote and Harnett had somehow seen it. Harnett's *Five Dollar Bill* (1877, Philadelphia Museum) was the first of a series and the first of his purely *trompe-l'oeil* pictures. He may also have discovered then that deception is effective in direct ratio to flatness, and the greater the depth, the less convincing the illusion.

During those years Harnett developed several iconographic types that, although not without precedent, became particularly his own. The *memento mori* still lifes were obviously traditional, but the "smoker" (mug and pipe or cigar box and pipes), writing-table, and book paintings were personal themes that he repeated in endless variations. The story element in Harnett is fundamental, though not always in an anecdotal sense. His still lifes are almost genre pictures. As he said, "I always group my figures, so as to try and make an artistic composition. I endeavor to make my composition tell a story."

The objects Harnett selected so carefully and repeated so frequently were the *dramatis personae* in compositions which were, like Chardin's, the expression of an attitude toward life, a desire to immortalize the simple joys of a humble world, to monumentalize the commonplace. His preference was for ordinary objects—the pottery mug, the meerschaum pipe, the package of tobacco, matches, hard biscuits, and the folded newspaper—as in *Still Life* (1877, Collection Dr. John J. McDonough, Youngstown, Ohio). But they also symbolize a simple male pleasure and become projections of a human being who has left them temporarily. The *Still Life—Writing Table* (1877, plate 669) has as many references to the world beyond as does

669 William Michael Harnett. *Still Life—Writing Table*. 1877. Oil on canvas, 8 × 12". Philadelphia Museum of Art. The Alex Simpson, Jr., Collection

a Vermeer genre scene of a woman writing or reading a letter, and basically the same expressive intentions.

Harnett was much concerned with nostalgia and the pathos of the discarded, as in *Job Lot—Cheap* (1878, plate 670), where a pile of second-hand books, each with its own character and history, reflects the human tragedy of the used, the obsolescent, the unwanted. He tells his story or draws his moral by implication (though his titles are rather obvious), through the objects and their interrelationship rather than iconographical detail.

During the Philadelphia period Harnett's stylistic qualities were set—a sharp-edged definition of form and a careful distinction of materials. He convinces us not through form alone but through the nature of material—its texture, weight, even temperature—contrasting the warmth of leather and the coldness of metal, the lightness of paper and the heaviness of marble, the softness of fruit and the hardness of wood, the sparkle of salt glaze and the glow of ivory. His early compositions, though simple and unpretentious, showed a greater feeling for monumentality, much in the manner of Chardin, than other still-life and *trompe-l'oeil* painters of his time and a pronounced feeling for classical, pyramidal composition, which seems to derive from Dutch still lifes.

Most of the *trompe-l'oeil* themes originated with Harnett, but the "rack picture," a webbing of tapes tacked to a vertical surface and holding letters, postcards, tickets, and so on, appears to have been done slightly earlier and with greater frequency by John Frederick Peto (1854–

1907), a fellow Philadelphian and admirer of Harnett. For some time after the rediscovery of Harnett in the 1930s, many of Peto's paintings with forged signatures passed for Harnett's, and only through the sleuthing of Frankenstein has the forgotten life's work of Peto been reconstructed. Peto was listed as a painter in the Philadelphia Academy from 1879 to 1887. He probably studied at the Academy and seems to have known Harnett well. Peto eked out a living painting portraits and "office boards" and taking photographs, but eventually he drifted into cornet playing at camp meetings, settled in Island Heights, N.J., in 1889, and sank into oblivion, though he painted to the end of his life. He borrowed from Harnett the smoking, writing-table, book, and money themes, and later the music and hunt subjects, but remained always himself. His recurrent rack picture seems to have grown out of the "office boards" done as decorations for business premises. The type goes back to the seventeenth century, tapes and all, and it offers the *trompe-l'oeil* painter the ideal condition for illusion, for the board or surface is identical with the picture's background and everything else is depicted as existing in front of it. The connections between rack picture and the compositional devices of Cubism, Dada, the *Merzbilder* of Kurt Schwitters, or the montage pictures of Robert Rauschenberg are striking, if fortuitous. Even so, Peto's involvement with the dilapidated, the fragmented, the discarded, and the apparently random is real and emotionally charged, though it is a visual trick. It is perhaps this dichotomy

670 William Michael Harnett. *Job Lot—Cheap*. 1878. Oil on canvas, 18 × 36″.
Reynolda House, Inc., Winston-Salem, N.C.

which makes a Peto more poignant than a Schwitters,
more tragic than a Harnett. Peto's paintings were more
anecdotal and sentimental than Harnett's, as witness his
Job Lot, Cheap (n.d., private collection, New York) and
The Poor Man's Store (1885, plate 671), and stylistically
quite different. One might almost say that Peto was not
really a *trompe-l'oeil* painter; that he merely used *trompe-
l'oeil* subjects, for his handling was never unusually de-
tailed, sharp-edged, or texturally differentiated. It is the
general quality of light rather than the character of
material that dominates his painting and connects him
with the "luminists." His granular surfaces and soft edges
emphasize the underlying form instead of the particulars
of texture. The feeling for paint is always more pro-
nounced than the illusion of reality, and in that sense
Peto is often a more satisfying painter than Harnett.
Despite a tendency to clutter in his paintings, the strong
shadows create an abstract pattern of volumes and an
unexpected nobility. Isolated from the art world and with
scant patronage, Peto continued to work and to follow
the development of Harnett, borrowing the monumental
hunt compositions which he transformed, as in *Still Life
with Lanterns* (after 1890, colorplate 77), so powerful in
its boldness of pattern and plasticity. On the whole, Peto
emerges as a more personal, intimate, and appealing but
more limited artist than Harnett.

When Harnett was ready to go abroad, he gravitated
(after working in London and Frankfort) to Munich,
where his meticulous realism would appear old-fashioned.
As always, he sold, but he received no serious critical
attention. In his four years there, his work took on an

671 John Frederick Peto. *The Poor Man's Store*. 1885. Oil on
canvas, 36 × 25½″. Museum of Fine Arts, Boston. M. and
M. Karolik Collection

unwonted richness of subject and complexity of composition, as well as a broader touch reflecting local taste. However, the increased elegance resulted in "fancy" pictures which, though admirably composed and painted, lack the authenticity of his earlier work. On the other hand, the hunt pictures begun in Munich led to his most notable later productions. They were derived from seventeenth-century hanging-fowl or game paintings and influenced by contemporary photographic studies. Harnett did four such still lifes, beginning in 1883. All show a miscellany of game and hunting paraphernalia hanging from an old wooden door (painted, rather than grained, as were most of the antecedents and many later copies) with heavy iron hinges and keyhole. The two later versions are rather more elaborate, but all are life-size, impressive compositions with strong diagonal thrusts and boldly modeled forms, combining intricately balanced formal elements and an unmatched virtuosity in *trompe-l'oeil* effects. His contemporaries admired their illusion as present critics do their formalism. The last, *After the*

673 William Michael Harnett. *Music and Good Luck*. 1888. Oil on canvas, 40 × 30". The Metropolitan Museum of Art, New York. Catharine Lorillard Wolfe Fund

Hunt (1885, colorplate 78), was painted in Paris and hung for many years in a famous downtown New York saloon, sponsoring imitation in countless hotel lobbies and bars.

Harnett continued to paint elaborate table-top still lifes with reminiscences of the Munich "fancy" pictures after his return to the United States in 1886, but his major activity was devoted to friezelike compositions suggested by the hunt theme. His late work in New York was a return to simplicity, to American subject matter, and to Classical order, as opposed to the opulence and Teutonism of the hunt paintings. Prime examples are the *Golden Horseshoe* (1886, Collection James W. Alsdorf, Winnetka, Ill.) and *The Faithful Colt* (1890, Wadsworth Atheneum, Hartford, Conn.). In them *trompe l'oeil* becomes expressive art, presented with such economy, taste, and sincerity that trickery vanishes. The same modest grandeur of conception informs his return to the rack theme in *Mr. Huling's Rack Picture* (1888, Kennedy Galleries, New York) and reaches a kind of consummation in *The Old Violin* (1886, plate 672). Reproduced as a chromolithograph, the latter was widely copied. Harnett himself redid it, as he did so many themes, in the more complex and formal *Music and Good Luck* (1888, plate 673). The violin turned up again in the rather fussy *Old Cupboard Door* (1889, Graves Art Gallery, Sheffield, England) and *Old Models*

672 William Michael Harnett. *The Old Violin*. 1886. Oil on canvas, 38 × 24". Collection William J. Williams, Cincinnati

674 William Michael Harnett. *Old Models*. 1892. Oil on canvas, 54 × 28″. Museum of Fine Arts, Boston. Charles Henry Hayden Fund

675 John Haberle. *The Changes of Time*. 1888. Oil on canvas, 24 × 18½″. Sally Turner Gallery, Plainfield, N.J.

(1892, plate 674), the last of his paintings, which combines minute detail with simplicity of form in a monumental statement on the nature of reality.

John Haberle (1856–1933), in his wry and somewhat raffish manner, exploited the humor inherent in the *trompe-l'oeil* process, trapping the viewer in visual paradoxes. In *The Changes of Time* (1888, plate 675) a satyr-head keyplate is screwed to both door and frame, so that the lock can never be opened. *A Favorite* (c. 1890, Museum of Fine Arts, Springfield, Mass.) contains an elaborate contraption of a wooden panel with an inset cigar-box lid in which a hinged flap with an attached string is cut; with the flap open, what would one see? A *trompe-l'oeil* frame

surrounds *Grandma's Hearthstone* (1890, Detroit Institute of Arts), but several objects in the picture overlap the frame. And in *A Bachelor's Drawer* (1890–94, plate 676) the contents of the drawer are perversely mounted all over the exterior so that the drawer cannot be opened. Throughout his work the whimsical humor has a nagging sense of mystery.

Haberle also differs from the other *trompe-l'oeil* painters in his flat, linear style, more common to watercolor, which militates against illusion, though he worked assiduously to achieve it, using the most difficult objects and trickiest effects to call attention to the effort involved—bills, stamps, coins, newspaper clippings (which are legible and allude always to himself), cracked glass, magnification, photographs, and wood graining. Haberle made a specialty of banknote pictures, perhaps because he was cantankerous enough to flaunt his prowess in the face of the Treasury Department agents who had requested, as they did of Harnett, that he stop the illegal reproduction of currency. Haberle is also interesting iconographically for his use of such vernacular and popular objects as cigarette, greeting, and playing cards and "girlie" pictures. In contrast to Harnett and Peto, he preferred nonaesthetic objects.

Haberle was born and lived in New Haven and worked as a preparator of paleontological exhibits. His career as a *trompe-l'oeil* artist seems to fall between 1887, when he

676 John Haberle. *A Bachelor's Drawer*. 1890–94. Oil on canvas, 20 × 36″. The Metropolitan Museum of Art, New York. Gift of Henry R. Luce, 1970

677 Jefferson David Chalfant. *The Old Flintlock*. c. 1898. Oil on canvas, 24⅞ × 17″. Collection Barbara B. Lassiter, Winston-Salem, N.C.

first exhibited a picture at the National Academy, and 1898, when his eyesight began to fail. He then turned to painting flower pieces, but as late as 1909 produced a large *trompe l'oeil* called *Night* (New Britain Museum of American Art), which represents an unfinished painting set in a frame of stained-glass panels with a gathered velvet curtain on one side. Haberle's art lacks the serious grandeur of Harnett and the sensitive lyricism of Peto, but it offers a waggish imagination.

A host of imitators and plagiarists followed Harnett. His hunt theme was copied many times by Richard LeBarre Goodwin (1840–1910), who simplified not only Harnett's composition but his decorative and exotic paraphernalia. *After the Hunt* also inspired Alexander Pope (1849–1924), who produced many original variations on the theme, and George W. Platt (1839–1899), possibly a fellow student of Harnett and Peto at the Pennsylvania Academy, who was active in the Far West and worked in a broad and more painterly manner. William Keane (dates unknown) adopted the Harnett music theme; and Claude Raguet Hirst (1855–1942), the only woman of the group, could have known Harnett in New York and was obviously influenced by his smoking pictures. By far the most interesting of these lesser personalities is Jefferson David Chalfant (1857–1931), who, though much beholden to Harnett, plagiarized with taste and beautiful craftsmanship. He tended to strip down Harnett's compositions and focus on the basic elements, rendering them with a luminous intensity that makes them memorable, as in *Violin and Bow* (1889, Metropolitan Museum, New York) or *The Old Flintlock* (c. 1898, plate 677).

Sharing some of the technical effects of the *trompe-*

l'oeil painters was the German-born Joseph Decker (1853–1920), who came to the United States as a boy, studied at the National Academy, and lived and worked in Brooklyn the rest of his life. He came under the influence of Inness and produced unimportant pastoral paintings, but his still lifes (plate 678) of an earlier vintage are remarkably interesting, original in composition and quite fresh and sensuous in handling.

THE NEW ROMANTICISM

The Romantic strain in American painting continued after the Civil War, though its character was altered, and, if it appeared less American than Realism, it seemed also more artistic. A shift from representation to impression has been noted in the earlier work of Inness, and Hunt brought back from abroad the new notion that art was not an imitation of nature but an expression of emotion. He had picked up the strand that led back to Page and Allston, but for the new Romantics poetic sentiment lay in the commonplace rather than in the sublime and the picturesque. The taste fostered by Inness, Hunt, and later La Farge was based on a new galaxy—Constable, Turner, Delacroix, Géricault, Corot, Millet, and the lesser luminaries of the Barbizon School.

It was William Morris Hunt (1824–1879) who was most influential in changing American preferences. Having studied and lived with Millet at Barbizon, he returned to Newport and Boston with paintings by his revered master, as well as Corot, Rousseau, and Daubigny, to spread the new gospel long before its apostles were honored in France. Hunt was born in Brattleboro, Vt., moved to New Haven, and then attended Harvard, but after the death of his Congressman father, he and his younger brother, Richard Morris, were taken abroad in 1843 by their mother. Hunt studied sculpture with Barye in Paris but decided on painting as a career. He went to Düsseldorf in 1846, found that stultifying, and the following year entered the studio of Couture, where he remained until he became Millet's devoted disciple. When Hunt settled in Newport in 1855, he was somewhat over-sophisticated for painting portraits of local worthies or summer residents, but, in spite of his intelligence and passion for art, he remained something of a dilettante. His search for the ephemeral essence may have been an unconscious accommodation to his lack of discipline and his limitations as an artist. That he could both admit the anatomical weakness in *The Bathers* (1877, plate 679) and decline to correct it for fear of failing to recapture its essence is an indication of crippling self-doubt. But he had no such timidity when it came to theorizing or teaching, and he profoundly affected his students, among whom at Newport were the James boys, Henry and William, and John La Farge.

Hunt moved to Boston in 1862. An attractive, gregarious gentleman of wit, a compelling figure with an aura of genius and the somewhat eccentric appearance of an artist, he was the more irresistible for being well born and married to a Boston heiress. An ardent group of female students filled his studio. His effect on taste was undeniable. Bostonians bought Barbizon paintings be-

678 Joseph Decker. *Russet Apples on a Bough.* c. 1880. Oil on canvas, 17½ × 27½". H. John Heinz III, Pittsburgh

679 William Morris Hunt. *The Bathers*. 1877. Oil on canvas, 24⅜ × 16⅛". Worcester Art Museum, Worcester, Mass.

680 William Morris Hunt. *Self-Portrait*. 1866. Oil on canvas, 30 × 25". Museum of Fine Arts, Boston. William Wilkins Warren Fund

fore the French did, and even the Impressionists had a friendlier reception in the 1880s in Boston than in Paris.

As an artist Hunt offered more promise than achievement, although it must be remembered that most of his work was destroyed by fire in 1872. He had learned from Couture a feeling for pigment and its direct application and from Millet how to idealize form by simplifying drawing, silhouette, and tonal mass. Many of his female figure pieces, such as *Marguerite* (1870, Museum of Fine Arts, Boston), are reminiscent of Corot in composition and gentle lyricism. Hunt, like Inness, made much of suggestion, of the stimulation of imagination by the undefined, as if resolution would destroy the poetic illusion. Often his paintings—for instance, *The Bathers* (1878, Metropolitan Museum, New York) and *The Ball Players* (1877, Detroit Institute of Arts)—remain elusive evocations of a mood in which substance seems on the point of vanishing. In contrast, his portraits are forthright and vigorous; the *Self-Portrait* (1866, plate 680) is simply conceived and freshly painted, and the more formal *Chief Justice Lemuel Shaw* (1859, Essex County Bar Association, Salem, Mass.) is handled with authority.

However, Hunt is probably best remembered for the ill-fated mural decorations for the New York State Capitol at Albany, executed under great stress in two months in 1878. The compositions for the two huge lunettes were based on studies done while Hunt was with Couture and reflect something of nineteenth-century French academic mural painting—bombastic, but with the breadth and fluency of a grander tradition. Hunt was not equipped to handle the heroic on such a scale, though the preparatory oil sketches for *The Flight of Night* (1878, colorplate 79) and *The Discoverer* (1878, Museum of Fine Arts, Boston) reveal, despite flabbiness in composition and drawing and irrelevance of theme, a feeling for dramatic movement and heroic poetry new in American mural painting. Unfortunately, the oil paint applied directly to the stone surface soon deteriorated. Although the decorations were well received, Hunt suffered a general depression which ended in what was evidently suicide by drowning several months later. Once again an American artist seems to have succumbed to a sense of inadequacy. Hunt had once said with regret, "In another country I might have been a painter."

Hunt's emphasis on poetic sentiment influenced a generation of Romantic figure painters. George Fuller (1822–1884) found a brooding mystery in the people and landscape of New England, transforming the ordinary into an

idyll of some distant time and place. Born in Deerfield, Mass., he studied art at the Boston Artists' Association and at the National Academy of Design and sculpture with Henry Kirke Brown in Albany. After an early career as an itinerant portraitist in Massachusetts and New York, the death of his father and brother in 1859 forced him to return to farming; but first he took a trip abroad, as if to fill his mind with the great art of the past. For the next fifteen years he farmed and painted ideal compositions, creating a somber poetry out of the material of his own existence. Alone and unhurried, he struggled to embody his visions in paint, and in his groping he occasionally struck a true chord of sentiment or evoked a haunting mood. Just as often he lost his way in murky color and undefined form. Then, a crop failure in 1875 led him to send some of his paintings to Boston for sale; the exhibition was enthusiastically received and he spent his remaining years as a successful painter. His contemporaries seem to have responded to an elusive note which faded with time or into the gloom of his pigment.

Robert Loftin Newman (1827–1912) was even less facile than Fuller, though his training promised more. Born in Richmond, Va., and raised in Tennessee, he went to Düsseldorf in 1850 but then gravitated to Paris and the studio of Couture. On a second trip abroad in 1854, he met Millet through Hunt and stayed on in Barbizon for eighteen months. After serving as a draftsman with the Confederate Army, Newman settled in New York City, where he painted in virtual seclusion. He had a distinct feeling for color and pigment and had learned from Millet to idealize form through simplification, but his technical equipment remained faulty. He might achieve a luminous color passage or the suggestion of a moving compositional relationship, but he rarely carried his ideas to completion.

John La Farge (1835–1910) was much like Hunt— upper-class, well educated, cosmopolitan. Both were highly intellectual, though La Farge had a more profound and incisive mind, and both were brilliant talkers, though La Farge seems to have had a more telling impact on American taste. They even had in common a streak of dilettantism, which La Farge, at least, overcame to emerge as the major artist-entrepreneur of his time. The most cultured and sophisticated artist working in the United States in the late nineteenth century, he had an immense potential for achievement and influence; yet, despite a highly successful career, he is hardly mentioned today as an important figure in American art history. Stylistically, La Farge stands somewhere between the Romanticism of Hunt and the Realism of Whistler, but instead of resolving the conflict, he led Romantic Realism up the high road to the academic fatuities of "imperial Classicism." Like many upper-class intellectuals of the day, he was torn between tradition and the current demands, between culture and science, between the ideal and the real.

Born in New York City into a family of French émigrés from Santo Domingo, the young La Farge was raised in a home of New World wealth and Old World culture. He showed an early interest in art, took lessons as a child from his grandfather, an amateur miniaturist, and later studied with an English artist, who taught him watercolor, and with a French painter after he left college. Upon graduation he drifted into the practice of law but continued to dabble in art. By his own account, he then discovered the Barbizon School from prints, especially Barye, Diaz, and Troyon, and read Ruskin, who led him to Turner.

La Farge went abroad in 1856 and in Paris stayed with his relatives, the Saint-Victors. The brilliant Romantic *feuilletoniste* Paul de Saint-Victor introduced him to Gautier, Baudelaire, Flaubert, Sainte-Beuve, Gavarni, and Chassériau. Groping for direction, La Farge went with the American painter Edward May to Couture's studio, where he stayed only a few weeks. Couture suggested that, since he was not advanced enough in painting, he copy old-master drawings on his own, which he did at the Louvre, as well as at Munich and Dresden. The greatest influence on La Farge was Chassériau, who had left Ingres for Delacroix and, in trying to reconcile the two divergent streams in French art, produced a strange hybrid that later had its impact on Puvis de Chavannes and Moreau, both of whom had certain affinities with La Farge. The attempt to find a common ground for Classicism and Romanticism must have attracted La Farge to Chassériau.

After a stopover in England, where he was impressed by the Pre-Raphaelite effort to express a Romantic idea in naturalistic terms, La Farge returned home to practice law. However, his interest in art continued, even to renting a studio. In 1859 he spent the year at Newport with William Morris Hunt, painting seriously for the first time. Though they had differences of opinion, Hunt had an important bearing on La Farge's aesthetic attitudes and early efforts. La Farge's *Portrait of the Artist* (1859, plate 681) is Huntian in the simplified silhouette, luminous haze enveloping form, and general Romantic feeling, although there is a greater concern with naturalistic detail than in the older artist. During the next decade La Farge worked from Romanticism toward Realism. In the early 1860s he became involved in the study of optics and, paralleling the development of Impressionism, set himself the problem of painting the "commonplace" aspects of nature in "the exact time of day and circumstances of light." Also at this time he discovered Japanese art; he was among the first artists of the Western world who understood and even wrote about its aesthetic significance.

La Farge's small, modest, searching efforts of the sixties—landscapes, flower pieces, and still lifes—were realistic, carefully painted, and rich in color. Less popular than the luxuriant flower studies but more pertinent to

681 John La Farge. *Portrait of the Artist*. 1859. Oil on wood, 16 × 11½″. The Metropolitan Museum of Art, New York. Samuel D. Lee Fund, 1934

his development are the *Portrait of a Young Man* (1865, Denver Art Museum), curiously French in character and reminiscent of Couture in its application of pigment; the lovely *Greek Love Token* (1866, colorplate 80), representing a wreath of spring flowers on a rough stucco wall, almost *trompe l'oeil* in effect; and the remarkable *Paradise Valley* (1866–68, Collection Miss Mary B. Lothrop, Boston), in which he tried to embody his theories of painting nature in light and air.

However, for La Farge painting was "never the *mere representation* of what we see," and he was impelled to look for the ideal. In the seventies he began to seek a viable contemporary mode for the religious themes and monumental decorations which were to make his reputation. In the early sixties he had painted some religious subjects which had impressed Richardson, who promised to use him when he had a likely project. In 1876 Richardson called on him to decorate the interior of Trinity Church, Boston. By this time La Farge had become interested in stained glass but had no real experience in monumental interior decoration. However, within four months, under the most onerous physical circumstances and without trained craftsmen, he designed and com-

pleted with ten to fifteen assistants the painting of the immense interior. It was the first work of its kind, and, despite its obvious aesthetic weaknesses, its hurried execution, and subsequent emasculation of the scheme by renovations, it remains a rich and coherent conception, the model for many later church interiors.

Trinity made La Farge the premier interior designer and mural painter in America, and with his activities in stained glass he had more work than he could handle. Among his major decorative commissions were those for St. Thomas's Church (1877), destroyed in a fire, on which he worked with the sculptor Augustus Saint-Gaudens; for the Church of the Incarnation (1885), and for the houses of Cornelius Vanderbilt (1881–82) and Whitelaw Reid (1887)—all in New York City; and four great lunettes in the Supreme Court Room of the Minnesota State Capitol in St. Paul (1903–05). The finest of his painted decorations is *The Ascension* (1888, plate 682), revealing both the strength and the weakness of his academic eclecticism. Almost brazenly dependent on Raphael's version of the theme, except for the mandorla of angels, it has an authority and grandeur of conception and composition that can come only from tradition, but La Farge's draftsmanship had not the sensitivity or originality to revitalize the motif in its own terms. In an effort to modernize the tradition, he attempted to transform the ideal form through the details of reality, the particulars of character and incident and of surface, space, and light. But the monumentality of the theme is negated by minutiae. La Farge had arrived at a Neoclassicism that paralleled the architectural "imperial Classicism" of Richard M. Hunt.

La Farge's major energies during his maturity were directed toward the revival of stained glass, an interest that was first aroused in 1873, when he saw the Pre-Raphaelite experiments in the medium, and his subsequent study of medieval glass in France. Commissioned to do a window for Memorial Hall at Harvard, he at first met disappointment because of the limitations of available materials, and he set to work reviving the craft from the ground up, manufacturing the glass, developing new kinds, such as the famous "opaline," and devising new techniques. He supervised all production and was responsible for several thousand windows in churches and dwellings. Technically, at least, he reconstituted the craft to its ancient level, but it took the genius of Louis C. Tiffany to transform that tradition into a resplendent expression of the international Art Nouveau style.

In 1886, his health failing, La Farge accompanied Henry Adams on a trip to Japan and the South Seas which reinforced his early interest in Oriental art and recalled him to a more personal kind of painting responsive to the experience of nature. His late watercolors (in many ways more satisfying than his decorative works) reveal both his innate sensitivity to color and delicacy of feeling and his basic deficiencies in drawing. But by this

time he had little to communicate beyond a tourist interest in reportage.

The suggestive poetry of *The Strange Thing Little Kiosai Saw in the River* (1897, plate 683), in its Pre-Raphaelite symbolism and Art Nouveau elegance, is closer to the essential La Farge, one must suppose, than the vacuous charade of the lunette painting *Athens* (1898) at Bowdoin College. Despite his culture, intelligence, and talent, La Farge leaves us unsatisfied. His intimate work seems incomplete, his public efforts empty. He was torn by conflict between the literal truth and the imaginative essence in his early paintings, between the traditional ideal and contemporary reality in his mural decorations, and between medieval abstraction and representation in his stained glass. The inspiration was neutralized into academic eclecticism.

La Farge's interest in Pre-Raphaelitism was exceptional, for the movement had only a limited influence in America, and even in his case the connection was sporadic and tenuous. The Pre-Raphaelite strain is most evident in his black-and-white illustrations for books and especially *The Riverside Magazine,* done in 1866. In the most famous of these, *The Wolf Charmer* (repeated later in several painted versions), and in *Bishop Hatto,* he revived a mood that traces back to Allston. The literary themes, laced with mystery and terror, were executed in the sinuous line and with the decorative disposition of form of the Pre-Raphaelites, and they were well received in England.

682 John La Farge. *The Ascension.* 1888. Mural painting, 25 × 20′. The Church of the Ascension, New York

683 John La Farge. *The Strange Thing Little Kiosai Saw in the River.* 1897. Watercolor, 12¾ × 18½″. The Metropolitan Museum of Art, New York. Rogers Fund, 1917

The chief example of the Pre-Raphaelite influence is Elihu Vedder (1836–1923), a friend and admirer of La Farge. Born in New York City, Vedder had only a rudimentary artistic training before going abroad in 1856. After studying briefly in Paris, he worked in Italy until his return to the United States in 1861. Since the art market was tight during the war years, he earned his living at a variety of hack jobs that included designs for comic valentines and sketches for *Vanity Fair*. Meanwhile, he began work on his strangely imaginative pictures, among them *The Questioner of the Sphinx* (1863, Museum of Fine Arts, Boston) and *The Lost Mind* (1864–65, Metropolitan Museum, New York). All are related to Pre-Raphaelitism in theme and style, though broader in treatment. They are not profound, having the quality of illustration, yet there is an air of mystery about Vedder's imagery that transcends both the triteness of subject and the almost naive academicism of style. His gift was for visual metaphor, literary and frequently literal, but sometimes unexpectedly apposite. *The Lair of the Sea Serpent* (1864, plate 684) is memorable even if one knows that the model was a dead eel washed up on the Long Island shore. The very ambivalence of the blowup creates a Romantic or surreal image.

Both Hunt and La Farge praised his work highly, but Vedder returned to Rome in 1866 to live permanently, except for occasional visits to the United States. He wandered the Campagna, painting small, charming landscapes with bright and delicate touches of color in the manner of the early Corot, and he continued his visionary symbolic paintings, but in the presence of Italian Renaissance art his style became more formal, intricate, and linear, and his color opaque and progressively monochromatic. Vedder is best remembered for his illustrations for *The Rubaiyat of Omar Khayyam,* published in 1884, in which the gentle Romantic melancholy of the drawings echoes Edward Fitzgerald's transformation of the medieval Persian original. The illustrations, including the lettering, are strikingly Pre-Raphaelite in imagery, linear pattern, and decorative arrangement.

With the American boom in mural painting during the 1890s, Vedder returned to carry out a series of commissions, notably for the Walker Art Gallery at Bowdoin College, along with La Farge, Thayer, and Cox, and for the Congressional Library building with a host of others. By then his art had become desiccated and mannered even by the standards of the mural-painting fraternity.

The brooding mood in Vedder's most imaginative work belied his disposition, which was open, friendly, and sunny. In contrast, William Rimmer (1816–1879) seems to have expressed all his emotional turmoil, frustration, and bitterness in his art. Better known as a sculptor and teacher of anatomy, he was also a painter, though few of the portraits he painted as an itinerant limner and none of his religious paintings for Catholic churches around Boston have survived. Most of those we know come from his later years and have not weathered time very well, since he was an amateur in paint as he was in sculpture. But his brain teemed with memories of art seen in prints or copies of old masters at Boston Athenaeum exhibitions—Michelangelo, William Blake, John Martin—and with mystical visions and nightmarish fantasies. *The Fall of Day* (1869, Museum of Fine Arts, Boston) is a transcendental expression of agony, as are so many of his tortured

684 Elihu Vedder. *The Lair of the Sea Serpent*. 1864. Oil on canvas, 21 × 36″. Museum of Fine Arts, Boston. Bequest of Thomas G. Appleton

685 William Rimmer. *Flight and Pursuit*. 1872. Oil on canvas, 18 × 26¼". Museum of Fine Arts, Boston. Bequest of Miss Edith Nichols

sculptural creations (see Chapter 18). In philosophic and aesthetic conception, and in the detail of anatomy and drawing, it is dependent on Blake and, through him or more directly, on Michelangelo. One of the most haunting and original imaginative paintings of the century is Rimmer's *Flight and Pursuit* (1872, plate 685). The panicked flight of an assassin/victim, man/conscience, good/evil down the endless corridors of the mind/time is a nightmare that probes the depths of Rimmer's own troubled spirit and beyond to the unconscious of man. In his work the Promethean image of a chained genius wars with the provincial amateur, and even his finest are flawed by the arrogance of his presumptions. Training would have helped, but he really believed that he needed nothing but recognition. Despite his vast anatomical knowledge, many of his drawings and paintings seem in their mannerism to be based on the Neoclassic clichés of instruction books. Also, he knew next to nothing about color.

ROMANTIC MYSTICISM: RYDER AND BLAKELOCK

Albert Pinkham Ryder (1847–1917) was the most original Romantic painter of the century. His art is the culmination of a tendency that began with Allston and came down through Page, Hunt, and, to a certain extent, La Farge. These artists sought the spiritual essence rather than the physical description of reality or a dream; and, as Allston had intuited, the abstract, nondescriptive character of music is closer to that essence than literature, and color is painting's closest analogy to sound. They were heirs to the Venetian tradition of luminous, translucent, sensuous color, conveying a meaning independent of the context in which it exists. Their emphasis was on the direct communication of emotion or mood instead of story or idea. Although the line of demarcation is not sharp, this group of Romantics differs from the literary stream that includes Cole, Quidor, Vedder, Rimmer, and, again to some extent, La Farge.

Ryder seems out of place in nineteenth-century America. He has been described as being closer to the European modern movement than to the American, as a Postimpressionist in essence, a premature Expressionist, a proto-abstractionist. Nevertheless, though he may have presaged subsequent artistic movements and inspired later artists, he belonged to his own time and place. He was a product of the new forces operating in American art, the "new movement" that encompassed all the novel currents brought back from Europe by the younger men, culminating in a split from the Academy and the formation of the Society of American Artists. Ryder is as close to Hunt, Fuller, and Blakelock as to Gustave Moreau or

Adolphe Monticelli, who have often been cited as parallels, or even to Matthijs Maris, who has been suggested as a possible influence. In the art scene of the time one discerns a grouping of "tonal" painters with a preference for the lower registers, crepuscular effects, and a brooding sadness. Among them were Hunt and his immediate circle, Newman, Fuller, the early La Farge, Ryder, and Blakelock, and, among pure landscapists, Inness and some of his disciples. Tangential but relevant are the nocturnes of Whistler and the nocturnal figure pieces of Thomas Dewing. It might even be possible to postulate a New England school of Romantic melancholy. In any case, Ryder does not stand isolated, though his art is obstinately his own. He certainly would be no stranger to the literature of Hawthorne, Melville, or Poe.

Ryder's dedication to his vision was part of his uniqueness. He was the only artist of his time on whom the external world had no hold physically or spiritually, socially or artistically. He made his own conditions and lived by them without compromise or complaint. Solitude, asceticism, irresponsibility were the precondition of his freedom to live completely and intensely with and for his art. He was not really a recluse, though there is a tendency to romanticize that aspect of his existence. He was friendly and approachable, somewhat eccentric, but by no means a crackpot. He had close friends in the art world—Daniel Cottier, the art dealer; Olin Warner, the sculptor; Alden Weir; and later in life the young painters Walter Pach and Marsden Hartley. Ryder was a founder of the Society of American Artists, along with Hunt, La Farge, and Saint-Gaudens, and showed at their annual exhibitions. Although he did not sell widely, he had a few loyal patrons, including the most important of the day, Thomas B. Clarke, and at the Clarke sale in 1899 his pictures brought prices only slightly lower than those of Inness, Homer, and Martin. Samuel Isham, generally conservative in his judgments, found him to be "among the most original and important of our native painters."

In a small walk-up tenement on 15th Street, New York, amid the clutter of years, through which a narrow path led to his easel, a chair, and a little coal stove on which he cooked what Pach described as an "unsavory brew . . . that was food, drink, and medicine for him," he worked and reworked the small magical canvases that embodied his dreams. Heedless of chemistry or craft, he laid on layer after layer of cheap pigment mixed with varnish, sometimes using alcohol as a solvent, and varnished the surface after each sitting until the paint stood out in undulating relief. He might carry an image in his mind for years before committing it to canvas. The painting remained in flux as he worked, evolving in response to what was happening in the process. Forms were altered, moved, or expunged; accidents of color led to new explorations; and the canvas could be put aside indefinitely until he had something to add. He once said, "The canvas I began ten years ago, I shall perhaps complete today or tomorrow. It has been ripening under the sunlight of the years that come and go." Any Ryder painting contains below the outer skin a sequence of other paintings.

Nothing deterred him, nor could he be prodded. Concerning an impatient client he remarked, "I was worried somewhat at first by his wanting to take his picture away before I had finished, but lately he has been very nice about it—only comes around once a year or so." The long maturation period produced the irreducible images, the translucent lacquered surfaces, the gemlike color, but it also led to a darkening and cracking of the pigment, so that the original intention has been irretrievably lost. In his later years pictures that he had reworked were sometimes painted out of existence. Because of his working method, dating his pictures is difficult, but a general chronology has been established on available evidence: the earliest works were done in the 1870s; the most productive period was about 1880 to 1900; after that he mainly reworked older pictures.

Ryder was born in New Bedford, Mass., when it was thriving as a whaling port. His sight was impaired in childhood by a faulty vaccination, and, as the youngest son, he was coddled and permitted to follow his own leanings. When the family moved to New York City in 1870, he took lessons from a Romantic painter, William E. Marshall, and attended the National Academy school. He showed for the first time at the Academy in 1873 and only once more after that, but he exhibited regularly with the Society of American Artists from 1878 to 1887. He never studied abroad, though he visited Europe several times, twice with a sea-captain friend when he spent his time absorbed in the moonlight and the ever-shifting sea. What he thought about the art he saw, he kept to himself. He was essentially self-taught and had learned what he wanted to know. The rest was a struggle to realize his personal vision.

From his earliest works Ryder seems to have known what he was after, searching, as he said, like the inchworm for "something out there beyond the place in which I have a footing." There was little change in his style; yet there is a great variety within a limited range. The pastoral scenes, which are closest to observed reality and least visionary, seem to be the earliest and the most nearly related to Hunt, Millet, and the Barbizon School. Remembered possibly from the countryside around New Bedford, *Pastoral Study* (n.d., National Collection of Fine Arts, Washington, D.C.) and *Evening Glow, The Old Red Cow* (late 1870s, plate 686) capture a bucolic mood in shimmering evening light. Here Ryder is not concerned with representation or truth to nature but with transforming his memory of it into pigment.

The works of his maturity fall into fairly distinct categories: those inspired by literary themes from Shakespeare, the Bible, and Wagnerian operas; and marine subjects. Some, like *The Tempest* (n.d., Detroit Institute of Arts), or *Jonah* (c. 1885), and *The Flying Dutchman*

686 Albert Pinkham Ryder. *Evening Glow, The Old Red Cow.* Late 1870s. Oil on canvas, 7½ × 8¾″. The Brooklyn Museum

(c. 1887), both in the National Collection of Fine Arts, Washington, D.C., encompass both themes, for his interest in the sea was overriding. But his most ambitious and successful paintings are based on literary themes. In *Macbeth and the Witches* (1890–1908, Phillips Collection, Washington, D.C.) and *Siegfried and the Rhine Maidens* (1888–91, plate 687) he picked up the thread of nineteenth-century Romantic iconography and wove it into patterns all his own. Gone are the details of time and place. Scenic devices and puppet figures are transmuted in the moonlight of his inner eye into a portentous drama. Twisted trees, looming crags, lowering clouds seem to respond to the tempestuous winds of magical words and sounds—all achieved through the greatest economy of means. Formal patterns lock in titanic conflict, coruscating lights illumine a moment that should not be seen, to be swallowed in unfathomable darkness. And woven into the whole is the rich but muted glow of paint. No Romantic painter in American history made story and storytelling so inseparable.

It is often said that all Ryder's marines are versions of the same picture—the silhouette of a little sailboat bob-bing on the vast sea glowing green out of blackness, the hulking cloud phantoms against the sky, the silver moonlight bathing the world in phosphorescence. These hallmarks of a Ryder have become clichés for both the public and the forger. Slightly more than 150 authentic Ryders are extant, and there are possibly five times that many fakes, so that the dross may cheapen the true metal. But such examples as the *Moonlight Marine* (1870–90, plate 688) have an indescribable surface richness, a depth and luminosity of color, a tightness of organization, an inner conviction. Ryder's fascination with the sea goes back to his youth in New Bedford, to the memory of its presence and threat, of two brothers who sailed before the mast, and it continued in his later ocean voyages and nocturnal ramblings along the New York waterfront. The image of the fragile boat—lost, lonely, tempest-tossed, a metaphor of man's fate—is not Winslow Homer's vision of man's heroic struggle against the elements; it is a more general and spiritual acceptance of the oneness of the universe, the wonder, beauty, and mystery that reside in nature. The reality of experience becomes a drama of abstract forms, the dynamics of the painting, rather than

687 Albert Pinkham Ryder. *Siegfried and the Rhine Maidens.* 1888–91. Oil on canvas, 19⅞ × 20½″. National Gallery of Art, Washington, D.C. Andrew Mellon Collection

688 Albert Pinkham Ryder. *Moonlight Marine.* 1870–90. Oil on wood, 11⅜ × 12″. The Metropolitan Museum of Art, New York. Samuel D. Lee Fund

the description of an event. In this respect Ryder, of all nineteenth-century American artists, comes closest to the aesthetic concepts of the twentieth.

After 1900 Ryder's creative energies seem to have diminished, but there are notable late paintings such as *The Race Track* (*Death on a Pale Horse*, 1890–1910, plate 689), a somewhat naive though starkly compelling metaphor. The only work that seems to have been painted from nature is the small and poignant *Dead Bird* (1890–1900, colorplate 81), which combines a direct observation of fact with a mystical empathy for the pitiable little corpse on a crumpled piece of paper to achieve a touching symbol of death. Ryder may not have been the first or only American artist to turn from external reality to interior self, but he was the most important and radical example of a shift from the objective to the subjective, from the particular to the general, from the temporal to the eternal, from impression to expression—one might say, from sight to soul.

Ralph Albert Blakelock (1847–1919) could be included among the landscapists except that his woodland scenes were really Romantic memories rather than studies of nature. His repertory was even more limited than Ryder's—dark foreground trees silhouetted in a fretwork of leaves against a sunset or moonlit sky, often with an encampment of Indians around a glowing fire. The arabesque of foliage, the sparkle of light through the dark mass, the small firelit figures create a shimmering surface. The luminescence is much like Ryder's, but Blakelock projects a gentle lyricism of mood that has none of Ryder's dramatic tension. Blakelock too reworked his poetic images over and over and, like Ryder, found a fascination with nuance and variation. Working with small touches of pigment, he built up his paint to a heavy impasto and polished the surface with pumice before applying the final layer of color.

Blakelock's career was shattered by the starkest tragedy. The son of a New York physician, he abandoned the study of medicine for art and music and attended Cooper Union, but was essentially self-taught. From 1869 to 1872 he traveled through the West making sketches, and the memory of Indian encampments later appeared in many of his paintings (colorplate 82). He was burdened by a large family—a wife and nine children—and was forced to sell his pictures to unscrupulous dealers who took outrageous advantage of his naiveté and need. He broke under the strain of a precarious existence in 1899 and was committed to an asylum, where he spent seventeen years in a kind of euphoric oblivion. During this time his reputation had grown and his paintings were bringing record prices when it was discovered that he was still alive and his release was arranged. Lionization, exploitation, and belated honors, including membership in the National Academy, meant nothing to him any longer, and he reentered the asylum, where he died. The forgery of Blakelock paintings began while he was still alive and

689 Albert Pinkham Ryder. *The Race Track (Death on a Pale Horse)*. 1890–1910. Oil on canvas, 28¼ × 35¼″. The Cleveland Museum of Art. Purchase, J. H. Wade Fund

the problem of authenticating his works is probably greater than for Ryder.

THE ROMANTIC LANDSCAPE

The shift in taste during the last quarter of the century is manifest in the later work of George Inness and, following him, two younger landscape painters, Alexander Wyant and Homer Martin, who made the transition from the Hudson River School to a new poetic tonalism. Under Barbizon influence, Inness had broken from the older tradition, and after his return from abroad in 1875, his art passed into a more radical phase of broad tonal painting. His Italian landscapes had transformed the wide vistas of the Hudson River tradition by a richer colorism, but added a picturesqueness foreign to his earlier American scenes. Assurance and a self-conscious aestheticism mark *The Monk* (1873, plate 690), a picture of striking Romantic effects in composition and light.

However, by the 1880s his style had become more intimate, his brushwork more cursory, as he sought to capture the vagaries of transient light. Some relationship to Daubigny and Diaz is apparent in the bold paint handling of that period, eventually becoming looser and more suggestive toward the end of his life. These late works have a remarkable affinity with the late silvery woodland idylls of Corot and with Whistler's nocturnes. Like Whistler, Inness was interested in the margins between the seen and the felt. This phase was Impressionism

of a sort, though it eschewed the clarity of bright sunlight and the tyranny of fact, seeking instead a poetic reverie expressed in evanescent forms and subtle tonalities. There is an almost musical intensity in the pink of flowering trees glowing through a silvery veil in *Spring Blossoms* (1889, plate 691) and a mysterious melancholy of dusk in *The Home of the Heron* (1893, plate 692). Inness was a prodigious worker, though erratic. Sublimely sure of his powers, he poured out "impressions" from memory. Too often they are only suggestions, touches of color that do not coalesce into forms, shapes that dissolve. Time has not treated these hastily reworked pictures kindly. After a decline, Inness's reputation is undergoing a readjustment to the overevaluation of his late works, and there is a growing recognition of the more enduring quality of his earlier, more solidly painted landscapes.

Wyant and Martin, belated Hudson River School painters, would have remained lost in the ruck of an outdated style, had they not both adjusted to the new artistic currents. Alexander Helwig Wyant (1836–1892), who had painted signs in Ohio, was self-taught and, inspired by an Inness landscape, went East to seek his advice. He returned to Cincinnati and worked there and in New York before going abroad to study in Karlsruhe and to travel in Ireland and England, where he was impressed by the paintings of Constable and Turner. His early landscapes are in the detailed naturalism of the Hudson River School, though his panoramic effects, as in *The Mohawk Valley* (1866, Metropolitan Museum, New York), indicate a kinship with Church and Bierstadt.

690 George Inness. *The Monk*. 1873. Oil on canvas, 39½ × 64″. Addison Gallery of American Art, Phillips Academy, Andover, Mass.

691 George Inness. *Spring Blossoms*. 1889. Oil on canvas, 30¼ × 45¾″. The Metropolitan Museum of Art, New York. Gift of George A. Hearn in memory of Arthur Hoppock Hearn, 1911

In 1873 Wyant lost the use of his right arm and had to learn to paint with his left. Whether because of this readjustment or changing taste, his style became more personal, smaller in scale, and akin to the Barbizon School, reflecting especially Corot and Rousseau. *Ark-* *ville Landscape* (c. 1890, plate 693) is characteristic of his new concern with more intimate subjects and delicate tonal relationships.

Homer Dodge Martin (1836–1897), originally from Albany, was also largely self-taught, though he studied

briefly at the National Academy with James M. Hart. His earlier landscapes of the White Mountains, the Adirondacks, and the North Carolina Smokies are similar to the earlier works of Kensett—thinly painted, dry, and studiously detailed. An example is *Lake Sanford in the Adirondacks, Spring* (1870, The Century Association,

New York). However, he went abroad in 1876 and later spent five years in France (1881–86). He met Whistler and worked in Normandy and Brittany, mostly at Honfleur, where he was profoundly influenced by Impressionism. Even after his return, he continued to paint recollections of the French landscape, notably in *Harp of the Winds: A*

692 George Inness. *The Home of the Heron.* 1893. Oil on canvas, 30 × 35″. The Art Institute of Chicago

693 Alexander Helwig Wyant. *Arkville Landscape.* c. 1890. Oil on canvas, 16¼ × 24¼″.
The Cleveland Museum of Art. The Charles W. Harkness Gift

View on the Seine (1895, colorplate 83), the best-known of his works, done after he had settled in 1893 in St. Paul, Minn. Unfortunately, overexposure has made it seem banal, although it was really a fresh and charming picture which struck a new note in American landscape painting. Martin never accepted the Impressionists' technique of broken color or the scientific study of light, but he incorporated into his own Romantic lyricism their higher-keyed palette and airiness.

Though Inness had some influence on Wyant and Martin, he had no direct heirs, except perhaps for Dwight W. Tryon (1849–1925), very popular in his own day but quite neglected now. Like Inness, Tryon sought a lyrical mood in the half-light of dawn and twilight, in the mystery of vaguely defined forms, but his work is more obvious and so more sentimental. Despite Martin's timid stab at Impressionism and the personal poeticism of Inness, the American Romantic landscapists were essentially retardataire, carrying the earlier native tradition to its ultimate demise.

THE AMERICAN IMPRESSIONISTS AND "THE TEN"

The "luminism" of Kensett, Whittredge, and Heade, and the outdoor paintings of Eakins, Eastman Johnson, and especially Homer had independently come within a breath of Impressionism. Sargent in his watercolors and Chase in his later Long Island landscapes had shown an awareness of Impressionism and had adapted a good deal of its vocabulary. But it was a new generation of American painters in France during the 1880s who finally reacted directly to the growing acceptance of Impressionism—Theodore Robinson, John Twachtman, Alden Weir, and Childe Hassam.

Except for Mary Cassatt, Theodore Robinson (1852–1896) was the closest of all to the French, perhaps because most of his short career was spent among them. Born in Vermont and raised in Wisconsin, he studied briefly in Chicago and New York and then in Paris, where he worked with Carolus-Duran and Gérôme from 1876 to 1878. He traveled in Italy (1878–79) and later returned to France for five years (1884–89). In 1888 he met Monet, settled in Giverny, and worked with the French master until his return to the United States. His sensitive and poetic *Girl at Piano* (c. 1887, Toledo Museum of Art) is still a rather old-fashioned picture, but the following year the full force of his conversion to Impressionism is apparent in *The Vale of Arconville* (c. 1888, Chicago Art Institute). Here the French flavor of the landscape and the peasant figure is unmistakable. Still, it would be conservative for a French Impressionist painting, less high-keyed and daring in the use of pure color. Robinson, like Mary Cassatt, was more concerned with three-dimensional form than the French Impressionists, who were

intent upon the dissolution of form in light. He did loosen up eventually; his touch became surer, though never bold, and his color more sonorous, but he preferred muted, pearly tonalities that conveyed a gentle, poetic tone, as in *Bird's-Eye View—Giverny* (1889, plate 694), which is quite close to the work of Pissarro and Sisley. On the other hand, *Port Ben, Delaware and Hudson Canal* (1893, colorplate 84), perhaps the finest of his American landscapes, suggests an acclimatization to the native scene and light, recalling the "luminist" tradition. Despite a certain lack of vigor, he remains the most interesting of the American Impressionists.

John Henry Twachtman (1853–1902) arrived at Impressionism in a more circuitous fashion. After assisting his father in painting floral designs on window shades, Twachtman studied in Cincinnati at the Ohio Mechanics Institute and with Duveneck. In 1875 he went to Munich, where he became a student of Loefftz, and in 1877 joined Duveneck and Chase in Venice. After shuttling between Europe and the United States, Twachtman came home in 1886, painting in the Barbizon manner, though his palette had been lightened by his contact with Impressionism. Not until 1888, when he moved to Greenwich, Conn., did his style become clearly Impressionist although far from orthodox. His preference for winter landscapes was unique, and his preoccupation with light on snow led to subtle variations within a narrow color range, at times, through overrefinement, to a haze of white pigment that is rather leaden. He flattened the picture decisively, so that the dark water of a brook or pool cuts jagged patterns in the banks of snow shimmering in the cold winter sun. Despite his faithfulness to visual experience, the result is sometimes strangely un-Impressionistic in its strong rhythmic forms and lyrical strivings. Twachtman caught the feel of the New England winter, but he also went beyond to poetic generalization, which can be effective, as in *The Hemlock Pool* (1902, colorplate 85), and at other times rather banal.

Julian Alden Weir (1852–1919) had neither the grace of Robinson nor the originality and singleness of purpose of Twachtman. He grafted a sparkling skin of Impressionism on an essentially conservative vision, producing pleasant but pedestrian pictures. Though he studied with Gérôme and was influenced by Bastien-Lepage, his drawing was flabby. At best, as in *Visiting Neighbors* (1903, Phillips Collection, Washington, D.C.), he adapted the Impressionist technique to a genteel sentimentality. In *The Red Bridge* (1895, colorplate 86) he even achieved an unexpected freshness of observation and originality of composition, but too often his routine application of fragmented color produced a mess of chalky pigment.

The most talented of the group was the somewhat younger Frederick Childe Hassam (1859–1935). Born in Dorchester, Mass., he attended the Boston Art Club and the Lowell Institute, was apprenticed to an engraver, and became an illustrator, an occupation he continued even

694 Theodore Robinson. *Bird's-Eye View—Giverny*. 1889. Oil on canvas, 26 × 32¼″. The Metropolitan Museum of Art, New York. Gift of George A. Hearn, 1910

after he was a successful painter. He went abroad first in 1883. A receptive student and facile craftsman, he brought back a proto-Impressionist style of tonal painting that was a bit slick yet perceptive. His many urban scenes of the 1880s were an innovation in American painting. Somber in hue but sprightly in execution, they project a romantic view of city life in the haze of snow, rain, or twilight that forecast the Ash Can School. Characteristic are *Rainy Day, Boston* (1885, plate 695) and *Boston Common at Twilight* (1885–86, Museum of Fine Arts, Boston).

A stay in Paris from 1885 to 1888 resulted in Hassam's conversion to Impressionism. *Le Jour du Grand Prix* (1888, colorplate 87) is a brilliant study influenced by Monet and Pissarro, in which the sparkle of a bright, clear day and the movement of city life are caught with a sure touch and a surface facility. Hassam came close to the central manner of the French—high-keyed pure color, clearly differentiated brushstrokes, dissolution of form, and a holiday mood. His city- and landscapes have an engaging exuberance, even if they are at times brassy, superficial, and in his later years routine. The vigorous optimism of his finest work differs from the muted poeticism of many of his contemporaries and is remarkably American in feeling.

When Durand-Ruel, the French dealer, brought the first exhibition of Impressionist painting to New York in 1886, he found a friendlier reception than he was accustomed to in Paris, and the same acceptance greeted Robinson at the Society of American Artists in 1888, when he exhibited the first Impressionist paintings by an American. Mary Cassatt and Sargent, who tried to interest people in Monet, may have prepared the ground, but in any case, Impressionism entered American art without much fuss. An entire generation of painters born about 1860 were influenced by Impressionism or remained faithful to it into the twentieth century. Theodore E. Butler (1860–1936) was a devoted follower of his father-in-law, Monet, at Giverny. Willard L. Metcalf (1858–1925) and the watercolorist Dodge MacKnight (1860–1950) grafted a modified and rather pretty version of Impressionism onto a conservative and sentimental vision with great success. The same was true of some of the figure painters who simply adapted the new technique to their old ends; Robert Reid (1862–1929) was probably the most devoted adherent of the manner. For Edmund C. Tarbell (1862–1938) and Frank W. Benson (1862–1951) Impressionism was a passing interest, and Gari Melchers (1860–1932) added it to an earlier Teutonic

695 Childe Hassam. *Rainy Day, Boston.* 1885. Oil on canvas, 26¼ × 48¼". The Toledo Museum of Art, Toledo, Ohio. Gift of Florence Scott Libbey, 1956

stolidity. The only one with real talent was Maurice Prendergast (1859–1924), who patiently worked out his own solutions somewhat later. Of greater interest than the academic Impressionists, are several lesser known painters who seem to have combined early Impressionism as it developed out of the Barbizon School with the native *plein-air* tradition of "luminism." There is a modest charm and a naturalistic veracity in the work of such painters as Frank Boggs (1855–1926) and Edward H. Potthast (1857–1927).

Prompted by Twachtman, a group of successful and congenial New York and Boston artists joined in an informal alliance called "The Ten" and exhibited jointly in 1898—Frank W. Benson, Joseph De Camp (1858–1923), Thomas W. Dewing, Childe Hassam, Willard L. Metcalf, Robert Reid, Edward E. Simmons (1852–1931), Edmund C. Tarbell, John W. Twachtman, and J. Alden Weir (replaced after Twachtman's death by William M. Chase). The binding tie was some connection with impressionism, but, except for Hassam, they also shared a poetic gentility characteristic of late nineteenth-century culture—an aristocratic politeness and a nostalgia for a less trying age. Benson, De Camp, and especially Tarbell depicted a world of genteel elegance, with porcelain ladies at tea in the filtered illumination of curtained interiors or in the dappled light of their gardens.

Of the figure painters in the group, Thomas W. Dewing (1851–1938) was the least beholden to Impressionism and, aside from his subject matter, more closely akin to the tonal landscapists. Born in Boston, he was trained in Paris at the Académie Julian. His early style is accomplished, solid, and unusually detailed for the period, but

as he developed his own manner, he shed the concern with the material for the evanescent mood and the twilight mist. There is more than a hint of Whistler and Inness in his garden scenes with gowned women floating like wraiths in the evening light (colorplate 88) and a brooding melancholy in his women seated alone in dimmed interiors, even an air of foreboding or tension that differentiates his art from the gentle decorum of "The Ten." Unfortunately for Dewing, few now look long enough to be touched by his haunting poetry.

ACADEMIC AND MURAL PAINTING

Academic painting at the end of the nineteenth century and the first years of the twentieth was a rather loose amalgam of acceptable styles or combinations thereof. The National Academy of Design was dominated by the pre-Civil War Hudson River School painters and other American-oriented artists who were unreceptive even to Corot or Millet and felt threatened by the work of young men trained in Munich or Paris. In 1877 a new ruling assuring each academician "seven feet on the line" precipitated a revolt among younger artists and some sympathetic academicians, leading to the formation of the Society of American Artists, which included established names such as La Farge and Inness and some who had yet to make their reputations, such as Saint-Gaudens and Ryder. The earliest of the Society's exhibitions were dominated by the brilliant brushwork of the Munich men and the new formal sophistication of their colleagues from Paris. Though the "new movement" seemed a threat

for a while, the two "academies" learned to live amicably together until their quiet merger in 1906. "Academic" included almost anything from the exoticism and technical bravura of Robert F. Blum (1857–1903), who was weaned on Fortuny and borrowed from the fashionable French academicians, to the agrarian sagas of Horatio Walker (1858–1938), who mixed a deep admiration for Millet and Troyon with a more fluent modern technique. In its ranks were the Romantic idealists Abbott Thayer (1849–1921) and George De Forest Brush (1855–1941), who exalted American womanhood into an image of milk-fed divinity and motherhood into cloying treacle— Thayer with the latest French chic and Brush with Düsseldorfian fanaticism in detail and enamel-like finish. The same kind of Romantic idealism was to be found among the mural painters who became a force toward the end of the century. Followers of Sargent, domesticated Impressionists, and Munich men who had learned to heighten their color were also numbered among the academicians. Academic art was anything pleasant or undisturbing, any style that was recognizable, any technical manner that indicated competence. Only a handful of these artists deserve a second look. Aside from Mary Cassatt, Cecilia Beaux (1863–1942) was the best of our nineteenth-century women painters, a very accomplished and vigorous portraitist in the manner of Sargent. Robert W. Vonnoh (1858–1933), a student of Carolus-Duran, painted solid and sober portraits in the French Realist tradition. And Robert Blum, with all his flamboyance, is worth reexamination for the brilliance of his technique.

The exceptional growth of mural painting in the last decades of the century may have been a response to the demands of "imperial Classicism" in architecture, where the scale of building and the blank surfaces of wall, ceiling, and dome called for decoration. As has been noted, the art of mural painting in the United States had had little support from government sources or popular taste. American painters had long been conditioned to private art production, and the absence of commissions for murals was never a critical issue. Then in 1876 La Farge's interior decor of Trinity Church initiated an era of architectural decoration in which architects were to play a major role. Soon afterward Eidlitz commissioned Hunt to do the Assembly Chamber of the New York State Capitol. By the 1880s, churches, hotels, and the new palatial clubs were employing artists to embellish their interiors. Historically oriented architects considered decoration integral to their grand conceptions and began to include the cost in their contracts. Mural painting, stained-glass windows, and sculptural ornamentation became common in such projects and in theaters, banks, and the mansions of the merchant princes. It did not matter that American painters had no training or tradition in mural techniques, though a nucleus of muralists had been trained under La Farge at Trinity Church— Francis Lathrop (1849–1909), George W. Maynard

(1843–1923), Francis D. Millet (1846–1912), and Kenyon Cox (1856–1919) among others. They found a ready-made formula in the Beaux-Arts style of the French academicians, as the architects had before them. The flourishing activity drew together architect, painter, and sculptor in a dream of Renaissance creativity, culminating in the Columbian Exposition. But Francis Millet, who was in charge of mural decoration at the Fair, was no Raphael, nor were Edward Blashfield (1848–1934), Carroll Beckwith (1852–1917), Kenyon Cox, William Dodge (1857–1935), Lawrence Earle (1845–1921), George W. Maynard, Walter McEwen (1860–1934), Gari Melchers, Robert Reid, C. S. Reinhart (1844–1896), Walter Shirlaw (1838–1910), Edward E. Simmons, C.Y. Turner (1850–1918), and J. Alden Weir, all part of that great congeries of talent, any longer names with which to conjure. Their concerted efforts at "imperial Classic" grandeur are gone with the plaster structures they graced, but acres of comparable mural painting still cover the walls of public buildings. It is difficult to be certain that all of it is as worthless as it would seem.

Some of the more famous projects that occupied the members of the National Society of Mural Painters, founded in 1895, were: the Walker Art Gallery at Bowdoin College by La Farge, Cox, Thayer, and Vedder; the New York Appellate Court Building in New York City by Cox and Simmons; the Pierpont Morgan Library by H. Siddons Mowbray; the Supreme Court Chamber of the Minnesota State Capitol in St. Paul by La Farge and the Assembly Chamber by Blashfield; the Criminal Courts Building in New York City by Simmons; the enlarged Boston State House by Reid, Simmons, and H. O. Walker; and the Baltimore Court House by Blashfield and Turner.

Aside from the Chicago Fair, the greatest mural bonanza was the decoration of the new Library of Congress, completed in the late 1890s, which employed most of the better known muralists of the time and established the principle of providing art for Federal buildings. The most impressive of the mural projects was the decoration of the new Boston Public Library. In 1890 the Committee of Selection chose the greatest living French muralist, Puvis de Chavannes, and three American expatriates, Sargent, Abbey, and Whistler. Whistler did nothing about the commission, and Puvis painted his canvases in France without having seen the interior for which they were intended. The pale, wispy allegorical figures are not up to his usual standard and, in any case, are not American painting.

Edwin Austin Abbey (1852–1911), one of America's most popular book and magazine illustrators, delighted a vast public with his historical and literary subjects. In his decoration of the Delivery Room he painted the *Quest for the Holy Grail* (plate 696) in a colorful panoply of costumed character actors. The figures are life size and crowded into a tapestry-like pageant, and the detail is too

insistent for the dramatic action, but the whole has illustrative interest and decorative charm.

Despite their shortcomings, the Sargent murals, unfortunately crowded in a narrow gallery over a staircase, are the most interesting and, coming from the hand of the most fashionable portrait painter, completely unexpected. Selecting the Judeo-Christian religion as subject, he devised his own theological program and wrestled with the presentation for more than twenty-five years. Nothing in his background prepared him for the task, and he fell back on art-historical precedent, though his eclecticism was not the usual academic Classical pastiche. He fitted the style of the theme with scholarly preciseness, from the neo-Baroque theatricality of *The Prophets* (plate 697) to the hieratic symbolism of the pseudo-Byzantine *Doctrine of the Trinity*. The disparity of modes does not make for coherence, the aggressive figures of *The Prophets* verge on the rhetorical, and the flat, abstract, medieval forms of the *Trinity* lunette and frieze are anachronistically modeled in the spirit of Pre-Raphaelite updating of antiquity. Still the murals reveal Sargent's remarkable gifts. His later decorations of the dome of the Boston Museum of Fine Arts (1916–25) and the Widener Library at Harvard (1922) are rather conventional and lack the daring of the Library paintings.

One may regret the opportunity lost by American mural painters, the endless repetition of buxom female allegorical figures in classical drapery personifying anything from the Trinity to the Telephone; but the Europeans were no more successful in finding an official voice.

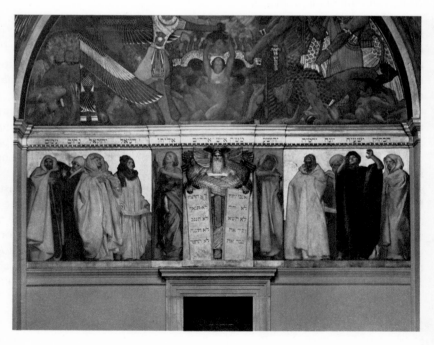

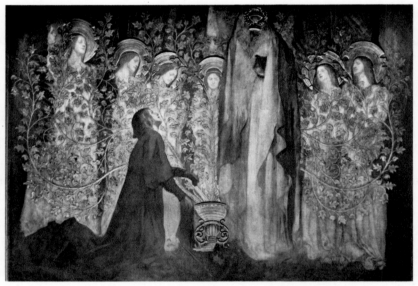

696 Edwin Austin Abbey. *Quest for the Holy Grail*, Panel XV: *The Golden Tree and the Achievement of the Grail.* 1890–91. Oil and gold leaf on canvas, height 8′. Courtesy Trustees of the Boston Public Library

697 John Singer Sargent. *The Prophets.* 1892–95. Oil on canvas, 7 × 38′. Courtesy Trustees of the Boston Public Library

CHAPTER EIGHTEEN

Sculpture

Mostly Monumental

Sculpture after the Civil War paralleled the evolution of painting, with the emergence of a new Realism and the discovery of Paris as a new influence, but its public character conditioned its development in ways that did not affect painting. Monuments, official portraits, and architectural sculpture speak for an establishment. They are commissioned, paid for, and judged as establishment taste, and the sculptor's function depends on public acceptance. Sculpture was, therefore, more conservative and rhetorical, less adventurous and idiosyncratic. American sculptors abroad found themselves at the École des Beaux-Arts, and their French contemporaries, under similar compulsions, were not much more innovative than they.

The response to the Civil War as an expression of individual sentiment or public attitude was more pronounced in sculpture than in painting. And, aside from the late work of Alexander Galt, the prevailing attitude was pro-North and antislavery. Abolitionist sentiments were strong especially among sculptors from New England, who saw the struggle in moral terms. The most outspoken antislavery partisan was John Rogers, who intended his political subjects as propaganda. Anne Whitney, a strong protagonist of both racial and women's liberation, did, among her earliest works during the war years, a reclining nude *Africa* (1864), a large plaster figure she subsequently destroyed, and a few years later a statue of *Toussaint l'Ouverture,* hero of the Haitian slave revolt. In Florence Thomas Ball produced a small composition which he was later to use again in the famous *Emancipation Group*. And Story saw his popular *Libyan Sibyl,* originally modeled in Rome about 1861, as an allegory on slavery, though it may not have been widely understood as such. Then, Edmonia Lewis, whose heritage as a black and an Indian gave her a particular interest in such themes, won recognition with the representation of two white heroes of black emancipation, a medallion bust of John Brown and a portrait of Colonel Robert Gould Shaw, who had been killed while leading his black regiment. The *Shaw* sold some one-hundred plaster replicas,

helping pay her way to Italy. Shaw's story soon spread abroad, and Margaret Foley, another New England sculptor, executed a bust of him in Rome in 1864. In 1866 Edmonia Lewis again responded to events with a *Freedwoman*; a year earlier John Q. A. Ward had marketed a good many copies of a *Freedman*.

After the war such sentiments were institutionalized in the North into civic monuments. Every hamlet, every village green had its war memorial or local hero in permanent stone, bronze, or cast iron, all of which kept a horde of sculptors lucratively busy. In the mood of that time, the war monuments did not so much commemorate victory as they celebrated the preservation of the Union or honored the fallen. They usually included allegorical representations of Peace or related abstractions and of the armed forces, in various permutations, though a single soldier galvanized into eternity served for most. Local as well as national heroes of the Union were exalted in appropriate, if not often stirring, memorials. The defeated South, steeped in rancor and burdened with the demands of reconstruction, could not freely participate in this orgy of plastic commemoration. Still, the mania for monuments for a while, at least, resulted in the erection of statues of southern Revolutionary War heroes, in affirmation of the southern heritage.

The assassination of Lincoln had created a martyr whose image could serve as a symbolic reference to the idealism and humanity that had motivated the conflict, and, with time, monuments to his memory began to rival in number even those to Washington. There were innumerable bust portraits and memorials by some of the leading sculptors of two generations, from the earliest by Henry Kirke Brown in Union Square, New York (1868) and Randolph Rogers for Fairmount Park, Philadelphia (1870), to the colossal effigy in the Lincoln Memorial shrine by Daniel Chester French, completed in 1922.

As in painting, postwar sculpture was for some time dominated by an older generation of established artists, both expatriate academic Neoclassicists and the native monument makers. The Neoclassicists prevailed at the

Centennial Exposition, but they were playing out their string on reputation. Hints of change were already evident in the work of John Q. A. Ward and the younger Augustus Saint-Gaudens and Daniel Chester French. Hiram Powers, no longer very active, was mostly occupied with occasional bust portraits and ideal heads. The major works of his last years were the *Edward Everett* (1870) and *The Last of the Tribe* (1873, National Gallery of Fine Arts, Washington, D.C.), the latter a nod to changing times and a belated admission of his American origins. Greenough produced little after his return to Rome from Florence in 1870, aside from bust portraits; noteworthy are only the standing *Governor Winthrop* (1876, Statuary Hall, U.S. Capitol, Washington, D.C.) and the *Circe* (plate 487).

Some of the expatriates took on commissions for monuments and portrait statues in response to the great postwar demand. Ives, as a native son, was commissioned by Connecticut to do several statues, and Jackson produced a Soldiers' Monument (1873) for Lynn, Mass. Story also turned to monumental statuary, including the *Chief Justice John Marshall* (1882–84) in Washington, D.C., and the Francis Scott Key Monument (1884–85) in Golden Gate Park, San Francisco. Randolph Rogers continued his career with a long series of portrait statues and war memorials. Harriet Hosmer worked on a memorial to Lincoln which she never completed, but by 1876 her career as a sculptor was effectively over, as was that of Emma Stebbins and Margaret Foley, who had done several large statues, including a *Stonewall Jackson* (1873) for Richmond, one of the first of the southern war memorials.

Almost alone of the old guard, Rinehart carried on the Neoclassic tradition of ideal sculpture in its purest form, executing after the war some of his most famous statues, among them the *Clytie* and the *Latona* (plate 498).

Neoclassicism could still attract new talent to Italy. Thomas Ridgeway Gould (1818–1881), the ex-dry-goods merchant turned sculptor, settled in Florence in 1868, did many ideal themes, the most famous of which, *The West Wind* (n.d.), was very popular at the Centennial, but he also executed a number of portrait monuments. Larkin Goldsmith Mead (1835–1910) began his career alongside John Q. A. Ward as an assistant in the studio of Henry Kirke Brown. He spent most of the war years in Italy (1862–65), bringing back several ideal pieces, as well as the *Battle Story,* a popular Civil War theme, and a model for a Lincoln Memorial (1866–83) commissioned for Springfield, Ill., at a cost of $200,000, one of the earliest and most ambitious of such monuments. Mead returned to Florence, where he worked many years on it and remained the rest of his life. As one of America's leading sculptors, he continued to produce an academic Classicism that took on a new acceptability in the context of the "imperial Classicism" of the Columbian Exposition, where he did the pedimental decorations of the Agricul-

ture Building of McKim, Mead (his younger brother) & White.

Edmonia Lewis (1845–?) created quite a sensation for at least a decade after her arrival in Rome in 1867, as much perhaps for her exotic origins and personality as for her talent as a sculptor, though she did have talent and managed to avoid the more obvious pitfalls of Victorian sentimentality. Born of a Chippewa mother and a black father, orphaned at three, she graduated from Oberlin College and made her way to Boston and to William Lloyd Garrison, who introduced her to Edward Brackett. With some instruction from Brackett, she was soon launched on a sculpture career. Following her early success with Civil War subjects, she turned in Rome to Indian and Biblical themes. She won some recognition with a *Hagar,* the symbol, as she said, of "all women who have struggled and suffered," then two statuettes based on Longfellow's *Hiawatha* (1867) and the *Old Arrow-Maker and His Daughter* (n.d.), another Indian subject. Her greatest triumph came with the *Death of Cleopatra,* exhibited at the Centennial, a typical Victorian literary subject but with an element of the macabre in the depiction of the effect of death on beauty that was both erotic and repellent. Then she simply disappeared from the scene, although it seems she was still active in Rome as late as 1885.

The fate of Pierce Francis Connelly (1841–after 1902), who settled in Florence in 1865, one of the last recruits to the Neoclassic tradition, is equally enigmatic. His spectacular career culminated in the Centennial, which displayed more of his works than of any other American sculptor. His group of eleven ideal statues at the Exposition was like a coda to a declining style. It was also the end of his career; he left for New Zealand to paint, returned to Florence briefly, and then vanished into practical oblivion. On the other hand, Moses Jacob Ezekiel (1844–1917), who arrived in Rome in 1874, spent the rest of his life there turning out a long succession of ideal pieces, portraits, and monuments that carried the memory of Neoclassicism into the twentieth century. Famous in his own time, he is now all but forgotten.

Of the old-guard monument sculptors, Thomas Ball continued to work as an expatriate in Florence, but his style was tied to the naturalism of the native school rather than to the Neoclassic tradition. Apart from an occasional ideal piece, he was mostly involved with commissions for portrait statuary and monuments, few of which are aesthetically interesting. His most famous work of the postwar years was the *Emancipation Group* (1874, plate 698). Blown up from the small earlier model, it looks more like a Rogers Group than a monument. However, more than any Lincoln memorial of the time it captured the imagination of the public in its mixture of naturalism and sentimentality. Henry Kirke Brown continued in great demand, producing two imposing equestrian monuments for Washington, D.C., the *General Winfield Scott*

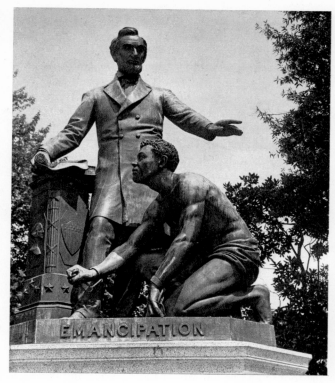

698 Thomas Ball. *Emancipation Group*. 1874. Bronze, heroic size. Washington, D.C.

(1871) and the *General Nathanael Greene* (1877), as well as several portrait statues for Statuary Hall.

REALISM

A transitional generation of monument makers, most of whom were born in the 1830s and came on the scene after the war, carried on the earlier naturalist tradition. Led by John Q. A. Ward, they had begun its conversion to a Realism that was fresher, more vital, and somewhat more sophisticated. Anne Whitney (1821–1915) was at least a decade older than the other sculptors of this group, but she had begun to work seriously only in her thirties and gone to Rome in 1867. There she fell temporarily under the spell of the antique and produced her quota of ideal compositions. She returned to Boston in 1871 and soon afterward received from Massachusetts the commission for the *Samuel Adams* destined for Statuary Hall. Cut in marble in Florence in 1875, it established her as one of New England's leading sculptors, and in the following years she executed portrait statues and busts of many New England worthies, including personalities in the women's rights movement. Anne Whitney maintained a straightforward naturalism in the manner of Thomas Ball, though with a modest sincerity and sensitivity, as in the perceptive characterization of *William Lloyd Garrison* (1880, plate 699).

Launt Thompson (1833–1894), born in Ireland and raised in Albany, received his training in the studio of

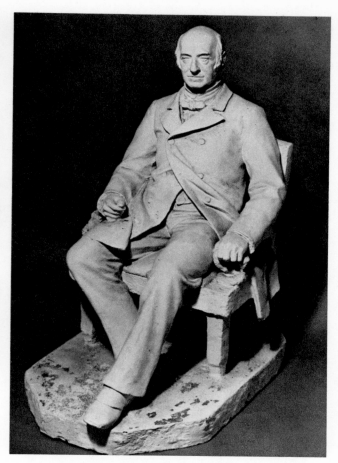

699 Anne Whitney. *William Lloyd Garrison*. 1880. Plaster, height $27\frac{1}{2}''$. Smith College, Northampton, Mass. Sophia Smith Collection

Erastus Palmer, where he also learned to cut cameos. In New York City, to which he moved in 1857, he quickly established himself with a series of ideal sculptures, attracting the patronage of William Waldorf Astor. After two years in Rome following the war, Thompson returned to an active career in portraiture and monumental statuary. His work of those years reflects a growing tendency in American sculpture away from prewar literalism to a more vivid sense of reality. For example, his *Sanford Robinson Gifford* (1871, plate 700) combines a new feeling for personality with a more animated handling of form. Later, he seems to have taken to drink, was ultimately confined to a mental institution, and died of cancer.

Beginning as a stonecutter with his father and brother, George Edwin Bissell (1839–1920) was largely self-taught, though he eventually studied in Paris and Rome. His career got under way only in 1883, with a commission for a soldiers' monument for Waterbury, Conn., succeeded over the years by a long roster of such monuments and portrait figures. By the end of the century, in works such as *Chancellor James Kent* (1899, plate 701), he had developed a style of surface vivacity and color directly responsive to the Beaux-Arts influence and a far cry from the

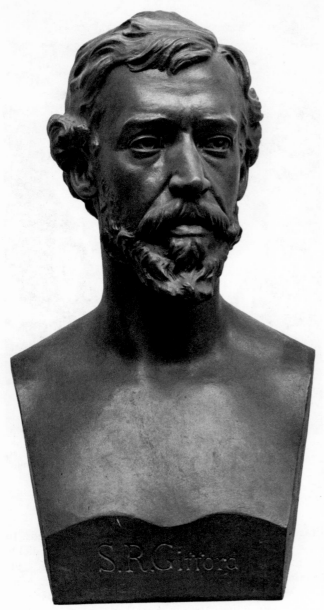

700 Launt Thompson. *Sanford Robinson Gifford*. 1871. Bronze, height 22¼″. The Metropolitan Museum of Art, New York. Gift of Mrs. Richard Butler, 1902

literal naturalism out of which he had come.

This was also true of Franklin Simmons (1839–1913), though his expatriation in Rome after 1867 removed him somewhat from the mainstream of sculpture in the United States. For a while he was caught up in the fading glow of Neoclassicism, but by the eighties his work reflected a consciousness of the new Realism. As a monument maker, beginning with the Civil War Monument for Lewiston, Me., in 1867, he carried out many commissions, culminating in the equestrian *General John A. Logan* (1901, Iowa Circle, Washington, D.C.), a vigorous group that can stand comparison with Saint-Gaudens's *Sherman*.

On the other hand, Martin Milmore (1844–1883) never made the transition from naturalism to Realism. After learning the rudiments of stonecutting from his older brother, he served a four-year apprenticeship with Thomas Ball, who recommended him in 1863 for the commission to create three colossal allegorical figures for Boston's Horticultural Hall. Thus, at nineteen, with Ball on his way to Italy, Milmore became the leading monumental sculptor in New England, a position he retained for the rest of his short life. Beginning with the Soldiers and Sailors Monument (plate 702) of 1868 in Forest Hills Cemetery, Roxbury, Mass., he continued, with his brother's assistance, for more than a decade, the prolific production of examples for Boston, Charlestown, and Fitchburg in Massachusetts; Claremont and Keene in New Hampshire; and even Erie, Pa. Milmore's work is typical of the practically anonymous monuments that crowded the cemeteries and dotted the urban landscape of the late nineteenth century, rather more competent than most, but no more memorable.

John Quincy Adams Ward (1830–1910) stands with one foot in antebellum provincial America and the other in a new world of industrial and imperial expansion. It is the measure of his stature as an artist that he could carry the integrity of the native tradition he inherited from Henry Kirke Brown over into a more sophisticated milieu without compromising or dissipating its force. He converted a naive naturalism into a heroic Realism, expressing some aspects of the American character more profoundly than any other nineteenth-century sculptor. Not so passionate as Rimmer nor so talented as Saint-Gaudens, he was uneven, but he was, on balance, the most solid sculptor of his era. He reminds one of Eakins in his commitment to reality and dedication to a native vision; his focus on America was even more pronounced, closer to the attitude of Winslow Homer. Suspicious of imaginative projection or allegory, he was at his best in making the simple and the obvious memorable.

Quincy Ward was born on a farm near Urbana, Ohio. His sister took him to Brown, whose Brooklyn studio was the best place for a student of sculpture. Ward served there as an assistant during the years of the *Washington* project, taking an active role, and became Brown's friend and hunting companion. After seven years with Brown, Ward spent two years in Washington doing bust portraits of political figures before opening a studio in New York. It was not until 1864 that he made his reputation with the *Indian Hunter* (plate 703), a statuette based on a sketch he may have done while still in Brown's studio, possibly suggested by Brown's *Aboriginal Hunter*, but he spent several months among the Indians of the North and Northwest before revising the composition. The result was a huge success, and he was commissioned to do a larger version (plate 704) for Central Park. The statuette projected a new kind of reality, dependent not only on ethnographic data but also on the convincing vitality of

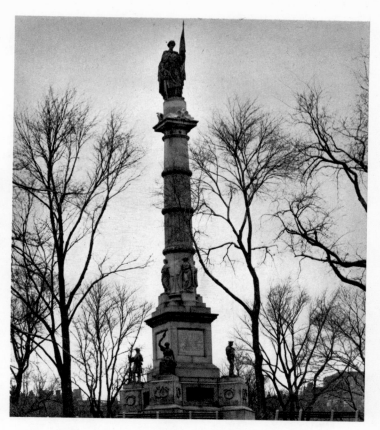

702 Martin Milmore. Soldiers and Sailors Monument. 1868. Forest Hills Cemetery, Roxbury, Mass.

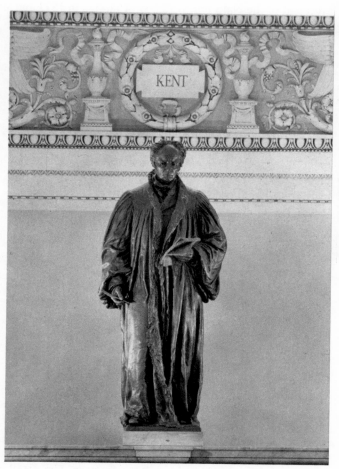

701 George Edwin Bissell. *Chancellor James Kent*. 1899. Bronze, heroic size. Library of Congress, Washginton, D.C.

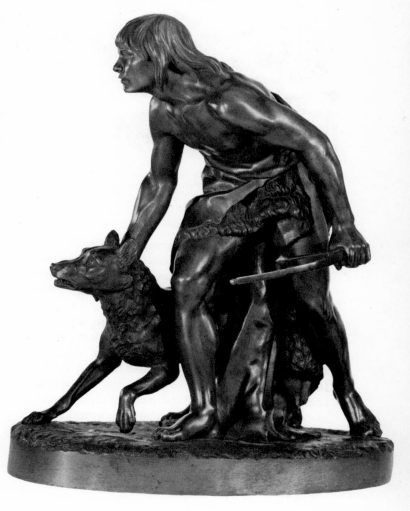

703 John Quincy Adams Ward. *Indian Hunter*. 1864. Bronze, height 16″. The New-York Historical Society

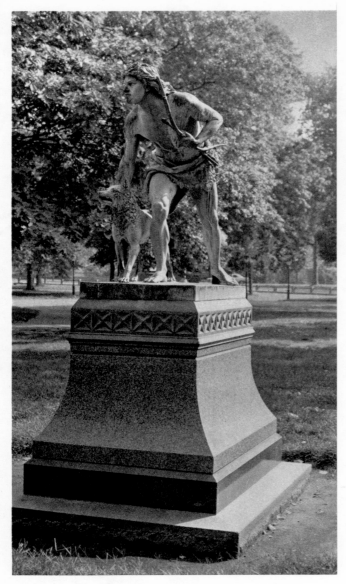

704 John Quincy Adams Ward. *Indian Hunter*. 1864. Bronze, height 10'. Central Park, New York

hunter's right arm and whipping the dog into line vitiated the power of the original sketch.

From then on Ward was caught up in the national passion for monuments. He executed war memorials, portrait statues, equestrian groups, allegorical figures, and architectural decorations with great success, became quite wealthy, and was much honored, being elected president of the National Academy of Design in 1873 and first president of the National Sculpture Society in 1893. No other artist of his time could match his prestige and power. Much of what he did is competent pomp, but everything he produced has a sense of scale and dignity, and some of his works are among the finest of American sculptural creations. He was not particularly good at historical subjects, though his *Lafayette* (1883, Burlington, Vt.) is an interesting conception and his *Washington* (1883, plate 705) is perhaps the most satisfying embodiment of the myth. One is surprised in the Garfield Monument (1887, Washington, D.C.) not so much at the pedestrian quality of the portrait figure of the President, whom Ward had not known, as at the exuberance of the pedestal figures. The winds of France had touched him by then, and nothing by an American of that period is any more authentically neo-Baroque.

Ward's real strength, as we know it, was in the present and the real, best seen in his *Horace Greeley* (1890) and the *Henry Ward Beecher* (1891). The *Greeley* (plate 706) is an antimonument monument, an attempt to realize an informal personality and pose within the limitations of a memorial, and the interplay of inconsequential detail and momentary action with profound feeling and dignity is quite remarkable. In contrast, the *Henry Ward Beecher* was intended as heroic, with the figure of the preacher conceived as a monolithic bulk on wide-planted legs capped by an arrogant leonine head. The intimacy and warmth of the preliminary study (plate 707) was transmuted in the monument in Borough Hall Square, Brooklyn, into public stance and intellectual power. The detail of dress was played down, emphasizing the enfolding cloak and focussing attention on the rugged and time-battered face. The pedestal is totally Victorian and curiously apt, transforming the usual allegorical posturing of Beaux-Arts base figures into an anecdotal realism that reduces the austerity of both the man and the monument. The figures of the young black woman and the two children placing garlands at his feet, though on the sentimental side, are appealing and sculpturally well conceived and executed. Both the *Greeley* and the *Beecher* have a psychological depth and human understanding equaled only by the great portraits of Eakins.

Ward worked to the very end in his eightieth year, leaving a formidable array of public monuments from Vermont to South Carolina. He had carried the nineteenth-century native tradition of Realism about as far as it could go before it was overwhelmed by the grandiosities of Beaux-Arts internationalism.

the subject. It is carefully, compactly, almost academically composed, but the concentrated tautness in the movement of the man and dog is emotionally compelling and new to American sculpture. All at once, an American creation takes its place in the mainstream of Western male nude figure sculpture, not as an echo, a pastiche, or a plagiarism but as an original conception on its own terms. Ward avoided the heroic, though the group is more than a genre piece—detailed without distracting from the generalization of form, and self-consciously composed without falling into mannerism. These are no mean achievements. However, in the Central Park version the needless ethnic elaboration of the head and the compositional afterthoughts that resulted in raising the

67 Mary Cassatt. *The Bath*. 1892. Oil on canvas, 39½ × 26″. The Art Institute of Chicago. Robert A. Walker Fund

68 John Singer Sargent. *Daughters of Edward Darley Boit*. 1882. Oil on canvas, 87″ square. Museum of
Fine Arts, Boston. Gift of Mary Louisa Boit, Florence D. Boit, Jane Hubbard Boit, and Julia Overing
Boit, in memory of their father

69 Winslow Homer. *Croquet Scene*. 1866. Oil on canvas, $15\frac{7}{8} \times 26''$. The Art Institute of Chicago

70 Winslow Homer. *Gloucester Harbor and Dory*. 1880. Watercolor, 9 × 13¼″. Fogg Art Museum, Harvard
University, Cambridge, Mass.

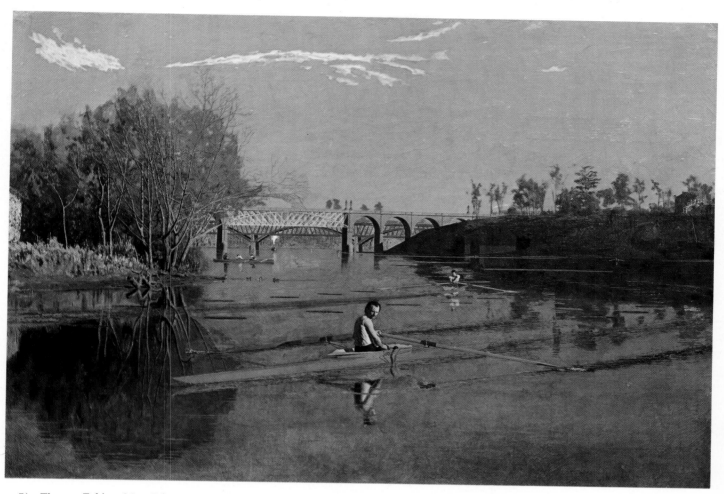

71 Thomas Eakins. *Max Schmitt in a Single Scull.* 1871. Oil on canvas, 32¼ × 46¼″. The Metropolitan
Museum of Art, New York. Alfred N. Punnett Fund and gift of George D. Pratt, 1934

72 Eastman Johnson. *Corn Husking at Nantucket.* 1876. Oil on canvas, 25⅝ × 54¼″. The Metropolitan
Museum of Art, New York. Rogers Fund, 1907

73 Frank Duveneck. *Elizabeth Boott Duveneck*. 1888. Oil on canvas, 65⅜ × 34¾″. Cincinnati Art Museum. Gift of the artist

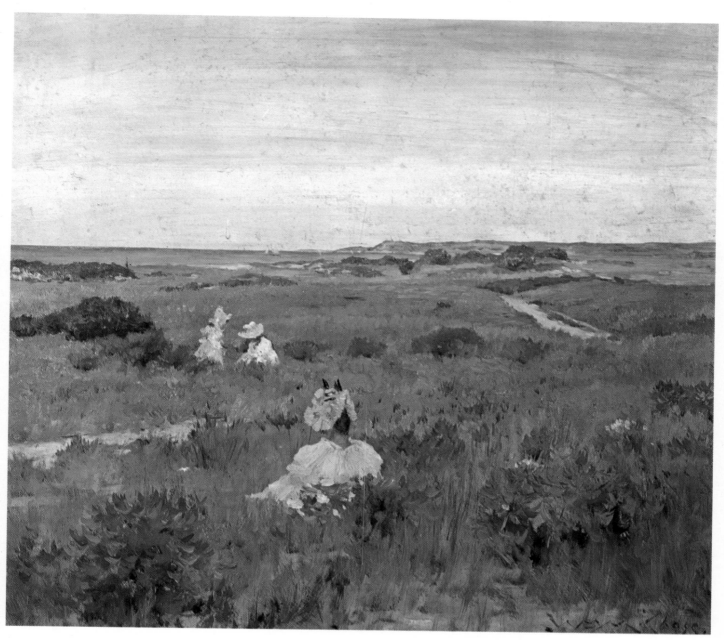

74 William Merritt Chase. *Landscape: Shinnecock, Long Island.* c. 1895. Oil on panel, 14¼ × 16″. The Art
Museum, Princeton University, Princeton, N.J.

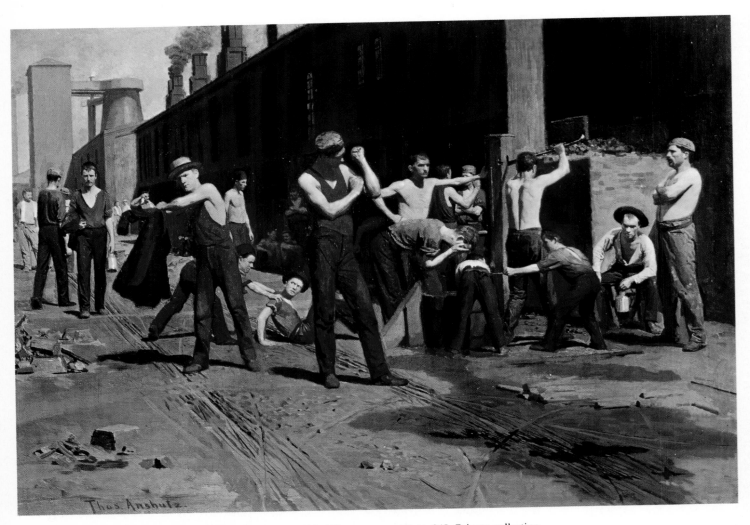

75 Thomas P. Anshutz. *Steelworkers—Noontime*. c. 1882. Oil on canvas, 17 × 24″. Private collection.
Courtesy Kennedy Galleries, Inc., New York

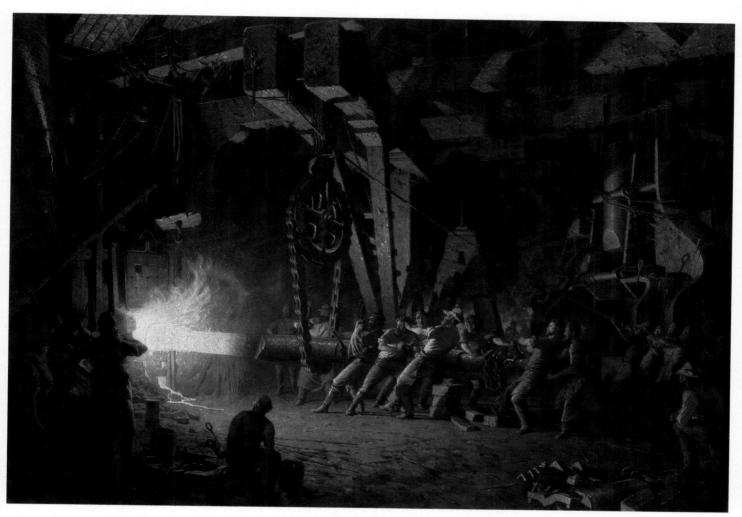

76 John F. Weir. *Forging the Shaft: A Welding Heat*. 1877. Oil on canvas, 52 × 73¼″. The Metropolitan Museum of Art, New York. Gift of Lyman G. Bloomingdale, 1901

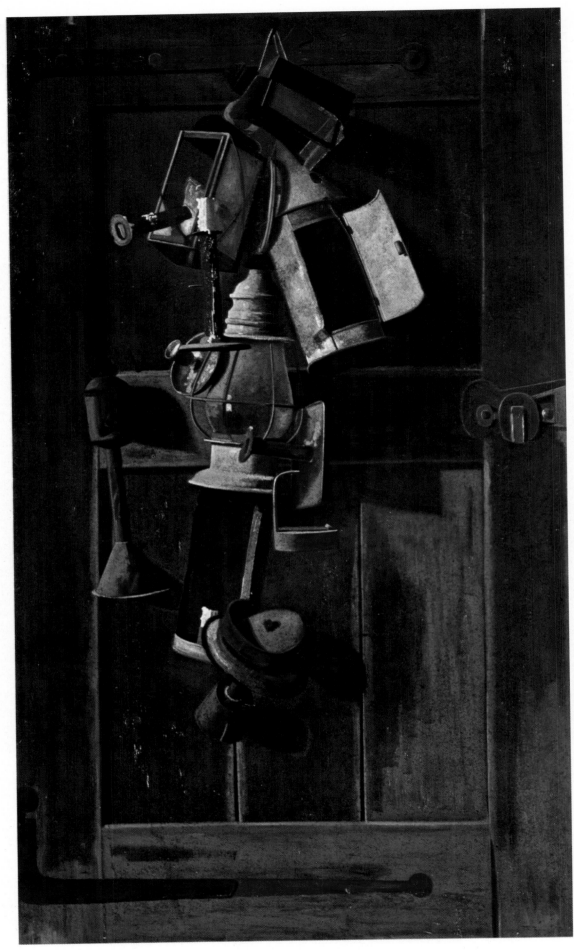

77 John Frederick Peto. *Still Life with Lanterns*. After 1890. Oil on canvas, 50 × 30″. The Brooklyn Museum. Dick S. Ramsay Fund

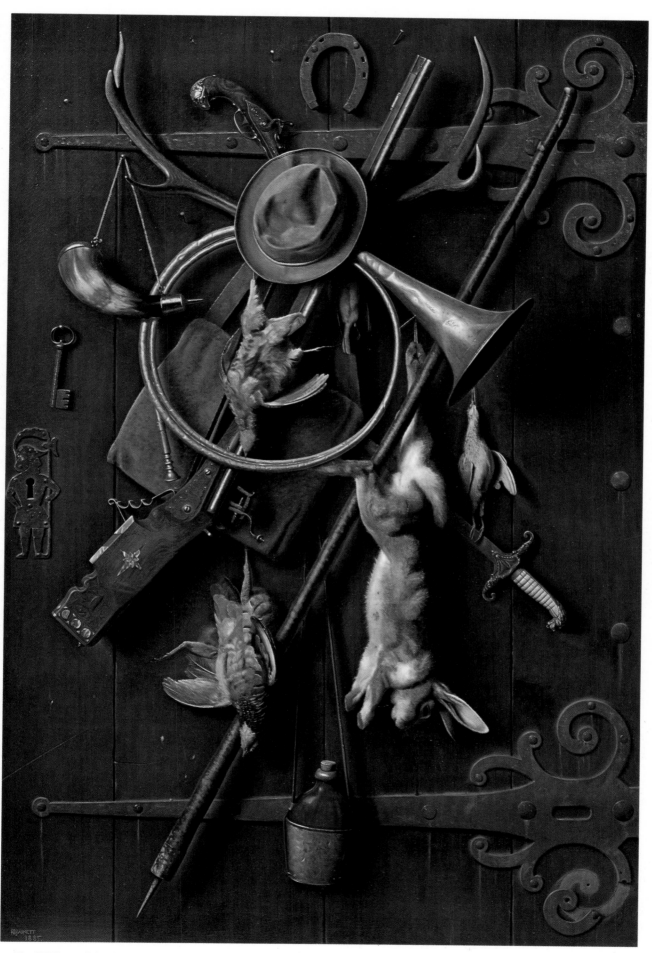

78 William Michael Harnett. *After the Hunt*. 1885. Oil on canvas, 71 × 48″. The Fine Arts Museums of
San Francisco. Mildred Anna Williams Collection

79 William Morris Hunt. *The Flight of Night*. 1878. Oil and chalk on canvas, 62 × 99″. The Pennsylvania
Academy of the Fine Arts, Philadelphia

80 John La Farge. *Greek Love Token*. 1866. Oil on canvas, 24 × 13″.
National Collection of Fine Arts, Smithsonian Institution, Washington, D.C.

81 Albert Pinkham Ryder. *The Dead Bird*. 1890–1900. Oil on wood, 4¼ × 9⅞″. The Phillips Collection, Washington, D.C.

82 Ralph Albert Blakelock. *Moonlight, Indian Encampment*. n.d. Oil on canvas, 26½ × 33¾″. National Collection of Fine Arts, Smithsonian Institution, Washington, D.C.

83 Homer Dodge Martin. *Harp of the Winds: A View on the Seine*. 1895. Oil on canvas, 28¾ × 40¾″. The
Metropolitan Museum of Art, New York. Gift of Several Gentlemen, 1897

84 Theodore Robinson. *Port Ben, Delaware and Hudson Canal*. 1893. Oil on canvas, 30½ × 34¾″. The Pennsylvania Academy of the Fine Arts, Philadelphia

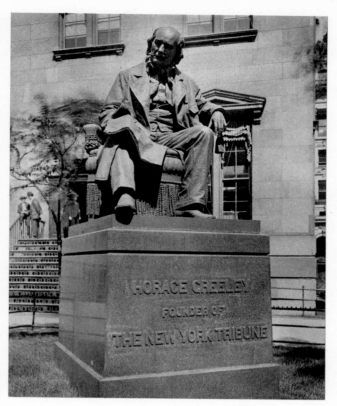

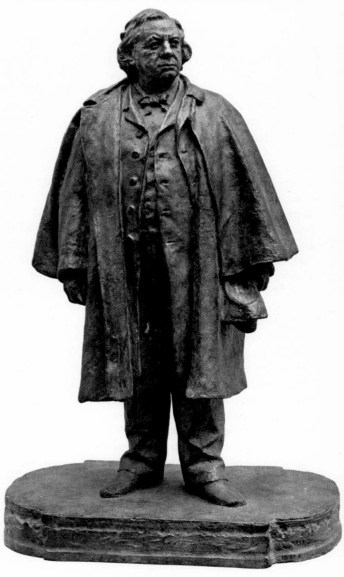

705 Above: John Quincy Adams Ward. *George Washington*. 1883. Bronze, heroic size. Federal Hall National Memorial, New York

706 Above right: John Quincy Adams Ward. *Horace Greeley*. 1890. Bronze, heroic size. City Hall Park, New York

707 Below right: John Quincy Adams Ward. *Henry Ward Beecher*. 1891. Bronze, height $14\frac{1}{2}''$. The Metropolitan Museum of Art, New York. Rogers Fund, 1917

BEAUX-ARTS—THE FIRST PHASE

In the decade following the Civil War, there were evidences of change in sculpture, though somewhat later and not so far-reaching or profound as in painting. Quincy Ward and his generation working in the United States had done much to give the native tradition of naturalism a new depth and vitality. And, despite the acclaim for Neoclassicists at the Centennial Exposition, three young sculptors, presaging a new direction in American sculpture, were showing their first works with some success. Olin Levi Warner, Augustus Saint-Gaudens, and Daniel Chester French were to lead American sculpture back to Europe and on to new heights of international recognition. Saint-Gaudens and Warner turned to Paris in the late 1860s, rather than Rome or Florence, and established it as the spiritual home of American sculptors for more than half a century.

It is a clue to the basically academic and conservative nature of American sculpture in the late nineteenth century that Saint-Gaudens and Warner both enrolled in the École des Beaux-Arts, the bastion of French academicism. Practically all the leading American sculptors in Paris were students there or studied with the same academicians —Jouffroy, Falguière, Mercié, Cavelier, Chapu, Frémiet. The turn to Paris in this first phase was part of a general cultural catching-up after the Civil War, a rejection of provincial naturalism and a search for new sources and directions. But only too soon, beginning with the 1880s, as sculpture became more closely connected with the grandiose architecture of academic eclecticism and "imperial Classicism," the second phase assumed the rhetorical bombast of the Beaux-Arts manner.

Saint-Gaudens and French were the legitimate artistic heirs to Quincy Ward's Realism, and Saint-Gaudens never entirely forgot that heritage, though both succumbed in different degrees to the insipid ideality of the Beaux-Arts style. Augustus Saint-Gaudens (1848–1907) was born in Dublin and brought to the United States as a child. At thirteen he was apprenticed to a cameo cutter and, while learning that craft, studied art at Cooper Union and the National Academy of Design. In 1867, with the support of his shoemaker father, he went to Paris and was admitted to the École des Beaux-Arts in the atelier of Jouffroy, one of the most celebrated of academicians. With the outbreak of the Franco-Prussian War, Saint-Gaudens moved on to Rome, where he spent two years. He made a living, as in Paris, by cutting cameos, but he also did bust portraits of Americans and began his first ideal piece, *Hiawatha,* which brought him his first patronage. After an interlude of two years in New York, he returned to Rome in 1874 to execute a commission for an ideal figure called *Silence* (plate 708), singled out by Wayne Craven as the birth of "a new kind of personification," described by Saint-Gaudens as "abstract," which was the stock-in-trade of Beaux-Arts

iconography. Though it was thought of as modern, there are antique precedents for this kind of allegorical system, philosophical rather than mythical, in which each symbol is a personification, usually a female figure, draped or nude, given self-explanatory or logical attributes. Instead of the Greek Mnemosyne as a stand-in for Memory, we have an unidentifiable nude looking into a mirror who could easily pass for Vanity, or given a sheaf of wheat, Agriculture. Unfortunately, what seemed a rational and modern substitution for an esoteric iconographic system of the past eventually turned into a stupefying repetition of meaningless figures. In Rome, Saint-Gaudens also developed an empathy for Italian *quattrocento* sculpture. He came back to America in 1875, with his underlying Realism hardly visible under layers of French surface vivacity, Renaissance elegance, and a dedication to ideality—all qualities which would be marketable in a *nouveau-riche* culture.

Saint-Gaudens had several pieces in the Centennial, and though he did not make a spectacular impression, he was thought of as one of the most promising men of the "new movement." He had also come to know Stanford White, McKim, and La Farge, men of great power in

708 Augustus Saint-Gaudens. *Silence.* 1874. Marble, height c. 8′. Masonic Home, Utica, N.Y.

aesthetic matters, and their conviction that Saint-Gaudens was America's greatest sculptor helped to establish him as such. In subsequent years he was to work with La Farge, on many important ventures with White, and also with McKim, as well as for the firm of McKim, Mead & White. From the outset Saint-Gaudens was an establishment artist. His aggressive role in the organization of the Society of Artists in 1877 was the result of outrage at being rejected at the annual Academy exhibition and was the last anti-establishment stand he took.

When he returned to Paris the same year, he had a series of important commissions to fill. The *Adoration of the Cross* for St. Thomas's Church in New York was part of a decorative project with La Farge. The eight-panel relief in painted plaster, destroyed by fire in 1905, was a conscious paraphrase of fifteenth-century Italian relief sculpture, as fine an example of academic eclecticism as the buildings of his architect friends. But the major project of those years was the bronze Admiral David Glasgow Farragut monument (1878–81, colorplate 89). He received the commission on the recommendation of Quincy Ward, and the result projected Ward's Realism into a new age so aptly that it unquestionably influenced Ward's own later *Beecher*. The figure itself is deceptively simple, the body encased in the most unheroic of costumes, the massive head topped by a ridiculous naval cap, yet what comes through is the commanding presence of a seaman, feet planted firmly apart on a rolling deck, eyes fixed on the distance. Only one flap of the coat answers to the breeze; the rest is adamant physical and mental resolution. It is an essentially naturalistic portrait, with just enough surface animation, especially in the face, to raise it above the literal. It has often been noted that the figure is reminiscent of Donatello's *St. George* for the facade of Orsanmichele, Florence, but this is no plagiarism; it is a brilliant re-creation that projects the same elevated spiritual force. Except for Quincy Ward's *Beecher*, the *Farragut* is the high point of Realist sculpture in nineteenth-century America. The stone base, designed by Stanford White, seems almost a stylistic contradiction. The exedra shape and the low relief carving are innovations in American memorial sculpture, reflecting White's brilliant decorative sense. The faintly Pre-Raphaelite allegorical figures are obviously the result of Saint-Gaudens's concern with instant ideality, but the Art Nouveau handling of masses, sharp definition of edges, slightly eccentric forms, and intricate rhythmic linear patterns of drapery and waves are certainly White's. The elegance and abstraction of the pedestal serve as a remarkable foil to the rugged reality of the figure.

In 1881 Saint-Gaudens settled in New York and in the next two decades established himself as the leading "modern" American sculptor. He was active in the decoration of the Vanderbilt and Villard Houses, including a series of relief medallions. From his early cameo-cutting days, he had shown a preference for relief carving and, over the years, had executed portraits, memorials, and decorative plaques in that form, with sensitivity, decorative flair, and a decided pseudo-Renaissance flavor. He was also increasingly occupied with major commissions, on which he was assisted during the eighties by the young Frederick MacMonnies and the recently arrived Alsatian, Philip Martiny, among others, as well as by his faithful younger brother, Louis. In those years, he executed the standing *Abraham Lincoln* (1887, plate 709) for Chicago's Lincoln Park, probably the most famous image of the President, which, though handled rather broadly, curiously recalls the wooden poses and literal naturalism of an earlier era. In contrast, *The Puritan: the Deacon Samuel Chapin* in Springfield, Mass., unveiled the same year, is an entirely modern conception, an imaginary reconstruction of a personality that is a theatrical fabrication, faithful in detail but not convincing as reality.

Perhaps his most famous work, often considered the high point of nineteenth-century American sculpture, is the Adams Memorial (1886–91, plate 710), commissioned by Henry Adams in memory of his wife. A radical departure in funerary monuments, it consists of a shrouded figure in bronze, seated on a rough boulder and backed by a granite plinth of Classical design. The brooding figure belongs within the province of philosophical allegory but is so broadly defined that it is susceptible of a variety of interpretations from the banal to the profound —and, in its day, from sacrilege to universal truth. Aside from its philosophic intentions, it is a handsome sculptural form with a richly worked surface, and it is a pity that the ideal figure under that magnificent drapery is rather commonplace. During this period, Saint-Gaudens also produced his only ideal nude, the chaste and elegantly mannered *Diana* (1892), a 13-foot hammered-copper weathervane for Stanford White's Madison Square Garden, now in the Philadelphia Museum.

Saint-Gaudens had been working on the Robert Gould Shaw Memorial (plate 711) since 1884, and it was not finished until twelve years later. Its heroic relief form was another innovation in American memorial sculpture, though it is reminiscent of similar reliefs in Roman art. The enframement of the action and the floating figure of Victory recall the Arch of Titus; the rhythmic pattern of marching troops, the military reliefs of Trajan's Column. It is, however, not a revivalist work, except for the incongruous intrusion of the Victory in a realistic conception. Saint-Gaudens successfully fused a noble idea with naturalistic detail, returning to the core of American Realism, and without idealization conveyed the heroic dedication of the anonymous, yet individualized, black troops and of the modest leader, who, ramrod straight on a mettlesome horse, seems so vulnerable in his historic mission. In its sincerity and unassuming literalness, it is the most moving of all Civil War memorials, revealing his great strength as a Realist and a portraitist.

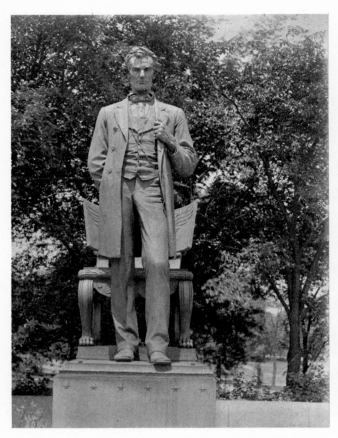

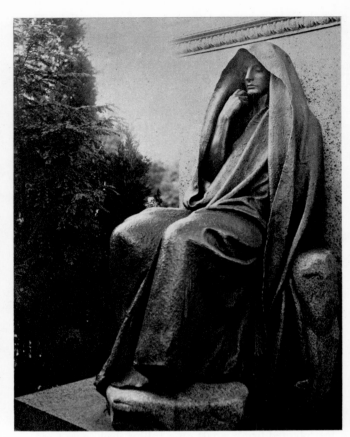

709 Augustus Saint-Gaudens. *Abraham Lincoln.* 1887. Bronze, height 11′6″. Lincoln Park, Chicago. Courtesy Chicago Historical Society

710 Augustus Saint-Gaudens. Adams Memorial. 1886–91. Bronze, height 70″. Rock Creek Cemetery, Washington, D.C.

He almost matched this in the more flamboyant and intentionally heroic *General William Tecumseh Sherman* (1897–1903, plate 712), his last major monument. Both as a portrait and as an equestrian statue, it is a brilliant performance, the finest of the genre in America. The lean, surging animal and the alertly poised rider make a dynamic group. The surface handling is a tour de force of jewelry-like finish, a demonstration of his technical skill but rather excessive in a monument of that scale. Though he thought that his Americanized Nike leading Sherman was "the grandest 'Victory' anybody ever made," she is both physically and aesthetically distracting, too real to be ideal and too ideal for the reality of the horse and rider.

Saint-Gaudens enriched as well as compromised the American Realist tradition. French training gave his work a new sensuousness and sophistication, but his penchant for the ideal, which seems a throwback to Neoclassicism, led American sculpture once again into a period of intellectual vapidity, though he himself did not succumb entirely to the pomp of "imperial Classicism." His sharp and penetrating sense of reality sets his work apart even from that of the other Realists, and his standard of technical excellence and refinement of taste were unmatched in his time.

Olin Levi Warner (1844–1896) was never so successful or influential as Saint-Gaudens. He entered the Beaux-Arts shortly after Saint-Gaudens and studied with Jouffroy and then with Carpeaux, whose assistant he became. After serving in the French Foreign Legion during the Franco-Prussian War, he could have remained with Carpeaux, but in 1872 he returned to the United States, where he had to maintain himself with hack decorative design. At the Centennial he gained some recognition and during the late seventies and early eighties slowly built a reputation with his delicate portrait medallions and graceful statuettes, of which the *Diana* (1883, colorplate 90) is the most noted. It could pass for the work of any French student of Jouffroy in its self-conscious search for classical purity of form and refinement of surface.

Warner began to receive monumental commissions, such as the *William Lloyd Garrison* (1885) from Boston, and by 1893 he was at work on projects for the Columbian Exposition, for which he served on the sculpture jury and designed the souvenir silver half-dollar. Having finally achieved national recognition, he was awarded the commission for the bronze doors of the new Library of Congress building, but he completed only one before his death. His was essentially a minor talent best seen in the

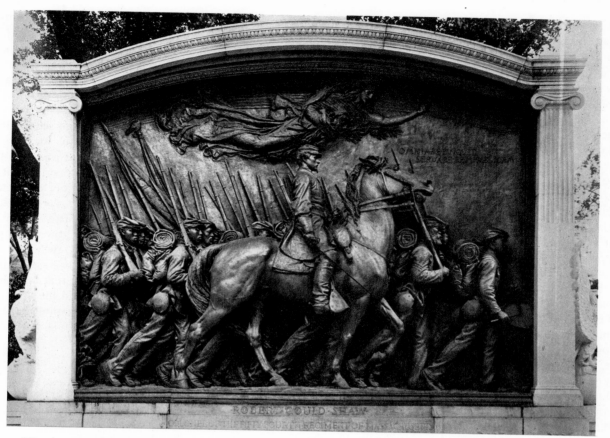

711 Augustus Saint-Gaudens. Robert Gould Shaw Memorial. 1884–96. Bronze, height c. 10′. Boston Common

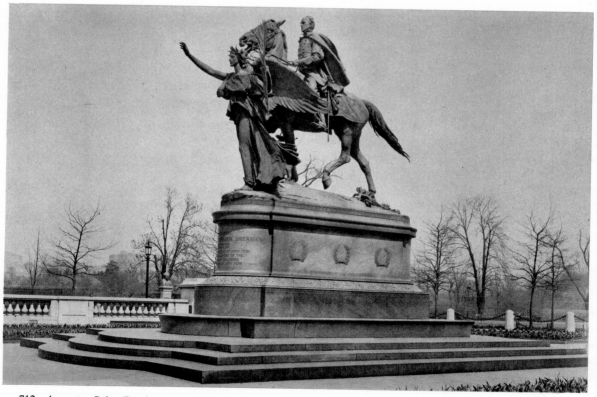

712 Augustus Saint-Gaudens. *General William Tecumseh Sherman.* 1897–1903. Bronze, heroic size. Central Park, New York

gemlike perfection of the small medallion portraits of Indian chiefs done during his travels through the Northwest Territory (1889–91).

The transition to the second phase of the Beaux-Arts style is best exemplified by the career of Daniel Chester French (1850–1931). Born in Exeter, N.H., the son of a successful lawyer, he was raised in Cambridge and then Concord, Mass., where he was given some instruction in sculpture by Abigail May Alcott. One of his earliest works was called *Joe's Farewell* (1871), a literary genre piece based on an incident in Dickens's *Barnaby Rudge*. The statuette was mass-produced and won him local acclaim, an indication of the innate feeling for the popular that was to inform all his art. French studied drawing with William Morris Hunt, heard Rimmer lecture on anatomy, and worked briefly with Quincy Ward. Local favor led to a commission for a monument commemorating the centennial of the Battle of Concord. The famous *Minute Man* (1873–74, colorplate 91) was cast in bronze and erected at the bridge in Concord in 1875 amid much pomp; a bronze replica exhibited at the Centennial the following year helped establish his reputation. The sculpture, an imaginary portrait of Captain Isaac Davis, the first officer killed in the battle, reveals French's uncanny ability to translate myth into common experience. He transformed a Classical model (said to have been a cast of the *Apollo Belvedere*) through naturalistic detail into a popular, patriotic, and palpably American image. Despite a thinness in modeling and a certain lack of sophistication, the figure has an undeniable verve and directness, and the composition is managed with competence.

French could hardly have savored his success, for he was already in Florence working with Thomas Ball and inevitably fell under the Classical spell. On his return to the United States, he settled in Washington, where his father was Assistant Secretary of the Treasury, and in the next decade he executed many portraits and received commissions for monumental allegorical statuary in new public buildings of the post-Centennial period, among them the St. Louis Customs House (1878), the U.S. Court House, Philadelphia (1879), and the Boston Post Office (1882), none of which were of much moment. His finest portraits of that period are the *Ralph Waldo Emerson* bust (1879, plate 713) and the seated *John Harvard* (1884) for Harvard University. French knew Emerson well and captured his appearance and spirit with remarkable fidelity but with a new breadth and *élan,* a noteworthy advance in American Realism. One can understand why Emerson said of it, "That is the face I shave every morning."

By 1886 French was in Paris to execute a statue of General Lewis Cass, destined for Statuary Hall, and while there worked in the studio of Mercié. Curiously, the *Gallaudet and His First Deaf-Mute Pupil* (1888, Columbia Institute for the Deaf, Washington, D.C.), done after his return to New York, shows little Parisian influence (the

monument is a sentimental costume piece, a blowup of a typical literary Rogers Group), but everything he did after that was pure Beaux-Arts ideality. French became *the* sculptor of "imperial Classicism." Well into the twentieth century, his studio produced a staggering sequence of monuments and architectural decoration. French was prolific, indefatigable, and very successful. The amalgam of exalted sentiment expressed in allegorical generality, ample though vapid Neoclassic forms, and ingratiating naturalistic detail produced a pseudo-heroic style to match the pomposities of "imperial Classical" architecture. None of his works is more characteristic than *The Angel of Death and the Sculptor* (1891–92, plate 714), a memorial to Martin Milmore. The conception of death arresting the hand of the creator at work is apt and even touching, but the matronly angel, swathed in voluminous drapery and sporting a set of oversized wings, is a typical, all-purpose Beaux-Arts prop that falls short of the tragic. The genre-like naturalism in the lithe boyish form of the living as against the idealization of the death symbol is telling, if obvious, perhaps explaining French's popularity and that of this work.

713 Daniel Chester French. *Ralph Waldo Emerson.* 1879. Bronze, height 23″. Chesterwood, a Property of the National Trust for Historic Preservation, Stockbridge, Mass.

714 Daniel Chester French. *The Angel of Death and the Sculptor*. 1891–92. Bronze, height 92″. Forest Hills Cemetery, Roxbury, Mass

BEAUX-ARTS—THE SECOND PHASE

While some of the older men, like French, moved into the second phase of the Beaux-Arts style, the majority of late nineteenth-century sculptors had just begun their careers before 1900. Most of their productive lives were still before them, but times were changing so rapidly that only their early work now has much validity. The two most interesting artists of this second generation reflect two different facets of French influence. Frederick MacMonnies was the culmination of the neo-Rococo phase of Beaux-Arts tradition and George Grey Barnard the harbinger of a new influence on the international scene, that of Rodin. That they both failed to respond to the challenge of a new age and succumbed to the lure of the grandiose is no denial of their original promise. They had at least opted for the new at one time.

Born in Brooklyn, Frederick William MacMonnies (1863–1937) showed an early interest in sculpture. He entered the Saint-Gaudens studio as a helper in 1881, was then a student, and later an assistant. He also attended the National Academy of Design and the Art Students League and, in 1884, went to Paris to study with Mercié

and with Falguière, whose assistant he became, absorbing the spiritual vivacity and the impressionist surface that were the hallmarks of that master's style. MacMonnies's first major effort, the *Diana* (1889), shows why he was called the "American Falguière." From his Paris studio in the next decade came an incredible range of projects. He established himself on a par with Saint-Gaudens and French, while adding a new lightness and verve to the fabric of American sculpture. In 1890 he was at work on three major commissions, the *Nathan Hale* for City Hall Park, New York, the *James S. T. Stranahan* for Prospect Park, Brooklyn, and three angels for St. Paul's Church, New York. In its basic naturalism the *Hale* (plate 715) recalls French's *Minute Man* (colorplate 91) and has a similar alertness and sense of vitality, but it is more theatrical and less convincing, almost feminine in mien, more like a dancing master than a schoolteacher. Perhaps the lack of masculine vigor was his legacy from Falguière and the neo-Rococo. In the early nineties MacMonnies did a series of delightful statuettes, preludes to his notorious *Bacchante*.

Once again America was faced with the problem of nudity in art, and this time in unequivocal terms. The *Bacchante and Infant Faun* (1893, colorplate 92) was a

715 Frederick MacMonnies. *Nathan Hale*. 1890. Bronze, heroic size. City Hall Park, New York

frankly sensuous, gamboling nude female that, in spite of its Beaux-Arts elegance and idealization, was seen as wanton. It may have been the expression of carefree joy in nakedness and movement that disturbed the defenders of moral rectitude, but ostensibly it was her "drunken indecency" that impelled the Women's Christian Temperance Union to join with Harvard's artistic arbiter, Charles Eliot Norton, to expel it from the new Boston Public Library. Charles McKim, who had received it as a gift from the sculptor, then offered it to the Metropolitan Museum of Art, where the trustees accepted it. The public scandal did not hurt MacMonnies's artistic standing, but his reputation as the *enfant terrible* of American sculpture followed him through his career, erupting much later in the controversy over his *Civic Virtue* or the "Fat Boy," as it was called, in New York's City Hall Park.

Although MacMonnies's grand opus at the Chicago Fair (plate 584), the centerpiece of the lagoon, borders on the absurd, it was proof that he could handle Beaux-Arts pomposity with the requisite aplomb. He had his spate of public commissions—a *Sir Harry Vane* for the Boston Public Library, a *Shakespeare* for the Library of Congress, and the monumental statuary for the Brooklyn Memorial Arch in the Prospect Park Plaza. The apogee of such activities was the *Horse Tamers* (c. 1900), a spectacular group of rearing animals and restraining male nudes, now also in Prospect Park Plaza. The surging mass is a demonstration of Beaux-Arts skill and bravura modeling. After the turn of the century, MacMonnies's work grew formally more flaccid as nineteenth-century allegorical symbolism continued to lose its relevance.

George Grey Barnard (1863–1938) stands somewhat apart from the second generation of American Beaux-Arts sculptors, but he shares with them a dedication to a monumental, allegorical, idealized art. Like Rodin, though perhaps not on the same scale, he had an aura of radicalism that was unsettling to his contemporaries. For instance, five of his works went to the Armory Show in 1913. For a time, at least, it seemed that he did not fit the pattern of "imperial Classicism" and that his genius could not be contained by the formulas of academic sculpture.

Raised in the Midwest, Barnard at first had to support himself as a jewelry engraver and later managed to study sculpture at the Chicago Art Institute, where he was inspired by the Michelangelo casts. By 1883 he had saved enough money to go abroad. He attended the École des Beaux-Arts, but his major influence was Rodin, whose source was also Michelangelo. Barnard spent almost a decade in Paris in poverty, virtual isolation, and struggle to achieve a personal style and to find a means of expressing humanity's most profound emotions, for he was intent on challenging the ages.

In 1886 Alfred Corning Clark saw the *Crouching Boy* (c. 1884) in Barnard's studio, paid for its execution in marble, and became his major support. Through Clark

Barnard got his first large commission, the memorial to the Norwegian poet Severin Skovgaard (1887), set up in Langesund, Norway. In 1888 he began work on what he called "the group," which went through a rather complex evolution, beginning with a quotation from a poem of Victor Hugo, "Je sens deux hommes en moi," and is now entitled *Struggle of the Two Natures in Man* (plate 716). The gigantic tableau took six years from clay to marble, and Barnard did the cutting himself, except for the preliminary roughing from the plaster. In those years he appears almost to have avoided public exposure, but in 1894, when the *Two Natures* was exhibited at the Salon, along with five others of his pieces, Barnard was an overnight sensation. The *Two Natures* heralded the arrival of a new and impressive talent. Though reminiscent of Michelangelo and Rodin, it had an air of originality, of a personal involvement, and it was executed with consummate skill and with a broadness that appeared modern. The theme seemed to transcend the allegorical clichés of the Beaux-Arts repertory and to reach into the wells of human memory for some profound psychic insight into heroic form. That it seems today artistically overblown and philosophically turgid may be a matter of taste.

Praised by Rodin, lauded by the critics, Barnard had attained an enviable international reputation. With the death of A. C. Clark in 1896, the *Two Natures* went to the Metropolitan Museum, but in the same year Barnard had a disappointing exhibition in New York. The American art world was less ready than the French for innovations. Thereafter Barnard worked on a series of individual pieces, of which *The Hewer* (1896–1902, plate 717), a brilliant Michelangelesque variation, is probably the most notable. In 1901 he replaced Saint-Gaudens at the Art Students League and in the following year undertook the mammoth project for the Capitol at Harrisburg, Pa., which absorbed him until its completion, on a much reduced scale, in 1910 and was an unfortunate anticlimax to an earlier career of bright promise. He had loomed as a protean figure, the greatest sculptor America had produced, but the colossal conceptions intended to equal Michelangelo's had become charades.

Among the many other sculptors of that generation trained at the École were Herbert Adams (1858–1945), who developed an individual and mannered portrait style derived from Italian Renaissance polychrome busts (plate 718), but he, too, was caught up in the passion for monumental sculpture. Paul Wayland Bartlett (1865–1925), the son of the Boston sculptor Truman Bartlett, was taken to Paris as a child and had a thorough training in art, including study with Frémiet, the *animalier,* at the Jardin des Plantes. He later executed many imaginary portrait statues in a typical Beaux-Arts popular genre style, among them a *Michelangelo* (c. 1898, plate 719) and a *Columbus* (c. 1898) for the Library of Congress. He is probably best known for the very elegant equestrian *Lafayette* (1899–1907) in the Louvre court, paid for by the pennies of

716 George Grey Barnard. *Struggle of the Two Natures in Man.* Completed 1894. Marble, 8'5½" × 8'3". The Metropolitan Museum of Art, New York. Gift of Alfred Corning Clark, 1896

717 George Grey Barnard. *The Hewer.* 1896–1902. Marble, height c. 7'. Private collection, New York

Sculpture: Mostly Monumental 593

718 Herbert Adams. *Primavera*. 1893. Polychromed marble, height 21½″. Corcoran Gallery of Art, Washington, D.C.

straw) for expositions or in permanent stone or bronze for public buildings, the sculptures produced had the common characteristics of the Beaux-Arts style—monumental scale, idealized conception, and generalized iconography. Within this framework it is difficult to single out what was specifically American or noteworthy.

The career of Karl Bitter (1867–1915) was abetted after his arrival in the United States in 1888 by the firm of Richard Morris Hunt. Bitter collaborated with Hunt on Biltmore and then on the Administration Building at the Columbian Exposition, where he was in charge of the execution of twenty-two colossal groups. He was in great demand by other architects, was active at the major expositions, and executed many public monuments. Philip Martiny (1858–1927) first worked in the United States as an assistant to Saint-Gaudens, through whom he met McKim. Hired to decorate the Agricultural Building of McKim, Mead & White at the Chicago Fair, he produced in the short time allotted an amazing galaxy of lively decorative figure groups. He had countless commissions and, like Bitter, with whom he worked, was prodigiously productive. Somewhat less prolific were Isadore Konti (1862–1938), who came to the United States in 1891 and began his career here as an assistant to Bitter at the Chicago Fair; the ultraconservative Frederick Wellington Ruckstull (1853–1942), who wielded too

American school children in a gesture of reciprocity for the French gift of Bartholdi's *Statue of Liberty*.

The Columbian Exposition put the final cachet on Beaux-Arts sculpture, which, in the mid-eighties, became the handmaiden of "imperial Classical" architecture. The scale of such building called for a monumental decorative art, and the Beaux-Arts architects sought their counterparts among the sculptors. Even European sculptors such as Karl Bitter and Isadore Konti from Vienna, Philip Martiny from Strasbourg, and John Massey Rhind from Edinburgh, all trained in the international Beaux-Arts tradition, were attracted to emigrate and supplement the roster of American sculptors working on public projects. And the sequence of international expositions, beginning with the Columbian in Chicago—the Pan-American in Buffalo in 1901, the Louisiana Purchase in St. Louis in 1904, and the Panama-Pacific in San Francisco in 1915 —provided financial and aesthetic support for a generation of American and European Beaux-Arts sculptors. The Beaux-Arts-dominated National Sculptors Society, formed in 1893, established a virtual monopoly in the field that persisted well into the twentieth century. The demand led to the growth of large sculpture ateliers, such as those of Saint-Gaudens, French, and Karl Bitter. Whether executed in impermanent staff (plaster and

719 Paul Wayland Bartlett. *Michelangelo*. c. 1898. Bronze, heroic size. Library of Congress, Washington, D.C.

much influence in the National Sculptors Society for the good of American sculpture; Charles Henry Niehaus (1855–1935), trained in Munich, the only American of that generation not to study in France, who added a stolid and meticulous realism to the Beaux-Arts spectrum; and the Rodinesque Charles Grafly. Whatever their original talents, they were all converted by the necessities of the situation into contractors rather than creators of sculpture.

THE "WILD WEST"

The earlier concern among American artists about American subjects was overwhelmed by the international character of the Beaux-Arts style and its "abstract" allegorical themes, except in the renewal of the connection with the native past. Toward the end of the century there was a growing awareness that the West was rapidly becoming "civilized." The Columbian Exposition helped focus attention on the beginnings of our national history and on the West, and much of the statuary at the Fair was concerned with the denizens, both human and animal, of the wilderness. The sculptors whose themes were Indians, pioneers, cowboys, and animals formed a more or less cohesive group; they often worked in several categories, and a surprising number came from the West. What may have set this group somewhat apart from the *fin-de-siècle* Beaux-Arts men, though many came out of the same French ateliers, was that they were recapitulating in their art, not the acceptable formulas of the studio, but the memory of their own experience.

By the end of the century the Indian wars were over, the Indian was no longer a threat, and a process of romanticization set in. The Indian became a symbol of our vanished past. The theme continued in isolated instances after the Centennial among sculptors who had studied in Paris. John J. Boyle (1851–1917), who came from a family of stonecutters, was an Eakins pupil at the Pennsylvania Academy and in 1877 entered the École des Beaux-Arts. After his return to Philadelphia in 1880, he was commissioned by Martin Ryerson of Chicago, who was interested in Indians, to do *The Indian Family*, or *The Alarm* (Lincoln Park, Chicago), and then by the city of Philadelphia to do a similar group called *The Stone Age in America* (1886–88, plate 720). Both groups reveal a direct and uncomplicated Realism based on a study of Indian life that harks back to Quincy Ward rather than the École. The *Stone Age* is an admirable, broadly handled, forceful, even heroic conception. For the Buffalo exposition of 1901 Boyle did two monumental Indian groups in staff which were unfortunately never executed in permanent material. They were the last of his works on Indian themes.

Though he later became one of the more successful Beaux-Arts sculptors, Paul Bartlett made his debut with

720 John J. Boyle. *The Stone Age in America*. 1886–88. Bronze, life size. Fairmount Park, Philadelphia

an Indian subject. The *Bear Tamer* (1887, plate 721), his first major effort, is a charming genre scene, full of spirited action, naturalistic detail, and a lush handling of material, hardly the harsh realism of Boyle. Bartlett's Indian is an exoticism rather than a serious subject. Along with his *Ghost Dancer* (Pennsylvania Academy of the Fine Arts, Philadelphia), a strangely disturbing but more convincing piece, the *Bear Tamer* was exhibited at the Chicago Fair with marked success, but Bartlett did not pursue the theme any further.

Cyrus Edwin Dallin (1861–1944), the first American sculptor to dedicate himself to the Indian theme, grew up near Salt Lake City among the Utes and retained a lifelong affection for Indians. In 1880 he went to Boston, studied with Truman Bartlett, and two years later opened his own studio, where he produced his earliest Indian subjects. In 1888 he went to Paris and worked with Chapu at the Académie Julian. The arrival in Paris of Buffalo Bill's Wild West Show stirred memories of his early experience, and he began the first of his four monumental equestrian groups, the *Signal of Peace* (1889–90, plate 722). This was followed by the *Medicine Man* (1898–99,

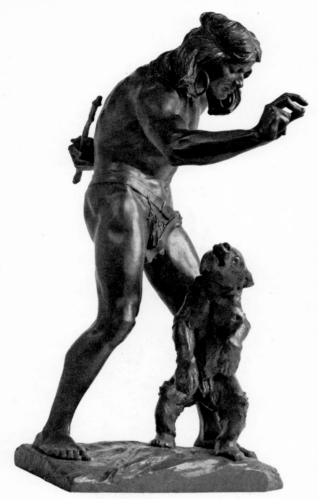

721 Paul Wayland Bartlett. *The Bear Tamer*. 1887. Bronze, height 68¼". Corcoran Gallery of Art, Washington, D.C. Gift of Mrs. Paul Wayland Bartlett

Proctor *Indian Scout,* the Dallin *Signal of Peace,* and the Bush-Brown *Buffalo Hunt*; in life, through Buffalo Bill's Wild West Show. There were a few tentative studies before he went to live among the Pueblo Indians. He had his first opportunity to utilize that experience in the four reliefs for the Marquette Building in Chicago. Then, in 1896 in Rome, he began working on a series of sculptures that established his reputation in the Indian field. *Sun Vow* (1898, plate 723), the most famous, shows no Neoclassic traces; it derives entirely from the French Beaux-Arts tradition in its mixture of graceful idealization and genre naturalism and in its vivacious and sensuous surface treatment. He was awarded a medal at the Paris Exposition of 1900, and his reputation as a sculptor of Indians led to commissions at the Pan-American Exposition for the pediment of the Anthropological Building and the *Despotic Age* group for the United States Government Building. He also executed the souvenir medal for the exposition. MacNeil continued to work on Indian themes until 1910, when he turned to the broader field of monumental and architectural sculpture.

Solon Hannibal Borglum (1868–1922) and his brother, Gutzon, were raised in Indian country, and most of Solon's work was concerned with western themes. Solon was born in Utah and was living as a rancher in Nebraska when his brother persuaded him to study art. At the Cincinnati Art School he won a scholarship in 1897 to study in Paris, where he worked under Frémiet and Puech. The sculptures of the next two years were on western subjects, spirited studies of horses with an occasional figure. On his return to the United States in 1899, he spent some time with his bride on an Indian reservation in North Dakota. He achieved his first recognition at the Paris Exposition of 1900, where he was awarded a silver medal for a series of three statuettes, among which was *On the Border of White Man's Land* (plate 724). The following year he had an exhibition in New York and an extensive collection of his small bronzes was shown at the Pan-American Exposition. For the St. Louis Fair he executed four large groups dealing with western life. Solon Borglum's knowledge of the West was personal and extensive; his modeling, in the *animalier* tradition, was full of movement and sparkle; the treatment of subject was melodramatic.

Most of the sculpture of John Gutzon Borglum (1871–1941) belongs in the twentieth century. He is best known for his colossal mountainside monuments, but his earliest sculpture was of western subjects. Born in the Idaho Territory, he studied painting first in San Francisco and Paris, and then sculpture with Mercié. His *Indian Scouts* was exhibited at the Chicago Fair, and the most famous of his early works, *The Mares of Diomedes* (1904, plate 725) at the St. Louis Exposition. In the latter, the surging action and impressionistic detail of the stampeding mustangs in mythological guise reflect the French *animalier* manner of Barye and Frémiet, rather than his later alle-

Fairmount Park, Philadelphia), done in Paris during a second visit while studying with Dampt; the *Protest* (c. 1904), executed in staff for the St. Louis exposition but never made permanent; and the *Appeal to the Great Spirit* (c. 1908, Museum of Fine Arts, Boston). Dallin's cycle is the epic of a race fated for extinction, from racial nobility, through the premonition of doom and the struggle against injustice, to tragic defeat. The conception is heroic and Romantic, the treatment broad and in the older tradition of native Realism, the detail ethnically accurate. Dallin's remain the most monumental and mythic images of the vanishing Indian.

Hermon Atkins MacNeil (1866–1947), an easterner, was born in Chelsea, Mass., and trained in Paris at the Académie Julian under Chapu and at the École under Falguière. He went to Chicago in 1891 to assist Philip Martiny on the Agricultural Building and did some work on his own on the Electricity Building. While there, he seems to have discovered the Indian—in art, through the

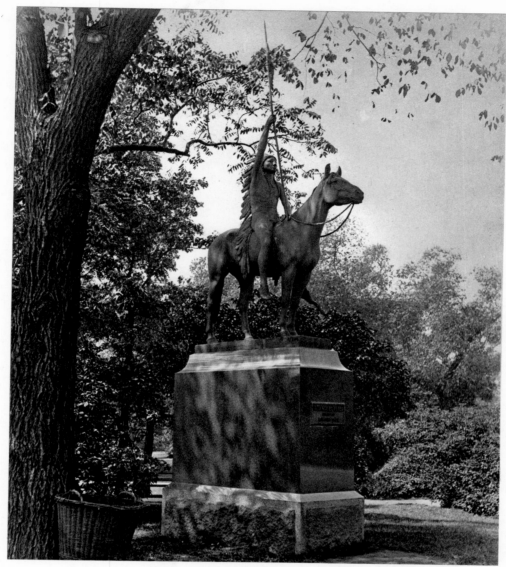

722 Cyrus Edwin Dallin. *A Signal of Peace*. 1889–90. Bronze, life size. Lincoln Park, Chicago. Courtesy Chicago Historical Society

giance to the heroic breadth of Rodin and Barnard.

Frederic Remington (1861–1909), the most famous illustrator of the West, turned to sculpture in 1895 with *The Bronco Buster* (colorplate 93), and before his death executed fifteen statuettes of cowboys, Indians, and Army troopers that were reproduced in large numbers and increased his already enormous popularity. Like his paintings and illustrations, they are shrewd, sharply observed, accurate, theatrical accounts of a romantic past. Remington very consciously exploited his own experience to create and maintain a myth; considering his lack of formal training in the medium, he did this with unusual verve and skill. Though the modeling is often too literal

and rather meager, verging at times on caricature, the statuettes exhibit an innate understanding of form and movement.

Alexander Phimister Proctor (1862–1950) is perhaps the most comprehensive of the western sculptors, covering the gamut of themes ranging in scale from statuette to monument. Born in Ontario and raised in Denver, his youthful experiences were of frontier life and the wilderness. He moved East in 1891 to study sculpture in New York and began to work on the decorations for the Columbian Exposition, for which he executed more than thirty-five animals. He also did two of the major sculptural groups at the Fair, the equestrian *Indian Scout* and

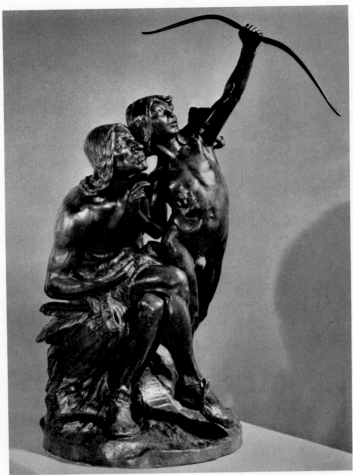

723 Hermon Atkins MacNeil. *Sun Vow*. 1898.
Bronze, height 73″. Whitney Gallery of American Art,
Cody, Wyo.

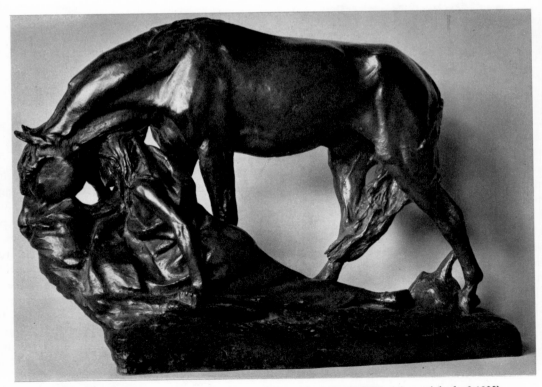

724 Solon Hannibal Borglum. *On the Border of White Man's Land*. 1906 (after original of 1899).
Bronze, height 19″. The Metropolitan Museum of Art, New York. Rogers Fund, 1907

725 John Gutzon Borglum. *The Mares of Diomedes*. 1904. Bronze, height 62″. The Metropolitan Museum of Art, New York. Gift of James Stillman, 1906

Cowboy that stood above the main basin. In addition, his *Charging Panther* was included in the fine arts exhibition and he was awarded a special medal for his contributions to the Fair. Although well launched as an animal sculptor, he left to study in Paris, but was soon called back by Saint-Gaudens to execute the horses for his equestrian statues of Generals Logan and Sherman (plate 712). Again in Paris in 1900 he won a gold medal with his *Indian Warrior* at the Exposition Universelle, for which he also executed the quadriga of the United States Building. From that time on Proctor was the most famous monumental animal sculptor in the country, but over the next half-century he executed a host of monuments on frontier themes, including cowboys and Indians.

Edward Kemeys (1843–1907) belonged to an older generation, but he came to art late and then only accidentally. He had been raised in New York City, fought through the Civil War, tried farming in Illinois, and was back working as a laborer in Central Park when he saw someone modeling a wolf's head at the zoo. His first sculpture, *Hudson Bay Wolves* (1871), produced without schooling, was an instant success and was bought for Philadelphia's Fairmount Park. From then on Kemeys dedicated himself to the study of the fauna of the American wilderness. The three statues he showed at the Centennial were well received. Abroad in 1877, he found neither the schools nor the zoos to his liking, but his *Bison and Wolves* met with success at the Salon of 1878. However, Kemeys never took to the French *animalier* tradition, retaining always a rather naive and direct Realism based on his naturalist interests. An ability to capture the character and personality of the animal in its natural habitat, as in the *Still Hunt* (1883, plate 726), made his work very popular. In 1892 he moved to Chicago, where he worked for the next eight years with regular hunting and sketching trips into the wilds. Kemeys executed many of the animal decorations at the Chicago Fair and was well represented in the fine arts section. The pair of bronze lions in front of the Chicago Art Institute also date from this period.

726 Edward Kemeys. *Still Hunt*. 1883. Bronze, 31 × 60″. Central Park, New York

Another animal sculptor at the turn of the century, Eli Harvey (1860–1957) found his animals in zoos rather than the wilderness, and was thoroughly trained at the Jardin des Plantes under Frémiet. Edward Clark Potter (1857–1923), the horse sculptor, was best known for his collaboration with Daniel Chester French on a series of equestrian monuments. He did several on his own and was also responsible for the supercilious lions in front of the New York Public Library. This tradition of animal sculpture was carried into the twentieth century by Frederick G. R. Roth (1872–1944), trained in Vienna and Berlin; Herbert Haseltine (1877–1962), in Munich, Rome, and Paris; and Anna Vaughn Hyatt Huntington (1876–1973), entirely in the United States.

The complacency in which American sculpture was bathed at the turn of the century is reflected in *The History of American Sculpture* (1903) by Lorado Taft. This publication deserves credit as the first attempt at a survey of American sculpture, even praise for its accomplishments, but it is now more interesting as an indication of the taste of a practicing Beaux-Arts sculptor, a member of the National Sculptors Society. It reveals a too easy acceptance of academic standards—lofty sentiment, idealized form, and technical skill—and of success as measured in public commissions, academic awards, and financial rewards. There is no sign of questioning. Aside from Barnard, Grafly, and Gutzon Borglum, who had responded to Rodin (not a very radical stance to assume at century's end), there seems to have been no awareness of the winds of change stirring abroad.

85　John Henry Twachtman. *The Hemlock Pool.* 1902. Oil on canvas, 30 × 25″. Addison Gallery of American Art, Phillips Academy, Andover, Mass.

86 Julian Alden Weir. *The Red Bridge*. 1895. Oil on canvas, 24¼ × 33¾". The Metropolitan Museum of
Art, New York. Gift of Mrs. John A. Rutherford

87 Right above: Childe Hassam. *Le Jour du Grand Prix*. 1888. Oil on canvas, 36 × 48". The New Britain
Museum of American Art, New Britain, Conn. Grace Judd Landers Fund

88 Right below: Thomas W. Dewing. *The Recitation*. 1891. Oil on canvas, 30 × 55". Detroit Institute of
Arts.

89 Augustus Saint-Gaudens. *Admiral David Glasgow Farragut*. 1878–81. Bronze and stone, heroic size.
Madison Square Park, New York

90 Olin Levi Warner. *Diana.* 1883. Bronze, height 23½ . The Metropolitan Museum of Art, New York.
Gift of the National Sculpture Society, 1898

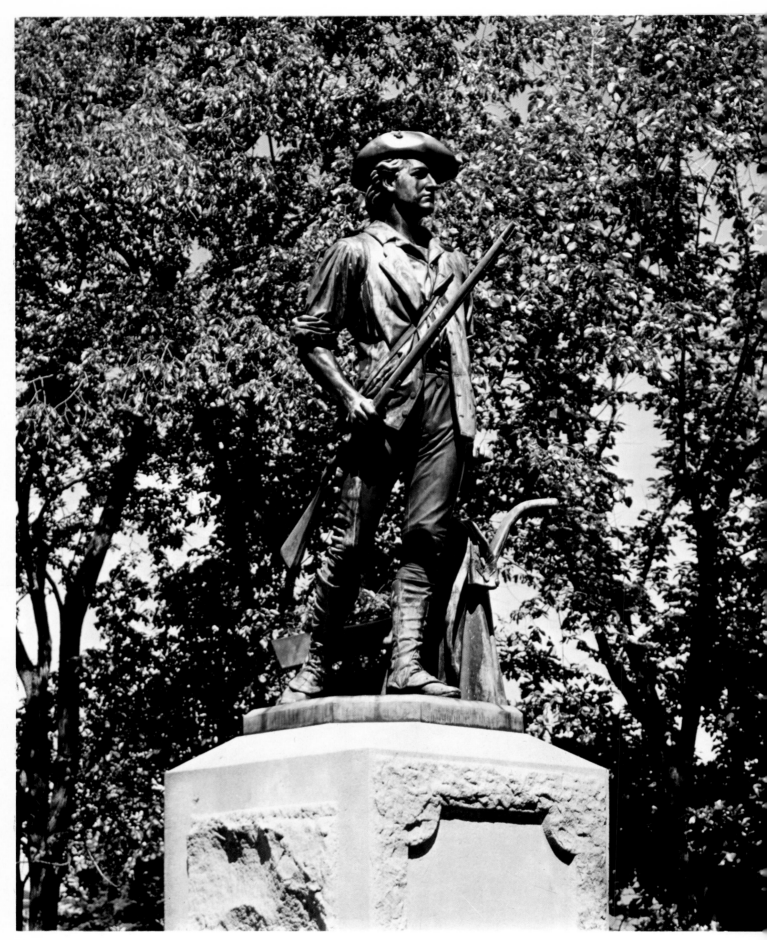

91 Daniel Chester French. *Minute Man*. 1873–74. Bronze, heroic size. Concord, Mass.

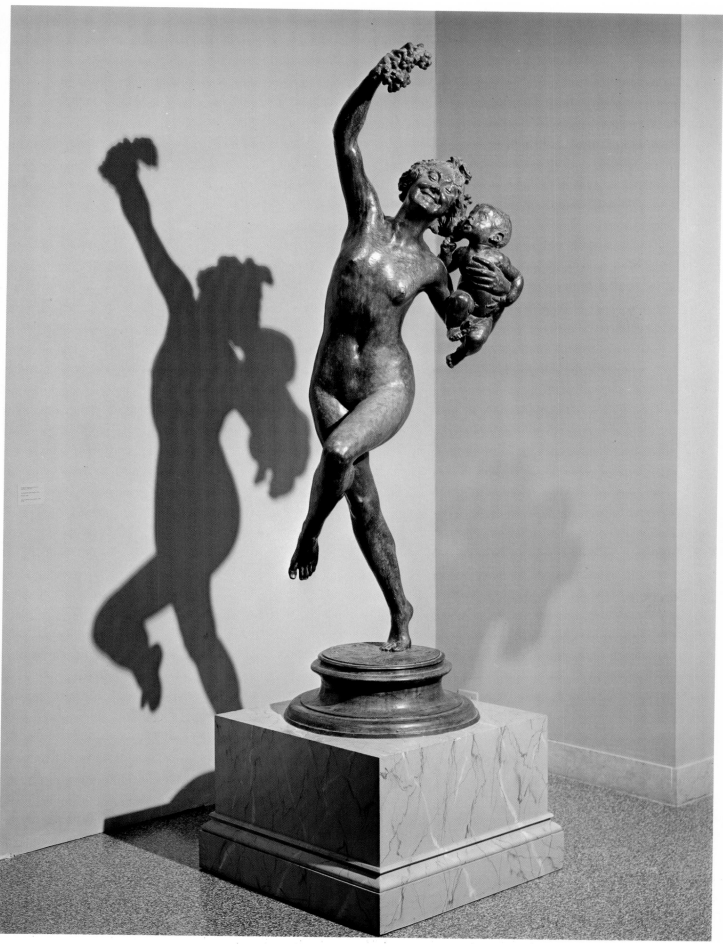

92 Frederick MacMonnies. *Bacchante and Infant Faun.* 1893. Bronze, height 83″. The Metropolitan Museum of Art, New York. Gift of Charles Follen McKim

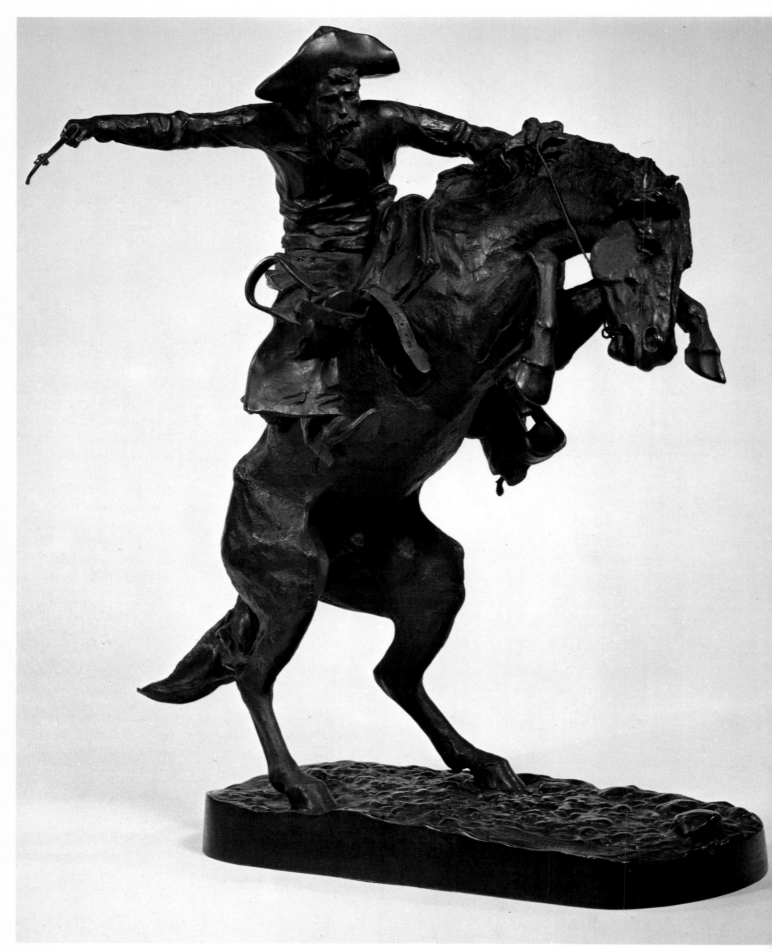

93 Frederic Remington. *The Bronco Buster*. 1895. Bronze, height 23″. National Cowboy Hall of Fame, Oklahoma City, Okla.

CONCLUSION

The Turn-of-the-Century Transition

The general historical consensus is that in the United States the period from about 1890 to 1910, or from the financial panic of 1893, coincidental with the Columbian Exposition, to the outbreak of World War I, was transitional. Much in the earlier decade presaged the twentieth century, while much in the later retained the character of the nineteenth. The 1890s, especially, witnessed the culmination of economic and social developments that had begun after the Civil War and were the fulfillment, in a sense, of the dream of American destiny. On the other hand, that last decade of the century saw also the acerbation of economic, social, political, and regional antagonism attendant on the country's phenomenal growth. It was the end of an era in its fruitions and failures, but it was also the beginning of a new one in the revolutionary scientific and technological advances that would transform the old and the evolutionary social and political forms to cope with such changes. By the end of the century industrial capitalism had reached monopolistic consolidation in almost all areas of the economy—in steel, oil, mining, utilities, railroads, finance, and from meat to tobacco. After the crash of 1893, this consolidation was intensified through the growing power of finance capital, preparing the way for the economy of the twentieth century.

Electricity, the automobile, the airplane, motion pictures, and somewhat earlier, the telegraph and telephone, and, somewhat later, radio, which have transformed the pattern of man's existence, serve to identify the twentieth century. The unprecedented immigration from eastern and southern Europe during these years increased the population enormously and drastically altered its ethnic and cultural composition. The immigrants, recruited to supply the demands of an expanding industrial economy, accelerated the trend toward urbanization. The majority, settling in the great cities, joined the increasing numbers of native-born displaced by the progressive mechanization of agriculture. The short and relatively painless Spanish-American War of 1898, from which the United States emerged with the new territories of Puerto Rico and the Philippines, was in a sense a symbolic climax to the imperial tendency that was to raise the United States to international dominance in the twentieth century.

Growth itself is not progress, and at the turn of the century the seams of the American polity were splitting. Everything had grown too rapidly and inequities were everywhere—in wealth, opportunity, status, and power. There was a dawning awareness of the prodigal squandering of natural resources, of the human cost in industrial expansion, of the subversion of government for private ends. There was perhaps no general consciousness that the roots of the dilemma were in the inequality of evolution between the scientific and technological advances upon which material progress was based and the social and political forms necessary to control and utilize its benefits. But reformers, and this was truly an era of reform, saw the problem in terms of the symptoms—poverty, injustice, corruption—or in terms of questions of land, labor, women, money. Battles were waged against the filth and degradation of slums, the corruption of politics, the power of trusts, the "robber barons," the evils of child labor and the sweatshop, the mistreatment of minorities, as well as demon rum. And the struggle for social justice had its effect eventually and in varying degrees in states and the nation beginning with the early years of the twentieth century. Tenement laws were passed; political parties were overhauled; electoral practices were transformed by the secret ballot, women's suffrage, direct primaries, the initiative and the referendum; a civil-service merit system was established; trusts were "busted" and public utilities controlled; an income tax to place some restriction on wealth was passed; child-labor laws were adopted, and regulations governing hours and conditions of labor were instituted, as was workmen's compensation; penal codes and the prison system were updated; intoxicating beverages were temporarily prohibited. Minorities received little benefit, but progress was made in general educational reforms, public health programs, and the conservation of natural resources.

American culture during these decades mirrors the ambivalence of looking backward to the nineteenth and forward to the twentieth century. It was insular, narrow-minded, self-satisfied, dominated by a provincial complacency that was the result of old ignorance and new wealth. American art had become essentially 'conservative. Academy exhibitions were invariably hailed as advances

over the previous year's, although they were really not much different. Artists who studied in the academies of Europe came into contact with and absorbed their standardized and spiritless products. Comparing themselves with European academicians, American artists were perhaps not unjustified in judging themselves the equals of what they thought was the best in European art. America was impressed by its recent artistic heroes: Inness, La Farge, Fuller, Martin, Wyant, Thayer, or George De Forest Brush in painting, and Quincy Ward, Saint-Gaudens, French, and Warner in sculpture. The international reputations of the renowned expatriates, Whistler, Sargent, and Cassatt, seemed to reinforce the belief in America's new artistic maturity, and no one was much perturbed that they had chosen to divorce themselves from American culture. Of the now revered trinity of "native" American artists, Homer, Eakins, Ryder, still active at the turn of the century, only Homer had achieved any kind of recognition.

In painting, "The Ten" had moved into prominence and remained dominant during the first decade of the twentieth century. But only in comparison with the academy could the members of this group appear progressive. The National Academy of Design was still dominated by the pseudo-classicism of Edwin Blashfield and Kenyon Cox; academic honors were showered upon such perennial favorite prize winners as Edward W. Redfield and Charles W. Hawthorne; and Cecilia Beaux, John W. Alexander, and Leopold Seyffert, to name only a few, were commanding stiff prices. Artistically, the "academy" was an agglomeration of many tendencies. In painting it included disciples of the Barbizon School, slick portraitists in the tradition of Sargent and Chase, remnants even of the Düsseldorf genre school, the brush wizards of Munich, students of the bastard style of French academic painting, Impressionists, proponents of the grand manner of Classicism and the Renaissance, and the various eclectic combinations and permutations of all these tendencies. In sculpture one found a provincial literal Realism, French academic elegance, or the beginnings of a Rodinesque grandeur. Most of it looked like decorative garden sculpture. The standards of judgment were technical proficiency and finish and conformity to some acceptable tradition, a scheme of things which left little room for the new or vital.

Organizationally, the academy was just as great a brake upon American art, its self-perpetuating membership contriving to stifle nonconformism through a rigid system of election of members. Such honor was conferred as a reward for compliance with its standards. The letters N. A. still carried status and affected sales. And the market for American art had become limited; dealers were handling either old masters or recognized academicians. The new museums and the great American collections then being formed were not primarily interested in American art. Nor were there many forums where an unknown or unconventional artist might be seen. The major markets or publicity channels for art were academy exhibitions in New York, Philadelphia, Boston, and Chicago, ruled by the twin evils of the "jury" and the "white card," systems preferential to members which produced both conformity and fierce competition. American artists had no *salon des refusés,* for the Society of American Artists had long since become another academy.

There was scarcely a hint of the twentieth century in American art of the last decade of the nineteenth. Radical, post-Impressionist developments in France were unknown. Of the then young men who would lead the American art world into the present, only Maurice B. Prendergast had some connection with and had been influenced by these developments in the nineties. Though exposed to the same currents, Robert Henri could not accept anything more radical than Manet as a point of departure. And Arthur B. Davies was a rather faint echo of the European symbolist movement. The "Ash Can" painters, George B. Luks, William J. Glackens, John Sloan, and Everett Shinn, were still working as newspaper illustrators and making their first forays into "art" under the aegis of Henri in Philadelphia during the nineties. MacMonnies' allegiance to Falguière and that of Barnard and the Borglum brothers to Rodin can hardly be called *avant garde.* At the close of the century, despite a burgeoning economy and a growing cultural sophistication, American art, committed to the false pomp of empire or disoriented from contemporary realities, appeared to be running down in a welter of confusion. It took the realism of the Ash Can School, though stylistically rooted in the art of the nineteenth century, to shepherd the twentieth century through its contemporary urban focus. Not until the second decade did American artists discover and begin to come to terms with modernism, the dominant stream in the art of the twentieth century.

Only in architecture, where the connections with economic and technological developments are more obvious, did the break from older, nineteenth-century attitudes and the embracing of newer conceptions surface in the 1890s, first in the Chicago School and then in the early work of Frank Lloyd Wright. Wright and his contemporaries of the second Chicago School—George B. Maher, William G. Purcell, George G. Emslie, Richard E. Schmidt, Hugh M. G. Garden—and of the California School—Charles S. and Henry M. Greene, Irving Gill, and even Bernard R. Maybeck—did most of their work in the twentieth century.

The year 1900, as a century marker, had more than the normal psychological impact of an epochal date. It heralded the twentieth century, which was from the start identified with modernity. The Paris Art Nouveau Exposition Universelle of that year was an exuberant introduction to a new age, closing a decade of *fin de siècle* doubt, introspection, and neuroticism that never touched America. Such attitudes were for older civilizations. America looked forward to the new century with unwitting optimism, to a new and more inclusive American destiny.

BIBLIOGRAPHY

SOURCES

Benjamin, Samuel Greene, *Art in America: A Critical and Historical Sketch*, New York: Harper, 1880.

Dunlap, William, *A History of the Rise and Progress of the Arts of Design in the United States*, 3 vols., rev. ed., New York: Benjamin Blom, 1965.

Jarves, James Jackson, *The Art-Idea* (1864), repr., Cambridge, Mass.: Belknap Press of Harvard University Press, 1960.

McCoubrey, John W., ed., *American Art 1700-1960: Sources and Documents*, Englewood Cliffs, N.J.: Prentice-Hall, 1965.

Tuckerman, Henry T., *Book of the Artists: American Artist Life* (1867), repr., New York: James F. Carr, 1966.

GENERAL

Cahill, Holger, and Alfred H. Barr, Jr., eds., *Art in America: A Complete Survey*, New York: Reynal & Hitchcock, 1935.

Fielding, Mantle, *Dictionary of American Painters, Sculptors, and Engravers*, Philadelphia: 1926; with addendum by James F. Carr, New York: J. F. Carr, 1965.

Goodrich, Lloyd, *Three Centuries of American Art*, New York: published for the Whitney Museum of American Art by Praeger, 1966.

Green, Samuel M., *American Art: A Historical Survey*, New York: Ronald Press, 1966.

Groce, George, and David Wallace, *The New-York Historical Society's Dictionary of Artists in America, 1564-1860*, New Haven: Yale University Press, 1957.

Hartmann, Sadakichi, *A History of American Art*, 2 vols., rev. ed., Boston: L. C. Page, 1932.

LaFollette, Suzanne, *Art in America, from Colonial Times to the Present Day*, New York and London: Harper, 1929.

Larkin, Oliver W., *Art and Life in America*, rev. and enl. ed., New York: Holt, Rinehart and Winston, 1960.

McCoy, Garnett, *Archives of American Art: A Directory of Resources*, New York: Bowker, 1972.

McLanathan, Richard, *The American Tradition in the Arts*, New York, Harcourt, Brace, and World, 1968.

Mendelowitz, Daniel M., *A History of American Art*, 2d ed., New York: Holt, Rinehart and Winston, 1970.

Pierson, William H., Jr., and Martha Davidson, *Arts of the United States: A Pictorial Survey*, New York: McGraw-Hill, 1960, repr., Athens, Ga.: University of Georgia Press, 1966.

SPECIAL TOPICS

Brooks, Van Wyck, *The Dream of Arcadia; American Writers and Artists in Italy 1760-1915*, New York: Dutton, 1958.

Clark, Eliot, *History of the National Academy of Design 1825-1953*, New York: Columbia University Press, 1954.

Fairman, Charles, *Art and Artists of the Capitol of the United States of America*, Washington, D.C.: United States Government Printing Office, 1927.

Harris, Neil, *The Artist in American Society: The Formative Years, 1790-1860*, New York: Braziller, 1966.

Kouwenhoven, John, *Made in America: The Arts in Modern Civilization*, New York: Norton, 1967.

Lynes, Russell, *The Art-Makers of Nineteenth-Century America*, New York: Atheneum, 1970.

————, *The Tastemakers*, New York: Harper, 1954.

Miller, Lillian, *Patrons and Patriotism, The Encouragement of the Fine Arts in the United States, 1790-1860*, Chicago and London: University of Chicago Press, 1966.

Saarinen, Aline, *The Proud Possessors: The Lives, Times, and Tastes of Some Adventurous American Art Collectors*, New York: Random House, 1958.

Stein, Roger B., *John Ruskin and Aesthetic Thought in America, 1840-1900*, Cambridge, Mass.: Harvard University Press, 1967.

ARCHITECTURE: GENERAL

Andrews, Wayne, *Architecture, Ambition and Americans*, New York: Harper, 1955.

————, *Architecture in America; A Photographic History from the Colonial Period to the Present*, New York: Atheneum, 1960.

Burchard, John, and Albert Bush-Brown, *The Architecture of America; A Social and Cultural History*, Boston: Little, Brown, 1961.

Coles, William A., and Henry Hope Reed, Jr., eds., *Architecture in America; A Battle of Styles*, New York: Appleton-Century-Crofts, 1961.

Early, James, *Romanticism and American Architecture*, New York: A. S. Barnes, 1965.

Fein, Albert, *Frederick Law Olmsted and the American Environmental Tradition*, New York: Braziller, 1972.

Fitch, James Marston, *American Building: The Historical Forces That Shaped It*, 2d ed., Boston: Houghton, Mifflin, 1966; rev. and enlarged, New York: Schocken, 1973.

——, *Architecture and the Aesthetics of Plenty*, New York: Columbia University Press, 1961.

Giedion, Sigfried, *Space, Time and Architecture*, 5th ed., Cambridge: Harvard University Press, 1967.

Gowans, Alan, *Images of American Living; Four Centuries of Architecture and Furniture as Cultural Expression*, Philadelphia: Lippincott, 1964.

Hitchcock, Henry-Russell, *Architecture, Nineteenth and Twentieth Centuries*, Harmondsworth, England, and Baltimore: Penguin Books, 1958.

Kaufmann, Edgar, Jr., ed., *The Rise of an American Architecture*, New York: Praeger, 1970.

Kimball, Sidney Fiske, *American Architecture*, Indianapolis: Bobbs-Merrill, 1928; repr. New York: AMS Press, 1970.

Kostof, Spiro, ed., *The Architect: Chapters in the History of the Profession*, New York: Oxford University Press, 1977.

Moore, Charles, Gerald Allen, and Donlyn Lyndon, *The Place of Houses*, New York: Holt, Rinehart and Winston, 1974.

Reps, John William, *The Making of Urban America; A History of City Planning in the United States*, Princeton: Princeton University Press, 1965.

Sanford, Trent, *The Architecture of the Southwest; Indian, Spanish, American*, New York: Norton, 1950.

Sky, Alison, and Michelle Stone, *Unbuilt America*, New York: McGraw-Hill, 1976.

Tallmadge, Thomas E., *The Story of Architecture in America*, new ed., New York: Norton, 1936.

Wrenn, Tony P., and Elizabeth D. Mulloy, *America's Forgotten Architecture*, by the National Trust for Historic Preservation, New York: Pantheon, 1976.

ARCHITECTURE: SPECIAL TOPICS

Colonial: General

Briggs, Martin S., *The Homes of the Pilgrim Fathers in England and America (1620-1685)*, London: Oxford University Press, 1932.

Eberlein, Harold, and Cortland Hubbard, *American Georgian Architecture*, Bloomington, Ind.: Indiana University Press, 1952.

Howells, John M., *Lost Examples of Colonial Architecture*, New York: Helburn, 1931.

Kimball, Sidney Fiske, *Domestic Architecture of the American Colonies and of the Early Republic*, New York: Scribner's, 1927; Dover, 1966.

Morrison, Hugh, *Early American Architecture, from the First Colonial Settlements to the National Period*, New York: Oxford University Press, 1952.

Newcomb, Rexford, *Spanish-Colonial Architecture in the United States*, New York: J. J. Augustin, 1937.

Pierson, William H., *American Buildings and Their Architects*, vol. 1 (the Colonial and Neoclassical Styles), Garden City, N.Y.: Doubleday, 1970.

Waterman, Thomas T., *The Dwellings of Colonial America*, Chapel Hill: University of North Carolina Press, 1950.

Colonial: Regional

Downing, Antoinette F., *Early Homes of Rhode Island*, Richmond, Va.: Garrett & Massie, 1937.

——, and Vincent J. Scully, Jr., *The Architectural Heritage of Newport, Rhode Island, 1640-1915*, Cambridge: Harvard University Press, 1952; 2d ed., New York: C. N. Potter, 1970.

Eberlein, Harold D., *The Manors and Historic Houses of the Hudson Valley*, Philadelphia and London: Lippincott, 1924.

Forman, Henry, *The Architecture of the Old South: The Medieval Style, 1585-1850*, Cambridge: Harvard University Press, 1948.

Garvan, Anthony, *Architecture and Town Planning in Colonial Connecticut*, New Haven: Yale University Press, 1951.

Hitchcock, Henry-Russell, *Rhode Island Architecture*, Providence: Rhode Island Museum Press, 1939.

Johnston, Frances, and Thomas T. Waterman, *The Early Architecture of North Carolina*, Chapel Hill: University of North Carolina Press, 1941.

Kubler, George, *The Religious Architecture of New Mexico in the Colonial Period and Since the American Occupation*, Colorado Springs: Taylor Museum, 1940.

Reynolds, Helen W., *Dutch Houses in the Hudson Valley before 1776*, New York: Payson & Clarke, 1929.

Waterman, Thomas T., and John A. Barrows, *Domestic Colonial Architecture of Tidewater Virginia*, New York: Scribner's, 1932; Da Capo, 1968.

——, *The Mansions of Virginia, 1706-1776*, Chapel Hill: University of North Carolina Press, 1946.

Nineteenth Century

Aidaca, Thomas, *The Great Houses of San Francisco*, New York: Knopf, 1974.

Barlow, Elizabeth, *Frederick Law Olmsted's New York*, New York: Praeger, 1972.

Condit, Carl W., *American Building Art: The Nineteenth Century*, New York: Oxford University Press, 1960.

——, *The Chicago School of Architecture; A History of Commercial and Public Building in the Chicago Area, 1875-1925*, Chicago: University of Chicago Press, 1964.

——, *The Rise of the Skyscraper*, Chicago: University of Chicago Press, 1952.

Coolidge, John, *Mill and Mansion: A Study of Architecture and Society in Lowell, Massachusetts, 1820-1865*, New York: Columbia University Press, 1942.

Frary, Ihna T., *They Built the Capitol*, Richmond, Va.: Garrett & Massie, 1940.

Gifford, Don, ed., *The Literature of Architecture: the Evolution of Architectural Theory and Practice in Nineteenth-Century America*, New York: Dutton, 1966.

Hamlin, Talbot F., *Greek Revival Architecture in America*, London: Oxford University Press, 1944.

Huxtable, Ada Louise, *The Architecture of New York: A History and Guide*, vol. 1 (Classic New York: Georgian Gentility to Greek Elegance), Garden City, N.Y.: Anchor Books, 1964.

Jackson, John Brinkerhoff, *American Space: The Centennial Years: 1865–1876*, New York: Norton, 1972.

Kidney, Walter C., *The Architecture of Choice: Eclecticism in America, 1880-1930*, New York: Braziller, 1974.

Kilham, Walter H., *Boston After Bulfinch; An Account of Its Architecture 1800-1900*, Cambridge: Harvard University Press, 1946.

Lancaster, Clay, "Oriental Forms in American Architecture, 1800-1870," *Art Bulletin*, vol. 29, Sept. 1947, pp. 83-93.

Meeks, Carroll, *The Railroad Station; An Architectural History,* New Haven: Yale University Press, 1956.

———, "Romanesque Before Richardson in the United States," *Art Bulletin,* vol. 35, March 1953, pp. 17-33.

Mumford, Lewis, *The Brown Decades; A Study of the Arts in America, 1865-1895,* 2d rev. ed., New York: Dover Publications, 1955.

———, *Sticks and Stones; A Study of American Architecture and Civilization,* 2d rev. ed., New York: Dover Publications, 1955.

Noffsinger, James P., *The Influence of the École des Beaux-Arts on the Architecture of the United States,* Washington, D.C.: Catholic University of America Press, 1955.

Schuyler, Montgomery, *American Architecture and Other Writings,* 2 vols., William H. Jordy and Ralph Coe, eds., Cambridge: Belknap Press of Harvard University Press, 1961.

Scully, Vincent J., *The Shingle Style: Architectural Theory and Design from Richardson to the Origins of Wright,* New Haven: Yale University Press, 1955.

Stanton, Phoebe B., *The Gothic Revival and American Church Architecture; An Episode in Taste, 1840–1856,* Baltimore: Johns Hopkins Press, 1968.

Teitelman, Edward, and Richard W. Longstreth, *Architecture in Philadelphia,* Cambridge, Mass.: M.I.T. Press, 1974.

Whiffen, Marcus, *American Architecture Since 1780: A Guide to the Styles,* Cambridge: M.I.T. Press, 1969.

ARCHITECTS

BUCKLAND Beirne, Rosamond, and John Henry Scarff, *William Buckland, 1734–1774, Architect of Virginia and Maryland,* Baltimore: Maryland Historical Society, 1958.

BULFINCH Place, Charles A., *Charles Bulfinch, Architect and Citizen,* Boston and New York: Houghton Mifflin, 1925.

BURNHAM Hines, Thomas S., *Burnham of Chicago, Architect and Planner,* New York: Oxford University Press, 1974.

Moore, Charles, *Daniel H. Burnham, Architect, Planner of Cities,* Boston and New York: Houghton Mifflin, 1921.

FURNESS O'Gorman, James F., *The Architecture of Frank Furness,* Philadelphia: Philadelphia Museum of Art, 1973.

HARRISON Bridenbaugh, Carl, *Peter Harrison, First American Architect,* Chapel Hill: University of North Carolina Press, 1949.

JEFFERSON Frary, Ihna T., *Thomas Jefferson, Architect and Builder,* Richmond, Va.: Garrett & Massie, 1939.

Jefferson, Thomas, *Thomas Jefferson, Architect; Original Designs in the Collection of Thomas Jefferson Coolidge, Jr., with an Essay and Notes by Fiske Kimball,* Cambridge: Riverside Press, 1916.

Lehmann, Karl, *Thomas Jefferson, American Humanist,* New York: Macmillan, 1947.

LAFEVER Landy, Jacob, *The Architecture of Minard Lafever,* New York: Columbia University Press, 1970.

LATROBE Hamlin, Talbot, *Benjamin Henry Latrobe,* New York: Oxford University Press, 1955.

McINTIRE Kimball, Sidney Fiske, *Mr. Samuel McIntire, Carver, The Architect of Salem,* Portland, Me.: published for the Essex Institute of Salem, Mass., by the Southworth-Anthoensen Press, 1940.

McKIM Granger, Alfred H., *Charles Follen McKim; A Study of His Life and Work,* Boston: Houghton Mifflin, 1913.

Moore, Charles, *The Life and Times of Charles Follen McKim,* Boston: Houghton Mifflin, 1929.

McKim, Mead and White, *A Monograph of the Work of McKim, Mead and White, 1879–1915,* 4 vols., New York: Architectural Book Publishing Company, 1915.

MILLS Gallagher, Helen, *Robert Mills, Architect of the Washington Monument, 1781–1855,* New York: Columbia University Press, 1935.

RICHARDSON Hitchcock, Henry-Russell, *The Architecture of H. H. Richardson and His Times,* New York: The Museum of Modern Art, 1936.

STRICKLAND Gilchrist, Agnes Addison, *William Strickland, Architect and Engineer, 1788–1854,* enl. ed., New York: Da Capo, 1969.

SULLIVAN Bush-Brown, Albert, *Louis Sullivan,* London: Mayflower, 1960.

Duncan, Hugh Dalziel, *Culture and Democracy; The Struggle for Form in Society and Architecture in Chicago and the Middle West During the Life and Times of Louis H. Sullivan,* Totowa, N.J.: Bedminster Press, 1965.

Morrison, Hugh, *Louis Sullivan, Prophet of Modern Architecture,* New York: Peter Smith, 1952.

Paul, Sherman, *Louis Sullivan, An Architect in American Thought,* Englewood Cliffs, N.J.: Prentice-Hall, 1962.

TOWN & DAVIS Newton, Roger Hale, *Town and Davis, Architects, Pioneers in American Revivalist Architecture, 1812–70,* New York: Columbia University Press, 1962.

UPJOHN Upjohn, Everard M., *Richard Upjohn, Architect and Churchman,* New York: Columbia University Press, 1939.

WHITE Baldwin, Charles, *Stanford White,* New York: Dodd, Mead, 1931.

WRIGHT *Frank Lloyd Wright,* introd. and notes by Martin Pawley, New York: Simon and Schuster, 1970.

Manson, Grant, *Frank Lloyd Wright to 1910: The First Golden Age,* New York: Reinhold, 1958.

Storrer, William Allin, *The Architecture of Frank Lloyd Wright,* Cambridge, Mass.: M.I.T. Press, 1974.

Twombly, Robert C., *Frank Lloyd Wright: An Interpretive Biography,* New York: Harper and Row, 1973.

PAINTING: GENERAL

Barker, Virgil, *American Painting: History and Interpretation,* New York: Macmillan, 1950.

Caffin, Charles, *The Story of American Painting: The Evolution of Painting in America from Colonial Times to the Present,* New York: Frederick A. Stokes, 1907; repr., New York, Johnson Reprint Corporation, 1970.

Gardner, Albert Ten Eyck, and Stuart P. Feld, *American Painting, a Catalogue of the Collection,* vol. I, New York: Metropolitan Museum of Art, 1965.

Howat, John K., and John Wilmerding, *Nineteenth-Century America: Paintings and Sculpture,* Greenwich, Conn.: New York Graphic Society, 1970.

Isham, Samuel, *The History of American Painting,* New York: Macmillan, 1905, new ed. with supplemental chapters by Royal Cortissoz, New York: Macmillan, 1927.

McCoubrey, John, *American Tradition in Painting,* New York: Braziller, 1963.

Prown, Jules David, *American Painting: From Its Beginnings to the Armory Show,* vol. I, Geneva, Switzerland: Skira Publishers, 1969.

Richardson, Edgar, *Painting in America: The Story of 450 Years,* New York: T. Y. Crowell, 1956.

PAINTING: SPECIAL TOPICS

The Arcadian Landscape: Nineteenth-Century American Painters in Italy, Lawrence, Kans.: University of Kansas Museum of Art, 1972.

Baur, John I. H., *American Painting in the Nineteenth Century: Main Trends and Movements,* New York: Praeger, 1953.

Bermingham, Peter, *American Art in the Barbizon Mood,* Washington, D.C.: Smithsonian Institution Press, 1975.

Black, Mary, and Jean Lipman, *American Folk Painting,* New York: C. N. Potter, 1966.

Blashfield, Edwin Howland, *Mural Painting in America,* New York: Scribner's, 1913.

Born, Wolfgang, *American Landscape Painting; An Interpretation,* New Haven: Yale University Press, 1948.

————, *Still-life Painting in America,* New York: Oxford University Press, 1947.

Boyle, Richard J., *American Impressionism,* Greenwich, Conn.: New York Graphic Society, 1974.

Burroughs, Alan, *Limners and Likenesses: Three Centuries of American Painting,* Cambridge: Harvard University Press, 1936.

Callow, James T., *Kindred Spirits; Knickerbocker Writers and American Artists, 1807–1855,* Chapel Hill: University of North Carolina Press, 1967.

Chamberlain, Georgia Stamm, *Studies on American Painters and Sculptors of the Nineteenth Century,* Annandale, Va.: Turnpike Press, 1965.

Curry, Larry, *The American West: Painters from Catlin to Russell,* New York: Viking Press, 1972.

Dawdy, Doris O., *Artists of the American West: A Biographical Dictionary,* Chicago: Swallow Press, 1974.

Detroit Institute of Arts, *The French in America, 1520–1880,* Detroit, 1951.

Dickson, Harold E., *Arts of the Young Republic; The Age of William Dunlap,* Chapel Hill: University of North Carolina Press, 1968.

Domit, Moussa M., *American Impressionist Painting,* Washington, D.C.: National Gallery of Art, 1973.

Drepperd, Carl, *American Pioneer Arts and Artists,* Springfield, Mass.: Pond-Ekberg Company, 1942.

Ewers, John C., *Artists of the Old West,* New York: Doubleday, 1973.

Fink, Lois, *Academy: The Academic Tradition in American Art,* Washington, D.C.: Smithsonian Institution Press, 1975.

Flexner, James, *First Flowers of Our Wilderness,* Boston: Houghton Mifflin, 1947.

————, *The Light of Distant Skies, 1760–1835,* New York: Harcourt, Brace, 1954.

————, *That Wilder Image; The Painting of America's Native School from Thomes Cole to Winslow Homer,* Boston: Little, Brown, 1962.

Frankenstein, Alfred, *The Reality of Appearance: The Trompe l'Oeil Tradition in American Painting,* Greenwich, Conn.: New York Graphic Society, 1970.

From Realism to Symbolism, Whistler and His World, exhibition, New York: Columbia University, 1971.

Gerdts, William H., *The Great American Nude: A History in Art,* New York: Praeger, 1974.

————, and Russell Burke, *American Still-life Painting,* New York: Praeger, 1971.

Goodrich, Lloyd, *American Genre; The Social Scene in Paintings and Prints (1800–1935),* New York: Whitney Museum of American Art, 1935.

Hagen, Oskar, *The Birth of the American Tradition in Art,* New York: Scribner's, 1940.

Hills, Patricia, *The American Frontier: Images and Myths,* New York: Whitney Museum of American Art, 1973.

————, *The Painters' America, Rural and Urban Life, 1810–1910,* New York: Praeger, 1974.

Hollmann, Clide Anne, *Five Artists of the Old West: George Catlin, Karl Bodmer, Alfred Jacob Miller, Charles M. Russell, and Frederic Remington,* New York: Hastings House, 1965.

Hoopes, Donelson F., *The American Impressionists,* New York: Watson-Guptill, 1972.

————, *The Beckoning Land; Nature and the American Artist: A Selection of Nineteenth-Century Paintings,* Atlanta, Ga.: The High Museum of American Art, 1971.

————, and Wend von Kalnein, *The Düsseldorf Academy and the Americans,* Atlanta, Ga.: The High Museum of American Art, 1972.

Howat, John K., and Dianne H. Pilgrim, *American Impressionist and Realist Paintings and Drawings from the Collection of Mr. and Mrs. Raymond J. Horowitz,* New York: The Metropolitan Museum of Art, 1973.

Landgren, Marchal E., *American Pupils of Thomas Couture,* College Park: University of Maryland, 1970.

Lipman, Jean, and Alice Winchester, eds., *Primitive Painters in America,* New York: Dodd, Mead, c. 1950.

Little, Nina Fletcher, *American Decorative Wall Painting, 1700–1850,* New York: Old Sturbridge Village, published in cooperation with Studio, 1952.

Novak, Barbara, *American Painting of the Nineteenth Century,* New York: Praeger, 1969.

Parry, Ellwood, *The Image of the Indian and the Black Man in American Art, 1590–1900,* New York: Braziller, 1974.

Quick, Michael, *American Expatriot Painters of the Late Nineteenth Century,* Dayton, Ohio: The Dayton Art Institute, 1976.

Richardson, Edgar, *American Romantic Painting,* New York: E. Weyhe, 1944.

Sears, Clara Endicott, *Highlights Among the Hudson River Artists,* Boston: Houghton Mifflin, 1947.

Soby, James Thrall, and Dorothy C. Miller, *Romantic Painting in America,* New York: Museum of Modern Art, 1943.

Stebbins, Theodore E., *American Master Drawings and Watercolors,* New York: Harper and Row, 1976.

Stein, Roger B., *Seascape and the American Imagination,* New York: C. N. Potter, 1975.

Sweet, Frederick A., *The Hudson River School and the Early American Landscape Tradition,* Chicago: Art Institute of Chicago, 1945.

Taft, Robert, *Artists and Illustrators of the Old West 1850–1900,* New York: Scribner's, 1953.

Whitney Museum of American Art, *A History of American Watercolor Painting,* New York, 1942.

Williams, Herman Warner, Jr., *Mirror of the American Past; A Survey of American Genre Painting: 1750–1900,* Greenwich, Conn.: New York Graphic Society, 1973.

Wilmerding, John, *A History of American Marine Painting,* Salem

and Boston: Peabody Museum and Little, Brown, 1968.

Worcester Art Museum, *Seventeenth-Century Painting in New England*, Louisa Dresser, ed., Worcester, Mass., 1935.

Wright, Louis B., George B. Tatum, John W. McCoubrey, and Robert C. Smith, *The Arts in America: The Colonial Period*, New York: Scribner's, 1966.

PAINTERS

ALLSTON Richardson, Edgar, *Washington Allston, a Study of the Romantic Artist in America*, Chicago: University of Chicago Press, 1948.

AUDUBON Adams, Alexander B., *John James Audubon, a Biography*, New York: Putnam, 1966.

Audubon, John James, *Audubon and His Journals*, Maria Audubon, ed., 2 vols., New York: Dover Publications, 1960.

Ford, Alice, *John James Audubon*, Norman: University of Oklahoma Press, 1964.

BIERSTADT Hendricks, Gordon, *Albert Bierstadt: Painter of the American West*, New York: Harry N. Abrams, Inc., 1975.

Trump, Richard Shafer, *The Life and Works of Albert Bierstadt*, unpublished Ph.D. dissertation, Columbus: Ohio State University, 1963.

BINGHAM Bloch, E. Maurice, *George Caleb Bingham*, Berkeley: University of California Press, 1967.

Christ-Janer, Albert, *George Caleb Bingham of Missouri; The Story of an Artist*, New York: Dodd, Mead, 1940.

BLAKELOCK Geske, Norman A., *Ralph Albert Blakelock, 1847–1919*, Lincoln: Nebraska Art Association, 1974.

BLYTHE Chambers, B. W., *David Gilmour Blythe: An Artist at Urbanization's Edge*, unpubl. Ph.D. diss., Philadelphia: University of Pennsylvania, 1974.

Miller, Dorothy, *The Life and Work of David G. Blythe*, Pittsburgh: University of Pittsburgh Press, 1950.

CASSATT Breeskin, Adelyn, *Mary Cassatt: A Catalogue Raisonné of the Oils, Pastels, Water-Colors and Drawings*, Washington, D.C.: Smithsonian Institution Press, 1970.

Bullard, E. John, *Mary Cassatt: Oils and Pastels*, New York: Watson-Guptill, 1972.

Carson, Julia, *Mary Cassatt*, New York: McKay, 1966.

Sweet, Frederick, *Miss Mary Cassatt, Impressionist from Philadelphia*, Norman: University of Oklahoma Press, 1966.

CATLIN Haberly, Lloyd, *Pursuit of the Horizon, a Life of George Catlin, Painter and Recorder of the American Indian*, New York: Macmillan, 1948.

CHASE Art Association of Indianapolis, John Herron Art Institute, *Chase Centennial Exhibition, Commemorating the Birth of William Merritt Chase*, Indianapolis, Ind., 1949.

Roof, Katherine Metcalf, *The Life and Art of William Merritt Chase*, 1917, reissued by Hacker Art Books, Inc., 1975.

CHURCH Huntington, David C., *The Landscapes of Frederic Edwin Church; Vision of an American Era*, New York: Braziller, 1966.

COLE Noble, Louis L., *The Course of Empire, Voyage of Life and Other Pictures of Thomas Cole, N.A.* (1853), republished, Cambridge: Belknap Press of Harvard University Press, 1964, as *The Life and Works of Thomas Cole*.

Wadsworth Atheneum, *Thomas Cole, 1801–1848, One Hundred Years Later*, Hartford, Conn., 1948.

COPLEY Prown, Jules David, *John Singleton Copley*, 2 vols., Cambridge: published for the National Gallery of Art by Harvard University Press, 1966.

DURAND Durand, John, *The Life and Times of A. B. Durand*, New York: Scribner's, 1894.

Lawall, David B., *A. B. Durand, 1796–1886*, Montclair, N.J.: Montclair Art Museum, 1971.

———, *Asher Brown Durand and His Art Theory in Relation to His Times*, unpubl. Ph.D. diss., Princeton, N. J.: Princeton University, 1966.

DURRIE Wadsworth Atheneum, *George Henry Durrie, 1820–1863, Connecticut Painter of American Life*, Hartford, Conn., 1947.

DUVENECK Cincinnati Museum Association, *Exhibition of the Work of Frank Duveneck*, Cincinnati: Cincinnati Art Museum, 1936.

Duveneck, Josephine W., *Frank Duveneck, Painter-Teacher*, San Francisco: J. Howell, 1970.

EAKINS Goodrich, Lloyd, *Thomas Eakins, His Life and Work*, New York: Whitney Museum of American Art, 1933.

Hendricks, Gordon, *The Life and Work of Thomas Eakins*, New York: Grossman Publishers, 1974.

Hoopes, Donelson F., *Eakins Watercolors*, New York: Watson-Guptill, 1971.

Porter, Fairfield, *Thomas Eakins*, New York: Braziller, 1959.

Schendler, Sylvan, *Eakins*, Boston: Little, Brown, 1967.

EARL Goodrich, Laurence B., *Ralph Earl, Recorder for an Era*, Albany: State University of New York Press, 1967.

Whitney Museum of American Art, *Ralph Earl, 1751–1801*, New York, 1945.

Sawitzky, William, *Ralph Earl, 1751–1801*, New York: Whitney Museum of American Art, 1945.

FEKE Foote, Henry Wilder, *Robert Feke, Colonial Portrait Painter*, Cambridge: Harvard University Press, 1930.

Whitney Museum of American Art, *Robert Feke*, New York, 1946.

HARNETT Frankenstein, Alfred, *After the Hunt; William Harnett and Other American Still Life Painters, 1870–1900*, rev. ed., Berkeley: University of California Press, 1969.

HEADE McIntyre, Robert G., *Martin Johnson Heade, 1819–1904*, New York; Pantheon, 1948.

Stebbins, Theodore E., *The Life and Works of Martin Johnson Heade*, New Haven: Yale University Press, 1975.

HESSELIUS Philadelphia Museum of Art, *Gustavus Hesselius, 1682–1755*, Philadelphia, 1938.

HOMER Gardner, Albert Ten Eyck, *Winslow Homer, American Artist, His World and His Work*, New York: C. N. Potter, 1961.

Goodrich, Lloyd, *Winslow Homer*, New York: published for the Whitney Museum of American Art by Macmillan, 1944.

———, *Winslow Homer*, New York: Whitney Museum of American Art, 1973.

Hoopes, Donelson F., *Winslow Homer Watercolors*, New York: Watson-Guptill, 1969.

Wilmerding, John, *Winslow Homer*, New York: Praeger, 1972.

HUNT Knowlton, Helen M., *Art Life of William Morris Hunt*, Boston: Little, Brown, 1900.

INNESS Cikovsky, Nicolai, *George Inness*, New York: Praeger, 1971.

Ireland, LeRoy, *The Works of George Inness; An Illustrated Catalogue Raisonné*, Austin: University of Texas Press, 1965.

McCausland, Elizabeth, *George Inness, An American Landscape*

Painter 1825–1894, New York: American Artists Group, 1946.

JOHNSON Baur, John I. H., *An American Genre Painter, Eastman Johnson, 1824–1906,* Brooklyn: Brooklyn Institute of Arts and Sciences, Brooklyn Museum, 1940.

Hills, Patricia, *Eastman Johnson,* New York: C. N. Potter, 1972.

KENSETT Howat, John K., *John Frederick Kensett, 1866–1872,* New York: Whitney Museum of American Art, 1968.

LA FARGE Cortissoz, Royal, *John LaFarge: A Memoir and a Study,* Boston: Houghton Mifflin, 1911.

Weinberg, Helene Barbara, *The Decorative Work of John LaFarge,* unpublished Ph.D. dissertation, New York: Columbia University, 1972.

LANE Wilmerding, John, *Fitz Hugh Lane,* New York: Praeger, 1971.

LEUTZE Groseclose, Barbara, *Emanuel Leutze, 1816–1868: A German American History Painter,* unpubl. Ph.D. diss., Madison, Wisc.: University of Wisconsin, 1973.

MORAN Wilkins, Thurman, *Thomas Moran, Artist of the Mountains,* Norman: University of Oklahoma Press, 1966.

MORSE Larkin, Oliver, *Samuel F. B. Morse and American Democratic Art,* Boston: Little, Brown, 1954.

MOUNT Cowdrey, Mary Bartlett, and Herman Warner Williams, Jr., *William Sidney Mount, 1807–1868, An American Painter,* New York: published for the Metropolitan Museum of Art by Columbia University Press, 1944.

Frankenstein, Alfred, *William Sidney Mount,* New York: Harry N. Abrams, Inc., 1975.

NEWMAN Landgren, Marchal E., *Robert Loftin Newman, 1827–1912,* Washington, D. C.: Smithsonian Institution Press, 1974.

PEALE Detroit Institute of Arts, *The Peale Family: Three Generations of American Artists,* Detroit, 1967.

Sellers, Charles Coleman, *Charles Willson Peale,* rev. ed., New York: Scribner's, 1969.

REMINGTON McCracken, Harold, *Frederic Remington, Artist of the Old West,* Philadelphia: Lippincott, 1947.

ROBINSON Johnston, Sona, *Theodore Robinson, 1852–1896,* Baltimore: The Baltimore Museum of Art, 1973.

RYDER Goodrich, Lloyd, *Albert P. Ryder,* New York: Braziller, 1959.

SARGENT Hoopes, Donelson F., *Sargent Watercolors,* New York: Watson-Guptill, 1970.

Mount, Charles Merrill, *John Singer Sargent; A Biography,* New York: Norton, 1955, reprinted by Kraus Reprint Company, 1969.

Ormond, Richard, *John Singer Sargent,* New York: Harper & Row, 1970.

Sweet, Frederick, *Sargent, Whistler, and Mary Cassatt,* Chicago: Art Institute, 1954.

SMIBERT Foote, Henry Wilder, *John Smibert, Painter,* Cambridge: Harvard University Press, 1950.

STUART Flexner, James, *Gilbert Stuart; A Great Life In Brief,* New York: Knopf, 1955.

Park, Lawrence, *Gilbert Stuart; An Illustrated Descriptive List of His Works,* 4 vols, New York: W. E. Rudge, 1926.

TRUMBULL Jaffe, Irma B., *John Trumbull,* Boston: New York Graphic Society, 1975.

Sizer, Theodore, *The Works of Colonel John Trumbull, Artist of the American Revolution,* rev. ed., New Haven: Yale University Press, 1967.

Trumbull, John, *The Autobiography of Colonel John Trumbull, Patriot Artist, 1756–1843,* New Haven: Yale University Press, 1953.

VANDERLYN Lindsay, Kenneth C., *The Works of John Vanderlyn, From Tammany to the Capitol,* Binghamton, N.Y.: Niles & Phipps, 1970.

WEIR Young, Dorothy Weir, *The Life and Letters of J. Alden Weir,* New Haven: Yale University Press, 1960.

WEST Evans, Grose, *Benjamin West and the Taste of His Times,* Carbondale: Southern Illinois University Press, 1959.

WHISTLER McMullen, Roy, *Victorian Outsider: A Biography of J. A. M. Whistler,* New York: Dutton, 1973.

Pennell, Elizabeth, and Joseph Pennell, *The Life of James McNeill Whistler,* 2 vols., London: Heinemann, 1908.

Sutton, Denys, *Nocturne: The Art of James McNeill Whistler,* London: Country Life, 1963.

Weintraub, Stanley, *Whistler: A Biography,* New York: Weybright and Talley, 1974.

SCULPTURE: GENERAL

Craven, Wayne, *Sculpture in America,* New York: T. Y. Crowell, 1968.

Gardner, Albert Ten Eyck, *American Sculpture: A Catalogue of the Collection of the Metropolitan Museum of Art,* Greenwich, Conn.: New York Graphic Society, 1965.

Taft, Lorado, *The History of American Sculpture,* 2 vols., new ed., New York: Macmillan, 1930.

200 Years of American Sculpture, Boston: David R. Godine, Publisher, in association with The Whitney Museum of American Art, 1976.

SCULPTURE: SPECIAL TOPICS

Brewington, Marion, *Shipcarvers of North America,* Barre, Mass.: Barre Publishing Company, 1962.

Bullard, Frederic, *Lincoln in Marble and Bronze,* New Brunswick, N.J.: Rutgers University Press, 1952.

Crane, Sylvia, *White Silence; Greenough, Powers, and Crawford, American Sculptors in Nineteenth-Century Italy,* Coral Gables, Fla.: University of Miami Press, 1972.

Forbes, Harriette, *Gravestones of Early New England, and the Men Who Made Them,* New York: Da Capo, 1967.

Gardner, Albert Ten Eyck, *Yankee Stonecutters: The First American School of Sculpture, 1800–1850,* Freeport, N.Y.: Books for Libraries Press, 1968.

Gerdts, William, *American Neo-Classic Sculpture; The Marble Resurrection,* New York: Viking Press, 1973.

Ludwig, Allan I., *Graven Images; New England Stone Carving and Its Symbols, 1650–1815,* Middletown, Conn.: Wesleyan University Press, 1966.

Pinckney, Pauline, *American Figureheads and Their Carvers,* New York: Norton, 1940.

Sharp, Lewis I., *New York Public Sculpture by 19th-Century American Artists,* New York: The Metropolitan Museum of Art, 1974.

Thorp, Margaret Farrand, *The Literary Sculptors,* Durham, N.C.: Duke University Press, 1965.

Wasserman, Jeanne L., ed., *Metamorphoses in Nineteenth-Century Sculpture,* Cambridge: Harvard University Press, 1975.

Whittemore, Frances, *George Washington in Sculpture,* Boston: Marshall Jones, 1933.

SCULPTORS

BALL Ball, Thomas, *My Three Score Years and Ten, An Autobiography,* Boston: Roberts Brothers, 1892.

BARNARD Dickson, Harold, "Barnard and Norway," *Art Bulletin,* vol. 44, March 1962, pp. 55–59.

———, "Barnard's Sculptures for the Pennsylvania Capitol," *Art Quarterly,* vol. 22, 1959, pp. 127–47.

BROWN Craven, Wayne, "Henry Kirke Brown: His Search for an American Art in the 1840's," *American Art Journal,* vol. 4, Nov. 1972, pp. 44–58.

———,"Henry Kirke Brown in Italy, 1842–1846," *American Art Journal,* vol. 1, Spring 1869, pp. 65–77.

CRAWFORD Gale, Robert, *Thomas Crawford, American Sculptor,* Pittsburgh: University of Pittsburgh Press, 1964.

FRENCH Cresson, Margaret French, *Journey into Fame: The Life of Daniel Chester French,* Cambridge: Harvard University Press, 1947.

Richman, Michael, *Daniel Chester French: An American Sculptor,* New York: The Metropolitan Museum of Art, 1976.

GREENOUGH Greenough, Horatio, *Form and Function,* Berkeley: University of California Press, 1947.

———, *Letters of Horatio Greenough, American Sculptor,* Madison: University of Wisconsin Press, 1972.

———, *The Travels, Observations, and Experiences of a Yankee Stonecutter* (1852), part 1, a facsimile reproduction, Gainesville, Fla.: Scholars' Facsimiles and Reprints, 1958.

Wright, Nathalia, *Horatio Greenough, The First American Sculptor,* Philadelphia: University of Pennsylvania Press, 1963.

POWERS Wunder, Richard P., *Hiram Powers, Vermont Sculptor,* Taftsville, Vt.: The Countryman Press, 1974.

———, "The Irascible Hiram Powers," *American Art Journal,* vol. 4, Nov. 1972, pp. 10–15.

REMINGTON McCracken, Harold, *Frederic Remington, Artist of the Old West,* Philadelphia, Lippincott, 1947.

RIMMER Whitney Museum of American Art, *William Rimmer, 1816–1879,* New York, 1946.

RINEHART Rusk, William, *William Henry Rinehart, Sculptor,* Baltimore: N.T.A. Munder, 1939.

ROGERS Rogers, Millard F., *Randolph Rogers; American Sculptor in Rome,* Amherst: University of Massachusetts Press, 1971.

Wallace, David, *John Rogers, the People's Sculptor,* Middletown, Conn.: Wesleyan University Press, 1967.

RUSH Marceau, Henri, *William Rush, 1756–1833, The First Native American Sculptor,* Philadelphia: Museum of Art, 1937.

SAINT-GAUDENS Cortissoz, Royal, *Augustus Saint-Gaudens,* Boston: Houghton Mifflin, 1907.

Saint-Gaudens, Augustus, *The Reminiscences of Augustus Saint-Gaudens,* 2 vols., ed. and amplified by Homer Saint-Gaudens, New York: Century Company, 1913.

Tharp, Louise Hall, *Saint-Gaudens and the Gilded Era,* Boston: Little, Brown, 1969.

STORY James, Henry, *William Wetmore Story and His Friends,* Boston: Houghton Mifflin, 1903.

WARD Sharp, Lewis I., "John Quincy Adams Ward; Historical and Contemporary Influences," *American Art Journal,* vol. 4, Nov. 1972, pp. 71–83.

486; Prairie House, pl. 620; River Forest Golf Club, 486–7, pl. 622; Rookery, The, detailing, 449; Winslow House, 486, pl. 621
WRIGHT, JOSEPH, 105, 179, 193, 214, 218; *Washington, George*, 221, pl. 313; *Wright Family, The*, 185, pl. 265
WRIGHT, PATIENCE LOWELL, 221
Wright Family, The, J. Wright, 185, pl. 265

WYANT, ALEXANDER, 555–6, 558, 610; *Arkville Landscape*, 556, pl. 693; *Mohawk Valley, The*, 555
Wyck House, near Philadelphia, 70
Wyckoff, Pieter, House, Brooklyn, N.Y., 27, pl. 32
WYMAN, GEORGE, H., 460; Bradbury Building, 460, pl. 578
Wynnestay House, near Philadelphia, 70

Y
Yale University, 277, 417, 429; Connecticut Hall, 53; Divinity School, R. M. Hunt, 429; Farnum Hall, R. Sturgis, 429; Library (Dwight Chapel), Austin, 278
Yates, Mrs. Richard, G. Stuart, 189, colorpl. 22
Yawger, Adrian V., House. *See* McAllister, James, House

Yeoman's House, Broughton, England, 18, pl. 14
YOUNG, AMMI B., 232, 242, 302, 316; Customs House, Boston, 242, pl. 329
Young Merchants, The, Page, 361–2, colorpl. 48

Z
Zenobia, Hosmer, 405

PHOTOCREDITS

Berenice Abbott, Abbott, Maine: 534, 540, 544; Addison Gallery of American Art, Phillips Academy, Andover, Mass.: 282, 690, colorplate 85; Albany Institute of History and Art: 433, 503, colorplates 9, 85; American Antiquarian Society: 43, 46, 300, 448; *American Architectural and Building News:* 328, 597; William W. Anderson, Concord, Mass.: 180; Wayne Andrews, Grosse Point, Mich.: 18, 59, 60, 63, 72, 81, 85, 104, 105, 107, 108, 117, 122, 125, 127, 131, 189, 195, 198, 209, 229, 322-324, 331-332, 351, 354, 356, 364, 366, 368, 372, 382, 384, 402, 525, 538, 539, 579, 600, 605, 608, 612, 613, 614, 621, colorplate 29; Archdiocese of Baltimore: 228, 367; Art Commission, City of New York: 429, 706, 712, 715; Arteaga Photos, St. Louis: 338; Art Institute of Chicago: 150, 434, 628, 646, 692, colorplates 67, 69; Atwater Kent Museum, Philadelphia: 245, 410, 530; Avery Architectural Library, Columbia University, New York: 3, 4, 5, 6, 7, 9, 11, 15, 19, 74, 89, 110, 112, 115, 118, 121, 123, 124, 126, 128, 133, 203, 206, 232, 240, 415, 516; Baltimore Museum of Art: 161; Baltimore & Ohio Railroad, Baltimore: 591; Barnum Museum, Bridgeport, Conn.: 405; Baton Rouge, La., Chamber of Commerce: 378; B. T. Batsford, National Monuments Record, London: 26; John Bayley, Landmarks Preservation Commission, New York: 374; Beake-Huntington, Springfield, Mass.: 526; Beinecke Rare Book and Manuscript Library, Yale University, New Haven: 411; Henry Beville, Washington, D. C.: colorplate 81; Lewis H. Bishop, Warsaw, N.Y. 373; Black Star Publishing, New York, Kosti Ruohomaa: 143; Irving Blomstrann, New Britain, Conn.: colorplate 87; Boatmen's National Bank, St. Louis, Mo.: 452; Bodleian Library, Oxford University: 57; George S. Bolster, Saratoga Springs, N.Y.: 523; Boston Atheneum: 273, 474, 486; Bostonian Society: 301, 325, 326, 327, colorplate 15; Boston Public Library: 617, 696, 697; Bowdoin College, Bowdoin, Maine: 386, colorplate 11; Brookline Historical Society, Mass.: 256; Brooklyn Museum: 154, 291, 641, 651, 658, 667, 686, colorplates 12, 26, 45, 46, 77; Milton W. Brown, New York: 185, 186, colorplates 58, 60, 62; Buffalo and Erie Historical Society, Buffalo, N.Y.: 545; Barney Burstein, Boston: 696, 697; Cambridge Historical Commission, Mass.: 360, 401; Carnegie Institute Library, Pittsburgh: 537; Carnegie Institute Museum of Art, Pittsburgh: 449; Carolina Art Association, Charleston: 86, 132, 133, 179, 241, 293, 311, 353, 408; Castle Museum, Nottingham: 149; Samuel Chamberlain, Nantucket, Mass.: 7, 98; Chase Home, Annapolis, Md.: 130; Chicago Architectural Photographing Service: 542, 553, 557, 560, 561, 566, 569, 572, 586; Chicago Histor-

ical Society: 552, 556, 562, 563, 564, 575, 585, 590, 595, 709, 722; Chichester Photographing Service: 96; Church of the Ascension, New York: 682; Cincinnati Art Museum, Ohio: 483, 655, colorplate 73; Cincinnati Historical Society, Ohio: 409; Geoffrey Clements, New York: 704, 724, 726, colorplates 34, 37, 38, 40, 41, 42, 43, 71, 72, 76, 83, 86, 90, 92; Cleveland Museum of Art, Ohio: 152, 164, 689, 693; Colonial Williamsburg, Va.: 58; H. Dunscombe Colt, New York: 173; Carl W. Condit, Evanston, Ill.: 558, 567, 570, 571, 573; Connecticut Historical Society, Hartford: 543; Corcoran Gallery of Art, Washington, D.C.: 463, 662, 718, 721; *Country Life,* London: 20, 120; William King Covell, Newport, R.I.; 379, 522; Culver Pictures, Inc., New York: 407; Charles F. Curry & Co., Kansas City, Mo.: 581; Henry Curtis, Newport, R.I.: 65, 267; George M. Cushing, Boston: 91, 183, 329, 371, 474, 485, 486; Dartmouth College Library, Hanover, N.H.: 257; Dwight Davis, Medford, Mass.: 97; Detroit Institute of Fine Arts, Mich.: 175, 280, 284, 420, 462, 652, colorplates 66, 88; James L. Dillon, Philadelphia: 314; Dyckman House Museum Association, Plainview, N.J.: 35; Eastern National Park & Monument Association, Philadelphia: 39, 61, 62; Herman Emmett, Baltimore, Md.: 496; Enoch Pratt Free Library, Baltimore: 239; Essex Institute, Salem, Mass.: 45, 59, 94, 101, 187, 188, 190, 191, 204, 345; Walker Evans, courtesy Museum of Modern Art, New York: 360; Jonathan Fairbanks, Wilmington, Del.: 394; Fairmount Park Commission, Philadelphia (A. J. Wyatt): 28; Federal Hall Memorial Association, New York: 330; Fogg Art Museum, Harvard University, Cambridge, Mass.: 155, 289, colorplates 13, 70; Charles Folger, Nantucket, Mass.: 349; Forbes Library, Northampton, Mass.: 584; Edwin Forrest Home, Philadelphia: 304, 305; Fort Worth Museum, Tex.: 644; Free Library of Philadelphia, Pa.: 381, 530, 532; Freer Gallery, Washington, D. C., Smithsonian Institution: 623; Daniel Chester French Museum, Stockbridge, Mass.: 713; Frick Art Reference Library, New York: 665; Louis H. Frohman, Bronxville, N. Y.: 533; Isabella Stewart Gardner Museum, Boston: 639; Philip Gendreau, New York: 410; Georgia Historical Society, Savannah, Ga.: 247; James Gibbs, *A Book of Architecture,* London, 1728: 74, 89, 124, 225; Glasgow Art Gallery, Scotland: 625; Gottscho-Schleisner, New York: 413; Gore Place, Waltham, Mass.: 202, colorplate 16; Greater London Council: 73; Grand Lodge of Free and Accepted Masons, Philadelphia: 303; Harris Photos, St. Augustine, Fla.: 50, 51; Harvard University News Office, Cambridge, Mass.: 69, 71; Haverhill Historical Society, Mass.: 246; Hedrich-Blessing, Chicago,

Ill.: colorplate 56; Heritage Foundation, Deerfield, Mass.: 258, 259; Hirschl and Adler Galleries, New York: 677; Historical Society of Wilmington, Del.: 38; Historical Society of Pennsylvania, Philadelphia: 83, 109, 153, 163, 168, 227, 286, 370; John Hopf, Newport, R.I.: 521; Cortland V.D. Hubbard, Philadelphia: 31, 317, 554; Illinois Conservation Department, Springfield, Ill.: 140; Independence National Historical Park Collection, Philadelphia: 306, colorplate 5; Jefferson Medical College, Philadelphia: 642; Joslyn Art Museum, Omaha, Neb.: 458; Kennedy Gallery, New York: 461, colorplate 75; Kentucky Historical Society, Frankfort: 339, 340; A. F. Kersting, London: 93, 113; Courtesy Fiske Kimball: 102, 115, 121, 123, 126, 206; Knoedler & Co., New York: 290; Richard Koch, New Orleans, La. (for Tulane University Library): 365; Krantzen Studio, Inc., Chicago, Ill. (for Rand McNally Co.): 565; *Ladies' Home Journal,* February, 1901: 620; Landmarks Preservation Commission, New York: 344; Samuel Lauver, Baltimore: 298; Lenox Library Association, Mass.: 609; Lensmen Ltd., Dublin: 224; Library of Congress, Washington, D. C.: 25, 34, 64, 70, 87, 114, 119, 129, 139, 141, 199, 214, 216, 218, 219, 220, 221, 230,236, 248, 249, 296, 297, 309, 315, 316, 319, 335, 336, 346, 355, 358, 361, 362, 378, 390, 481, 482, 493, 519, 701, 710, 719; Litchfield Historical Society, Conn.: 254, 255; Long Island Historical Society, Brooklyn, N.Y.: 32, 33; Louisiana State Museum, New Orleans: 142, 144; Lyndhurst, Tarrytown, N.Y. (National Trust for Historic Preservation): 383; Maine Historical Society, Portland: 171; Manley Commercial Photography, Inc., Tucson, Ariz.: 138; C.M. Manthorpe, S. Charleston, W. Va.: colorplate 2; Marblehead Historical Society, Boston: 99, 100; Louis S. Martel, Waterford, Conn.: 546; Maryland Historical Society, Baltimore: 193, 207, 215, 222, 223, 226; Maryland Institute, Baltimore: 496; Massachusetts Historical Society, Boston: 29, 145, 182, 211; Richard Merrill, Melrose, Mass.: 194; Metropolitan Museum of Art, New York: 2, 41, 160, 176, 196, 251, 263, 268, 271, 275, 278, 279, 281, 425, 426, 428, 441, 443, 451, 464, 465, 469, 470, 472, 476, 478, 487, 488, 489, 492, 497, 498, 501, 502, 506, 515, 627, 629, 630, 631, 635, 636, 645, 649, 653, 654, 661, 663, 666, 673, 676, 681, 683, 688, 691, 694, 700, 707, 716, 724; Edward Michael, Utica, N.Y.: 708; Michigan Department of State Archives, Lansing: 359; Minneapolis Institute of Arts, Minn.: 432; *Minneapolis Star,* Minn.: 577; Missouri Botanical Garden, St. Louis (Claude Johnston): 406; Missouri Historical Society, St. Louis: 389; Monterey History and Art Association, Cal.: 250; Courtesy Hugh Morrison: 3, 5, 8, 11, 15, 30, 110,

112, 118, 128; Moss Archives, Seabright, N.J.: 602; Munson-Williams-Proctor Institute, Utica, N.Y.: 424; Museum of Art, Rhode Island School of Design, Providence: 156, 334, 350, 388, 391, 398; Museum of the City of New York: 36, 213, 380, 403, 414, 417, 550, 551, 580, 583; Museum of Fine Arts, Boston: 158, 274, 283, 288, 422, 437, 471, 479, 480, 504, 505, 528, 640, 660, 671, 674, 680, 684, 685, colorplates 25, 39, 50, 68; Museum of Modern Art, New York: 360, 587; Museum of New Mexico, Santa Fé 55; National Archives, Washington, D. C.: 212; National Collection of Fine Art, Smithsonian Institution, Washington, D.C.: 455, 456, 500, colorplates 80, 82; National Cowboy Hall of Fame, Oklahoma City, Okla.: colorplate 93; National Gallery of Art, Washington, D.C.: 162, 165, 253, 272, 442, 466, 633, 687, colorplates 22, 65; National Gallery of Canada, Ottawa: colorplate 14; National Maritime Museum, Greenwich, England: 157; National Park Service, Department of the Interior, Philadelphia: 243, 244, 511, 698; National Portrait Gallery, London: 151; Nelson-Atkins Museum of Fine Arts, Kansas City, Mo.: colorplate 27; Newark Museum of Art, N.J.: 477, 725; New London County Historical Society, Conn.: 546; New Milford Historical Society, Conn.: 260, 261; New Mexico Department of Development, Santa Fé: 52, 53; New-York Historical Society, New York: 40, 147, 148, 172, 252, 262, 264, 312, 387, 439, 484, 507-509, 517, 527, 549, 582, 619, 650, 703, colorplates 36, 47, 51; New York Public Library, New York: 271, 426; New York State Historical Association, Cooperstown: 357, 439, 446, 659; Richard Nickel, Chicago: 574; North Carolina Museum of Art, Raleigh: 512; North Carolina State Department of Archives, Raleigh: 294; Edward Nowak, New York: 589; Ohio Chamber of Commerce, Columbus: 343; Old Print Shop, New York: 377, 440; *Old Time New England,* XXI, No. 1., July, 1930 (SPNEA): 22; Oneida Historical Society, Utica, N.Y. (Munson-Williams-Proctor Museum): 396, 397; Peabody Museum, Cambridge, Mass.: 457; Peabody Museum, Salem, Mass.: 299; Peale Museum, Baltimore: 295, 416, 548; Penn Central Co., New York: 588; Penn Central Co., Philadelphia: 593a; Pennsylvania Academy of The Fine Arts, Philadelphia: 265, 266, 270, 287, 308, 637, 656, 657, colorplates 24, 48, 49, 79, 84; Pennsylvania Historical Society, Philadelphia: 531; Pennsylvania History and Museum Commission, Harrisburg, Pa.: 37; Pennsylvania Hospital, Philadelphia: 468; Philadelphia Historical Commission: 593a; Philadelphia Museum of Art: 106, 111, 167, 304, 305, 307, 627, 638, 642, 643, 664, 669, colorplate 20; Philadelphia Office of the City Representative: 520; Phillips

Academy, Andover, Mass.: 201; Phillips Collection, Washington, D. C.: 648, colorplate 81; Photocraft, Savannah, Ga.: 247; Piaget, St. Louis, Mo.: 453; James Pierce, Brunswick, Me.: colorplate 11; Pilgrim Society Collection, Plymouth, Mass.: 47; Pioneer Village, Salem, Mass.: 1; Pittsburgh Historical & Landmarks Foundation, Pa.: 536; Eric Pollitzer, New York: 423, colorplates 33, 46; Portland Museum, Maine: 491; Preservation Society of Newport County, R.I.: 67, 80, 400, 596, 607, 615, 616; Princeton Art Museum, N.J.: 395, colorplate 74; Redwood Library, Newport, R.I.: 267; Reynolda House, Inc., Winston Salem, N.C.: 670; Rhode Island Historical Society, Providence: 334; Ernest J. Rosenfeld, New York: 538; St. Augustine Historical Society, Fla.: 50, 51; St. Louis Art Museum, Mo.: 174, 454, 459, 634; St. Louis Mercantile Library Association, Mo.: 453, 499; E.T. Sale, *Interiors of Virginia Houses of Colonial Times*: 116; Sandak, Inc., Stamford, Conn.: 10, 13, 16, 17, 23, 24, 54, 76, 77, 134, 135, 200, 208, 235, 242, 369, 513, 541, 555, 604, 702, 714, colorplates 1, 4, 6-8, 18, 19, 30-32, 52, 54, 55, 57, 59, 61, 63, 89; Schopplein Studio, San Francisco, Cal.: colorplate 78; Service Photographique des Musées Nationaux, Paris: 467; G. W. Sheldon: *Artistic Country Seats*, Appleton, New York: 598, 599, 601, 603; Julius Shulman, Los Angeles: 578; Les Smith, Natick, Mass.: colorplate 91; Mason Philip Smith, Portland, Maine: 171; Smith College, Northampton, Mass.: 699; Smithsonian Institution, Washington, D.C.: 302; Society for the Preservation of New England Antiquities, Boston: 12, 21, 27, 28, 78, 79, 84, 92, 181, 205, 352, 473; State of Connecticut Development Commission, Hartford: 529; State Historical Society of Missouri, Columbia: 338; State Historical Society of Wisconsin, Madison: 547; S.G. Stoney, *Plantations of the Carolina Low Country*: 133; Studio 3 Photographics, Charleston, S.C.: 184; Suffolk Museum and Carriage House, Stony Brook, N.Y.: 444; J.N. Summerson, *Architecture in Britain*: 14; Tate Gallery, London: 624; Taylor and Dull, New York: 210; Taylor Museum, Colorado Springs, Colo.: 56; Edward Teitelman, Camden, N.J.: 392, 404, 592; Terminal Railroad Association of St. Louis, Mo.: 594a; Texas Parks & Wildlife Department, Austin: 136, 137; Toledo Museum of Art, Ohio: 695; Trinity College, Hartford, Conn.: 435; Tulane University Library, New Orleans, La.: 337, 365; Charles Uht, New York: 717; Union College, Schenectady, N.Y.: 524; United States Geodetic Service, Washington, D.C.: 214; University of Pennsylvania, Philadelphia: 647; University of Virginia, Information Service, Charlottesville: 234, colorplate 17; Vassar College, Poughkeepsie, N.Y.: 518; Virginia Museum of Fine Arts, Richmond: 348; Virginia State Chamber of Commerce, Richmond (P. Flournoy): 292; Virginia State Library, Richmond: 494, 495, 514; Vose Galleries, Boston: 435; Wadsworth Atheneum, Hartford, Conn.: 166, 421; Wakefield Historical Society, Mass. (Donald T. Young): 178; Walker Art Center, Milwaukee, Wis.: 436; Walters Art Gallery, Baltimore: 447, colorplate 44; Washington & Lee University, Lexington, Va.: 269; T.T. Waterman, *The Mansions of Virginia*, University of North Carolina Press: 19; Webb Gallery of American Art, Shelburne Museum, Vt.: 460; E. M. Weil, Albany, N.Y.: 535; F. Peter Weil, Chicago: 559; Whitney Gallery of Western Art, Cody, Wyo.: 723; Wichita Art Museum, Kans.: 450; William J. Williams, Cincinnati, Ohio: 672; The Henry Francis du Pont Winterthur Museum, Winterthur, Del: 159, 170, 313; Wisconsin State Historical Society, Menomenie: 547; Worcester Art Museum, Mass.: 44, 177, 285, 431, 679, colorplates 3, 35; Richard Wurts, Litchfield, Conn.: 88, 375, 376, 568, 611; A. J. Wyatt, Philadelphia: colorplates 20, 28; Yale University Art Gallery, New Haven, Conn.: 146, 169, 276, 277, 310, 490, 632, 668, colorplates 10, 21, 23; F. R. Yerbury, Newbury, England: 14; Bob Zucker, Yonkers, N.Y.: 705.